Perspective Drawing

PERSPECTIVE DRAWING
A Step-by-Step
Handbook

MICHAEL E. HELMS

Purdue University

Prentice Hall, Englewood Cliffs, New Jersey 07632

Library of Congress Cataloging-in-Publication Data

HELMS, MICHAEL E.
 Perspective drawing: a step-by-step handbook/Michael E. Helms.

 p. cm.
 ISBN 0-13-659293-7
 1. Perspective. 2. Drawing—Technique. I. Title.
NC750.H45 1990 89-22795
720′.28′4—dc20 CIP

Editorial/production supervision and
 interior design: Mary Anne Shahidi
Cover design: Wanda Lubelska
Manufacturing buyer: Mary Noonan/Denise Duggan
Page layout: Bob Wullen

The author and publisher of this book have used their best efforts in preparing this book. These efforts include the development, research, and testing of the theories and programs to determine their effectiveness. The author and publisher make no warranty of any kind, expressed or implied, with regard to these programs or the documentation contained in this book. The author and publisher shall not be liable in any event for incidental or consequential damages in connection with, or arising out of, the furnishing, performance, or use of these programs.

Printed in the United States of America
10 9 8 7 6 5 4 3 2

ISBN 0-13-659293-7

Prentice-Hall International (UK) Limited, *London*
Prentice-Hall of Australia Pty. Limited, *Sydney*
Prentice-Hall Canada Inc., *Toronto*
Prentice-Hall Hispanoamericana, S. A., *Mexico*
Prentice-Hall of India Private Limited, *New Delhi*
Prentice-Hall of Japan, Inc., *Tokyo*
Simon & Schuster Asia Pte. Ltd., *Singapore*
Editora Prentice-Hall do Brasil, Ltda., *Rio de Janeiro*

Contents

Chapter 8 Modified Visual Ray Technique 224

PART 3: ARCHITECTURAL SHADES AND SHADOWS

Chapter 9 Oblique Shades and Shadows 240

Chapter 10 Multi-view Shades and Shadows 297

Glossary of Abbreviations 337

Index 339

PART 4: LAB EXERCISES 341

Preface

I have been asked on more than one occasion why I am writing a book on perspective drawing. With the advancement of computer technology and the availability of new software dealing with perspective drawing, this question is a valid one.

The computer is a wonderful new tool, and it should be included in the array of tools that are available to the architectural illustrator. The obvious advantage of using the computer is that once the wire-frame perspective is complete, you can change your viewing point and obtain different views of the structure. However, it has been my experience that most projects require only one view of the structure. If this view is chosen wisely, it will be the most appropriate view of the structure.

The ability initially to design the perspective setup so that the final perspective will show the structure to its best advantage is an invaluable skill. Understanding the interrelationships between the variables that affect the design of the perspective setup is very important, whether you are drawing the perspective with the computer or drawing it manually. The need for this basic knowledge and also the need to expose further the perspective plan method of drawing perspectives were two of the reasons why I felt this book would be useful.

The perspective plan method has long been recognized as the more professional way to draw perspectives, but this method has been ignored by many authors. These same authors acknowledge the existence of this method, but they also state that only experienced illustrators should use it. I disagree. Therefore, I have included in this book a detailed discussion of the perspective plan method.

Seventeen years of professional experience creating architectural renderings and fourteen years of experience teaching the same techniques have given me a good insight into both areas. I have tried to include in this book the techniques which work both on the job and in the classroom. The book's step-by-step format has good application in the classroom. Each step or statement is illustrated in an adjacent figure. I have used this book in my classes with excellent results.

Another reason for writing this book was the need to go back to the basics when constructing shadows on an architectural rendering. Many shortcuts have been tried, but very few actually work. The concept of intersecting planes is the foundation for all shade and shadow methods. This concept is fully explained; therefore, the process of constructing shadows should be more logical and considerably easier.

This book includes the following four parts: exterior perspective drawing, interior perspective drawing, architectural shades and shadows, and lab exercises. The three major parts of the book are independent of each other; thus, each area can be studied separately.

Basic information and theories are presented first in each part, and then detailed examples, fully illustrated, are presented to give the reader particular information on each technique. Each individual step is explained verbally and visually. The verbal explanation of each step and the visual representation of that step are identified by the same number. Also, the most important information is presented in a series of numbered statements.

Part Four contains specially designed lab exercises. Each chapter has designated lab exercises. Each lab sheet is designed to give the student specific practice with a particular concept, be it measuring points, vanishing points, or inclined horizon lines. The student works the labs on the tear-out exercise sheets. An entire semester's course could be designed strictly by using these lab sheets. It is suggested, however, that each instructor supplement these sheets with individual problems or projects that are unique to his or her particular class.

This book is designed to be used as instructional material at the junior college or college level. Institutions having schools of architecture or engineering graphics departments as well as technical schools offering architectural drafting programs should be interested in this text. Professionals wanting to improve their perspective drawing skills will find this book helpful, also.

I would like to acknowledge the eminent contribution that my wife has made to this project. Without her help and understanding, this book would not have been possible. Thank you, Marcy, for everything.

Perspective
Drawing

PART 1
EXTERIOR PERSPECTIVE

1

Introduction

Part One gives the reader a practical approach for setting up and drawing an exterior perspective. This unit is based on the author's fifteen years of professional and teaching experience with this subject.

It is important that the basic theory behind perspective drawing be understood. For without this understanding it would be impossible for one to become truly proficient with this skill. Therefore, in this text new terms will be defined and their theoretical importance to the process will be discussed.

Typically, a class assignment in perspective drawing involves a problem in which the perspective is already set up. The problem is given to the students, and they follow the instructions and draw the perspective.

The students learn to work this type of perspective problem; however, they do not really understand how to set up a perspective themselves. This understanding comes from studying the theoretical basis of perspective drawing and from actually designing the perspective setup.

The first part of this text discusses the process used in designing the typical perspective setup. The process begins with the student or professional receiving a set of blueprints of a structure which is to be drawn in perspective. After the discussion with the client, the following decisions must be made about the design of the perspective setup:

1. From what angle will the structure be viewed?
2. What will be the most appropriate eye level?
3. How dramatic should the perspective be?
4. What is an appropriate size for the final perspective drawing?

The answers to these questions will dictate the design of the setup.

This design process involves the relationship between the following component parts of the setup: the object, the cone of vision, the picture plane, the station point, the horizon line, the ground line, the horizontal measuring line, the vanishing points, and the measuring points. Each component part of the perspective setup will be discussed at length here.

After one has designed the setup to fulfill the requirements of the project, the next step is to draw the actual perspective. The discussion presented at this point will take the reader through the step-by-step procedure of drawing the perspective by the perspective plan method.

The perspective plan method is presented in lieu of the more popular visual ray method. Most textbooks cover the visual ray method in great length but acknowledge that most professional illustrators use the perspective plan method. As a professional freelance illustrator, I have used the perspective plan method exclusively for producing complicated formal presentation drawings.

By using the perspective plan method, the artist greatly increases his or her flexibility. With the visual ray method, one must draw the perspective at the same scale as the elevation drawings. This is not true with the perspective plan method. The preliminary sketch used to design the perspective setup can be drawn at one scale, the elevations can be drawn at another scale, and the final perspective can be drawn at yet another scale.

Following the section on the step-by-step drawing of the perspective, a number of basic perspective drawing techniques will be discussed. These are specific techniques which were not mentioned in the previous sections but which are very important to drawing perspectives. With the ability to execute these particular techniques and the ability to design the perspective setup, the student should be able to draw a variety of complicated perspectives.

1.1 NECESSARY EQUIPMENT

Using the right tools makes any task easier, and perspective drawing is no exception. The following is a list of equipment and materials needed for drawing perspectives. Some exercises concerning the use of the equipment will be given.

T Square (24″ or 48″). See Fig. 1–1.

The 24″ T square is adequate for smaller projects; however, larger projects require the 48″ T square. The larger T square can also be used as a straight edge when drawing receding lines on a small project. See Fig. 1–2.

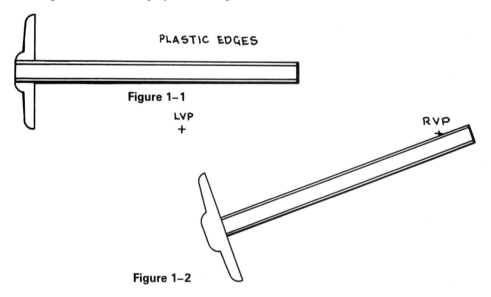

PLASTIC EDGES

Figure 1–1

LVP
+

RVP
+

Figure 1–2

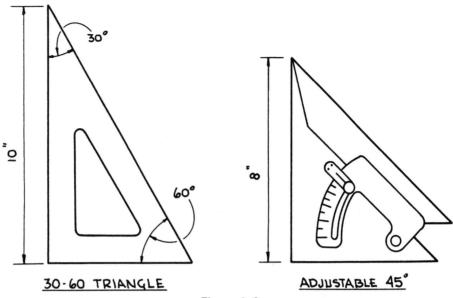

Figure 1–3

Triangles (30°–60° and adjustable 45°). See Fig. 1–3.

The adjustable 45° triangle is a very useful tool. With this one triangle you can draw angled lines from 1° to 90°. If you have not used it before, it can be somewhat confusing. There is an overlapping scale on the triangle. See Fig. 1–4. The readings begin at 0°–90° at the bottom of the scale and continue up to 45°–45° at the top. Located close to a thumb screw is a line which indicates the angle at which the triangle is to be set. See Fig. 1–5.

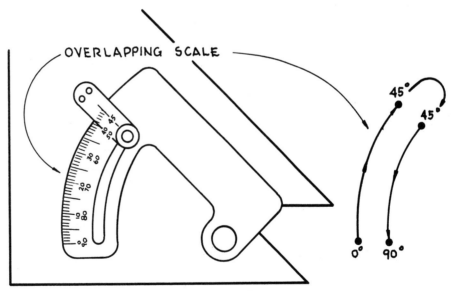

Figure 1–4

EXERCISE 1

Loosen the thumb screw and set the indicator line at 70°. Tighten the screw. The triangle is now set not only at 70°, but also at 20°. See Fig. 1–5. If you were to set the triangle at 10°, it would also be set at 80°. This is the effect of the overlapping scale. The two angles created with the one setting will always add up to 90°.

Confusion sometimes occurs after you have the triangle set at the desired angle, in this case 70°. You must now manipulate the triangle in relation to your T square in order

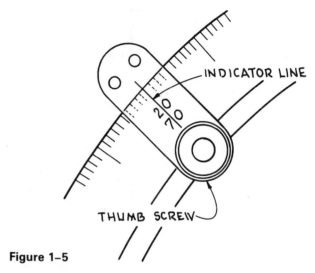

Figure 1–5

to draw the 70° angle in the desired direction. The 70° angle with the horizontal can go either right or left and either up or down. With the triangle sitting upright on your T square, the straight edge of the adjustable arm will give you a 70° line going to the upper left. See Fig. 1–6.

To draw a 70° line going to the upper right, you need to rotate the triangle to the right so that it is resting on the adjustable arm. See Fig. 1–7. Figures 1–8 and 1–9 show how the triangle must be positioned in order to draw the 20° angled lines.

Common sense will tell you most of the time how the triangle must be positioned in order to draw the desired angle. The closer the desired angle comes to 45°, the more difficult it becomes to distinguish between the two angles.

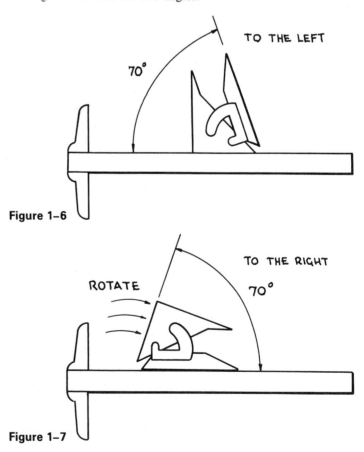

Figure 1–6

Figure 1–7

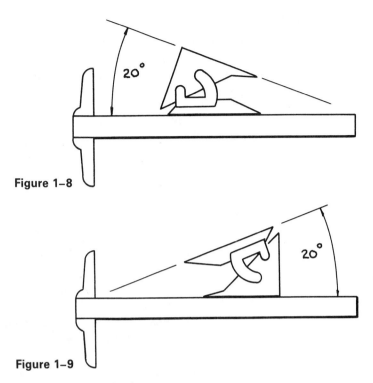

Figure 1-8

Figure 1-9

Scales (Architectural and Engineering)

It is impossible to draw accurate perspective drawings without knowing how to use the architectural and engineering scales. Which device you use depends on the type of perspective you are drawing. Larger projects require use of the engineering scale, while most smaller projects require use of the architectural scale. The architectural scale is the most frequently used.

There are many different types of architectural scales, but the most popular type is the triangular-shaped device. See Fig. 1–10. Like the adjustable triangle, the architectural scale is a very useful tool. It, too, can be confusing to use, however. This device has three sides on which are eleven different scales. These scales range from the smallest—3/32″ = 1′-0—to the largest—3″ = 1′-0. The other scales are 1/8″, 3/16″, 1/4″, 3/8″, 1/2″, 3/4″, 1″, 1 1/2″, and full. Most of the confusion occurs because there are overlapping scales on each edge of the device. A closer look at one edge will help you understand the proper procedure for using this device. See Fig. 1–11.

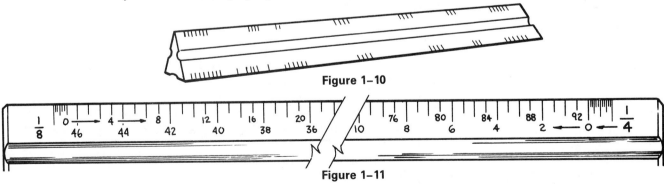

Figure 1-10

Figure 1-11

Let's look at the edge that has the 1/4″ and 1/8″ scales. This edge, which is typical of the others, has the 1/4″ = 1′-0 scale starting at the zero on the right and running to the left. The 1/8″ = 1′-0 scale starts at the zero on the left and runs to the right. Notice that the zero on the 1/4″ end is positioned lower than the zero on the 1/8″ end. Also, the numbers that belong to the 1/4″ scale are physically larger than the numbers on the 1/8″

scale. The 1/4″ scale numbers run in this sequence: 0, 2, 4, 6, 8, and so on, up to 46. All these numbers line up horizontally with the zero on the 1/4″ end. The 1/8″ scale numbers run in this sequence: 0, 4, 8, 12, 16, and so on, up to 92. All these numbers line up horizontally with the zero on the 1/8″ end. The missing numbers in these sequences were omitted for the sake of clarity.

Between the zeros the scale is divided into feet. To the right of the 1/4″ zero and to the left of the 1/8″ zero the scale is divided into inches. Because of the small size of the 1/8″ scale, each division to the left of the zero equals two inches. Because of the larger size of the 1/4″ scale, there is adequate space to the right of the zero to represent each inch. Therefore, the larger the scale used, the more accuracy you can achieve. In fact, the 3″ = 1′-0 scale is accurate to 1/8″.

EXERCISE 2

The procedure to use when measuring a given line is the following. You want to measure line AB in Fig. 1–12 using the 1/4″ = 1′-0 scale.

Step 1. See Fig. 1–12.

 1a. You begin to measure line AB by putting the zero in the 1/4″ scale at the right end of the line.

 1b. Look to see where the left end of the line falls. In this case, it falls between the 12′ and 11′ marks.

Step 2. See Fig. 1–13.

 2a. When the end of the line falls between two foot indicators, always shift the scale so that the end of the line moves to the smaller of the two numbers. In this case the scale is moved to the left to line up point A with the 11′ mark.

 2b. This shift will place the opposite end of the line (point B) within the inch indicators. You can now determine the length of the line at the 1/4″ scale. Line AB is 11′-9″ long.

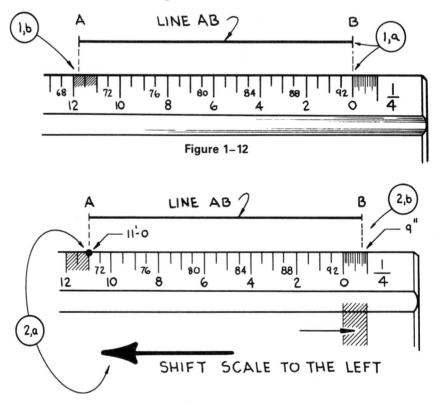

Figure 1–12

Figure 1–13

This same procedure is used regardless of the scale you are using.

The engineering scale looks physically identical to the architectural scale. Upon closer examination, however, you will see the scales represented on the engineering scale are different. These scales are $1'' = 10'$, $20'$, $30'$, $40'$, $50'$, and $60'$. Obviously, these scales are much smaller than the scales represented on the architectural scale.

The engineering scale is much easier to use because there are no overlapping scales on this device. The individual scales read from left to right. Because these scales are so small, there are no inch indicators, only foot indicators. To measure the length of a line, you put the zero on one end of the line and read the measurement on the opposite end. See Fig. 1–14.

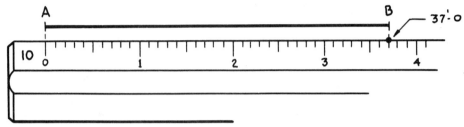

Figure 1–14

Long Straight Edge

The best long straight edge looks like the horizontal part of a T square. See Fig. 1–15. You can obtain these from mail order houses in lengths of $5'$ to $8'$. If obtaining one is inconvenient, then a metal yardstick or meter stick can be used. Wooden yardsticks are usually not straight enough.

When drawing a very large perspective, you may need a longer straight edge than you have. In this case, you could use some fishing line, a thumb tack, and a piece of tape. When using these materials to assist you in drawing lines to a distant vanishing point, first find your vanishing point. Next, because you don't want to put a hole in your drawing table, take a thumb tack and push it through a piece of masking tape from the sticky side. See Fig. 1–16A. Then tape it to your table so that the vertical part of the tack is protruding directly over the vanishing point. See Fig. 1–16B. Then tie the fishing line to the tack. See Fig. 1–16C.

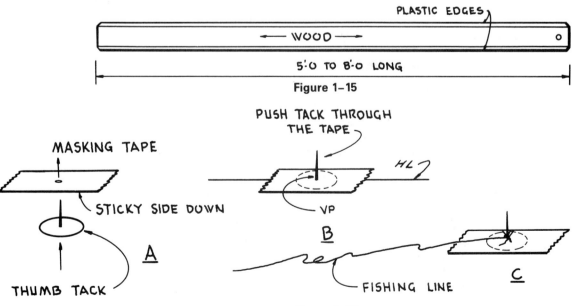

Figure 1–15

Figure 1–16

When drawing a line through a point (A) from the long vanishing point, pull the string taut and mark two dots (C and D) approximately 4″ apart along the taut string. See Fig. 1–17. Remove the string and with a short straight edge draw the line.

This inverted thumb tack technique works well with conventional straight edges as well. You might want to lay an eraser on top of the tack to protect yourself. See Fig. 1–18.

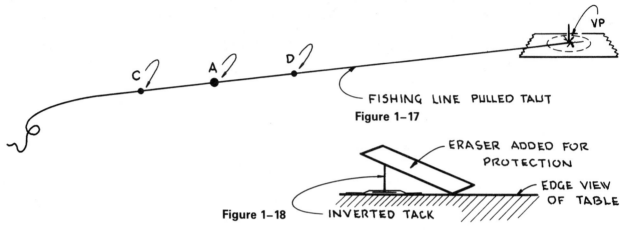

Figure 1–17

Figure 1–18

Drawing Table

Drawing a variety of perspectives requires a rather large drafting table. Minimum size should be 4′, but the ideal size would be 8′ to 10′. The surface should be slanted or adjustable and should be covered with a board cover of good quality.

Drafting Tape

A 1/2″ wide masking tape of good quality should be used.

BAD POINT

GOOD POINT
Figure 1–19

Drawing Lead (2H and 6H)

A mechanical drafting pencil should be used. This device allows you to interchange leads. Use a 2H lead while drawing the perspective. You should always keep a sharp point on the pencil. Many errors are committed because of a dull point. The best point has a long taper. See Fig. 1–19. This type of point stays sharper longer.

You should use a harder lead (5H or 6H) when transferring the completed perspective. Again, a sharp point is essential.

Lead Pointer

It is not necessary to buy an expensive pencil sharpener. The small hand-held lead pointers are quite effective. See Fig. 1–20. Their smaller size makes these sharpeners very convenient to carry and easy to store.

Graphite Paper (Transfer Paper)

Many times after you have drawn the perspective you will need to transfer it onto a piece of board. This could be bristol board for inking, or it could be illustration board or mat board for painting. In any case, you will want to transfer the perspective without leaving a residue that might hinder the inking or painting process. Most, if not all, commercial transfer paper leaves a waxy residue on the board.

One of the best transfer papers you can make yourself. The following items are required:

Figure 1–20

1. Newspaper
2. 18″ × 24″ drawing paper of good quality

3. Graphite from your lead pointer
4. Rubber cement *thinner*
5. Paper towels

The following is the procedure for making this graphite transfer paper.

Step 1. See Fig. 1–21.

1a. Spread newspaper out on a table. This is to keep the excess graphite off the table. You may prefer to do this on the floor.

1b. Lay the 18″ × 24″ drawing paper in the center of the newspaper.

1c. Take the top off your lead pointer and dump some graphite in the middle of the drawing paper.

1d. Pour some rubber cement *thinner* onto the graphite. Don't worry about its running all over—it will evaporate in a matter of seconds.

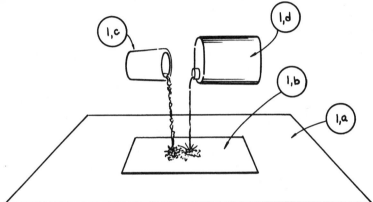

Figure 1–21

Step 2. See Fig. 1–22.

2a. Take some paper toweling and spread the mixture of graphite and thinner onto the paper. You will probably have to add more graphite and thinner as you proceed to cover the entire 18″ × 24″ sheet of paper with a smooth, even coat of graphite. Once this is complete, take a clean piece of toweling and rub off all the excess graphite. Begin in the middle of the paper with strokes to the edges. Use some pressure with these strokes. You should now have a fairly even, grey covering of graphite. Because you will probably get some graphite on the back of the paper, turn it over and wipe it off as well.

Take an Ex-acto knife and cut the graphite paper into two pieces (18″ × 12″). If done properly, these sheets of graphite transfer paper should last for years. They are ideal for transferring perspectives to ink or paint because they leave no residue on the board surface.

Soft Eraser

Drawing Paper (18″ × 24″)

Tracing Paper (Transparent)

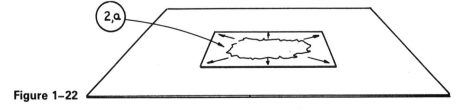

Figure 1–22

1.2 PROGRESSION IN REALISTIC DRAWING

There are basically three major groups of drawings:

1. Multi-view orthographic
2. Paraline ⎤
3. Perspective ⎦ — Pictorial Drawings

Of the three types, multi-view drawings are the least realistic. In fact, normally, one multi-view drawing will not effectively represent a given object. A sequence of multi-view drawings is usually required to describe the object fully.

The multi-view drawings are generated by viewing the object directly (straight on) from the sides, the top, and the bottom. It is similar to viewing the object through a glass box. See Fig. 1–23. Project the image seen on each side of the object to the glass box using lines of projection that are perpendicular to the glass walls. Next, unfold the box to view all the sides at once. See Fig. 1–24. With the sides unfolded, you see the

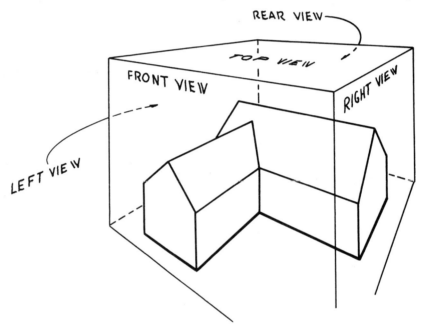

Figure 1–23

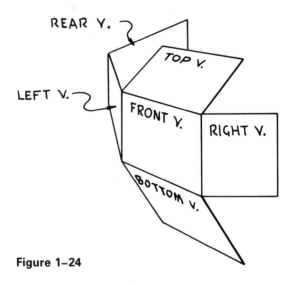

Figure 1–24

standard alignment for multi-view drawings. See Fig. 1–25. Notice how the top, front, and bottom views line up vertically and the rear, left side, front, and right side line up horizontally. This alignment must be maintained at all times. The vertical spacing between the top, front, and bottom views can vary. (Notice the arrows in Fig. 1–25.) Also, the horizontal spacing between the rear, left side, front, and right side views can vary. The relationship between the top and front views is very important when discussing the typical perspective setup. This relationship will be discussed in great detail later.

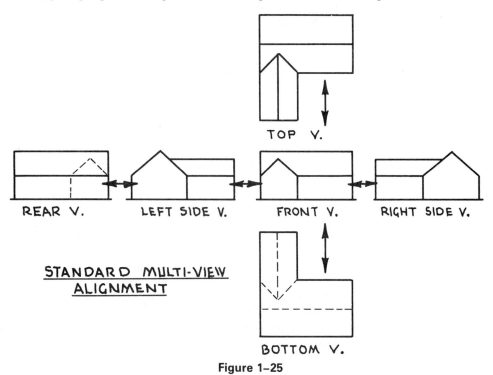

TOP V.

REAR V. LEFT SIDE V. FRONT V. RIGHT SIDE V.

STANDARD MULTI-VIEW
ALIGNMENT

BOTTOM V.

Figure 1–25

Multi-view drawings are easy to draw because you can make measurements directly on the drawings. Because multi-view drawings are only two-dimensional, inclined surfaces are not represented as true size. Their true shapes can be obtained by using auxiliary views, however.

Paraline drawings include the following pictorial drawings:

a. Oblique
b. Isometric ⎤
 ⎬— Axiometric Drawings
c. Dimetric ⎦

Paraline drawings are more realistic than multi-view drawings because they are three-dimensional. As you look at the drawings, three sides are represented instead of only two. Axiometric drawings have none of the three sides parallel to the reference plane, while oblique drawings have one side parallel to the reference plane. Parallel lines on the object appear parallel in the drawing; consequently, you can make direct measurements along the major axes of these drawings. These characteristics make paraline drawings easier to draw, yet they also cause some distortion and often cause unrealistic-looking drawings. Fig. 1–26 shows the house presented in Fig. 1–25 drawn three different ways.

Each one of the drawings in Fig. 1–26 describes the object better than any of the individual multi-view drawings. As a group they are still not as pleasing to the eye as would be a perspective drawing of the same object. Therefore, this progression in realism leads us to perspective drawing.

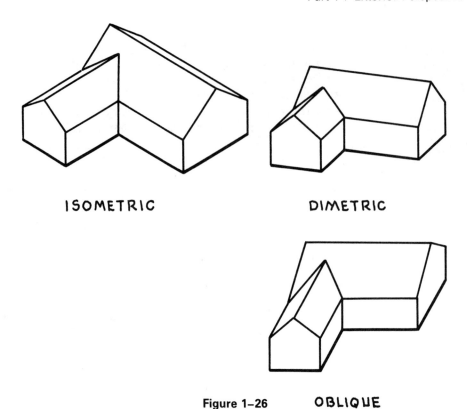

ISOMETRIC DIMETRIC

Figure 1-26 OBLIQUE

Of the three types of drawings, perspective drawings are, if drawn properly, the most realistic-looking. See Fig. 1–27. This realism basically comes from the converging nature of the horizontal lines in a perspective drawing. The drawings look realistic because the eye perceives objects in this manner. Features of the same size appear smaller as they move away from the observer. Perspective drawings are somewhat more difficult to draw because you cannot measure directly upon the object.

Figure 1-27 PERSPECTIVE

2

The Perspective Setup

2.1 MULTI-VIEW DRAWINGS OF THE PERSPECTIVE SETUP

It is ironic that in order to draw a perspective drawing, the most realistic type of drawing, you must use multi-view drawings, the least realistic. The standard perspective setup is created from two multi-view drawings. It is critical that you understand and visualize how the perspective setup is created. If you cannot, the task of drawing perspectives by the perspective plan method will be much more difficult.

To help this visualization process, look at a typical residential setting. See Fig. 2–1. This perspective drawing includes a house, tree, privacy fence, sidewalk, and driveway.

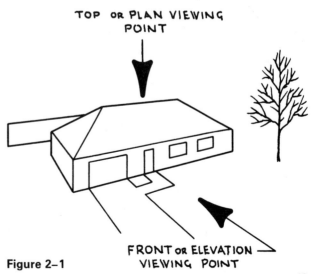

TOP OR PLAN VIEWING POINT

FRONT OR ELEVATION VIEWING POINT

Figure 2–1

What if you were asked to draw multi-views of this setting—the top and front views in particular? What would they look like? The top or plan view of this setting would resemble what you would see if you were flying in an airplane directly overhead. See Fig. 2–2. You would see the tops of the house and tree as well as the sidewalk and drive. You would see in full view the ground plane. The privacy fence would appear as a straight line because you would be seeing an edge view of it. Any vertical plane viewed from above will appear to be a straight line. Only width and depth dimensions are represented in this view.

The front or elevation view of this setting would look like Fig. 2–3. You would see the front of the house, the tree, and the part of the privacy fence that would be visible to the left of the house. The ground plane would be represented by a horizontal line. This is true because you would be seeing an edge view of it. Only horizontal and vertical dimensions would be represented in this view.

Remember two important relationships which exist between these two multi-view drawings. The first is that the plan view will always line up vertically with the elevation view. This relationship is maintained so that you can project from one view to the other. Notice the lines of projection between Figures 2–2 and 2–3. The plan view of the tree lines up vertically with its elevation view.

The second important relationship between these two multi-view drawings is the distance between them is variable. This distance could be 1″ or 10″. It doesn't make any difference. Normally, for the sake of clarity, they are separated by some distance. However, they could very easily be pushed together so that one is on top of the other.

In developing the basic perspective setup, certain items are first omitted, and then the two multi-view drawings are overlapped. This typically is where some confusion

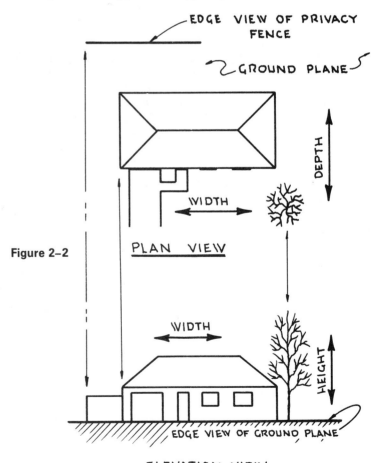

Figure 2–2

Figure 2–3

takes place. It is somewhat difficult to visualize one drawing superimposed over another. This is basically what takes place, however, when you begin to develop the standard perspective setup. You work exclusively with the plan and elevation views of the perspective setting.

2.2 DEVELOPING THE PERSPECTIVE SETUP

You begin this developmental process by working with a given object, such as a house. See Fig. 2–4. You can consider the multi-view drawings in Fig. 2–4 to be the blueprints for your perspective.

The decision has been made to draw a perspective of this house. This could be a professional or a classroom assignment. In order to create the perspective setup, you need to answer such basic questions as the following:

1. Which sides of the house should be visible in the perspective?
2. Which side should be emphasized the most?
3. From what height do you wish to view the house?
4. How large do you want the final perspective to be?
5. What kind of statement do you want the perspective to make?

To be able to answer these questions and then to be able to create a perspective which reflects these answers, you must have a good working knowledge of the perspective setup and all its component parts. The component parts of a standard perspective setup are the following:

1. Plan view of the object being drawn
2. Picture Plane (PP): an invisible vertical plane of reference on which the perspective is being drawn
3. Ground Plane (GL): the horizontal surface on which the object is resting
4. Cone of Vision: the field of view of the observer
5. Observer or Station Point (SP): the person from whose vantage point the object is being viewed
6. Horizon Line (HL): the height the observer's eye is above the ground plane
7. Center of Vision (CV): the theoretical center of the perspective
8. Vanishing Points (VP): points toward which parallel lines converge
9. Measuring Points (MP): vanishing points for lines that mark off width and depth measurements on receding horizontal lines (base lines)
10. Horizontal Measuring Line (HML): a horizontal line in the PP on which all width and depth measurements are made

All these component parts will be visible in either the plan or elevation views of the perspective setting.

Let's develop a pictorial sketch of this setting, component by component. This may help you visualize the mechanics behind the standard perspective setup. First, you have a pictorial view of the ground plane — a horizontal surface. See Fig. 2–5.

Next, you add the object sitting on the ground plane. See Fig. 2–6.

Now you need to add the picture plane (PP), the plane of reference. See Fig. 2–7. The perspective will be drawn on this invisible surface. The intersection between the PP and the ground plane locates the ground line (GL).

Now locate the observer (SP) by using a cone of vision. See Fig. 2–8.

The horizon line (HL) is added to the PP the same distance above the ground plane as the observer's eye. See Fig. 2–9.

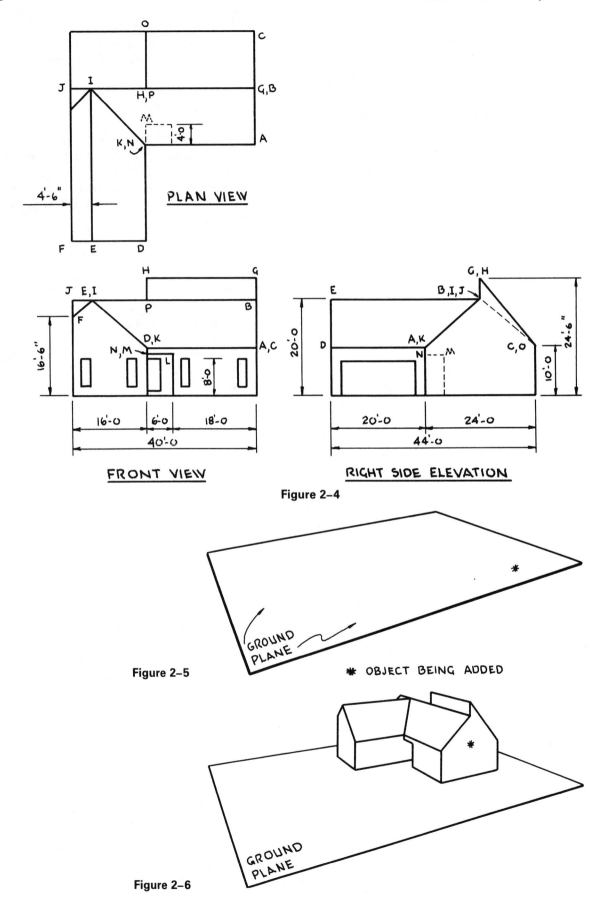

PLAN VIEW

FRONT VIEW RIGHT SIDE ELEVATION

Figure 2–4

Figure 2–5

GROUND PLANE

✴ OBJECT BEING ADDED

GROUND PLANE

Figure 2–6

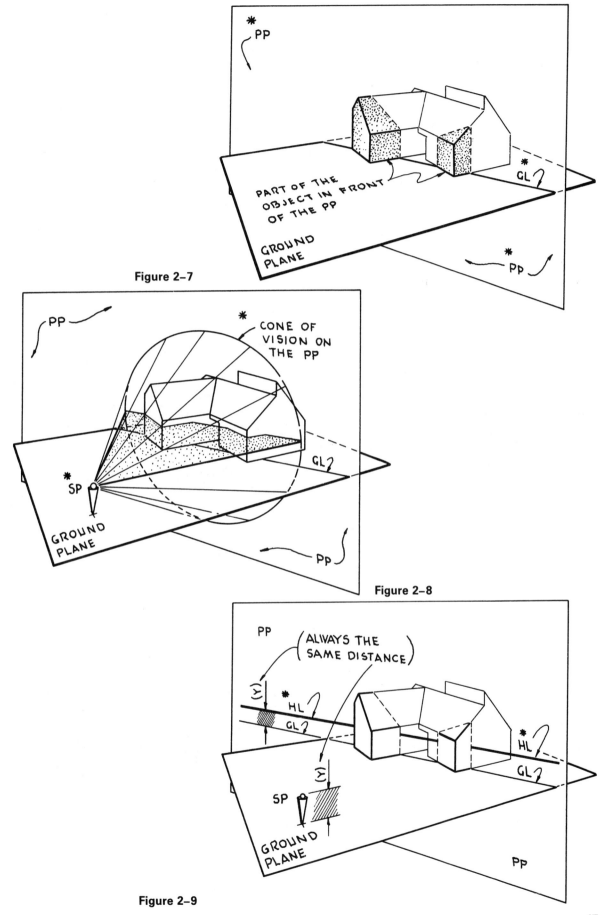

PP

Figure 2–7

PART OF THE OBJECT IN FRONT OF THE PP

GROUND PLANE

GL

PP

Figure 2–8

PP

CONE OF VISION ON THE PP

GL

SP

GROUND PLANE

PP

Figure 2–9

PP

(ALWAYS THE SAME DISTANCE)

(Y)

HL

GL

(Z)

SP

HL

GL

GROUND PLANE

PP

The center of vision (CV), vanishing points (VPs) and measuring points (MPs) will all be located on the HL. See Fig. 2–10.

Finally, you add the horizontal measuring line (HML) to the PP. Width and depth measurements are made on this line. See Fig. 2–11.

Now you have a complete pictorial view of the perspective setting containing all its component parts. You might want to compare Fig. 2–11 with Fig. 2–1 on page 13. There are some similarities. The big difference between the two pictorial drawings is that Fig. 2–11 is complete. The only component parts of the perspective setup represented in Fig. 2–1 were the object and the ground plane. The other components were there but not illustrated.

You should consider the object and all the component parts of the perspective setup as one unit. Like any other complicated object, more than one multi-view drawing

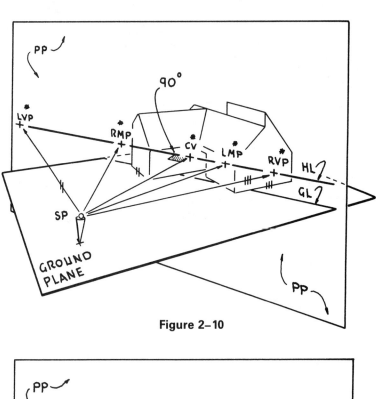

Figure 2–10

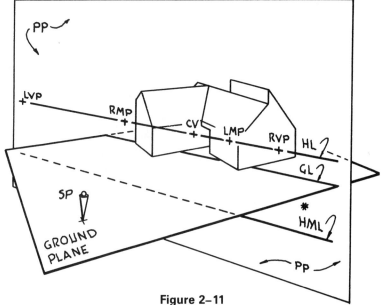

Figure 2–11

is required in order to describe the perspective setting properly. Therefore, you now need to draw the plan and elevation views of this perspective setting. The plan view will show what you would see if you were flying directly over the setting. The elevation view will show what you would see if you were standing behind the observer. See Fig. 2–12.

Let's draw the plan view first. Looking down from above, you would see the plan view of the house. See Fig. 2–13. You would also see an edge view of the vertical PP. In the plan view it appears as a horizontal line. (If you are having difficulty visualizing this, hold a piece of paper vertically on your desk top and stand up and look down at it. What you are seeing is an edge view of the paper. It should appear as a straight line.)

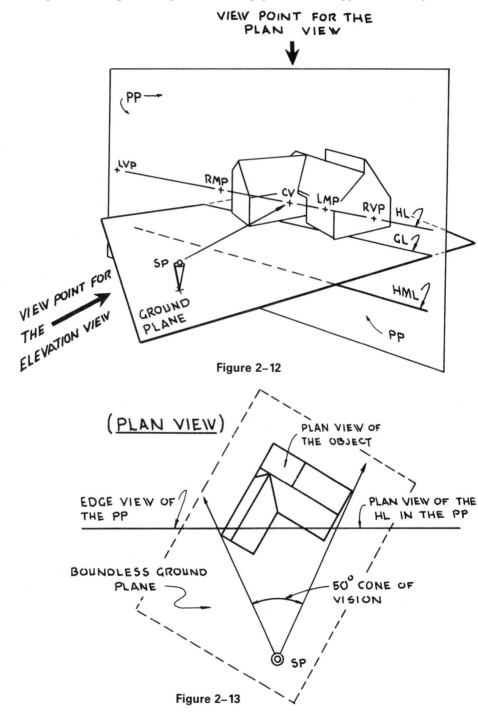

Figure 2–12

Figure 2–13

Because the horizon line (HL) is located in the vertical PP, you will also see an edge view of it. Therefore, the PP and HL will coincide in the plan view. See Fig. 2–13. The plan view of the perspective setting will also show the top of the observer (SP) and the observer's accompanying cone of vision. Also visible but not shown in the plan view is the boundless ground plane. See Fig. 2–13.

The center of vision, vanishing points, and measuring points will be visible on the PP, HL. See Fig. 2–14. The plan view of the perspective setting shown in Fig. 2–11 is now complete.

Directly below this plan view draw the elevation view of the perspective setting. First, you would see the house supported by the ground plane. See Fig. 2–15. Here you are seeing the ground plane as an edge view (GL). Even though it is invisible, you must realize you are looking through the vertical PP. In this view the PP is boundless. You would also see the back of the observer. See Fig. 2–15. Lined up with the observer's eye (SP) is the CV on the HL. The HL is located on the PP. Located on the HL are the CV, MPs, and VPs. Somewhere below the GL is located the horizontal measuring line

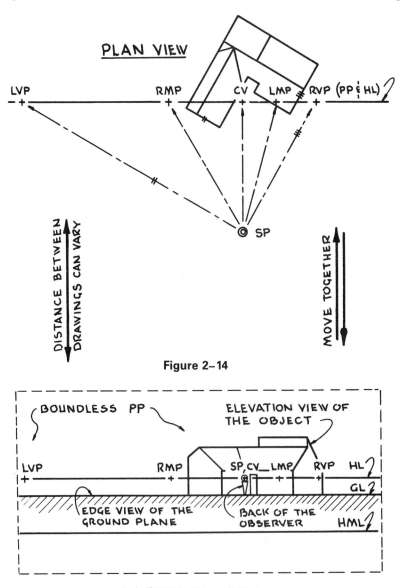

PLAN VIEW

Figure 2–14

ELEVATION VIEW

Figure 2–15

(HML). Just like the HL and GL, the HML is also drawn on the PP. The elevation view of the perspective setting is now complete.

These two drawings represent the plan and elevation views of the perspective setting shown in Fig. 2–11. You will use these two multi-view drawings to draw the perspective of the house. Notice that these two drawings are lined up vertically, as they should be. Also remember the vertical distance between them is unimportant. As stated before, they could be an inch or a foot apart, or they could be superimposed. In order to continue with the perspective process, you need to move the two drawings together so that the two horizon lines form one line. See Fig. 2–16. For the sake of clarity, eliminate the observer and object from both views. See Fig. 2–17. They are not needed to draw the perspective.

This one drawing is in actuality the superimposed plan and elevation views of the perspective setting. This drawing constitutes the completed perspective setup. It is now ready to be used to draw the perspective of the house. However, you are not ready to do this yet.

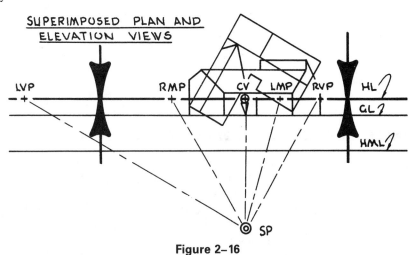

Figure 2–16

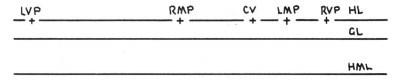

Figure 2–17

Now that you have become acquainted with the basic perspective setup, you need to study each component part in more detail. This will enable you to answer the following questions:

1. What is the best angle with which to view the house?
2. How far away from the house should you be standing?
3. At what height should the observer be above the ground?
4. How dramatic do you want the perspective to look?

The discussion that follows is about each of the component parts and its relationship with the other parts which make up the standard perspective setup. This discussion should help you *design* an appropriate perspective setup.

2.3 PLAN VIEW OF THE OBJECT

First, you must draw at a small scale the plan view of the object. For residential structures, $3/32'' = 1'$-0 scale is recommended. For larger commercial projects, you will have to use a smaller scale — $1'' = 20'$ or $1'' = 40'$, for example. Normally, just the outline of the structure is required for this plan view. This drawing should show all recesses and projections which will affect the perspective angle. You should include sidewalks and parking areas if they are to be included in the perspective. Often you can use the site plan provided in the set of blueprints for your plan view, provided it is at an appropriate scale. This small-scale plan view of the object will be used to lay out the preliminary HL. See Fig. 2–18 for the plan view of the given structure.

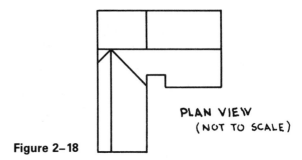

PLAN VIEW
(NOT TO SCALE)

Figure 2–18

2.4 ANGLE THE OBJECT MAKES WITH THE PICTURE PLANE

Now you must decide how you want to view the object. In other words, which sides do you want to see in the perspective? Do you want to see the front and right side, or the front and left, or maybe just the front and none or very little of the sides? Normally, you should show the front entry of the house, if at all possible. Which face of the house do you want to emphasize? Generally, the front is emphasized the most.

In the upper half of a clean sheet of paper, draw a horizontal line. This line represents the temporary location for the PP. See Fig. 2–19. You are seeing an edge view of the PP because this is the plan view of it (looking down from above). Now take the plan

Figure 2–19

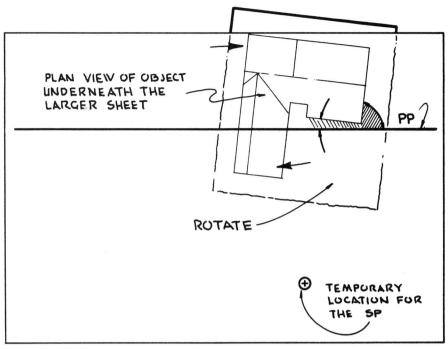

Figure 2–20

view of the house which you have just drawn and slide it under the sheet with the PP. See Fig. 2–20. Put an *X* in front of the PP to indicate the approximate location of the observer (SP). The observer is viewing the house through the vertical PP from this approximate location. Now move the plan view of the house under the new sheet of paper, forming different angles with the PP.

While doing this, you decide to see the front and right side of this L-shaped house. As usual, the main emphasis will be on the front of the house.

Now you need to select the most appropriate angle for the object to make with the PP. As you manipulate the plan view of the house, the front walls should form a smaller angle with the PP than the right side walls. The walls forming the smaller angle with the PP will receive the most emphasis. Remember that as you put more emphasis on one wall, you have less emphasis on the other walls. The more you see of the front of the house, the less you will see of the end.

If the corners of the house are square, the two angles formed with the PP will total 90° when added together. See Fig. 2–21. The larger the difference between the size of these two angles, the farther apart the vanishing points will be. If one of the angles is

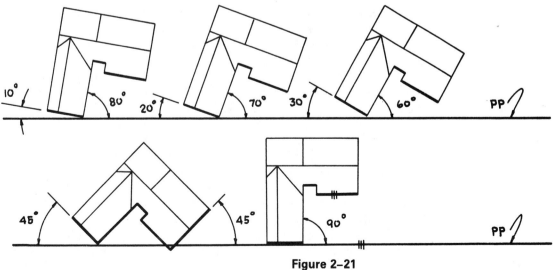

Figure 2–21

20° or less, the VPs are going to be very far apart. This fact may influence your decision if you are working on a small drawing table. There are ways to draw perspectives without the long VPs. One of these methods will be discussed later.

You have begun a trial-and-error process in selecting the most appropriate angle for the object to make with the PP. You may think you have the object angled properly but find out later that some correction is necessary. Don't be discouraged. This is to be expected.

Once you think you have the proper alignment, tape the plan view of the house to your drawing table. The plan view should still be underneath the sheet of paper with the PP. See Fig. 2–22.

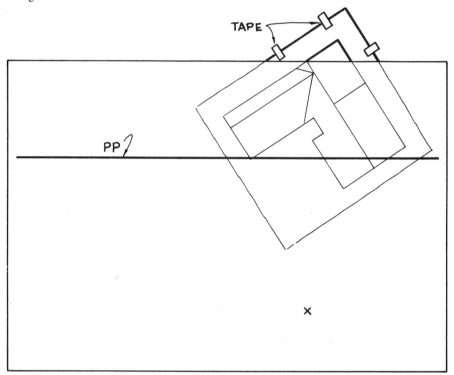

Figure 2–22

2.5 USING A CONE OF VISION TO LOCATE THE OBSERVER (STATION POINT)

Now that you have the object temporarily located in relation to the PP, you must find the best location for the observer (SP). You locate the observer by using a cone of vision. It is important that you understand the effect that different-sized cones of vision have on the final perspective.

It is universally accepted that most people see objects without distortion inside a 60° cone of vision. See Fig. 2–23. Think of the observer's eye (SP) as being at the apex of the cone and that the observer is looking straight ahead. The direct line of sight is horizontal with the ground. See Fig. 2–24. The lines of sight radiate from the observer's eye to form the 60° nondistorted cone of vision. See Fig. 2–25.

As you are deciding which size cone of vision to use, you must be aware of the vertical as well as the horizontal diffusion of the cone. The cone of vision has a three-dimensional nature. If there is any doubt as to whether the object is totally inside the chosen cone of vision, you may want to check it out in both the plan and side views of the perspective setup. See Figures 2–26 and 2–27.

The object in these two figures is a tall building; by looking at the plan view of this proposed setup, you might think that the location of the observer (SP) is appropriate because the building appears to be inside the 60° cone of vision. See Fig. 2–26. Because

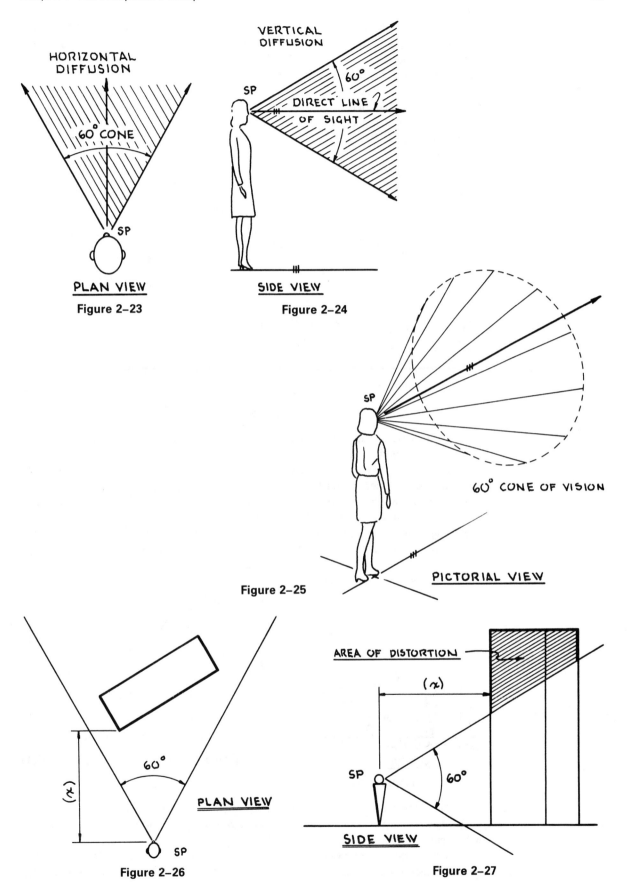

HORIZONTAL DIFFUSION

60° CONE

SP

PLAN VIEW

Figure 2–23

VERTICAL DIFFUSION

SP

60°

DIRECT LINE OF SIGHT

SIDE VIEW

Figure 2–24

60° CONE OF VISION

PICTORIAL VIEW

Figure 2–25

60°

(x)

PLAN VIEW

SP

Figure 2–26

AREA OF DISTORTION

(x)

SP

60°

SIDE VIEW

Figure 2–27

this is a tall building, there is some doubt as to whether the entire height of the building is included within the 60° cone. In order to confim this, you must draw a side elevation of this setup. See Fig. 2–27. With the observer's eye the same distance from the structure and 5'-6" off the ground, you redraw the 60° cone of vision. Now you discover that the observer is too close to the building because the top of it is outside the cone. It will probably appear distorted if the perspective is drawn with the observer at this location. The observer must move back until all the building is included inside the 60° cone of vision. See Fig. 2–28.

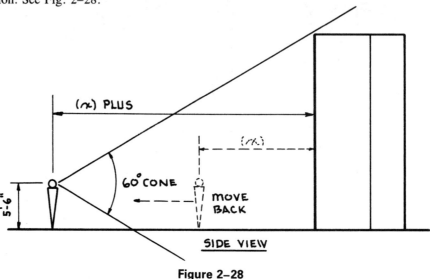

Figure 2–28

In this case it was better to use the side view to determine the location of the SP, but in most cases the plan view location for the SP will be correct. The only time you need to recheck with the side view is when you are working with very tall or very small objects. A small object is illustrated in Fig. 2–29.

As you draw more perspectives and become more comfortable with the perspective process, you may want to use distortion in some of your drawings. It is an art to be able to use distortion skillfully in order to dramatize a certain feature of a building. Many times perspectives of tall buildings will have the front corner distorted. See Fig. 2–30A. The same building, undistorted, is illustrated in Fig. 2–30B. The distorted perspective is much more dramatic.

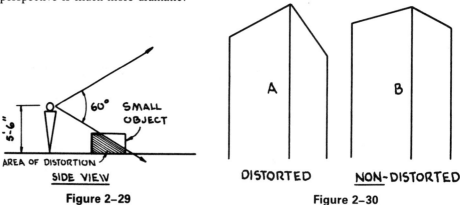

Figure 2–29 **Figure 2–30**

The beginner should stay with non-distorted situations. Consequently, the object being viewed must be contained inside the maximum 60° cone of vision or distortion will occur.

When drawing an exterior perspective, you generally keep the primary object inside a much smaller cone, such as 30° to 45°. Using a smaller cone of vision on the

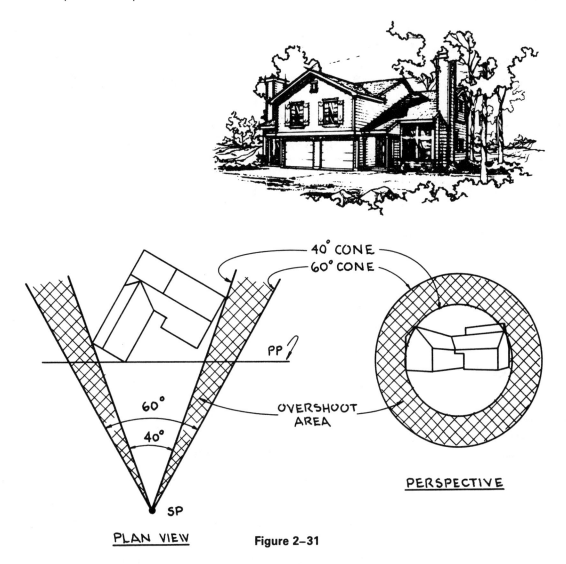

PLAN VIEW Figure 2–31

primary object allows some overshoot, the difference between the smaller cone and the maximum 60° cone, to draw in features surrounding the primary object. See Fig. 2–31. These features might be trees, cars, parking areas, and other buildings.

The choice of a cone of vision can have a dramatic effect on the final perspective. Your choice basically ranges from 30° to 60°. A perspective drawn with a 30° cone looks much different than one drawn with a 60° cone. Let's use the house you are drawing as an example and experiment with different-sized cones of vision. See Fig. 2–32. Only the size of the cone of vision changes in these four examples. Notice what happens to the observer (SP) as you change from a 30° cone to a 60° cone. The larger the cone of vision, the closer the observer is to the object. Also notice what happens to the drawn perspective as you change the size of the cone of vision.

The following are the effects that small and large cones of vision have on the final perspective.

Perspective characteristics caused by using a small cone of vision (30° to 40°):

1. The perspective is less dramatic. (Line convergence is minimized.)
2. Depth dimensions are exaggerated. (More of the sides of the object are visible.)
3. Vanishing points are farther apart.
4. The statement made by the perspective is soft, unoffensive, and safe.

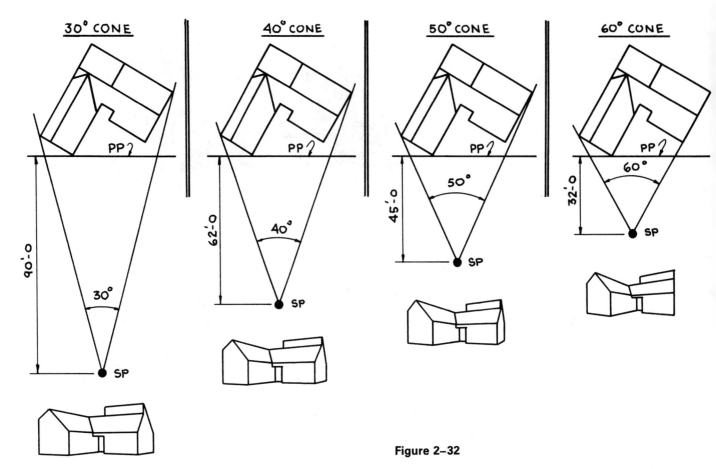

Figure 2–32

Perspective characteristics caused by using a large cone of vision (40° to 60°):

1. The perspective is dramatic. (Line convergence is maximized.)
2. Depth dimensions are minimized. (Less of the sides of the object are visible.)
3. Vanishing points are closer together.
4. The statement made by the perspective is loud, offensive, and startling.

As you can see from the illustrations in Fig. 2–32 and the list of effects caused by using different cones of vision, the size of the cone you choose is very important to the character of the finished perspective. Special characteristics of each new object will dictate the size of the cone of vision you might use. Based on the previous discussion, you now choose to use a 45° cone of vision to draw your perspective.

Having made this decision, you need to go back to the plan view of the house which is taped to your table and draw in the 45° cone of vision. You can erase the *X,* which was the temporary location for the SP, because you are now going to find its actual location by using the cone of vision. You want one leg of the cone to extend through the extreme right corner of the house (point B), and the other leg to extend through the extreme left corner of the house (point A). See Fig. 2–33. In order to draw these two lines, you need to set your adjustable 45° triangle at the appropriate angle. To determine this angle you might find it helpful to make a small freehand sketch of the cone of vision off to the side. See Fig. 2–34A.

To draw the sketch, first make a *V.* This is supposed to represent the 45° cone of vision. Now through the point of the *V* draw a horizontal and a vertical line. See Fig. 2–34B. The vertical line bisects the cone of vision creating two 22 1/2° angles. Subtract 22 1/2° from 90° and you get 67 1/2°. This is the angle that the legs of the cone make with the horizontal line. Set your adjustable 45° triangle at 67 1/2°. This small sketch technique works with any size of cone of vision.

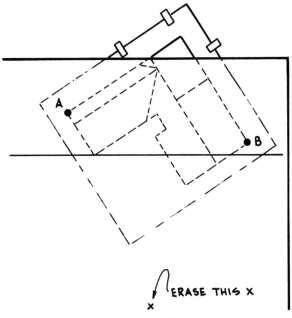

Figure 2–33

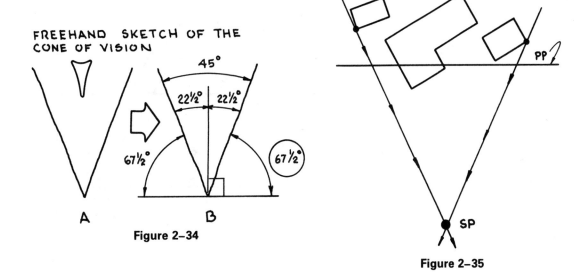

Figure 2–34

Figure 2–35

With your adjustable triangle set at the correct angle, draw a 67 1/2° line through point A and a 67 1/2° line through point B. See Fig. 2–36. Extend these lines until they intersect at the location of the observer (SP). (If you were working with more than one object in the same setting, and you wanted to see them all in the perspective, the cone of vision would include them all.) See Fig. 2–35.

Now you can evaluate the relationship between the object and the observer (SP). See Fig. 2–36. Does this seem to be a reasonable location for the SP? Can you see all of the house you want to see from this location? The only question in this particular example would be the recessed entry. Can you see the entry door from this location? You can determine this by drawing visual rays from the SP to points in question on the house. See Fig. 2–37. A visual ray drawn from the SP to the right corner of the entry shows that the door will be hidden from view if the house stays at this angle with the PP. Since you want to see the entry door, or at least part of it, you must change one of two things — the angle the house makes with the PP, or the location of the SP.

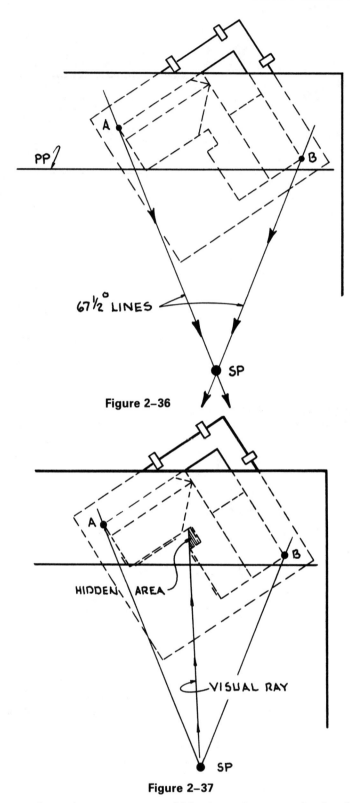

Figure 2–36

Figure 2–37

Since you have chosen to create a fairly dramatic perspective by choosing the 45° cone of vision, you will not want to change that. Therefore, you should rotate the house in relation to the PP. Untape the plan view of the house and rotate it so that point A stays on the left leg of the cone of vision and point B stays on the right leg of the cone. See Fig. 2–38. Rotate the house just enough to solve the problem of the hidden entry door. This may take a few tries. Each time you stop the rotation, redraw the visual

ray from the SP to the same right corner of the entry. Once you have determined that enough of the door is showing, retape the plan view to your table.

Now trace the outline of the house on the sheet with the PP. You can now remove the sheet of paper underneath. See Fig. 2–39.

Once you are satisfied with the angle of the house and the cone of vision, you are ready to move on.

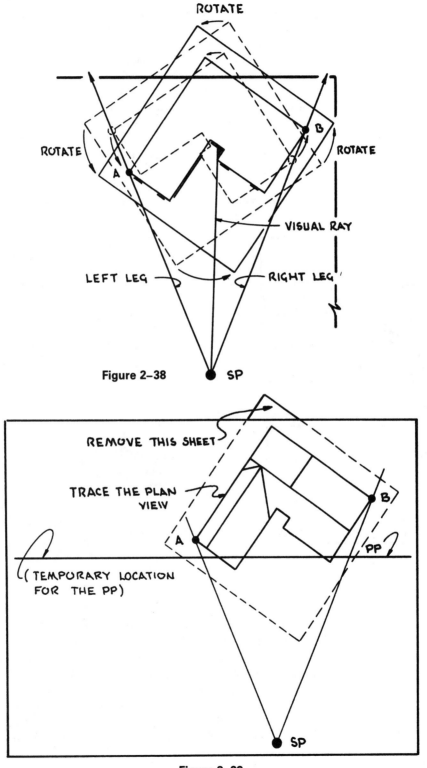

Figure 2–38

Figure 2–39

2.6 FINAL LOCATION OF THE PICTURE PLANE (CHOOSING A SCALE FOR THE PERSPECTIVE)

The final location of the PP will be determined by the overall size of the finished perspective. The horizontal line that you have drawn in the plan view of the perspective setup (see Fig. 2–39) represents the temporary location of the PP. You now have to move it backwards or forwards to satisfy the size requirements of the perspective.

Before you can do this, there needs to be a discussion about the effect the location of the PP has upon the size of an object being drawn in perspective. The basic assumption for the following illustrations is that the observer and object do not move—the PP is the only item in motion. See Fig. 2–40. In example 1 the PP is 6' in front of the object. The projected image of the object onto the PP is 2'. In example 2 the PP is moved back to within 3' of the object projecting a 3' image onto the PP. Example 3 has the PP moved back until it contains the front face of the object. The image reflected here (5'-0) is true size. Any line or surface which is in the PP is represented as true size. Example 4 has the PP moved 3' behind the front face of the object. The projected image is 7'-0 wide. And, finally, example 5 has the PP 6' behind the front face of the object, reflecting an image of 9'-0.

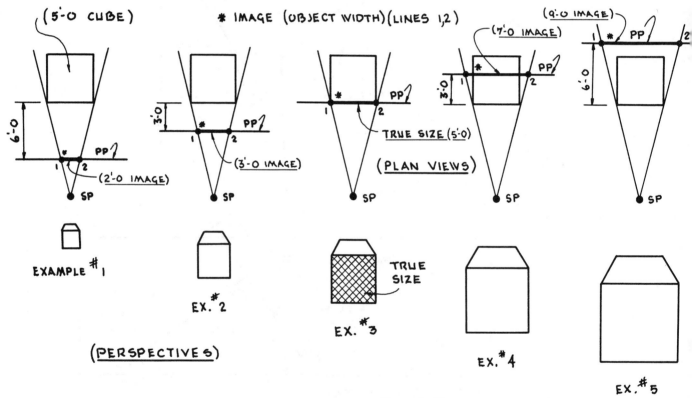

Figure 2–40

As you can see, the location of the PP has a definite effect on the size of the finished perspective. Objects that are behind the PP appear smaller than true size, while objects that are in front of the PP appear larger than true size. Objects in the PP will be true size. Common sense might tell you this when you think of the example of a railroad track and telephone poles vanishing in the distance. See Fig. 2–41. Objects far away from you do appear smaller.

With this in mind, there are two ways to change the size of a perspective. One way is to change the scale chosen to draw the perspective, and the second is to change the location of the PP. Obviously, the larger the scale, the larger the perspective. For most residential renderings 1/4" = 1'-0 scale is used. Large commercial building

perspectives can be drawn at as small a scale as $1'' = 40'-0$ or at as large a scale as $1/8'' = 1'-0$.

If you can, it is preferable to draw the perspective at the same scale as the blueprint elevations. By doing that you can save much measuring and time by folding the elevation in half (horizontally) and by ticking off the width and depth spacing of features on the structure directly onto the horizontal measuring line (HML). Therefore, a convenient scale for residential perspectives is $1/4'' = 1'-0$ because most residential blueprint elevations are drawn at that scale.

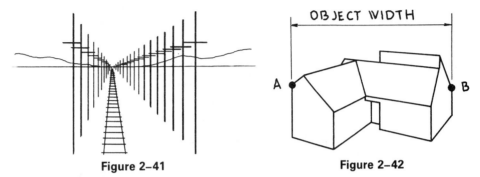

Figure 2–41 **Figure 2–42**

Once you have chosen a scale for the perspective, $1/4'' = 1'-0$ in this case, you must decide what the final size of the perspective will be.

The final size of the perspective is measured horizontally across the house from point A to point B. See Fig. 2–42. This is called the final "object width." The final object width is measured in full inches. Most people think in terms of full scale, $1'' = 1''$. So, if you are drawing on a $20'' \times 14''$ piece of paper, you would probably need an object width of $13''$. This will leave $3 \ 1/2''$ on each side of the house for landscaping. The house plus the landscaping will be considered the "picture width."

You must position the PP in the precise location that will give you a $13''$ final object width at the chosen $1/4'' = 1'-0$. Return to the small-scale preliminary perspective setup (Fig. 2–39). Remember, this plan view is drawn at $3/32'' = 1'-0$ scale. Even though the PP is at a temporary location, you can tell what the final size of the perspective will be by measuring the distance between points 1 and 2 at the $3/32'' = 1'-0$ scale. See Fig. 2–43. These points are where the legs of the cone of vision pierce the PP. The

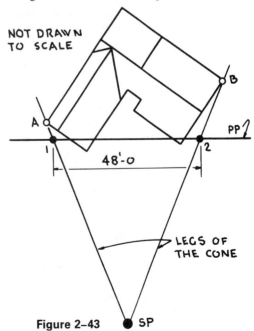

Figure 2–43

distance between points 1 and 2, the preliminary object width, measures 48′. You have already decided to draw the perspective at 1/4″ = 1′-0 scale. At the 1/4″ scale there are 4′ per inch. Therefore, you divide the preliminary object width of 48′ by 4 to get the final object width in full inches. The result is 12″. You have already decided on a final object width of 13″. With the PP at its present location, the final object width of 12″ is too small. So, you must move the PP back, or away, from the observer. You could move it back, measure, divide, and, by trial and error, finally end up with a 13″ image; however, there is an easier way to do this. Two things you know for sure. First, you want a 13″ image and, second, you want to draw the perspective at 1/4″ = 1′-0 scale. Therefore, all you have to do is to use this simple formula:

$$\frac{\text{Desired final object width in full inches}}{\substack{\text{Scale at which the perspective is to be drawn} \\ \text{(Decimal equivalent)}}} = \substack{\text{Required distance between} \\ \text{points 1 and 2}}$$

Using the data for this particular perspective you have the following:

$$\frac{13''}{1/4'' \text{ scale or .250}} = {}^*52'$$

You might find these decimal equivalents for the different scales helpful.

3/32	= .0937
1/8	= .125
3/16	= .1875
1/4	= .250
3/8	− .375
1/2	= .500
3/4	= .750

You know you are looking for a distance of 52′ between points 1 and 2 on the PP. So you need to rest your architectural scale on your T square with the 3/32″ = 1′-0 scale next to the paper. See Fig. 2–44. With the zero indicator on the 3/32″ scale moving along the left leg of the cone of vision, move the T square up or down until the 52′ indicator touches the right leg of the cone of vision. At this location draw a horizontal line using the scale as a straight edge. This horizontal line represents the proper location for the PP, which will give a final object width of 13″. See Fig. 2–45.

This process might seem confusing at first. After drawing a few setups, however, you will find it is quite easy and very rewarding. It is gratifying to discover that you can predetermine the size of the finished perspective before you even begin to draw it.

You have now positioned the PP in the proper location to give you the desired perspective size. The PP, in this case, is positioned in the front one-third portion of the object. See Fig. 2–46. Typically, this is the most convenient area for the PP to be located, although it is not a requirement.

Let's say, for the sake of discussion, that the PP didn't even touch the object. See Fig. 2–47. This should not pose a problem. All this means is that when you begin to draw the perspective, you will have to project into the PP to establish a starting point. See Fig. 2–48.

Let's say you have located the PP and for some reason you don't like its location. You can move it by changing the scale of the perspective or by changing the desired finished object width.

*This figure is at the scale of the preliminary setup.

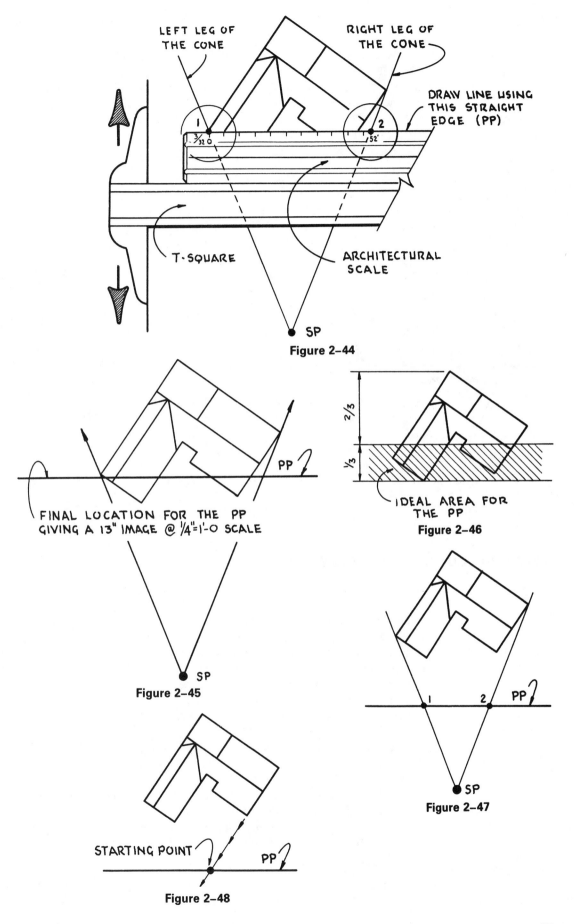

LEFT LEG OF
THE CONE

RIGHT LEG OF
THE CONE

DRAW LINE USING
THIS STRAIGHT
EDGE (PP)

1

2

3/32 0

'52'

T·SQUARE

ARCHITECTURAL
SCALE

SP

Figure 2–44

FINAL LOCATION FOR THE PP
GIVING A 13" IMAGE @ 1/4"=1'-0 SCALE

PP

SP

Figure 2–45

2/3

1/3

IDEAL AREA FOR
THE PP

Figure 2–46

1 2 PP

SP

Figure 2–47

STARTING POINT

PP

Figure 2–48

What if you want to move the PP so that it goes through a major feature on the object? If it is a minor move, the size of the final object width won't change much. See Fig. 2–49. But, if it is a major move, you might want to see what the new final object width will be with the PP at this new location. See Fig. 2–50. All you have to do is measure the distance between points 1 and 2 and multiply this number by the scale with which you will draw the perspective. See Fig. 2–51. This process will give you the new final object width in full inches.

(1/4″ scale)

45′ × .250 = 11 1/4″ new final object width

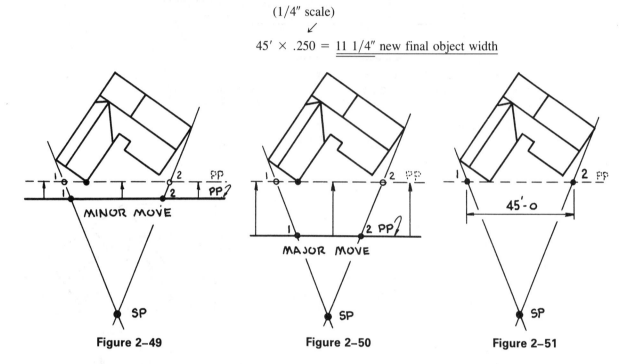

Figure 2–49 Figure 2–50 Figure 2–51

2.7 LAYING OUT THE PRELIMINARY HORIZON LINE

All the work that you have done so far has been at a very small scale on what is called the preliminary picture plane, horizon line (PP, HL). You might consider this to be a small-scale preliminary design sketch. This was done to save time and paper. Too, it is much easier to make changes on a small-scale drawing than on a large one. As you know by now, designing a perspective setup to meet certain specifications requires some changes along the way. This design process is equivalent to a calculated trial-and-error process. The more you draw, the easier the process will become.

Before you can begin to draw the perspective, however, you must first locate the center of vision (CV), the vanishing points (VPs), the measuring points (MPs), and dimension x on the preliminary PP, HL. Once you have plotted all these points, you can measure (at the small 3/32″ scale) and document the distances between them. Taking these data, you can then lay out on a new sheet of paper the final horizon line (HL) at the scale chosen for the perspective (1/4″ = 1′-0).

With this discussion in mind, let's finish the preliminary PP, HL by locating these points. This will require following some set rules.

Since you are now following a set procedure, the following discussion will be presented in a statement and step format. Each step will be numbered to help you follow the procedure.

Statement 1. Your plan view of the perspective setup consists of the plan view of the object, an edge view of the PP, and the plan view of the observer (SP). See Fig. 2–52.

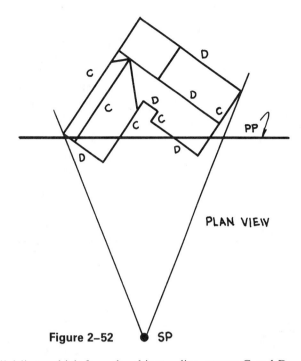

Figure 2–52 ● SP

There are two sets of parallel lines which form the object — line groups C and D. See Fig. 2–52. Lines that are parallel in the multi-view drawing will vanish to the same VP in the perspective drawing. Step 1 illustrates the universal way to find the VPs for any set of horizontal parallel lines.

Step 1. See Fig. 2–53.

1a. From the station point draw a line parallel to the set of lines (group D) for which you want to find the vanishing point. Extend this line until it intersects with the PP. This point of intersection is the LVP.

1b. Follow the same procedure to find the VP for the group C lines. This point of intersection will be the RVP.

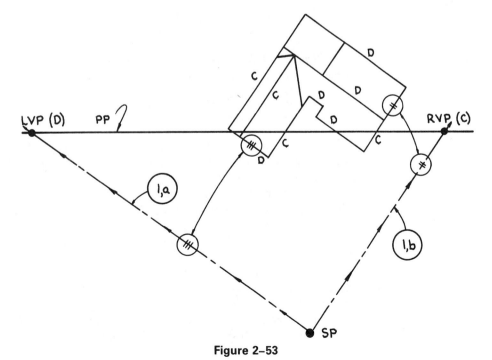

Figure 2–53

Step 2. See Fig. 2–54.

2a. You can use this procedure to find the VP for any horizontal line. You could find the VP for a stick lying in the yard of the house. You would simply draw a line that is parallel to the stick through the SP and extend it until it intersects with the PP. This will be the VP for the line (stick) and any other line parallel to it.

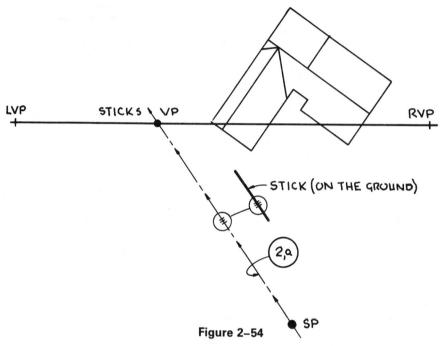

Figure 2–54

Statement 2. This particular perspective setup requires only the right and left VPs. However, some perspectives require more than two VPs. Don't let this situation confuse you. Use the same procedure to find the additional VPs.

Step 3. See Fig. 2–55.

3a. Draw a vertical line from the SP until it intersects with the PP, HL, locating the center of vision (CV).

Statement 3. The center of vision is the theoretical center of the perspective. It is the intersection between the direct line of sight from the observer's eye (SP) and the PP.

Statement 4. The measuring points are the heart of the perspective plan method of drawing perspectives. This method is sometimes called the measuring point method.

Statement 5. Since these measuring points are so important, a few words concerning the theory behind their use might be helpful to your understanding their significance.

In theory, the measuring points are actually vanishing points for lines that transfer true size width and depth measurements from the PP into the perspective. See Fig. 2–56. This is a plan view of an object of which the front corner is touching the PP at point A. The object is x wide and y deep. Dimensions x and y are measured in the PP. Lines 1 and 2 are drawn connecting the ends of dimensions x and y in the PP to the far right and far left corners of the object, forming two isosceles triangles. These two horizontal lines, 1 and 2, when drawn in perspective, transfer the true length measurements from the PP to receding lines called base lines. You find the vanishing points for these lines in the same way you found the right and left VPs. Drawing lines parallel to lines 1 and 2 from the SP through the PP locates their VPs. See Fig. 2–57. These two VPs are called measuring points (MPs) in the perspective setup.

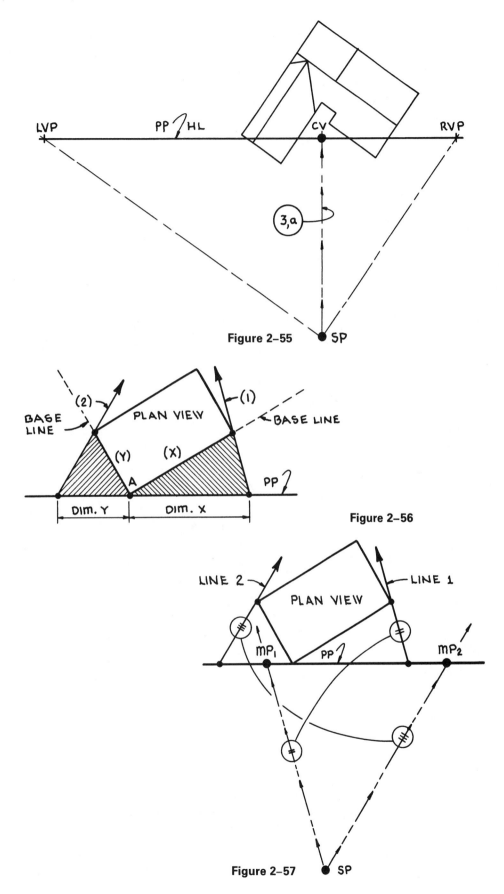

Figure 2–55

Figure 2–56

Figure 2–57

Statement 6. There are two universal ways to locate the measuring points. The first is by bisecting angles, and the second is by rotating the SP into the PP.

Step 4. See Fig. 2–58. (Bisecting)

4a. Bisect angle CV, SP, RVP to locate the left measuring point (LMP).

4b. Bisect angle CV, SP, LVP to locate the right measuring point (RMP).

Step 5. See Fig. 2–59. (Rotating method)

5a. Rotate the SP into the PP using an arc centered at the RVP. The point where this arc crosses the PP locates the RMP.

5b. Rotate the SP into the PP using an arc centered at the LVP. The point where this arc crosses the PP locates the LMP.

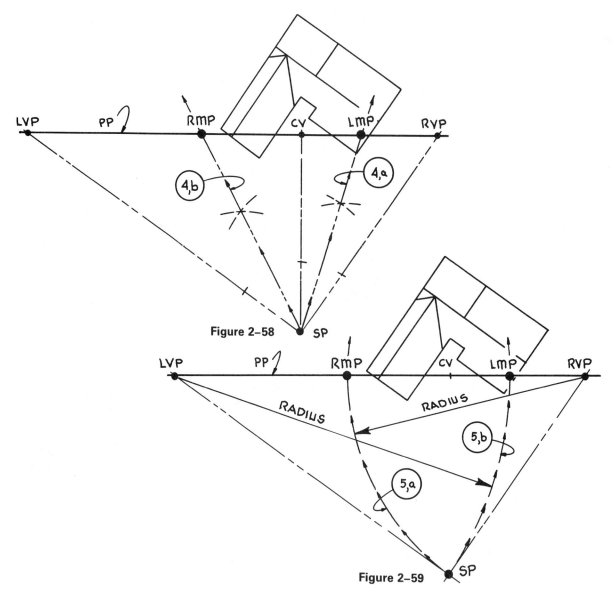

Figure 2–58

Figure 2–59

Statement 7. Both of these methods will work with any perspective setup. Sometimes one method will be more appropriate than the other. You choose the one you prefer.

Step 6. See Fig. 2–60.

6a. To find the starting point for your perspective, measure from the CV to where one of the walls of the house crosses the PP. This distance is typi-

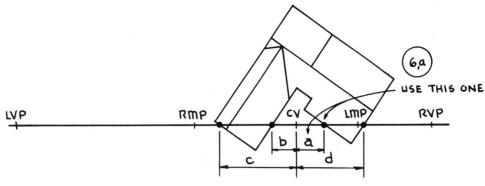

Figure 2-60

cally called dimension x (Dim. x). Many times you will have more than one choice for dimension x. In this instance, you would have four choices for dimension x—a, b, c, and d. It doesn't matter which measurement you choose—just select one and work with it. In this case, you select distance a as your dimension x.

Step 7. See Fig. 2-61.

7a. Using the base line dimensioning technique, scale the distance from the

CV to the LMP (Dim. A)

CV to the RVP (Dim. B)

CV to the RMP (Dim. C)

CV to the LVP (Dim. D)

CV to the starting point (Dim. x)

These measurements will be at the same scale as the preliminary PP, HL, that is, $3/32'' = 1'\text{-}0$.

Statement 8. With the tabulation of these data, you have completed the work on the *preliminary* PP, HL. Until now, you have basically been working with the plan view of the perspective setup. From now on you will be working with the elevation view of the perspective setup. Remember that these two multi-view drawings have been superimposed for convenience.

As you look at the elevation view of the perspective setup, you no longer see an edge view of the PP. Now you are looking through the PP. Where in the plan view you saw a full view of the ground plane, now in the elevation view you see an edge view of the ground plane. This edge view will be called the ground line (GL). You no longer see the observer (SP) or the cone of vision. It is very important that you can visualize what you are seeing in this elevation view of the perspective setup. If you are having difficulty visualizing this, turn back to page 15 and read pages 15 to 21 again.

Now you are ready to draw the perspective.

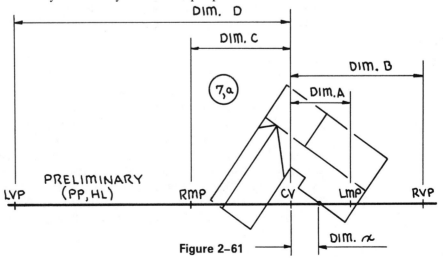

Figure 2-61

3

Drawing the Perspective

3.1 LAYING OUT THE FINAL HORIZON LINE

Step 8. See Fig. 3–1. (Not drawn to scale)

8a. Take the measurements from the $3/32'' = 1'$-0 scale preliminary PP, HL and lay out the final HL at $1/4'' = 1'$-0 scale. Begin laying out the $1/4''$ HL by locating the CV directly in the middle of a new sheet of paper ($20'' \times 14''$).

Statement 9. At this point you may have discovered that you have chosen a scale or such an acute angle for the perspective that you will have an inaccessibly long vanishing point (off your table). If this is the situation, turn to page 88 and follow the discussion presented there. It will explain to you how to construct a series of grid lines which approximate the inaccessible VP. After reading that discussion, return to statement 10 in this sequence.

3.2 CHOOSING THE EYE LEVEL

Statement 10. The only remaining decision to make concerns the relationship of the horizon line (HL), which is at the same height as the observer's eye, and the ground plane, which you see as an edge view (GL) in the elevation drawing. This important relationship will determine at what height the observer will be when viewing the object. Normal eye level would have a $5'$ relationship between the GL and the HL. See Fig. 3–2. Sometimes, because of courtyards and other peculiarities of a building, you may want to have the observer higher above the ground. To do this you would increase the vertical distance between the HL and GL. See Fig. 3–3.

Occasionally, for a dramatic effect, the HL and GL can coincide. This means the

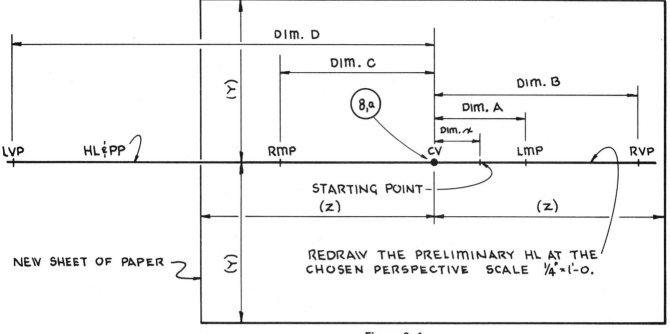

Figure 3–1

Figure 3–2

Figure 3–3

Figure 3–4

observer's eye is on the ground. See Fig. 3–4. Sometimes the structure is located on a hill and it is being observed from below. The observer is looking up at the structure; therefore, the GL is located above the HL. See Fig. 3–5.

Your decision concerning the relationship between the HL and the GL will depend upon the effect you want to create with the perspective. As you are making your deci-

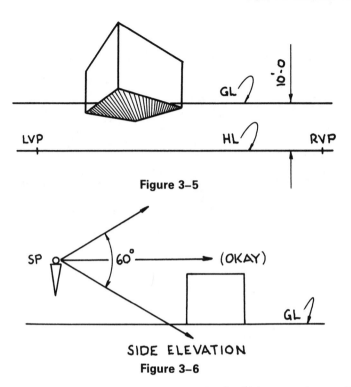

Figure 3–5

SIDE ELEVATION

Figure 3–6

sion, remember that the object should be contained within a maximum 60° cone of vision. If you have any doubt about whether your object is contained within a maximum 60° cone of vision, draw a sketch of the side view of the setup to check. See Fig. 3–6.

Statement 11. Because you are working with an average house sitting on flat ground, you decide to use a normal eye level of 5'-0.

Step 9. See Fig. 3–7. (Not drawn to scale)

9a. Locate the GL 5'-0 (at 1/4″ = 1'-0 scale) below the HL.

Figure 3–7

3.3 LOCATING THE HORIZONTAL MEASURING LINE

Statement 12. In order to make width and depth measurements in the perspective drawing, you need to draw a line on which to make these measurements. This line is also located in the PP and is called the horizontal measuring line (HML). The location of this line is somewhat arbitrary. The HML can coincide with the GL, or it can be above or below it. See Fig. 3–8.

The location of the HML normally depends upon the complexity of the object being drawn. The more complex the object, the farther the HML should be below the GL. See Fig. 3–9. By dropping the bottom out of the object and drawing it lower, you can draw it more accurately. The more complex the object, the more important accuracy becomes.

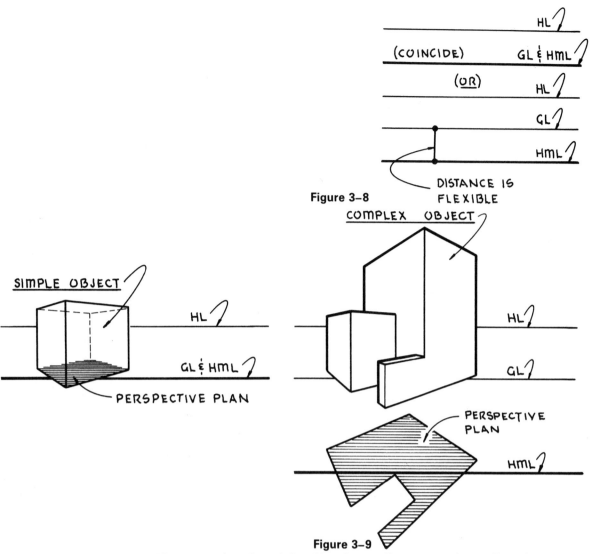

Figure 3–8

COMPLEX OBJECT

SIMPLE OBJECT

HL

GL & HML

PERSPECTIVE PLAN

PERSPECTIVE PLAN

HML

Figure 3–9

The perspective plan of the object is actually a perspective outline of the object drawn directly below the finished perspective. The vertical placement of the perspective plan depends upon the location of the HML. Normally, you should drop the HML down far enough to be able to draw the complete perspective plan below the GL. See Fig. 3–9. There is a certain amount of confusion when the perspective plan overlaps the drawn perspective. See Fig. 3–10. Properly locating the HML will come with practice, however. To be safe, you could always draw it a good distance below the GL.

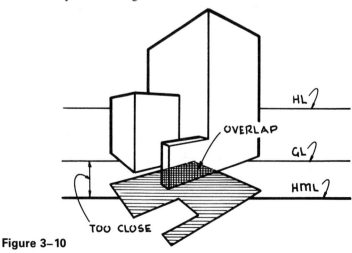

Figure 3–10

Once you have the complete perspective plan drawn, you project vertically from it to draw the perspective of the object, which is drawn in relation to the GL. See Fig. 3–11.

Step 10. See Fig. 3–12.

10a. Locate the HML a good distance below the GL.

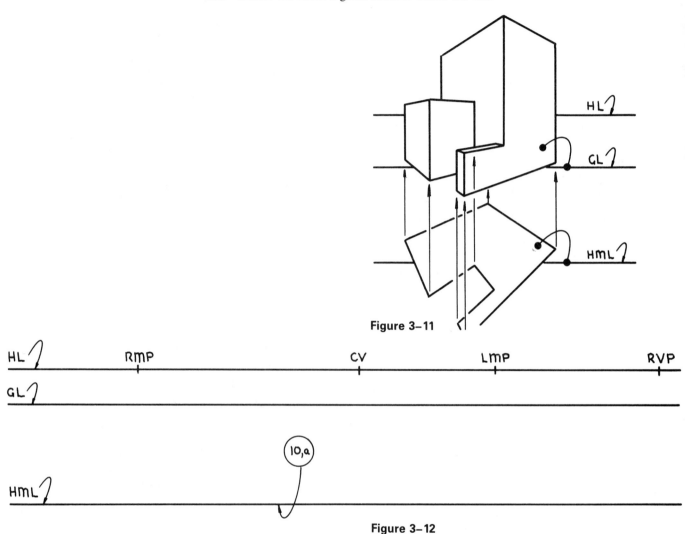

Figure 3–11

Figure 3–12

3.4 DRAWING THE PERSPECTIVE PLAN

Statement 13. Before you actually draw the object in relation to the GL, you need to draw a complete perspective plan of the object in relation to the HML. You need to complete the perspective plan before you project up to draw the perspective.

Statement 14. Refer to the plan view of the perspective setup to draw the perspective plan. See Fig. 3–13. Even though this plan view is drawn at a small scale, it can still be scaled. You can take measurements directly from this drawing. Points of interest have been identified by numbers in order to help with the following explanation. (For your convenience, this plan view will be redrawn when needed.)

Step 11. See Fig. 3–14.

11a. Project the CV vertically down to the HML, locating point 1.

PLAN VIEW

Figure 3–13

Figure 3–14

11b. Scale the distance of dimension x to the right of point 1 to find point 2.

Step 12. See Fig. 3–15.

12a. Through point 2 draw a line from the LVP. This line is considered a left base line (LBL₁).

Statement 15. Any horizontal line in the ground plane vanishing to either vanishing point is considered to be a base line. Lines going to the RVP are right base lines (RBLs), and lines going to the LVP are left base lines (LBLs).

12b. Next, you need to find points 3 and 10 on LBL₁ (see Ref. Fig. 3–13). Scale the distance from point 2 to point 3 (10'-0). Make a 10'-0 measurement to the right of point 2 on the HML. Now you must transfer this measurement to LBL₁ with a line drawn from the LMP. Where this line crosses the LBL₁ locates point 3 in perspective.

12c. Scale the distance from point 2 to point 10 (8'-0). Make an 8'-0 measurement to the left of point 2 on the HML. Transfer this measurement to LBL₁ with a line drawn from the LMP. Where this line crosses LBL₁ locates point 10 in perspective.

12d. To locate point 15, 6'-0 to the left of point 10, measure 6'-0 farther to the

Figure 3–15

left on the HML. Transfer this measurement to LBL₁ with a line drawn from the LMP. See Fig. 3–15.

Step 13. See Fig. 3–16.

13a. Draw a right base line (RBL₁) through point 3. This base line represents the right side of the house in the perspective plan.

13b. On this RBL₁ you want to scale the depth of the house, which is 24'-0. Since the point where you want to begin the 24'-0 measurement (point 3) is not in the PP (it is in front of the PP), you must refer this point back to the PP in order to establish a starting point for the 24' measurement. Since you are now working with a RBL (line 3,11,4), you must refer point 3 to the PP on a line drawn to the RMP. Where this line crosses the PP, HML at point 3p is the starting point for the 24'-0 measurement.

13c. Make the 24'-0 measurement on the HML to the right of point 3p. Transfer this measurement to RBL₁ with a line drawn from the RMP. This locates point 4 in perspective. This is the back right corner of the house in the perspective plan.

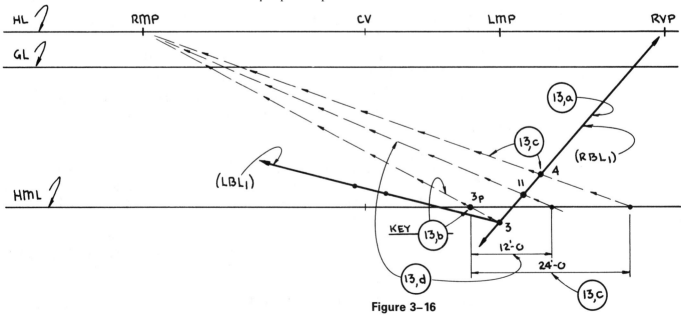

Figure 3–16

13d. To find point 11 measure 12'-0 to the right of point 3p. Transfer this measurement to RBL₁ with a line from the RMP. This locates point 11.

Statement 16. As you can see, you make all width and depth measurements on the HML. When you are working with a LBL, you must use the LMP to transfer the measurement from the HML to the LBL. When you are working with a RBL, you must use the RMP to transfer the measurements from the HML to the RBL. There is a definite pattern to this process. The steps in this process are as follows:

1. Determine if you are working with a right or left base line. Does the line vanish to the right or left vanishing point?
2. Determine if the starting point for your measurement is in the PP. Is it on the HML?
3. If the starting point is in the PP, you can make your measurement on the HML starting at that point.
4. If the starting point is not in the PP, you must project it into the PP, HML with a line drawn to the appropriate measuring point. (If you are working with a RBL, you use the RMP. If you are working with a LBL, you use the LMP.) The starting point for your measurement is where this line of projection crosses the HML.
5. Make the measurement to the right or left of this starting point on the HML.
6. Project this measurement to the same base line with a line drawn from the same MP.

Step 14. See Fig. 3–17.

14a. Draw LBL₂ and LBL₃ through points 11 and 4. LBL₂ represents the ridge of the roof in the perspective plan.

14b. Draw RBL₂ and RBL₃ through points 10 and 15.

Note: All these lines should be drawn lightly. After you get the complete perspective plan drawn, then you can darken the outline of the house.

Statement 17. Continue to get your measurements from the plan view of the perspective setup.

Step 15. See Fig. 3–18.

15a. To locate points 8 and 7 on RBL₃ you need to scale the distance from point 15 to point 8 (4'-0) and from point 15 to point 7 (20'-0). You want to start these measurements at point 15. Unfortunately, it is behind the PP. Therefore, you must refer point 15 forward into the PP with a line from the RMP to locate point 15p. Remember, you are working with a RBL; therefore, you will use the RMP to find the starting point (15p) for the measurements on the HML.

15b. Measure 4' to the right of point 15p and 20' to the left. Transfer these measurements to the RBL₃ with lines drawn to the RMP. This will locate points 8 and 7 in the perspective plan.

Step 16. See Fig. 3–19.

16a. Using the LVP, draw LBL₄ from point 8 to its point of intersection with RBL₂. This point of intersection is point 9. This short line segment represents the house wall which contains the front door.

16b. Through point 7 draw LBL₅. The distance between points 7 and 6 is 16'-0; therefore, you want to make a measurement of 16'-0 along LBL₅ starting at point 7. Point 7 is not in the PP; it is in front of it. Therefore, you must refer point 7 back to the PP on a line through the LMP. This locates the starting point 7p for the 16'-0 measurement.

Figure 3-17

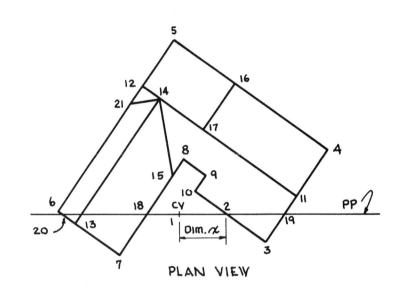

PLAN VIEW

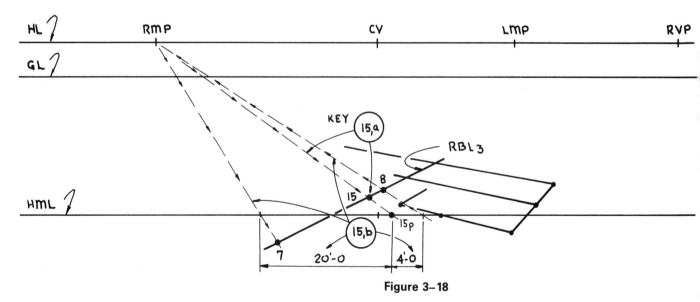

Figure 3-18

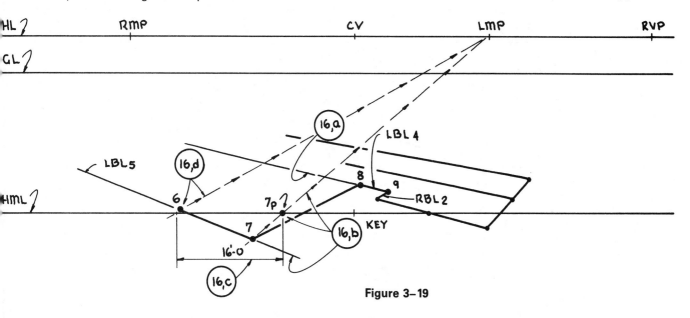

Figure 3-19

16c. Measure 16'-0 to the left of point 7p.

16d. Transfer this measurement to LBL$_5$ with a line drawn to the LMP. This locates point 6 in the perspective plan.

Step 17. See Fig. 3–20.

17a. To locate point 13 you must measure the distance between points 7 and 13 (11'-6') to the left of point 7p on the HML.

17b. Transfer this measurement to LBL$_5$ with a line from the LMP. This locates point 13 in the perspective plan.

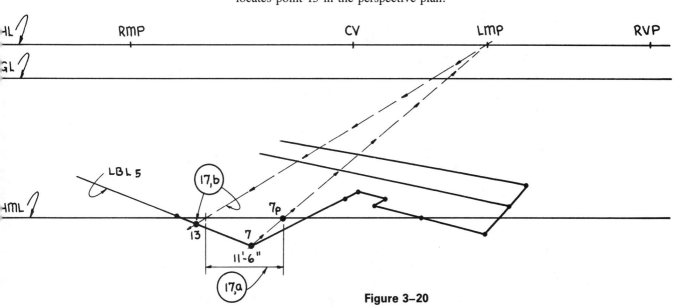

Figure 3-20

Step 18. See Fig. 3–21.

18a. Through points 13 and 6 draw two more base lines—RBL$_4$ and RBL$_5$. The ridge of the roof is represented by RBL$_4$, while RBL$_5$ represents the far left side of the house.

18b. Extend RBL$_3$ to locate line 17,16.

18c. Connect points 14 and 15 with a line.

18d. It is not necessary to draw line 14,21 in the perspective plan.

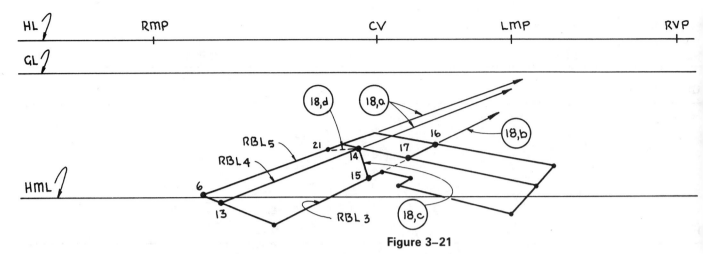

Figure 3-21

Statement 18. Except for doors and windows, the perspective plan of the house is complete. Using it as a guide, you are now ready to draw the actual perspective of the house in relation to the GL. You will project vertically from the perspective plan up into the area of the perspective.

3.5 DRAWING THE ACTUAL PERSPECTIVE USING TRUE HEIGHT LINES

Statement 19. In order to draw the perspective of the house, you need to refer to the dimensioned elevations. See Fig. 3-22.

Note: Specific points on the house have been identified by letters. This labeling will make the explanation more easily understood.

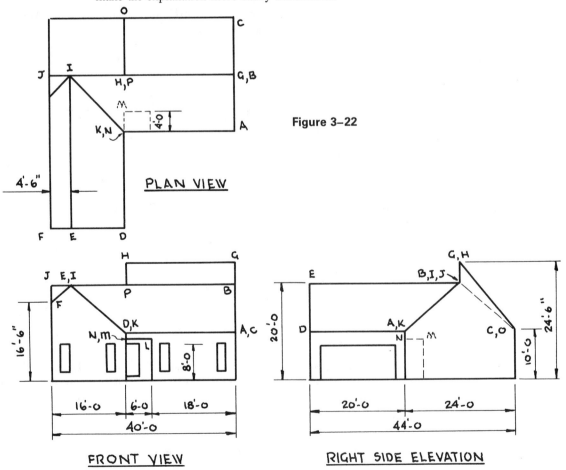

Figure 3-22

PLAN VIEW

FRONT VIEW

RIGHT SIDE ELEVATION

Statement 20. When you were drawing the perspective plan of the house, you were dealing with only width and depth measurements. Now that you are ready to begin to draw the actual perspective, you must deal with height measurements as well.

Remember that a line or plane which is drawn in or which touches the PP will be true length. See Fig. 3–23. Vertical plane x in this figure intersects with the PP at line AB. Plane x is made up of hundreds of vertical lines. The vertical lines which are in that part of plane x which is in front of the PP are larger than true size. Consequently, the vertical lines which are in that part of plane x which is behind the PP are smaller than true size. The one vertical line in plane x that represents its true height is the line of intersection between plane x and the PP (line AB).

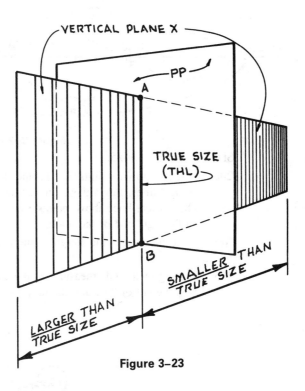

Figure 3–23

All vertical measurements must be made on true height lines. In complicated perspectives there can be more than one THL — there can be many THLs. You can tell the location of these THLs by the intersection of lines in the perspective plan with the HML. The HML is in the PP. So, every time a line in the perspective plan crosses the HML, a THL is indicated.

Step 19. See Fig. 3–24.

19a. The outside walls of the house cross the HML at four points — 20, 18, 2, and 19 — indicating the locations of four THLs. All four are usable, but you will want to pick only one with which to begin the perspective. Normally, the THL that is on the extreme end of the house is used first (THL 19).

19b. Draw a vertical line through point 19 and label it a THL.

19c. This THL intersects the GL at point 19p.

Note: All the points indicated in the perspective plan are also represented in the perspective. Point 19 is in the perspective plan and point 19p is in the perspective. They are the same point.

19d. Through point 19p draw a line to the RVP.

Figure 3–24

Step 20. See Fig. 3–25.

20a. Directly above points 3, 11, and 4 in the perspective plan, draw three vertical lines. Begin these lines at the line drawn in the previous step (19d). The vertical lines above points 3 and 4 represent the front and back corners on the right end of the house.

Note: Continue to get the height dimensions from the house elevations. See Fig. 3–22.

20b. Starting at the GL measure on the THL$_{19}$ the eave height of 10′, the roof ridge height of 20′, and the tallest point on the house, 24′-6″.

Figure 3–25

20c. Project the 20' and 24'-6" measurements from THL_{19} back to the vertical above point 11 with lines drawn to the RVP. This will locate points B and G in perspective.

20d. Project the 10' measurement to the verticals above points 3 and 4 with a line from the RVP. This will locate points A and C in the perspective.

Step 21. See Fig. 3–26.

21a. Draw lines from A to B, from B to G, and from G to C. This will complete the right end of the house.

21b. From points 3p, A, B, and G, draw lines toward the LVP.

21c. Project verticals up from points 8, 10, 14, 15, and 17 in the perspective plan. These should be light construction lines.

21d. The vertical above point 15 will locate points 15p and K in the perspective.

21e. The vertical above point 17 will locate points P and H in the perspective.

21f. The vertical above point 14 will locate point I in the perspective.

21g. The verticals above points 8 and 10 will become actual corners on the house.

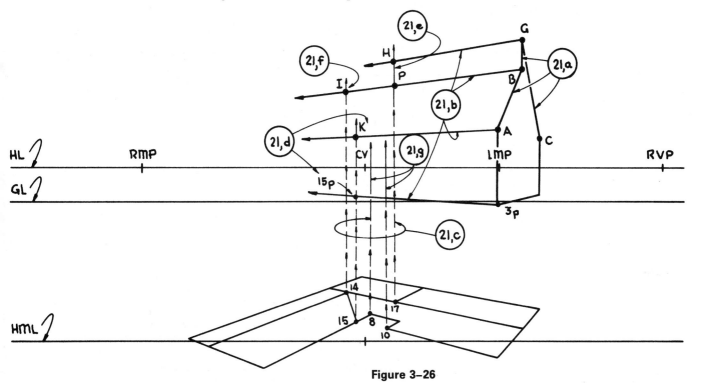

Figure 3–26

Step 22. See Fig. 3–27.

22a. Starting at points I, K, and 15p, draw lines forward from the RVP. The line through point 15p should extend back toward the RVP as well. It will stop at the vertical above point 8.

22b. Project verticals up from points 7, 13, and 6 in the perspective plan.

22c. The vertical above point 7 will locate points 7p and D.

22d. The vertical above point 13 will locate point E.

22e. Draw lines from 7p to D, from D to E, and from I to K.

Step 23. See Fig. 3–28.

23a. Starting at point 7p, draw a line to the LVP.

23b. Draw a vertical above point 6. This vertical line will form the far left front corner of the house. It also locates point 6p in the perspective.

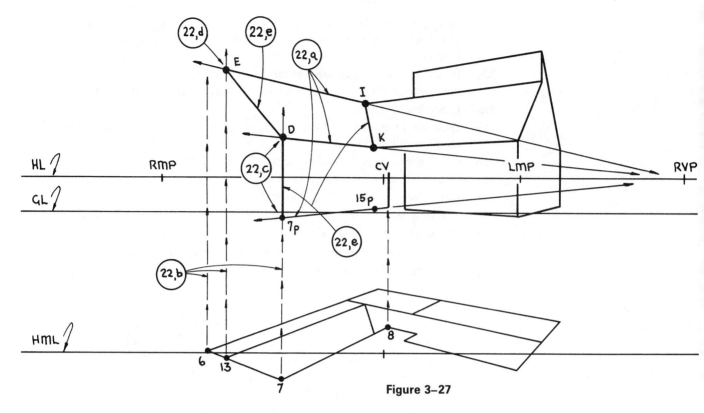

Figure 3–27

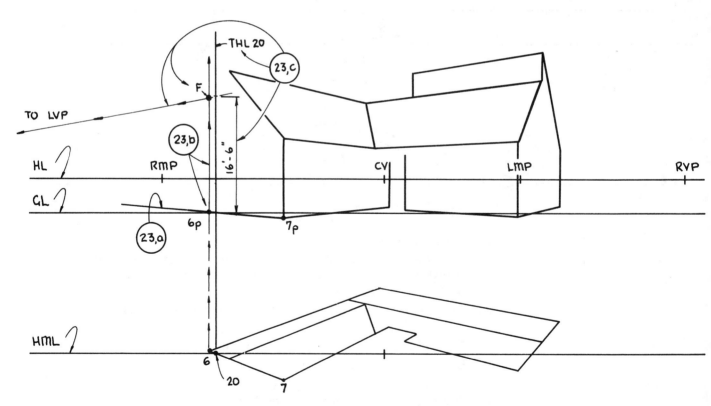

Figure 3–28

22c. Draw another THL above point 20 in the perspective plan. You are trying to locate point F, 16′-6″ above the ground. Measure 16′-6″ on this THL and transfer this measurement to the vertical above point 6 on a line through the LVP. This will locate point F in the perspective. See Fig. 3–28.

Step 24. See Fig. 3–29.

24a. Draw a line between points F and E.

24b. Using THL$_{18}$ establish the height of the ceiling 8′-0 in the recessed entrance. Starting at the GL make an 8′-0 measurement on this THL and transfer it back to the verticals above points 15 and 8 on a line drawn to the RVP. This locates points N and M.

24c. Starting at points N, M, and 8p, draw three lines to the right from the LVP. The line drawn from point N will locate point L.

24d. Draw a vertical line between points N and K.

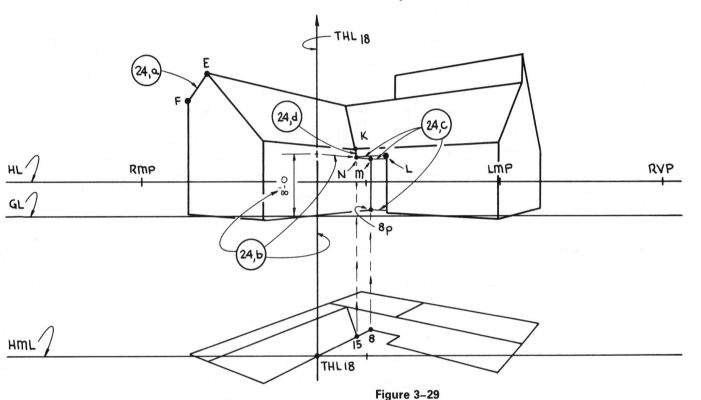

Figure 3–29

Statement 21. This should complete the outline of the house drawn in perspective. Now you have to add the doors and windows. Again, you can scale the elevations to get the size and spacing of these features. See Fig. 3–30. You make the width and depth measurements along the HML and height measurements on the appropriate THL. Find the location of the doors and windows in the perspective plan first; then project them vertically into the perspective.

Note: The tops of the front entry door and all the windows are 7′-6″ above the ground. The front entry door is 3′ × 7′. All the windows are 2′ × 6′ and are spaced 2′ from the corners of the house. The garage door is 7′ × 16′ spaced 2′ off the front corner.

Step 25. See Fig. 3–31.

25a. To find the location of the front entry door, you must make a 3′ measurement to the right of point 8 on line 8,9. This line is a LBL; therefore, you

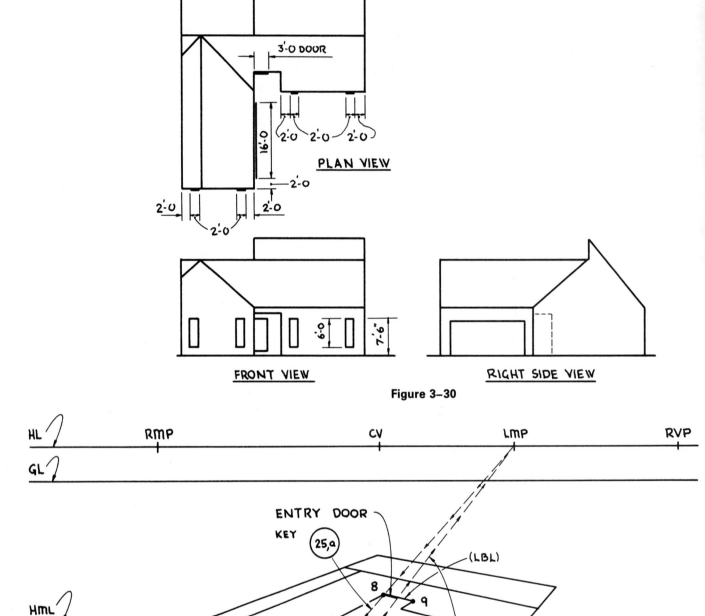

PLAN VIEW

FRONT VIEW **RIGHT SIDE VIEW**

Figure 3–30

Figure 3–31

must work with the LMP. Point 8 is not in the PP, so you must project it into the PP along a line from the LMP locating point 8p. This gives you a starting point for the 3′ measurement.

25b. Measure 3′ to the right of point 8p on the HML and transfer this measurement back to line 8,9 with a line back to the LMP. This locates the front entry door in the perspective plan.

Step 26. See Fig. 3–32.

26a. To find the horizontal location of the windows on line 6,7 you must project

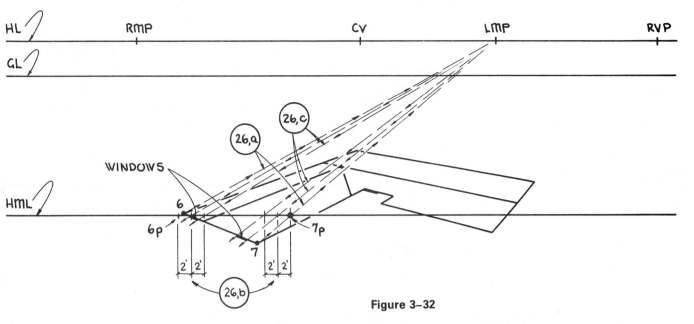

Figure 3–32

points 6 and 7 onto the HML. You do this with lines going to the LMP because line 6,7 is a LBL. This will locate points 6p and 7p on the HML.

26b. Make two consecutive measurements of 2′ to the right of point 6p. Do the same to the left of point 7p.

26c. Transfer these measurements to line 6,7 with lines drawn to the LMP. This will locate the windows in the perspective plan.

Step 27. See Fig. 3–33.

27a. To find the horizontal location of the windows on line 10,3 you must project points 10 and 3 into the HML. You do this with lines going to the LMP because line 10,3 is also a LBL. This will locate points 10p and 3p on the HML.

27b. Make two consecutive measurements of 2′ to the right of point 10p. Do the same to the left of point 3p.

27c. Transfer these measurements to line 10,3 with lines drawn to the LMP. This will locate the windows in the perspective plan. See Fig. 3–33.

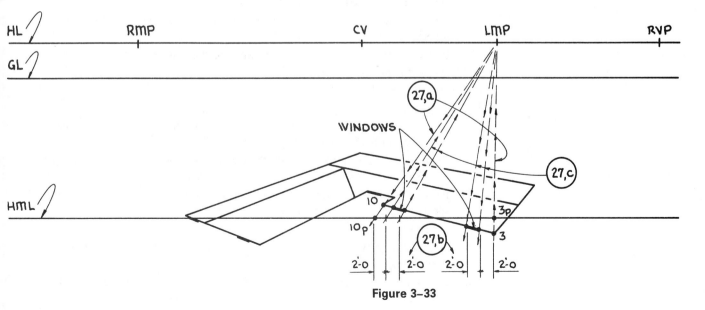

Figure 3–33

Step 28. See Fig. 3–34.

28a. To find the horizontal location of the garage door on line 7,8 you must project point 7 onto the HML. You do this with a line going to the RMP because line 7,8 is a RBL. This will locate point 7p on the HML.

28b. Make two consecutive measurements of 2′ and 16′ to the right of point 7p.

28c. Transfer these measurements to line 7,8 with lines drawn to the RMP. This will locate the garage door in the perspective plan.

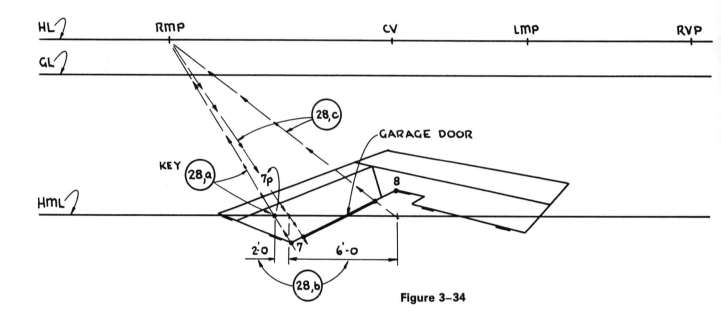

Figure 3–34

Statement 22. You have now located all the doors and windows in the perspective plan. Use these horizontal locations to project vertically into the perspective.

Step 29. See Fig. 3–35.

29a. Use THL_{20} to find the vertical location for the windows in line 6,7. Measure up from the GL 7′-6″ and then down 6′-0.

29b. Project these measurements across the face of the house with two lines from the LVP.

29c. Project vertically the horizontal locations of these windows from the perspective plan.

29d. Draw the windows.

Step 30. See Fig. 3–35.

30a. Use THL_2 to find the vertical location for the windows in line 10,3. Measure up from the GL 7′-6″ and then down 6′-0.

30b. Project these measurements across the face of the house with two lines from the LVP.

30c. Project vertically the horizontal locations of these windows from the perspective plan. Darken the windows.

Step 31. See Fig. 3–36.

31a. Use THL_{18} to find the vertical location for the garage door. Measure up from the GL 7′-0.

31b. Project this measurement across the face of the garage with a line drawn to the RVP.

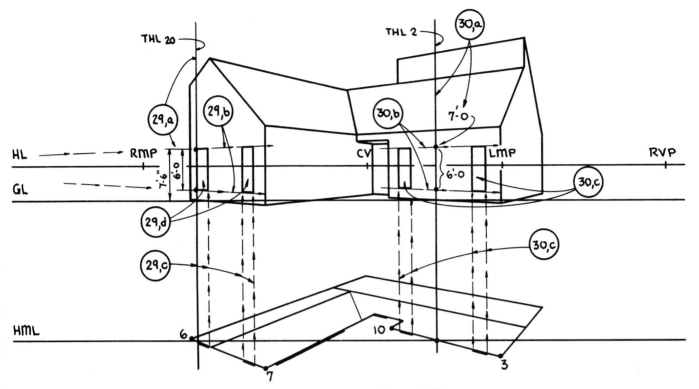

Figure 3–35

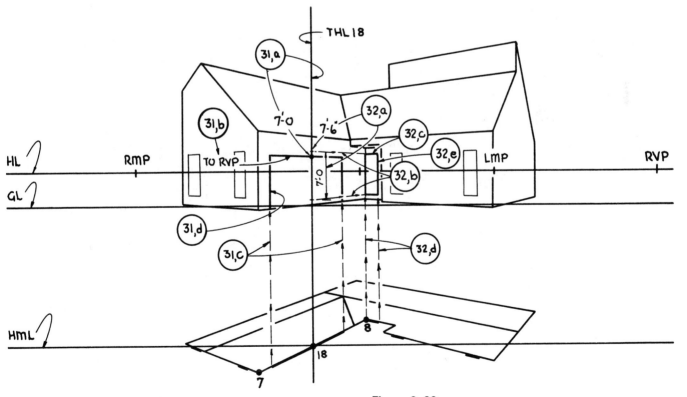

Figure 3–36

31c. Project vertically the horizontal location of the garage door from the perspective plan.

31d. Darken the outline of the garage door.

Step 32. See Fig. 3–36.

32a. Again, use THL_{18} to find the vertical location for the front entry door. Measure up from the GL 7'-6" and then down 7'-0.

32b. Project these measurements to the vertical above point 8 with lines drawn to the RVP.

32c. Project these two points across the wall which contains the front door with lines from the LVP.

32d. Project vertically the horizontal location of the front door from the perspective plan.

32e. Darken the outline of the door.

Statement 23. The perspective of the house is now complete. Add a few more details and some landscaping and you have a pen-and-ink rendering of the house. See Fig. 3–37.

Figure 3–37

Statement 24. At first glance perspective drawing seems quite complicated, and, to a certain extent, it is. If you approach the task with logical thinking, however, it becomes much easier. In these materials we have established a logical process to be used in drawing an exterior perspective.

The process began with your making decisions as you initially designed the preliminary perspective setup. Some of these decisions concerned the following:

1. The relationship between the object and the PP
2. The distance between the object and the observer
3. The overall size of the final perspective
4. The relationship between the observer and the ground plane

All these decisions were made in relation to the small-scale preliminary horizon line.

Next in the process was a step-by-step procedure for drawing the perspective plan of the object using the HML for width and depth measurements and using the MPs to transfer these measurements into the perspective. Then you drew the actual perspective, projecting from the perspective plan and using THLs to make vertical measurements. It is not important for you to memorize all these steps, but it is important that you understand the process.

All this information is basic for drawing accurate perspectives, but not all the basics have been covered in this one perspective problem. On the following pages more basic material will be discussed.

4

Basic Perspective Techniques

4.1 AUXILIARY TRUE HEIGHT LINES

Statement 1. One key to being able to draw complicated perspectives more easily is the ability to find auxiliary true height lines when necessary. You can draw any perspective by using just one true height line (THL). However, this method requires that a number of corners be turned as you transfer height measurements from the single THL to their final destination.

Refer, for example, to the house you have just drawn. See Fig. 4–1. You decide to use THL$_{19}$ on the right end of the house to locate the windows on the far left front face of the house. To accomplish this, you would have to turn three corners in transferring the height measurements from THL$_{19}$ to the far left face. Every time you turn a corner, you risk making a mistake. It is preferable to make the height measurement on a THL which will allow you to project directly to the measurement's final destination. This is why you used THL$_{20}$ when you were locating these windows. This THL was already in the same vertical plane as the windows. See Fig. 4–1.

Figure 4–1

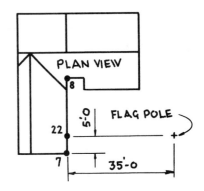

<div align="center">

Figure 4–2

</div>

Statement 2. Sometimes you will have to find new or auxiliary THLs. Perhaps you want to draw a 30' flag pole in front of the house you have just drawn. See Fig. 4–2. First, you must find the exact location of the flag pole on the perspective plan.

Step 1. See Fig. 4–3.

 1a. Project point 7 into the PP with a line from the RMP locating point 7p on the HML.

 1b. Measure 5'-0 to the right of point 7p and transfer this measurement to line 7,8 with a line from the RMP locating point 22.

 1c. Through this point draw a line (LBL) from the LVP. The flag pole stands 35' to the right of the house along this line.

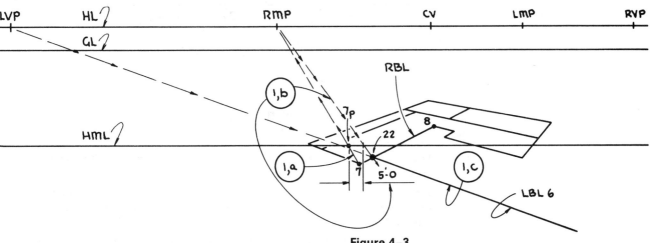

<div align="center">

Figure 4–3

</div>

Step 2. See Fig. 4–4.

 2a. Project point 22 into the PP with a line drawn to the LMP locating point 22p on the HML.

 2b. Measure 35' to the right of point 22p and transfer this measurement to LBL_6 with a line from the LMP. This locates the flag pole in the perspective plan. See Fig. 4–4.

Statement 3. In order to find the height of the flag pole directly, refer to the plan view of the perspective setup. See Fig. 4–5. First, you need to project the location of the flag pole into the PP along a line that is parallel to one of the sides of the house. This gives you two choices — to the right or to the left. Either direction would work, but, in this case, the one going to the right is more convenient. Because this line is parallel to the right vertical face of the house, it will go to the RVP. Now refer to the perspective plan of the house.

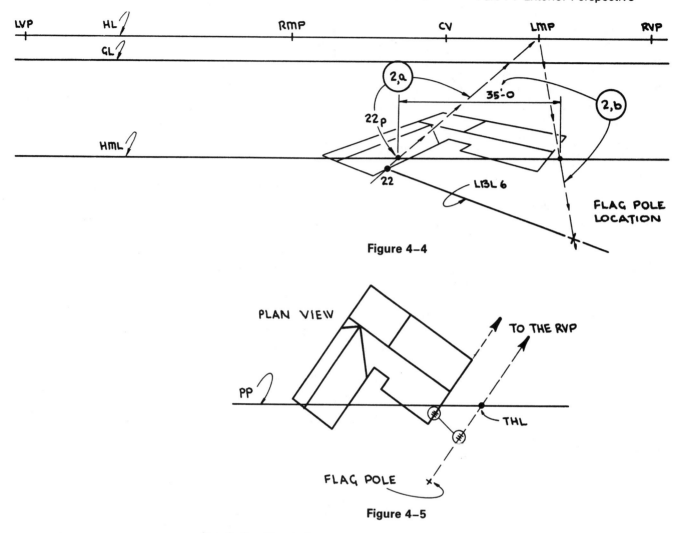

Figure 4-4

Figure 4-5

Step 3. See Fig. 4–6.

3a. Draw a line to the RVP from the location of the flag pole. Where this line crosses the HML locates point FP$_p$.

3b. Because FP$_p$ is in the PP, you can erect an auxiliary true height line (Aux. THL) at this point. Starting at the GL make a 30′ measurement on this auxiliary THL.

3c. Draw a vertical above the perspective plan location of the flag pole.

3d. With lines from the RVP project the 30′ measurement forward to determine the exact height and location of the flag pole in the perspective. Because the flag pole is in front of the PP, it is drawn larger than true size. See Fig. 4–6.

Statement 4. You created a 30′ high vertical plane which originated at the RVP. It came forward to intersect with the PP at the auxiliary THL and continued forward to include the flag pole. You would have achieved the same result had you chosen to go to the LVP.

Note: Let's try another example. Here is a perspective setup with the HL, GL, and VPs located. The *x* on the ground plane indicates the location of a 20′ flag pole. Draw in the flag pole.

Step 1. See Fig. 4–7.

1a. To prove you can go in either direction to find an auxiliary THL, project

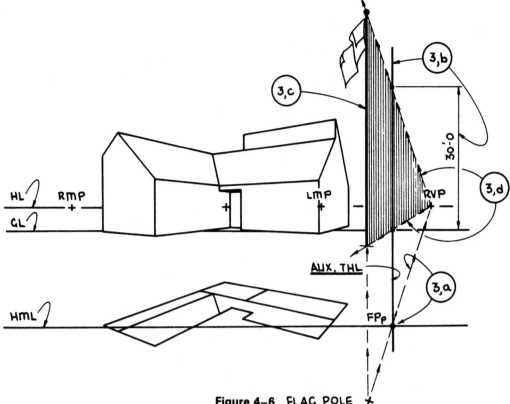

Figure 4-6 FLAG POLE

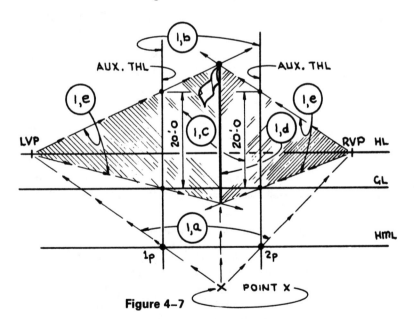

Figure 4-7

the location of the flag pole into the PP, HML with lines drawn to both the right and left vanishing points (locating points) 1p and 2p.

1b. Erect two auxiliary THLs at these points.

1c. Starting at the GL make measurements of 20'-0 on both auxiliary THLs.

1d. Draw a vertical line above point x.

1e. Project these 20' measurements forward to the vertical line above point x with lines from both VPs.

Note: The two vertical planes created are the same height (20′) and intersect at the flag pole. The results are the same, regardless of the VP you use.

Statement 5. To find new or auxiliary THLs, you don't have to use either VP. You can project to *any point* on the HL. The key is that you come out from the HL the same way you went to it.
Note: Use the same setup as in Fig. 4–7 for this example.

Step 1. See Fig. 4–8.

 1a. Draw a line from the location of the flag pole (x) in the perspective plan to a *random point* on the HL.

 1b. Where this line intersects with the PP, HML at point 3, erect an auxiliary THL.

 1c. Starting at the GL make a measurement of 20′-0 on this auxiliary THL and project it forward with lines from the random point on the HL. See Fig. 4–8.

 1d. Where these two lines intersect with a vertical above point x locates the 20′ flag pole in perspective. See Fig. 4–8.

Figure 4–8

Statement 6. With this knowledge concerning auxiliary THLs, you should be able to locate any point in space. This technique of finding auxiliary THLs will make drawing complicated perspectives much easier.

4.2 VERTICAL AND INCLINED HORIZON LINES

Statement 1. Every plane in space has its own horizon line. Almost every line which is contained within a plane will vanish to that plane's horizon line. Lines which are parallel to the HL will not vanish to it.

Let's discuss, for instance, the ground plane. It is a horizontal plane; therefore, it will have a horizontal HL. See Fig. 4–9. All the lines in this plane, except the ones running parallel to the HL, will vanish to the original HL. See Fig. 4–10.

If a horizontal plane has a horizontal HL, then a vertical plane will have a vertical HL. The object in Fig. 4–11 has two visible vertical sides—plane A and B. The HL for plane A is going to be a vertical line. To find the HL for vertical plane A, you need to find a vanishing point for one line in the plane. Line AB is in plane A, and it vanishes to the RVP. If you can find one point on a nonexistent vertical line, you can draw that vertical. Therefore, the vertical HL for plane A will go through the RVP. See Fig. 4–11. Plane A is called a right vertical plane; consequently, its HL is called a right vertical

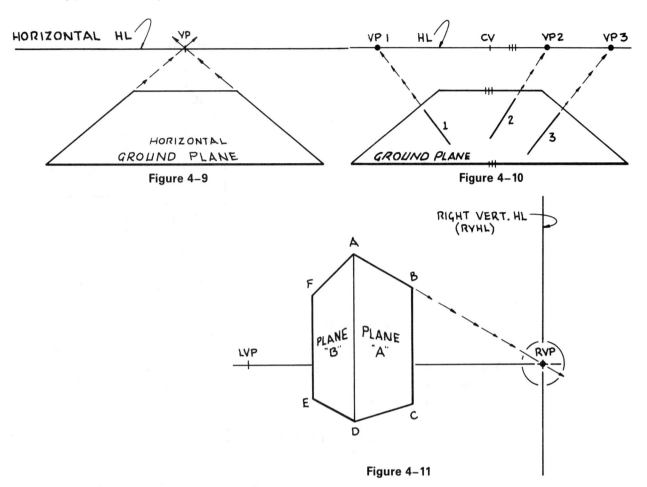

Figure 4-9

Figure 4-10

Figure 4-11

horizon line (RVHL). All inclined and horizontal lines in plane A will vanish to the RVHL. See Fig. 4-12.

Plane B is considered to be a left vertical plane because all the horizontal lines in this plane will vanish to the LVP. See Fig. 4-13. Its HL will be a vertical line drawn through the LVP and will be called a left vertical horizon line (LVHL). As an example,

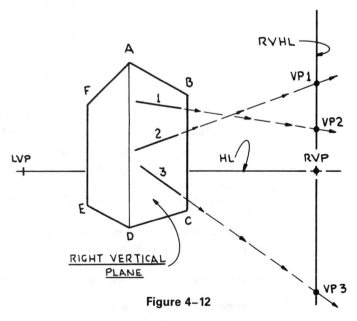

Figure 4-12

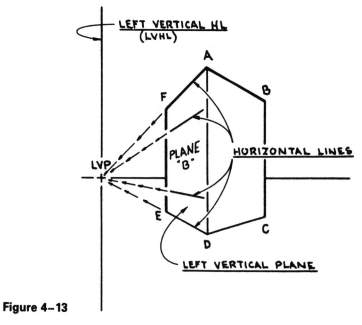

Figure 4–13

let's say you have a line in plane B and you want to draw more lines parallel to it. Because line 1 is in a left vertical plane, it will vanish to the LVHL. To find its vanishing point, extend line 1 until it intersects with the LVHL, locating VP₁. This will be the VP for all lines drawn parallel to line 1. See Fig. 4–14.

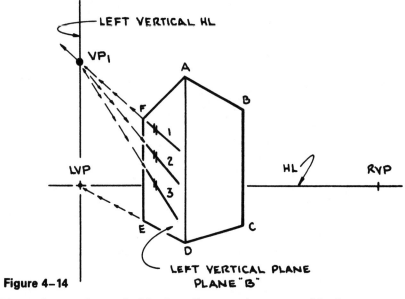

Figure 4–14

Vanishing points on the vertical horizon lines can be very useful when you are drawing a complicated roof system as in Fig. 4–15. Inclined lines 1, 2, 3, and 4 are all parallel and are in left vertical planes. Consequently, they will vanish to the same VP₁ on the LVHL. Lines 5 and 6 are parallel and are in left vertical planes. They will vanish to VP₂ on the LVHL.

Inclined lines 7, 8, 9, and 10, also in Fig. 4–15, are parallel and are in right vertical planes. They will vanish to VP₃ on the RVHL. Lines 11 and 12 will vanish to VP₄ on the RVHL as well. Find the VP for just one of these lines and you can use it to draw the rest. This is a very accurate way to draw parallel inclined lines in a perspective.

New Problem. You are given the following elevations of a house. Only the angle of the roof pitch is indicated. The elevations are not drawn to scale. See Fig. 4–16. Now you must draw the house.

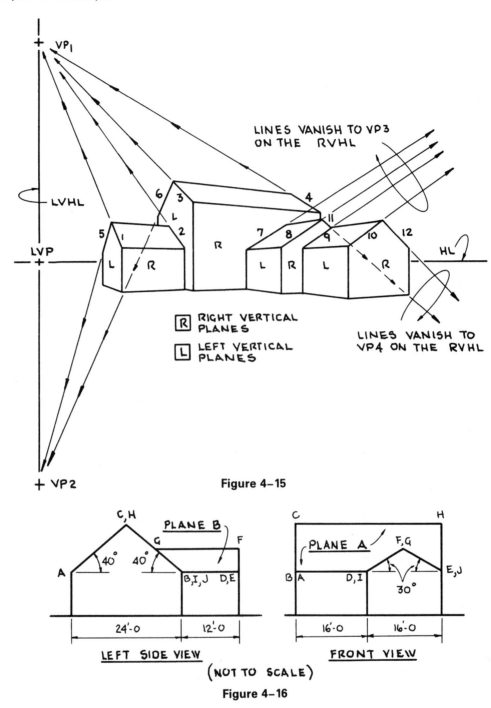

Figure 4–15

Figure 4–16

In Fig. 4–17 you have the house drawn except for the roof. Since the ridge heights are not given and the elevations are not drawn to scale, you have to use the angle data supplied to draw the roof system. Draw the roof according to the following steps.

Step 1. See Fig. 4–18.

Note: According to the elevations, the end gable makes 40° angles with the horizontal. You must find the vanishing points for lines CB and AC. They are in a left vertical plane; therefore, they will vanish to the left vertical horizon line (LVHL).

 1a. Because you are working with 40° inclined lines in a *left vertical plane,* you want to construct 40° angles above and below the original HL at the *LMP.*

 1b. Extend these angles until they intersect with the LVHL. This will locate

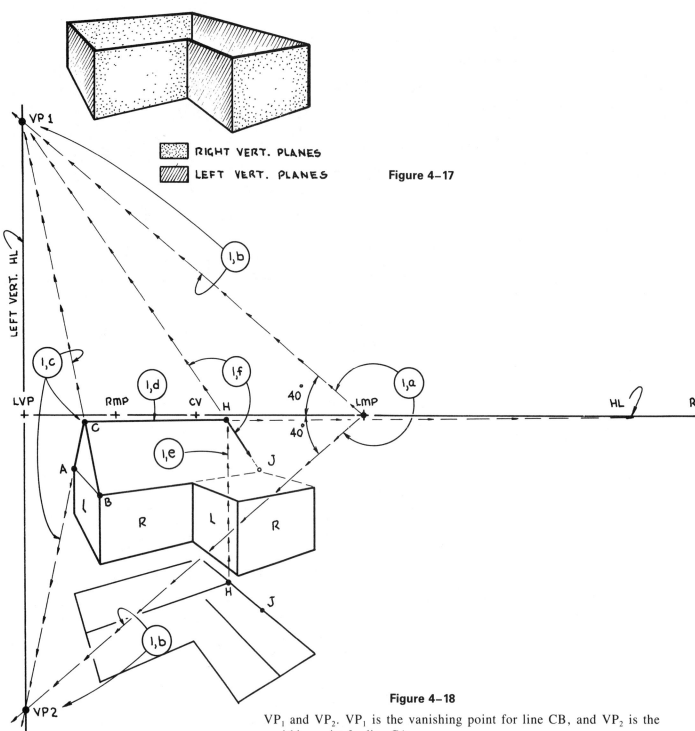

Figure 4–17

Figure 4–18

VP₁ and VP₂. VP₁ is the vanishing point for line CB, and VP₂ is the vanishing point for line CA.

1c. From point B draw a line to VP₁. Start a line at point A drawn from VP₂. The intersection of these two inclined lines will locate point C on the ridge of the main roof.

1d. Through point C draw the ridge of the roof on a line to the RVP.

1e. Project point H from the perspective plan to the ridge line.

1f. Line HJ is also a 40° inclined line in a left vertical plane; therefore, it is parallel to line CB and will also vanish to VP₁ on the LVHL.

Note: Only a part of this line HJ will be visible after you draw in the front gable. Step 2. See Fig. 4–19.

Note: According to the elevations in Fig. 4–16, lines DF and FE form 30° angles with the horizontal. These two lines are in a right vertical plane; therefore, they will vanish to the RVHL, which is a vertical line drawn through the RVP.

2a. Because you are working with 30° inclined lines in a *right vertical plane*, you want to construct 30° angles above and below the original HL at the *RMP*.

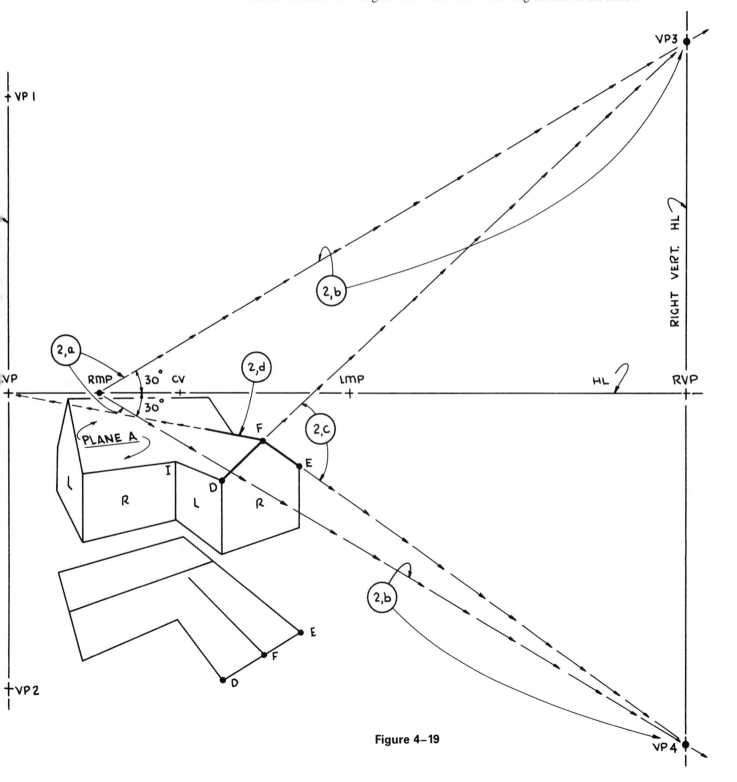

Figure 4–19

2b. Extend these angles until they intersect with the RVHL at VP_3 and VP_4. VP_3 is the vanishing point for line DF, and VP_4 is the vanishing point for line FE.

2c. From point D draw a line to VP_3. Start a line at point E, drawn from VP_4. The intersection between these two inclined lines will locate point F on the ridge of the front gable.

2d. Through point F draw the lower ridge of the roof along a line to the LVP.

Statement 1. Your problem now is to find where this ridge line intersects with plane A (point G). Refer to the elevations in Fig. 4–16.

Statement 2. It has already been stated that every plane in space has its own horizon line, and almost all the lines contained within that plane will vanish to the plane's HL. You can find the HL for any plane by finding the VPs for two *nonparallel* lines in that plane. Once you find two points on a straight line, you can draw the straight line. In this case you want to find two vanishing points on the same HL.

Vertical planes have vertical horizon lines and horizontal planes have horizontal horizon lines; moreover, inclined planes will have inclined horizon lines. Planes A and B on the house you have been drawing are both inclined planes, and they will have inclined horizon lines. What you need to determine is the line of intersection (IG) between these two planes. See Fig. 4–16. You know where this line begins (at point I), but you can't draw line IG because you don't have point G located. It would be convenient if you could find the vanishing point for line IG.

The following statement gives the rationale for finding this vanishing point.

Statement 3. The line of intersection between two planes will always vanish to the intersection between the horizon lines of the two planes. Therefore, if you can find the horizon lines for inclined planes A and B and extend them until they intersect, you will have found the vanishing point for the line of intersection between the two planes (line IG, in this case).

Step 3. See Fig. 4–20.

3a. To find the inclined HL for plane A you need to find the vanishing points for two *nonparallel* lines which are in that plane. Lines CB and CH are two nonparallel lines in plane A. Line CB vanishes to VP_1 on the LVHL and line CH vanishes to the RVP. You have found two vanishing points on the same horizon line.

3b. Thus, a line connecting VP_1 and the RVP will be the inclined horizon line for plane A.

3c. Lines ID and DF are two *nonparallel* lines in plane B. Line ID vanishes to the LVP and line DF vanishes to VP_3 on the RVHL. You have found two vanishing points on the same horizon line.

3d. Therefore, a line connecting the LVP and VP_3 will be the inclined horizon line for plane B.

3e. The intersection between these two inclined HLs is the vanishing point for line IG.

3f. Draw in line IG.

Statement 4. Let's try one more example of this idea. The left vertical planes of the house in Fig. 4–21 have a common vertical HL which goes through the LVP. The ground plane has a horizontal HL—the original HL. The left vertical planes intersect the horizontal ground plane, forming lines 1 and 2. These two lines of intersection vanish to the LVP, which happens to be the point of intersection between the HLs of the horizontal and vertical planes. This is more evidence to prove statement 3.

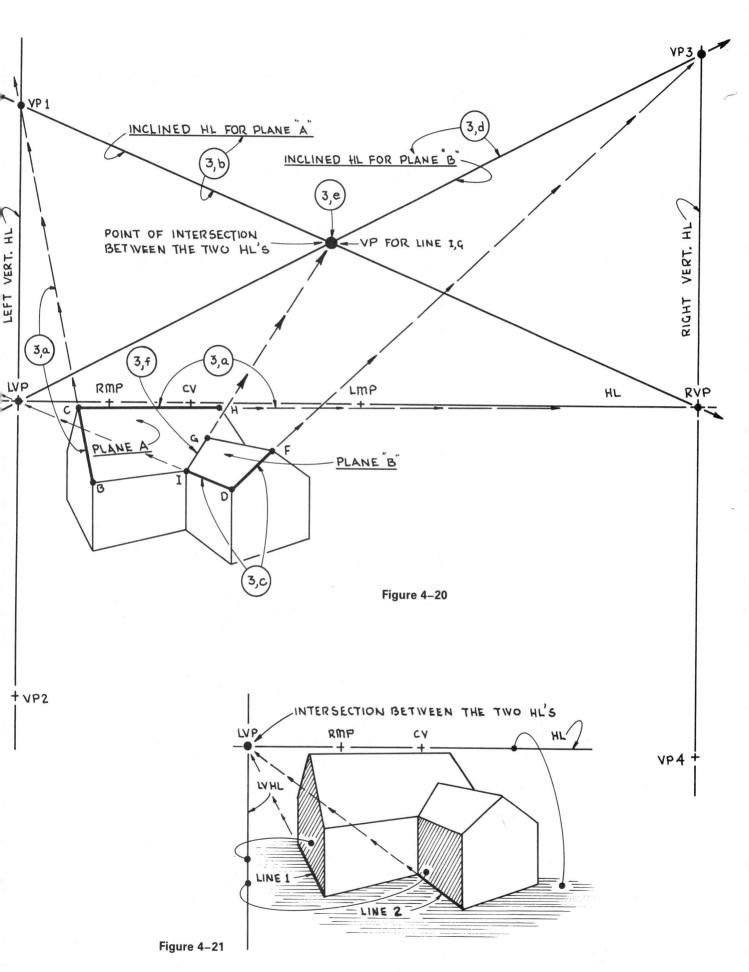

Figure 4-20

Figure 4-21

Statement 5. The knowledge of how to use vertical and inclined HLs is invaluable if you plan to become proficient in drawing complicated perspectives. Another way to find point G is illustrated in Fig. 4–22.

Step 1. See Fig. 4–22.

1a. Project point 1 onto the main ridge of the roof, locating point 2.

1b. Project point 2 from the main ridge to the lower ridge on a line from VP₁. This locates point G.

1c. Connect points I and G with a line.

Statement 6. The shortcut illustrated in Fig. 4–22 shows how to use the knowledge of vanishing points on vertical horizon lines. Shortcuts are good; but, in order to use them correctly, you must first understand the theory behind them.

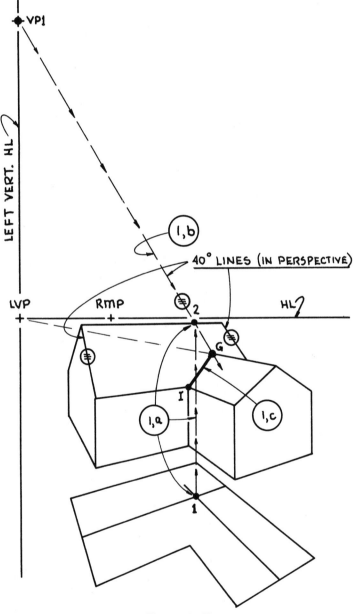

Figure 4–22

4.3 TYPICAL OVERHANG CONDITIONS (GABLE AND HIP)

Statement 1. The houses you have drawn to this point have had no overhangs. Overhangs were omitted for the sake of simplicity. Most houses that you will be asked to draw will have overhangs, however; therefore, drawing the two most common types of roofs—gable and hip—should be discussed. There are no new rules to learn, only certain points to emphasize. Both types of roofs are illustrated in Figures 4–23 and 4–24.

Statement 2. Use the partial house illustrated in Fig. 4–24 as a guide while you draw a house with a gable roof with overhangs. Three walls of this house and the roof ridge have already been drawn in the partial perspective plan illustrated in Fig. 4–25.

Step 1. See Fig. 4–26.

1a. Extend all four lines in order for them to receive the measurements projected for the overhangs.

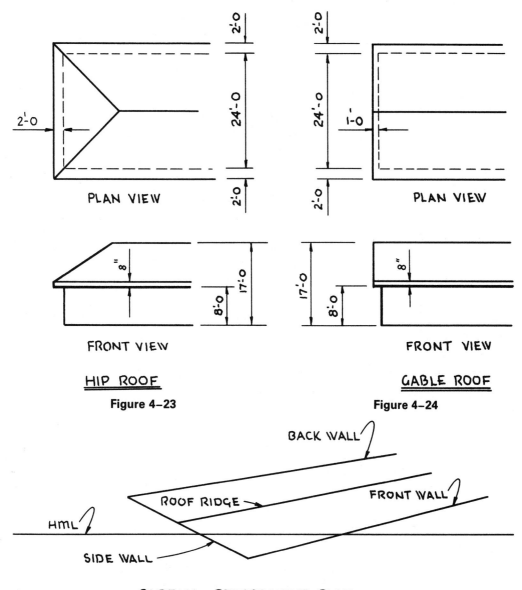

PLAN VIEW

FRONT VIEW

HIP ROOF

Figure 4–23

PLAN VIEW

FRONT VIEW

GABLE ROOF

Figure 4–24

BACK WALL

ROOF RIDGE

FRONT WALL

HML

SIDE WALL

PARTIAL PERSPECTIVE PLAN

Figure 4–25

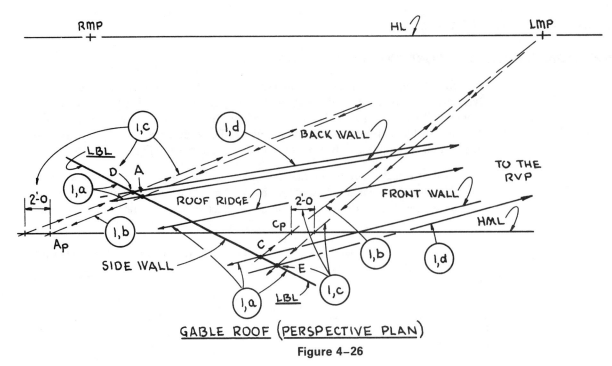

GABLE ROOF (PERSPECTIVE PLAN)

Figure 4–26

1b. There are 2'-0 overhangs on the back and front of the house; therefore, you want to make 2' measurements behind point A and in front of point C. Because you are working with a left base line (LBL), you want to project points A and C into the PP with lines drawn from the LMP. This will locate points A_p and C_p on the HML. These will be the starting points for the 2' measurements.

1c. Measure 2'-0 to the left of point A_p and 2'-0 to the right of point C_p. Transfer these measurements from the HML to the LBL with lines drawn from the LMP, locating points D and E.

1d. Through points D and E draw lines to the RVP. These two lines represent the front and back overhangs in the perspective plan.

Step 2. See Fig. 4–27.

2a. The end overhang on the house is 1'-0. You need to make a 1'-0 measurement to the left of point C. Because you are working with a right base line

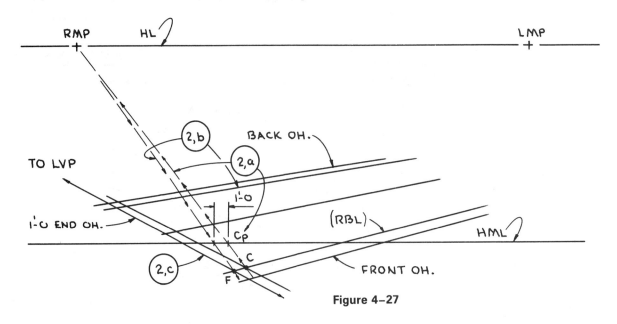

Figure 4–27

(RBL), you need to project point C back into the PP with a line drawn to the RMP. This will locate point C$_p$ on the HML. This will be the starting point for the 1'-0 measurement.

2b. Make a 1'-0 measurement to the left of point C$_p$ and transfer it to the RBL with a line from the RMP, locating point F.

2c. Through point F draw a line to the LVP. This line represents the end over-hang in the perspective plan.

Statement 3. You now have three walls, the roof ridge, and all the overhangs drawn in the perspective plan of the house. Using the perspective plan as a guide, draw the partial perspective of the house. Note: Four true height lines (THLs) are indicated in Fig. 4–28 at points K, L, M, and N. Typically, you will want to use the THL that is in the same vertical plane as the end overhang (THL K).

Step 3. See Fig. 4–28.

3a. Draw a vertical above point K. This will be the THL you will use to make the height measurements. (Refer to the elevation in Fig. 4–24 for the height data.)

3b. Draw vertical lines above points G, I, and J. (These should be light construction lines).

3c. Starting at the GL mark off measurements of 8'-0, 0-8", and 17'-0 on THL K.

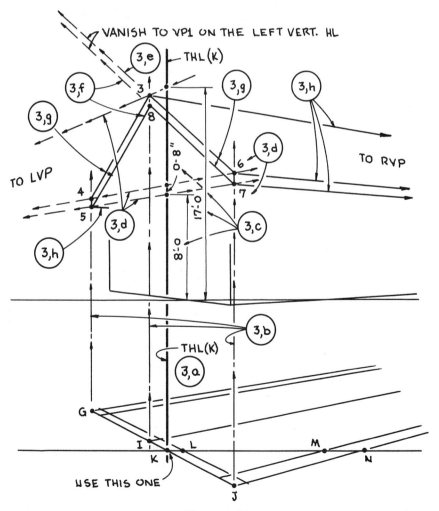

Figure 4–28

3d. Because verticals G, I, and J and THL K are all in the same left vertical plane, you can transfer the measurements from the THL to the other verticals along lines from the LVP. This transfer will locate points 3, 4, 5, 6, and 7 on verticals G, I, and J.

3e. Draw a line between points 6 and 3 and extend it until it intersects with the left vertical horizon line (LVHL) at VP_1.

3f. From point 7 draw a line to the VP_1. This will locate point 8.

3g. Draw lines between points 3 and 4, 4 and 5, 5 and 8, and 7 and 6.

3h. Starting at points 5, 3, 6, and 7, draw lines to the RVP.

Step 4. See Fig. 4–29.

4a. Project point E vertically to the front overhang, locating point 9.

4b. Draw a line starting at point 9 to the LVP.

4c. This line should intersect with the back overhang at point 10.

4d. Starting at point 10 draw an inclined line parallel to line 5,8.

4e. Line 9,10 intersects with the vertical above C at point 11.

4f. Starting at point 11, draw a line to the RVP.

Note: Because the overhang is above the HL, you should see some of the soffit area.

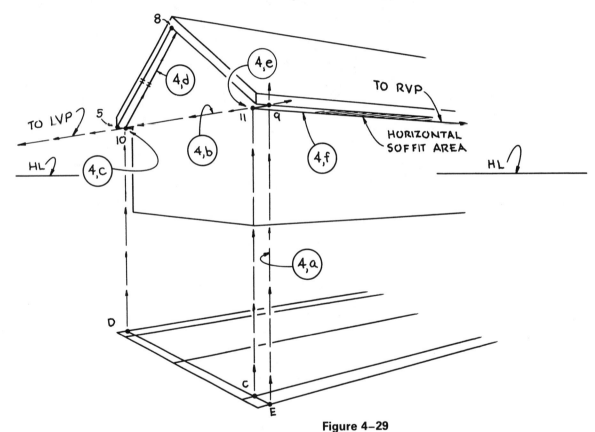

Figure 4–29

Statement 4. The key to drawing a typical gable roof with overhangs is to lay out the complete outline of the overhangs and roof ridges in the perspective plan first. You do this by making measurements on the HML and transferring them to the base lines using the appropriate measuring points. Next, use the THL that is in the same vertical plane as the end overhang to make the height measurements.

Statement 1. The procedure for drawing a hip roof with overhangs is quite similar to that of the gable roof. Normally, the gable overhangs on the ends of the house

are shorter than the overhangs on the back and front of the house. By contrast, the over-
hangs on a hip roof are the same size—front, back, and end. In this case, they are all
2′-0. Use the partial house illustrated in Fig. 4–23 as a guide to draw a hip roof house
with overhangs.

Step 1. See Fig. 4–30.

 1a. Locate the 2′-0 front and back overhangs by using the LMP.

Step 2. See Fig. 4–31.

 2a. Locate the 2′-0 end overhang by using the RMP.

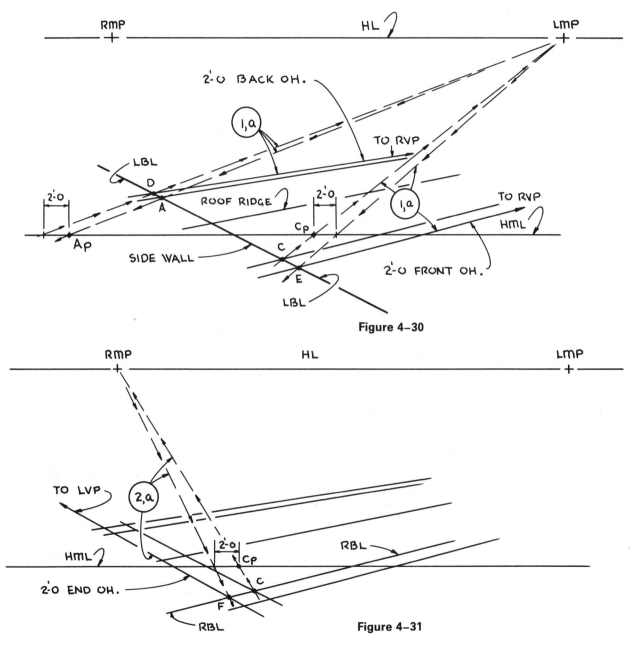

Figure 4–30

Figure 4–31

Statement 2. As you look at the plan view of this hip roof house, notice that
the distance from the point of the hip to the end wall (x) is equal to half the depth of the
house (2x). See Fig. 4–32. This is a typical condition on a hip roof. In this case, the
house is 24′-0 deep; therefore, distance x is 12′-0.

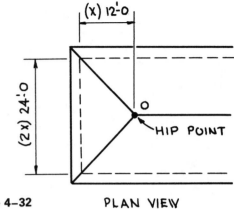

Figure 4–32 PLAN VIEW

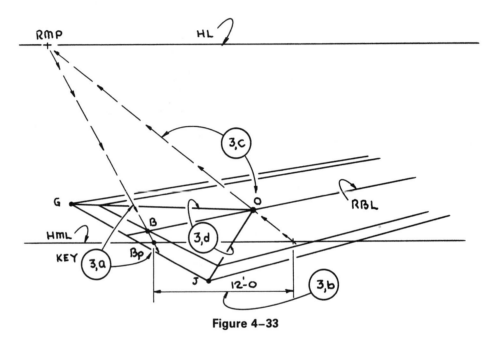

Figure 4–33

Step 3. See Fig. 4–33.

3a. You want to locate the point of the hip (point O). Since you are working with a right base line (RBL), you want to project point B into the PP with a line drawn from the RMP locating point B_p.

3b. This is the starting point for a 12'-0 measurement to the right of point B_p on the HML.

3c. Transfer this measurement back to the RBL with a line drawn to the RMP. This locates the point of the hip roof (point O).

3d. Draw lines between points G and O and between points J and O. This completes the perspective plan of the hip roof.

Statement 3. Because of the similarity between this procedure and the procedure used in drawing the gable roof, only the construction for drawing the hip roof will be shown. See Figs. 4–34 and 4–35. No verbal explanation will be given, but the chronological steps are identified by the circled numbers 1 through 10.

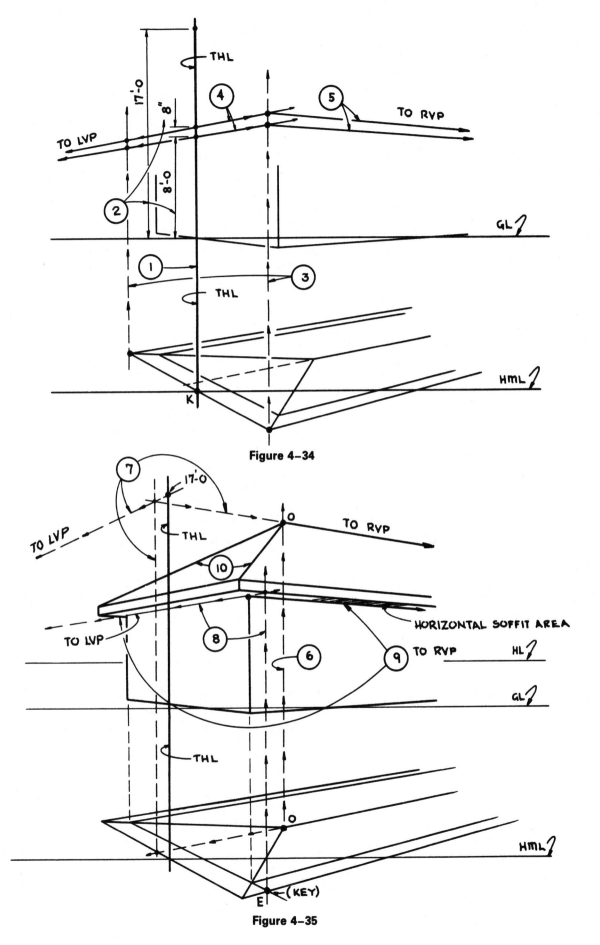

Figure 4-34

Figure 4-35

4.4 MODIFIED VERTICAL SCALE

Statement 1. Sometimes it is necessary or preferable to stretch the truth a little when drawing a perspective. For example, a true perspective is drawn at some scale, perhaps $1/4'' = 1'$-0. As usual, the width and depth measurements are made on the HML at the 1/4″ scale and height measurements are made on the THLs at the same scale. This will give you a true perspective. Sometimes, however, mainly with two-story houses, the true perspective will look too tall and somewhat unnatural.

To solve this problem, you could use a smaller vertical scale than the scale used for the horizontal measurements. If you are drawing the perspective at $1/4'' = 1'$-0 scale, the next smaller available scale is $3/16'' = 1'$-0. You could then make horizontal measurements at $1/4'' = 1'$-0 scale and vertical measurements at $3/16'' = 1'$-0 scale. Unfortunately, there is too much difference between these two scales. The perspective would look too long instead of too tall. Therefore, it is best to split the difference between the two scales for the vertical measurements. The following is a discussion on how this should be done.

Statement 2. Let's say you want to draw a box, the sides of which could be the walls of a house with the following dimensions: width 40′, depth 24′, and height 17′. The box will be drawn at $1/4'' = 1'$-0 scale from an 8′-0 eye level. The perspective plan has already been drawn for you in Fig. 4–36. You are now ready to project vertically into the area of the perspective and to begin the vertical measurements.

PERSPECTIVE PLAN

Figure 4–36

Step 1. See Fig. 4–37.

 1a. To begin this procedure, you want to work with the THL on the end of the box (THL₁). Draw the true height line.

 1b. Where THL₁ crosses the HL, measure down 5′-0 and up 3′-0 using the $1/4'' = 1'$-0 scale. Now repeat the procedure, but this time use the $3/16'' = 1'$-0 scale. Always use this 3′-5′ combination, whether you are drawing a house or a skyscraper.

 1c. Put tick marks halfway between the two 3′ and 5′ measurements. You can just estimate this distance.

 1d. Through these two tick marks draw light construction lines to the RVP.

Statement 3. The assumption is that these two lines form an 8′-0 high vertical plane which is drawn at the smaller scale $3/16'' = 1'$-0. Now you must locate a new "artificial THL" at the 3/16″ scale that reads vertically 8′-0 between these two lines.

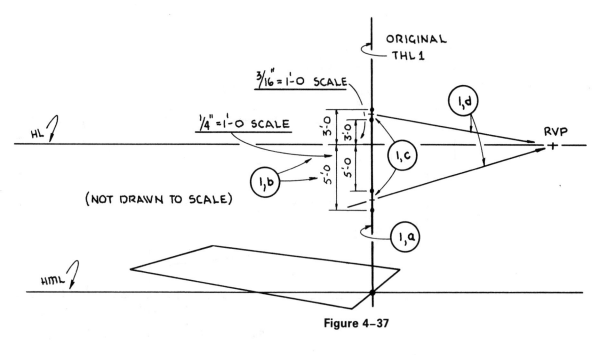

Figure 4-37

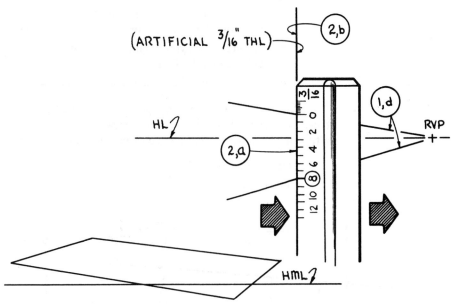

Figure 4-38

Step 2. See Fig. 4–38.

2a. Holding your architectural scale vertically, slide it along the two lines drawn in step 1,d until it reads 8'-0 on the 3/16" scale.

2b. Draw a vertical at this point. This line will be the new artificial 3/16" THL for this perspective.

Statement 4. The new artificial 3/16" THL you have just found would be sufficient to draw this very simple object. Let's say you were drawing a complicated object and you wanted to find another "artificial THL" in the front plane of the object. This would be very easy to do.

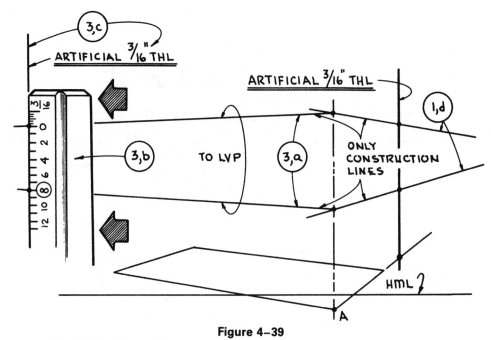

Figure 4–39

Step 3. See Fig. 4–39.

3a. In light construction lines, turn the corner at point A and extend to the LVP these two lines which form the 8′-0 high vertical plane.

3b. Again holding your architectural scale vertically, slide it along the two lines going to the LVP until it reads 8′-0 on the 3/16″ scale.

3c. Draw a vertical line at this point. This line will be another artificial 3/16″ THL.

Statement 5. From this point on, you will make all vertical measurements on these "artificial THLs." You can now erase the two lines you have been using to find the artificial THLs. They were just construction lines, not part of the object.

Step 4. See Fig. 4–40.

4a. Measure down from the HL at the 3/16″ scale the given eye level of 8′-0 to locate the ground line (GL).

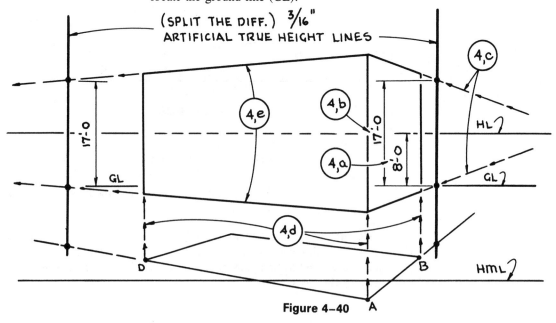

Figure 4–40

4b. Measure up from the GL the height of the walls (17'-0).

4c. Through this measurement and the GL draw two lines from the RVP.

4d. Draw verticals above points A, B, and D.

4e. Draw two lines to the LVP. Darken the perspective box.

Statement 6. If you were to compare the box in Fig. 4–40 with the same size of box drawn at a true 1/4″ scale, you would probably notice very little difference. See Fig. 4–41. If you were to make houses out of these two boxes, the difference would be more apparent. See Fig. 4–42. There is nothing wrong with the true 1/4″ perspective. For some reason, however, the split-the-difference perspective appears more pleasing to the eye. It is more important to think about using the "artificial THL" when you are drawing two-story houses. It is not so important when you are drawing a large commercial project. Although this technique is not too difficult to use, it is not for the beginner.

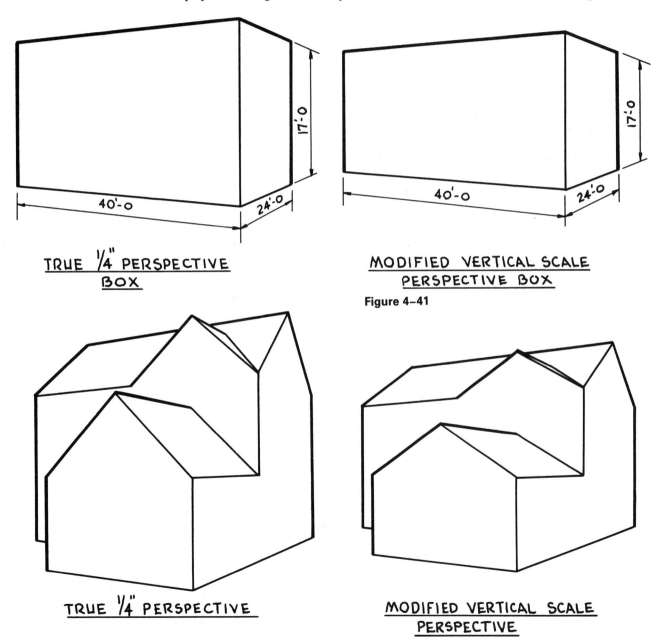

TRUE 1/4″ PERSPECTIVE
BOX

MODIFIED VERTICAL SCALE
PERSPECTIVE BOX

Figure 4–41

TRUE 1/4″ PERSPECTIVE

MODIFIED VERTICAL SCALE
PERSPECTIVE

Figure 4–42

4.5 INACCESSIBLE VANISHING POINT

One of the difficulties in drawing two-point perspective is that occasionally one of the vanishing points will *not* be located on your table. There are a number of reasons which might cause this problem. Some are the following:

1. Your table is too small.
2. A large-scale drawing is required.
3. A narrow cone of vision was used to set up the perspective.
4. One side of the object makes a small angle with the PP.

One of the easiest ways to solve this problem is to get a larger drawing table. Since this may not be an acceptable solution, you could try to make your table bigger by tacking on some stiff cardboard in order to reach the VP. Using another table beside yours might work, too.

When these solutions to the problem prove to be impractical, there are other methods which can be used. Only one will be presented here. This particular method employs two different vertical scales which, when used together, will approximate lines drawn to the inaccessible VP.

Before proceeding it might be wise to review the events which have typically preceded the discovery of the inaccessible VP.

1. You drew, at a small scale (3/32″ = 1′-0), the plan view of the object.
2. You chose the angle the object would make with the PP.
3. You chose the cone of vision size.
4. You chose the scale at which the perspective was to be drawn.
5. You chose the final object width.
6. You moved the PP in order to obtain this object width.
7. You finished laying out the preliminary HL by locating the VPs, MPs, CV, and dimension x.
8. You scaled the distance between these points at the 3/32″ = 1′-0 scale.
9. You took these data and laid out the final HL at the perspective scale 1/4″ = 1′-0.

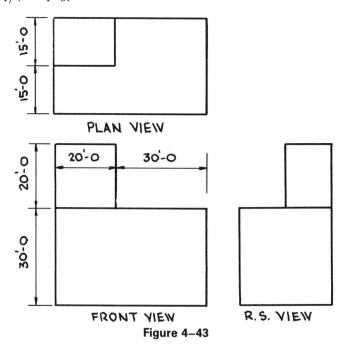

Figure 4-43

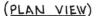
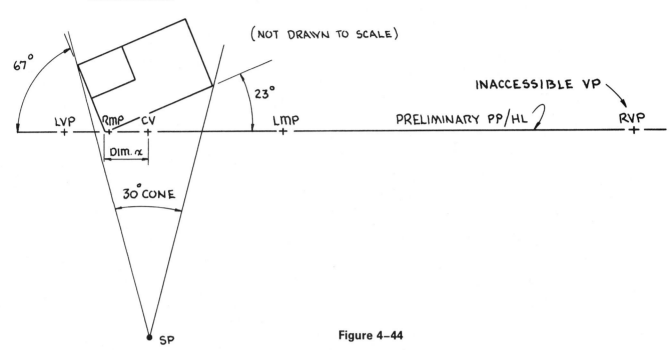

Figure 4–44

You thus discovered the inaccessible vanishing point.

The object in Fig. 4–43 will be used to explain this alternative method.

In Fig. 4–44 the plan view of this object has already been placed in relation to the preliminary PP, HL, and the SP, CV, VPs, MPs, and dimension x have been located. You have already discovered the inaccessible VP, and you are going to use the following method to solve this problem.

Step 1. See Fig. 4–45. (Not drawn to scale)

1a. Draw through the SP a line (line 1) parallel to the side of the object that is going to the inaccessible vanishing point.

Statement 1. The objective now is to choose two different scales which will divide the space between line 1 and the PP into an equal number of units. The smaller the two scales used, the greater the accuracy. Since the plan view is drawn at the $3/32'' = 1'-0$ scale, you might think in terms of $1/8''$ and $1/4''$ for the two scales.

1b. Holding your architectural scale vertically and using the $1/8''$ scale, move it along the PP and line 1 until it reads a whole number, such as 11 units.

1c. Mark that location with a vertical line (line 2).

1d. Again holding your architectural scale vertically and using the $1/4''$ scale, move it along the PP and line 1 until it also reads 11 units.

1e. Also mark this location with a vertical line (line 3).

1f. Using the scale of the preliminary setup ($3/32'' = 1'-0$), measure the distance from the CV to lines 2 and 3 (Dim. E and Dim. F).

Statement 2. You are now done with the $3/32''$ preliminary HL. Your next move is to draw lines 2 and 3 on the final HL.

Step 2. See Fig. 4–46. (Not drawn to scale)

2a. Using the scale of the perspective ($1/4'' = 1'-0$), add lines 2 and 3, using dimensions E and F, to the final HL.

2b. Starting at the HL and using the appropriate scale for each line, measure

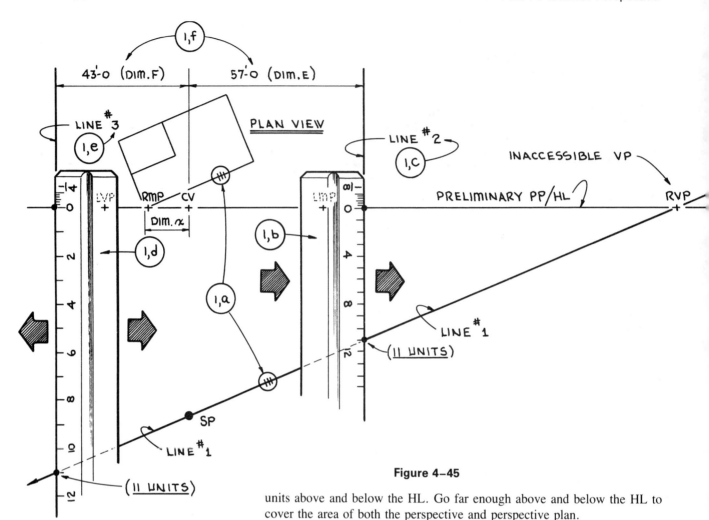

Figure 4-45

units above and below the HL. Go far enough above and below the HL to cover the area of both the perspective and perspective plan.

Statement 3. At this point you should take a piece of transparent tracing paper and tape it down over your setup. The objective is to make a grid with lines going to the inaccessible VP on this overlay sheet of paper. Once you have done this, you will untape it and slip it under the paper on which you are drawing the perspective. These grid lines will be subdued, but they will be visible enough to use as guide lines when you are required to draw lines to the inaccessible VP.

Step 3. See Fig. 4-47.

3a. Draw the HL and the CV on the tracing paper. This will allow you to properly realign the tracing paper under the other sheet when the time comes.

3b. Using a straight edge, draw lines connecting the companion points on the 1/8″ and 1/4″ scale lines. All these lines are now drawn as if they were vanishing to the inaccessible VP. Untape the tracing paper and slip it under your drawing paper. Realign the HL and CV and retape. Now you are ready to use these grid lines as guides whenever a line drawn to the inaccessible VP is required.

Step 4. See Fig. 4-48.

4a. Based on your preliminary perspective setup, locate point A the distance of dimension x to the left of the CV. This will be the starting point for your perspective plan drawing of the object.

4b. Using the grid lines as a guide, draw a line through point A. This line will be a RBL vanishing to the inaccessible RVP.

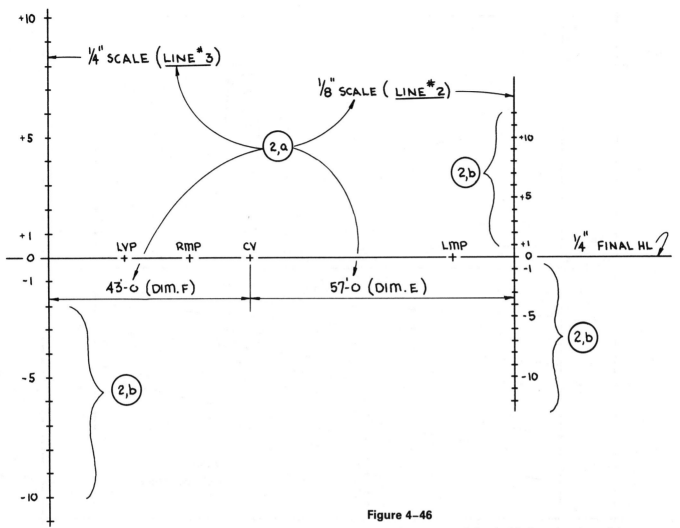

Figure 4–46

4c. Using the preliminary perspective setup and the multi-view drawing of the object as references, draw the rest of the perspective plan. Use the grid lines whenever lines going to the RVP are required.

Step 5. See Fig. 4–49.

5a. Project point A up to the GL and redraw RBL_1.

5b. Using good perspective plan drawing techniques, complete the perspective of the object. Lines RBL_1, 1, and 3 have to be drawn by using the grid lines as guides.

Statement 4. This method of drawing grid lines which approximate the inaccessible VP allows you to draw large perspectives on a small table. It will work with any two-point perspective. Again, this method is only one of several which can be used.

4.6 COMMONLY USED PERSPECTIVE SETUPS

It is more important that you as a student of perspective drawing understand the universal concepts that all perspective setups have than that you memorize the individual characteristics of a few popular setups. Too much emphasis has been placed on three particular perspective setups — 30°-60°, 45°-45°, and one-point. This overemphasis has weakened the student's ability to be creative with the perspective process. Because of their popularity, however, a short discussion about each setup is warranted.

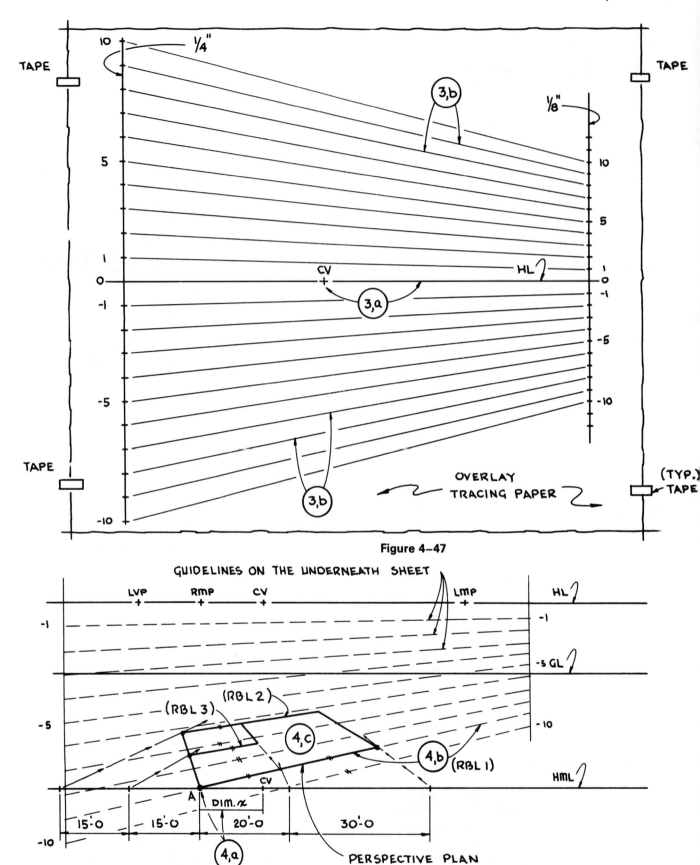

Figure 4–47

Figure 4–48

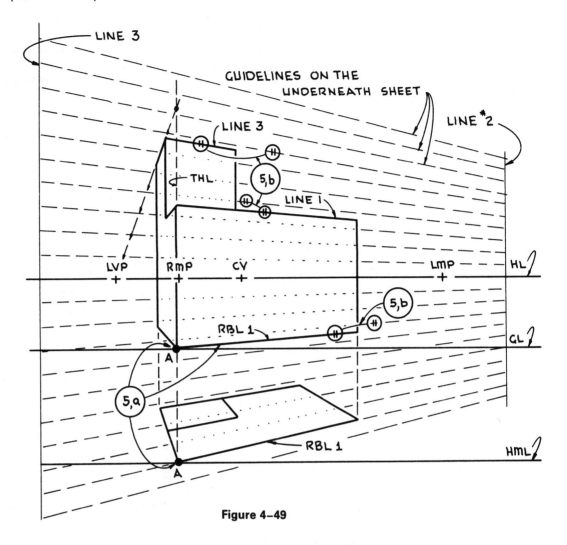

Figure 4–49

30°-60°

The 30°-60° setup has a unique relationship between the MPs, the CV, and the VPs. See Fig. 4–50.

This relationship allows you to lay out a HL very quickly. Simply draw a horizontal line and divide it in half. Then divide the left half of the line in half, and then divide in half again. In a matter of seconds you have laid out a fairly accurate HL. You can use this HL to make a quick perspective sketch. This 30°-60° HL will provide a good starting point.

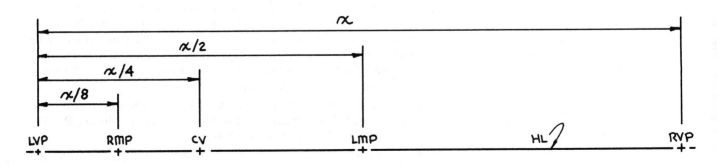

Figure 4–50

45°-45°

In a 45°-45° perspective, two perpendicular sides of an object are emphasized equally. Of all the angles possible in a two-point perspective, the 45°-45° setup offers the least distance between the right and left vanishing points. Very seldom do you have an inaccessible VP with a 45°-45° perspective. See Fig. 4–51.

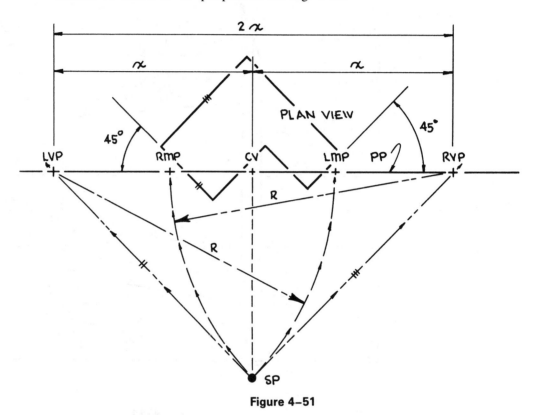

Figure 4–51

One-point (0°-90°)

At first glance, the one-point perspective setup looks quite different from other perspective setups. The only difference is that in a one-point perspective only one group of parallel lines vanishes to a VP. The other group of parallel lines does not vanish or converge in the drawn perspective. This is true because the lines are positioned parallel to the PP. See Fig. 4–52. You find the CV, the MPs, and the VPs using the same method as with two-point perspectives.

A simple object is drawn in one-point perspective in the following discussion.

Step 1. See Fig. 4–52.

 1a. To find the VP for the Group 1 lines, you draw a line parallel to these lines through the SP. Then extend this line until it intersects with the PP. As you can see, the line just drawn is parallel to the PP; therefore, it will never intersect with it. The VP for Group 1 lines is at infinity. Consequently, when these Group 1 lines are drawn in the perspective, they will be horizontal lines drawn with your T square.

 1b. To find the VP for the Group 2 lines, you draw a line parallel to these lines through the SP. Then extend this line until it intersects with the PP. This locates VP2 (the VP for the Group 2 lines).

 1c. To find the CV of this setup, you project the SP directly into the PP. In a one-point perspective the CV and VP2 are the same point.

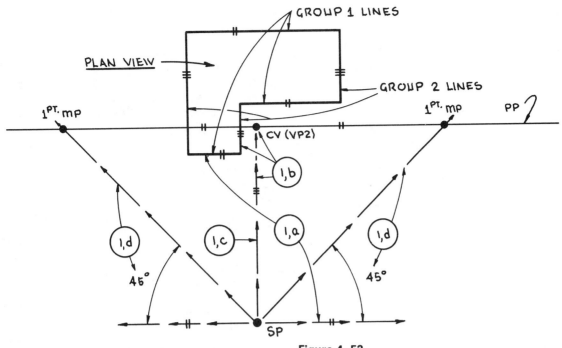

Figure 4–52

1d. To find the MPs in a one-point perspective, you draw 45° lines from the SP to the PP. In other words, the distance from the SP to the PP is the same as the distance from the CV to each MP. You can draw most one-point perspectives with using just one of the MPs.

Step 2. See Fig. 4–53.

2a. As in other types of perspective setups, you make your width and depth measurements on the HML. In one-point perspective the width measurements are transferred from the HML into the perspective with lines drawn to the CV.

2b. Depth measurements are transferred from the HML into the perspective with lines drawn to one of the MPs.

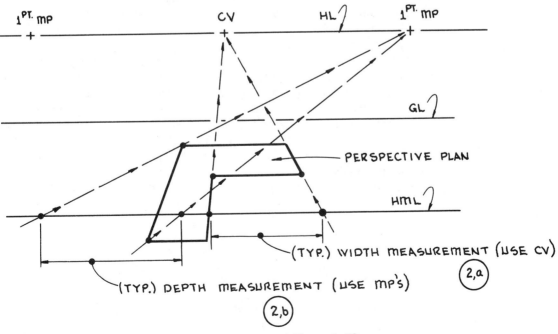

Figure 4–53

Step 3. See Fig. 4–54.

3a. Height measurements are, as usual, made on true height lines (THLs). Angles which appear in the walls of the object that are parallel to the PP will be actual size. Also, circles drawn in these same walls will appear as circles. Of course, their size will vary with the walls' relationship with the PP.

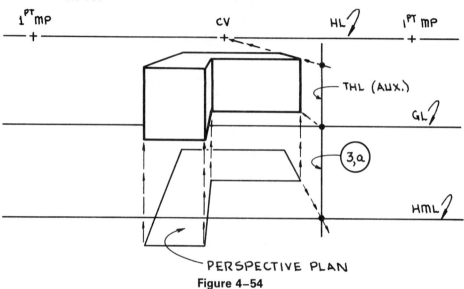

Figure 4–54

4.7 VISUAL RAY PERSPECTIVE (A QUICK SKETCH TECHNIQUE)

The visual ray or common office method of drawing perspectives is best used as a design tool. It can also be used to produce final perspective drawings, but it is not as versatile as the perspective plan method. With the visual ray method, you have to project directly from the multi-view drawings of the object in order to draw the perspective. If the multi-view drawings are not drawn at the same scale as the perspective, they must be redrawn. This can be time consuming if the project is very complicated. Also, a large drawing space is required because you must tape the multi-view drawings in place in order to project from them. Consequently, the best use for the visual ray method is not in producing large presentation drawings.

The best use for the visual ray method is as a design tool used when you are designing the preliminary perspective setup. You want to use this method to its best advantage. The visual ray method allows you to visualize the basic shape of the object very quickly. The sooner you can visualize the object, the easier it is to make changes in the preliminary setup. The entire design process involved in laying out the perspective setup to reflect the best view of the object is basically a trial-and-error process. Ideally, you want to make changes at the preliminary stage of the perspective process. You certainly don't want to have the perspective half-drawn and discover you have taken a weak view of the object.

Changes which you might want to make in the preliminary perspective setup would involve four variables:

1. The angle the object makes with the PP
2. The size of the cone of vision
3. The location of the PP
4. The eye level

Let's try a simple example to show how the visual ray method works. The object in Fig. 4–55 will be used in this example. The perspective of this object will be drawn according to the following guidelines:

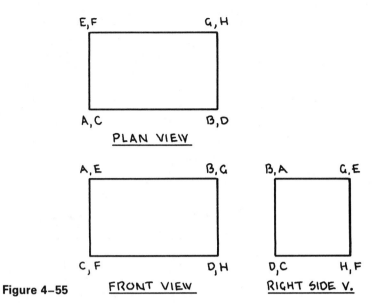

Figure 4-55

1. 30°-60° perspective
2. Emphasis on the front view
3. Eye level at 14'-0
4. Front corner of object is in the PP
5. SP is located

Remember that the multi-view drawings must be drawn at the same scale as the perspective.

Statement 1. In a typical visual ray setup, the PP and HL are not superimposed. This allows more room to draw the perspective. You find the VPs and CV the same way you did in the perspective plan method. This time you have only located points A, O, and B in the PP. Now you must project these points onto the HL, where they become the LVP, CV, and RVP. See Fig. 4-56.

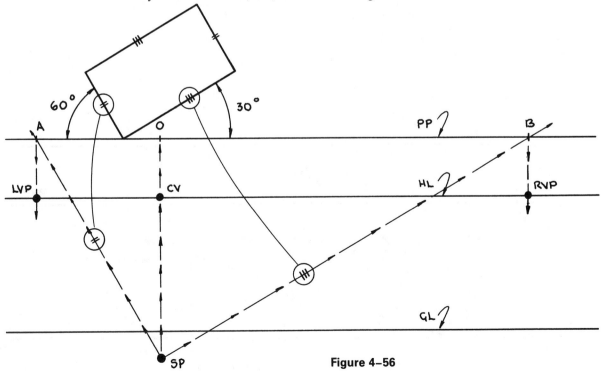

Figure 4-56

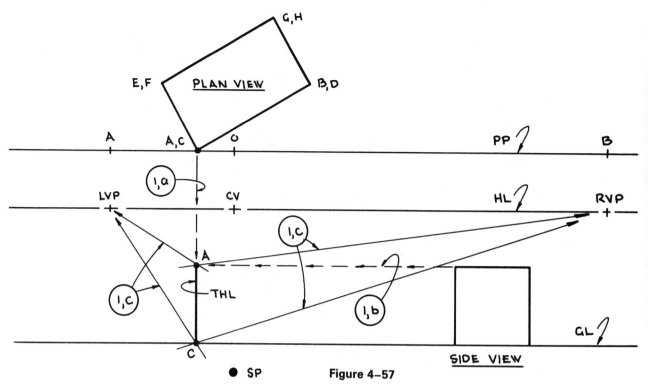

Figure 4–57

Step 1. See Fig. 4–57.

 1a. To begin the perspective you project the front corner of the object, which is a THL, down to the GL.

 1b. Project the height of the object over from the side elevation. This locates line AC in perspective.

 1c. From points A and C draw lines to both VPs.

Step 2. See Fig. 4–58.

 2a. From the SP draw light construction lines to verticals EF and BD.

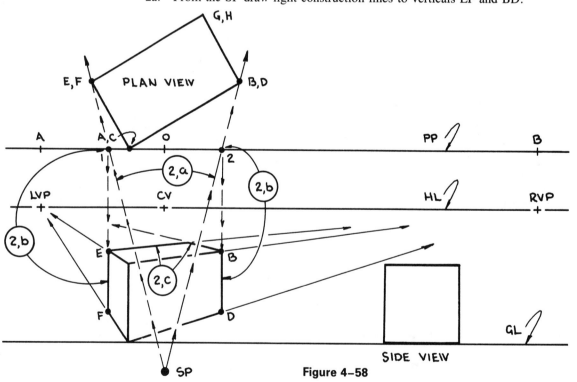

Figure 4–58

2b. Where these two lines pierce the PP at points 1 and 2, drop two verticals into the perspective. Thus, lines EF and BD are located in perspective.

2c. To complete the perspective draw a line from point E to the RVP and a line from point B to the LVP.

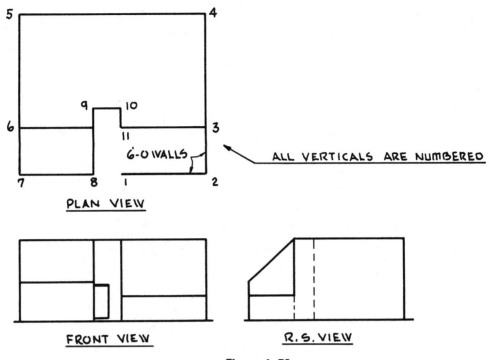

Figure 4–59

Statement 2. Now that you see how the visual ray method works, let's use a modified version of it to design a perspective setup. Use the object in Fig. 4–59 for the following discussion.

Statement 3. You are assigned to draw a perspective of this structure. The client would like to see the front and right sides in the perspective. He definitely wants to be able to see some of the front entry door. He also wants the finished perspective to be very dramatic and to fit on a 20″ × 14″ sheet of paper.

You plan to draw the final perspective by the perspective plan method, but your first task is to design a preliminary perspective setup that will fulfill these requirements.

Step 1. See Fig. 4–60. (Not drawn to scale)

1a. You start by drawing the plan view of the structure at a small scale (3/32″ = 1′-0).

1b. Next, you position the plan view of the structure in relation to the PP. You do this with the requirements of the perspective in mind.

1c. Now you choose a cone of vision size between 30° and 60°.

1d. Next you find the VPs, the CV and the MPs.

Statement 4. At this point it would be helpful to know if this combination of chosen variables will give you the best view of the structure based on the requirements of the client. Here is where you can use some of the visual ray techniques to make a quick and accurate preliminary sketch of the structure. This modified visual ray technique requires you to draw the perspective sketch directly over the plan view of the structure. Also, instead of projecting height dimensions from the side elevation of the

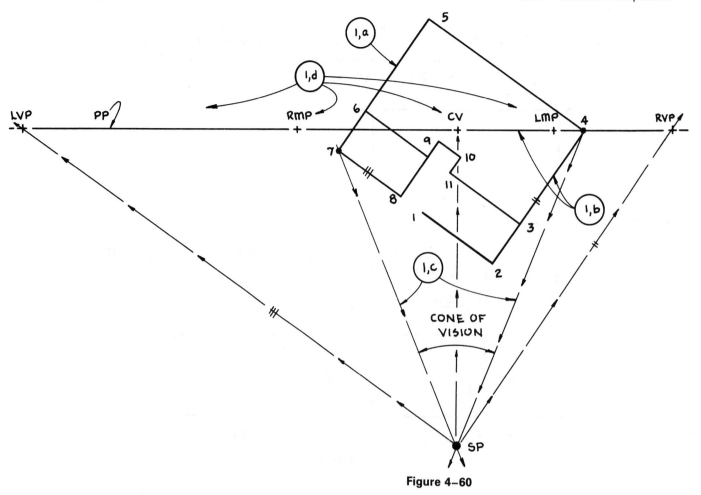

Figure 4–60

structure, true height lines (THLs) are used to receive direct height measurements. This technique saves both time and space.

Step 2. See Fig. 4–61.

2a. Tape a piece of tracing paper over your preliminary setup.

2b. With light construction lines drawn from the SP, project all the corners of the building and walls into the PP. The vertical corners have been numbered. This locates all twelve verticals in perspective, ready to be used.

2c. Draw a vertical through one of the THLs.

2d. Now you must make a decision on the last variable, the eye level. You decide on a 10′-0 eye level.

2e. Measure down 10′-0 below the PP, HL and then up 17′-0, the height of the building.

Step 3. See Fig. 4–62.

3a. Draw lines through these measurements from the RVP.

3b. Draw verticals through the projections of points 2 and 3 in the PP.

3c. Make a 6′-0 measurement on the THL (the height of the wall).

3d. Project this measurement forward from the RVP to the vertical drawn through the projection of point 2 in the PP. This locates the front corner of the building.

3e. Turn the corner at verticals 3 and 2 and draw lines to the LVP.

3f. Draw verticals through the projection of points 1 and 11 in the PP.

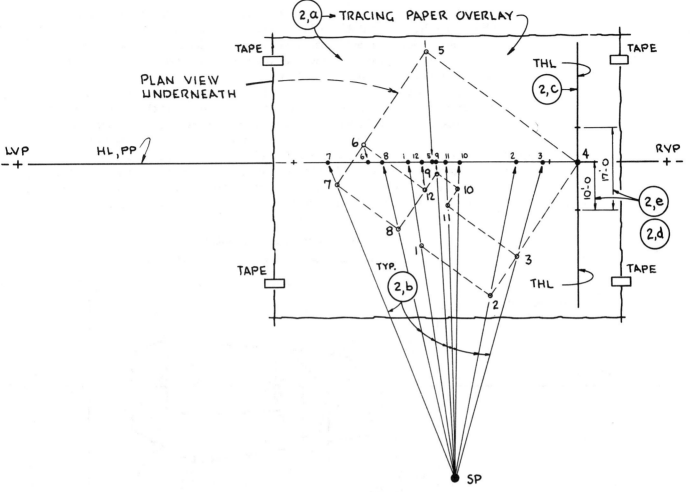

Figure 4–61

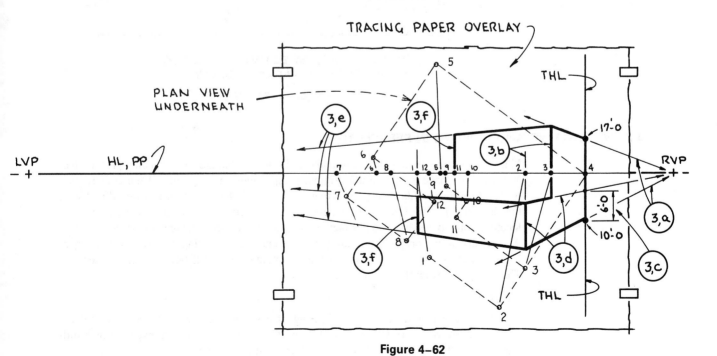

Figure 4–62

Statement 5. Continue to draw one wall at a time until the sketch is complete. See Fig. 4–63. If you prefer, this could be a freehand sketch. Remember that this is just a small-scale preview of what the final perspective might look like. It does not have to be exact. If the sketch does not show what you thought it might, you can at this time make some changes in one or more of the variables.

If the perspective is not dramatic enough (if it does not have strong enough line convergence), you could use a larger cone of vision, or you could change the angle the object makes with the PP. Perhaps you cannot see over the wall to view the front door. In this instance you would have to raise the eye level or move around to the front of the structure to look through the opening in the wall. You should make a new sketch every time you make a change. This will either confirm the improvement or dictate new action.

After you have drawn a few of these sketches, you will become more proficient. The completion of the entire sketch should not take more than 5 to 10 minutes.

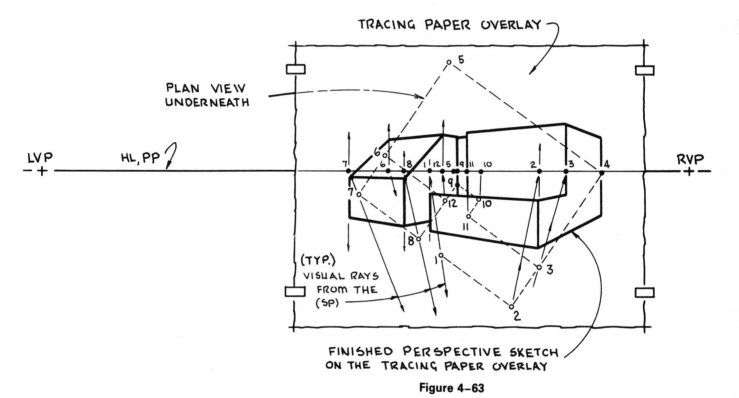

Figure 4–63

4.8 MULTIPLYING AND DIVIDING IN PERSPECTIVE

Many times you will be required to make additions or changes to an existing perspective. You may not have access to the original perspective drawing with all the construction points. One disadvantage of perspective drawing is that you cannot measure directly on the drawing. If you don't know where the true height lines and measuring points are located, you have to use another method to make the desired changes in the perspective. A short discussion on the subdividing of lines and the expanding of surfaces in perspective without the measuring points or the true height lines will be given in this section. The following examples are not drawn to scale.

EXAMPLE 1

You are given a perspective drawing of a simple building, and you are told the building is drawn 30'-0 wide by 20'-0 deep. The contractor wants to expand this building into one that is 30'-0 wide by 60'-0 deep. See Fig. 4–64.

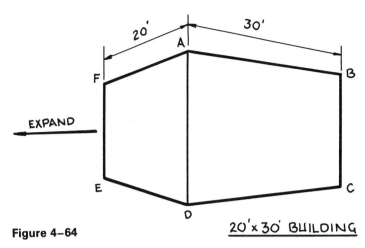

Figure 4-64

Step 1. See Fig. 4-65.

1a. You can find the vanishing point for lines FA and ED by extending them until they intersect at the LVP. This also locates the HL.

1b. Draw diagonals AE and DF, locating point G.

1c. Through point G draw a line to the LVP, locating point H on line FE.

1d. Draw a line from A through H and continue it until it intersects with line ED extended, locating point I 20'-0 behind point E.

1e. Draw a vertical through point I, locating points J and K. Vertical plane ADIK is 40'-0 deep.

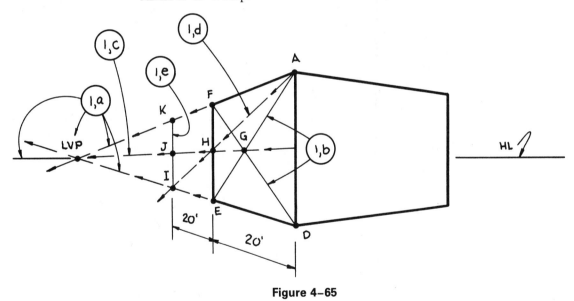

Figure 4-65

Step 2. See Fig. 4-66.

2a. A line through points F and J will locate point L 20'-0 behind point I.

2b. Draw a vertical through point L, locating point M. Now the left vertical plane ADLM is 60'-0 deep. The original building of 30' × 20' is now 30' × 60' accurately drawn in perspective.

EXAMPLE 2

You are given a perspective of another simple building, and you are asked to divide the end of the building into ten equal units. This is not the original perspective; therefore, you do not have access to the measuring points.

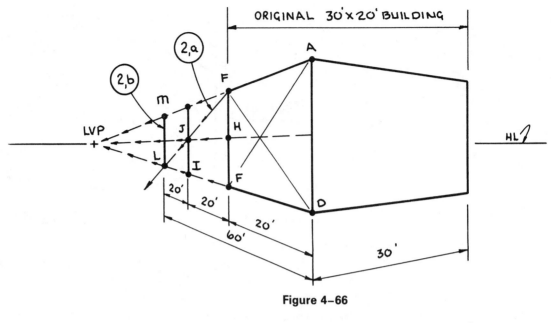

Figure 4–66

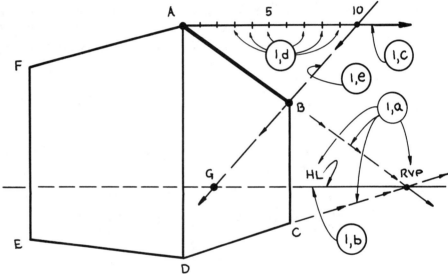

Figure 4–67

Step 1. See Fig. 4–67.

1a. First, you must find the HL. You can do this by vanishing lines AB and DC until they intersect at the RVP on the HL.

1b. Draw the HL through the RVP.

1c. You want to divide line AB into ten equal perspective units. Start a horizontal line at point A and draw it to the right.

1d. Take an appropriate scale and, beginning at point A, mark off ten equal units on this horizontal line.

1e. Draw a line from the tenth unit on the horizontal line through point B and extend it until it crosses the HL at point G. This point is an auxiliary measuring point.

Step 2. See Figs. 4–68, 4–69.

2a. Transfer the measurements from the horizontal line to line AB with lines

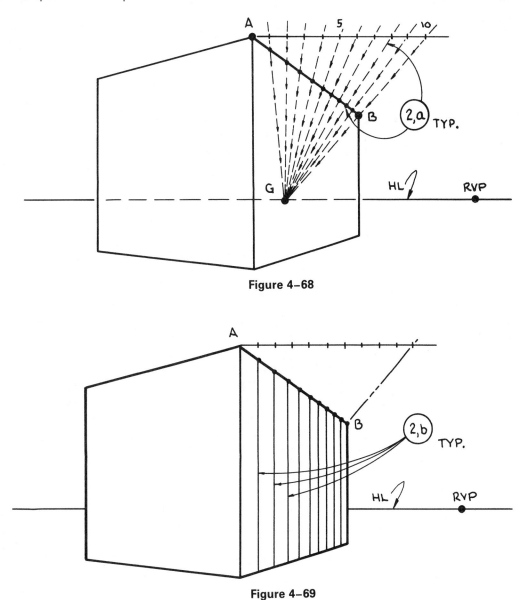

Figure 4–68

Figure 4–69

drawn to point G. This will accurately divide line AB into ten equal perspective units.

2b. Drawing vertical lines through these units will better illustrate the perspective spacing. See Fig. 4–69.

4.9 DRAWING SIDEWALKS, DRIVEWAYS, AND PEOPLE IN PERSPECTIVE

Statement 1. There is one key to drawing sidewalks and driveways correctly in the perspective. Make sure the horizontal lines forming these features vanish to points on the original HL. This is assuming a horizontal ground plane. Too many times a house will be drawn on a horizontal surface, but the driveway and sidewalks look as though they are falling off a cliff. See Fig. 4–70. This problem could ruin an otherwise good perspective. In a standard situation, the right and left vanishing points will be used to draw these features. See Fig. 4–71.

Figure 4-70

Figure 4-71

Statement 2. Sometimes you may want the drive to slope a little. Therefore, you must draw the lines forming the drive from the appropriate vertical horizon line (VHL). The example in Fig. 4–72 has the lines forming the drive in left vertical planes. Consequently, these lines will vanish to the left vertical horizon line (LVHL).

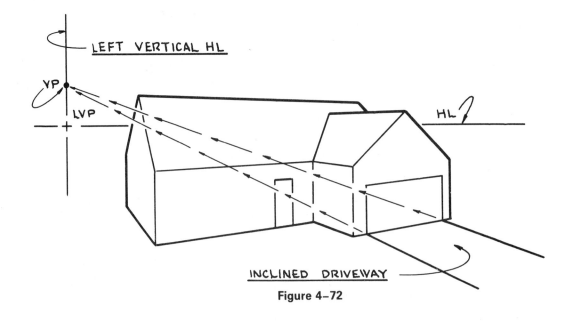

Figure 4-72

Statement 3. On more complicated houses you may want to put more emphasis on the front entry. You can do this by pulling the observer's eye into that space by a dramatic turn in the drive or sidewalk. The house in Fig. 4–73 has a standard sidewalk drawn with lines from the LVP. The entry door is not emphasized. The same house in Fig. 4–74 has the walk drawn turning and coming toward the observer. This treatment has a tendency to dramatize and draw attention to the entry door. The following is a short discussion concerning the proper method to use to draw this sidewalk.

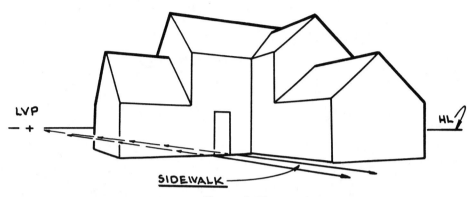

Figure 4–73

Figure 4–74

Step 1. See Fig. 4–75.

1a. Draw lines 1 and 2 from the LVP.

1b. Locate points A and B on these two lines where you want the turn in the sidewalk to begin.

1c. Pick a point at random on the HL (point 1).

1d. Draw lines from point 1 on the HL through points A and B.

1e. If the lines drawn from point 1 do not give you the effect you want, try another point on the HL (point 2). You may want to try yet another point (point 3).

Statement 4. Point 3 generates the most dramatic lines because they establish the sidewalk in the approximate direction of the observer. The key to making the sidewalk look horizontal is to draw the lines that define the walk from a point on the original HL. You can use this same technique for drawing curved driveways.

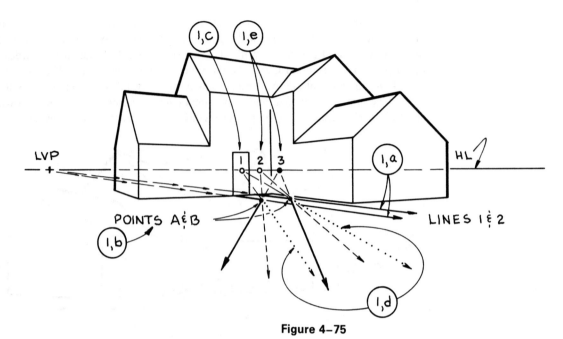

Figure 4–75

Step 1. See Fig. 4–76.

 1a. Using the same house as before, draw a curved driveway from a side entry garage door. Draw lines 1 and 2 from the RVP.

 1b. Locate points A and B on these two lines where you want the curve in the driveway to begin.

 1c. Pick a point at random on the HL (point 1).

 1d. Draw lines from point 1 on the HL through points A and B.

 1e. If the lines drawn from point 1 do not give you the effect you desire, try another point on the HL (point 2). Keep trying until you achieve the desired effect.

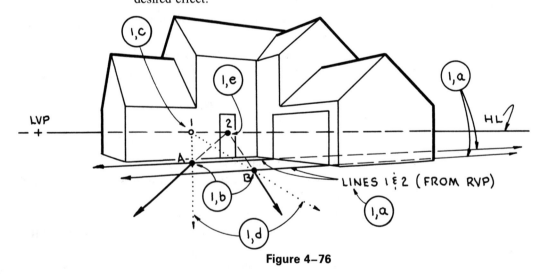

Figure 4–76

Step 2. See Fig. 4–77.

 2a. Once you have decided the direction of the driveway, round the corners of the turn. The curved drive is now complete, and it should look horizontal.

Statement 5. Including people in the perspective automatically gives the drawing scale. Everybody can relate to the size of the human figure. That is why it is important

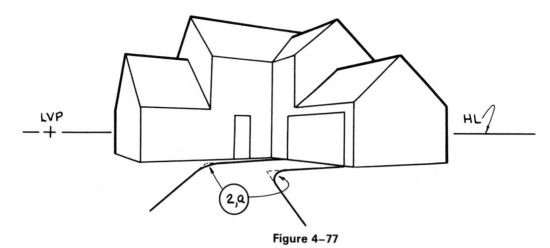

Figure 4-77

that you draw the figures at the proper scale. If the HL is at 5'-0, to draw the people at the proper scale, you simply position their eyes directly on the HL. See Fig. 4–78.

If you find drawing the human figure difficult, use a drawing file. There are many commercial ones available. You can even make your own.

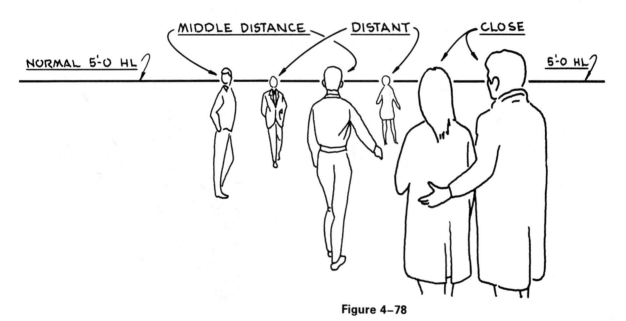

Figure 4-78

The following discussion outlines steps to follow if you are working with a perspective which does not have a normal 5'-0 HL.

Step 1. See Fig. 4–79.

 1a. Indicate where you want the person to stand by placing an *x* on the ground plane.

 1b. Draw a line from the *x* to a random point on the HL.

 Note: Make sure this line goes to the left or right on its way to the HL. The random point should not be located in the area directly above point x.

 1c. Where this projection line crosses the ground line (GL) at point A, erect an auxiliary true height line.

 1d. Make a 6'-0 measurement (the height of the person) on this auxiliary THL.

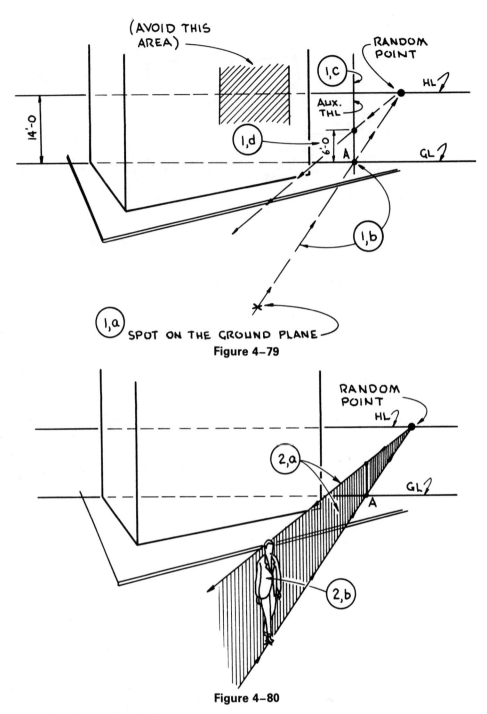

Figure 4–79

Figure 4–80

Step 2. See Fig. 4–80.

2a. Project this measurement forward with a line from the random point on the HL. You have just created a 6'-0 high vertical plane which runs from the HL, pierces the PP at vertical A, and continues forward to determine the height of the person.

2b. Draw in the person.

Summary Statement

There is no substitute for fundamental instruction on the basic concepts of perspective drawing. Chapters Two and Three, which dealt with designing the perspective setup and

drawing the actual perspective, covered these concepts. The material discussed in this chapter added more specific information about these concepts. For example, the ability to locate any point in space using auxiliary true height lines is an invaluable skill. The discussion concerning intersecting planes and the importance of their accompanying horizon lines should allow students to accurately draw complicated objects which are composed of vertical and inclined surfaces. These and other techniques discussed in this chapter were presented to help students deal with different situations which they might encounter when drawing a perspective.

Only through practical experience and the desire to improve will a student increase his or her efficiency and flexibility when drawing a complicated exterior architectural perspective.

5

Designing the Perspective Setup

5.1 INTRODUCTION

The following material has been developed to help both the student who has a good background in perspective plan drawing and the student who has a limited knowledge of perspective drawing.

The first part of this text is designed to show the student who has had basic instruction in perspective plan drawing how to develop a typical interior perspective drawing.

The student is encouraged to focus on the basics of perspective drawing when using this material. These basics consist of a working knowledge of how to do the following:

1. Use a preliminary layout to design the perspective setup properly.
2. Find the station point and its effect on the rest of the perspective.
3. Use a nondistorted 60° cone of vision to include items in the perspective.
4. Find vanishing and measuring points.
5. Find the picture width and use it to choose an appropriate scale for the perspective.
6. Find and use new true height lines.
7. Find and use new base lines.

This discussion merely puts the procedure for using these basics into a logical order. The student who has a good working knowledge of these basics will need to use this text only a few times.

The second part of this material is designed to help the student who has a limited knowledge of perspective drawing. In this unit the use of grids for drawing the perspective is discussed. Certain basic procedures will be covered. These procedures consist of a working knowledge of how to do the following:

1. Design the perspective grid using a preliminary sketch.
2. Draw the original grid using only measuring points and then using only diagonals.
3. Draw architectural objects and people in the perspective.
4. Expand the original grid using only measuring points and then using only diagonals.

You might remember one fact as you study the following material. The examples presented are only hypothetical situations designed to explain the perspective plan and grid methods of drawing interior perspectives. Only by coincidence would your own particular perspective setups look like these examples. It would be unwise and almost impossible to illustrate all the possible situations which might occur when drawing an interior perspective. Some perspective setups will show three walls; others will show only two. Sometimes the long vanishing point will go to the left, and sometimes it will go to the right. Therefore, it is important that you understand the basic procedure for setting up and drawing the perspective and that you not memorize the particular steps in each example.

5.2 LOCATING THE OBSERVER

There must be a need to draw a perspective of a confined space, whether it be as a class assignment or as a professional job. The plan you wish to use should be drawn at a small scale — 1/8″ = 1′-0 or 1/4″ = 1′-0. The room in Fig. 5–1 will be used in this example. The floor plan from the set of blueprints can be used.

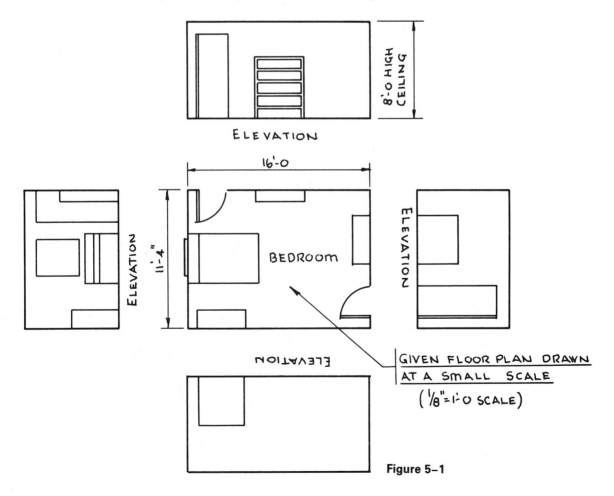

Figure 5–1

This small-scale floor plan will be used to draw a preliminary sketch of the perspective setup. The actual designing of the perspective setup can be accomplished more easily at this smaller scale. Since designing the setup is a trial-and-error process, changes can also be made more easily on a smaller drawing. When you are satisfied with the location of the observer and the spacing of the measuring and vanishing points on the preliminary picture plane, horizon line (PP, HL), you can document this information in preparation for drawing the actual perspective. After all the design work is complete on the preliminary layout, you can then choose an appropriate scale for the final perspective drawing.

You begin this design process by making an analysis of the space to be drawn. Because it is better to draw the perspective with the observer (SP) inside the space, you must decide which end of the room you wish to see. By having the observer (SP) inside the space, only part of the room will be visible in the perspective. In this example you have decided to emphasize the end of the room with the bed. See Fig. 5–2.

Also, you want to locate the observer (SP) in a logical location inside the room. Many times a doorway will be a good location; however, sometimes this location will not give you the best view of the room. You will have to experiment.

You experiment by taking the floor plan and laying it in front of you on your drawing table. Take a 30°-60° triangle and think of the apex of the 60° angle as the observer and the two sides forming the 60° angle as the legs of the nondistorted 60° cone of vision. See Fig. 5–3. Theoretically, you should be able to see without distortion everything which is included inside the cone of vision. See the shaded area in Fig. 5–4. Actually, objects which appear in the double-shaded area of the cone of vision could appear distorted because they are located so close to the observer (SP). See Fig. 5–4.

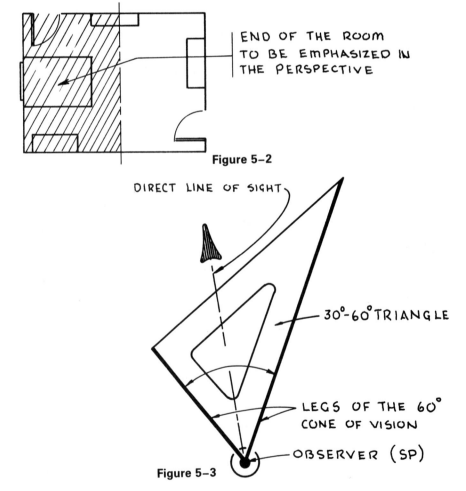

END OF THE ROOM
TO BE EMPHASIZED IN
THE PERSPECTIVE

Figure 5–2

DIRECT LINE OF SIGHT

30°-60° TRIANGLE

LEGS OF THE 60°
CONE OF VISION

OBSERVER (SP)

Figure 5–3

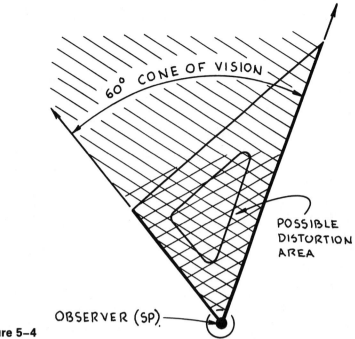

Figure 5-4

With this in mind, lay the 30°-60° triangle on your floor plan and manipulate it so that you are placing the observer (SP) at different locations inside the space. Obviously, you should be placing the observer in the far end of the room away from the end you want to see. While you are manipulating the triangle (cone of vision), notice the different locations for the observer and what you can see inside the cone of vision. See Figures 5-5, 5-6, 5-7, 5-8, 5-9, and 5-10 for different examples. These are only a few locations of the many that are possible.

In some locations of the SP you will see two walls; in others you will see three walls. You must decide which view will best show what you want to see.

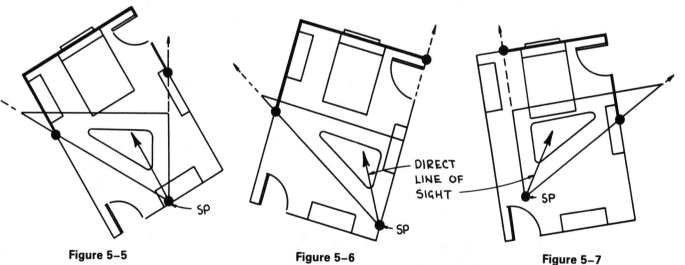

Figure 5-5 **Figure 5-6** **Figure 5-7**

You can help this decision process by drawing visual rays from the observer (SP) to major points of interest inside the room. See Fig. 5-11. Sometimes closer objects will block your view of other objects in the room. By drawing these visual rays you can determine how much of the space you will actually be able to see. For the completed perspective drawn from this angle, see Fig. 6-22 on page 133. For the purpose of this discussion, you have chosen the setup in Fig. 5-10. The observer is standing in the

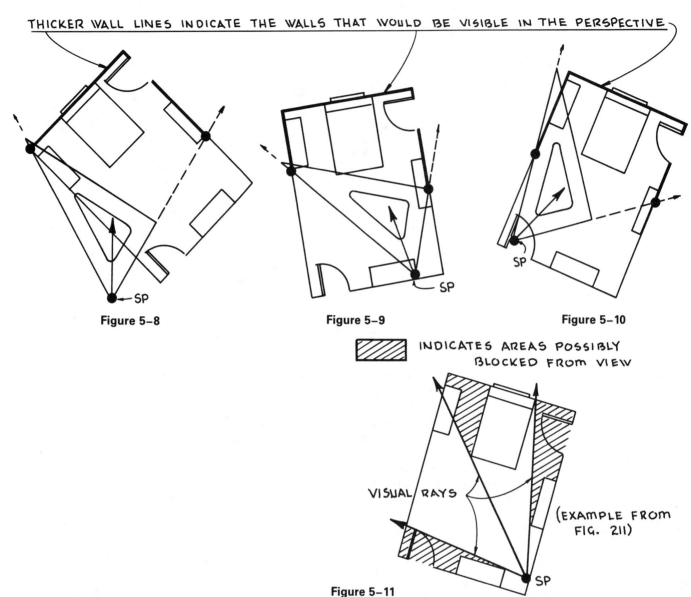

THICKER WALL LINES INDICATE THE WALLS THAT WOULD BE VISIBLE IN THE PERSPECTIVE

Figure 5–8

Figure 5–9

Figure 5–10

INDICATES AREAS POSSIBLY BLOCKED FROM VIEW

VISUAL RAYS

(EXAMPLE FROM FIG. 211)

Figure 5–11

doorway. Having made this decision, trace around the 60° angle of the 30°-60° triangle. See Fig. 5–12. The apex of the 60° angle will be the location of the observer for this particular perspective drawing. Rotate your 30°-60° triangle and position it along one of the legs of the cone of vision. You do this in order to draw another line which forms a 60° angle with that leg of the cone. See Fig. 5–13. This line represents an edge view of the picture plane (PP). Usually, you will want to draw the PP through a major feature in the room, such as a corner, but it can be drawn in any location. The room can be totally in front of or behind the PP, or the PP can go through the middle of the space. See Fig. 5–14. Move the triangle up or down along the leg of the cone of vision until you find an appropriate location for the PP. In this case you choose location 1 (from Fig. 5–14) in which the PP is going through the back corner of the room. This is a typical situation. Because it is touching the PP, this back corner will be a true height line (THL) in the perspective.

5.3 LAYING OUT THE PRELIMINARY PICTURE PLANE, HORIZON LINE

Now that you have properly located the picture plane (PP), you need to lay out the rest of the *preliminary* PP, HL. This involves locating the vanishing points (VPs), the center

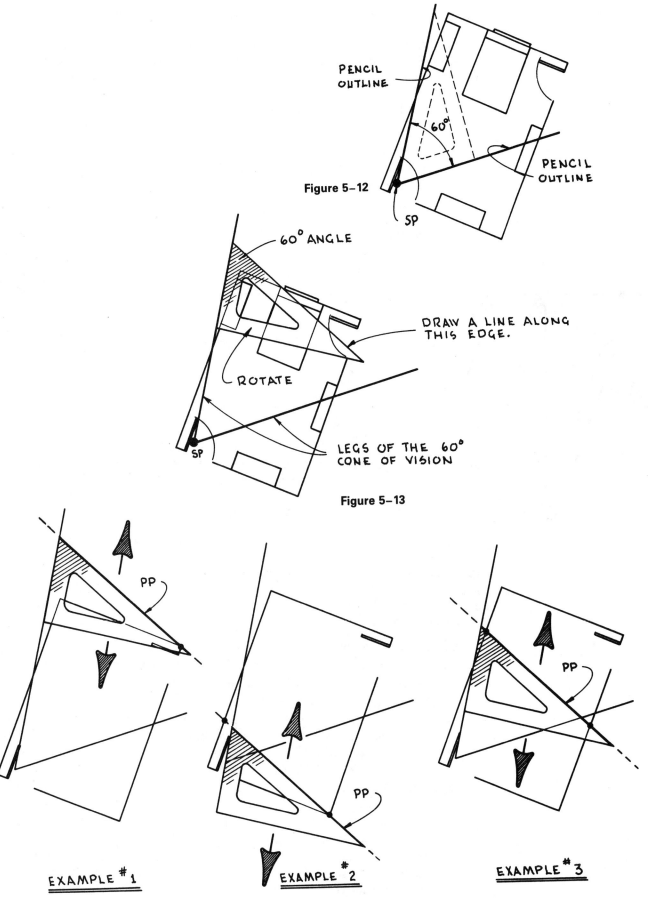

PENCIL
OUTLINE

60°

PENCIL
OUTLINE

SP

Figure 5-12

60° ANGLE

DRAW A LINE ALONG
THIS EDGE.

ROTATE

SP

LEGS OF THE 60°
CONE OF VISION

Figure 5-13

PP

EXAMPLE #1

PP

EXAMPLE #2

PP

EXAMPLE #3

Figure 5-14

117

of vision (CV), the measuring points (MPs), and dimension x (the distance from the CV to the starting point for the perspective). This preliminary PP, HL will be drawn at the same scale as the floor plan. This scale is independent of the scale you will use to draw the perspective.

Use the following steps to lay out the preliminary PP, HL.

Note: Rotate the floor plan so that the preliminary PP forms a horizontal line.

Step 1. See Fig. 5–15.

1a. Extend the preliminary PP, HL to the left and to the right.

1b. Originating at the SP, draw lines parallel to the walls of the room until they intersect the PP, HL. These intersections locate the right and left vanishing points.

1c. Using your 30°-60° triangle, draw a line from the SP perpendicular to the PP. Where this line crosses the PP locates the center of vision (CV).

Figure 5–15

Statement 1. Measuring points are actually vanishing points for lines which transfer true size width and depth measurements from the horizontal measuring line (HML) into the perspective. There are two universal ways to locate the measuring points. The first is by bisecting angles, and the second is by rotating the SP into the PP. Both of these methods will work with any perspective setup. Sometimes one method will be more appropriate than the other.

Step 2. See Fig. 5–16. (Bisecting method)

2a. Bisect angle CV, SP, RVP to locate the left measuring point (LMP).

2b. Bisect angle CV, SP, LVP to locate the right measuring point (RMP).

Step 3. See Fig. 5–17. (Rotating method)

3a. Rotate the SP into the PP using an arc centered at the RVP. The point where this arc crosses the PP locates the RMP.

3b. Rotate the SP into the PP using an arc centered at the LVP. The point where this arc crosses the PP locates the LMP.

Step 4. See Fig. 5–18.

4a. Measure the distance from the CV to the back corner of the room which is touching the PP. This will be the dimension x. This also will locate the starting point for the perspective drawing.

Note: The distance between the CV and any point where the walls of the room cross the PP can be used as dimension x. In this case, the walls only touch the PP at the back right corner of the room.

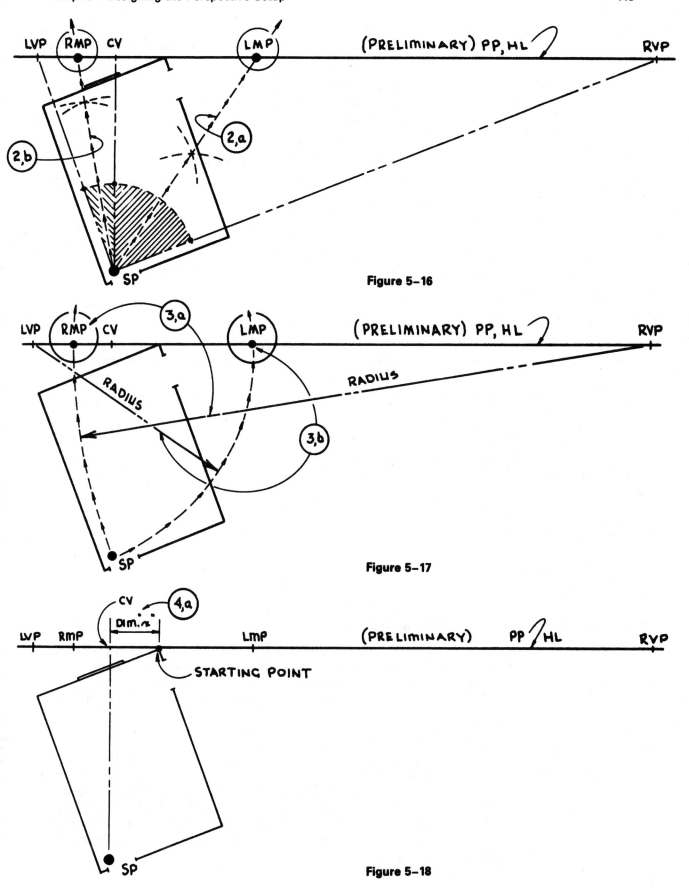

Figure 5-16

Figure 5-17

Figure 5-18

Step 5. See Fig. 5–19.

5a. Using the base line dimensioning technique, scale the distance between the following:

CV and the RMP (Dim. A)

CV and the LVP (Dim. B)

CV and the LMP (Dim. C)

CV and the RVP (Dim. D)

CV and the back corner of the room (Dim. x)

These measurements will be at the same scale as the preliminary PP, HL $(1/8'' = 1'\text{-}0)$.

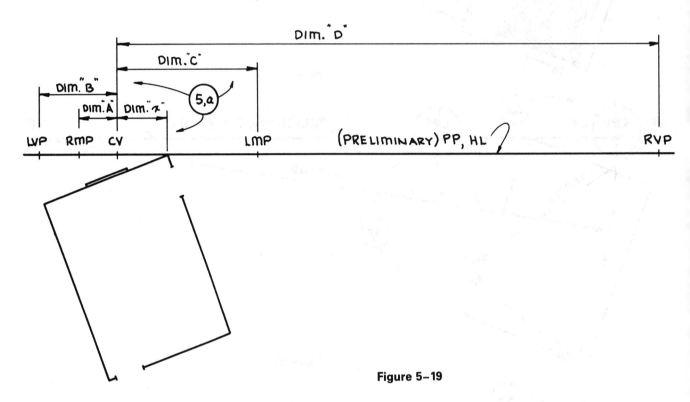

Figure 5–19

5.4 CHOOSING AN APPROPRIATE SCALE

Statement 2. At this point you have to choose a scale for your perspective. First, you must determine the picture width (PW), which is the actual size or width of the completed perspective. How big do you want the final perspective to be? You can determine the PW by going back to the floor plan and the original 60° cone of vision. See Fig. 5–20.

Step 6. See Fig. 5–20.

6a. Extend the legs of the 60° cone of vision until they intersect with the PP, HL at points 1 and 2.

6b. The distance between these points will be equivalent to the PW drawn at the scale of the *preliminary* HL. In this case the PW is 20' at $1/8'' = 1'\text{-}0$ scale.

Now you must choose a scale that will fulfill the size requirements of the perspective. These requirements are based on how the perspective is going to be used — for presentation, for reproduction, and so on.

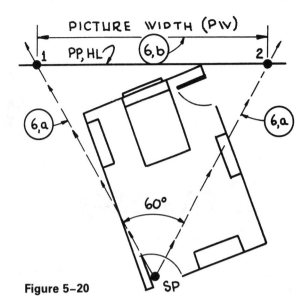

Figure 5-20

Use the following formula to choose an appropriate scale for your perspective.

$$\begin{pmatrix} \text{Picture width} \\ \text{from the} \\ \text{preliminary HL} \end{pmatrix} \times \begin{pmatrix} \text{Proposed} \\ \text{perspective} \\ \text{scale} \end{pmatrix} = \begin{array}{c} \text{Actual perspective} \\ \text{width in inches} \end{array}$$

↓		↓		↓
20′	×	3/8″ = 1′-0	=	7 1/2″ image (full scale)
20′	×	1/2″ = 1′-0	=	10″ image (full scale)
20′	×	3/4″ = 1′-0	=	15″ image (full scale)
20′	×	1″ = 1′-0	=	20″ image (full scale)

Note: You might find these decimal equivalents for the different scales helpful.

1/8	= .125
3/16	= .1875
1/4	= .250
3/8	= .375
1/2	= .500
3/4	= .750

Statement 3. For this example you have chosen the 3/8″ = 1′-0 scale, which will give you a finished picture width of 7 1/2″.

Summary Statement

The thought process involved in designing the perspective setup is as important as the process of drawing the actual perspective. If the design of the setup is faulty, the final product will be flawed; therefore, each variable influencing the design of the perspective setup must be chosen carefully. The vertical and horizontal location for the station point in relation to the interior space will directly affect the final look of the drawn perspective. The location of the picture plane and its angular alignment with the space is an important variable. The final consideration would be the overall size of the perspective drawing. All of these decisions must be made during the process of designing the perspective setup. Having completed this process, the next step is to lay out the final horizon line and to draw the perspective.

6

Drawing the Perspective by the Perspective Plan Method

6.1 DRAWING THE WALLS OF THE ROOM

Step 7. See Fig. 6–1. (Not drawn to scale)

7a. Take the measurements from the 1/8″ = 1′-0 scale *preliminary* PP, HL, and lay out a new HL at 3/8″ = 1′-0 scale. Start laying out the new HL by locating the CV in the middle of a *new* sheet of paper. Redraw the preliminary HL at the chosen perspective scale.

Statement 4. At this point you may have discovered that you have chosen a scale or such an acute angle for your perspective that you will have an inaccessibly long vanishing point (off your table). If this applies to your perspective, turn to page 138 and follow the alternative method of drawing the perspective without the long vanishing point. If this doesn't apply to your perspective, continue with step 8 in this sequence.

Step 8. See Fig. 6–2.

8a. Locate the ground line, horizontal measuring line (GL, HML) 5′ (to scale) below the HL.

Statement 5. This 5′ measurement is the normal eye level. This relationship between the HL and GL can vary because of the desired effect required for different perspectives.

Statement 6. All width and depth measurements will be made on the horizontal measuring line (HML). These measurements will be transferred to right base lines

122

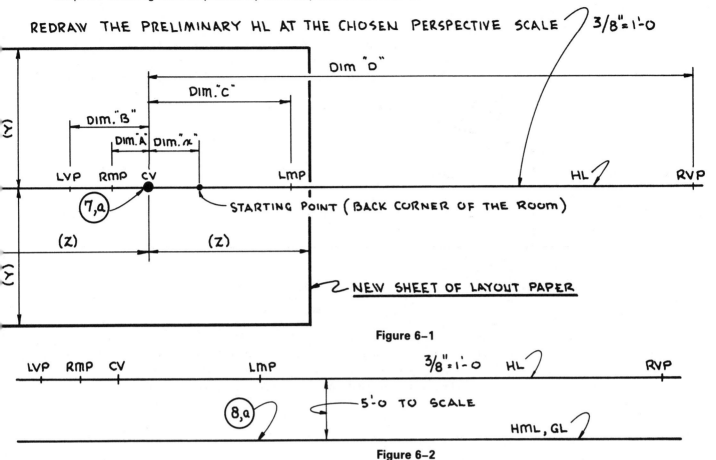

Figure 6–1

Figure 6–2

(RBLs) with lines drawn to the RMP. Conversely, measurements transferred to left base lines (LBLs) will use lines drawn to the LMP.

Note: A base line is any horizontal line in the ground plane which vanishes to either the right or the left vanishing points.

Step 9. See Fig. 6–3.

9a. Scale the distance of dimension x to the right of the CV to locate point A. This is the starting point for your perspective as well as the back right corner of the room.

9b. Draw a vertical through point A. Because this vertical is in the PP, it is a true height line (THL). Reflecting an 8′ ceiling height, make a measurement of 8′ above the GL on this true height line.

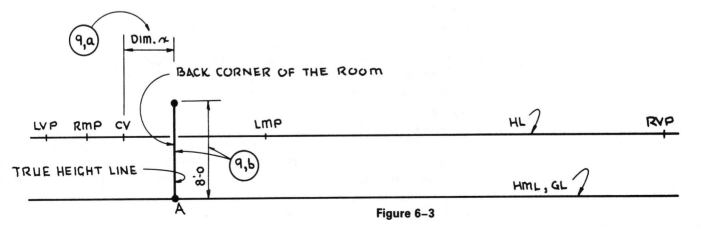

Figure 6–3

Step 10. See Fig. 6–4.

10a. Through the top and bottom of the true height line, draw lines projecting from the LVP. The bottom line is considered to be a left base line (LBL). The two lines together define the height of the right wall of the room.

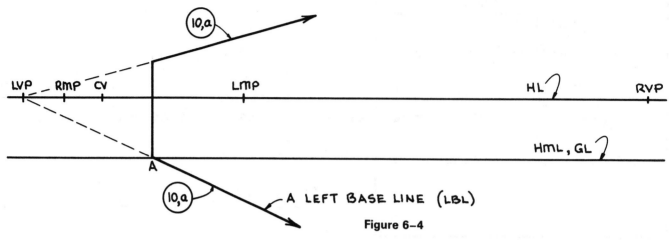

Figure 6–4

Step 11. See Fig. 6–5.

11a. Next, you must determine the lengths of the walls which are visible in the perspective. You can do this by returning to your floor plan and measuring the parts of the walls that are included inside the 60° cone of vision.

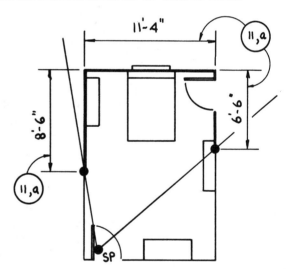

Figure 6–5

Step 12. See Fig. 6–6.

12a. Measure to the right of the back corner (starting point) 6′-6″ on the GL, HML.

12b. Project this measurement to the left base line (LBL) with a line from the LMP. Draw a vertical line. This last vertical is just a construction line. It is not actually the end of the wall.

Step 13. See Fig. 6–7.

13a. From the top and bottom of the true height line, draw lines projecting from the RVP. The bottom line is considered to be a right base line (RBL). The two lines together define the height of the back wall of the room.

13b. Measure to the left of the back corner 11′-4″, the length of the back wall.

13c. Project this measurement to the RBL with a line from the RMP.

13d. Draw a vertical line — the back left corner of the room.

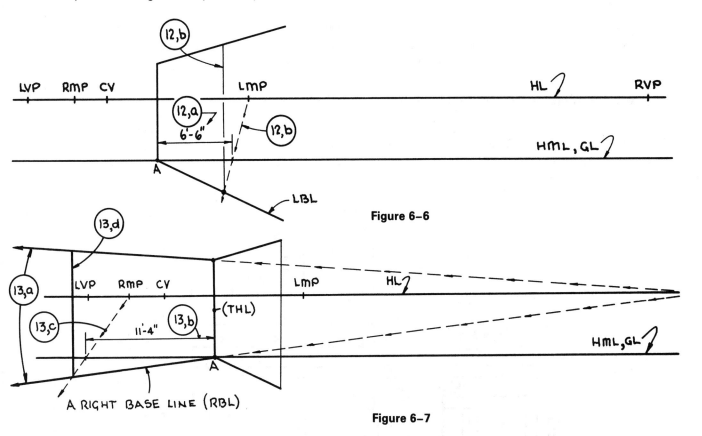

Figure 6-6

Figure 6-7

Step 14. See Fig. 6–8.

14a. Through the top and bottom of this vertical line, draw lines projecting from the LVP. The bottom line is considered to be a left base line (LBL). These two lines together define the height of the left wall of the room.

14b. Project the back left corner of the room into the PP with a line drawn to the LMP.

14c. Where this line crosses the HML at point B marks the starting point for an 8'-6" measurement to the right of that point.

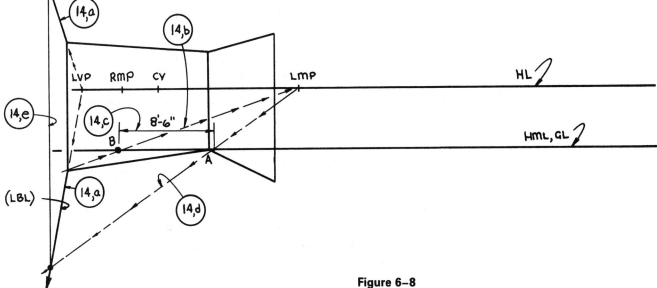

Figure 6-8

14d. Project this measurement back to the LBL with a line from the LMP.

14e. Draw a vertical line through this point. This last vertical line is just a construction line. It is not actually the end of the wall.

6.2 DRAWING INTERIOR OBJECTS

Statement 1. You now have portions of the three walls drawn in perspective. To complete the perspective, you must draw in the doors, windows, and furniture. Refer to Fig. 6–9 for the dimensions required to draw these items.

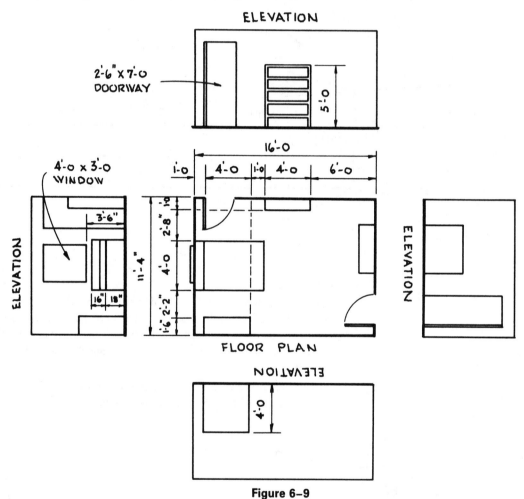

Figure 6–9

Statement 2. You should draw the outline of the furniture, door, and window on the floor before you draw the perspective of each.

Step 1. See Fig. 6–10.

1a. To begin to locate the bookshelves, bed, and dresser on the back wall, measure to the left of point A on the HML 1′-0, then 2′-8″, then 4′-0, and then 2′-2″.

1b. Transfer these measurements from the HML to line AB, which is the original RBL, with lines from the RMP. You have now located points 1, 2, 3, and 4.

1c. Project these points forward into the room with light construction lines from the LVP.

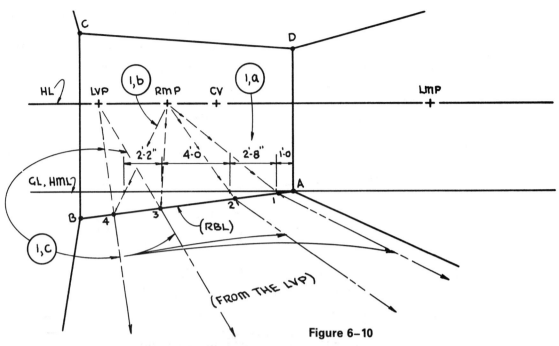

Figure 6–10

Statement 3. This is the basic procedure that you will use over and over again as you complete the perspective plan outline of the objects. You make the width and depth measurements on the HML. Then you transfer these measurements onto the base line with which you are working with lines from the appropriate measuring point (RBL uses the RMP; LBL uses the LMP). Once the measurements are transferred to the base lines, they are then projected into the room with lines from the appropriate vanishing point (VP).

Step 2. See Fig. 6–11.

2a. To begin to locate the bookshelves, bed, and dresser on the right wall, measure to the right of point A on the HML 1′-0, then 4′-0, then 1′-0, and then 4′-0.

2b. Transfer these measurements to line AF, which is the original LBL, with lines from the LMP. You have now located points 5, 6, 7, and 8.

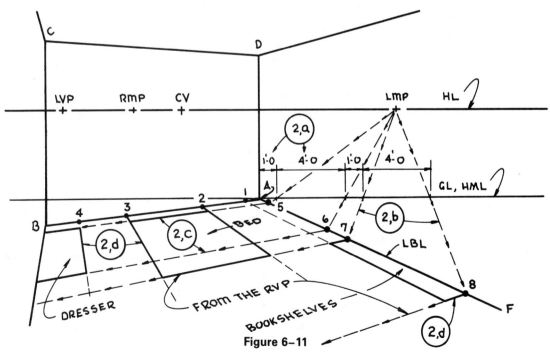

Figure 6–11

2c. Project these points into the room with light construction lines from the RVP.

2d. Using the plan view of the room as a guide, darken the outline of the book-shelves, bed, and dresser.

Step 3. See Fig. 6–12.

3a. Locate by the same method the horizontal location of the window and door in the back and right side walls.

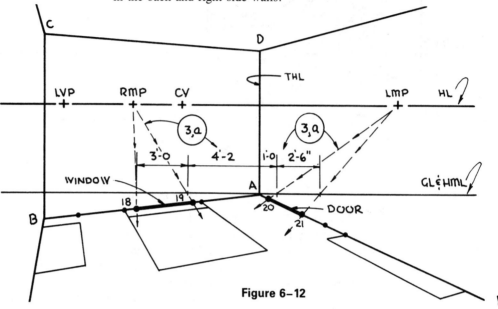

Figure 6–12

Statement 4. Now you are ready to draw the objects, using their perspective outlines on the floor as guides. All height measurements will be made on true height lines (THLs). These are vertical lines which are in the PP. The only THL you now have is the back right corner of the room (line DA). You could use it exclusively to complete the perspective or you could find and use new THLs as well.

Note: The height measurements are given in the elevation views of the room. Refer to Fig. 6–9 on page 126.

Step 4. See Fig. 6–13.

4a. The original THL (line DA) will be used to draw the bed, bookshelves, door, and window in that order. Beginning at the GL, make measurements of 1'-6", then 6", and then 10".

4b. Draw vertical lines above points 2 and 3.

4c. Transfer the measurements from the THL to these verticals with lines from the RVP.

4d. At the lower four of these six intersections, project into the room with lines from the LVP.

Step 5. See Fig. 6–14.

5a. Draw verticals above points 13, 14, 15, and 16.

5b. Using your visualization ability, darken the outline of the bed.

Step 6. See Fig. 6–15.

6a. To draw the bookshelves, begin at the GL on the original THL (line DA) and make five 1' measurements.

6b. Project these measurements along the right wall with lines from the LVP. These lines will intersect the vertical above point 7.

6c. Project these line intersections to the vertical drawn above point 17 with lines from the RVP.

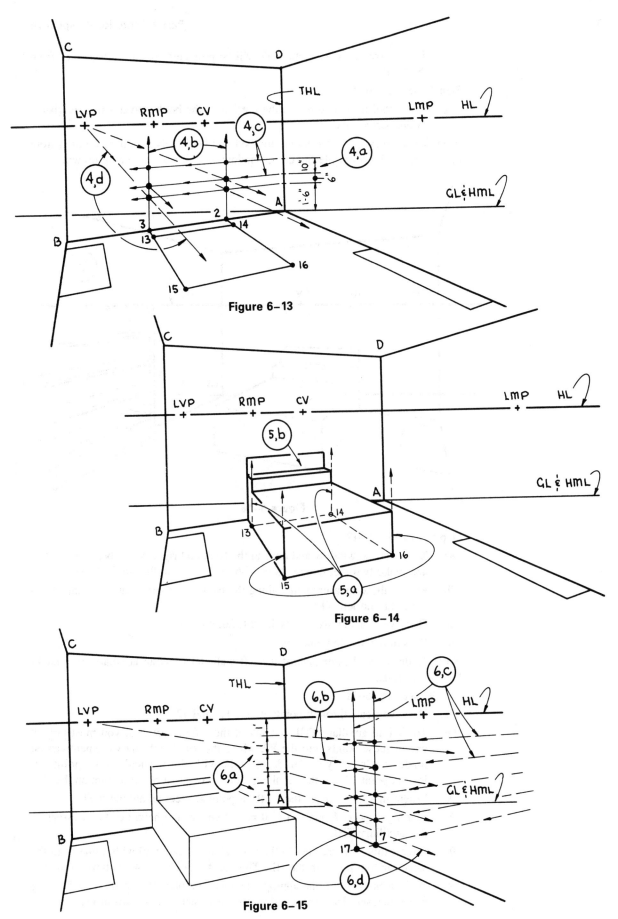

Figure 6-13

Figure 6-14

Figure 6-15

6d. The intersections on vertical 17 will be projected forward along lines from the LVP.

Step 7. See Fig. 6–16.

7a. Add detail to and complete the portion of the bookshelves which is visible in the perspective.

Note: To simplify the illustrations, the bed and bookshelves will be omitted from the following figures while the door, window, and dresser are being drawn.

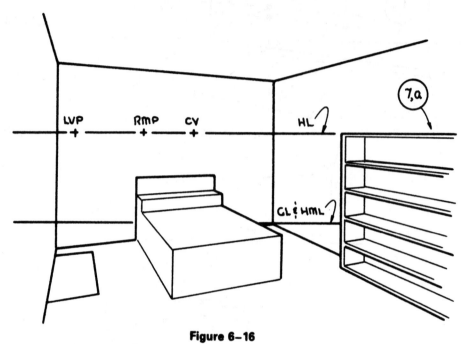

Figure 6–16

Step 8. See Fig. 6–17.

8a. To locate the window and door in the back and right walls, begin at the GL and make two measurements of 3'-6" and 3'-6" on the original THL.

8b. Project these measurements along the back and right walls with lines from the right and left VPs.

8c. Draw verticals above points 18, 19, 20, and 21.

8d. Darken the window and door.

Note: To draw the dresser against the left wall, let's use an auxiliary true height line (Aux. THL).

Step 9. See Fig. 6–18.

9a. Draw verticals through points 9, 10, 11, and 12.

9b. To find an auxiliary THL for any of these four verticals, you must project one of these points into the PP, where the true height measurement can be made. Let's say you decide to work with the vertical above point 10. Project point 10 into the PP along a line drawn to a random point on the HL.

9c. Where this line crosses the HML at point J, erect an auxiliary THL.

9d. Starting at point J, make a 4'-0 measurement (the height of the dresser) on this auxiliary THL.

9e. Project this measurement to the vertical above point 10 with a line from the same random point on the HL. This locates point 22, 4'-0 above point 10.

9f. With lines drawn to the appropriate VPs, complete the perspective drawing of the dresser. The completed interior perspective is shown in Fig. 6–19.

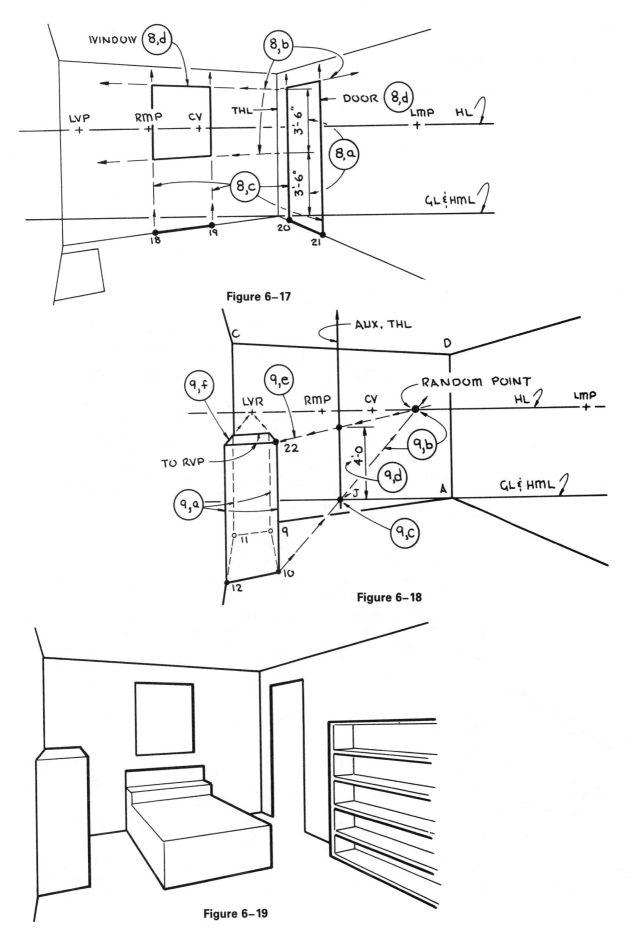

Figure 6-17

Figure 6-18

Figure 6-19

6.3 PROPERLY LOCATING THE STATION POINT

Statement 1. You must be cautious about drawing items that are outside the 60° cone of vision. There is a good chance that items drawn outside the cone will look distorted. You can draw the cone of vision on the perspective by placing the point of a compass on the CV and scribing an arc the radius of which is one-half the original picture width (PW). See Fig. 6–20.

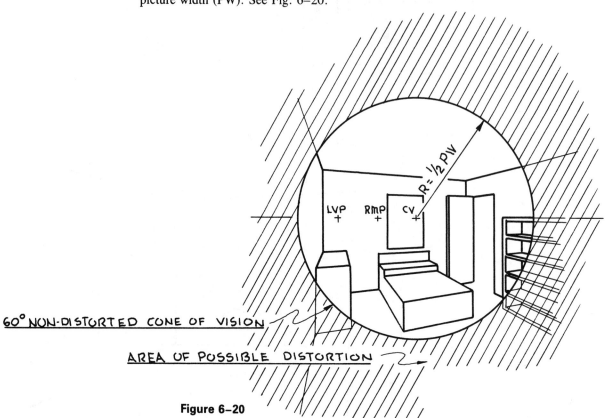

60° NON-DISTORTED CONE OF VISION

AREA OF POSSIBLE DISTORTION

Figure 6–20

Statement 2. Earlier in this discussion when you were instructed to manipulate the 60° cone of vision to try to find a good location for the observer (SP), you were shown six different angles by which you could view the room (page 115). Eventually, you chose and drew the sixth example, which happened to be a 70°-20° perspective. Here is how the other five examples would have looked had you chosen to draw them (Figures 6–21, 6–22, 6–23, 6–24, 6–25). All these perspectives are correct. They are just different from the one you chose to draw.

Figure 6-22

Figure 6-23

Figure 6-24

Figure 6–25

Statement 3. Earlier it was stated that it was better to locate the observer (SP) inside the space, if at all possible. The observer was inside the space in four of the five previous examples. Let's compare the drawn 70°-20° perspective with the SP inside the space to a 70°-20° perspective drawn with the SP outside the space. The advantages and disadvantages of both are listed.

70°-20° PERSPECTIVE WITH THE OBSERVER (SP) INSIDE THE ROOM

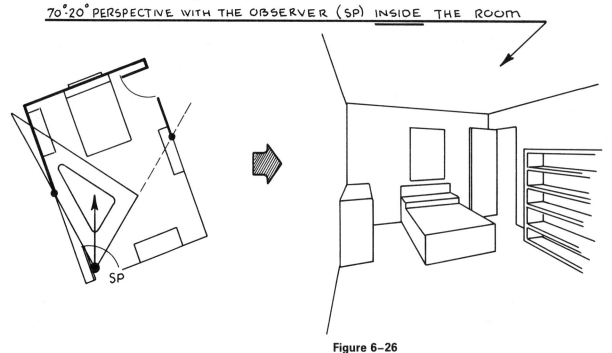

Figure 6–26

Advantages

 1. More realistic view (how it would actually look if you were in the room).

 2. Lines converge more (more dramatic).

 3. A logical location for the observer.

Disadvantages

 1. Perspective does not show the entire room.

 2. Furniture near the observer may be distorted.

70°-20° PERSPECTIVE WITH THE OBSERVER (SP) OUTSIDE THE ROOM

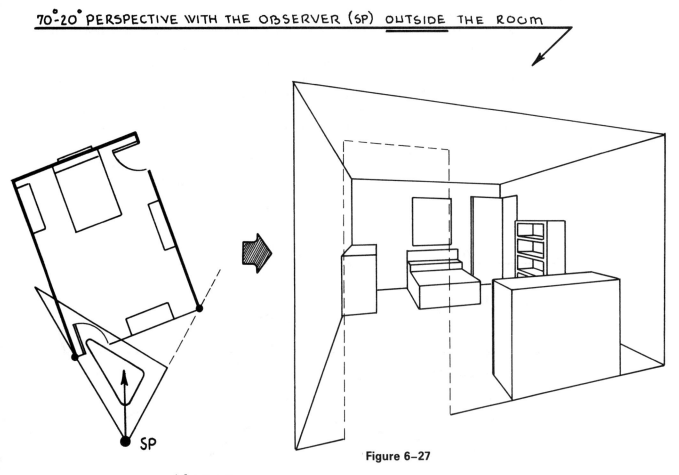

Figure 6–27

Advantages

1. Perspective shows the entire room.

Disadvantages

1. An unrealistic view of the room (walls have to be removed).
2. Not very dramatic (less line convergence).
3. See backs of furniture against the walls.

You can see that it is preferable to get the observer as close as possible but still be able to show what you want in the perspective.

The location of the observer in the main example in this discussion was only one of many possible locations from which to view the room. You can position the room at any angle with the PP. You will be able to take this sequence of steps and adapt it to any perspective setup. Sometimes the long vanishing point will go to the left, and sometimes it will go to the right. Some perspective setups will show three walls, while others will show only two. Do not let these variations confuse you. If you have a good working knowledge of the basics of the perspective plan drawing, you will be able to handle these variations.

6.4 USING AUXILIARY BASE LINES

Statement 1. You have just completed an interior perspective by using only the original right and left base lines to project width and depth measurements into the perspective. This technique works well, but it is not the most effective way to project measurements from the HML into the perspective area. The ideal situation would be if

you could project measurements from the HML directly to the line with which you are working. This procedure requires you to find and use new base lines independent from the original base lines.

Any horizontal line in the ground plane which vanishes to the right or left vanishing point is considered to be a base line. Measurements on the HML can be projected directly to these lines from the appropriate measuring point.

To demonstrate this procedure, let's use the perspective setup used in the previous example. Horizontal lines AB and CD are drawn on the floor. See Fig. 6–28.

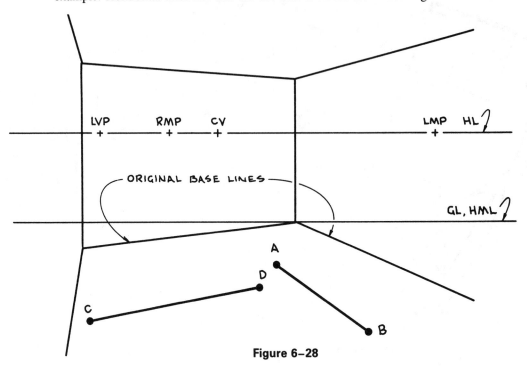

Figure 6–28

Let's consider line AB first. You want to locate point E 3'-0 in front of point A on line AB.

Step 1. See Fig. 6–29.

1a. First, you must determine if line AB is a right or left base line. Visually or physically extend line AB until it intersects the horizon line. Since it crosses the HL at the LVP, line AB is considered to be a left base line. Therefore, the LMP will be used to project measurements from the HML to this line.

1b. You want to begin the 3'-0 measurement at point A on line AB. Unfortunately, width and depth measurements can be made only on the HML, which is in the PP. So, you must determine if point A is in the PP. In order for it to be in the PP, it must be *on* the HML. In this case, point A is in front of the PP. If it were in the PP, the 3'-0 measurement could be made directly on the HML starting at point A.

Since point A is not in the PP, you must find a starting point for the measurement on the HML. In order to find this starting point, you must project point A into the PP, HML with a line drawn to the LMP. This locates point A_p on the HML.

1c. Make the 3'-0 measurement to the right of point A_p.

1d. Project this measurement to line AB with a line from the LMP. This locates point E 3'-0 in front of point A.

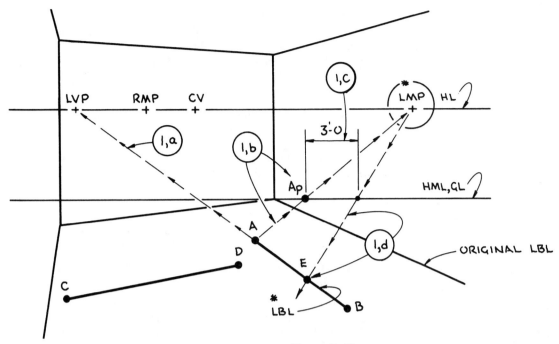

Figure 6–29

Statement 2. You projected this measurement directly to the base line with which you were working. The original LBL was never used.

Now let's consider line CD. You want to locate point F 4'-0 to the left of point D on line CD.

Step 2. See Fig. 6–30.

2a. First, you must determine if line CD is a right or a left base line. Visually or physically extend line CD until it intersects the HL. Since it crosses the HL at the RVP, line CD is considered to be a right base line. Therefore, the RMP will be used to project measurements from the HML to this line.

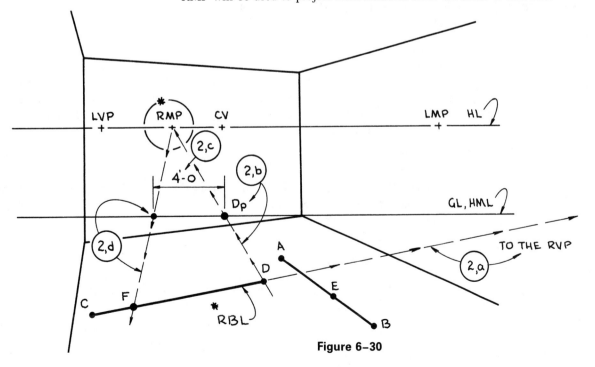

Figure 6–30

2b. You want to begin the 4′-0 measurement at point D. If point D were in the PP, the 4′-0 measurement could begin at point D on the HML. Unfortunately, point D is in front of the PP. Therefore, to find a starting point for the 4′-0 measurement on the HML, you must project point D into the PP, HML with a line drawn to the RMP. This locates point D_p on the HML.

2c. Make the 4′-0 measurement to the left of point D_p.

2d. Project this measurement to line CD with a line from the RMP. This locates point F 4′-0 to the left of point D.

Statement 3. For review purposes the basic steps used to project measurements from the HML directly to auxiliary base lines are listed below.

1. Determine if you are working with a right or a left base line. (Does the line vanish to the right or to the left vanishing point?)

2. Determine if the starting point for your measurement is in the PP. (Is it on the HML?)

3. If the starting point is in the PP, you can make your measurement on the HML beginning at that point.

4. If the starting point is not in the PP (on the HML), you must project it into the PP with a line drawn to the appropriate measuring point. If you are working with a RBL, you use the RMP. If you are working with a LBL, you use the LMP. The starting point for your measurement is where this line of projection crosses the HML.

5. Make the measurement to the right or to the left of this starting point on the HML.

6. Project this measurement to the same base line with a line drawn from the same measuring point.

If you become proficient with this procedure, you will be able to project width and depth measurements directly to any horizontal line in the ground plane.

6.5 DRAWING THE PERSPECTIVE WITHOUT THE LONG VANISHING POINT

Statement 1. This method allows you to draw your perspective by approximating the inaccessible vanishing point. A series of lines vanishing to the inaccessible vanishing point will be drawn on the floor and wall. These lines will be used as guides when it is necessary to draw lines on furniture, windows, doors, and so on, which are vanishing to the inaccessible vanishing point. This method will allow you to draw large-scale perspectives on a small table.

Statement 2. For the purpose of this example, let's say you choose to draw the perspective at 1/2″ = 1′-0 scale instead of the 3/8″ = 1′-0 scale used in the previous example. (This is the same room used in Chapter Five). This large scale will cause the RVP to fall off your table. See Fig. 6–31. Consequently, you must use this alternative method to draw your perspective. Continue with step 1.

Step 1. See Fig. 6–32.

1a. Locate the GL and HML 5′-0 (to scale) below the HL.

Statement 3. This 5′-0 measurement is the normal eye level. This relationship between the HL and GL can vary with the desired effect required for different perspectives.

1b. Scale the distance of dimension x to the right of the CV to locate the back corner of the room, which will be the starting point of your perspective.

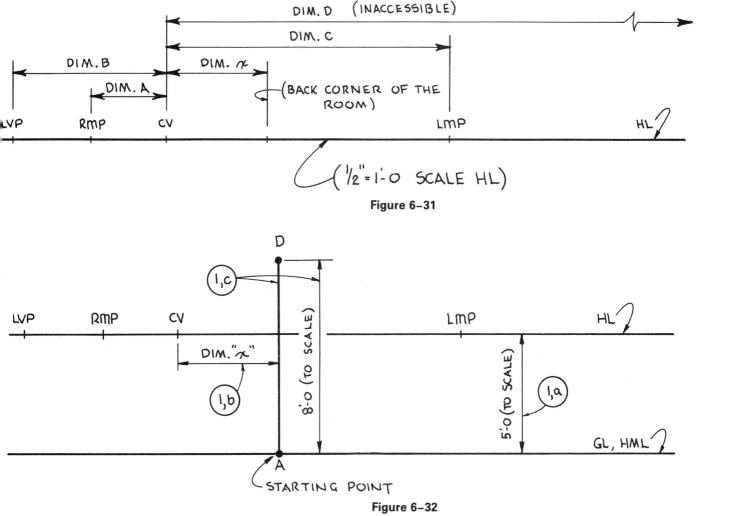

Figure 6–31

Figure 6–32

1c. Draw a vertical (AD) at this starting point. Because this vertical is in the PP, it is a THL. Reflecting an 8'-0 ceiling height, make a measurement of 8'-0 above the GL on this true height line.

Step 2. See Fig. 6–33.

2a. Through the top and bottom of the true height line AD, draw lines projecting from the LVP. The bottom line is considered a LBL. The two lines together define the height of the right wall of the room.

Step 3. See Fig. 6–34.

3a. In order to draw the back wall, you will have to approximate the inaccessible RVP. Take the floor plan and project point B into the PP at point E. This line of projection should always go parallel to one of the walls. In this case, you are extending the left wall of the room until it intersects with the PP. Measure the distance from point B to point E (Dim. Z).

3b. Next, measure the distance from point E to point A (Dim. Y).

Statement 4. You have just constructed in the plan view a triangle with the sides AB, BE, and EA. It is possible to draw this triangle in perspective without using the long vanishing point. Once you have this triangle drawn, you will have a line drawn which is vanishing to the inaccessible VP (line AB). This line is the key to drawing the perspective without the long vanishing point.

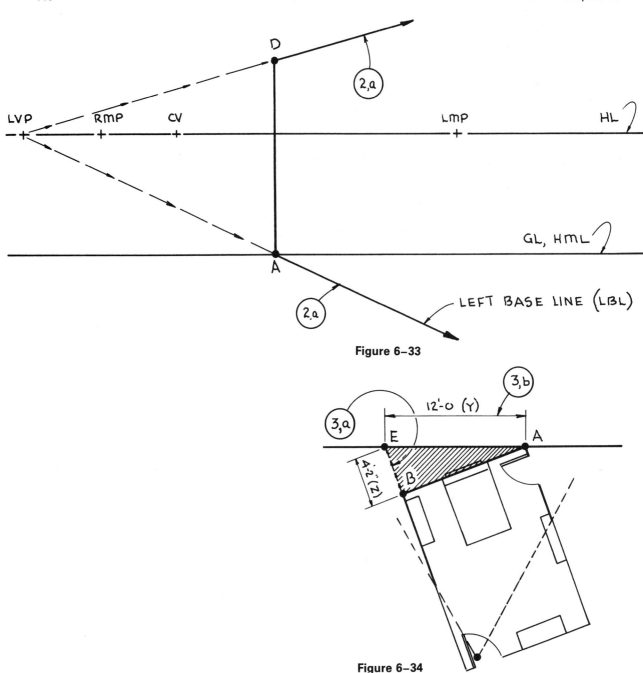

Figure 6–33

Figure 6–34

Note: It is not possible or wise to cover all the possible variations in drawing an interior perspective, but a digression at this point is warranted. This last step is crucial for you to understand in order for you to be able to draw the perspective without the long vanishing point. Therefore, you need to see an example of a perspective setup showing only two walls as compared to the three-wall example with which you have been working.

The smaller the angle that one of the walls makes with the PP, the greater the possibility that its accompanying VP might fall off your table.

Fig. 6–35 shows you how to find dimensions Y and Z when the perspective setup shows only two walls. (Continue the sequence.)

Step 4. See Fig. 6–36.
 4a. Measure 12′-0 to the left of point A (Dim. Y) to locate point E on the HML, GL. (Dim. Y is from Fig. 6–34.)

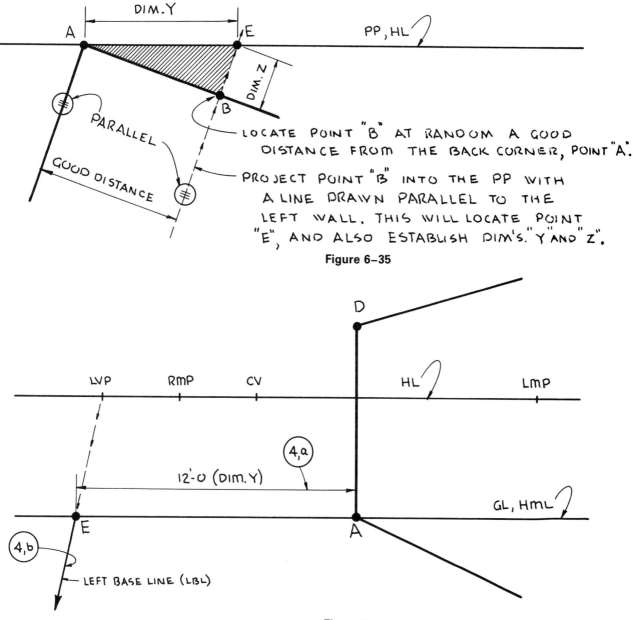

LOCATE POINT "B" AT RANDOM A GOOD DISTANCE FROM THE BACK CORNER, POINT "A".

PROJECT POINT "B" INTO THE PP WITH A LINE DRAWN PARALLEL TO THE LEFT WALL. THIS WILL LOCATE POINT "E", AND ALSO ESTABLISH DIM'S. "Y" AND "Z".

Figure 6-35

Figure 6-36

4b. Through point E draw a line from the LVP. This line is considered to be a LBL.

Step 5. See Fig. 6-37.

5a. From point E measure to the right 4'-2" (Dim. Z).

5b. Project a line through that point from the LMP until it intersects with the LBL, locating point B.

5c. Now you can draw a line from point B to point A. This is considered to be a RBL; consequently, this line is vanishing to the inaccessible RVP.

5d. Draw a vertical line above point B. This line represents the back left corner of the room.

Step 6. See Fig. 6-38.

6a. Draw a line from point B to the HL. In this case, the line was drawn to the CV. Actually, any point on the HL would work.

6b. Where this line intersects with the HML at point G, draw a vertical line. This vertical line is in the PP; therefore, it is a THL.

6c. Make a measurement of 8′-0 on this THL.

6d. Project this measurement to the vertical above point B with a line from the CV. This locates point C 8′-0 above point B.

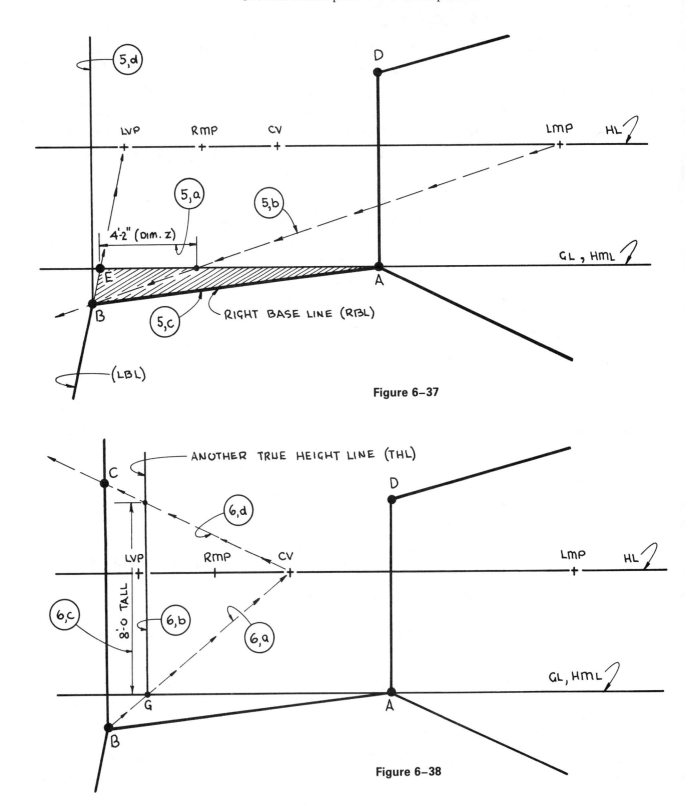

Figure 6-37

Figure 6-38

Step 7. See Fig. 6–39.

7a. Draw a line connecting points C and D. This line is vanishing to the inaccessible RVP.

7b. A line drawn from the LVP through point C will be the line of intersection between the ceiling and the left wall.

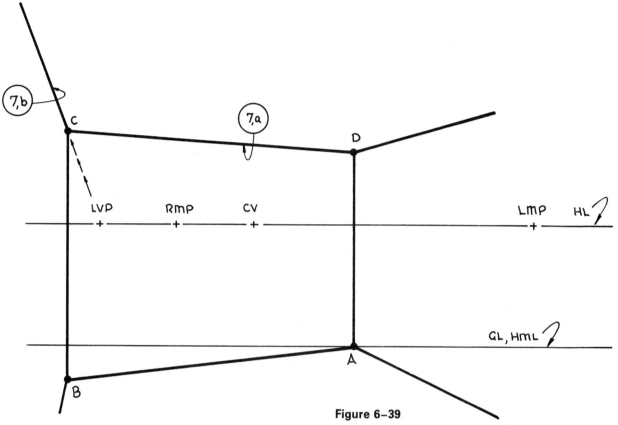

Figure 6–39

Statement 5. You now have three walls of the room drawn. Presently, you have only two lines that are vanishing to the inaccessible RVP. These are lines CD and BA. In order to be able to draw accurately all the items in the room—furniture, windows, and doors—you need more lines going to the RVP. You will want to use these added lines as guides when you draw the rest of the perspective. Lines vanishing to the RVP on the floor and back wall are necessary.

Step 8. See Fig. 6–40.

8a. In increments of 2′, measure to the right of point A. If you want more guide lines, you can measure in increments of 1′.

8b. Project these measurements to the LBL with lines from the LMP, locating points 1, 2, 3, and 4.

Step 9. See Fig. 6–41.

9a. Close to the left wall draw, at random, a line from the LVP. You want to draw this line a good distance from the back corner (point A). This is done for accuracy. This line is another LBL.

9b. This LBL crosses line BA at point F. Project point F into the PP with a line through the LMP, locating point H.

9c. In increments of 2′ measure to the right of point H.

9d. Project these measurements to the new LBL with lines drawn from the LMP, locating points 5, 6, 7, and 8.

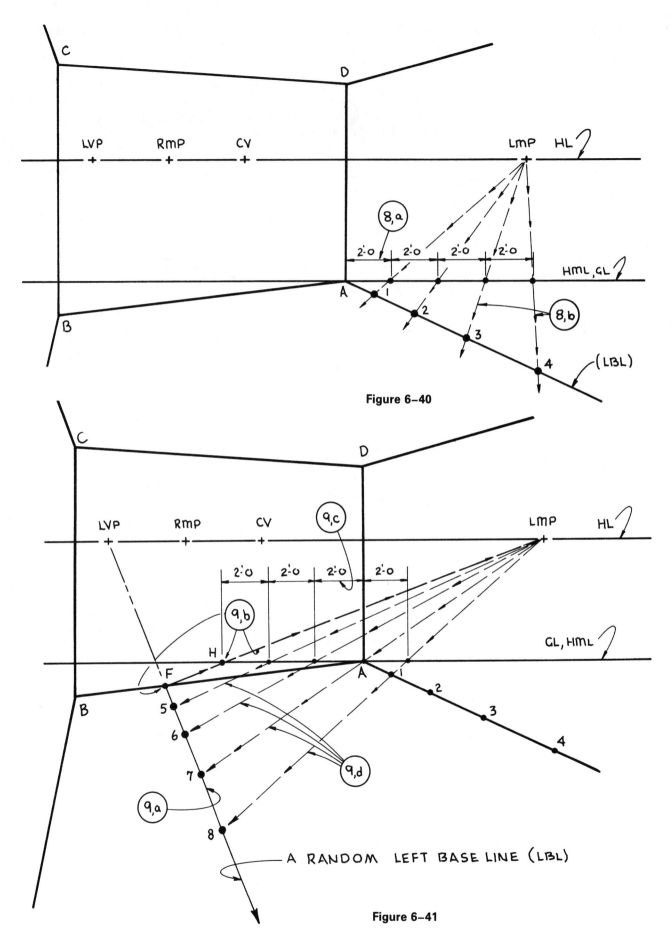

Figure 6-40

Figure 6-41

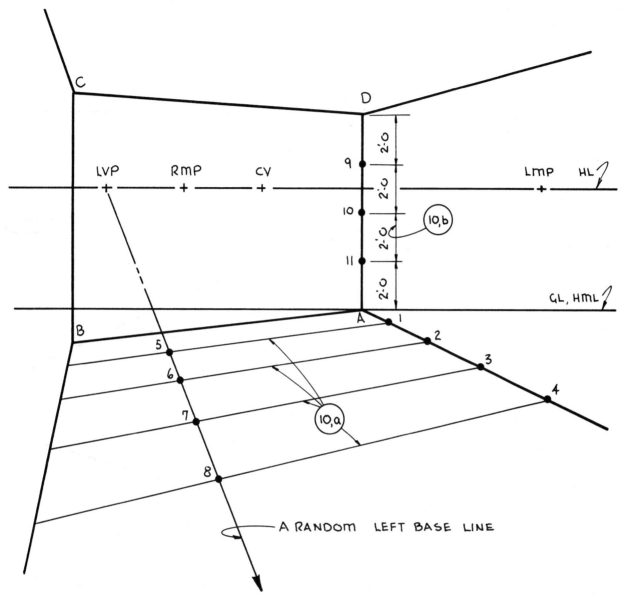

Figure 6-42

Step 10. See Fig. 6–42.

10a. Draw lines connecting points 5 and 1, 6 and 2, 7 and 3, and 8 and 4. Extend these lines to the left until they hit the left wall. These four lines are vanishing to the inaccessible RVP.

10b. To get guide lines on the back wall, mark off 2′ measurements on the true height line AD, locating points 9, 10, and 11.

Step 11. See Fig. 6–43.

11a. Mark off 2′ measurements on the true height line above point G.

Step 12. See Fig. 6–44.

12a. Project these measurements to the vertical line BC with lines from the CV, locating points 12, 13, and 14.

Step 13. See Fig. 6–45.

13a. Draw lines connecting points 12 and 9, 13 and 10, and 14 and 11. These three lines are vanishing to the RVP.

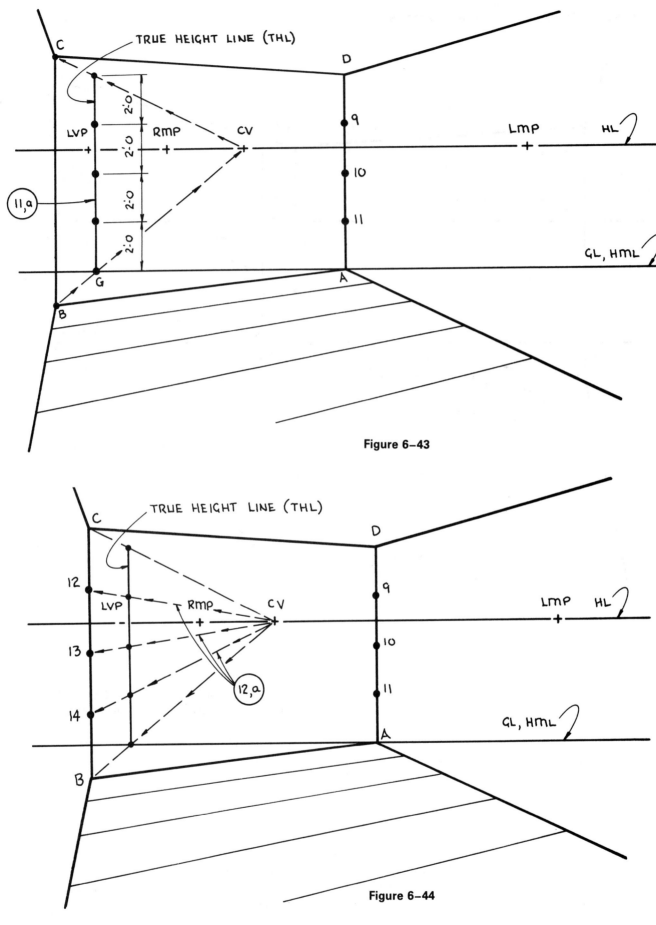

Figure 6-43

Figure 6-44

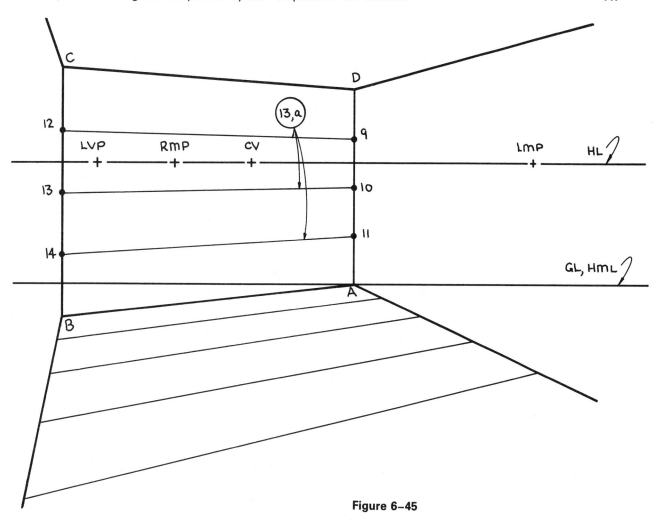

Figure 6–45

Step 14. See Figs. 6–46, 6–47, and 6–48.

14a. If your perspective needs more guide lines above or below the back wall, you can use the two true height lines to find more.

Statement 6. Lines which vanish to the inaccessible VP should be drawn parallel to the nearest guide line.

Statement 7. Using the basics of perspective plan drawing and these guide lines approximating the RVP, complete the interior perspective. The perspective will include doors, windows, and furniture. See Fig. 6–49.

Statement 8. This completes the section which explains how to draw the perspective without one of the vanishing points.

6.6 DRAWING AN INTERIOR PERSPECTIVE REQUIRING MORE THAN TWO VANISHING POINTS

In the previous sections we have been discussing the basics of interior perspective drawing by the perspective plan method. A very simple rectangular room was used in the main example. Now let's consider drawing a space which is not rectangular but which has angled walls.

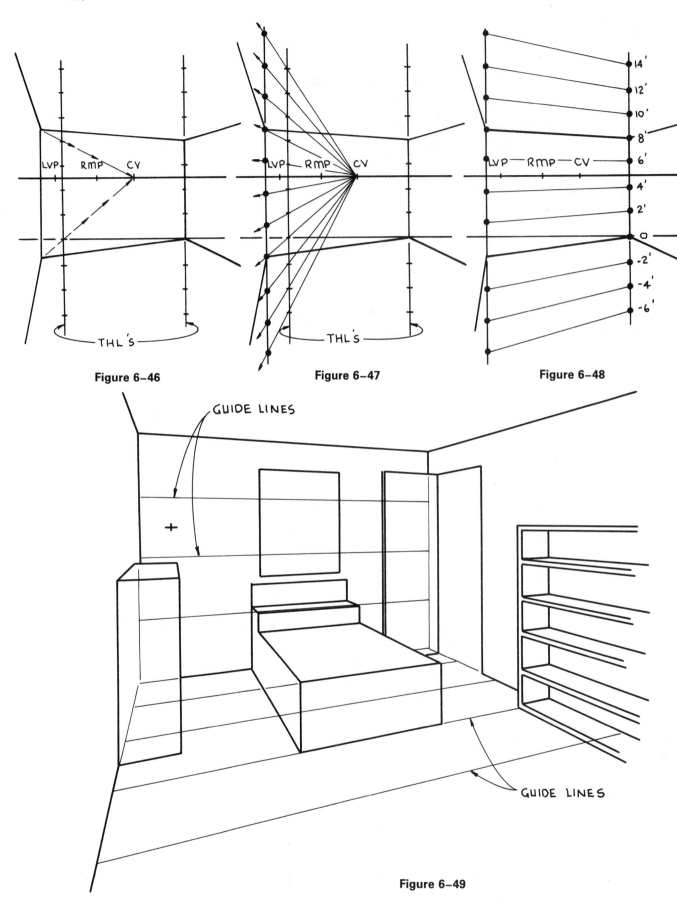

Figure 6-46 **Figure 6-47** **Figure 6-48**

Figure 6-49

The plan view of this space is shown in Fig. 6–50. At first glance this looks like a complicated situation. However, if you follow the basic steps for laying out an interior perspective, this space is not that complicated. In review, the basic steps for laying out the preliminary horizon line are as follows:

1. Draw a small-scale sketch of the space (1/8″ = 1′-0). The scale of this preliminary drawing is independent of the scale chosen for the final perspective.

2. Use the 60° angle of your 30°-60° triangle to determine the best view of the space. This will locate the observer (station point). The perspective will be drawn from this vantage point. Before you move the triangle, use your pencil and trace around the 60° angle.

3. Locate the PP by turning the 30°-60° triangle over and drawing a line which forms a 60° angle with one leg of the 60° cone of vision. Draw the PP through a convenient corner in the room.

4. Turn your triangle over again and locate the center of vision (CV) by drawing a perpendicular line from the SP to the PP.

5. Still working on the preliminary sketch, locate the vanishing points for each of the walls which is visible inside the cone of vision. You do this by drawing lines through the SP which are parallel to each wall. Extend these lines until they intersect with the PP, HL. Each point of intersection will be the vanishing point for any horizontal line drawn in that particular wall. Parallel walls will vanish to the same vanishing point.

6. In order to make width or depth measurements along each wall, you need to find a measuring point for each wall. Parallel walls will use the same MP. Using the VP for each wall as the location for the point of your compass, rotate the SP into the PP. Where this arc crosses the PP will locate a measuring point for each of the different-angled walls. It might be helpful to label each wall and its accompanying vanishing point and measuring point. An example of such a labeling procedure would be wall A, vanishing point A(VP$_A$), and measuring point A(MP$_A$). Each time you want to make a width or depth measurement along wall A, you must use MP$_A$.

7. The starting point for your perspective will be at the corner of the room which is in the PP. The distance from this corner to the CV will be dimension x. The preliminary PP, HL is now complete.

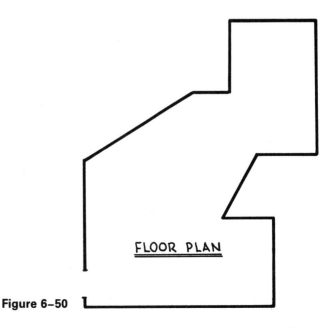

FLOOR PLAN

Figure 6–50

8. Using the scale of the preliminary sketch (1/8″ = 1′-0), measure the distance from the CV to all the different MPs and VPs, and measure dimension x. Document these data.

9. Using the picture width (PW) and the simple formula presented on page 121, now choose an appropriate scale for the final perspective drawing.

10. Take the data from the preliminary PP, HL and lay out a new HL at the scale chosen for the perspective. You do this by drawing a horizontal line in the center of a new sheet of paper. Place the CV at the midpoint of this line, and lay out the final horizon line at the new scale.

11. Locate the GL, HML the prescribed distance below the HL (normally 5′-0). Drop the CV down to this line and locate the starting point for the perspective by measuring the distance of dimension x to the right or to the left of the CV.

12. Draw a THL through this starting point and proceed to draw the perspective.

Statement 1. These twelve steps are universal. They can be used for any type of perspective setup, regardless of the angle the room makes with the PP or the number of walls which are visible in the perspective. This is the basic procedure you need to use when beginning any interior perspective drawing.

Using these basic steps, let's now draw the space shown in Fig. 6–51. The walls and corners have been labeled to help in the following discussion.

Figure 6–51

Step 1. See Fig. 6–52.

1a. Draw the plan view of the space at a small scale (1/8″ = 1′-0).

1b. Using the 60° angle of your 30°-60° triangle as a cone of vision, locate an appropriate spot for the SP.

1c. Once you are satisfied with the location of the SP, trace around the 60° angle of your triangle.

Step 2. See Fig. 6–53.

2a. Turn over your 30°-60° triangle and slide it up or down along one leg of the cone of vision. You are doing this in order to draw a line which forms a 60° angle with that leg of the cone. This line represents an edge view of the PP.

You will want to draw the PP through a major feature in the room, such as a corner.

2b. Using the hypotenuse of the 30°-60° triangle as a straight edge, draw in the PP.

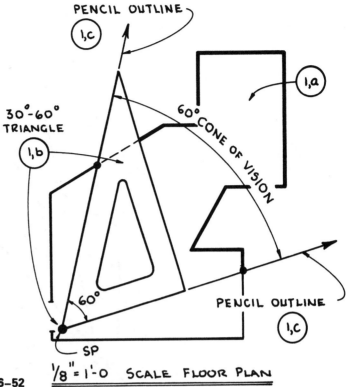

Figure 6–52

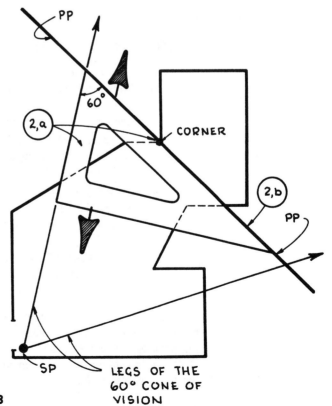

Figure 6–53

Step 3. See Fig. 6–54.

3a. Again using your 30°-60° triangle, draw a line perpendicular to the PP through the SP. The point where this line crosses the PP locates the CV.

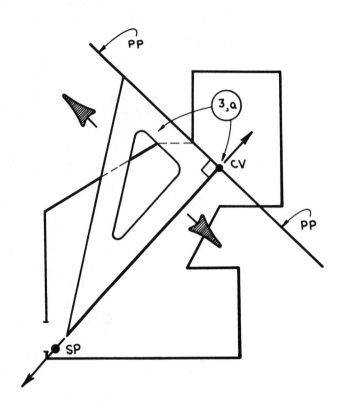

Statement 2. At this point turn the floor plan so that the PP is horizontal.

Step 4. See Fig. 6–55.

4a. To find the vanishing point for the horizontal lines in the "Group A" walls, draw a line parallel to this group of walls through the SP and extend this line until it crosses the PP. This will locate VP_A.

4b. To find the VP for the horizontal lines in the "Group B" walls, draw a line parallel to this group of walls through the SP and extend this line until it crosses the PP. This will locate VP_B.

Step 5. See Fig. 6–56.

5a. To find the VP for the horizontal lines in wall C, draw a line parallel to this wall through the SP and extend this line until it crosses the PP. This will locate VP_C.

5b. To find the VP for the horizontal lines in wall D, draw a line parallel to this wall through the SP and extend this line until it crosses the PP. This will locate VP_D. This is the last VP you have to find.

Statement 3. One of the universal ways to locate a measuring point for any horizontal line in the ground plane is to rotate the SP into the PP using that line's vanishing point as the center of the arc. All the width and depth measurements made on the HML are transferred to the given line using its accompanying measuring point. Now locate the necessary measuring points on the preliminary PP, HL.

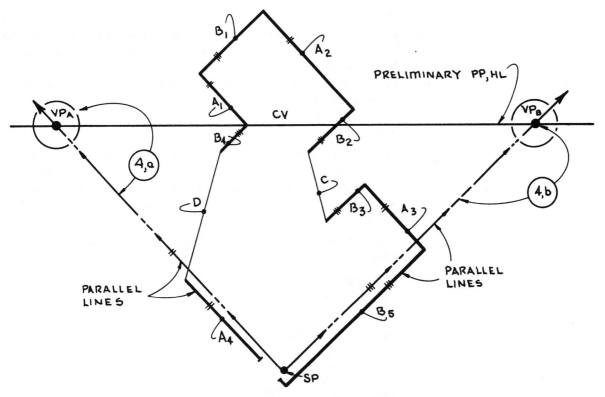

Figure 6–55

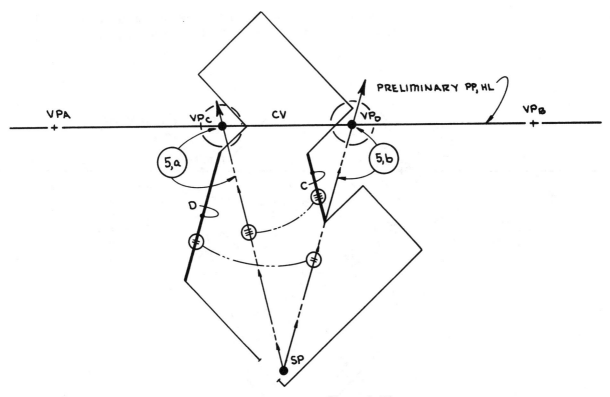

Figure 6–56

Step 6. See Fig. 6–57.

6a. To locate the measuring point for the "Group A" walls, rotate the SP into the PP using VP$_A$ as the center of the arc. The point where this arc crosses the PP locates MP$_A$.

6b. To locate the measuring point for the "Group B" walls, rotate the SP into the PP using VP$_B$ as the center of the arc. The point where this arc crosses the PP locates MP$_B$.

Step 7. See Fig. 6–58.

7a. To locate the measuring point for wall C, rotate the SP into the PP using VP$_C$ as the center of the arc. The point where this arc crosses the PP locates MP$_C$.

7b. To locate the measuring point for wall D, rotate the SP into the PP using VP$_D$ as the center of the arc. The point where this arc crosses the PP locates MP$_D$.

Step 8. See Fig. 6–59.

8a. Using the base line dimensioning technique, scale the distance between the following:

 CV and VP$_D$ (Dim. A)

 CV and MP$_A$ (Dim. B)

 CV and MP$_C$ (Dim. C)

 CV and VP$_B$ (Dim. D)

 CV and VP$_C$ (Dim. E)

 CV and MP$_B$ (Dim. F)

 CV and MP$_D$ (Dim. G)

 CV and VP$_A$ (Dim. H)

 CV and the corner of the room in the PP (Dim. x).

These measurements will be at the same scale as the preliminary PP, HL $(1/8'' = 1'\text{-}0)$. The preliminary PP, HL is now complete.

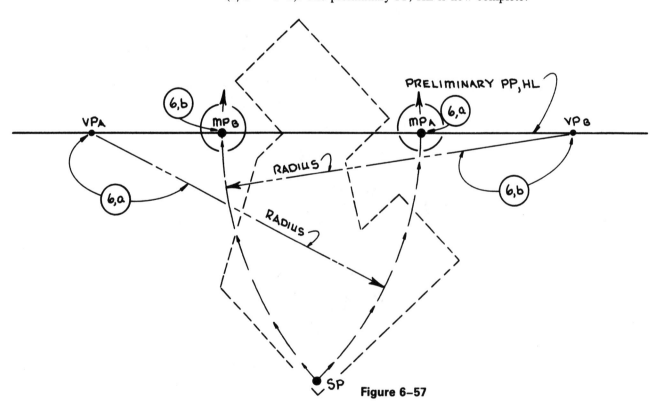

Figure 6–57

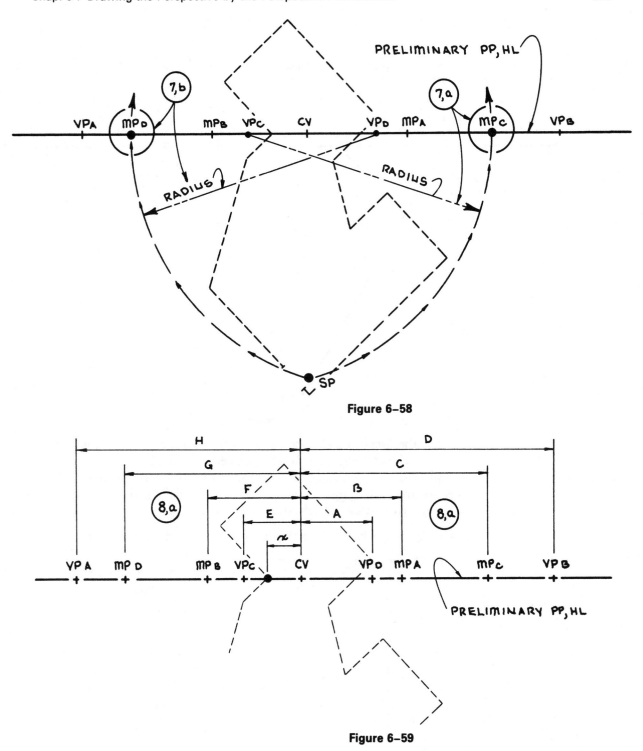

Figure 6–58

Figure 6–59

Statement 4. At this point you have to choose a scale for your perspective. First, you must determine the PW, which is the actual size or width of the completed perspective. How large do you want the final perspective to be? You can determine the PW by returning to the floor plan and the original 60° cone of vision. See Fig. 6–60.

Step 9. See Fig. 6–60.

9a. Extend the legs of the 60° cone of vision until they intersect the PP, HL at points 1 and 2.

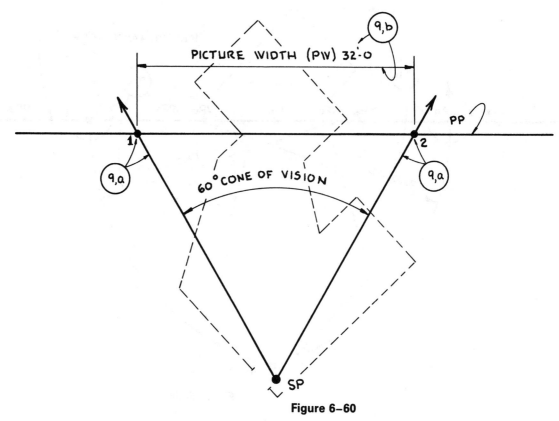

Figure 6–60

9b. The distance between these points will be equivalent to the PW drawn at the scale of the preliminary HL. In this case, the PW is 32′-0 at 1/8″ = 1′-0 scale.

Note: Now you must choose a scale that will fulfill the size requirements of the perspective. These requirements are based on how the perspective is going to be used for presentation, for reproduction, and so on.

Use the following formula to choose an appropriate scale for your perspective.

$\left(\begin{array}{c}\text{Picture width}\\ \text{from the}\\ \text{preliminary HL}\end{array}\right)$	×	$\left(\begin{array}{c}\text{Proposed}\\ \text{perspective}\\ \text{scale}\end{array}\right)$	=	Actual perspective width in inches
↓		↓		↓
32′	×	3/8″ = 1′-0	=	12″ image (full scale)
32′	×	1/2″ = 1′-0	=	16″ image (full scale)
32′	×	3/4″ = 1′-0	=	24″ image (full scale)
32′	×	1″ = 1′-0	=	32″ image (full scale)

Note: You might find these decimal equivalents for the different scales helpful.

1/8	= .125
3/16	= .1875
1/4	= .250
3/8	= .375
1/2	= .500
3/4	= .750

Statement 5. For this example you have chosen the 3/8″ = 1′-0 scale, which will give you a finished picture width of 12″.

Step 10. See Fig. 6–61. (Not drawn to scale)

10a. Take the measurements from the 1/8″ = 1′-0 scale preliminary PP, HL and lay out a new HL at 3/8″ = 1′-0 scale. Begin laying out the new HL by locating the CV in the middle of a new sheet of paper.

10b. Locate the GL, HML 5′-0 (to scale) below the HL.

10c. Scale the distance of dimension x to the left of the CV to locate point 10. This is the starting point for your perspective.

Statement 6. Draw the outline of the walls on the ground plane before you actually draw the walls.

Statement 7. Refer to the dimensioned floor plan in Fig. 6–62 as you draw the perspective.

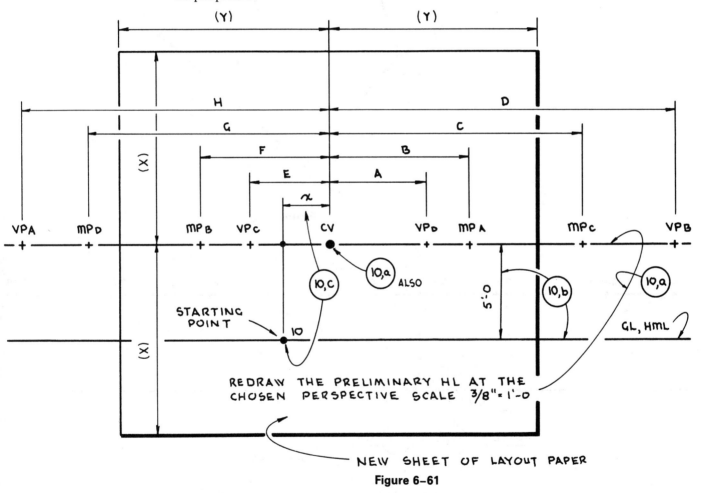

Figure 6–61

Step 11. See Fig. 6–63.

11a. Through point 10 on the GL, HML draw a line to VP_A. This line represents wall A_1.

11b. In order to find point 11 8′-0 behind point 10, measure 8′-0 to the left of point 10 on the HML.

11c. Transfer this measurement to wall A_1 with a line drawn to MP_A, locating point 11.

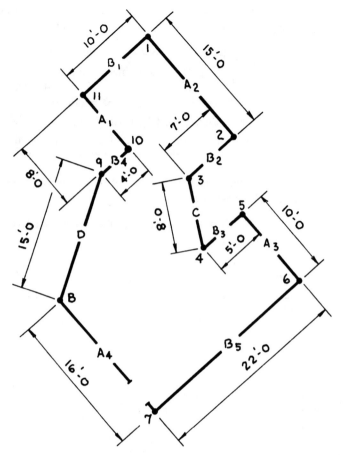

Figure 6-62

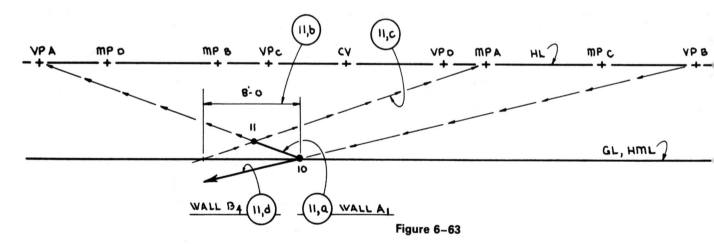

Figure 6-63

11d. Through point 10 draw a line from VP$_B$. This line represents wall B$_4$.

Statement 8. Refer to the dimensioned floor plan in Fig. 6–62 as you continue to draw the perspective outline of the room.

Step 12. See Fig. 6–64.

12a. Through point 11 draw a line to VP$_B$.

12b. Now you want to locate point 1 10′-0 to the right of point 11. You want to begin this measurement at point 11, but point 11 is not in the PP. Width and

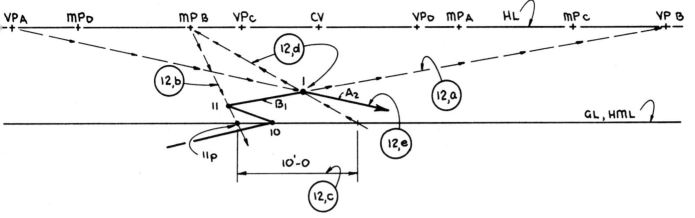

Figure 6–64

depth measurements can only be made in the PP on the HML; therefore, you must project point 11 into the PP in order to get a starting point for the measurement. Because you are working with one of the "Group B" walls, you will use a line drawn from MP_B to make this projection. This will locate point 11_p in the PP (the starting point for the 10'-0 measurement).

12c. Make the 10'-0 measurement to the right of point 11_p on the HML.

12d. Project this measurement back to wall B_1 with a line drawn to MP_B, locating point 1.

12e. Through point 1 draw a line from VP_A. This line represents wall A_2.

Statement 9. The procedure explained in step 12b will be used again and again as you continue to lay out the perspective outline of the room. If you need a more thorough discussion of this procedure, you can turn to Section 6.4 (using auxiliary base lines) on page 135 and review that material.

Step 13. See Fig. 6–65.

13a. To locate point 2 15'-0 in front of point 1, you must project point 1 into the PP with a line drawn from MP_A. Measuring point A is used because you are now working with one of the "Group A" walls. Where this line of projection crosses the PP, HML locates point 1_p (the starting point for the 15'-0 measurement).

13b. Make the 15'-0 measurement to the right of point 1_p on the HML.

13c. Project this measurement back to wall A_2 with a line drawn to MP_A locating point 2 in perspective.

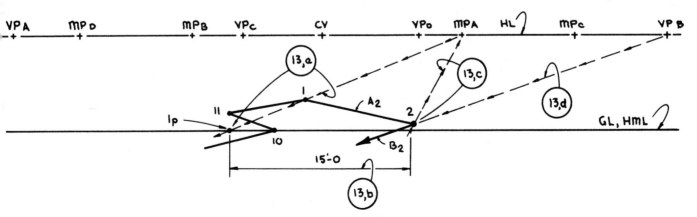

Figure 6–65

13d. Through point 2 draw a line from VP$_B$. This line represents wall B$_2$.

Note: Continue to refer to the dimensioned floor plan in Fig. 6–62 on page 158.

Step 14. See Fig. 6–66.

14a. To locate point 3 7'-0 to the left of point 2, you must project point 2 into the PP with a line drawn from MP$_B$. Measuring point B is used because you are now working with one of the "Group B" walls. Where this line of projection crosses the GL, HML locates point 2$_p$ (the starting point for the measurement).

14b. Make the 7'-0 measurement to the left of point 2$_p$ on the HML.

14c. Project this measurement forward to wall B$_2$ with a line drawn from MP$_B$ locating point 3 in perspective.

14d. Through point 3 draw a line from VP$_C$. This line represents wall C.

Step 15. See Fig. 6–67.

15a. Now you want to locate point 9 4'-0 to the left of point 10 along wall B$_4$. In this case, point 10 is already in the PP; therefore, you can begin the 4'-0 measurement at point 10. Make this measurement on the HML to the left of point 10.

15b. Project this measurement to wall B$_4$ with a line drawn from MP$_B$ locating point 9 in perspective.

15c. Through point 9 draw a line from VP$_D$. This line represents wall D.

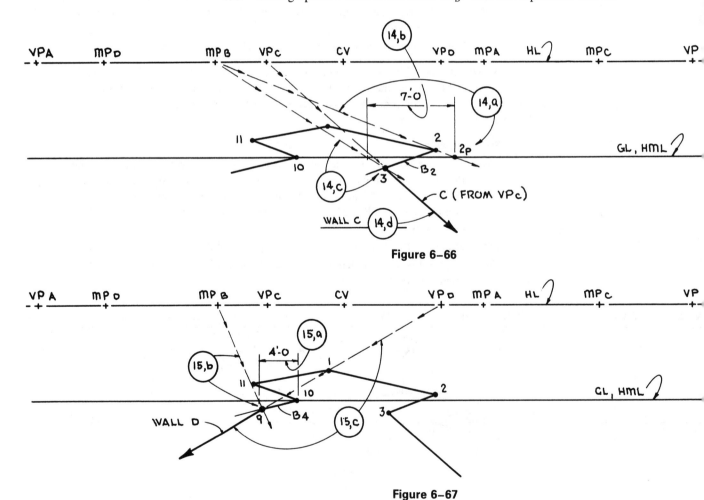

Figure 6–66

Figure 6–67

Step 16. See Fig. 6–68.

16a. To locate point 4 8'-0 in front of point 3, you must project point 3 into the PP with a line drawn to MP$_C$. Measuring point C is used because you are now working with wall C. The point where this line of projection crosses the GL, HML locates point 3$_p$ (the starting point for the measurement).

16b. Make the 8'-0 measurement to the left of point 3$_p$ on the HML.

16c. Project this measurement forward to wall C with a line drawn from MP$_C$ locating point 4 in the perspective.

16d. Through point 4 draw a line from VP$_B$. This line represents wall B$_3$.

Step 17. See Fig. 6–69.

17a. To locate point 5 5'-0 to the right of point 4, you must project point 4 into the PP with a line drawn to MP$_B$. Measuring point B is used because you are working with one of the "Group B" walls. The point where this line of projection crosses the GL, HML locates point 4$_p$ (the starting point for the measurement).

17b. Make the 5'-0 measurement to the left of point 4$_p$ on the HML.

17c. Project this measurement forward to wall B$_3$ with a line drawn from MP$_B$, locating point 5 in the perspective.

17d. Through point 5 draw a line from VP$_A$. This line represents wall A$_3$.

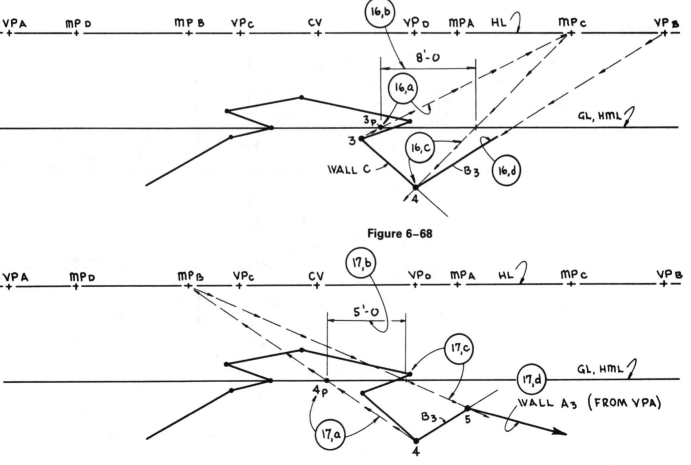

Figure 6–68

Figure 6–69

Statement 10. You have now completed the perspective plan of the walls which will be visible in the finished perspective. After reading this discussion, you can see the repetitive nature of the basic steps which must be taken when laying out the perspective plan of an interior space. The key to this process is that you use the appropriate measuring point and vanishing point when drawing each wall. The floor plan you have just drawn is somewhat different, but the basic procedure used to draw each wall is universal in nature. You would use this same basic procedure to draw any complicated space.

Statement 11. Let's now use the THL and the VPs to actually draw the walls.

Step 18. See Fig. 6–70.

18a. Draw verticals through points 1, 2, 3, 4, 5, 9, 10, and 11.

18b. The vertical drawn through point 10 is a THL because it is in the picture plane. Starting at the GL, make an 8′-0 measurement on this THL, locating point 10c. This measurement reflects an 8′-0 ceiling height.

18c. Project this 8′-0 measurement to the vertical drawn above point 11 with a line drawn to VP_A, locating point 11c.

18d. Through point 11c draw a line to VP_B, locating point 1c on the vertical drawn above point 1.

18e. Through point 10c draw a line from VP_B, locating point 9c on the vertical drawn above point 9.

18f. Through point 9c draw a line from VP_D.

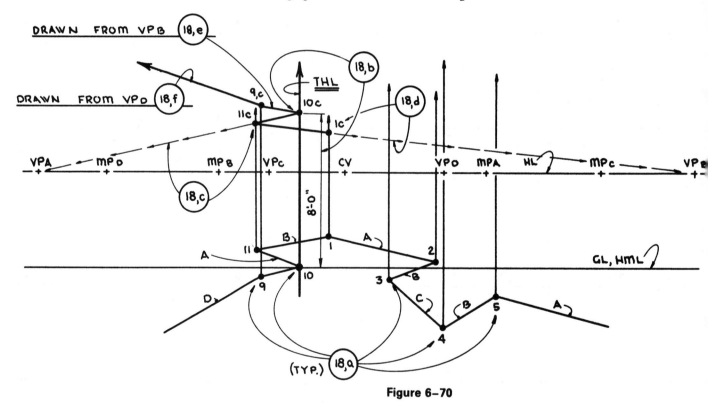

Figure 6–70

Step 19. See Fig. 6–71.

19a. Through point 1c draw a line from VP_A, locating point 2c on the vertical drawn above point 2.

19b. Through point 2c draw a line from VP_B, locating point 3c on the vertical drawn above point 3.

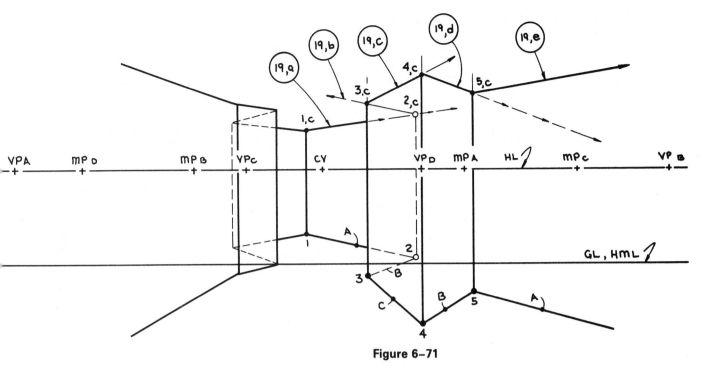

Figure 6-71

19c. Through point 3c draw a line from VP$_C$, locating point 4c on the vertical drawn above point 4.

19d. Through point 4c draw a line from VP$_B$, locating point 5c on the vertical drawn above point 5.

19e. Through point 5c draw a line from VP$_A$.

Statement 12. This completes the perspective drawing of the given interior space. See Fig. 6–72. The extreme right and left walls were not completed because they extend outside the original 60° cone of vision. (Refer to Fig. 6–52 on page 151). If you want to see more of these two walls, you would have to move the SP outside the space. By having the SP inside the space, the view of the room is more realistic.

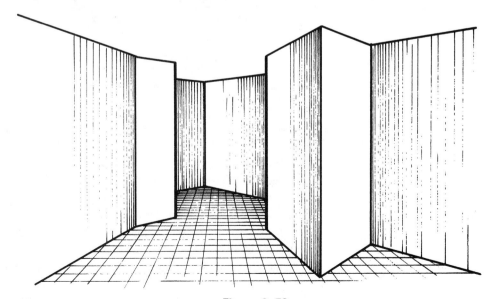

Figure 6-72

6.7 DRAWING A TYPICAL CATHEDRAL CEILING

It is impractical to try to cover all the possible situations which might occur when drawing an interior perspective. However, a situation that should be discussed is one in which you are required to draw features above the original 8'-0 ceiling height. Two situations will be covered in this section. In one case, the ceiling beams will be parallel to the walls which are receding to the distant vanishing point. In other words, the beams will be somewhat perpendicular to your line of sight. In the second case, the ceiling beams will be parallel to the walls which are receding to the close vanishing point. Therefore, the beams will be more parallel to your line of sight.

The important point to remember in both cases is that you must first draw the outline of the beams and of the ceiling ridge line on the floor before you can draw them on the ceiling. Focusing on this concept, let's look at these two cases.

For the first example, use the 14'-0 by 16'-0 space illustrated in Fig. 6–73. A 60° cone of vision has been used to locate the observer (SP) just outside the space. The ceiling ridge line and beams are also indicated in Fig. 6–73.
Note: The walls which are visible in the perspective have already been drawn in the following illustrations.

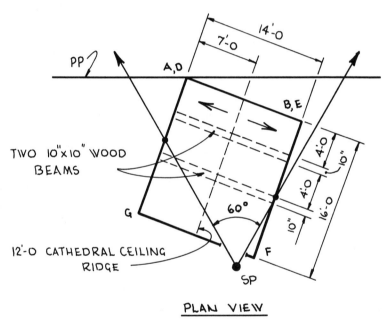

PLAN VIEW

Figure 6–73

Step 1. See Fig. 6–74.

1a. First, you need to draw the ceiling ridge line on the floor. Taking dimensions from the plan view in Fig. 6–73, measure 7'-0 to the right of point D on the HML.

1b. Project this measurement to LBL DE with a line drawn from the LMP, locating point 1.

1c. Draw the ridge line through point 1 from the RVP.

1d. To locate the ceiling beams along the left wall, line DG, measure to the left of point D 4'-0, 0-10", 4'-0, and 0-10".

1e. Project these measurements to RBL DG with lines drawn from the RMP, locating points 2, 3, 4, and 5.

1f. Through these points draw four lines from the LVP. These lines form the outlines of the beams on the floor.

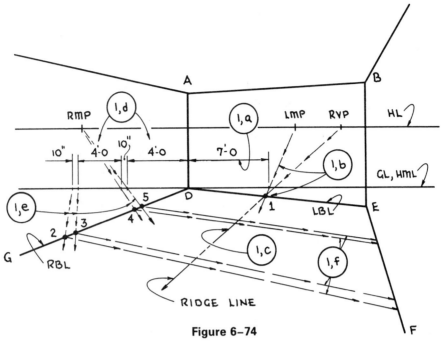

Figure 6–74

Step 2. See Fig. 6–75.

2a. Vertical line AD is a THL because it is in the PP. You want to use this THL to locate the 12'-0 high ceiling ridge line. Make a 12'-0 measurement above point D.

2b. Transfer this measurement to the vertical line drawn above point 1 with a line drawn from the LVP, locating point C.

2c. Through point C draw the ceiling ridge line from the RVP.

2d. To complete the cathedral ceiling draw lines AC and CB.

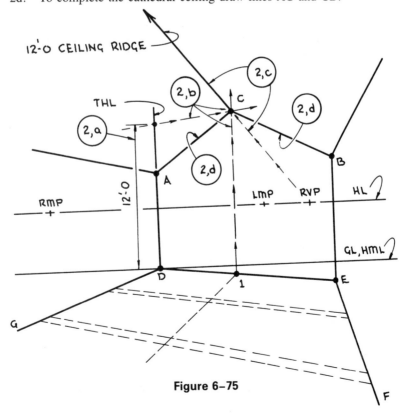

Figure 6–75

Step 3. See Fig. 6–76.

3a. Now you want to draw the 10″ square ceiling beams. Measure down 10″ from the 12′-0 mark on the THL.

3b. Project this 10″ measurement from the THL to the vertical drawn above point 1 with a line from the LVP. This will locate point H.

3c. Through point H draw a light construction line from the RVP.

3d. On the THL measure down 10″ from point A.

3e. Project this measurement along the left wall with a line from the RVP.

3f. Also project this same 10″ measurement along the back and right walls with lines from the left and right vanishing points.

3g. Project the ends of the beams up both the left and right walls. These vertical lines will intersect with the 10″ measurement projected around the top of the 8′-0 walls to form the four 10″ square shaded areas. When drawn, the ceiling beams will attach to the walls at these locations.

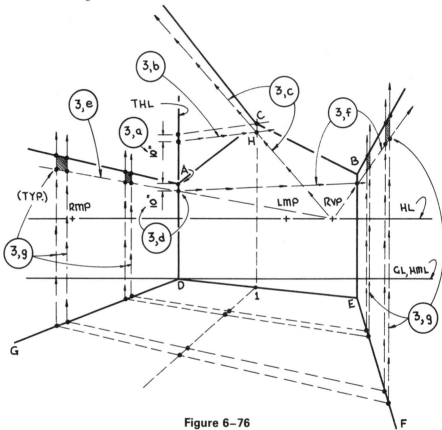

Figure 6–76

Step 4. See Fig. 6–77.

4a. Project vertically the intersection between the plan view of the ridge line and the plan view of the beams to the actual ceiling ridge. These four lines will intersect with the two lines coming from the RVP to form the two 10″ square shaded areas.

4b. Using the six shaded areas as a guide, draw the ceiling beams.

Statement 1. The key to drawing this beamed cathedral ceiling was that you drew features on the floor first, and then you projected them to the ceiling. Fig. 6–78 shows the completed perspective.

The second case involves the same space, but this time the ceiling beams are parallel with the side walls. Consequently, the cathedral ceiling ridge line is parallel with

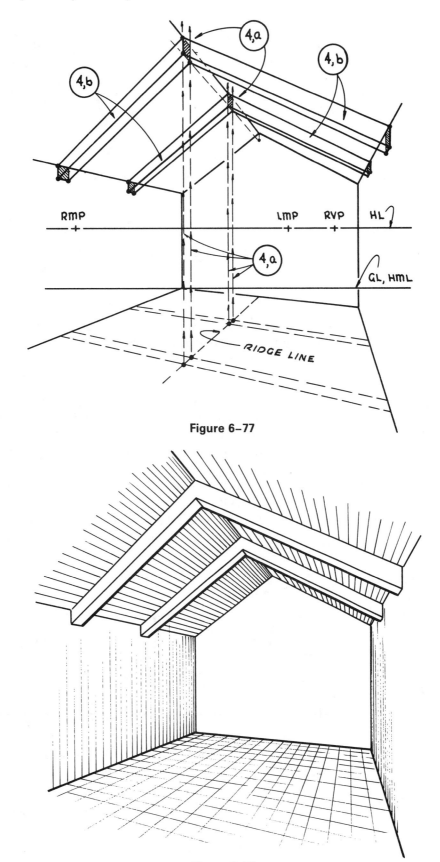

Figure 6-77

Figure 6-78

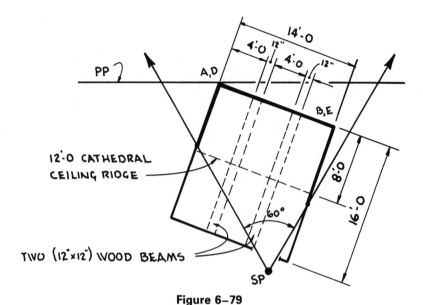

Figure 6–79

the back and front walls. See Fig. 6–79. The observer (SP) and PP are in the same location as in the previous example. As before, you must draw the beams and ridge line on the floor before you draw them in place.

Step 1. See Fig. 6–80.

1a. First, you want to locate the beams along the back wall, line DE. Taking dimensions from the plan view in Fig. 6–79, make consecutive measurements of 4'-0, 1'-0, 4'-0, and 1'-0 to the right of point D on the HML.

1b. Transfer these measurements to LBL DE with lines from the LMP, locating points 1, 2, 3, and 4.

1c. Through these points draw the outline of the beams with four lines from the RVP.

1d. To locate where the ridge line intersects with the left wall, make an 8'-0 measurement to the left of point D on the HML.

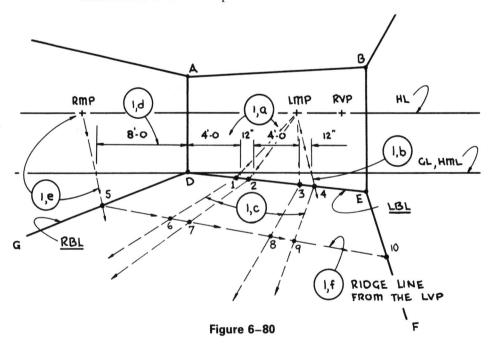

Figure 6–80

1e. Transfer this measurement to RBL DG with a line from the RMP, locating point 5.

1f. Through point 5 draw the ridge line from the LVP.

Step 2. See Fig. 6–81.

2a. Vertical line AD is a THL. You want to use this THL to locate the 12′-0 high ceiling ridge line. Make a measurement of 12′-0 above point D.

2b. Draw vertical lines above points 5 and 10.

2c. Project the 12′-0 measurement made in step 2a. to the vertical above point 5 with a line drawn from the RVP, locating point C.

2d. Through point C draw the ceiling ridge line from the LVP, locating point K.

2e. Draw lines AC and BK.

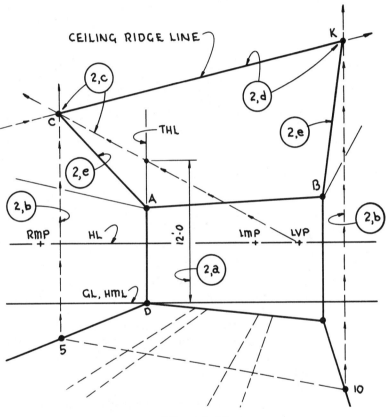

Figure 6–81

Step 3. See Fig. 6–82.

3a. Now you want to draw the 12″ square ceiling beams. Measure down 12″ from the 12′-0 mark on the THL.

3b. Project this 12″ measurement forward along the left wall with a line drawn from the RVP, locating point I.

3c. To locate where ceiling beams intersect with the back wall, measure down 12″ from point A on the THL.

3d. Project this 12″ measurement along the back wall with a line drawn from the LVP.

3e. Project points 1, 2, 3, and 4 up the back wall until they intersect with the 12″ measurement projected from the THL. The shaded 12″ square areas created by this action will be the areas of intersection between the ceiling beams and the back wall.

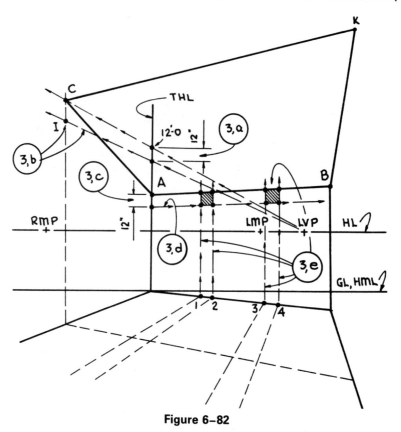

Figure 6–82

Step 4. See Fig. 6–83.

4a. Through point I draw a light construction line from the LVP.

4b. Project points 6, 7, 8, and 9 vertically to form the two 12″ square shaded areas.

Step 5. See Fig. 6–84.

5a. Draw the back portion of the two ceiling beams.

Statement 2. The next step in this process is to complete the drawing of the two ceiling beams. Unfortunately, the other wall which is supporting the front half of these ceiling beams is not visible in the perspective. The front wall is too close to the observer to be seen. Consequently, you cannot locate where these beams intersect with the front wall.

In order to complete this drawing, you must have some knowledge of vertical horizon lines. A short discussion concerning how to find vanishing points on vertical horizon lines will be given. If you need a more complete discussion on this subject, refer to section 4.2 on page 68.

Let's begin this discussion with three statements.

1. Every plane in space has its own horizon line. Horizontal planes will have horizontal HLs, inclined planes will have inclined HLs, and vertical planes will have vertical HLs.

2. Most lines which are contained within a given plane will vanish to vanishing points on that plane's horizon line. Lines which are parallel to the horizon line will not vanish to it, but the rest of the lines will.

3. Parallel lines in space will vanish to the same vanishing point.

If you want to find the vanishing point for an inclined line in a vertical plane, you would have to extend the inclined line until it intersects with the vertical plane's horizon line. This is the procedure you must follow in order to draw the front part of the ceiling beams.

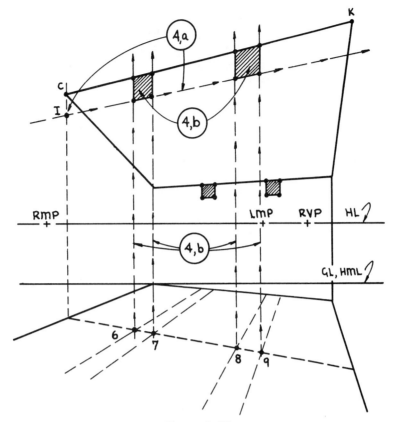

Figure 6–83

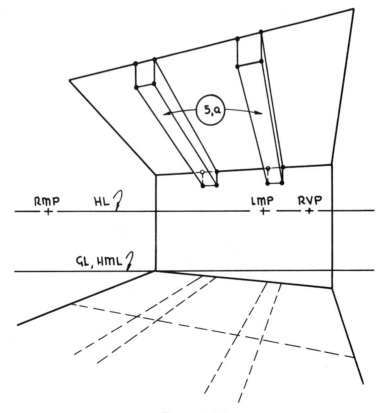

Figure 6–84

Inclined line AC is in a vertical plane and it is also parallel to the ceiling beams which have already been drawn. See Fig. 6–85. If you should want to find the vanishing point for line AC or any line parallel to it, you would first have to locate the vertical horizon line for plane A.

Theoretically, once you find one point on a nonexistent vertical line, you can draw the vertical line. In this case you want to find one vanishing point on a vertical horizon line. Extend the line of intersection, GD, between vertical plane A and the ground plane until it intersects with the original horizon line. See Fig. 6–85. This locates one vanishing point on the vertical horizon line. Now draw in the vertical horizon line for plane A through the RVP. Extend line AC until it intersects with the vertical horizon line. This point is the vanishing point for line AC or any other line parallel to it. If you were to extend the drawn ceiling beams, they would vanish to this same vanishing point. See Fig. 6–85.

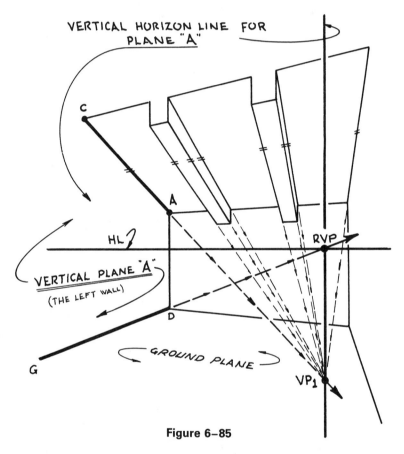

Figure 6–85

As the ceiling reaches its highest point at point C, it turns and slopes down to the 8′-0 ceiling height at point J. See Fig. 6–86. This is a side view showing wall A. If you could find the vanishing point for line JC, you would locate the vanishing point for the front part of the ceiling beams as well. Line JC is in vertical plane A; therefore, it will vanish to the vertical HL for plane A. Unfortunately, you cannot locate point J because it is inaccessible; however, you can draw line GH parallel to line JC and find its vanishing point. See Fig. 6–86. Once you have found this vanishing point, you can use it to draw the front half of the ceiling beams.

Step 6. See Fig. 6–87.

6a. Locate point H 4′-0 above point A on the THL.

6b. Project point A forward to vertical C5 with a line drawn from the RVP, locating point G.

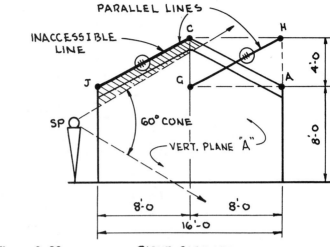

Figure 6–86 RIGHT SIDE VIEW

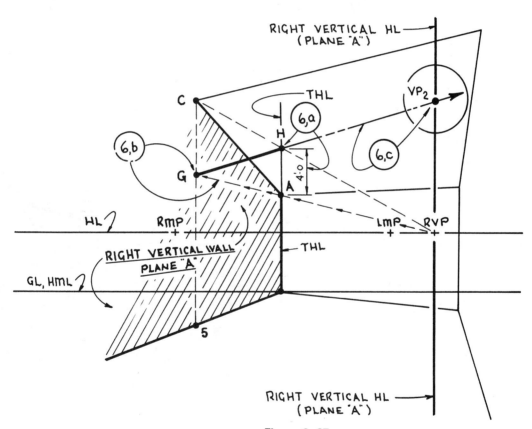

Figure 6–87

6c. Draw line GH and extend it until it intersects with the vertical horizon line for plane A at VP$_2$. This will be the vanishing point for the inclined lines which form the front half of the ceiling beams.

Step 7. See Fig. 6–88.

7a. Using VP$_2$ draw the front half of the ceiling beams and complete the right wall.

Statement 3. This is only one example of a practical application of the theory behind intersecting planes in space and their accompanying horizon lines. The com-

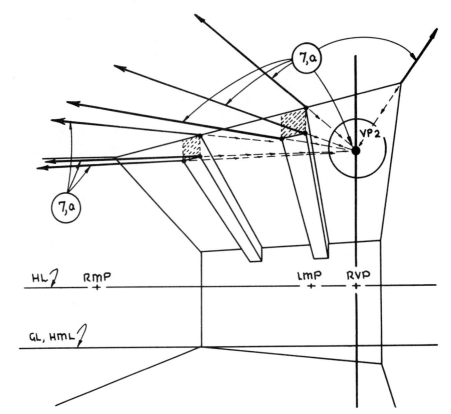

Figure 6–88

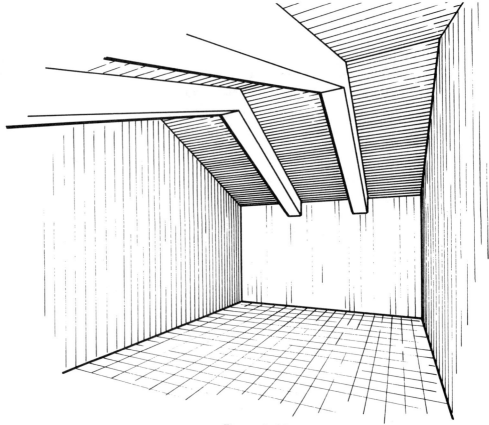

Figure 6–89

pleted perspective in Fig. 6–89 was made possible by using a vanishing point on a vertical horizon line. Without this vanishing point the perspective could not have been completed.

Summary Statement

The material presented in this chapter ranged from the very basic to the more complex. Drawing the walls and interior objects using the measuring points to make width and depth measurements requires basic knowledge of the perspective plan method. Projecting height measurements into the space using true height lines is a very basic perspective drawing skill. Being able to project width and depth measurements directly to auxiliary base lines allows the student to draw more efficiently. Material was also presented dealing with the following situations: drawing a perspective having an inaccessible vanishing point, drawing a perspective requiring more than two vanishing points, and drawing a perspective having the dominant features above the ceiling line. Whether basic or complex, all these techniques are an important part of perspective drawing.

7

Drawing the Perspective by the Grid Method

7.1 DRAWING THE GRID LINES BY USING THE MEASURING POINTS

Statement 1. For the person who can draw perspectives by the perspective plan method, drawing a grid after the walls have been drawn is a waste of time. Width and depth measurements can be made directly by using the measuring points. Consequently, the grid lines are not necessary. However, for the person who has a limited knowledge of the perspective plan method, the grid system works well. Many of the projection techniques used in the perspective plan method are also used with the grid method. Persons who have difficulty with the first method sometimes have difficulty with the grids as well. There is much visualization required with both methods.

Statement 2. The room and setup in Fig. 6–9 on page 126 will be used in the following discussion. The three walls have already been drawn and you are ready to develop the grid lines.

Step 1. See Fig. 7–1.

 1a. The grid lines can be in 1′ or 2′ increments. In this example 2′ increments will be used. Mark off 2′-0 measurements on the HML to the right and left of point A.

 1b. Transfer the 2′-0 measurements to the right of point A to line AF with lines drawn from the LMP.

 1c. Transfer the 2′-0 measurements to the left of point A to line BA with lines drawn from the RMP.

Step 2. See Fig. 7–2.

2a. At these points of intersection on lines BA and AF, draw vertical grid lines.

2b. Through these same points of intersection on lines BA and AF, draw floor grid lines from the left and right vanishing points.

2c. At the points of intersection between the lines drawn from the RVP and line BG, draw more vertical grid lines.

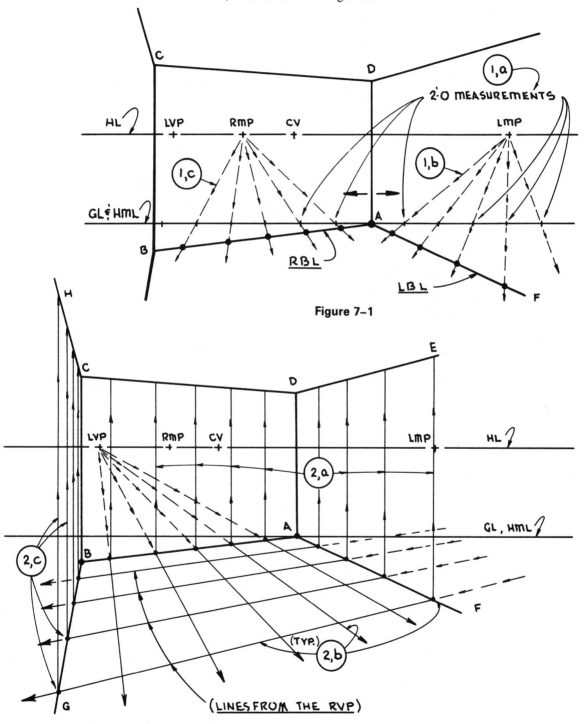

Figure 7–1

Figure 7–2

Step 3. See Fig. 7–3.

3a. Starting at point A on THL AD, mark off 2′ increments.

3b. Through these measurements draw grid lines from the right and left vanishing points.

3c. At the points of intersection between the grid lines from the RVP and vertical line BC, draw grid lines from the LVP.

Statement 3. This completes the grid pattern for this space. Now you need to draw the interior objects by using these grid lines as guides. You will plot points on the floor for the width and depth measurements and project from the walls for the height measurements. All these measurements will come from the floor plan and elevations of the room. Refer to Fig. 6–9 on page 126. You might find it helpful to grid off these multi-view drawings to match the perspective grid. It is still a good idea to draw the outline of the objects on the floor before you deal with the height measurements.

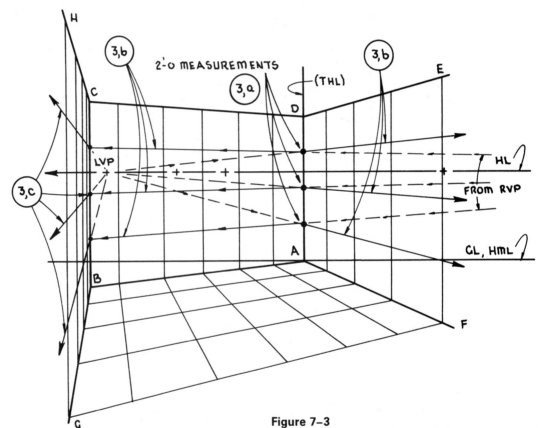

Figure 7–3

Statement 4. Not all this grid space will be usable. Only the space which is included inside the nondistorted 60° cone of vision is considered to be totally usable space. Objects drawn outside this cone will probably appear distorted. The area to the right of, to the left of, behind, below, and above the actual grid is usable space. See Fig. 7–4. A discussion concerning expansion into these areas will be presented in sections 7.5 and 7.7.

You can draw the cone of vision on the perspective grid by placing the point of a compass on the CV and scribing an arc the radius of which is one-half the original picture width. See Fig. 7–4.

Statement 5. Instead of discussing the step-by-step procedure for drawing the interior objects in the room, let's discuss the more general techniques used when drawing with grids. Some of these techniques are used when you

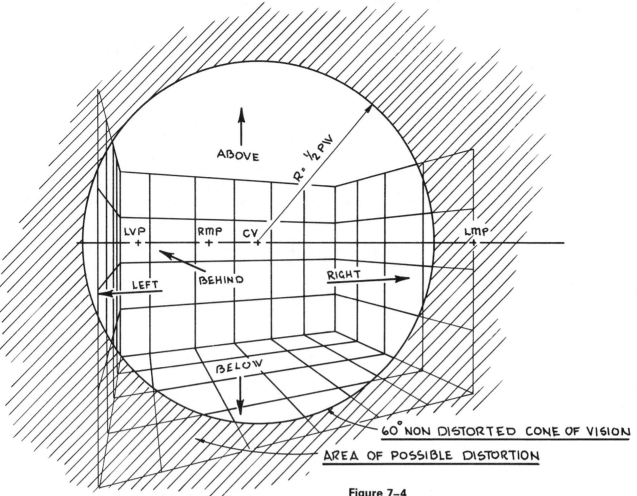

Figure 7-4

1. Project height measurements into the grid space
2. Subdivide a grid square
3. Draw a circle in perspective
4. Expand the grid using the measuring points and true height lines
5. Expand the grid using only diagonals

7.2 PROJECTING HEIGHT MEASUREMENTS INTO THE GRID SPACE

Statement 1. Using the same grid space, let's locate two vertical lines within the space. See Fig. 7–5 for the heights and locations of these two vertical lines.

Figure 7-5

PLAN VIEW

Step 1. See Fig. 7–6.

1a. Locate verticals 1 and 2 on the grid floor. You do this by plotting the two points using the grid coordinates.

1b. Draw a line from point 1 to one of the vertical grid walls and extend that line until it intersects the HL at a convenient point (point 1_{HL}).

1c. Where this line intersects the wall (point 1_w), make the 6′-0 vertical measurement (the height of line one). You want to count the grid lines and plot this point. You cannot use your architectural scale to make this measurement because the wall is not in the PP. You have taken the time to grid the walls, so now you want to use these grid lines to estimate height measurements.

1d. Draw a line from point 1_{HL} through the 6′-0 measurement on the grid wall and extend it into the grid space until it intersects with vertical 1. Vertical 1 is now drawn 6′-0 high in perspective. This is the same way you would find the vertical height for chairs, tables, lamps, persons, stairs, balconies, windows, and so on.

Figure 7–6

Statement 2. This procedure has a definite pattern. You locate where the vertical is to be drawn by putting an *x* on the grid floor. You can do this mentally. Draw a line from this *x* to a random point on the HL. Where this projection line pierces the wall at the floor line, make the vertical measurement by counting the grid lines. Estimate the spacing between the grid lines, if necessary. Draw a line from the same random point on the HL through the vertical measurement and project it to the vertical drawn above the *x*. This vertical is now drawn the prescribed height in perspective.

Try to draw vertical 2.

Step 2. See Fig. 7–7.

2a. Draw a line from point 2 on the grid floor to a random point on the HL.

2b. Where this projection line pierces the wall at the floor line, make the vertical measurement of 7′-0 (the height of line 2) by counting the grid lines and estimating.

2c. Draw a line from the same random point on the HL through the vertical measurement and project it to the vertical above point 2. This vertical is now drawn 7′-0 high in perspective.

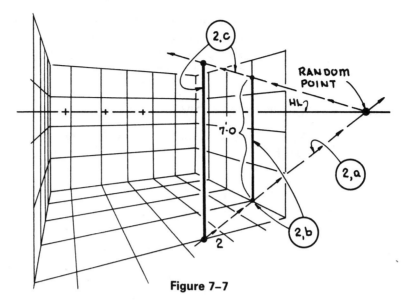

Figure 7–7

Statement 3. It is critical that you understand this projection technique. All heights in the grid space will be found using this method.

7.3 SUBDIVIDING A GRID SQUARE BY USING DIAGONALS

Take, for an example, just one 2'-0 grid square from the grid with which you have been working. (It has been enlarged in Fig. 7–8.) You need to break down this 2'-0 square into smaller units to obtain 6" measurements on line 1,4. See Fig. 7–8.

Step 1. See Fig. 7–8.

1a. Draw the diagonals of the enlarged square, locating perspective center point 0.

1b. Draw a horizontal and vertical line through point 0. Remember that the horizontal line is drawn from the LVP in this case. These lines will divide the 2'-0 square into four 1'-0 squares.

1c. Draw diagonals 8,5 and 6,5, locating points 9 and 10.

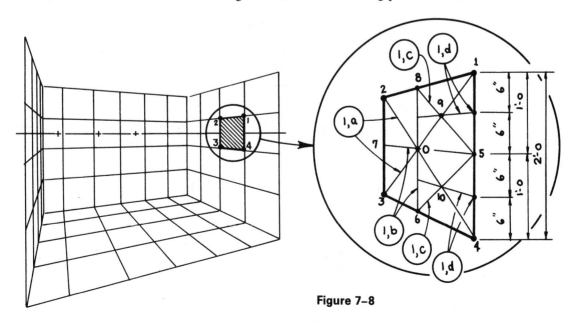

Figure 7–8

1d. Draw two horizontal lines from the LVP through these two points, thus dividing line 1,4 into 6″ divisions. This was accomplished without making any measurements. This procedure can be used on any size of rectangular shape drawn in perspective.

7.4 DRAWING A CIRCLE IN PERSPECTIVE

Use the same grid shown in Fig. 7–8. This time, however, you want to draw a circle on the right wall. The following technique will work for circular tables, round hot tubs, circular mirrors, round area rugs, and so on. It will work for both horizontal and vertical surfaces.

Step 1. See Fig. 7–9.

1a. Draw diagonals 4,2 and 1,3, locating point 0.

1b. Draw quarter lines 8,6 and 5,7 through point 0.

1c. Draw four more diagonals — 8,5; 5,6; 6,7; and 7,8.

1d. Draw quarter lines 14,17; 16,19; 18,13; and 20,15 through points 10, 11, 12, and 9. You have now divided the original square into 16 smaller squares.

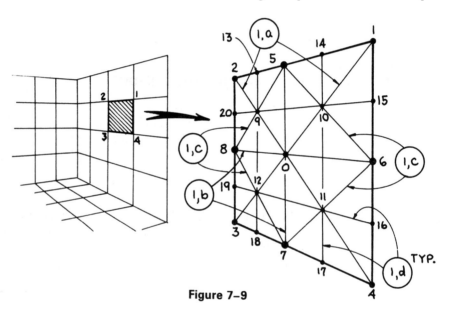

Figure 7–9

Statement 1. You already have four points on the perspective circle located — 5, 6, 7, and 8. However, you need more points on the circle to sketch it more accurately. You can locate eight more points on the circle by drawing eight more lines.

Step 2. See Fig. 7–10.

2a. You now want to think in terms of these four long overlapping rectangles:

1,2,20,15;
1,4,17,14;
4,3,19,16; and
3,2,13,18.

2b. Draw diagonals
1,20 and 2,15;
1,17 and 4,14;
4,19 and 3,16;
3,13 and 2,18.

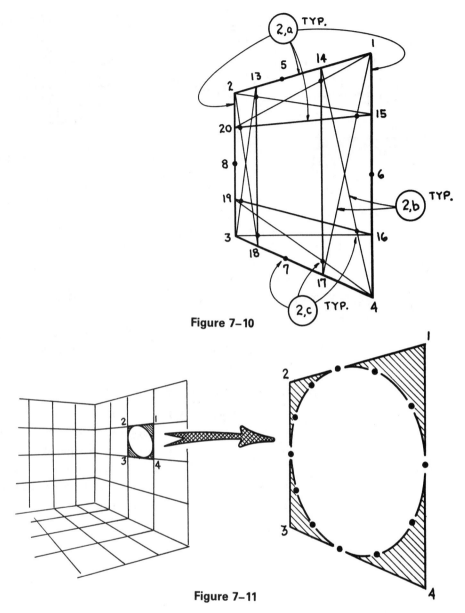

Figure 7–10

Figure 7–11

2c. Where these diagonals cross lines 14,17; 16,19; 13,18; and 20,15 will locate eight more points on the circle. These intersections are indicated by black dots.

Step 3. See Fig. 7–11.

3a. Using these twelve points as a guide, draw the perspective circle.

Statement 2. This technique may seem complicated, but it really isn't; in fact, it could all be done freehand. After you practice a few times, you will see how easy it is.

7.5 EXPANDING THE GRID BY USING THE MEASURING POINTS

Statement 1. As was stated earlier, all the space inside the 60° cone of vision is usable. There is the prime area inside the grid space, but there is also usable space outside the grid. See Fig. 7–12.

In order to use this bonus space, you need to expand the original grid to include this space. You can expand the grid by using the measuring points and true height lines.

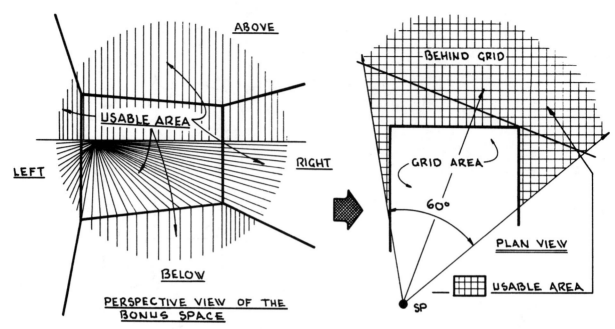

Figure 7–12

The following discussion will outline the procedure used in expanding the original grid vertically, backwards, and sideways.

Expanding the Grid Vertically

Step 1. See Figs. 7–13 through 7–16.

Note: Some of the grid lines have been omitted for clarity.

1a. You want to expand the grid vertically, above and below the original grid. First, extend the THL AD (Fig. 7–13).

1b. Make 2'-0 measurements above and below line AD (Fig. 7–13).

1c. Extend the verticals on all three walls (Fig. 7–14).

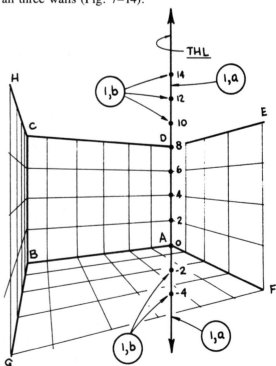

Figure 7–13

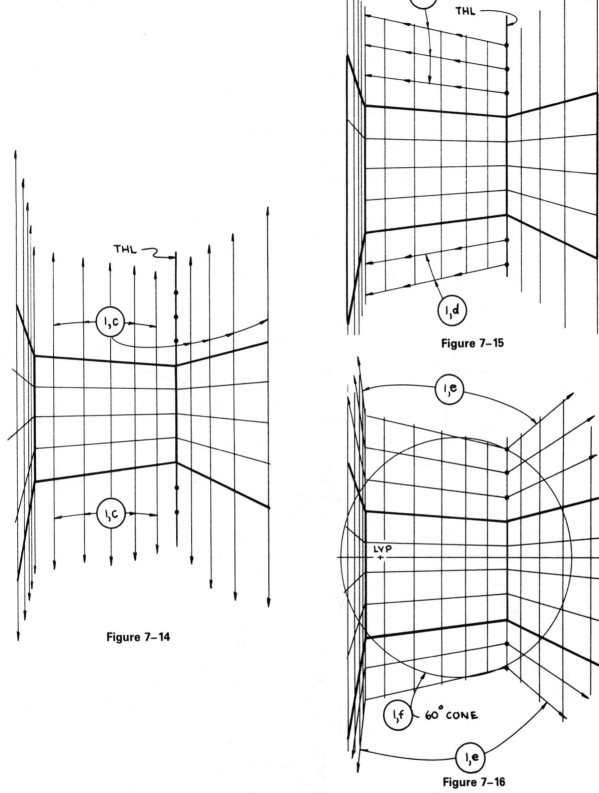

Figure 7–14

Figure 7–15

Figure 7–16

1d. Draw lines from the RVP through the 2'-0 measurements on the THL (Fig. 7–15).

1e. Finish the expanded grid by drawing the rest of the horizontal grid lines from the LVP (Fig. 7–16).

1f. Check the 60° cone of vision to see how much of this new grid area is usable (Fig. 7–16).

185

Expanding the Grid Backwards

Step 1. See Figs. 7–17 and 7–18.

Note: Some grid lines have been omitted for clarity.

 1a. You want to add a 12'-0 × 11'-4" room behind the existing grid (Fig. 7–17).

 1b. To begin, extend the left base line (line AF) to the LVP (Fig. 7–18).

 1c. On the HML make a 12'-0 measurement (depth of the new room) to the left of point A (Fig. 7–18).

 1d. Transfer this measurement to the LBL extended with a line drawn to the LMP, locating point I. Point I is located 12'-0 behind point A.

Step 2. See Fig. 7–19.

 2a. Extend lines DE, BG, and CH to the LVP.

 2b. Draw a vertical through point I, locating point L.

 2c. Draw lines from the RVP through points I and L, locating points J and K.

 2d. Complete the back wall of the new room by drawing vertical KJ.

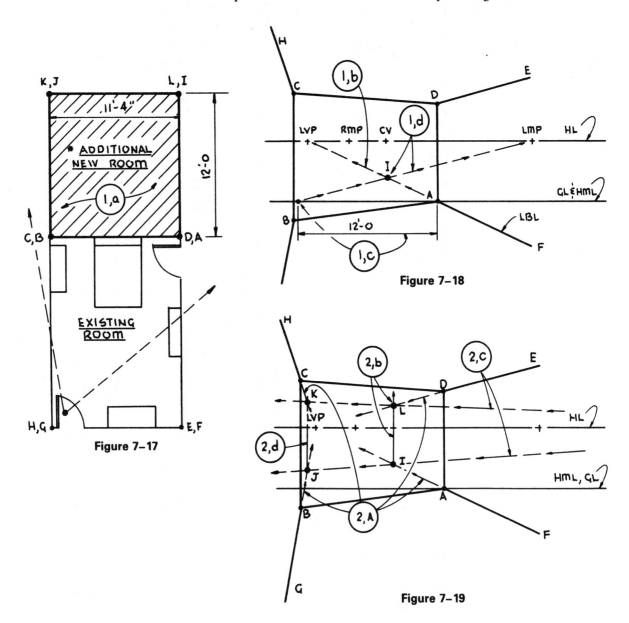

Figure 7–17

Figure 7–18

Figure 7–19

Step 3. See Figs. 7–20 through 7–23.

3a. To extend the grid lines into the new room make 2'-0 measurements to the left of point A on the HML (Fig. 7–20).

3b. Transfer these measurements to the LBL extended with lines to the LMP (Fig. 7–20).

3c. Through these points draw grid lines from the RVP (Fig. 7–21).

3d. Extend the horizontal grid lines from the original grid to the LVP (Fig. 7–22).

3e. Now draw all the missing vertical and horizontal grid lines in the room addition. You have now expanded backwards the original grid by 12'-0 (Fig. 7–23).

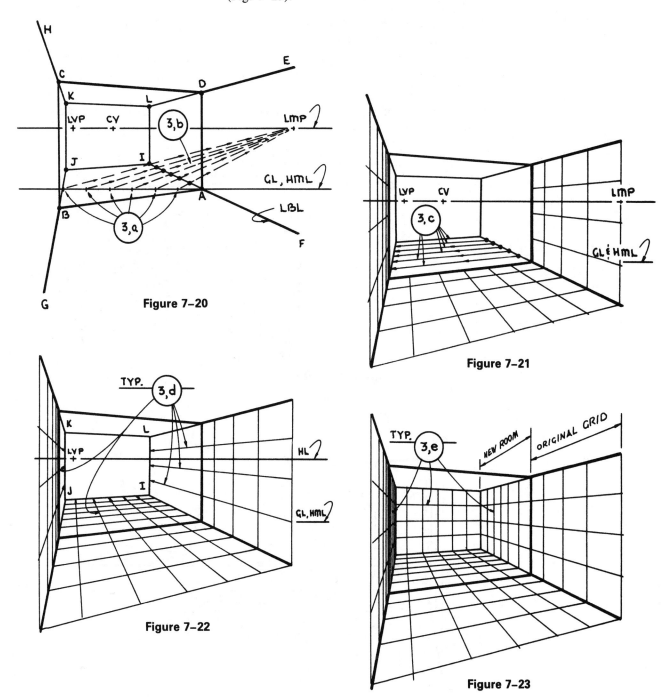

Figure 7–20

Figure 7–21

Figure 7–22

Figure 7–23

Expanding the Grid Sideways

Step 1. See Figs. 7–24 and 7–25.

Note: Some grid lines have been omitted for clarity.

1a. You use the same basic procedure to expand the grid to the right or left. In this case, the original grid will only be expanded to the right (Fig. 7–24).

1b. Extend the RBL (line BA) toward the RVP (Fig. 7–25).

1c. Measure in increments of 2'-0 to the right of point A on the HML (Fig. 7–25).

1d. Transfer these measurements to the RBL extended with lines to the RMP (Fig. 7–25).

Step 2. See Figs. 7–26 and 7–27.

2a. Through these points on the extended RBL draw new grid lines from the LVP (Fig. 7–26).

2b. Draw new vertical grid lines through these same points (Fig. 7–27).

2c. Extend line CD and the other horizontal grid lines from the original grid to the RVP (Fig. 7–27).

Note: Keep in mind the 60° cone of vision. Don't get too far outside this cone with your expansion work (Fig. 7–27).

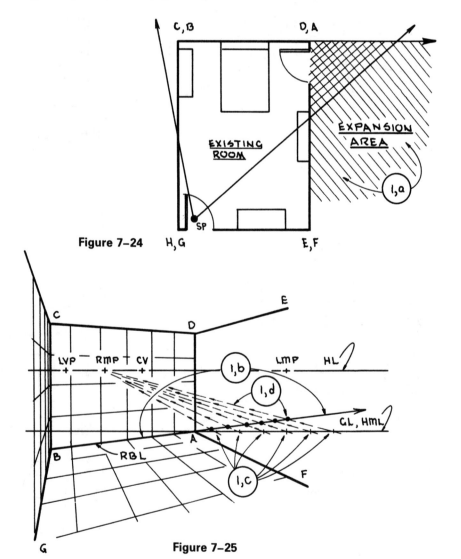

Figure 7–24

Figure 7–25

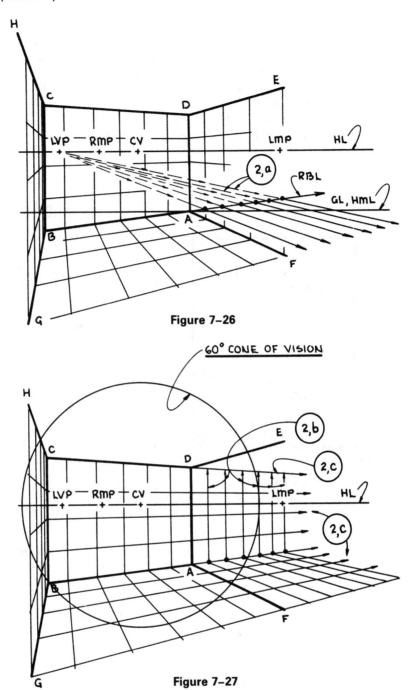

Figure 7-26

Figure 7-27

7.6 DRAWING THE ORIGINAL GRID BY USING ONLY DIAGONALS

The subject presented in this section is based on material developed by Professor Judy Watson, Technical Graphics Department, Purdue University. This material is presented with her permission.

The purpose of this discussion is to explain how to draw the grid by using only one true height line and two diagonals on the vertical walls. This method for drawing the grid does not require the use of measuring points or a working knowledge of the perspective plan method.

The room illustrated in Fig. 7–28 will be used in this discussion. You want to draw a perspective grid which will emphasize the back and left walls of this room. Consequently, the observer (SP) should be located in the shaded area by the entry door.

To begin, you want to design the perspective setup using a small-scale preliminary sketch. The scale in this example is $1'' = 10'$-0. Having done this, you want to choose an appropriate scale for the final perspective. Taking the data from the preliminary sketch, you next lay out the final horizon line at the chosen scale, and then you draw the grid. The following steps will outline this procedure.

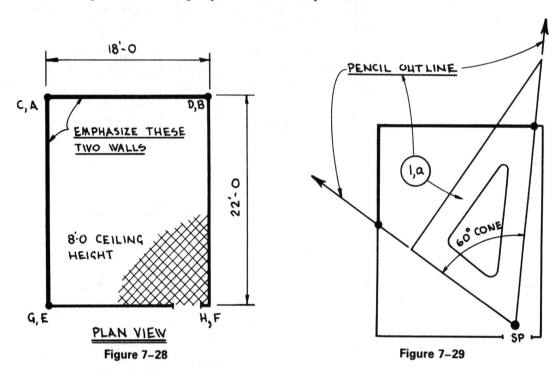

Figure 7–28

Figure 7–29

Step 1. See Fig. 7–29.

1a. Using the 60° angle of your 30°-60° triangle as the nondistorted 60° cone of vision, locate the observer (SP) inside the room beside the entry door. The portion of the walls visible in this perspective has been darkened. In this particular setup the back wall will receive more emphasis than the left wall. Trace around the 60° cone of vision.

Step 2. See Fig. 7–30.

2a. In order to locate the properly aligned PP, turn the 30°-60° triangle over and draw a line through the back corner of the room. This line should form a 60° angle with the legs of the cone of vision. Using the hypotenuse of the 30°-60° triangle as a straight edge, draw the PP.

Step 3. See Fig. 7–31.

3a. To locate the center of vision (CV), turn the 30°-60° triangle over again and draw a line through the SP perpendicular to the PP. The point where this line intersects the PP locates the CV. This line also indicates your direct line of sight.

Note: Now turn your paper so that the preliminary PP, HL forms a horizontal line.

Step 4. See Fig. 7–32.

4a. To find the left and right vanishing points, draw lines from the SP parallel to the walls of the room. Extend these lines until they intersect the preliminary PP, HL, locating the vanishing points.

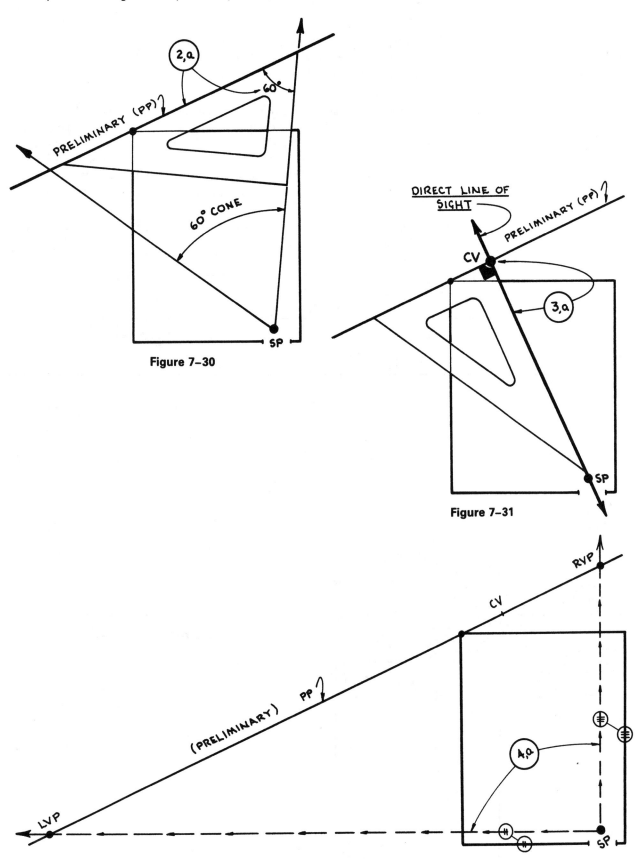

Figure 7–30

Figure 7–31

Figure 7–32

Step 5. See Fig. 7–33.

5a. Using the same scale as the preliminary sketch (1″ = 10′-0), measure the distance from the CV to the left and to the right VPs. Also, measure the distance from the CV to the back corner of the room (Dim. x).

Step 6. See Fig. 7–34.

6a. Using the original 60° cone of vision, determine the picture width (PW) — the actual size or width of the completed perspective. To do this, extend both legs of the original cone of vision until they intersect the preliminary PP, HL, locating points 1 and 2. The distance between these points will be equivalent to the PW drawn at the scale of the preliminary sketch.

6b. Measure the distance between points 1 and 2. In this case, the PW is 29′-8″ at 1″ = 10′-0 scale.

6c. Measure the distance between point 1 and the CV, and point 2 and the CV (dimensions C and D).

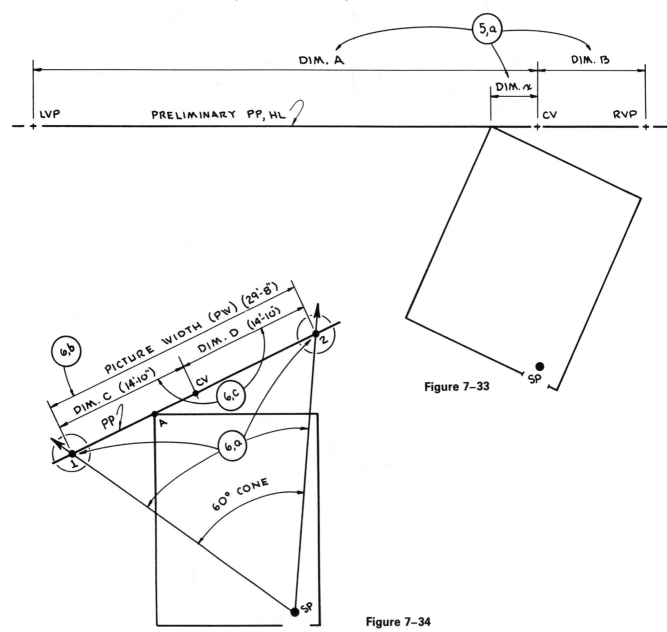

Figure 7–33

Figure 7–34

Statement 1. At this point you have to choose a scale for your perspective. You must choose a scale that will fulfill the size requirements of the perspective. These requirements are based on how the perspective is going to be used—for presentation, for reproduction, and so on.

Use the following formula to choose an appropriate scale for your perspective.

$$\left(\begin{array}{c}\text{Picture width}\\\text{from the}\\\text{preliminary HL}\end{array}\right) \times \left(\begin{array}{c}\text{Proposed}\\\text{perspective}\\\text{scale}\end{array}\right) = \begin{array}{c}\text{Actual perspective}\\\text{width in inches}\end{array}$$

↓		↓		↓
29'-8"	×	3/8" = 1'-0	=	11-1/8" image (full scale)
29'-8"	×	1/2" = 1'-0	=	14-13/16" image (full scale)
29'-8"	×	3/4" = 1'-0	=	22-1/4" image (full scale)
29'-8"	×	1" = 1'-0	=	29-5/8" image (full scale)

Note: You might find these decimal equivalents for the different scales helpful.

1/8 = .125
3/16 = .1875
1/4 = .250
3/8 = .375
1/2 = .500
3/4 = .750

Statement 2. For this example you have chosen the 3/8" = 1'-0 scale, which will give you a finished picture width of 11-1/8".

Step 7. See Fig. 7–35.

7a. Take the measurements from the 1" = 10'-0 scale preliminary PP, HL and lay out a new horizon line (HL) at the chosen 3/8" = 1'-0 scale. Begin laying out the new HL by locating the CV directly in the middle of a new sheet of paper.

Figure 7–35

7b. Locate the GL 5'-0 (to scale) below the HL.

7c. Locate point A on the GL 5'-0 (Dim. x) to the left of the CV. This will be the starting point for the perspective.

Step 8. See Fig. 7–36.

8a. Draw a vertical above point A. Because this vertical is in the PP, it is a THL. Reflecting an 8'-0 ceiling height, make a measurement of 8'-0 above the GL on this THL.

8b. Through the top and bottom of the THL, draw lines from the LVP. These two lines form the back wall.

8c. Also through the top and bottom of the THL, draw lines from the RVP. These two lines form the left wall.

Figure 7–36

Statement 3. You now have the two walls drawn. Next, you want to develop a grid system which will allow you to draw architectural features on the walls as well as objects in the room. In order to develop this grid you must use the THL and a diagonal line on each wall.

To draw these diagonals accurately, you must refer to the original preliminary sketch. See Fig. 7–37. Using the scale of this sketch (1″ = 10'-0), measure the distance from point A to point 3 and the distance from point A to point 4. Points 3 and 4 are located where the legs of the original cone of vision pierce the two walls.

Statement 4. The key to this process is that points 1 and 3 and points 2 and 4 are in direct line with the SP. See Fig. 7–37. In other words, if you were to draw a vertical line in the perspective through point 1, it would also appear to go through point 3. The same is true about points 2 and 4. Using this knowledge and the THL, you can draw the diagonals on the walls.

Step 9. See Fig. 7–38.

9a. Draw a light vertical construction line through point 2. This vertical line is now drawn accurately in perspective 17'-0 (Dim. F) to the right of point A. Point 4 will be located on this vertical line.

9b. To begin to locate point 4, measure the distance of dimension F (17'-0) on the THL. This measurement should begin at the GL.

9c. Using a line drawn from the LVP, project this 17'-0 measurement to the vertical line drawn through point 2. This will locate point 4 17'-0 above and 17'-0 to the right of point A.

9d. Draw a line from point A to point 4. This is a diagonal line (45°) drawn in perspective on the back wall.

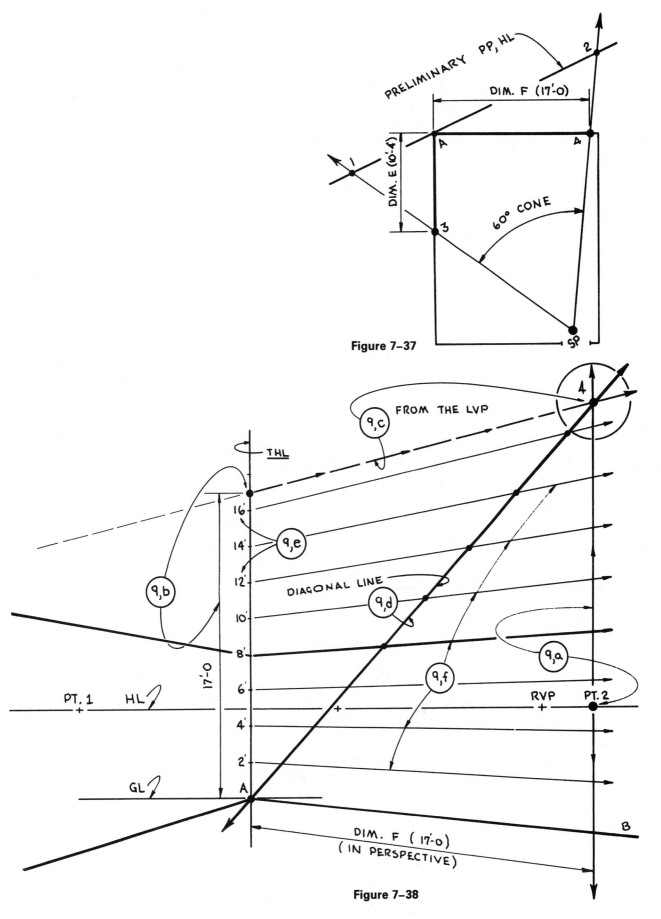

Figure 7–37

Figure 7–38

9e. Because you are going to work with 2'-0 grid lines, make measurements of 2'-0 on the THL starting at the GL. (One-foot grid lines could be used.)

9f. Project these 2'-0 measurements to the diagonal line with lines drawn from the LVP.

Step 10. See Fig. 7–39.

10a. Through these points of intersection on the diagonal line, draw vertical grid lines.

10b. Where these vertical grid lines intersect line AB, draw horizontal grid lines from the RVP.

Statement 5. Follow the same steps to develop a grid on the left wall and finish the grid on the floor.

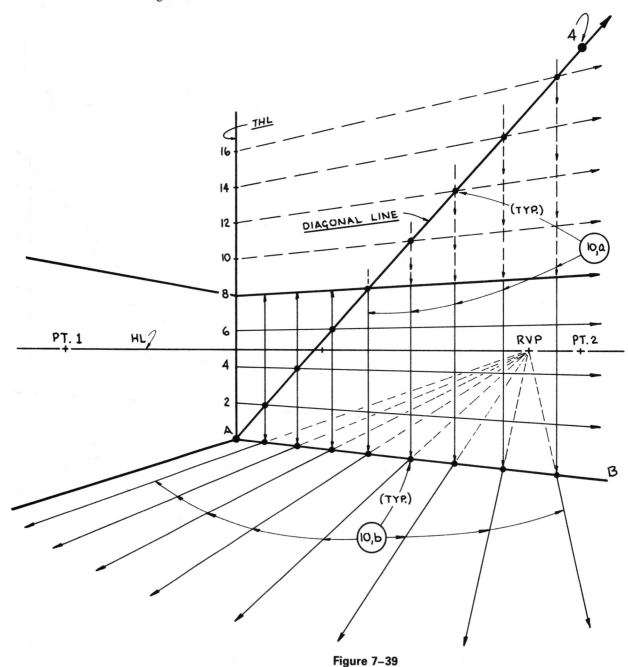

Figure 7–39

Step 11. See Fig. 7–40.

11a. Draw a light vertical construction line through point 1. This vertical line is now drawn accurately in perspective 10'-4" (Dim. E) to the left of point A. Point 3 will be located on this vertical line.

11b. To begin to locate point 3, measure the distance of dimension E (10'-4") on the THL.

11c. Using a line drawn from the RVP, project this 10'-4" measurement to the vertical line drawn through point 1. This will locate point 3 10'-4" above and 10'-4" to the left of point A.

11d. Draw a line from point A to point 3. This is a diagonal line (45°) drawn in perspective on the left wall.

11e. Use the same 2'-0 measurements on the THL which were established in step 9,e.

11f. Project these 2'-0 measurements to the diagonal line with lines drawn from the RVP.

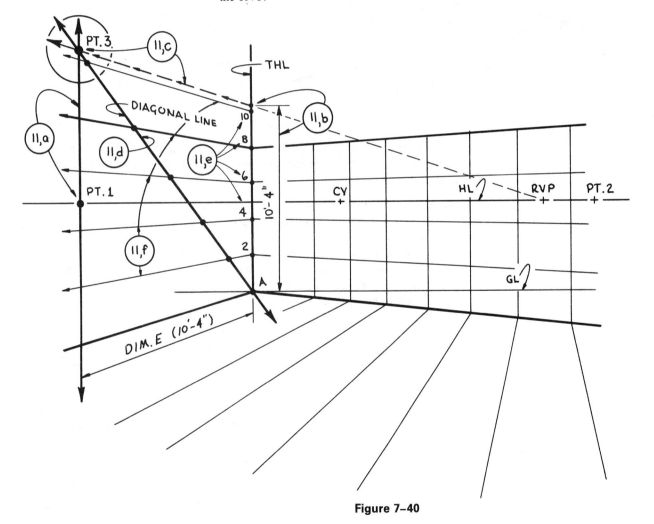

Figure 7–40

Step 12. See Fig. 7–41.

12a. Through these points of intersection on the diagonal line, draw vertical grid lines.

12b. Where these vertical grid lines intersect line AE, draw horizontal grid lines from the LVP.

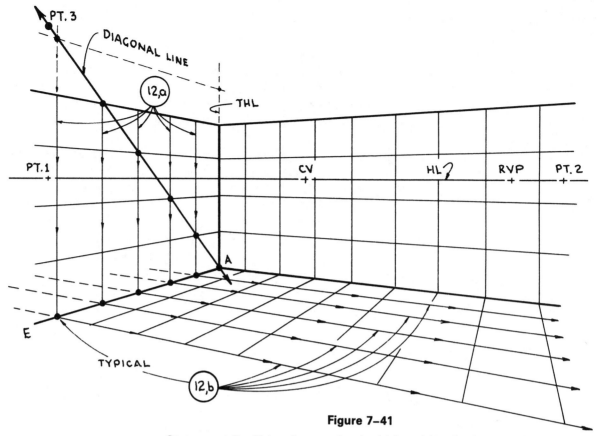

Figure 7–41

Statement 6. Using the completed grid for width, depth, and height measurements, draw any architectural features or objects which are necessary to complete the perspective.

Statement 7. You have just completed a grid showing only two walls. Now let's discuss this same procedure of using diagonal lines on the walls to draw a grid showing three walls.

Because of the similarity between this discussion and the one just completed, only illustrations will be used to outline this procedure. Chronological steps will be identified in each illustration to facilitate this discussion.

This procedure begins with Fig. 7–42 and ends with Fig. 7–56.

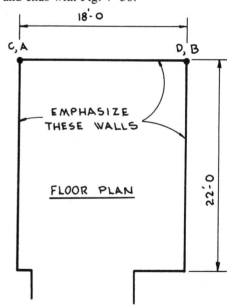

Figure 7–42

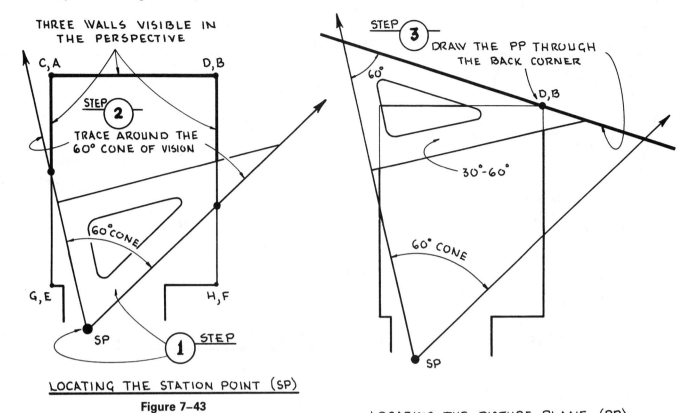

THREE WALLS VISIBLE IN
THE PERSPECTIVE

STEP **2**

TRACE AROUND THE
60° CONE OF VISION

60° CONE

STEP **1**

LOCATING THE STATION POINT (SP)

Figure 7-43

STEP **3** DRAW THE PP THROUGH
THE BACK CORNER

60°

30°-60°

60° CONE

LOCATING THE PICTURE PLANE (PP)

Figure 7-44

STEP **4** LOCATE THE
CENTER OF VISION (CV)

CV

PP

30°-60°

SP

LOCATING THE CENTER OF VISION (CV)

Figure 7-45

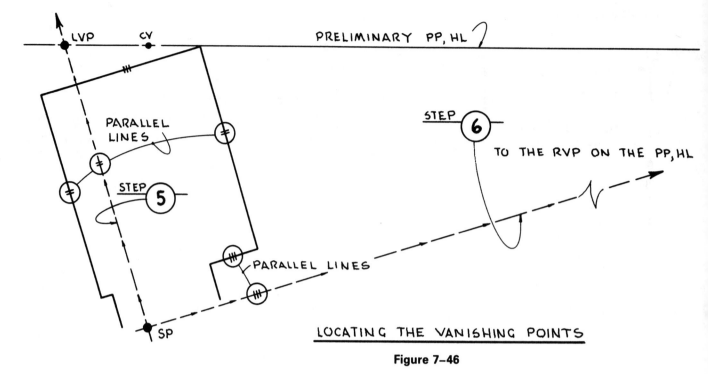

LOCATING THE VANISHING POINTS

Figure 7–46

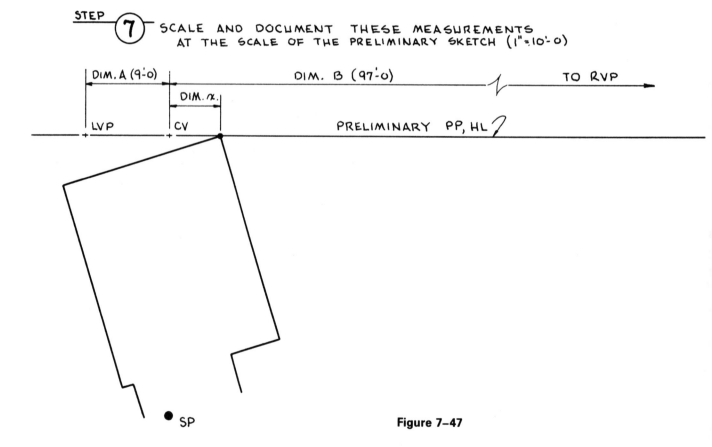

Figure 7–47

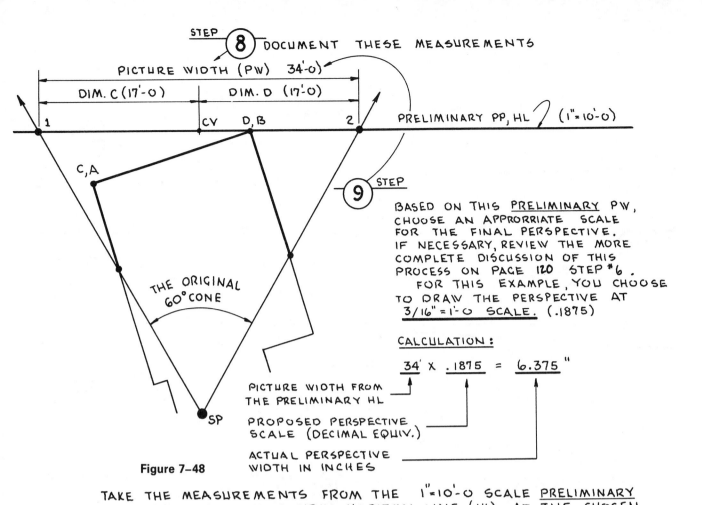

STEP ⑧ DOCUMENT THESE MEASUREMENTS

PICTURE WIDTH (PW) 34'-0)

DIM. C (17'-0) DIM. D (17'-0)

1 CV D,B 2 PRELIMINARY PP, HL (1"=10'-0)

C,A

THE ORIGINAL
60° CONE

SP

STEP ⑨

BASED ON THIS <u>PRELIMINARY</u> PW,
CHOOSE AN APPRORRIATE SCALE
FOR THE FINAL PERSPECTIVE.
IF NECESSARY, REVIEW THE MORE
COMPLETE DISCUSSION OF THIS
PROCESS ON PAGE 120 STEP #6.
 FOR THIS EXAMPLE, YOU CHOOSE
TO DRAW THE PERSPECTIVE AT
<u>3/16"=1'-0 SCALE.</u> (.1875)

<u>CALCULATION:</u>

<u>34'</u> X <u>.1875</u> = <u>6.375"</u>

PICTURE WIDTH FROM
THE PRELIMINARY HL

PROPOSED PERSPECTIVE
SCALE (DECIMAL EQUIV.)

ACTUAL PERSPECTIVE
WIDTH IN INCHES

Figure 7-48

STEP ⑩ TAKE THE MEASUREMENTS FROM THE 1"=10'-0 SCALE <u>PRELIMINARY</u>
PP. HL AND LAY OUT A <u>NEW</u> HORIZON LINE (HL) AT THE CHOSEN
3/16"=1'-0 SCALE. START LAYING OUT THE NEW HL BY LOCATING
THE CV DIRECTLY IN THE MIDDLE OF A NEW SHEET OF PAPER.

DIM. B (TO RVP) (97'-0)

DIM. C (17'-0)

DIM. D (17'-0)

DIM. A (9'-0)

DIM. x (5'-5")

1 LVP CV FINAL HL (3/16"=1'-0) 2

5'-0

B GL

NEW SHEET OF PAPER

STARTING POINT FOR
THE PERSPECTIVE

STEP ⑪ LOCATE THE GROUND LINE (GL)
5'-0 BELOW THE HL (NORMAL EYE LEVEL)

Figure 7-49

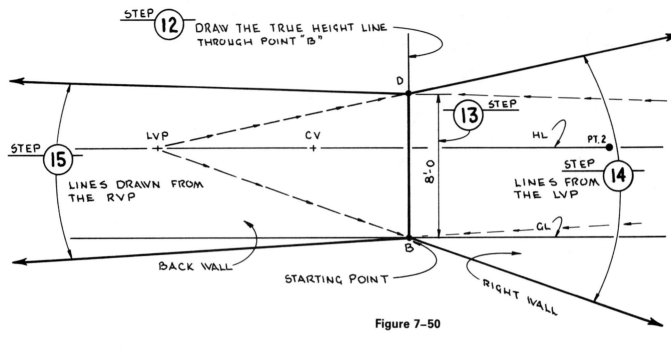

STEP (12) DRAW THE TRUE HEIGHT LINE THROUGH POINT "B"

STEP (13)

STEP (15)
LINES DRAWN FROM THE RVP

STEP (14)
LINES FROM THE LVP

LVP CV HL PT. 2

8'-0

D

GL

BACK WALL

STARTING POINT

B

RIGHT WALL

Figure 7–50

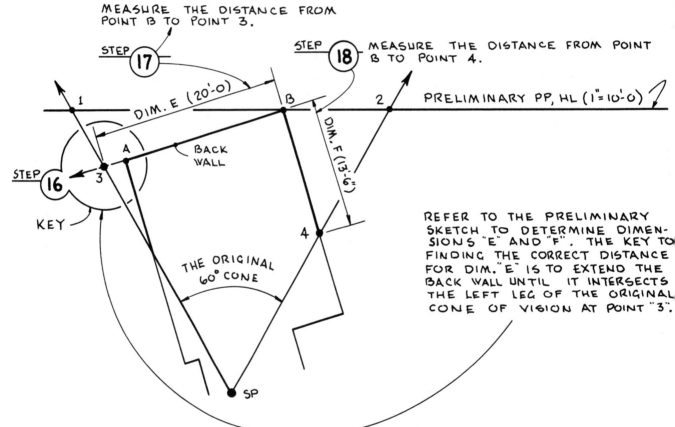

MEASURE THE DISTANCE FROM POINT B TO POINT 3.

STEP (17)

STEP (18) MEASURE THE DISTANCE FROM POINT B TO POINT 4.

1 DIM. E (20'-0) B 2 PRELIMINARY PP, HL (1"=10'-0")

A BACK WALL

STEP (16)

3

DIM. F (13'-6")

KEY

4

THE ORIGINAL 60° CONE

SP

REFER TO THE PRELIMINARY SKETCH TO DETERMINE DIMENSIONS "E" AND "F". THE KEY TO FINDING THE CORRECT DISTANCE FOR DIM. "E" IS TO EXTEND THE BACK WALL UNTIL IT INTERSECTS THE LEFT LEG OF THE ORIGINAL CONE OF VISION AT POINT "3".

Figure 7–51

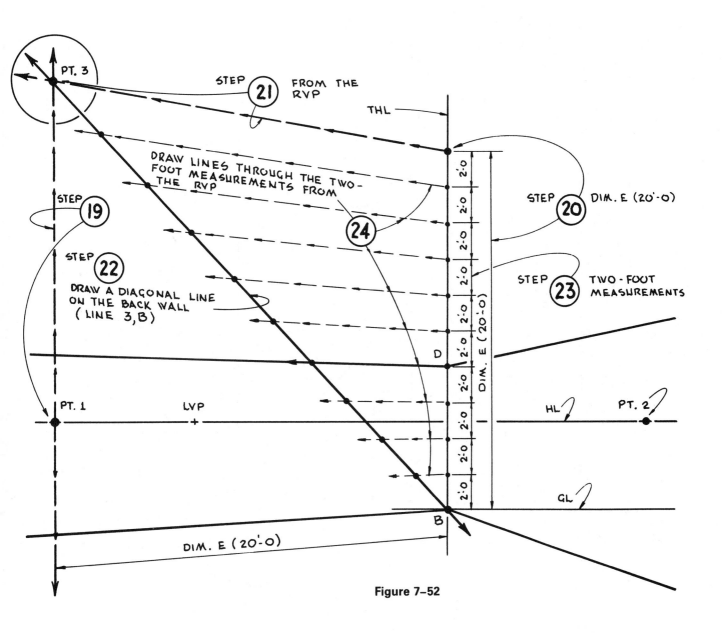

Figure 7–52

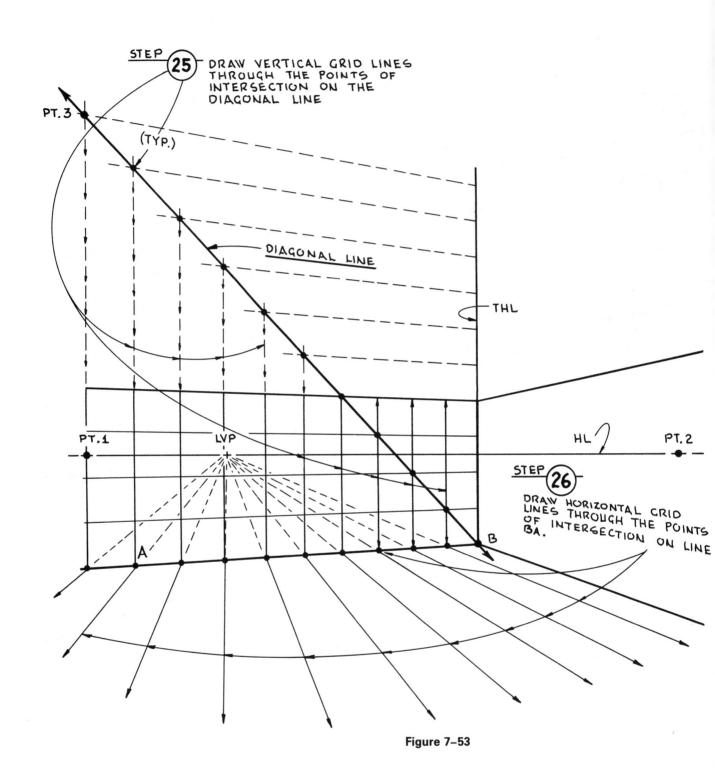

STEP 25 DRAW VERTICAL GRID LINES THROUGH THE POINTS OF INTERSECTION ON THE DIAGONAL LINE

PT. 3

(TYP.)

DIAGONAL LINE

THL

PT. 1 LVP HL PT. 2

STEP 26 DRAW HORIZONTAL GRID LINES THROUGH THE POINTS OF INTERSECTION ON LINE BA.

A B

Figure 7–53

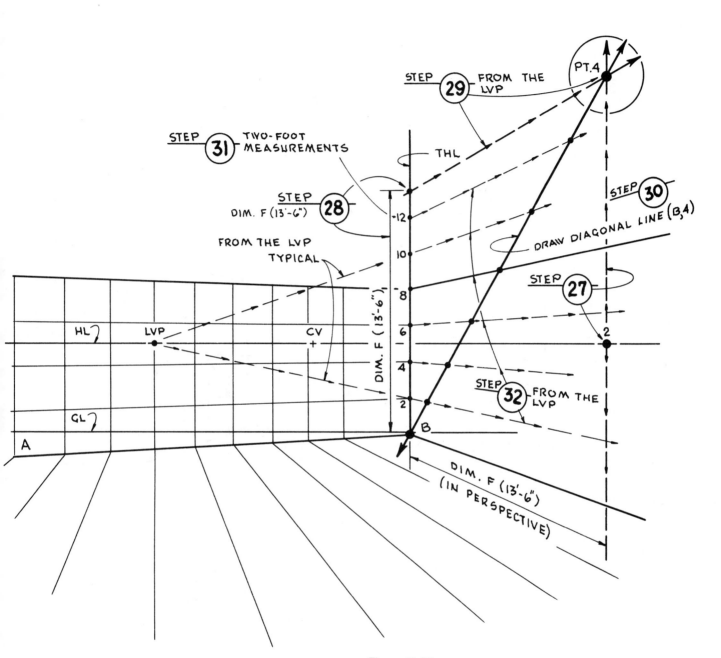

Figure 7–54

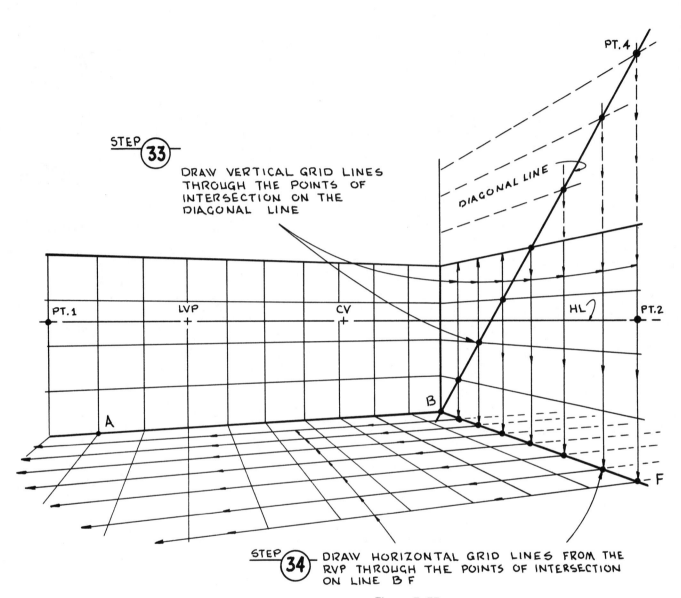

STEP 33 DRAW VERTICAL GRID LINES THROUGH THE POINTS OF INTERSECTION ON THE DIAGONAL LINE

PT. 4

DIAGONAL LINE

PT. 1 LVP CV HL PT. 2

A B F

STEP 34 DRAW HORIZONTAL GRID LINES FROM THE RVP THROUGH THE POINTS OF INTERSECTION ON LINE B F

Figure 7–55

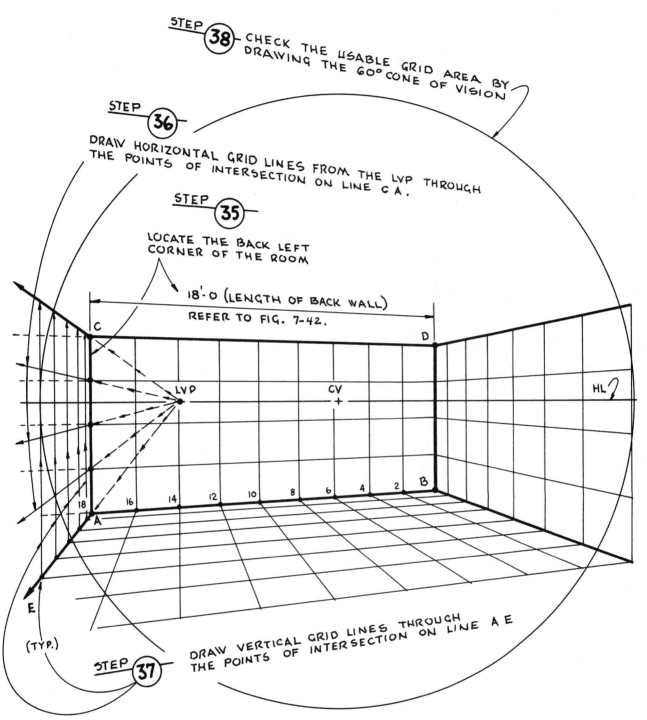

STEP 38 - CHECK THE USABLE GRID AREA BY DRAWING THE 60° CONE OF VISION

STEP 36 - DRAW HORIZONTAL GRID LINES FROM THE LVP THROUGH THE POINTS OF INTERSECTION ON LINE CA.

STEP 35 - LOCATE THE BACK LEFT CORNER OF THE ROOM

18'·0 (LENGTH OF BACK WALL)
REFER TO FIG. 7-42.

C
D
LVP
CV
+
HL
B
18 16 14 12 10 8 6 4 2
A
E
(TYP.)

DRAW VERTICAL GRID LINES THROUGH THE POINTS OF INTERSECTION ON LINE A E

STEP 37

THE THREE-WALLED GRID DRAWN BY USING WALL DIAGONALS IS NOW COMPLETE. THE KEY TO DRAWING THIS GRID BY THIS METHOD WAS STEP 16 ON PAGE 202.

Figure 7-56

7.7 EXPANDING THE GRID BY USING DIAGONALS

Statement 1. As already stated, you can use diagonals to subdivide a square, to draw circles in perspective, and to draw the original grid. Now let's discuss the technique of using only diagonals to expand the original grid. A closer examination into the unique nature of the diagonal is warranted.

Diagonals appear as 45° lines when viewed in typical multi-view drawings. See Fig. 7–57. A pictorial view of this grid space showing the diagonals drawn in perspective is illustrated in Fig. 7–58. An enlargement of the plan view of this grid is shown in Fig. 7–59. The overall grid floor size is 8'-0 × 8'-0. Each grid square is 2'-0 × 2'-0.

Let's look closer at grid square ABCD. See Fig. 7–59. One of the diagonals for this square is line CA. As you draw the diagonal from point C to point A, you are actually locating point A 2'-0 to the right of and 2'-0 behind point C. If you were to extend diagonal CA to point E, you would actually be locating point E 4'-0 to the right of and 4'-0 behind point C. See Fig. 7–60. Moreover, if you were to extend diagonal CAE to point H, you would actually be locating point H 6'-0 to the right of and 6'-0 behind point C. See Fig. 7–61.

If you were to extend this diagonal (CH) until it intersected the HL, you would be locating its vanishing point as well as the vanishing point for any other diagonal parallel

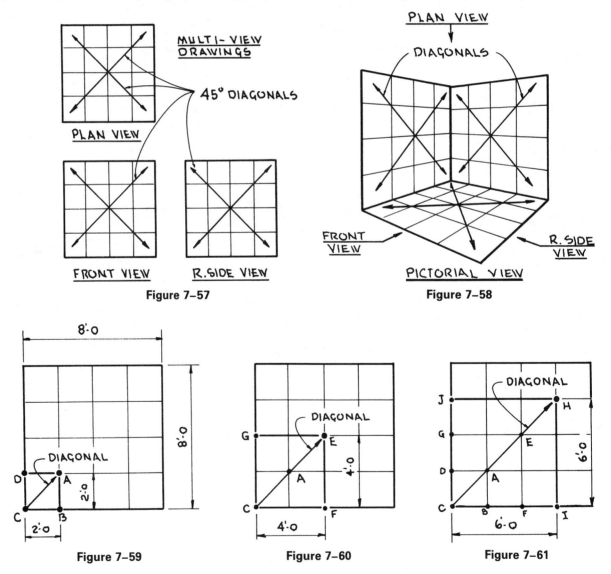

Figure 7–57 Figure 7–58

Figure 7–59 Figure 7–60 Figure 7–61

to it. See Fig. 7–62. This vanishing point is called the diagonal vanishing point (DVP). This is a very useful point to find when you are expanding the grid by using only diagonals.

There is a diagonal vanishing point to the left as well, but many times one of the DVPs will be inaccessible. See Fig. 7–63. You can find both DVPs by tracking different diagonals to the HL.

With this information in mind, let's expand a grid using only diagonals. The 12′ × 16′ × 8′ grid in Fig. 7–64 will be used in this discussion. The grid is divided into 2′-0 grid squares.

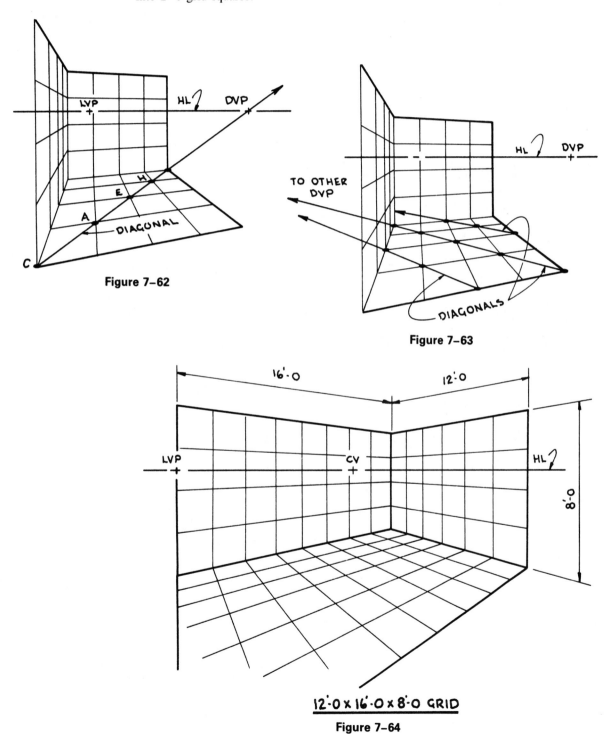

Figure 7–62

Figure 7–63

12ʹ·0 × 16ʹ·0 × 8ʹ·0 GRID

Figure 7–64

Expanding the Grid Vertically

Step 1. See Fig. 7–65.

1a. To begin, extend all the vertical grid lines.

1b. Draw a diagonal starting at point A and extend it above the original grid.

1c. This diagonal will cross the extended verticals at points 1, 2, 3, and 4.

1d. Through these points draw lines to the RVP, stopping at points 5, 6, 7, and 8 on vertical line AB extended.

1e. Through these points draw horizontal grid lines from the LVP. Now the original grid has been expanded to a grid measuring 16′ × 12′ × 16′.

1f. All this new grid area may not be usable. Draw a 60° cone of vision on the PP to determine which part is usable.

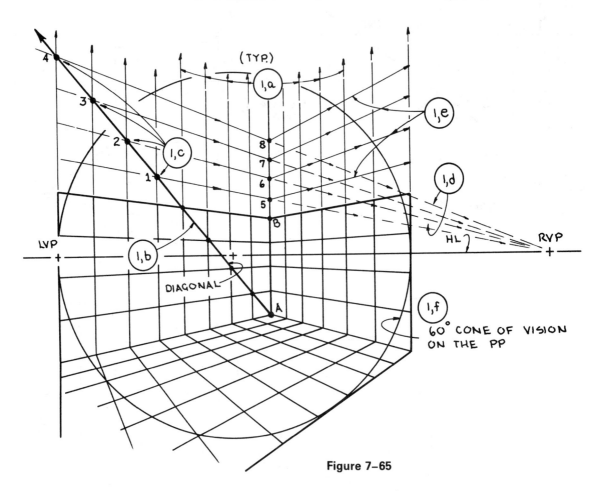

Figure 7–65

Expanding the Grid Backwards

Now you want to make the original 16′ × 12′ × 8′ grid 12′-0 deeper. See Fig. 7–66.

Step 1. See Fig. 7–67.

Note: Some grid lines have been omitted for clarity.

1a. You can begin by finding the right diagonal vanishing point on the HL. Trace one or more diagonals on the grid floor to the HL. This should locate the DVP.

1b. Extend the LBL (line AD) toward the LVP. You are now trying to find point H on this line 12′-0 behind point A. Refer to Fig. 7–66.

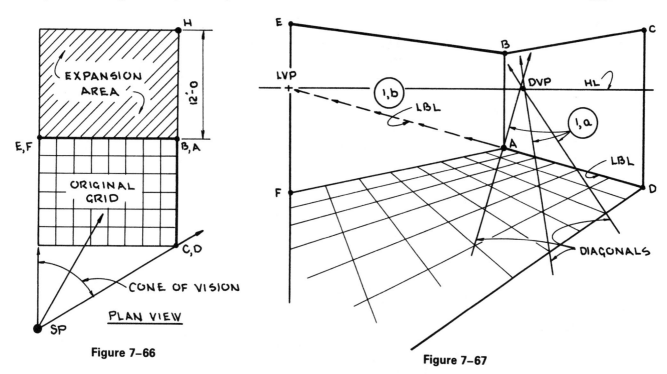

Figure 7–66

Figure 7–67

Statement 2. First, let's look at the solution to this problem in the plan view. See Fig. 7–68. Because you can measure directly in a multi-view drawing, you can locate point H 12′-0 behind point A. This is fine, but you need to relate this to the perspective. Diagonal line 1 is drawn in the plan view, and, if extended, it will go to the DVP on the HL. See Fig. 7–68.

What if you draw a diagonal through point H and extend it until it hits the grid in one direction and the HL in the other? See Fig. 7–69. This diagonal will also vanish to the DVP on the HL, and it hits the grid 12′-0 to the left of point A. This diagonal forms an isosceles triangle with equal 12′-0 sides. See Fig. 7–69. Now you want to redraw the triangle in the perspective.

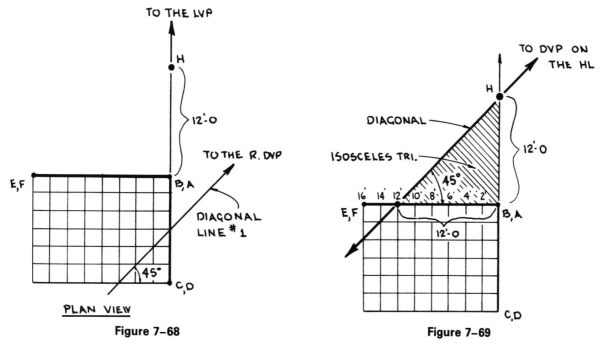

Figure 7–68

Figure 7–69

Step 2. See Fig. 7–70.

2a. To redraw this triangle in the perspective, count 12′-0 to the left of point A on line AF.

2b. Project this point to the LBL extended with a line drawn to the DVP, locating point H 12′-0 behind point A. You have just drawn the isosceles triangle in perspective.

2c. Extend line BC toward the LVP.

2d. Draw a vertical above point H, locating point I.

Step 3. See Fig. 7–71.

3a. Through points I and H draw lines from the RVP. This completes the wall outline.

3b. To draw the necessary grid lines, transfer the 2′-0 measurements from line AF to line AH with lines drawn to the DVP.

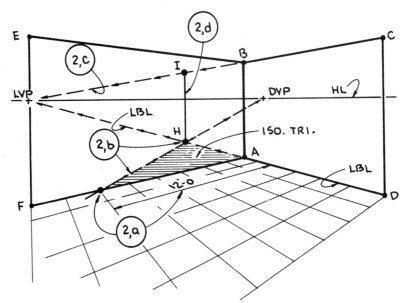

Figure 7–70

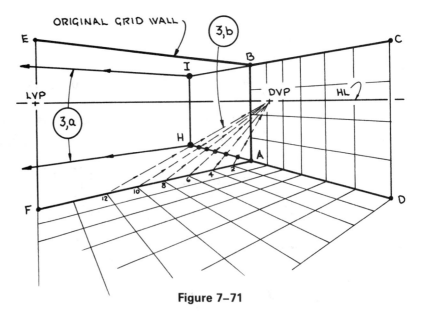

Figure 7–71

Step 4. See Figs. 7–72, 7–73.

4a. Through these transferred measurements, draw grid lines from the RVP. See Fig. 7–72.

4b. Extend the horizontal grid lines from the original grid toward the LVP. See Fig. 7–72.

4c. Turn the corner at vertical IH and draw horizontal grid lines from the RVP. See Fig. 7–73.

4d. Draw the last vertical grid lines on the new walls. This completes the backwards expansion of the grid. See Fig. 7–73.

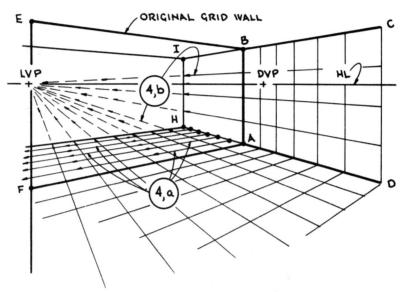

Figure 7–72

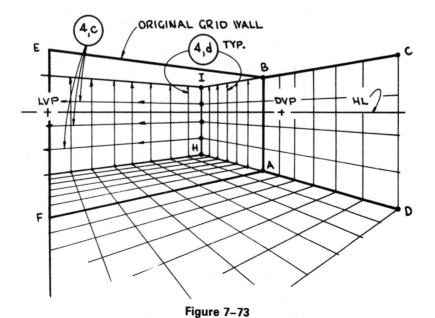

Figure 7–73

Statement 3. The procedure to expand the grid forward or sideways is quite similar to the procedure previously discussed. Therefore, these two expansion problems will be illustrated with very little verbal explanation. The illustrations are presented in chronological order.

Expanding the Grid Forward

Steps 1–6. See Figs. 7–74–7–77.

Note: Some grid lines have been omitted.

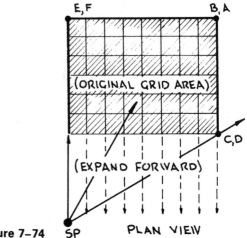

Figure 7–74

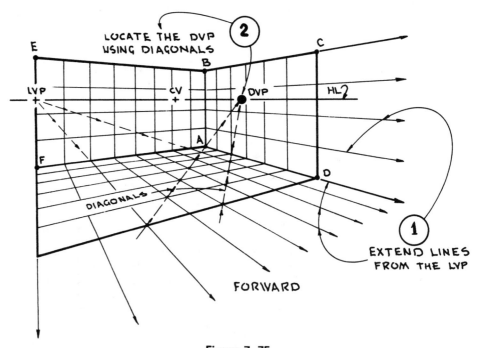

Figure 7–75

Expanding the Grid Sideways

Steps 1–9. See Figs. 7–78–7–82.

Note: Some grid lines have been omitted.

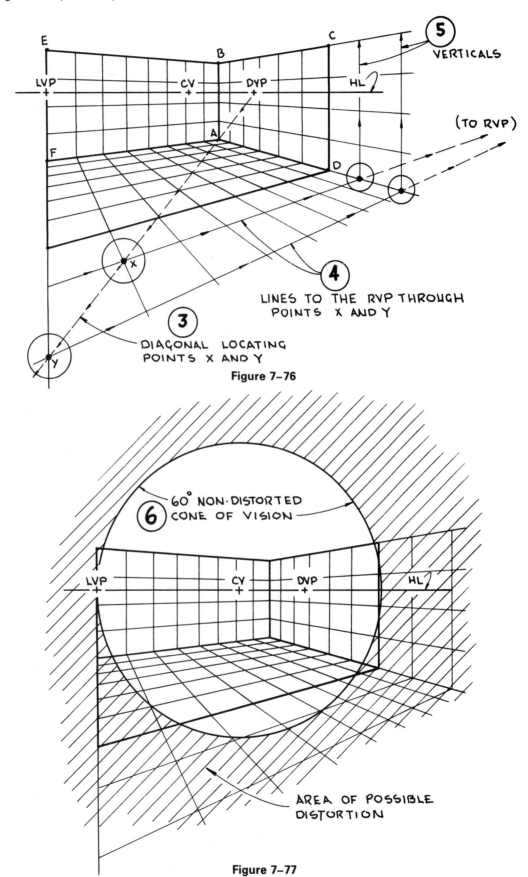

Figure 7–76

Figure 7–77

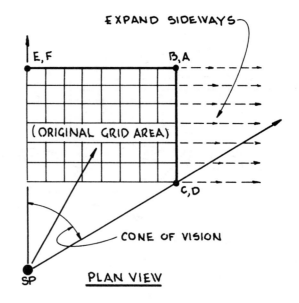

PLAN VIEW

Figure 7-78

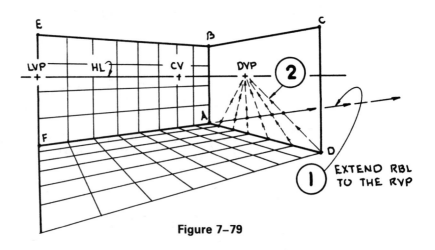

Figure 7-79

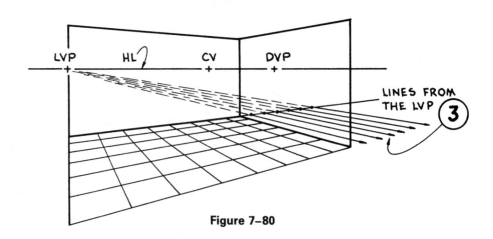

Figure 7-80

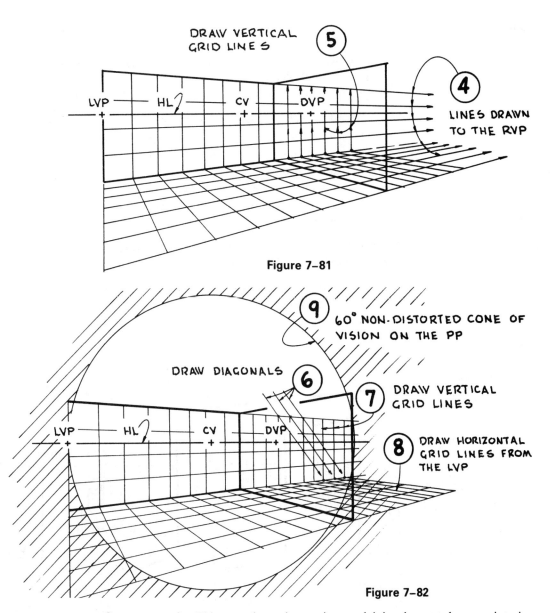

Figure 7–81

Figure 7–82

Statement 4. This completes the section explaining how to draw an interior perspective space by the grid method. As stated earlier, personal preference will dictate which method you use when drawing the perspective. The perspective plan method is more precise and flexible, but it is somewhat involved. The grid method is not so precise, but it does allow you to draw a basic perspective even if you do not have much formal perspective training. Grids work well in design sketches; whereas the perspective plan method works better with more formal presentation drawings. The ideal situation would be to have a good working knowledge of both methods.

7.8 DRAWING A PERSON IN AN INTERIOR PERSPECTIVE

It is advantageous to be able to properly draw or trace a person in any given perspective situation. Most people have difficulty drawing a realistic-looking human figure. This problem can easily be overcome. The solution is to develop or purchase a drawing file which contains a variety of human figures drawn at different scales. When the perspective requires that a person be drawn, simply trace an appropriately scaled figure from the file.

We now need to discuss how to decide the appropriate scale for the figure. By adding people to a perspective, you are automatically adding warmth and scale to the drawing. Most spaces are inhabited; therefore, adding people gives credibility to the per-

spective. However, if you were to add an incorrectly scaled person to the drawing, you would lose this authenticity.

The following text discusses these four different situations:

1. Adding people to an interior perspective drawn with a normal 5′-0 horizon line.

2. Adding people to an interior perspective drawn by the perspective plan method with a lower-than-normal horizon line.

3. Adding people to an interior perspective drawn by the grid method with a lower-than-normal horizon line.

4. Adding people to an interior perspective of unknown scale with an unknown height for the horizon line.

Adding People to an Interior Perspective Drawn with a Normal 5′-0 Horizon Line

If you are working with a perspective drawn with a normal 5′-0 horizon line (HL), you can draw many properly scaled people in the perspective by merely hanging them on the 5′-0 HL. See Fig. 7–83. All the figures drawn in this illustration are approximately 5′-0 tall. The HL is at their eye level.

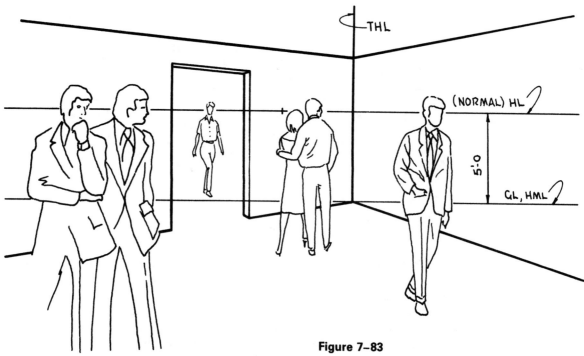

Figure 7–83

Adding People to an Interior Perspective Drawn by the Perspective Plan Method with a Lower-than-Normal Horizon Line

In this example the horizon line is only 3′-6″ above the ground line. If you were to hang the people on this HL, they would all be approximately 3′-6″ tall. Therefore, you must project to the PP in order to obtain the proper height measurement.

Step 1. See Fig. 7–84.

1a. Place an X on the floor where you want the person to stand.

1b. From this X draw a line to a random point on the HL.

1c. Where this line crosses the GL, HML (point A) draw a vertical line. Because this vertical is in the PP, it is a THL.

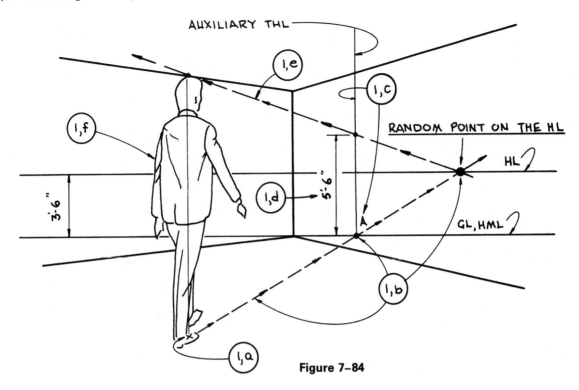

Figure 7–84

1d. Using the same scale as the perspective drawing, measure the desired height of the person (5'-6") on this THL. This measurement will begin at the ground line (GL).

1e. Project this measurement into the space with a line drawn from the same random point on the HL.

1f. Using your artistic ability or your drawing file, draw the person at the appropriate scale.

Adding People to an Interior Perspective Drawn by the Grid Method with a Lower-than-Normal Horizon Line

In this example, the perspective was drawn with a 3'-6" horizon line by the grid method. With this method you must project your height measurements from the grid walls.

Step 1. See Fig. 7–85.

1a. Place an X on the grid floor where you want the person to stand.

1b. From this X draw a line to the base of a random grid vertical. In this example, you have drawn to the vertical above point 1. Extend this line until it intersects the HL at point 2.

1c. Plot the desired height of the person on the chosen grid vertical, beginning at point 1.

1d. Project this measurement into the space with a line drawn from the same point on the HL (point 2).

1e. Draw the properly scaled figure.

Statement 1. To prove that you can choose any vertical on the grid walls and achieve the same results, this process is repeated in the same illustration (Fig. 7–85). This time a line was drawn from point X to the right grid wall and then on to the HL, locating point 4. The 5'-6" measurement was plotted on the random grid vertical above point 3 and then projected forward into the space with a line drawn from the same point on the HL (point 4). The results are the same.

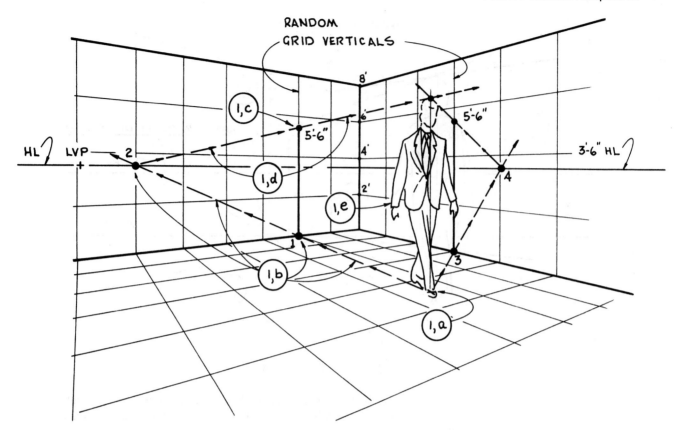

Figure 7-85

Adding People to an Interior Perspective of Unknown Scale with an Unknown Height for the Horizon Line

Occasionally, you may need to add a figure or figures to an interior perspective which has been drawn at an unknown scale and with an unknown height for the horizon line. In this instance, you will have to refer to common architectural features for the height measurements. The following discussion will describe this process.

Step 1. See Fig. 7–86.

1a. First, determine where in the interior space you want the person to stand. Place an *X* on the floor at that location. Also, decide the height you want the person to be. In this example, you decide the person should be approximately 5'-6" tall.

Step 2. See Fig. 7–87.

2a. Now you must find the original HL for this perspective. You do this by extending two parallel lines until they intersect. The top and bottom lines of a wall will normally work in this procedure. The intersection of these two extended lines is the location of their vanishing point. This vanishing point will be on the original horizon line.

2b. Through this vanishing point draw a horizontal line which represents the original HL.

2c. Because the perspective is drawn at an unknown scale, you must establish a vertical scale which is based on a standard-sized architectural feature, such as a door, window, or ceiling height. The interior will probably include one

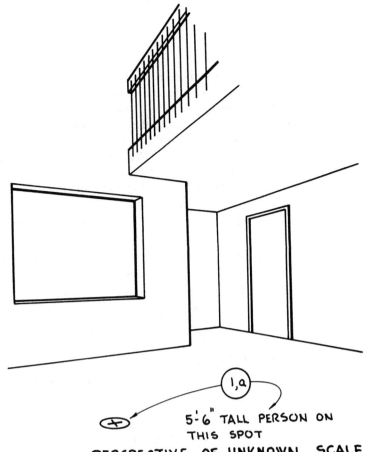

1,a

5'-6" TALL PERSON ON THIS SPOT

PERSPECTIVE OF UNKNOWN SCALE

Figure 7-86

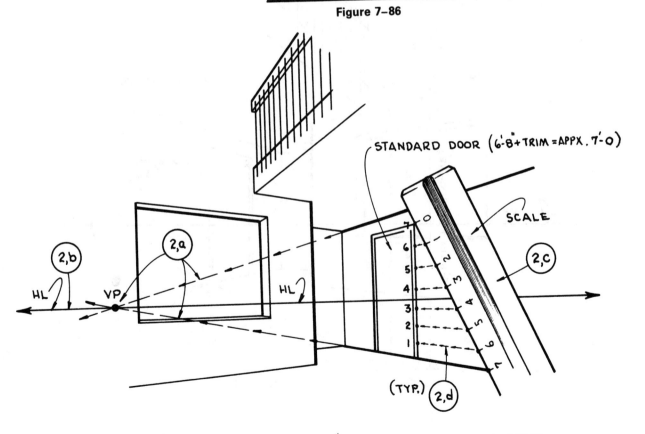

STANDARD DOOR (6'-8"+TRIM=APPX. 7'-0)

SCALE

2,a 2,b 2,c

HL VP HL

2,d (TYP.)

5'-6" TALL PERSON ON THIS SPOT

Figure 7-87

of these features. In this example, the entry door on the right wall will be used to establish a vertical scale. You can assume that this door is approximately 7'-0 tall, if you include the trim. Based on this assumption, you now must divide the vertical height of the door into seven equal units. This will be the vertical scale you will use to draw the 5'-6" tall person.

Using your architectural scale, choose an appropriate scale to subdivide the door. Putting the zero indicator on the top of the door trim, rotate the scale until the 7'-0 indicator lines up with the base of the wall. Mark these divisions on the wall. See Fig. 7–87.

2d. Project these divisions back to the door with lines drawn to the LVP.

Step 3. See Fig. 7–88.

3a. Draw a line from the X on the floor to the base of the vertical scale (point A). Extend this line until it intersects the HL at point B.

3b. Measure the desired height of the person (5'-6") on the vertical scale.

3c. Project this measurement into the space with a line drawn from point B on the HL. This line will transfer the 5'-6" measurement from the wall to the vertical drawn above point X.

Step 4. See Fig. 7–89.

4a. Using this projected height measurement as a guide, draw the person.

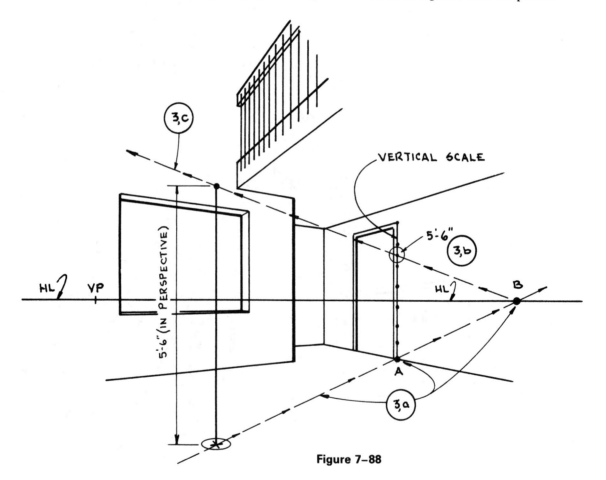

Figure 7–88

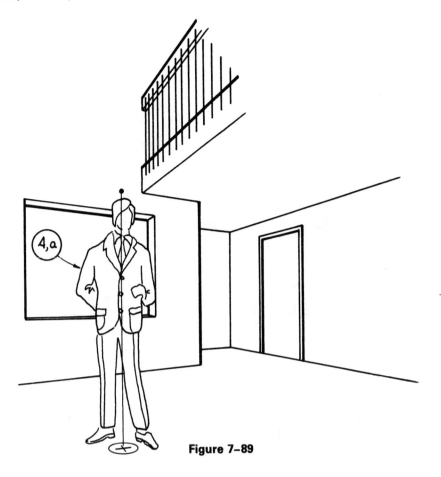

Figure 7–89

Summary Statement

The material discussed in this chapter involved drawing the original grid as well as describing different techniques on how to use the grid to draw the final perspective. The grid lines can be located by using measuring points or diagonals. Both methods were discussed. On many occasions, the original grid space will not include the entire interior. Therefore, it is important that the student be able to expand the original grid into usable areas. Several ways to do this were presented. These techniques and others mentioned in this chapter are very important when the perspective is being drawn by the grid method.

8

Modified Visual Ray Technique

8.1 USING A QUICK SKETCH PERSPECTIVE TECHNIQUE AS A DESIGN TOOL

The ability to sketch and design in perspective is a very useful skill. For a few people this comes naturally. But for most of us it is very difficult to sketch freehand with much accuracy. Some people can acquire this skill; others simply cannot. This section is for those people who have a difficult time sketching accurately but who cannot take the time to draw a precise perspective. The following technique is a modification of the visual ray method. If you are not familiar with this method of drawing perspectives, you should turn to page 96 and review the section entitled "Visual Ray Perspective (A Quick Sketch Technique)" before you continue this discussion. You want to pay particularly close attention to how you can project vertical lines from the plan view drawing of the object into the PP with lines drawn from the SP. This automatically locates them in perspective.

In addition, the ability to find auxiliary THLs is important to this quick sketch technique. It is suggested that you review this procedure by rereading the section entitled "Auxiliary True Height Lines" on page 64. Being able to visualize and use these two procedures should allow you to use the following quick sketch technique.

Quick Sketch Technique Using the Long Vanishing Point

Let's assume a hypothetical situation where you are talking with a client. This is your second meeting, and you are showing the client your design for his or her project. You have a blueprint of the floor plan drawn at $1/8'' = 1'$-0 scale. See Fig. 8–1. The client

PROPOSED OFFICE BUILDING

Figure 8-1

likes your idea but is having difficulty visualizing the space. This is becoming obvious by the nature of your client's questions.

Now is the time to sit down and make a quick, accurate sketch of the space. Any problems which may be created by your design can be solved at this time. It is very much to your advantage if you can sketch while the client is watching.

All you need to make this sketch is a piece of tracing paper, a pocket architectural scale, a small 30°-60° triangle, and a pencil or marker. See Fig. 8-2. All these items can be carried in a small brief case. If you prefer, most of the work can be done freehand.

Lay the blueprint of the floor plan in front of you. Place on top of it a piece of transparent tracing paper. You could tape it to the blueprint or you could just hold it in place. See Fig. 8-3.

In this case, the client is concerned about how the space will look from the front entry door, so you will make your sketch from that general location.

Note: The floor plan will not be emphasized in the following illustrations because it is under the transparent tracing paper.

Figure 8-2

Step 1. See Figs. 8-4, 8-5, 8-6.

 1a. Using a 30°-60° triangle as the 60° cone of vision, place the 60° angle close to the entry door. Manipulate the triangle until you are seeing what you want to see inside the 60° cone. Move it around until you are satisfied with its location. Fig. 8-4.

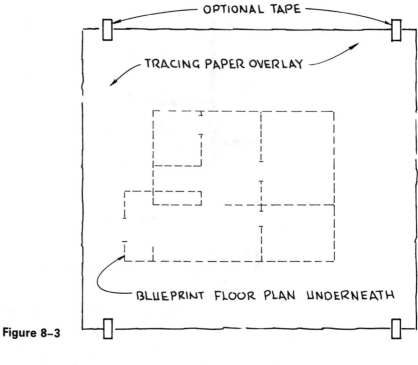

Figure 8–3

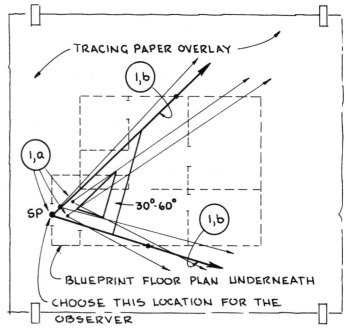

Figure 8–4

1b. Trace lightly around the 60° angle. These two pencil lines represent the legs of the 60° cone of vision. The apex of the 60° angle is the location of the observer. Fig. 8–4.

1c. Turn the 30°-60° triangle over and draw a line that forms a 60° angle with one of the legs of the cone of vision and that goes through the back corner of the space (point A). This line represents an edge view of the PP, properly aligned. Fig. 8–5.

1d. Turn the floor plan and tracing paper around so that the PP is running horizontally. This will facilitate drawing the sketch. Fig. 8–6.

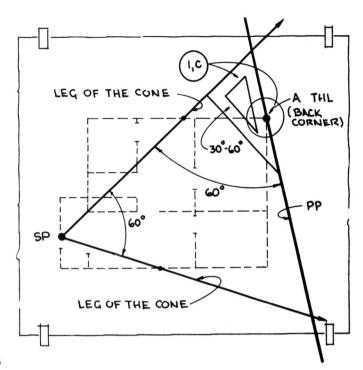

Figure 8–5

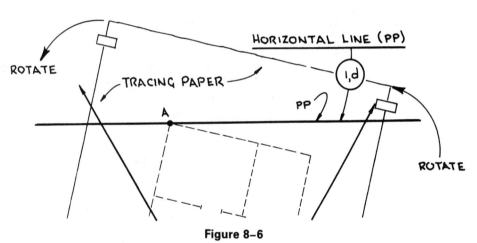

Figure 8–6

Step 2. See Figs. 8–7, 8–8.

2a. Find the right and left vanishing points by drawing two lines from the SP parallel to the two sets of walls. Extend these two lines until they cross the PP, locating the right and left vanishing points. Fig. 8–7.

Statement 1. You will always be able to locate the close VP, but sometimes the long VP will be too far out to be of practical use. Try to locate both if you possibly can; but if you can't, there is an easy way to draw the sketch without using the long VP. This method will be discussed later.

2b. For the sake of the following discussion, number all the verticals on the floor plan which might affect the perspective sketch. Fig. 8–8.

Note: You will want to refer to Fig. 8–8 continually as you draw the sketch.

Statement 2. You are now ready to begin the sketch. The sketch will be drawn directly over the floor plan. All the following construction lines should be drawn lightly,

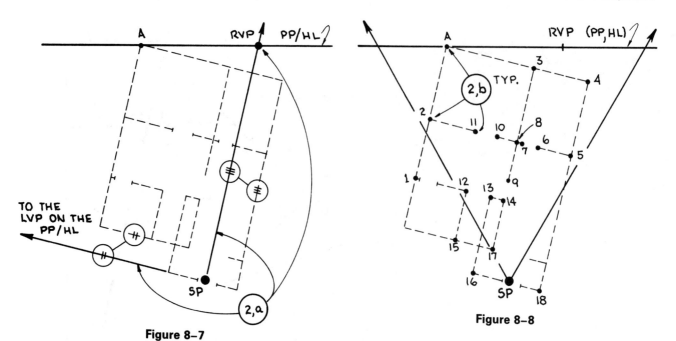

Figure 8–7

Figure 8–8

because some of these lines will be hidden in the final sketch. Once you have the rough outline of the rooms sketched, you will want to darken the visible lines. This could be done freehand with a marker over the pencil lines.

Step 3. See Fig. 8–9.

3a. Begin the sketch by drawing a vertical line through point A. This line represents the extreme back corner of the space. Because this vertical is in the PP, it is a THL.

3b. Reflecting an 8'-0 ceiling height, measure down from point A 5'-0, and then measure up 8'-0.

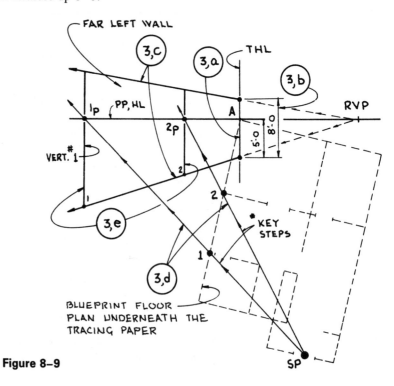

Figure 8–9

3c. To draw wall A,1 (the far left wall), project two lines from the RVP through the top and bottom of vertical A.

3d. To locate verticals 1 and 2 in this wall, project these two points from the overlaid floor plan into the PP with lines drawn from the SP. You have located points 1_p and 2_p in the PP.

3e. Draw verticals through these two points. Fig. 8–9.

Step 4. See Fig. 8–10.

4a. To draw wall A,4 (the extreme back wall), project lines from the LVP through the top and bottom of THL A.

4b. Project verticals 3 and 4 from the overlaid floor plan into the PP with lines drawn from the SP, locating points 3_p and 4_p.

4c. Through these two points draw verticals 3 and 4 in the perspective.

4d. Draw four horizontal lines from the RVP through the top and bottom of these two verticals.

Statement 3. The pattern should be obvious to you now. In order to draw a vertical in the perspective, you first must project the plan view of the vertical into the PP with lines drawn from the SP. Where these lines of projection pierce the PP is the actual location for that vertical in perspective. Of course, the plan view of each vertical is located in the floor plan under the tracing paper.

Note: Continue to refer to Fig. 8–8 for the location of the numbered vertical lines. The individual walls are identified by the two vertical lines forming the ends of that particular wall.

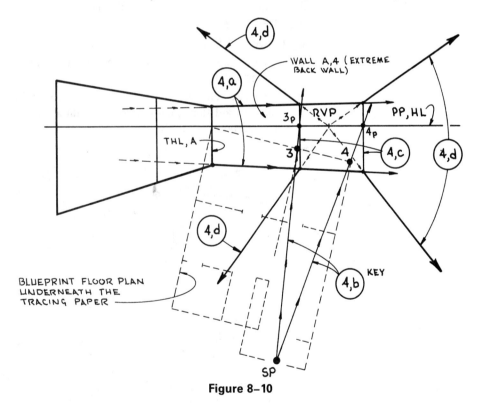

Figure 8–10

Step 5. See Fig. 8–11.

5a. To draw wall 2,5 draw two horizontal lines from the LVP through the top and bottom of vertical 2.

5b. Draw vertical 5.

5c. To draw wall 3,9 draw two horizontal lines from the RVP through the top and bottom of vertical 3.

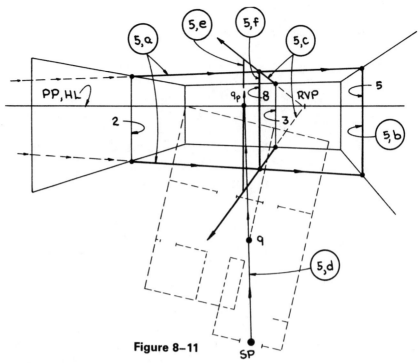

Figure 8–11

5d. To locate vertical 9 in the perspective, project the location of vertical 9 in the overlaid floor plan into the PP with a line drawn from the SP. This locates point 9_p in the PP.

5e. Draw a vertical line through this point.

5f. Draw vertical 8.

Step 6. See Fig. 8–12.

6a. To draw wall 1,12 draw two lines from the LVP through the top and bottom of vertical 1.

6b. To locate vertical 12 in the perspective, project the location of vertical 12 in the overlaid floor plan into the PP with a line from the SP. You have just located point 12_p in the PP.

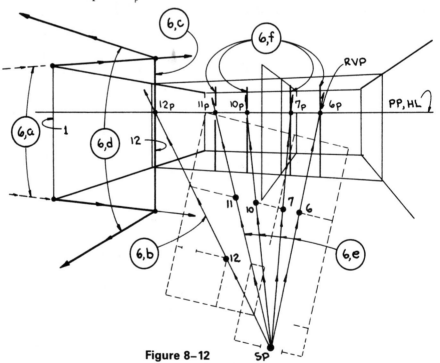

Figure 8–12

6c. Draw vertical 12 through this point.

6d. To draw the portion of wall 12,15 which is visible in the perspective, draw two horizontal lines from the RVP through the top and bottom of vertical 12.

6e. To locate doors 6,7 and 10,11 in the perspective, project these points from the overlaid floor plan into the PP with lines from the SP. You have located points 6_p, 7_p, 10_p, and 11_p in the PP.

6f. Draw vertical lines through these points. See Fig. 8–12.

Step 7. See Figs. 8–13 and 8–14.

7a. To find the heights of doors 6,7 and 10,11, make a measurement of 7'-0 on the original THL. Fig. 8–13.

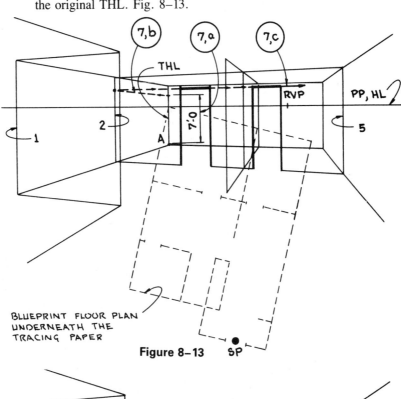

Figure 8–13 SP

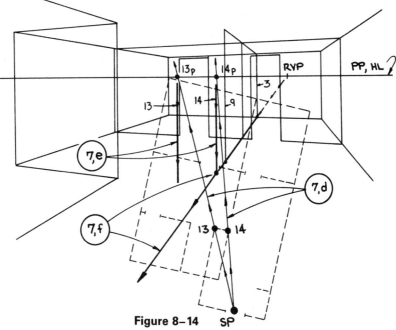

Figure 8–14 SP

7b. Project this measurement forward along wall A,1 with a line from the RVP. Fig. 8–13.

7c. Turn the corner at vertical 2 and project the 7'-0 measurement along wall 2,5 with a line from the LVP, locating the tops of the two doors. (This height could have been estimated.) Fig. 8–13.

7d. To locate verticals 13 and 14 in the perspective, project these two points from the overlaid floor plan into the PP with lines drawn from the SP. This will locate points 13_p and 14_p in the PP. Fig. 8–14.

7e. Draw vertical lines through these points. Fig. 8–14.

7f. Project forward the base of wall 3,9, locating the base of vertical line 14. Fig. 8–14.

Step 8. See Fig. 8–15.

8a. To find the height of the counter, verticals 13 and 14, make a measurement of 3'-0 on the original THL.

8b. Project this measurement forward along wall A,1 with a line from the RVP.

8c. Turn the corner at vertical 1 and project the 3'-0 measurement along wall 1,12 with a line drawn from the LVP to verticals 13 and 14.

8d. Through these two points of intersection draw lines from the RVP, completing the counter outline in the perspective.

Note: The rough light sketch is now complete.

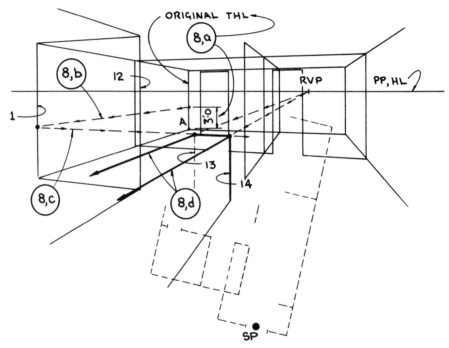

Figure 8–15

Step 9. See Fig. 8–16.

9a. Beginning in the foreground and working toward the back of the perspective, darken with a marker the visible lines.

9b. You can add some detail (wall thickness, counter top, furniture, and so on) if you wish.

Statement 4. As you can see, this technique is similar to other perspective drawing in that there is much repetition involved. However, this type of sketch should require only five to ten minutes to draw.

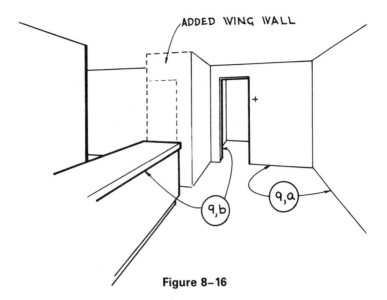

ADDED WING WALL

9,b

9,a

Figure 8-16

Statement 5. Now you have an accurate perspective sketch drawn in front of the client. The client can look at the sketch and visualize how the space would look if he or she were standing just inside the front entry door. Hypothetically, the client was pleased with the overall layout of the space but was concerned that a person might see into the accounting room from the foyer. Because of your sketch, a small wing wall was added to block this view. See the dotted lines in Fig. 8-16.

Statement 6. The previous sketch was made on the assumption that both vanishing points were easily accessible. With small sketches such as this one, this would generally be the case. What if you were working with a 1/4″ floor plan and the long vanishing point was too far out to be conveniently used? Remember, you would probably be working on a small table and would have no access to a long straight edge. The following discussion will address this problem.

Quick Sketch Technique with an Inaccessible Vanishing Point

Statement 7. Let's use the same interior with which you have just worked. This time, however, the LVP is inaccessible. Refer to page 229, Step 4,a, Fig. 8-10. The first time you were instructed to use the LVP was when you were drawing the top and bottom of wall A,4. The following discussion picks up the sequence at that point. This time you do not have the LVP, however.
Note: Continue to refer to Fig. 8-8 for the location of each vertical line in the floor plan.

Step 1. See Fig. 8-17.
1a. To locate vertical line 4 in the perspective, project point 4 from the overlaid floor plan into the PP with a line drawn from the SP. You have just located point 4_p in the PP.
1b. Draw a vertical through this point.

Statement 8. You have vertical 4 accurately located in perspective, but now you want to draw lines from the top and bottom of line A to complete the back wall. For this you need the LVP, however, and you do not have an accessible one. If you were to have access to the LVP, drawing the back wall would be easy. The key to solving this problem is finding an auxiliary THL which is in the same vertical plane as vertical line 4.

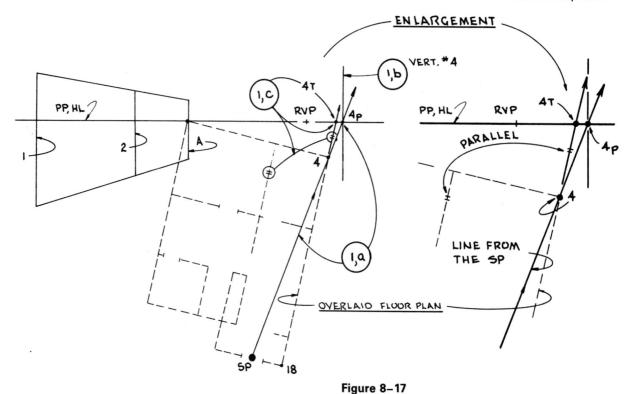

Figure 8–17

1c. Project point 4 from the overlaid floor plan into the PP with a line drawn parallel to the walls going to the close vanishing point (RVP). In other words, extend wall 4,18 into the PP. This locates point 4_T in the PP. A closer view of this procedure is also shown in Fig. 8–17.

Step 2. See Fig. 8–18.

2a. Through point 4_T draw a vertical line. This line is an auxiliary THL and can be used to project height measurements to any vertical line drawn in wall 4,18. This includes vertical line 4.

2b. Beginning at the PP, HL, measure down 5'-0 and then up 8'-0 on this auxiliary THL.

2c. Transfer these measurements from the auxiliary THL to vertical line 4 with lines drawn from the RVP. This locates the top and bottom of line 4.

Step 3. See Fig. 8–19.

3a. Draw lines between the top and bottom of verticals A and 4. These two lines are vanishing to the inaccessible LVP.

Statement 9. You now have a wall drawn which is vanishing to the inaccessible LVP. As a review, the key to drawing lines which approximate the inaccessible vanishing point involves the ability to do the following:

1. Project individual vertical lines from the overlaid floor plan into the PP with lines drawn from the SP.

2. Project individual vertical lines into the PP with lines drawn parallel to the walls vanishing to the close vanishing point, locating an auxiliary THL.

3. Make the appropriate measurement on the auxiliary THL.

ENLARGEMENT

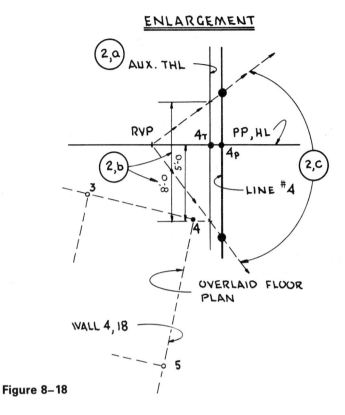

Figure 8-18

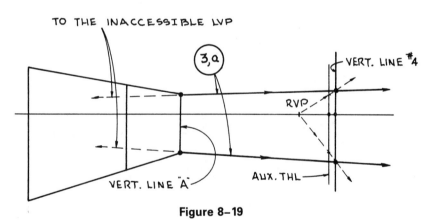

Figure 8-19

4. Transfer these measurements from the auxiliary THL to the projected vertical with lines drawn from the close VP.

If you can learn to adapt this four-step sequence to different situations, you will be able to sketch any perspective using only one VP. This procedure can give you a tremendous amount of flexibility in your sketching.

Statement 10. Now using the top and bottom lines in wall A,4 as a guide to drawing other lines which vanish to the inaccessible LVP, complete the perspective sketch. A numbered sequence of chronological steps will be presented in Figs. 8–20 through 8–26. Because of the similarity between this procedure and the previous one, very little written explanation will be given.

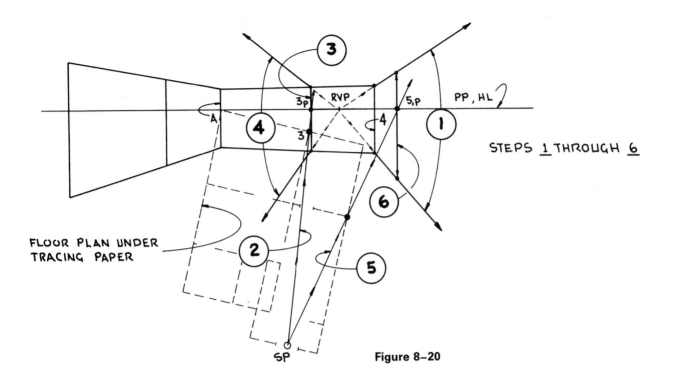

STEPS 1 THROUGH 6

FLOOR PLAN UNDER
TRACING PAPER

Figure 8-20

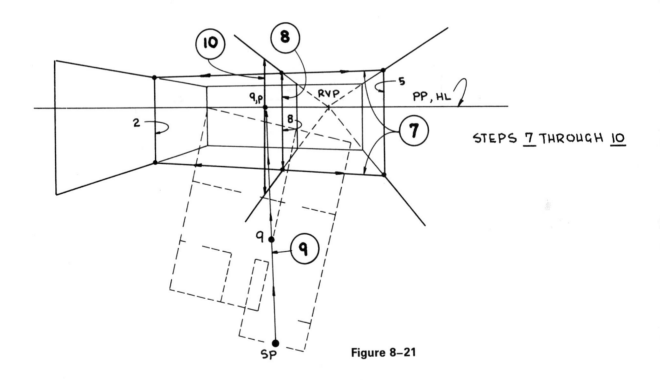

STEPS 7 THROUGH 10

Figure 8-21

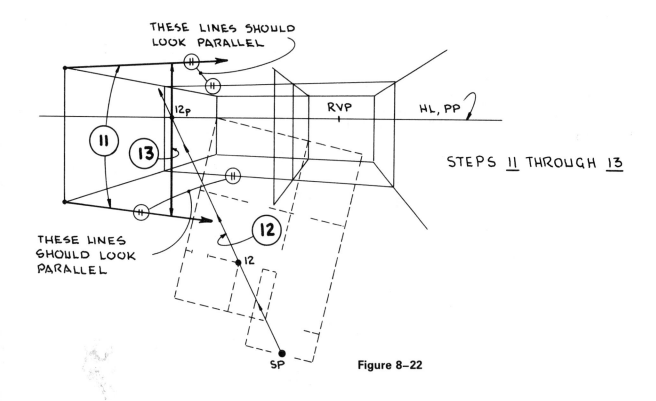

Figure 8–22

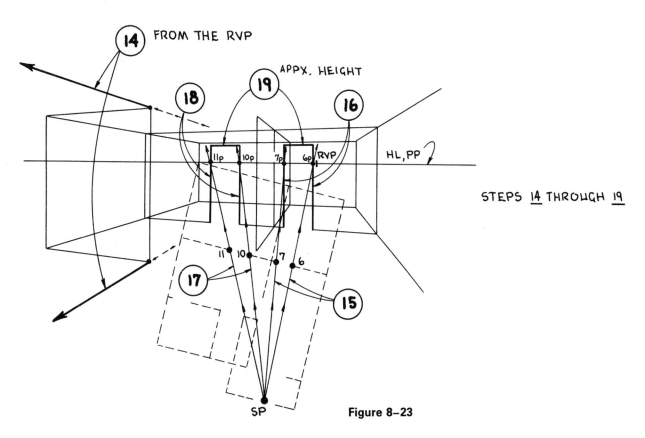

Figure 8–23

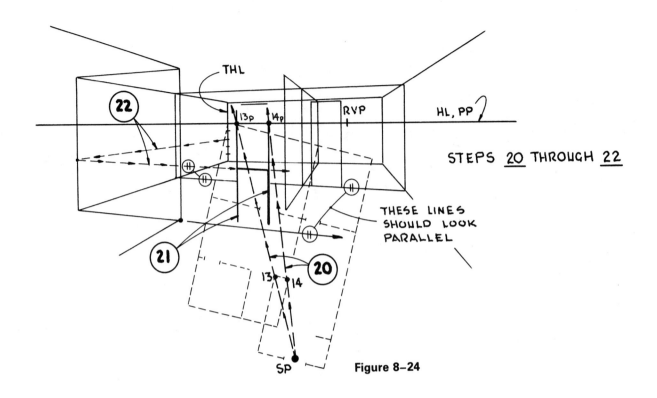

THL

13p 14p RVP HL, PP

STEPS 20 THROUGH 22

THESE LINES
SHOULD LOOK
PARALLEL

13 14

SP

Figure 8–24

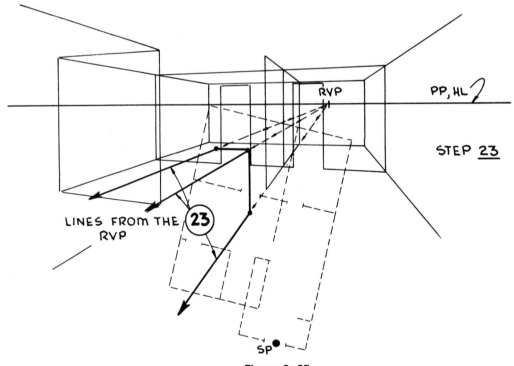

RVP PP, HL

STEP 23

LINES FROM THE
RVP

SP

Figure 8–25

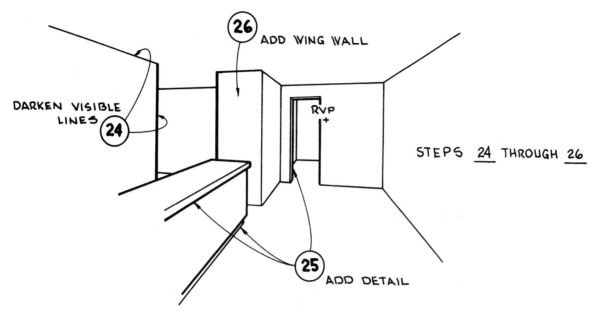

Figure 8-26

Summary Statement

This quick sketch technique can be used as a sales tool as well as a design tool. Being able to use this technique in a presentation setting is very important. Most people are unable to draw. This fact makes this skill even more impressive. The ability to design in three-dimension is an invaluable skill. This quick, accurate technique makes this skill more attainable. Many preliminary designs can be eliminated by the ability to visualize the space as early in the design process as possible. Once the sketch is approved, the full-sized perspective can be drawn.

9

Oblique Shades and Shadows

9.1 INTRODUCTION

When creating an architectural illustration, there is a natural progression of steps that must be taken. The first step is to draw the perspective of the structure from a set of given blueprints. This perspective should accurately depict the structure to its best advantage.

The second step is to show the effects of an external light source by casting shades and shadows on the perspective drawing. Properly cast shades and shadows will add depth and character to any architectural illustration. Quite often, complicated architectural designs can be clarified by the resultant effects of sunlight, shade, and shadow values. An illustration will appear dull and uninteresting if shades and shadows are omitted. See Fig. 9–1a. Just as you can create a desired effect with the drawn perspective, you can enhance that effect by adding appropriate shading. See Fig. 9–1b.

The third step in this process is to render the completed perspective with a chosen medium. This rendering, be it pen and ink or color, should accurately represent the architectural materials involved as well as reflect proper sunlight, shade and shadow values. Proper completion of all three steps will assure a quality illustration.

Traditionally, three methods are used for casting shades and shadows:

1. **Oblique:** The vertical light plane can make any angle with the picture plane. See Fig. 9–2a.
2. **Parallel:** The vertical light plane is always parallel to the picture plane. See Fig. 9–2b.
3. **Multi-view:** The vertical light plane forms a 45° angle with the picture plane. See Fig. 9–2c.

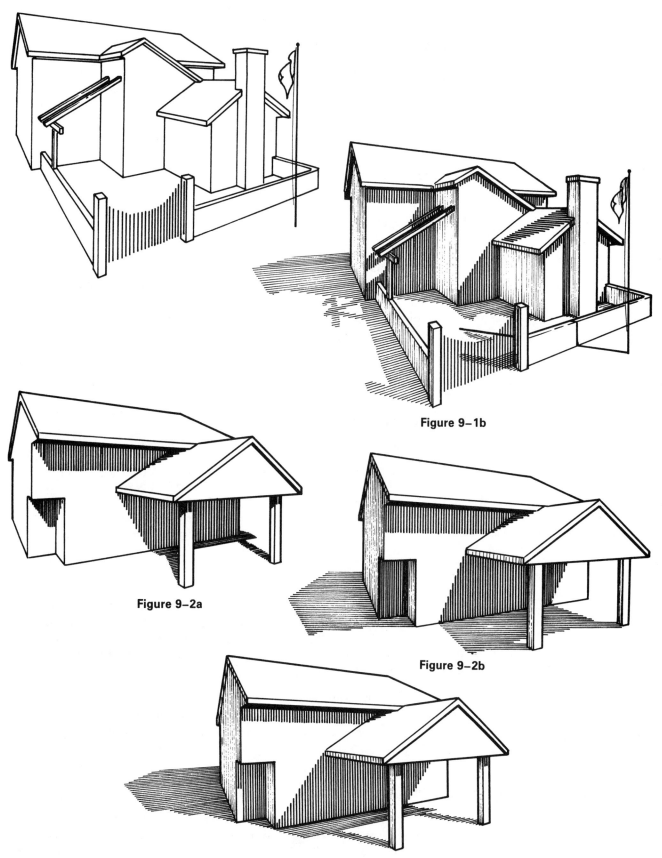

Figure 9–1b

Figure 9–2a

Figure 9–2b

Figure 9–2c

The advantages and disadvantages of each method are listed as follows:

Oblique Shades and Shadows

Advantages

1. Good method used to teach the theory of intersecting planes.
2. A very versatile method—the sun can be at any location.
3. Shadows developed directly on the perspective.
4. Works well on all perspective setups.

Disadvantages

1. More difficult to learn.
2. Sometimes requires a large work space.
3. Shadow patterns *not* very predictable.

Parallel Shades and Shadows

Advantages

1. Very simple method—requires few rules.
2. Very compact method—requires little work space.
3. Shadows are developed directly on the perspective.
4. Works well on three-dimensional site plans.
5. Predictable shadow patterns.

Disadvantages

1. Limited flexibility—sun location is very limited.
2. Does not work well on one-point perspectives.

Multi-View Shades and Shadows

Advantages

1. Very simple method—requires few rules.
2. Very compact method—requires little work space.
3. Can be used to explain architectural detail on elevation drawings.
4. Very predictable shadow patterns.

Disadvantages

1. Limited flexibility—sun location is very limited.
2. Shadows constructed on the elevation drawings, then transferred to the perspective.

Two of the three methods of casting shadows will be discussed in this text. The oblique method will be covered because of its versatility and the fact that the shadows are constructed directly on the perspective. The widespread use of the multi-view method makes it imperative that this method be discussed. The format for these discussions will be as follows:

1. Definition of terms
2. A short discussion about the theory behind each method
3. Step-by-step procedure for casting shadows of a given line onto a particular surface

9.2 THEORY OF INTERSECTING PLANES

The process of casting shadows is based on the theory of intersecting planes in space. Some of these planes are visible, and some are not. This fact makes it somewhat difficult to understand what actually is happening when shadows are formed. You will be

working with an invisible plane of reference (PP), as well as with invisible light planes and visible object planes.

Not only will you be working with these planes, but you will also be locating and using vanishing points on each plane's horizon lines. If you recall from Section 4.2, page 68, every plane in space has its own horizon line. Every line that is contained within a plane will vanish to that plane's horizon line. Being able to locate the horizon line for a given plane, be it visible or invisible, is an invaluable skill when casting shadows by the oblique method.

In order to begin the discussion on oblique shades and shadows, you should first review some familiar terms and learn some new ones. This can best be accomplished by developing an illustration, component by component, and explaining each component as it is introduced into the setting.

Figure 9–3 shows the ground plane. The ground plane is the surface upon which the object casting the shadow is resting. The picture plane is added in Fig. 9–4. The picture plane is the invisible vertical plane of reference on which the perspective is drawn. A horizontal line representing the horizon line is drawn on the picture plane. The horizon line (HL) is the theoretical intersection between the ground and the sky. The line of intersection between the picture plane (PP) and the ground plane is called the ground line (GL). A flag pole, the object casting the shadow, is also added to the setting in Fig. 9–4.

Figure 9–3

Figure 9–4

In Fig. 9–5 a distant light source is added to the setting. The oblique shades and shadow method assumes that the sun is the source of light. Even though the individual light rays come from the same source, they are considered to be parallel to each other by the time they reach the earth.

In theory, the atmosphere is completely saturated with these parallel light rays. Shades and shadows are formed by objects which interrupt the passage of these light rays. Therefore, the vertical flag pole in Fig. 9–5 is blocking individual light rays, which in turn form a vertical plane of light. The line of intersection between this vertical plane of light and the picture plane is called the vertical light horizon line (VLHL): The point of intersection between this line and the original horizon line is the VH. Theoretically, the VH is the vanishing point for all shadows cast by vertical lines onto horizontal surfaces. The intersection between the vertical plane of light and the ground plane is called the horizontal direction of light. The shadow cast by the flag pole onto the ground will fall along this line. See Fig. 9–5.

Figure 9–5

At this point, the length of the shadow is unknown. Fig. 9–6 illustrates the addition of the VL to this setting. The VL is the vanishing point for all light rays. The VL is always located on the vertical light horizon line — directly above or below the VH. A single light ray passing through the top of the flag pole pierces the ground plane along the horizontal direction of light on its way to the VL. This piercing point indicates the shadow of the top of the flag pole and determines the length of the entire shadow. See Fig. 9–6.

A summary of the new terms just discussed and their descriptions are as follows:

Light source: the distant sun

Light rays: are parallel to each other and vanish to the VL

VH: the vanishing point for all shadows cast by vertical lines onto horizontal surfaces; will always be located on the original horizon line

Figure 9–6

VL: the vanishing point for all light rays; will always be located directly above or below the VH

Vertical light horizon line: the line of intersection between the vertical plane of light and the picture plane (PP)

Horizontal direction of light: the line of intersection between the vertical plane of light and the ground plane

Shade: the surface area of an object from which direct light is excluded by the object itself

Shadow: the surface area of objects or planes from which direct light is excluded by an intervening form

The flexibility of the oblique shade and shadow method is the key factor in its popularity. With the other methods, one is limited to one or two sun locations. This is not true with the oblique method. The sun can be in front of or behind the observer, as well as to the right or to the left. The location of the sun dictates the location of the VL in the picture plane.

The location of the VL can be in one of four quadrants. See Fig. 9–7. If the VL is located *above* the horizon line, the sun is shining into the observer's eyes. If the VL is located in the upper left-hand quadrant, the sun is in front of the observer to the left. Consequently, if the VL is located in the upper right-hand quadrant, the sun is in front of the observer to the right. If the VL is located *below* the horizon line, the sun is behind the observer. If the VL is in the lower left-hand quadrant, the sun is behind the observer over his or her right shoulder. Therefore, if the VL is located in the lower right-hand quadrant, the sun is again behind the observer over his or her left shoulder. Once you understand the importance of the location of the VL, you can accurately predict the direction of the shadow cast.

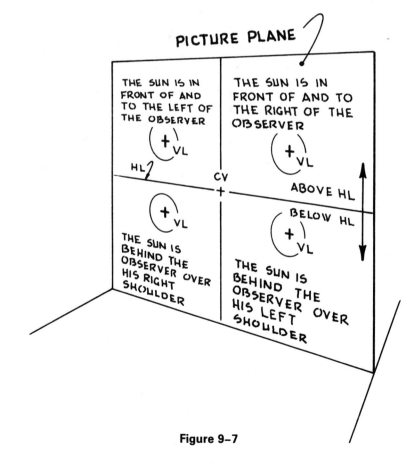

Figure 9–7

At this point it is important to explain how the VL is located in the picture plane. Theoretically, the air is filled with parallel light rays. The observer (SP) is viewing an object through the vertical picture plane. Of all the light rays coming through space, only one will pass through the observer's eye. Where this single light ray pierces the picture plane is the location for the VL. See Fig. 9–8.

To better illustrate this important concept, Fig. 9–9 shows how the VL can be located in the four different quadrants. Remember that normally there is only one VL and one VH per problem. When the light source is in front of the observer, the light ray strikes the picture plane above the horizon line on its way down to the SP (observer's eye). This locates the VL above the horizon line (VL_4 and VL_1). When the light source is behind the observer, the light ray passes through the SP and then continues forward and downward to pierce the picture plane below the horizon line. This locates VL_2 and VL_3 below the horizon line. See Fig. 9–9.

One important concept in perspective drawing is that parallel lines will always vanish to the same vanishing point. Since the light rays are parallel to each other, they will vanish to the same point (the VL). See Fig. 9–10. All light rays will be drawn to or from the VL.

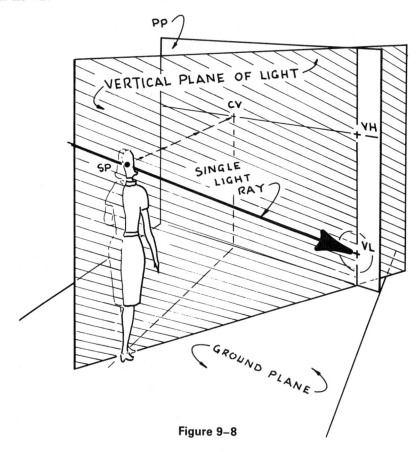

Figure 9–8

Fig. 9–11 illustrates the effects on the length and direction of a shadow cast by a flag pole when the VL is located in each of the four quadrants. Remember that in a normal situation, there would be only one VH and one VL. This example has four of each to illustrate a point. Notice that in each case the VL is always directly above or below its accompanying VH, which is always located on the original horizon line. Also notice that VL_4 is closer to the horizon than VL_1. The shadow of the flag pole cast by VL_4 is longer than the shadow cast by VL_1. Shadows always grow longer as the sun approaches the horizon. These shadows illustrate the fact that the oblique method is a very accurate and realistic way to cast shadows.

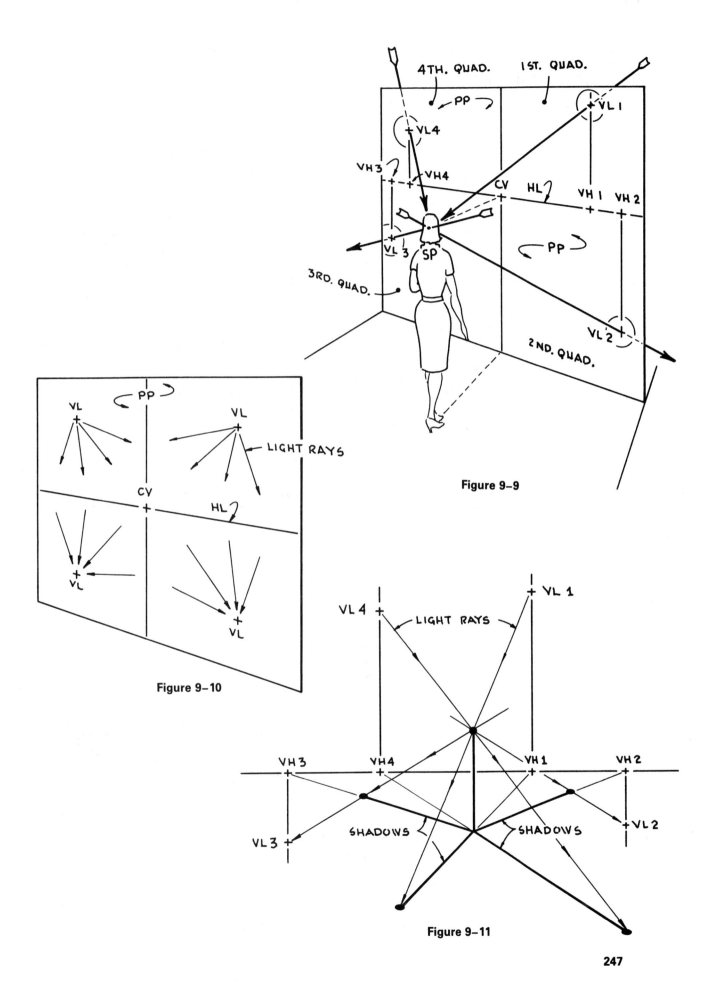

Figure 9-9

Figure 9-10

Figure 9-11

247

9.3 SUNLIGHT-SHADE ANALYSIS

Once the perspective of the given structure is drawn, you are ready to begin the process of casting shadows. The first step in this process is to locate the VL in an appropriate location. The shadows cast should show the structure to its best advantage. The previous discussion is fundamental to locating the VL properly. Once the VL is located, the VH will be located either directly above or below the VL on the original horizon line.

The second step is to make a good sunlight-shade analysis of the structure. It is important that one determine which walls are in sunlight and which are in shade. The only lines casting shadows are those lines which separate sunlit and shaded surfaces. Lines which separate two sunlit surfaces or two shaded surfaces will not cast shadows.

Let's make a sunlight-shade analysis of the simple object in Fig. 9–12. The VL is located in the lower right-hand quadrant, therefore indicating that the sun's location is to the left and behind the observer. Through the extreme back left and the front right corners of the object, draw lines on the ground plane to the VH. See Fig. 9–13. These lines establish the verticals which will cast shadows (verticals AB and DE). A light ray drawn to the VL through the top of one of these verticals will establish the length and direction of the cast shadow. See Fig. 9–14. With the sun coming from behind and over the left shoulder of the observer, you should expect the shadow to go in this direction. Therefore, you should analyze that the front and left walls of the object are in sunlight and the right and back walls are in shade. The top is also in sunlight. See Fig. 9–15. The two vertical lines and two horizontal lines which separate the sunlight and shade surfaces are the only lines on the object casting shadows. See Fig. 9–15. By contrast, if the VL were located in the upper right-hand quadrant, indicating the sun is in front of the observer to the right, the sunlight-shade analysis would look like Fig. 9–16.

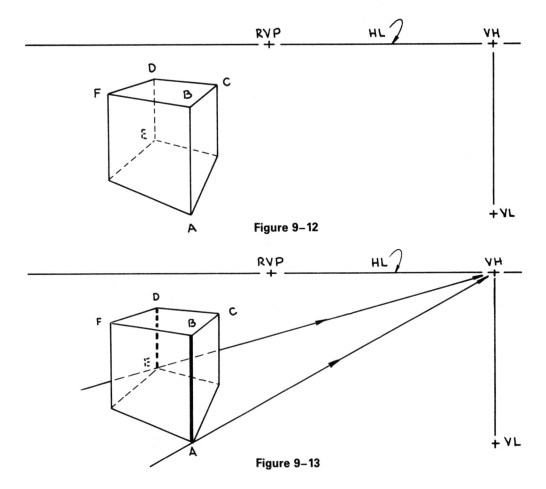

Figure 9–12

Figure 9–13

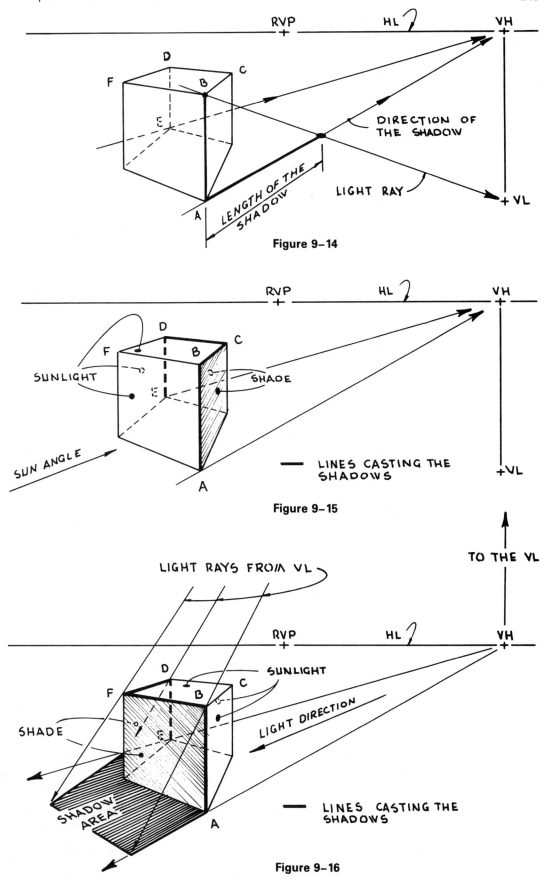

Figure 9-14

Figure 9-15

Figure 9-16

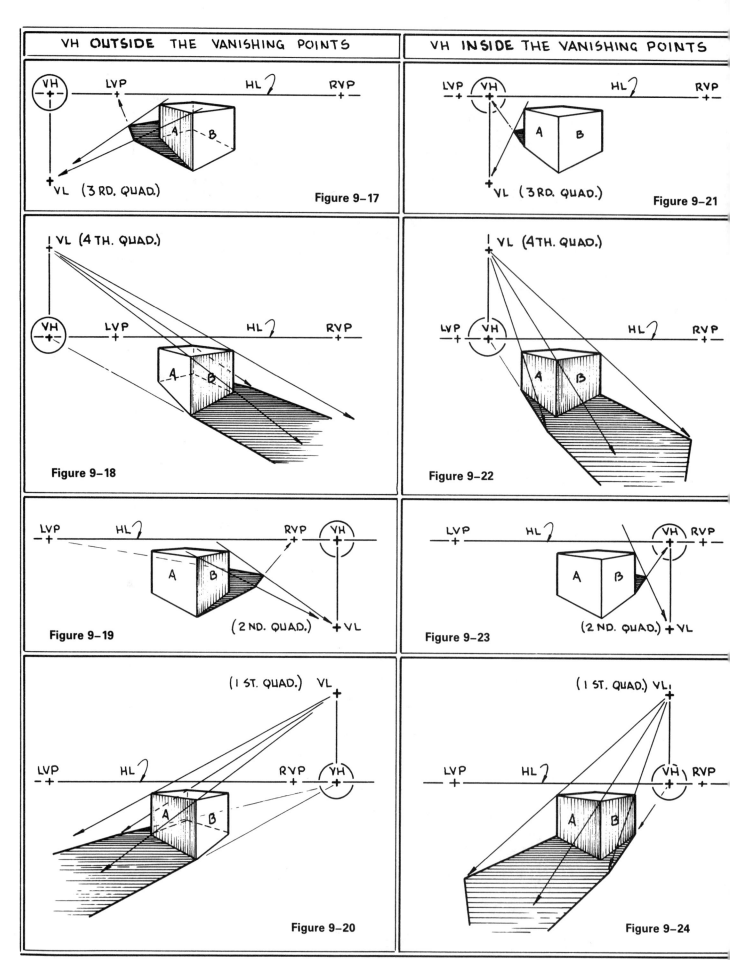

VH **OUTSIDE** THE VANISHING POINTS	VH **INSIDE** THE VANISHING POINTS

VH · LVP · HL · RVP · A · B · VL (3 RD. QUAD.)

Figure 9-17

VH · LVP · HL · RVP · VL (3 RD. QUAD.)

Figure 9-21

VL (4 TH. QUAD.) · VH · LVP · HL · RVP · A · B

Figure 9-18

VL (4TH. QUAD.) · LVP · VH · HL · RVP · A · B

Figure 9-22

LVP · HL · RVP · VH · A · B · (2 ND. QUAD.) VL

Figure 9-19

LVP · HL · VH · RVP · A · B · (2 ND. QUAD.) VL

Figure 9-23

(I ST. QUAD.) VL · LVP · HL · RVP · VH · A · B

Figure 9-20

(I ST. QUAD.) VL · LVP · HL · VH · RVP · A · B

Figure 9-24

You can quickly determine the sunlight and shade surfaces by observing the given location of the VH and VL. When the VH is located *outside* the two vanishing points, sides A and B will be illuminated differently. See Fig. 9–17. One side will be in sunlight, while the other will be in shade. The determining factor for this is the location of the VL. See Figures 9–17, 9–18, 9–19, and 9–20.

When the VH is located *inside* the two vanishing points, sides A and B will be illuminated the same. See Fig. 9–21. Both will either be in sunlight or in shade. The determining factor for this is, again, the location of the VL. See Figures 9–21, 9–22, 9–23, and 9–24.

Knowing how the location of the VH and VL will affect the illumination of these vertical surfaces will help you make a quick sunlight-shade analysis. This analysis may seem like a waste of time on these simple objects, but it will become invaluable when you start to cast shades and shadows on more complicated structures.

9.4 BASIC SHADOW CONSTRUCTION

Having determined the sunlight and shade surfaces on the illuminated object and thereby identifying the lines casting the shadows, you must now construct the shadow using some established rules. The object in Fig. 9–15 will be used for this discussion. The sunlight-shade analysis has been completed, and it was determined that the two vertical and the two horizontal lines darkened are the only lines casting the shadows.

It is very important that you cast the shadow of only one line at a time. Don't worry about the other lines. Cast the shadow of one line and then move on to the next until you have the entire shadow outline complete.

Let's cast the shadow of line AB first. See Fig. 9–25. What kind of line is line AB, and where is its shadow likely to fall? Line AB is a vertical line and its shadow will fall onto the ground plane.

Rule 1. Vertical lines cast shadows onto horizontal surfaces in the horizontal direction of light. They vanish to the VH.

Draw a line through the bottom of line AB to the VH. See Fig. 9–25. The shadow of line AB will lie along this line. To determine the length and direction of this shadow, use rule 2.

Rule 2. The shadow of any point on a vertical line is located on a horizontal surface by projecting a light ray from that point to the horizontal direction line. [See Fig. 9–26.]

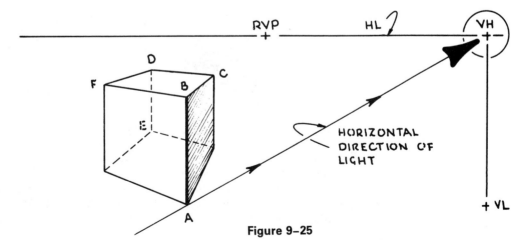

Figure 9–25

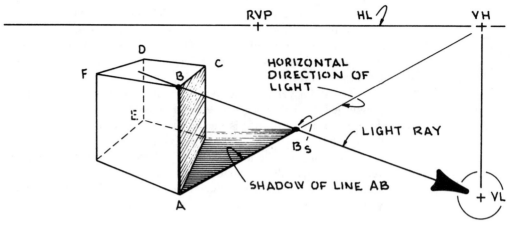

Figure 9–26

Draw a light ray through point B. This light ray intersects the line drawn to the VH locating the shadow of point B on the ground. The shadow of vertical line AB is now complete.

Next, you must cast the shadow of line BC. Again, you must determine what kind of line is casting the shadow and onto which surface the shadow is being cast. In this instance, line BC is a horizontal line casting a shadow onto the horizontal ground plane. You have already cast the shadow of point B onto the ground; therefore, the shadow of line BC will start at that point and proceed in some direction.

Rule 3. When the line casting the shadow is parallel to the surface receiving the shadow, the line and its shadow will vanish to the same vanishing point.

Line BC is parallel to the ground plane. Since line BC vanishes to the right vanishing point (RVP), its shadow will also vanish to the RVP. See Fig. 9–27. A light ray drawn to the VL through point C will locate the shadow of point C on the ground. See Fig. 9–28.

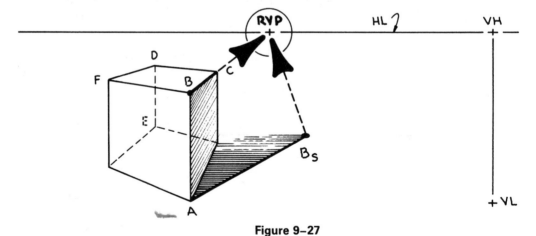

Figure 9–27

Referring to Fig. 9–15, you will notice that line CD is the next line casting a shadow. Rule 3 also applies in this case. Line CD is a horizontal line casting a shadow onto the horizontal ground plane. There is a parallel relationship between the two. Since line CD vanishes to the LVP, its shadow will also vanish to the LVP. See Fig. 9–29. A light ray drawn to the VL through point D will locate the shadow of point D on the ground. See Fig. 9–30.

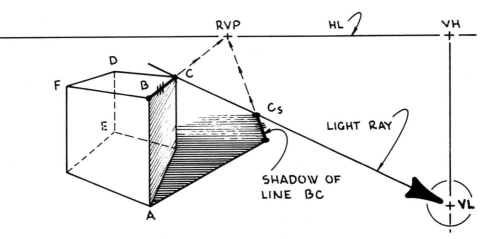

Figure 9–28

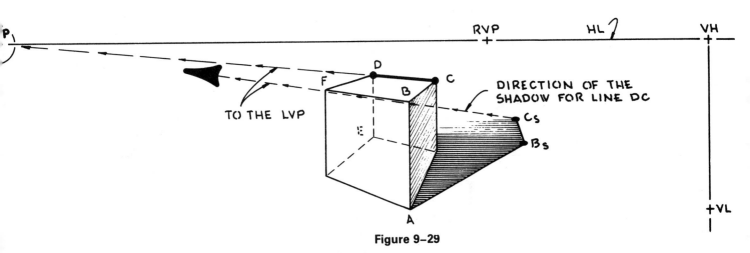

Figure 9–29

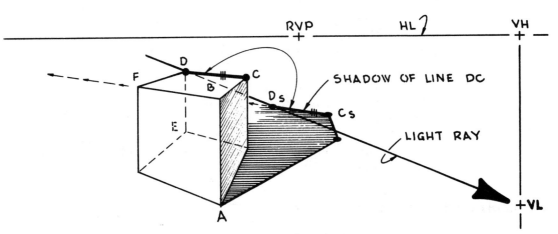

Figure 9–30

The shadow of vertical line DE will fall on the ground in the direction of the VH (rule 1). A line drawn from point E to the VH will go through the shadow of point D. See Fig. 9–31. The outline of the shadow of the object on the ground is now complete.

To illustrate one more rule for casting shadows by the oblique method, let's add a flag pole to the setting in Fig. 9–31. See Fig. 9–32. Because the flag pole is a vertical line and it will cast a shadow onto the horizontal ground plane, the shadow will vanish to the VH (rule 1). Once the shadow reaches the vertical front wall of the object, the shadow must change direction.

Rule 4. All shadows cast by vertical lines onto vertical surfaces will be vertical.

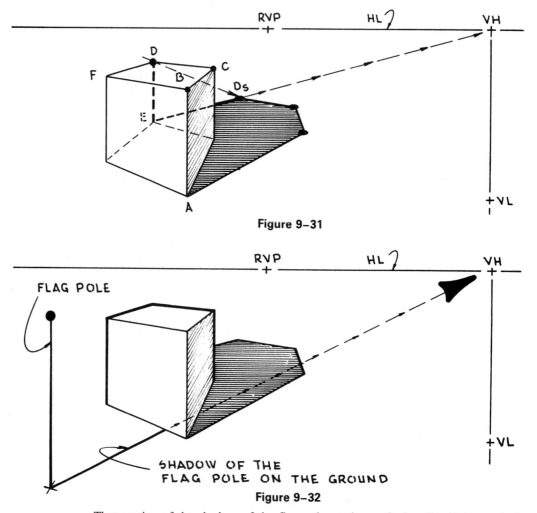

Figure 9–31

Figure 9–32

That portion of the shadow of the flag pole on the vertical wall will be vertical. See Fig. 9–33. The shadow will be terminated by drawing a light ray to the VL through the top of the flag pole.

Figures 9–34 through 9–37 further illustrate the process of casting shadows using the aforementioned rules. The circled number beside each shadow line indicates which rule was used to cast that particular shadow.

9.5 LIGHT HORIZON LINES (THE THEORETICAL SOLUTION)

The four rules just mentioned will allow you to solve many shade and shadow problems. Unfortunately, a working knowledge of these four rules alone will not enable you to deal with all possible situations. Could you correctly cast the shadow of an inclined line onto

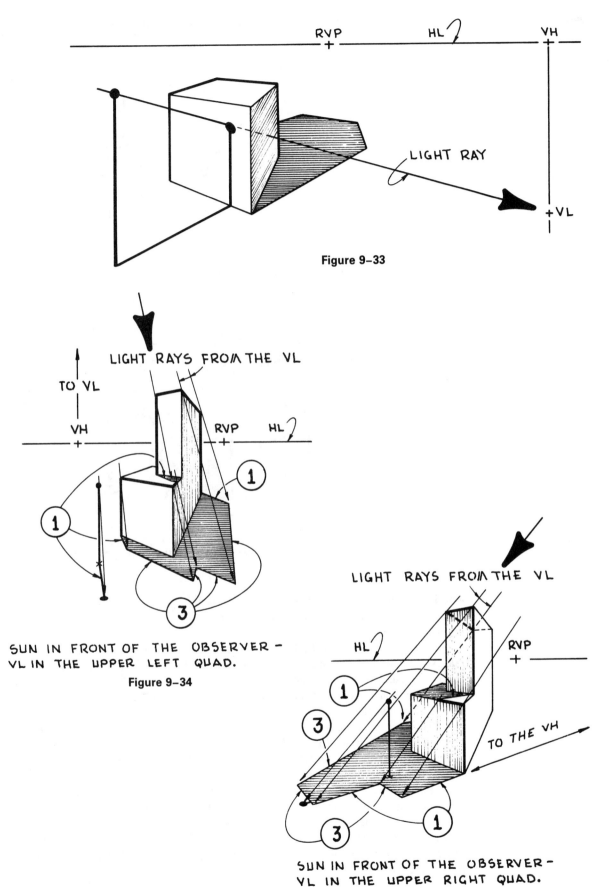

Figure 9–33

SUN IN FRONT OF THE OBSERVER –
VL IN THE UPPER LEFT QUAD.

Figure 9–34

SUN IN FRONT OF THE OBSERVER –
VL IN THE UPPER RIGHT QUAD.

Figure 9–35

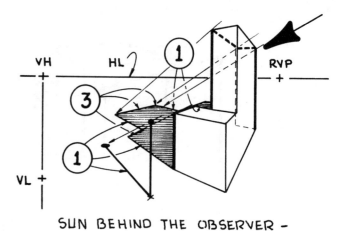

Figure 9–36 SUN BEHIND THE OBSERVER –
 VL IN THE LOWER LEFT QUAD.

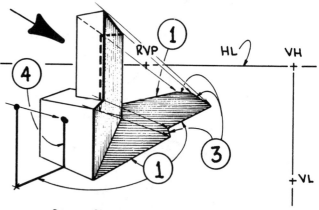

Figure 9–37 SUN BEHIND THE OBSERVER –
 VL IN THE LOWER RIGHT QUAD.

a horizontal surface, or cast the shadow of a vertical line onto an inclined surface? To be able to solve these problems and others, you need to understand the theory behind casting these shadows.

This theory involves the intersection of invisible light planes with visible solid planes. The lines of intersection between these planes are actually the cast shadows. Each individual shadow will vanish to the intersection between the two planes' accompanying horizon lines. It is very important that you understand these concepts. Therefore, a more complete discussion about intersecting planes will follow.

The perspective setting shown in Fig. 9–38 will be used in this discussion. The location of the VL in the lower left-hand quadrant indicates the sun's position as being behind the observer over his or her right shoulder. A good sunlight-shade analysis will identify the lines casting the shadows. See Fig. 9–39.

First, let's cast the shadow of the flag pole onto the ground. As stated before, the air is saturated with light rays. The object casting the shadow, the flag pole in this example, will single out only the light rays that skim by its surface. This selection process creates an invisible plane of light. Because the flag pole is vertical, a vertical plane of light is created. See Fig. 9–40. All the light rays in this vertical plane of light created by the flag pole will vanish to the VL. The actual shadow of the flag pole on the ground will be the line of intersection between this invisible light plane and the ground plane. In

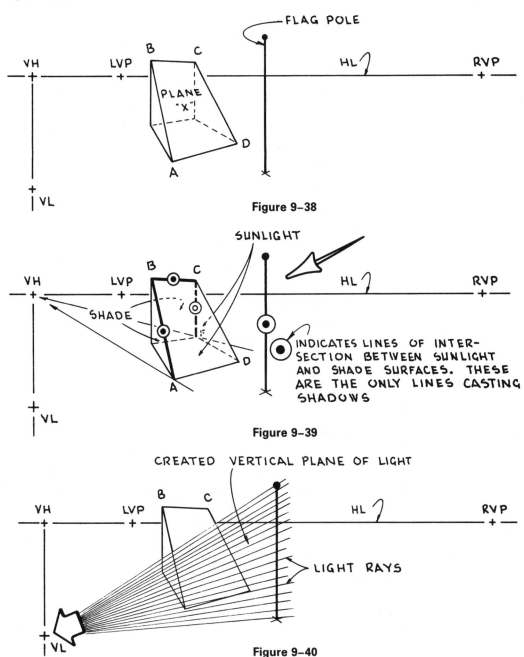

Figure 9-38

Figure 9-39

Figure 9-40

order to find the vanishing point for this shadow, you must find the horizon lines for the intersecting planes. Once you have found the horizon lines, you must extend them, if necessary, until they intersect. This point of intersection between the two planes' horizon lines will be the vanishing point for the shadow in question.

Every plane in space, be it visible or invisible, will have its own horizon line (HL). Visible planes will have visible horizon lines, while invisible light planes will have invisible light horizon lines. Also, vertical planes will have vertical horizon lines, while inclined planes will have inclined horizon lines. Furthermore, almost every line which is contained within a plane will vanish to that plane's own horizon line. Lines which are parallel to the horizon line will not vanish to it. These lines are the only exception.

With this knowledge you should be able to locate the horizon line for each plane with which you are working. In this case, you are working with a vertical light plane and

the ground plane. When locating the horizon line for a vertical or horizontal plane, you must find the vanishing point for only *one* line that is contained within the plane. In other words, if you can locate one point on a nonexistant vertical or horizontal line, you can draw in that line. How many vertical lines can you draw through a single point? Just one. In this case, you are trying to find a single vanishing point on a single horizon line.

Remember, the purpose for this discussion is to enable you to locate the horizon line for the plane of light which was created by the line casting the shadow, as well as to locate the horizon line for the plane or surface which is receiving the shadow. Once you find the intersection between these two horizon lines, you have found the *vanishing point* for the shadow in question.

Referring to the problem in Fig. 9–40, you now want to locate the horizon line for the plane of light created by the flag pole. This vertical plane of light is composed of thousands of individual light rays. Each one is considered to be a line contained within the plane. The vanishing point for each of these light rays is the VL; therefore, the VL must be on the light plane's horizon line. The horizon line for the plane of light is the original vertical light horizon line. See Fig. 9–41. You have now located one of the horizon lines you need to find.

The surface receiving the shadow of the flag pole is the ground plane. The horizon line for the horizontal ground plane is the original horizon line. See Fig. 9–41. You have now located the horizon line for the light plane and the horizon line for the plane receiving the shadow (the ground plane). These two horizon lines intersect at the VH.

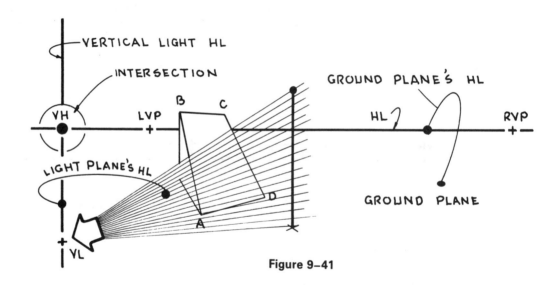

Figure 9–41

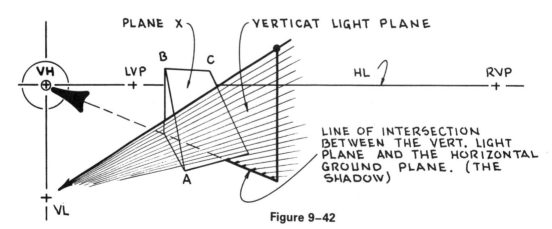

Figure 9–42

Therefore, the shadow cast by the flag pole onto the ground will vanish to the VH. See Fig. 9–42. This fact should not be surprising because this theoretical explanation only proves Rule 1, which states: The shadow cast by a vertical line onto a horizontal surface will vanish to the VH. The shadow formed is actually the line of intersection between the plane of light and the ground plane. See Fig. 9–42.

A light ray drawn through the top of the flag pole to the VL indicates that the entire shadow of the flag pole does not fall onto the ground. A portion of the shadow falls onto the inclined plane. The problem shifts from a vertical line casting a shadow onto a horizontal surface to a vertical line casting a shadow onto an inclined surface. The situation has changed, but the procedure is exactly the same. You must find the horizon line for the created plane of light and then find the horizon line for the surface receiving the shadow. The intersection between these two horizon lines will be the vanishing point for the shadow in question.

Since the line casting the shadow, the flag pole, has not changed, the created plane of light and its accompanying horizon line remain the same. However, the surface receiving the shadow is now inclined plane x instead of the ground plane. Therefore, you can no longer use the original horizon line but must locate the horizon line for plane x. To locate the horizon line for an inclined plane, you must find the vanishing points for *two nonparallel* lines that are contained within that plane. Once you find two points on a straight line, you can draw that line. In this case, you want to find two vanishing points on the same horizon line.

Line BC is in plane x, and it vanishes to the right vanishing point (RVP). See Fig. 9–43. If you were to extend horizontal line EA, it would vanish to the LVP. This would indicate that vertical plane AEB is a left vertical plane, and that all the lines in this plane will vanish to the left vertical horizon line. See Fig. 9–43. Inclined line AB will vanish to VP_1 on the left vertical horizon line. Line AB is not only in plane AEB, but it is also in plane x. Therefore, the vanishing point for line AB (VP_1) is also on the inclined horizon line for plane x. You have now located two vanishing points on the inclined horizon line for plane x (RVP and VP_1). The inclined horizon line is drawn through these two points. See Fig. 9–43. If the vertical light horizon line and the inclined

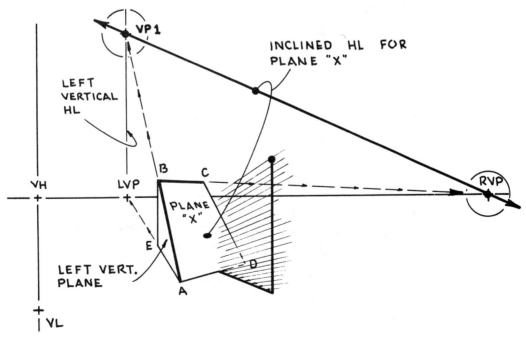

Figure 9–43

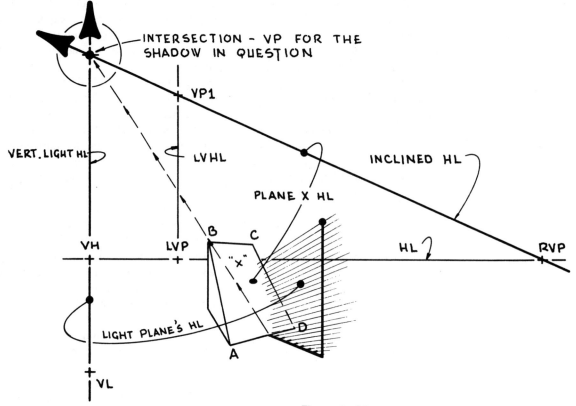

Figure 9-44

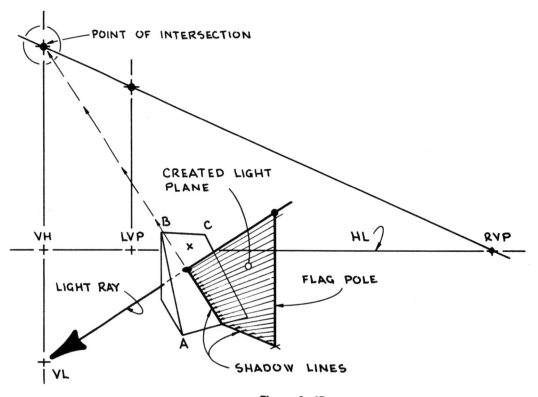

Figure 9-45

horizon line do not intersect, extend them until they do. See Fig. 9–44. This intersection between these two horizon lines is the vanishing point for the shadow cast by the flag pole onto the inclined surface. See Fig. 9–44. A light ray drawn to the VL through the top of the flag pole will terminate the shadow on plane x. See Fig. 9–45.

As you can see in Fig. 9–45, the shadow cast by the flag pole onto the ground and inclined planes is actually the line of intersection between these planes and the vertical plane of light. By using this concept of intersecting planes, you have the ability to cast the shadow of any line onto any surface.

At this point, a review of the general steps you must take when casting the shadow of a line onto another surface might be helpful. These steps apply only when you cannot cast the required shadow using the four basic rules stated earlier.

To draw the shadow of a line cast onto a plane you must proceed as follows:

Step 1. Find the horizon line for the light plane created by the line casting the shadow. This will be a light horizon line and it will *always* go through the VL.

Step 2. Find the horizon line for the plane or surface which is receiving the shadow.

Step 3. Extend these two horizon lines until they intersect.

Step 4. Vanish the shadow in question to this intersection.

The shadow of the flag pole in Fig. 9–45 is now complete, but the shadow of the solid object still must be cast. Refer to Fig. 9–39 and review the sunlight-shade analysis. Three lines on the object will cast shadows — lines AB, BC, and CF. Cast the shadow of only one line at a time.

Again, you begin to cast the shadow of a line by identifying what kind of line is casting the shadow and by determining what type of plane is going to receive the shadow. Let's start with line AB. Line AB is an inclined line, and its shadow will be cast onto the ground plane. The air is still saturated with light rays and only a select few will skim past the edge of solid line AB. Because line AB is an inclined line, these select light rays will form an inclined light plane (plane y). See Fig. 9–46. The line of intersection between this recently created light plane and the ground plane will be the required shadow. This shadow will vanish to the intersection between the inclined light plane's horizon line and the horizon line for the ground plane.

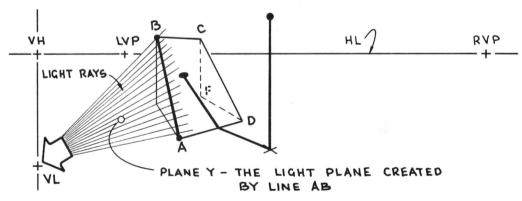

PLANE Y – THE LIGHT PLANE CREATED
BY LINE AB

Figure 9–46

In order to find the inclined light horizon line for the created plane of light, you must locate the vanishing point for two nonparallel lines contained within that plane. Since the individual light rays making up the light plane vanish to the VL, you can consider the VL to be one of the required vanishing points. See Fig. 9–47. When trying to locate any *light* horizon line, remember that all light horizon lines will go through the VL. Since the line casting the shadow (line AB) actually created the light plane, it is

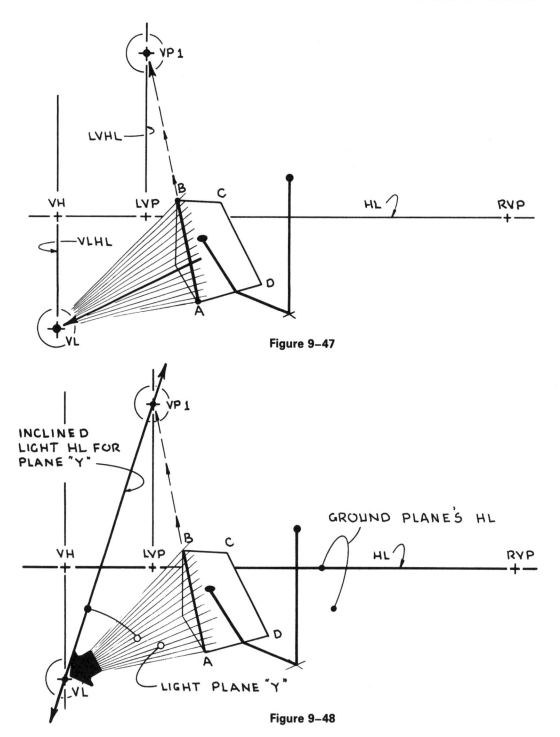

Figure 9–47

Figure 9–48

also contained within that plane. Line AB vanishes to VP₁ on the left vertical horizon line. See Fig. 9–47. This is another vanishing point on the inclined light horizon line. Now that you have two vanishing points on the same horizon line, you can draw it. See Fig. 9–48.

Now you need to locate the horizon line for the plane receiving the shadow. In this case it is the ground plane, and its horizon line is the original horizon line. See Fig. 9–48. The intersection between the inclined light horizon line and the original horizon line is called VH', and it is the vanishing point for the shadow cast by line AB onto the ground. See Fig. 9–49. A light ray drawn to the VL through point B will terminate the

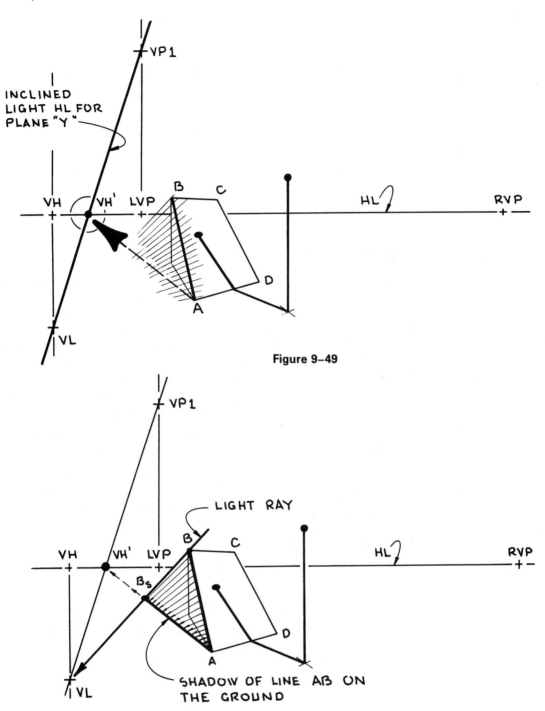

Figure 9–49

Figure 9–50

shadow. See Fig. 9–50. As you can see, the shadow of line AB on the ground is actually the line of intersection between the inclined light plane and the ground.

According to the sunlight-shade analysis, line BC casts the next shadow. Since line BC is a horizontal line and its shadow is going to fall onto a horizontal surface, line BC and its shadow will vanish to the same vanishing point (rule 3). The shadow of line BC will start at the shadow of point B, already located, and will vanish to the right vanishing point (RVP). See Fig. 9–51. A light ray drawn to the VL through point C will terminate this shadow. The shadow of vertical line CF will be drawn to the VH (rule 1). See Fig. 9–51. The shadow outline of the object is now complete.

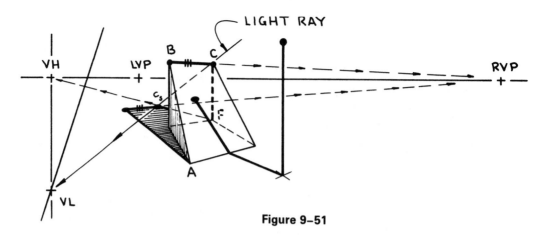

Figure 9-51

9.6 EXPANDING PLANES (THE PRACTICAL SOLUTION)

It is important that you understand the basic theory of casting oblique shades and shadows. Consequently, the theory of intersecting planes has been presented, using the one example completed in Fig. 9–51. Without this basic knowledge it would be very difficult for you to deal with the many different situations you might encounter when casting shadows. You should now be able to generalize this information and apply it to different settings.

Sometimes, however, the theoretical solution to the problem is not always practical. In other words, the vanishing point for the shadow in question, the intersection between the two horizon lines, is not always accessible. In these cases you need to use a common sense approach to the problem. The following statement outlines an important concept:

> The shadow cast by a given line onto a given surface will vanish to the intersection between the line casting the shadow and the surface receiving the shadow.

In many cases, this solution to the problem will require you to extend both the line casting the shadow and the surface receiving the shadow until they intersect.

The following three examples will further explain this technique.

Example 1. See Fig. 9–52.

GIVEN: 1. Slant-board and box (The slant-board is resting against the box.)

2. Lines AB and CD in right vertical planes*

3. Location of the HL, VPs, VH, and VL

*Any line that is in a right vertical plane will vanish to the right vertical horizon line (a vertical line drawn through the RVP).

Required: Cast the shadow of lines AB and CD onto the ground and box.

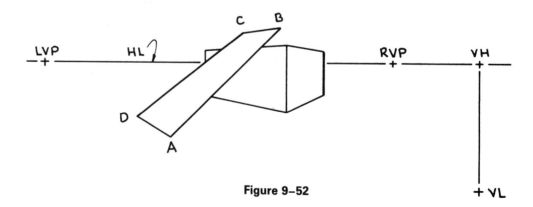

Figure 9-52

Step 1. See Fig. 9–53.

 1a. Locate the light horizon line for the plane of light created by line AB.

Step 2. See Fig. 9–54.

 2a. Locate the horizon line for the plane receiving the shadow — the original HL.

 2b. The intersection between the inclined light horizon line (ILHL) and the original horizon line locates VH'.

 2c. The shadow of line AB cast onto the ground will vanish to VH'.

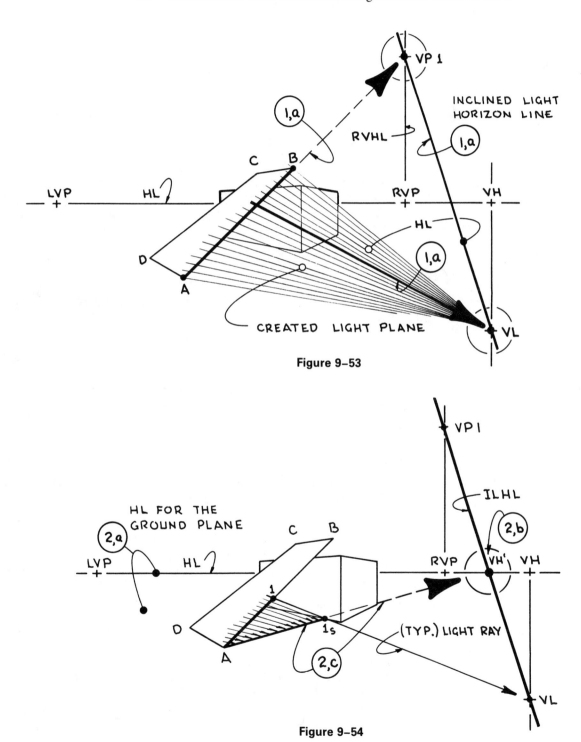

Figure 9–53

Figure 9–54

Step 3. See Fig. 9–55.

3a. Line AB is still creating the same inclined light plane; therefore, the same light horizon line is used.

3b. The left vertical side of the box is now receiving the shadow. The horizon line for this plane is the left vertical horizon line (a vertical line through the LVP).

3c. Extend both the left vertical horizon line and the inclined light horizon line until they intersect. This intersection will be the vanishing point for the shadow cast by line AB onto the side of the box.

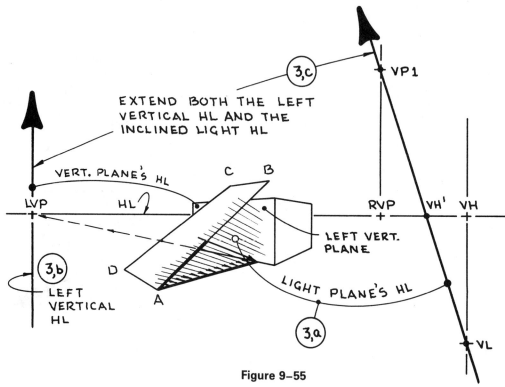

Figure 9–55

Statement 1. Since this intersection appears to be inaccessible, you must think in terms of locating the intersection between the line casting the shadow and the surface receiving the shadow.

Step 4. See Fig. 9–56.

4a. Since the slant board is resting against the box, line AB is already intersecting with the plane receiving the shadow at point x.

4b. Therefore, the shadow cast by line AB onto the box will vanish to this point.

4c. Notice that if you were to extend this shadow line, it would indeed vanish to the inaccessible intersection between the inclined light horizon line and the left vertical horizon line. The theoretical solution would work, but, in this case, it is not very practical.

Note: Notice that the two shadow lines are actually the lines of intersection between the created light plane and the two surfaces receiving the shadows. See Fig. 9–56.

Step 5. See Fig. 9–57.

5a: Line CD is parallel to line AB. Therefore, the shadow of line CD cast onto the ground will also vanish to the VH′.

5b. The shadow of line CD cast onto the box will vanish to the intersection between line CD and the side of the box receiving the shadow (point y).

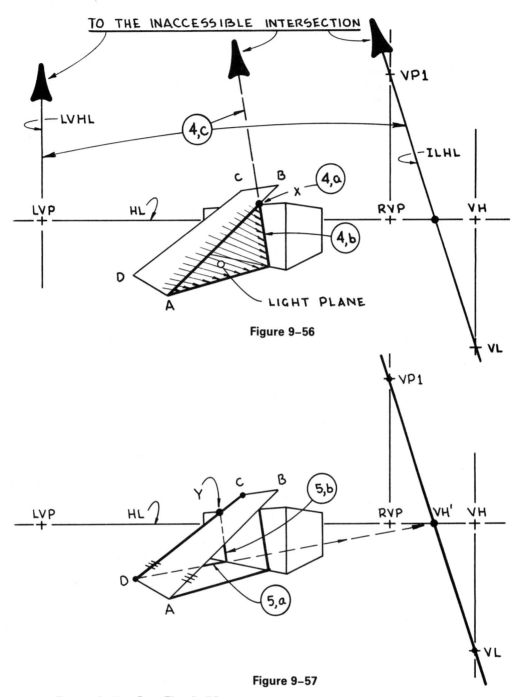

Figure 9–56

Figure 9–57

Example 2. See Fig. 9–58.

GIVEN: 1. Multi-level object

 2. Location of the HL, VPs, VH, and VL

Required: Cast the shadows of lines AB and BC.

 Step 1. See Fig. 9–58.

 1a. Vertical line AB casts a shadow onto the ground plane in the direction of the VH (rule 1).

 1b. A light ray drawn to the VL through point B will locate the shadow of B on the ground (rule 2).

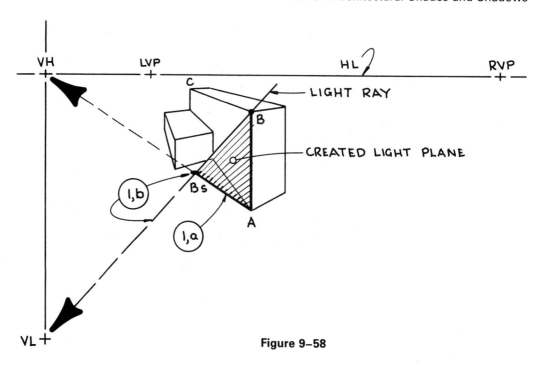

Figure 9–58

Step 2. See Fig. 9–59.

2a. Horizontal line BC casts a shadow onto the horizontal ground plane in the direction of the LVP (rule 3).

Statement 1. The shadow of line BC will next fall onto vertical plane y. The theoretical solution to this situation would have you locate the light horizon line for the plane of light created by line BC. Then locate the horizon line for the plane receiving the shadow. Intersect these two horizon lines and you have the vanishing point for the shadow in question. This may or may not be a practical solution to the problem, however. Let's work through the problem and see.

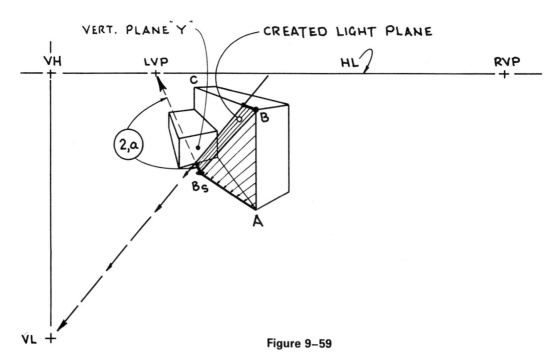

Figure 9–59

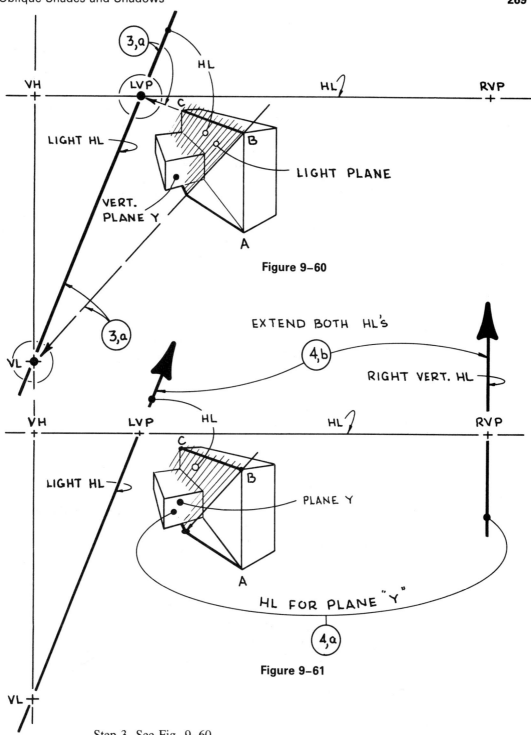

Figure 9–60

Figure 9–61

Step 3. See Fig. 9–60.

3a. The line casting the shadow (BC) vanishes to the LVP, and the light rays which comprise the created light plane vanish to the VL. Therefore, the light horizon line goes through the LVP and the VL.

Step 4. See Fig. 9–61.

4a. The plane receiving the shadow (plane y) is a right vertical plane. This means its horizon line is a vertical line through the RVP.

4b. Extend both the right vertical horizon line and the light horizon line until they intersect.

Statement 2. Since this intersection appears to be inaccessible, you must think in terms of locating the intersection between the line casting the shadow (BC) and the surface receiving the shadow (plane y).

Step 5. See Fig. 9–62.

5a. Expand plane y vertically until it intersects with line BC at point x.

5b. The shadow of line BC cast upon vertical plane y will vanish to point x.

Step 6. See Fig. 9–63.

6a. Notice that if you were to extend this shadow line, it would likely vanish to the intersection between the right vertical horizon line (RVHL) and the light horizon line. Here, again, the more practical solution works better.

6b. The portion of the shadow cast by line BC onto horizontal plane z will vanish to the LVP (rule 3).

Example 3

GIVEN: 1. Solid object

2. Inclined surface

3. HL, VPs, VH, and VL

Required: Cast the shadow of lines AB, BC, and CD.

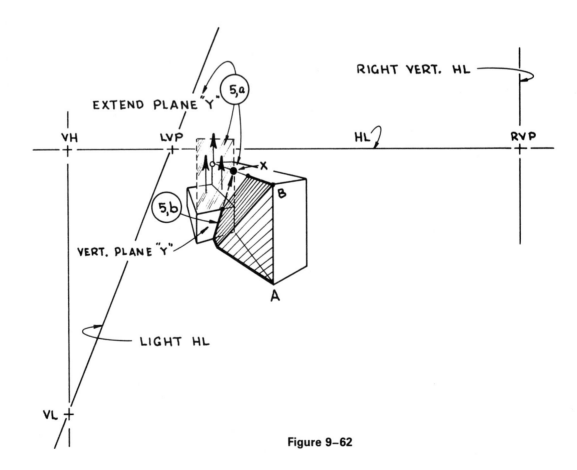

Figure 9–62

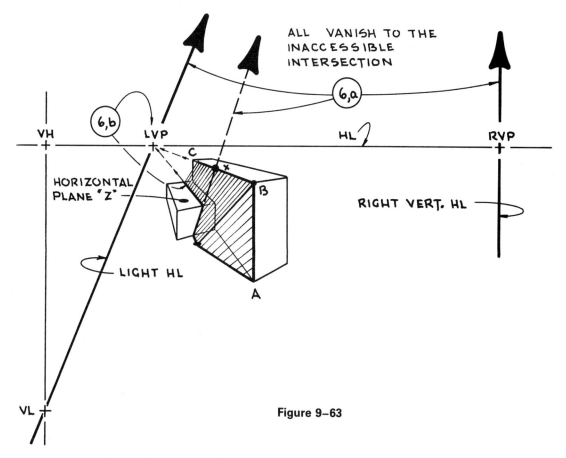

Figure 9–63

SOLUTION 1 — THEORETICAL SOLUTION

The vanishing point for the shadow is at the intersection between the horizon lines. See Figures 9–64 through 9–67.

Note: Circled numbers refer to the rule which applies in casting that particular shadow line.

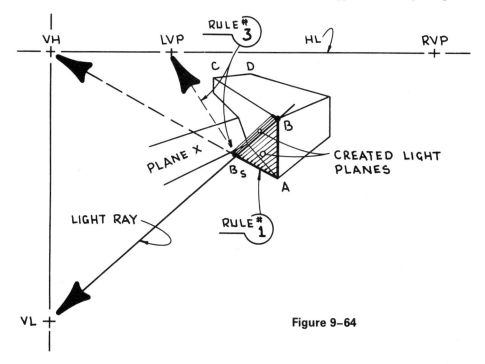

Figure 9–64

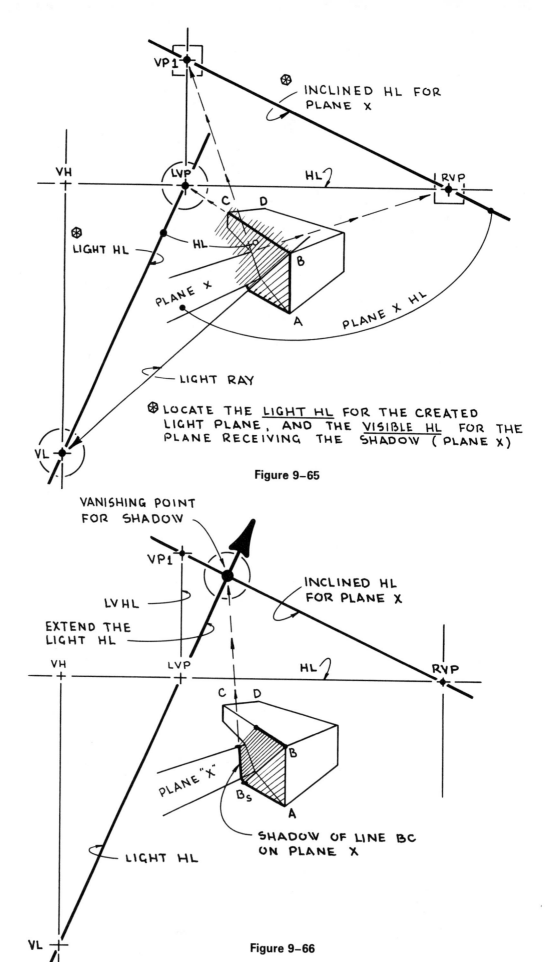

VP1

⊛ INCLINED HL FOR PLANE X

VH

LVP

HL

RVP

⊛ LIGHT HL

HL

C D

PLANE X

B

A

PLANE X HL

LIGHT RAY

VL

⊛ LOCATE THE <u>LIGHT HL</u> FOR THE CREATED LIGHT PLANE, AND THE <u>VISIBLE HL</u> FOR THE PLANE RECEIVING THE SHADOW (PLANE X)

Figure 9-65

VANISHING POINT FOR SHADOW

VP1

INCLINED HL FOR PLANE X

LVHL

EXTEND THE LIGHT HL

VH LVP HL RVP

C D

PLANE "X"

B

Bs

A

SHADOW OF LINE BC ON PLANE X

LIGHT HL

VL

Figure 9-66

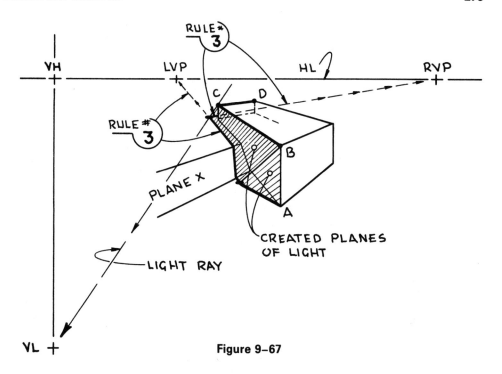

Figure 9-67

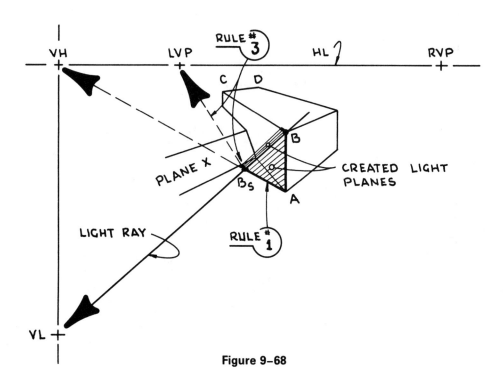

Figure 9-68

SOLUTION 2 — PRACTICAL SOLUTION

Extend the plane receiving the shadow to intersect the line casting the shadow. See Figures 9–68 through 9–71.

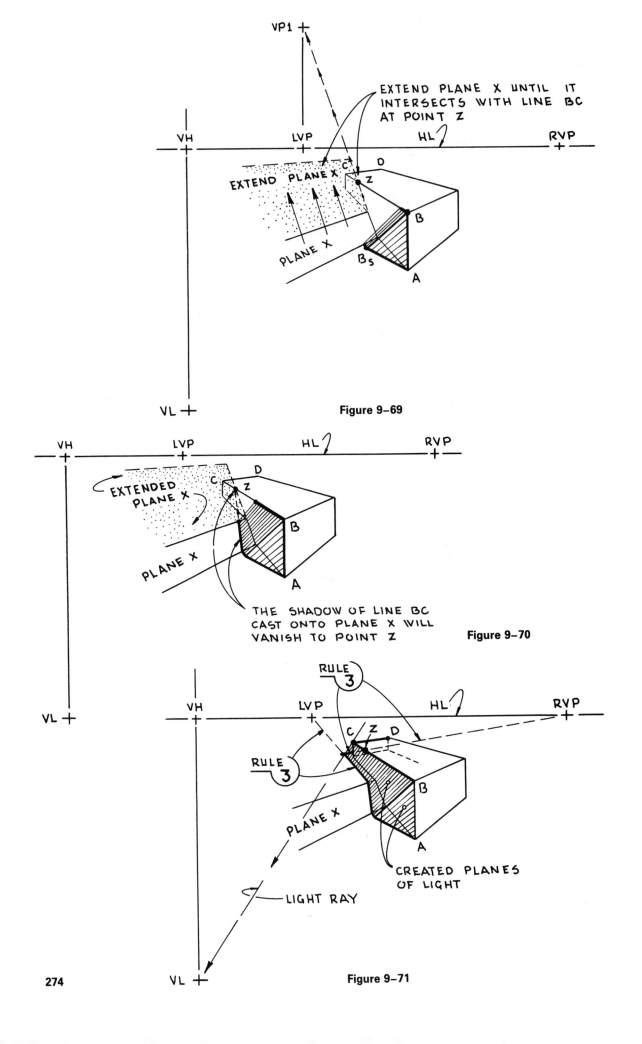

VP1

EXTEND PLANE X UNTIL IT
INTERSECTS WITH LINE BC
AT POINT Z

VH LVP HL RVP

EXTEND PLANE X

PLANE X

Figure 9-69

VH LVP HL RVP

EXTENDED
PLANE X

PLANE X

THE SHADOW OF LINE BC
CAST ONTO PLANE X WILL
VANISH TO POINT Z

Figure 9-70

RULE
3

VH LVP HL RVP

RULE
3

PLANE X

CREATED PLANES
OF LIGHT

LIGHT RAY

VL

Figure 9-71

Statement 1. Both the practical and the theoretical solutions for casting the shadow of line BC onto the inclined plane are illustrated in Fig. 9–72. Notice that both solutions give the same results. The shadow cast onto plane x vanishes to both located intersections. When one solution doesn't work, try the other.

At this point, it might be wise to restate the rules and concepts used in casting oblique shades and shadows.

Rule 1. Vertical lines cast shadows onto horizontal surfaces in the horizontal direction of light. They vanish to the VH.

Rule 2. The shadow of any point on a vertical line is located on a horizontal surface by projecting a light ray from that point to the horizontal direction line.

Rule 3. When the line casting the shadow is parallel to the surface receiving the shadow, the line and its shadow will vanish to the same vanishing point.

Rule 4. All shadows cast by vertical lines onto vertical surfaces will be vertical.

Concept of Intersecting Planes. The shadow cast by a line onto a given plane will vanish to the intersection of that plane's horizon line and the light horizon line for the light plane which was created by the line casting the shadow.

Concept of Extending Planes. In order to find the shadow of a line cast onto a surface, you must extend the surface which is receiving the shadow until it intersects the line casting the shadow. This point of intersection will be the vanishing point for the shadow in question.

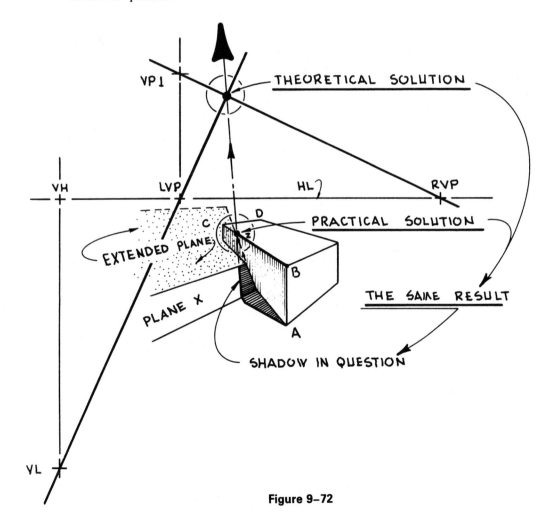

Figure 9–72

9.7 LINE-TO-SURFACE CROSS-REFERENCE

The following pages are designed to give you a quick reference to specific examples of different situations that you might encounter when casting shades and shadows by the oblique method. The standard procedure when working with shade and shadow problems is first to make a complete sunlight-shade analysis to determine which lines are going to cast shadows. Taking one line at a time, identify what type of line is casting the shadow and determine what type of surface the shadow is likely to fall upon. Use the appropriate rule or concept to cast that particular shadow.

The following cross-reference and index is provided to help you locate the most appropriate example for the particular situation. Each example is identified by the type of line casting the shadow, the type of surface receiving the shadow, and the relationship between the two.

		SURFACE SHADOW IS CAST UPON		
		VERTICAL	HORIZONTAL	INCLINED
LINE CASTING SHADOW	VERTICAL	Case 1	Case 2	Case 3
	HORIZONTAL	Case 4	Case 5	Case 6
	INCLINED	Case 7	Case 8	Case 9

CASE #	DESCRIPTION	PAGE #
1	Vertical Onto Vertical	277
2	Vertical Onto Horizontal	277
3	Vertical Onto Inclined	279
4	Horizontal Onto Vertical Subcase 1. Nonparallel Subcase 2. Perpendicular Subcase 3. Variable	280
5	Horizontal Onto Horizontal	282
6	Horizontal Onto Inclined Subcase 1. Nonparallel Subcase 2. Parallel	283
7	Inclined Onto Vertical	285
8	Inclined Onto Horizontal	288
9	Inclined Onto Inclined	288

CASE 1: VERTICAL LINE CASTING SHADOW ON VERTICAL SURFACE

Rule 4. All shadows cast by vertical lines onto a vertical surface will be vertical.

NEED: 1. VL
 2. VH

PROCEDURE: Draw the shadow of vertical line AB. See Fig. 9–73.

 Step 1. From point B draw a line to the VH (rule 1).
 Step 2. At the point where the shadow of line AB first intersects the vertical wall, draw a vertical.
 Step 3. A light ray drawn through point A to the VL will locate the shadow of A on the vertical wall.
 Extra: To complete the shadow outline —
 Step 4. The shadow of line AC on the vertical wall will vanish to point C (concept of extending planes).

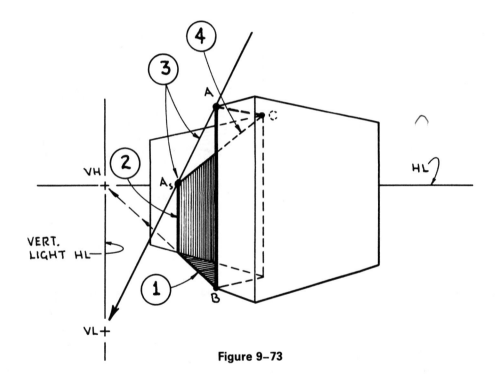

Figure 9–73

CASE 2: VERTICAL LINE CASTING SHADOW ON HORIZONTAL SURFACE

Rule 1. Vertical lines cast shadows onto horizontal surfaces in the horizontal direction of light. They vanish to the VH.

NEED: 1. VL
 2. VH

PROCEDURE 1: Draw the shadow of vertical line AB. See Fig. 9–74.

 Step 1. From the bottom of vertical line AB draw a line to the VH.

 Step 2. Draw a light ray through point A to the VL, locating the shadow of A on the ground.

PROCEDURE 2: Draw the shadow of vertical line CD. See Fig. 9–75.

 Step 1. To find the shadow of vertical line CD, which falls onto the ground, project line CD to the ground at point O.

 Step 2. Draw the shadow of line CD on top of the block and the ground plane by the same steps given in procedure 1.

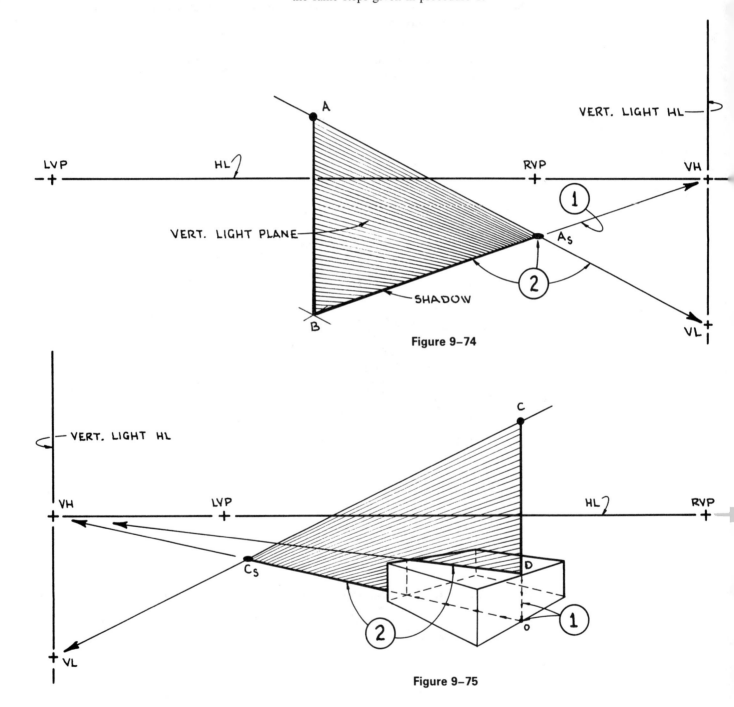

Figure 9–74

Figure 9–75

CASE 3: VERTICAL LINE CASTING SHADOW ON INCLINED SURFACE
Concept of intersecting planes (See pages 254–264.)

NEED: 1. VH, VL
2. Vertical horizon line
3. Vertical light horizon line
4. Inclined horizon line for inclined plane
5. Intersection of vertical light horizon line and inclined horizon line

PROCEDURE: Draw the shadow of vertical line AB. See Fig. 9–76.

Step 1. Draw a line from the bottom of vertical AB to the VH. This will locate the shadow of line AB on the horizontal ground plane (rule 1).

Step 2. The light horizon line for the vertical light plane created by the flag pole is a vertical line through the VH.

Step 3. To find the horizon line for the inclined plane x, you must locate the vanishing points for two nonparallel lines which are in plane x. Extend lines EC and CD to find their vanishing points (LVP, VPEC).

Step 4. Draw the inclined horizon line through the LVP and VPEC and extend it until it intersects the vertical light horizon line at point O.

Step 5. The shadow of the flag pole on the inclined plane will vanish to point O.

Extra: To complete the shadow outline —

Step 6. The remainder of the shadow of the flag pole will fall on the horizontal surface in the direction of the VH (rule 1).

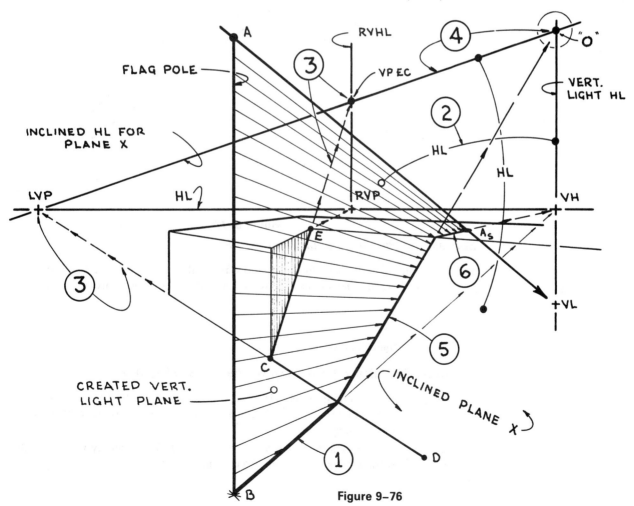

Figure 9–76

CASE 4: HORIZONTAL LINE CASTING SHADOW ON VERTICAL SURFACE

Subcase 1. Parallel relationship (Fig. 9–77)
Subcase 2. Perpendicular relationship (Fig. 9–78)
Subcase 3. Variable relationship (Fig. 9–79)

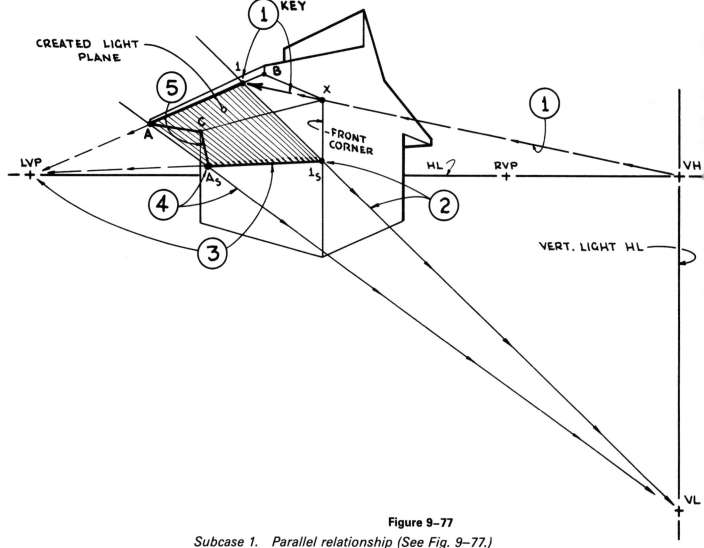

Figure 9–77

Subcase 1. Parallel relationship (See Fig. 9–77.)

Rule 3. When the line casting the shadow is parallel to the surface receiving the shadow, the line and its shadow will vanish to the same vanishing point.

NEED: 1. VL
 2. VH
 3. Vanishing points

PROCEDURE: Draw the shadow of line AB. See Fig. 9–77.

Step 1. Draw a line from the VH through point x to line AB. This will locate the exact point (point 1) on line AB casting a shadow into the front corner of the building.

Step 2. Draw a light ray to the VL through point 1. This light ray will locate the shadow of point 1 on the front corner.

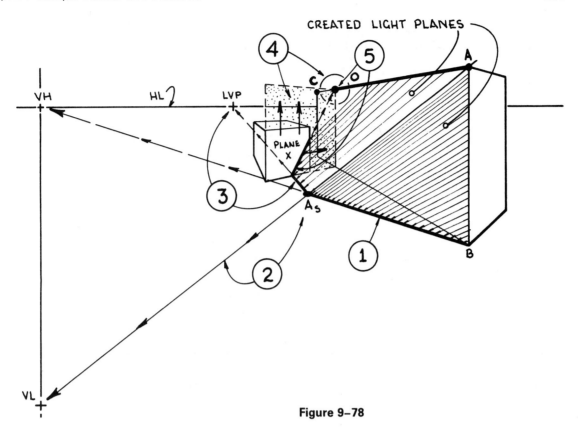

Figure 9–78

Step 3. Line AB vanishes to the LVP; therefore, its shadow will also vanish to the same point (rule 3).

Step 4. A light ray drawn to the VL through point A will locate its shadow.

Extra: To complete the shadow outline—

Step 5. The shadow of line AC on the vertical wall will vanish to point C (concept of extending planes).

Subcase 2. *Perpendicular relationship (Fig. 9–78)*

Concept of extending planes (See pages 264–271.)

NEED: 1. VL

 2. VH

 3. Intersection between planes

PROCEDURE: Draw the shadow of horizontal line AC.

Step 1. The shadow of vertical line AB falls on the ground in the direction of the VH (rule 1).

Step 2. A light ray drawn through point A to the VL will locate the shadow of point A on the ground (rule 2).

Step 3. The shadow of line AC falls on the ground in the direction of the LVP (rule 3).

Step 4. Extend vertical plane x until it intersects the line casting the shadow (line AC).

Step 5. The shadow of line AC on vertical plane x will vanish to this intersection (point O).

Subcase 3. Variable relationship (Fig. 9–79)
Concept of extending planes (See pages 264–271.)

NEED: 1. VL
 2. VH
 3. Intersection between planes

PROCEDURE: Draw the shadow of line AB.

 Step 1. The shadow of vertical line AC falls on the ground in the direction of the VH (rule 1).
 Step 2. A light ray drawn to the VL through point A locates its shadow on the ground (rule 2).
 Step 3. The shadow of horizontal line AB falls on the ground in the direction of vanishing point AB (rule 3).
 Step 4. Extend vertical plane x to the right until it intersects the line casting the shadow at point O.
 Step 5. The shadow of line AB on vertical plane x will vanish to this intersection.

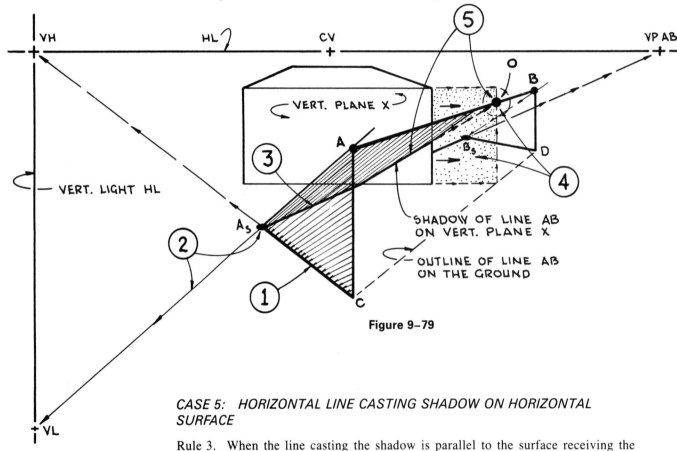

Figure 9–79

CASE 5: HORIZONTAL LINE CASTING SHADOW ON HORIZONTAL SURFACE

Rule 3. When the line casting the shadow is parallel to the surface receiving the shadow, the line and its shadow will vanish to the same vanishing point.

NEED: 1. VH, VL
 2. Vanishing points

PROCEDURE: Draw the shadow of line AB. See Fig. 9–80.

 Step 1. The shadow of vertical line BD falls on the ground along a line drawn from the VH (rule 1).

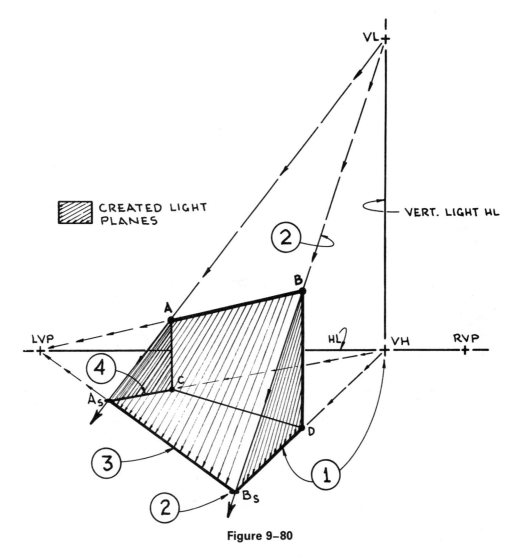

Figure 9–80

Step 2. A light ray drawn from the VL through point B locates the shadow of point B on the ground (rule 2).

Step 3. The shadow of line AB will vanish to the left vanishing point (rule 3).

Extra: To complete the shadow outline —

Step 4. The shadow of vertical line AC falls on the ground along a line drawn from the VH.

CASE 6: HORIZONTAL LINE CASTING SHADOW ON INCLINED SURFACE

Subcase 1. Nonparallel relationship (Fig. 9–81)

Subcase 2. Parallel relationship (Fig. 9–82)

Subcase 1. Nonparallel relationship (See Fig. 9–81.)

Concept of intersecting planes (See pages 254–264.)

NEED: 1. VL, VH

2. Vertical horizon line

3. Inclined horizon line for the inclined plane

4. Vertical light horizon line

5. Intersection of the light horizon line with the inclined horizon line

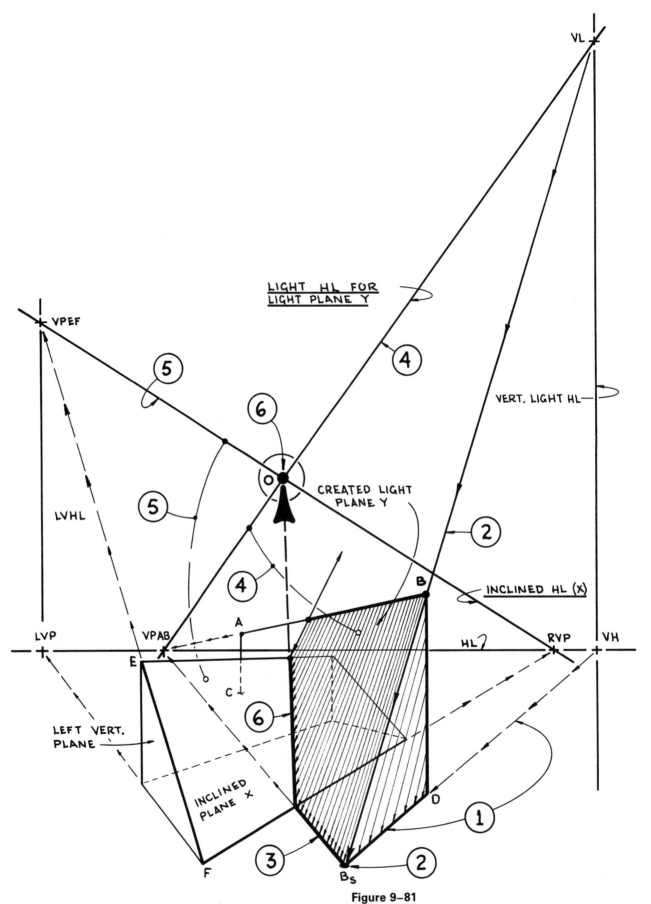

Figure 9–81

PROCEDURE: Draw the shadow of line AB. See Fig. 9–81.

Step 1. The shadow of vertical line BD falls on the ground along a line drawn from the VH (rule 1).

Step 2. A light ray drawn from the VL through point B locates its shadow on the ground (rule 2).

Step 3. Because line AB is parallel to the ground, the portion of its shadow falling onto the ground will vanish to vanishing point AB (VPAB) (rule 3).

Step 4. Locate the light horizon line for the created light plane y.

Step 5. Locate the horizon line for the plane receiving the shadow (inclined plane x).

Step 6. The portion of the shadow of line AB which falls on inclined plane x will vanish to the intersection between the light horizon line and the inclined horizon line (point O).

Subcase 2. Parallel relationship (See Fig. 9–82.)

Rule 3. When the line casting the shadow is parallel to the surface receiving the shadow, the line and its shadow will vanish to the same vanishing point.

NEED: 1. VH, VL, VPs
 2. Vertical horizon line
 3. Inclined horizon line
 4. Vertical light horizon line
 5. Intersection of the inclined horizon line and the vertical light horizon line

PROCEDURE: Draw the shadow of line AB. See Fig. 9–82.

Step 1. Vertical line AC is casting a shadow onto inclined plane x. The light horizon line for the plane of light created by line AC is the original vertical light horizon line.

Step 2. The inclined horizon line for plane x, the plane receiving the shadow, goes through the LVP and VP_1.

Step 3. Extend this inclined horizon line until it intersects the vertical light horizon line at point O.

Step 4. The shadow of vertical line AC cast upon inclined plane x will vanish to point O.

Step 5. A light ray drawn through point A from the VL will locate the shadow of point A on the roof.

Step 6. Line AB, the line now casting the shadow, is a horizontal line which vanishes to the LVP. All the horizontal lines contained within plane x, the plane receiving the shadow, vanish to the LVP. There is a parallel relationship between line AB and plane x. Therefore, line AC and its cast shadow on plane x must vanish to the same vanishing point (LVP).

Step 7. A light ray drawn through point B from the VL will locate the shadow of point B on the roof.

CASE 7: INCLINED LINE CASTING SHADOW ON VERTICAL SURFACE
Concept of intersecting planes (See pages 254–264.)

NEED: 1. VH, VL
 2. Vertical horizon lines
 3. Inclined light horizon line
 4. Intersections of the light horizon line and two horizon lines

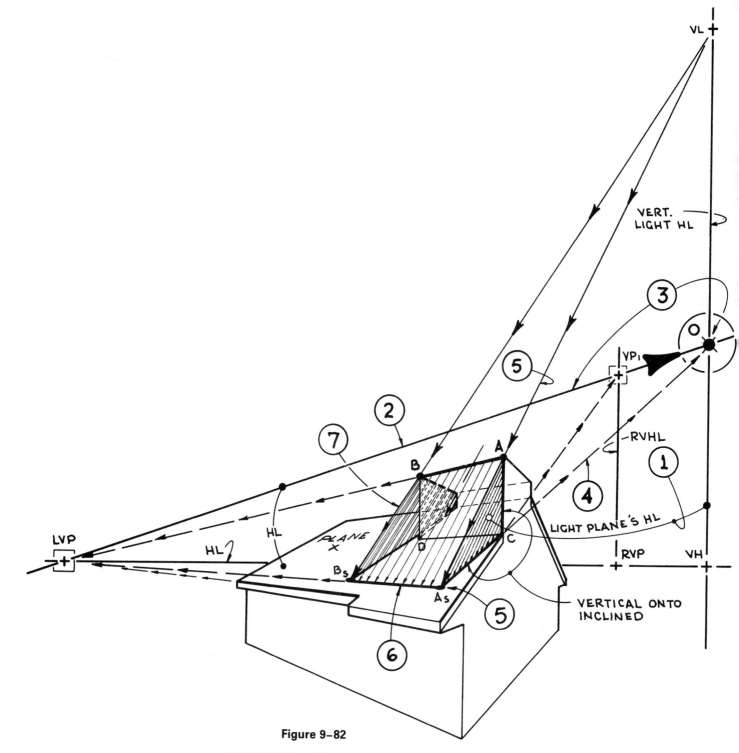

Figure 9-82

PROCEDURE: Draw the shadow of line AB. See Fig. 9–83.

Step 1. Locate the inclined light horizon line for the created plane of light y.

Step 2. Locate the horizon line for the plane receiving the shadow, the ground plane.

Step 3. The portion of the shadow cast by line AB onto the ground will vanish to the intersection of the light horizon line and the original horizon line (point O).

Step 4. Locate the horizon line for the left vertical plane — the plane now receiving the shadow.

Step 5. The portion of the shadow cast by line AB onto the left vertical plane will vanish to the intersection of the light horizon line and the left vertical horizon line (point Z).

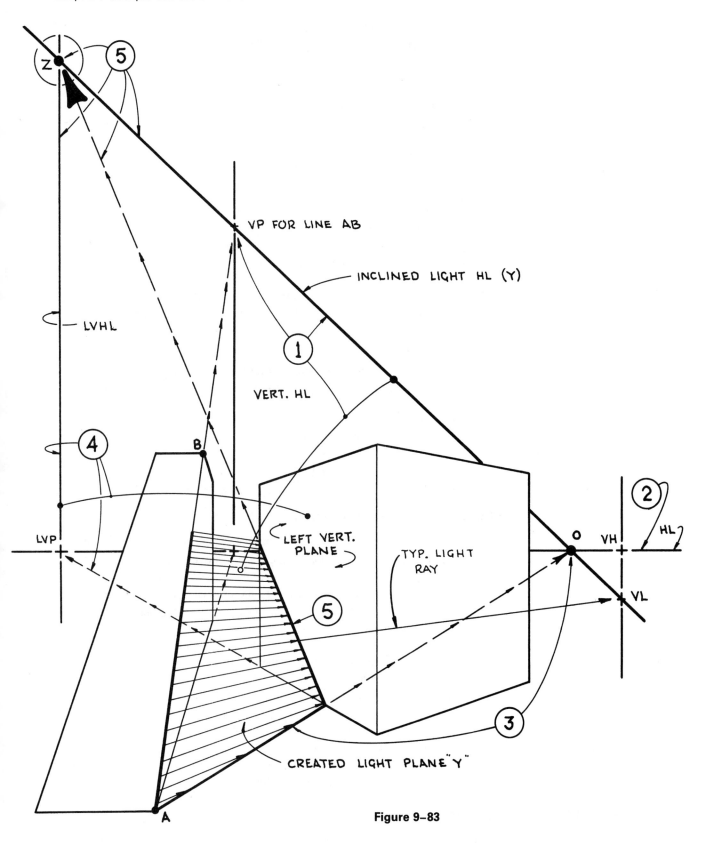

VP FOR LINE AB

INCLINED LIGHT HL (Y)

LVHL

VERT. HL

①

B

④

LEFT VERT.
PLANE

TYP. LIGHT
RAY

Z

⑤

LVP

⑤

O VH

②

HL

VL

③

A

CREATED LIGHT PLANE "Y"

Figure 9–83

CASE 8: INCLINED LINE CASTING SHADOW ON HORIZONTAL SURFACE
Concept of intersecting planes (See pages 254–256.)

NEED: 1. VH, VL
 2. Vertical horizon line
 3. Inclined light horizon line
 4. Intersection of the light horizon line and the original horizon line

PROCEDURE: Draw the shadow of line AB. See Fig. 9–84.

Step 1. The shadow of vertical line BC cast onto the ground will vanish to the VH (rule 1).

Step 2. A light ray drawn through point B to the VL will locate the shadow of point B on the ground (rule 2).

Step 3. Locate the inclined light horizon line for the created plane of light y.

Step 4. Locate the horizon line for the plane receiving the shadow, the ground plane — the original HL.

Step 5. The shadow cast by line AB onto the ground will vanish to the intersection of the light horizon line and the original horizon line (point O).

Step 6. A light ray drawn through point A to the VL will locate the shadow of point A on the ground.

CASE 9: INCLINED LINE CASTING SHADOW ON INCLINED SURFACE
Concept of intersecting planes (See pages 254–256.)

NEED: 1. VH, VL
 2. Two vertical horizon lines
 3. Inclined horizon line
 4. Inclined light horizon line
 5. Intersection of the inclined light horizon line and two visible horizon lines

PROCEDURE: Draw the shadow of line AB. See Fig. 9–85.

Step 1. Locate the inclined light horizon line for the created plane of light y.

Step 2. Locate the horizon line for the plane receiving the shadow (the ground).

Step 3. The shadow cast by line AB onto the ground will vanish to the intersection of the light horizon line and the original horizon line (point O).

Step 4. Locate the horizon line for inclined plane x — the plane now receiving the shadow.

Step 5. The portion of the shadow cast by line AB onto inclined plane x will vanish to the intersection of the light horizon line and the inclined horizon line (point Z).

Extra: To complete the shadow of line AB —

Step 6. The portion of the shadow cast by line AB onto the horizontal surface will vanish to the intersection of the light horizon line and the original horizon line (point O).

Step 7. A light ray drawn through point A to the VL will locate the shadow of point A and terminate the shadow.

9.8 LIGHT RAY ANGLE DATA

The previous discussion has presented the rules and basic concepts used when casting shadows by the oblique method. Many examples were given, and they all had one fact in common. The locations of the VH and the VL were already established in each case.

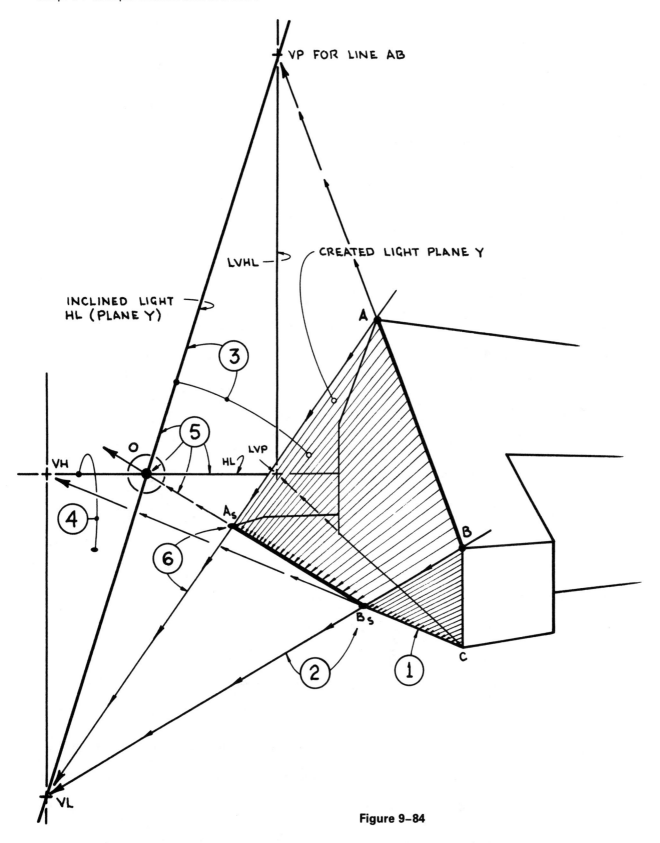

Figure 9-84

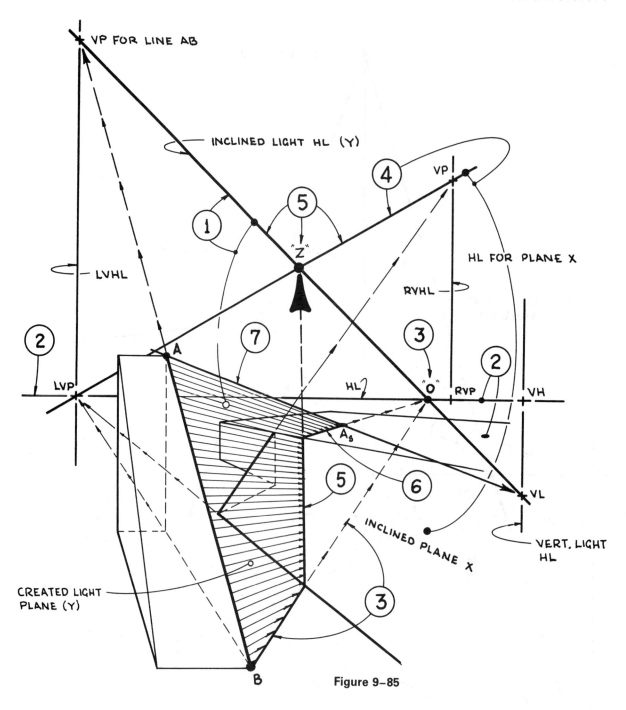

Figure 9–85

This was done to expedite the learning process. A more realistic situation would be for you to locate the VH and the VL. You could use your knowledge about the resultant shade and shadow effects on the object when the VL is located in each of the four quadrants or you could use given light ray data.

With all the current emphasis on energy-efficient construction, it is conceivable that you might have to develop an illustration that accurately depicts the effects of the sun at a given time and place. This would require some knowledge about the angular nature of the light ray.

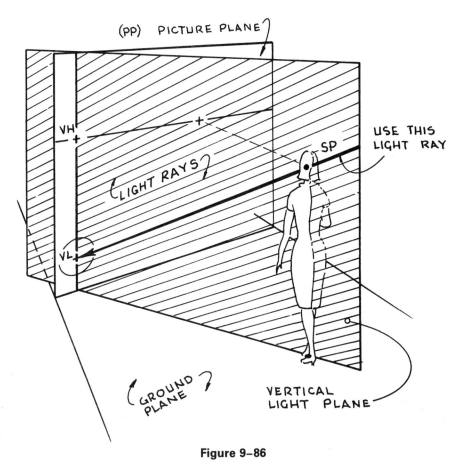

Figure 9–86

For the purpose of this discussion, the single light ray which goes through the observer's eye and pierces the picture plane at the VL will be used. See Fig. 9–86. This light ray has three angular properties:

1. Plan angle of light
2. Elevation angle of light
3. True angle of light

The plan angle of light is the resultant angle between the light ray and the picture plane. See Fig. 9–87. This angle can be measured between the picture plane and the projected outline of the light ray onto the ground plane. Another line drawn parallel to the picture plane through the projection of the station point will form the same angle. See Fig. 9–87.

The elevation and plan views of this perspective setting in Fig. 9–87 are illustrated in Fig. 9–88. Notice that the plan angle of light does not appear in the elevation view. The plan angle of light appears only in the plan view. Therefore, the plan angle of light is always drawn from the station point (SP) in relation to a line drawn parallel to the picture plane. See Fig. 9–88.

The elevation angle of light is the angle formed between the light ray and an imaginary horizontal plane represented by the horizon line (HL). See Fig. 9–89. By projecting the light ray into the picture plane, a line is formed on the picture plane which will allow you to measure this angle.

The elevation and plan views of this perspective setting in Fig. 9–89 are illustrated in Fig. 9–90. Notice that the elevation angle of light does not appear in the plan view of this setting. The elevation angle of light appears only in the elevation view. Therefore,

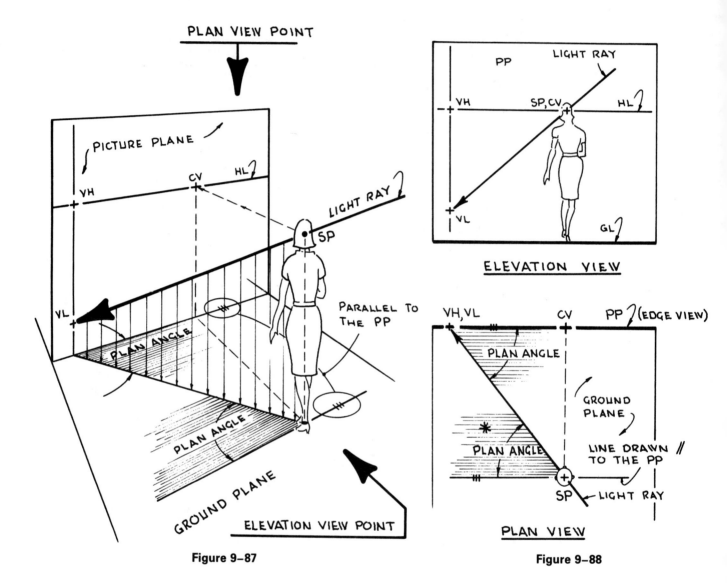

Figure 9–87

Figure 9–88

the elevation angle of light is always drawn from the center of vision (CV) in relation to the horizon line. See Fig. 9–90.

In order to record accurately the true angle of light, you must rotate the light ray into the picture plane. See Fig. 9–91. This operation is illustrated best in the plan view of the perspective setting in Fig. 9–92. With your compass set at the distance between the VH and the station point (SP), draw an arc and extend it until it intersects the PP,HL at point x. Now refer to the elevation view of the perspective setting in Fig. 9–92. Draw a line from point x to the VL. The angle this line makes with the horizon line will be the true angle of light.

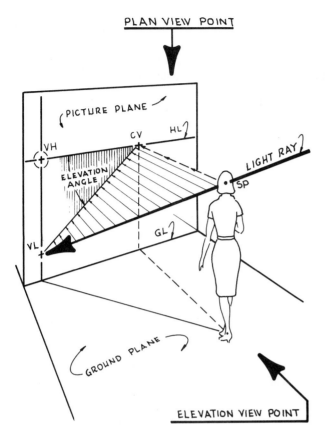

Figure 9–89

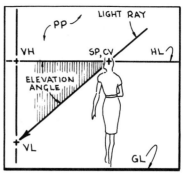

ELEVATION VIEW

PLAN VIEW

Figure 9–90

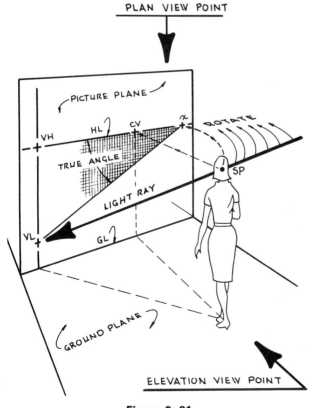

Figure 9–91

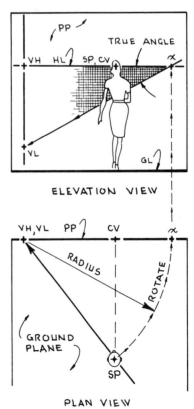

ELEVATION VIEW

PLAN VIEW

Figure 9–92

If you were to superimpose the plan and elevation views, you would have a composite illustration showing all three angles as they would appear in a standard setup. See Fig. 9–93.

Let's now take this information and locate the VH and VL using given light ray data.

Example 1

GIVEN: 1. Plan angle of light: 52°
 2. Elevation angle of light: 38°
 3. True angle of light: 28°
 *4. Location of the sun: From behind over the observer's left shoulder

*You can solve this problem by having only three of the four items given. However, you must know the plan angle of light and the location of the sun.
Required: Locate the VH and VL.

With the location of the sun to the left and behind the observer, the VL will be located in the lower right quadrant. You must draw the plan angle of light so that the VL will be located in this quadrant. The plan angle of light is drawn from the station point (SP) and it is used to locate the VH on the PP,HL. You have two options when drawing the plan angle of light—draw it to the left or draw it to the right. See Fig. 9–94. Since the VH and VL have a vertical relationship, the 52° plan angle of light must be drawn to the right in this case. This action will locate the VH to the right of the center of vision (CV), making it possible to locate the VL directly below the VH in the lower right quadrant. See Fig. 9–94. A vertical line drawn through the VH is called the vertical light horizon line.

The elevation angle of light is always drawn from the center of vision in relation to the horizon line. See Fig. 9–95. Because the VL can be located in any of the four quadrants, the elevation angle of light can be drawn in four different directions. Since the VL is to be located in the lower right quadrant, the 38° elevation angle of light will be drawn to the right below the horizon line (option 3). See Fig. 9–95. This angle extended intersects the vertical light horizon line at the VL. Based on the given angle data, the VL and VH are now located, ready to be used to cast all the required shadows.

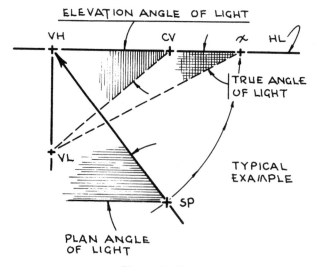

Figure 9–93

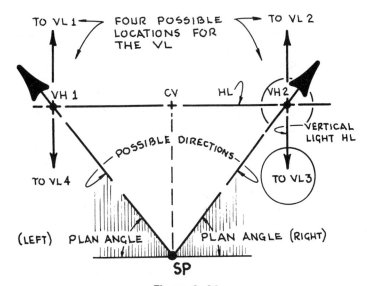

Figure 9–94

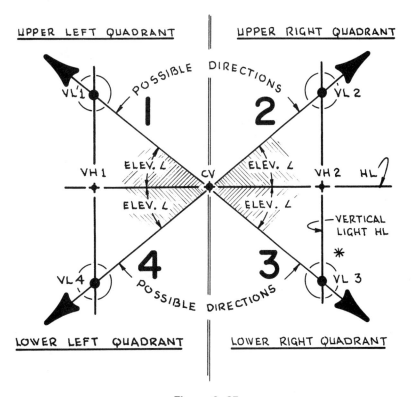

Figure 9–95

Summary Statement

Any discussion of perspective drawing or casting perspective shades and shadows should always be based on the concept of intersecting planes. This is a difficult concept for many students to understand because much visualization is required. Every line drawn in perspective and every shadow cast represents a line of intersection between two planes. Perspective drawing involves visible planes and an invisible plane of reference. The process of casting shades and shadows involves lines of intersection between visible planes and invisible light planes. If the student can understand this basic concept, the process of drawing perspectives and casting shades and shadows will seem more logical and much easier. Therefore, the material in this chapter represents a logical presentation of this basic concept. All the figures were drawn in a way to illustrate this concept of intersecting planes.

Theoretical solutions to shade and shadow problems were discussed. When these solutions were not appropriate, a more practical solution was suggested. Also, a line-to-surface cross-reference was given to help the student refer to an appropriate example of the type of problem in question.

The procedure to use when solving a complicated shade and shadow problem is to break the object down into individual lines which are casting shadows onto a particular surface.

Finally, the angular nature of the light ray was discussed. This information is important to the student who is given a problem of casting shadows of an object with the sun in a specified location.

All this information was presented to help the student realize the natural and logical solution to these complicated shade and shadow problems.

10

Multi-view Shades and Shadows

10.1 INTRODUCTION

The multi-view method is the most popular method for casting shades and shadows. One reason for its popularity is that it is a more predictable way to cast shadows. This predictability is a function of the plan and elevation angles created by the light rays used with this method. Both angles formed are 45°. Because of this unique situation, the length of a shadow cast by an overhang will equal the depth of that overhang. Many architectural illustrators use this fact to enhance their elevation drawings.

The normal front elevation drawing of a structure is represented by only two dimensions—height and width. See Fig. 10–1A. Accurately cast shadows by the multi-view method can add the third dimension—depth. See Fig. 10–1B. At the same time

A B

Figure 10–1

you are enhancing your drawing, you are also giving the observer more information about the structure. If you draw a two-foot shadow cast by an overhang, the knowledgeable observer will realize that this shadow was created by a two-foot overhang. You can relate depth information without drawing a side elevation.

Many architectural illustrators use this technique to create pleasing architectural renderings in elevation. See Fig. 10–2. These drawings are used for presentation purposes or as effective designs on cover sheets for sets of architectural drawings.

For the architectural illustrator who knows how to draw perspectives, this technique is used to cast shadows on the perspective drawing. The actual shadows are constructed on the elevation drawings and then transferred to the completed perspective drawing. Because of the aforementioned predictability of this method, with a little practice, many illustrators skip the construction work on the elevation drawings and draw the shadows directly on the perspective. You would not want to do this in the classroom, however.

Figure 10–2

10.2 BASIC THEORY

Before you are able to draw shadows directly on the perspective drawing, you must first develop a good working knowledge of the multi-view shades and shadow method. This working knowledge should be based on the theory behind the multi-view method as well as the rules you must follow when casting shadows by this method. The following discussion will cover some basic theory and will give some detailed examples.

The term *multi-view* shades and shadows comes from the fact that you construct the shadows on the multi-view drawings of the structure—the architectural elevations. Therefore, it is not surprising that the typical light ray that creates these shadows is best illustrated by the typical multi-view drawing setup. The traditional definition for the light ray used in the multi-view method is considered to be the body diagonal of a cube. See Fig. 10–3. The light ray would enter the upper left front corner of the cube and exit through the lower back right corner. The resultant multi-view drawings of this light ray are shown in Fig. 10–4. Notice that in each view the light ray makes a 45° angle with the horizontal or vertical plane.

In most architectural renderings the ideal situation would be to have the front of the structure in direct sunlight and the side in shade. This illumination pattern makes the structure easier to render. Dictates of each assignment might make this impossible, but illuminating the front of the structure is preferable. Depending on the alignment of the structure with the picture plane, you may want to change the direction of the light rays. If the perspective shows the front and left sides of the structure, you will want to bring

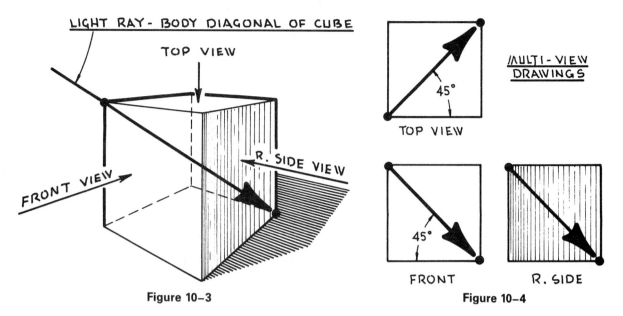

Figure 10–3

Figure 10–4

the light in from the right. This action will put the left side of the structure in shade. In this case the standard light ray would be the body diagonal of the cube, but this time it would enter the upper right front corner and exit through the lower back left corner. See Fig. 10–5. The multi-view drawings of the light ray in this alignment are shown in Fig. 10–6.

The traditional direction of the light rays illustrated in Fig. 10–4 will be used in most of the following examples. The top (plan) and the front (elevation) views of the light ray will be used the most. The only change made in the standard alignment for

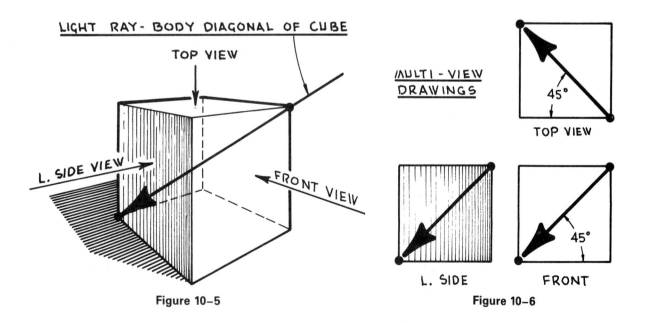

Figure 10–5

Figure 10–6

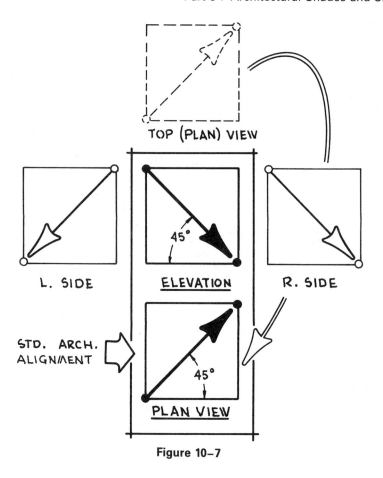

Figure 10–7

these multi-view drawings will be to move the plan view directly below the elevation view. See Fig. 10–7. This is done to conform with standard architectural practices.

10.3 SHADOWS OF POINTS

To start this discussion on multi-view shades and shadows, let's cast the shadows of individual points, then of lines, and then of solid objects. Shadows of most complicated structures can be broken down into cast shadows of individual points and lines. The key to this method is to construct the shadows on the multi-view drawings and then to transfer them to the drawn perspective.

Let's consider point A located x distance from the vertical wall (plan view) and y distance above the ground plane (elevation view). See Fig. 10–8. Point A is casting its shadow either onto the wall or onto the ground plane. To start this procedure, draw 45° lines through both the plan and elevation views of point A. See Fig. 10–9. Be sure these two 45° lines are drawn correctly—based upon the traditional direction of light. Refer to Fig. 10–7. The light ray drawn in the plan view intersects the vertical wall before the light ray drawn in the elevation view intersects the ground. Because of the 45° nature of the light ray, this action means point A is closer to the wall than to the ground. Casual observation would also determine this fact. Since the light ray drawn through the plan view of point A strikes the wall first, you must project that piercing point into the elevation view with a vertical line. See Fig. 10–9. Note: Whenever you project a point from the plan view into the elevation view, use a vertical line.

Where the vertical line of projection intersects the 45° light ray drawn in the elevation view locates the shadow of point A on the wall. See Fig. 10–9. This point shadow obviously does not represent the entire shadow pattern for this example. The next step in

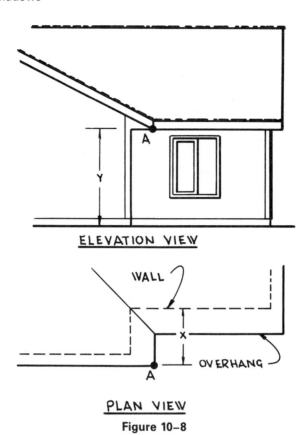

ELEVATION VIEW

PLAN VIEW

Figure 10-8

ELEVATION VIEW

PLAN VIEW

Figure 10-9

the process would be to transfer the shadow of point A to the drawn perspective. See Fig. 10–10. When transferring the shadow from the multi-view drawings to the perspective, you can use existing architectural features as a guide. In this case you would want to use the window.

Let's try another example where the point shadow falls on the ground plane. Point B on the roof system of the house in Fig. 10–11 is x distance from the vertical wall and y distance above the ground plane. Draw 45° lines through the plan and elevation views of point B. See Fig. 10–11. Notice that the 45° line drawn in the elevation view intersects the ground plane first. Therefore, project this point of intersection into the plan view to locate the shadow of point B on the ground. See Fig. 10–11. Using the sidewalk as a guide, transfer this point shadow to the perspective. See Fig. 10–12.

Casting the shadows in the previous two examples required use of only the plan and the front elevation views. Sometimes you must use the side view as well. To cast the shadow of point C in Fig. 10–13, draw 45° lines through the plan and the elevation views of point C. With the information given, it is impossible to locate the point where the light ray intersects the roof. Besides the elevation and the plan views of the house, the right side view is also required to solve this problem. See Fig. 10–14. Note: In the standard multi-view setup, the front and the side views must line up horizontally. This

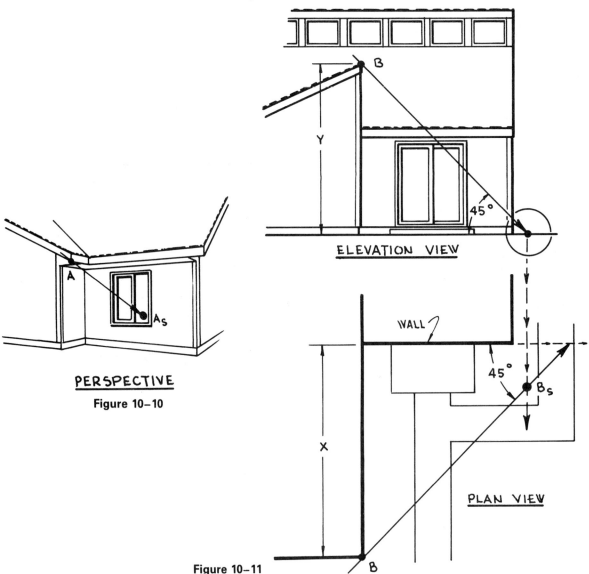

ELEVATION VIEW

PERSPECTIVE

Figure 10–10

WALL

PLAN VIEW

Figure 10–11

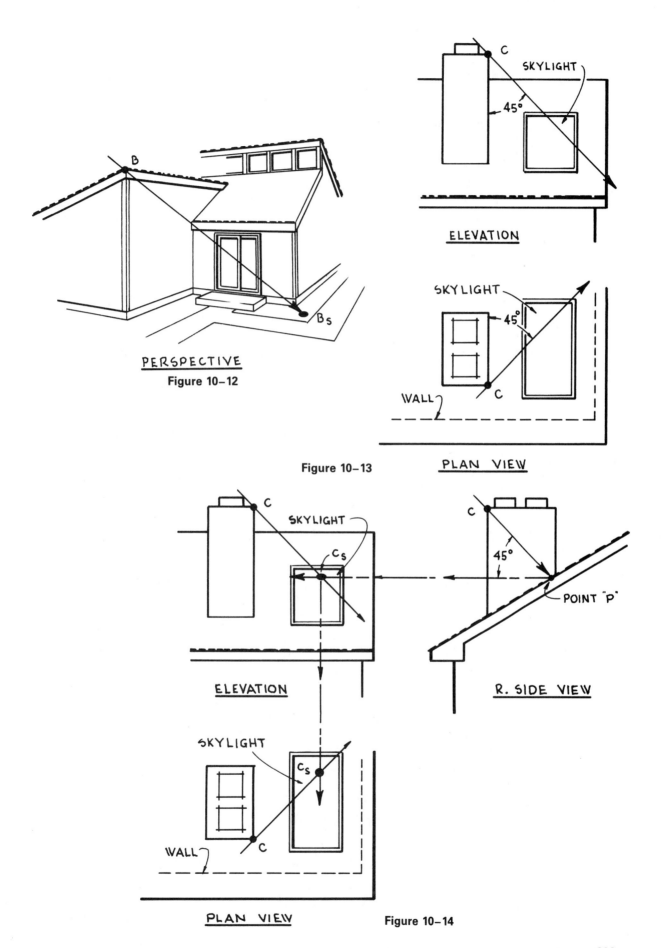

PERSPECTIVE
Figure 10-12

ELEVATION

SKYLIGHT

45°

C

SKYLIGHT

45°

WALL

C

Figure 10-13

PLAN VIEW

C

SKYLIGHT

C_s

ELEVATION

SKYLIGHT

C_s

C

WALL

PLAN VIEW

C

45°

POINT "P"

R. SIDE VIEW

Figure 10-14

alignment will allow you to project points from one view to the other. Horizontal lines will be used in this process.

Through the side view of point C, draw a 45° line. See Fig. 10–14. This light ray intersects the roof at point P. Using a horizontal line, project point P into the front elevation view. The point where this horizontal line intersects the light ray in the front view locates the shadow of point C on the roof.

Project the shadow of point C from the elevation view into the plan view. In this instance the shadow of point C will appear in both views. See Fig. 10–14. Using the skylight as a guide, transfer the shadow from the multi-view drawings to the perspective sketch. See Fig. 10–15.

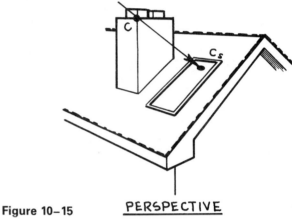

Figure 10–15 <u>PERSPECTIVE</u>

10.4 SHADOWS OF STRAIGHT LINES

Next, we want to cast the shadows of straight lines. These shadow patterns can be characterized by the relationship between the line casting the shadow and the surface receiving the shadow. The three relationships in question are parallel, perpendicular, and inclined. Each case will be treated separately.

CASE 1: LINE PARALLEL TO SURFACE

Statement 1: *When the line casting the shadow is parallel to the surface receiving the shadow, the line and its shadow will be parallel.*

Line AB, the bottom edge of the fascia illustrated in Fig. 10–16, will cast a shadow onto the vertical wall of the house. There is a parallel relationship between line AB and the wall. With this knowledge, to locate the shadow of line AB you need only to cast the shadow of a single point on that line. Locate randomly point C on line AB. See Fig. 10–17. Draw 45° lines through both the plan and the elevation views of point C. One of the 45° lines intersects the wall at point x before the other 45° line intersects the ground at point y. See Fig. 10–17. Projecting point x into the elevation view will locate the shadow of point C on the vertical wall. A horizontal line drawn through the shadow of point C represents the shadow of line AB on the vertical wall. Using the door and the window as a guide, transfer this shadow from the multi-view drawings to the perspective sketch. See Fig. 10–18. Notice in Fig. 10–17 that the length of the shadow equals the depth of the overhang. This fact is a function of the 45° light ray.

CASE 2: LINE PERPENDICULAR TO SURFACE

Statement 2. *When the line casting the shadow is perpendicular to the surface receiving the shadow, the shadow itself will be a 45° line.*

Horizontal line AB will cast a shadow onto the vertical front wall of the house illustrated in Fig. 10–19. Line AB has a perpendicular relationship with the vertical wall. To begin to locate the shadow of point A, draw 45° lines through both the plan and

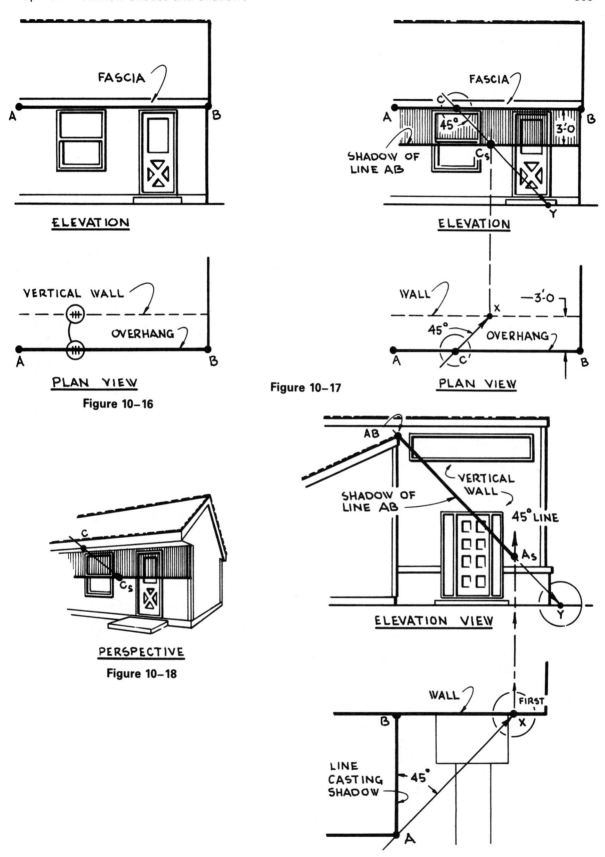

ELEVATION

VERTICAL WALL

OVERHANG

PLAN VIEW

Figure 10–16

FASCIA

SHADOW OF LINE AB

45°

3'-0

C_s

ELEVATION

WALL

45°

OVERHANG

—3'-0

PLAN VIEW

Figure 10–17

PERSPECTIVE

Figure 10–18

AB

SHADOW OF LINE AB

VERTICAL WALL

45° LINE

A_s

ELEVATION VIEW

WALL

FIRST

LINE CASTING SHADOW

45°

PLAN VIEW

Figure 10–19

the elevation views of point A. See Fig. 10–19. One of the 45° lines intersects the wall at point x before the other 45° line intersects the ground at point y. Project point x into the elevation view to locate the shadow of point A on the wall. A line connecting the shadow of point A with point B represents the shadow of line AB on the vertical wall. Because of the perpendicular relationship between the line casting the shadow and the surface receiving the shadow, the shadow has to be a 45° line. Using the entry door as a guide, now transfer the shadow from the multi-view drawings to the perspective. See Fig. 10–20.

Using the house illustrated in Fig. 10–20, let's cast the shadow of vertical line AC. See Fig. 10–21. Because vertical line AC is perpendicular to the ground plane, its shadow in the plan view will be a 45° line. The shadow of line AC will track across the ground at a 45° angle until it intersects the vertical wall at point x. At that point the relationship between the line casting the shadow and the surface receiving the shadow changes from perpendicular to parallel. Vertical line AC is parallel to the wall which is now receiving the shadow. Therefore, the shadow of line AC on the vertical wall must be parallel to line AC. See Fig. 10–21. Refer to statement 1. The complete shadow outline for both lines AB and AC are drawn in Fig. 10–22.

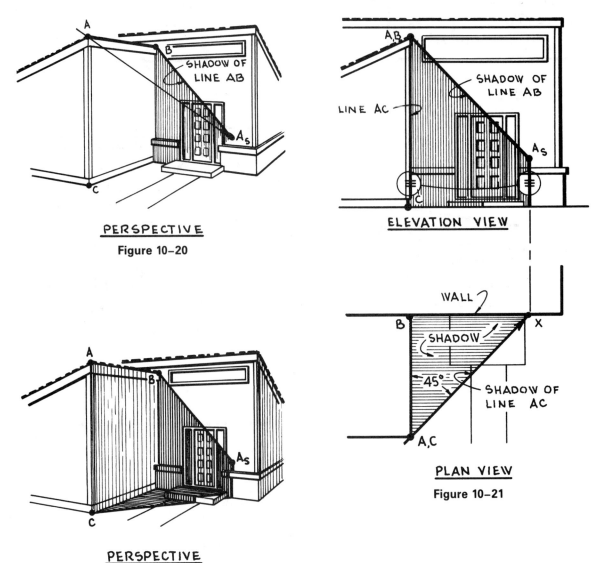

PERSPECTIVE

Figure 10–20

ELEVATION VIEW

PLAN VIEW

Figure 10–21

PERSPECTIVE

Figure 10–22

CASE 3: LINE INCLINED TO SURFACE

Statement 3. *When the line casting the shadow is inclined to the surface receiving the shadow, the shadow can be drawn by casting the shadow of two points on that line.*

Inclined line AB will cast a shadow onto the vertical wall. See Fig. 10–23. To locate this shadow, you must cast the shadows of two points on line AB. Once you have found these two point shadows, you can draw the line shadow. Draw 45° lines through both the plan and the elevation views of points A and B. See Fig. 10–23. The 45° lines in the plan view intersect the wall at points x and x′ before the 45° lines in the elevation view intersect the ground at points y and y′. Projecting points x and x′ into the elevation view will locate the shadows for points A and B. See Fig. 10–23. A line drawn between these two point shadows will be the shadow of line AB cast onto the vertical wall. Using the windows as a guide, now transfer the shadow from the multi-view drawing to the perspective. See Fig. 10–24.

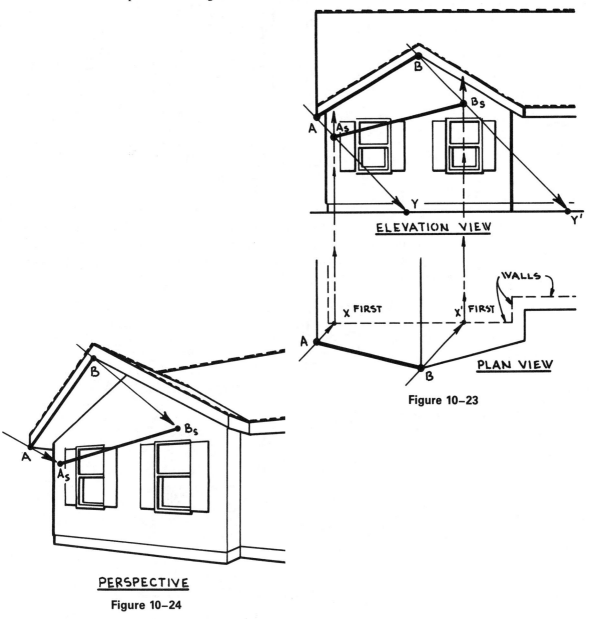

Figure 10–23

PERSPECTIVE

Figure 10–24

10.5 SHADOWS OF SOLID OBJECTS

Casting shadows of solid objects utilizes the techniques just discussed. You are still casting shadows of points and lines, but now these shadows combine to form the overall shadow of a solid object. For the purpose of this step-by-step discussion, let's use the perspective setting shown in Fig. 10–25. The sun is behind the observer over his or her left shoulder. This is the traditional location for the sun when casting shadows by the multi-view method.

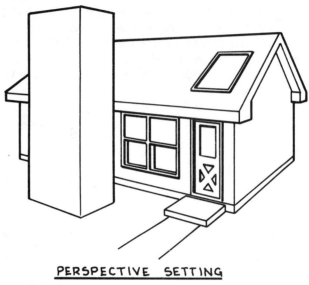

PERSPECTIVE SETTING

Figure 10–25

The first step you must perform when casting the shadow of a solid object is to make a good sunlight-shade analysis. You must determine which surfaces are in sunlight and which are in shade. The lines separating the sunlight and shade surfaces are the only lines casting shadows. Figure 10–26 illustrates the results of this analysis. The darkened lines are the only lines casting shadows.

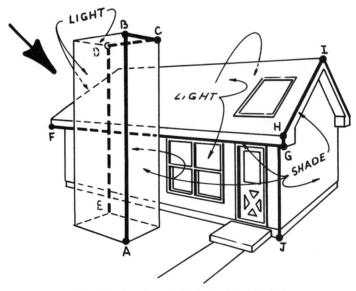

SUNLIGHT - SHADE ANALYSIS

Figure 10–26

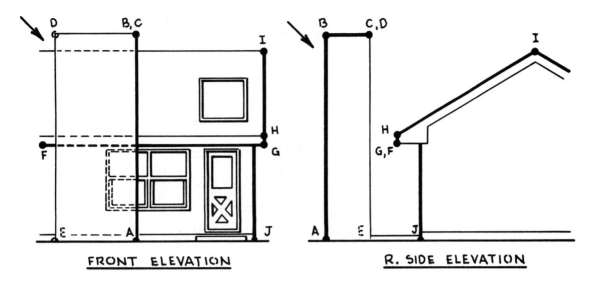

FRONT ELEVATION R. SIDE ELEVATION

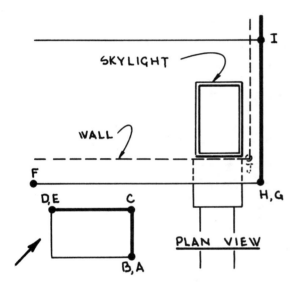

PLAN VIEW

Figure 10–27

You will actually construct the shadow outline on the multi-view drawings of the structure. See Fig. 10–27. The key to drawing these more complicated shadows is to cast the shadow of only one line at a time. Determine what type of line is casting the shadow and establish the relationship between that line and the surface the shadow is likely to fall upon. Treat each line separately, and move around the object. The following discussion will be presented in a step-statement format.

Step 1. See Fig. 10–28.

 1a. To cast the shadow of vertical line BA, draw 45° lines through both the plan and the elevation view of point B.

 1b. The 45° line drawn in the plan view intersects the vertical wall at point x before the 45° line drawn in the elevation view intersects the ground at point y.

 1c. Project point x into the elevation view.

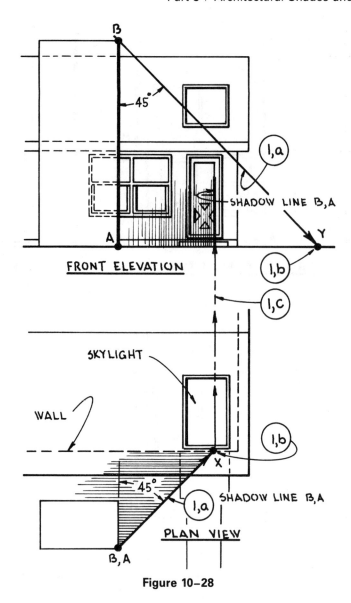

Figure 10–28

Statement 1. The shadow of line BA runs across the ground at a 45° angle and vertically up the wall.

Step 2. See Fig. 10–29.

2a. The 45° line drawn in the plan view crosses the fascia at point z. Project point z into the elevation view of the fascia.

2b. Draw a 45° line through the side view of point B. This line intersects the roof at point W.

2c. Project point W into the front view of the house, locating the shadow of point B on the roof.

2d. Connect the shadow on the fascia with the shadow of point B on the roof. This completes the shadow of vertical line BA in the elevation view.

2e. Project vertically to locate the plan view of point B's shadow.

Statement 2. Notice that the shadow of vertical line BA in the plan view appears as an unbroken straight line. This is true because the only two dimensions repre-

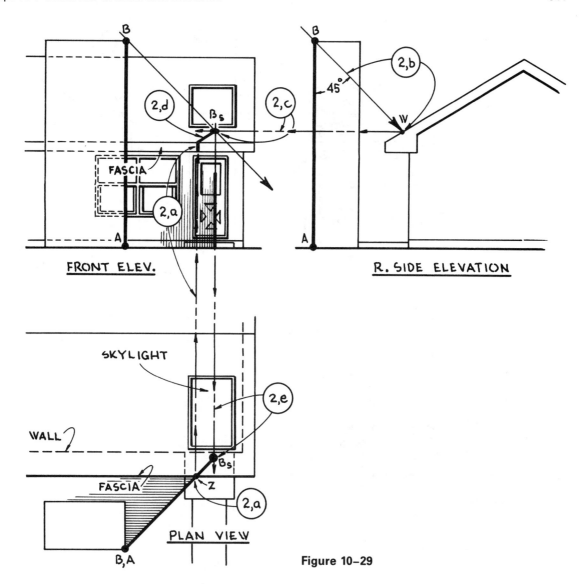

Figure 10-29

sented in the plan view are width and depth. The height dimension is not represented in this view. You have to look at the elevation view to get the proper height relationship.

Step 3. See Fig. 10-30.

3a. To locate the shadow of point C on the roof, draw a 45° line through the side view of point C. This line intersects the roof at point V.

3b. Project point V into the front view, locating the shadow of point C on the roof. A line drawn between the point shadows of B and C represents the shadow of horizontal line BC on the roof.

3c. Because line CD is parallel to the roof, the line and its shadow will be parallel. Therefore, a horizontal line drawn through the shadow of point C will represent the shadow of line CD on the roof.

3d. A 45° line drawn through the elevation view of point D will terminate this shadow.

3e. Using vertical lines, project the shadows of lines DC and BC from the elevation view to the plan view.

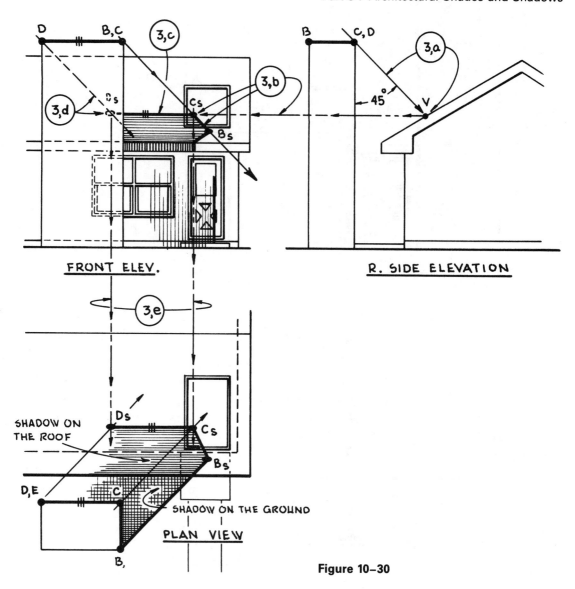

Figure 10–30

Step 4. See Fig. 10–31.

4a. Casting the shadow of vertical line DE will complete the shadow outline of the free-standing object. Draw 45° lines through both the plan and the elevation views of point D. The 45° line drawn in the plan view intersects the wall at point x and the fascia at point z.

4b. Project points x and z into the elevation view, locating the hidden shadow of vertical line DE on the wall and the fascia.

4c. Connecting the shadow on the fascia to the shadow of point D completes the hidden shadow outline.

4d. The shadow of vertical line DE in the plan view is represented by the 45° line.

Statement 3. To complete the entire shadow pattern, you must cast the shadows of lines FG, GH, HI, and J. Refer to the sunlight-shade analysis (Fig. 10–26).

Step 5. See Fig. 10–32.

5a. Horizontal line FG, the lower edge of the fascia, will cast its shadow onto the front vertical wall of the house. There is a parallel relationship between

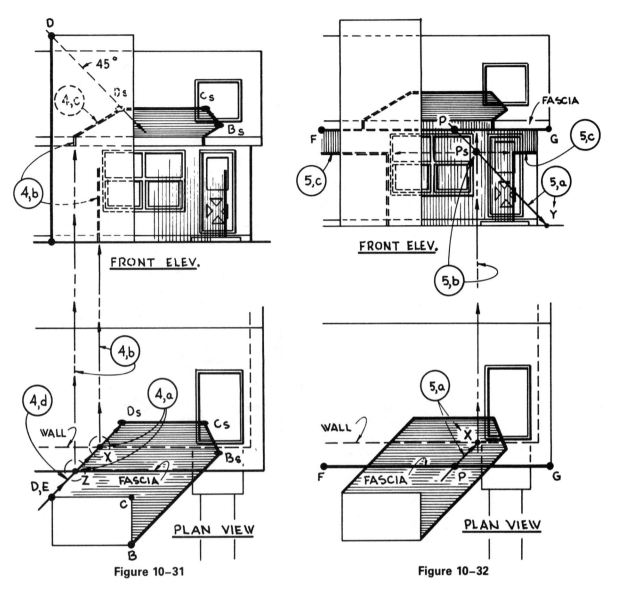

Figure 10–31 **Figure 10–32**

this line and the house. Therefore, line FG and its shadow will be parallel. A single point shadow will allow you to draw the entire shadow. Through both the plan and the elevation views of random point P, draw 45° lines. The 45° line drawn in the plan view intersects the wall at point x before the 45° line drawn in the elevation view intersects the ground at point y.

5b. Project point x into the elevation view, locating the shadow of point P on the front wall of the house.

5c. A horizontal line drawn through the shadow of point P represents the shadow of line FG.

Statement 4. Shadows of lines J, GH, and HI will form the main shadow pattern of the house on the ground plane. This shadow pattern will only be visible in the plan view. Refer to the sunlight-shade analysis illustrated in Fig. 10–26.

Step 6. See Fig. 10–33.

6a. The shadow of vertical line J will run across the ground at a 45° angle.

6b. The shadow of vertical line HG will be located on the ground plane by using 45° lines of projection.

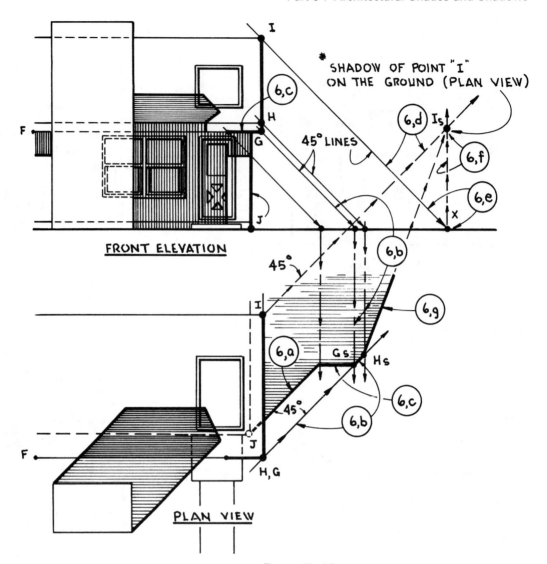

Figure 10–33

6c. A portion of horizontal line FG will cast its shadow onto the ground plane. Because line FG is parallel to the ground, the line and its shadow will be parallel. Therefore, the portion of the shadow cast onto the ground by line FG will be a horizontal line drawn through the shadow of point G.

6d. The shadow of point I on the ground is located by drawing 45° lines through both the plan and the elevation views of point I.

6e. The 45° line drawn in the elevation view intersects the ground plane at point x.

6f. Project point x into the plan view to locate the shadow of point I on the ground.

6g. Connecting the shadow of point I with the shadow of point H locates the shadow of line HI.

Note: Because of the lack of space, the shadow pattern will be terminated at this point.

Step 7. See Fig. 10–34.

7a. Using the architectural features on the house as a guide, transfer the constructed shadow pattern from the multi-view drawings to the perspective drawing.

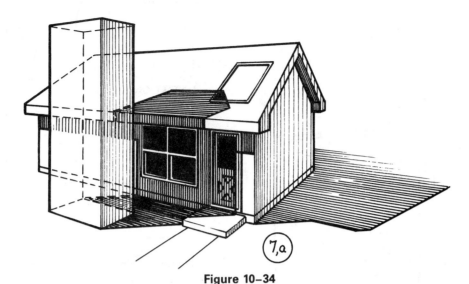

Figure 10-34

10.6 SHADOWS OF CIRCULAR DISKS

The previous discussion on multi-view shades and shadows covered casting shadows of straight lines. This process required you to determine what kind of line was casting the shadow and also to determine the relationship between that line and the surface receiving the shadow. The majority of the time you will be casting shadows of straight lines. However, occasionally you will work with curved lines. The process is basically the same as before. You must determine what kind of line is casting the shadow and what its relationship is with the surface receiving the shadow. Is it a parallel, a perpendicular, or an angular relationship? As before, you derive this information from a good sunlight-shade analysis. This analysis will determine exactly which lines are casting the shadows. Using 45° lines drawn in the plane and elevation views, you cast the shadow of each line—one at a time—to develop the shadow outline.

Most curved objects have a circular characteristic. Their basic geometric shape can be generated by a series of circular disks. Cylinders, cones, and spheres can all be reduced to this basic geometric shape. Therefore, this discussion concerning casting shadows of curved lines by the multi-view method will begin with the shadows cast by circular disks.

A circular disk can cast three basic shadow patterns—a straight-line shadow, a circular shadow, and an elliptical shadow. What determines the shadow pattern is the relationship between the disk and the surface receiving the shadow.

CASE 1: CIRCULAR DISK CASTING A STRAIGHT-LINE SHADOW

Statement 1. *A circular disk will cast a straight-line shadow when the disk is parallel to the light rays.*

The circular disk shown in Fig. 10–35 fulfills this requirement. It will be used in this example. The plan and elevation views of this perspective setting are shown in Fig. 10–36.

Step 1. See Fig. 10–36.
 1a. In the elevation view, draw two 45° lines tangent to the top and to the bottom of the circular disk. Extend these lines until they intersect the ground plane at points y and y′.
 1b. In the plan view, project the edge view of the disk onto the wall with a 45° line locating point x.

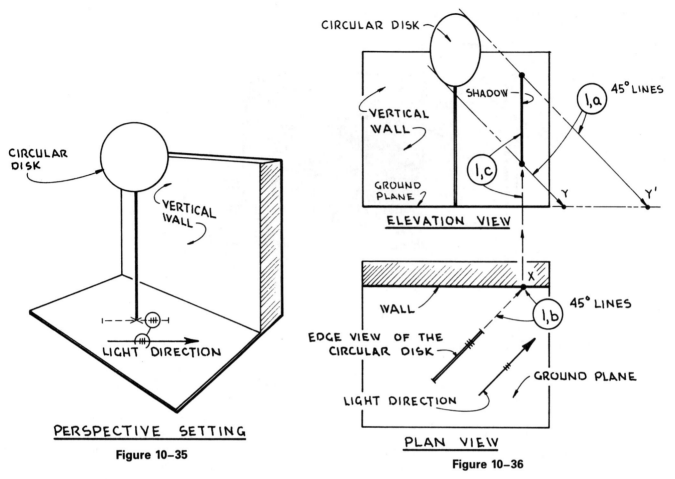

CIRCULAR DISK

VERTICAL WALL

LIGHT DIRECTION

PERSPECTIVE SETTING

Figure 10-35

CIRCULAR DISK

SHADOW

45° LINES

1,a

VERTICAL WALL

1,c

GROUND PLANE

Y Y'

ELEVATION VIEW

WALL

x

EDGE VIEW OF THE CIRCULAR DISK

45° LINES

1,b

LIGHT DIRECTION

GROUND PLANE

PLAN VIEW

Figure 10-36

1c. The light ray in the plan view intersects the wall before the light rays in the elevation view intersect the ground. Therefore, project point x into the elevation view, locating the straight-line shadow of the disk on the wall.

Note: The shadow of the disk is drawn in perspective in Fig. 10–37.

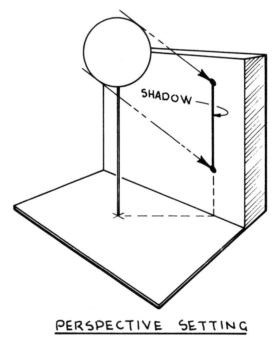

SHADOW

PERSPECTIVE SETTING

Figure 10-37

CASE 2: CIRCULAR DISK CASTING A CIRCULAR SHADOW

Statement 2. *A circular disk will cast an identical circular shadow when the disk is parallel to the surface receiving the shadow.*

Example 1

The circular disk shown in Fig. 10–38 is y distance above the ground and x distance from the vertical wall. The disk is closer to the wall; therefore, its shadow is likely to fall onto the wall. There is a parallel relationship between the disk and the wall. The plan and the elevation views of this perspective setting are shown in Fig. 10–39.

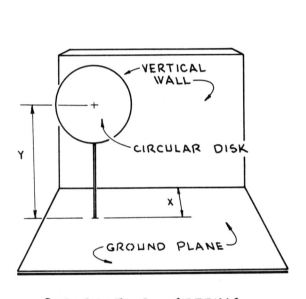

PERSPECTIVE SETTING

Figure 10–38

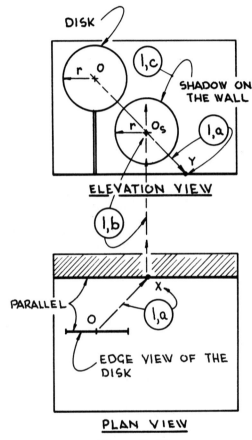

Figure 10–39

Step 1. See Fig. 10–39.

1a. Draw 45° lines through both the plan and the elevation views of the center of the disk — point O. The 45° line drawn in the plan view intersects the wall at point x before the 45° line drawn in the elevation view intersects the ground plane at point y.

1b. Project point x into the elevation view, locating the shadow of point O.

Note: Actually, point O is not casting a shadow. Only the circular edge of the disk is casting a shadow. This mythical shadow of point O must be located in order to draw the outline of the shadow.

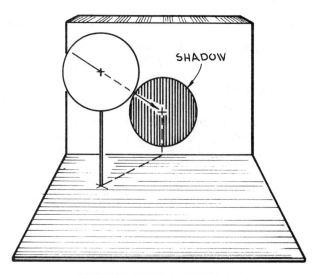

PERSPECTIVE SETTING

Figure 10–40

1c. Placing the point of your compass on the shadow of point O, draw a circle with the same radius as the original disk. This circle represents the shadow cast by the circular disk onto the wall. Fig. 10–40 shows the shadow drawn in perspective.

Example 2

The circular disk illustrated in Fig. 10–41 is *y* distance above the ground and *x* distance from the vertical wall. The disk is closer to the ground than to the wall. Therefore, the shadow of the disk is likely to fall on the ground.

Note: The plan and elevation views of the perspective setting shown in Fig. 10–41 are illustrated in Fig. 10–42. The shadow cast by the circular disk is also shown. The circled numbers represent the chronological steps taken to cast the shadow. The completed shadow is drawn in perspective in Fig. 10–43.

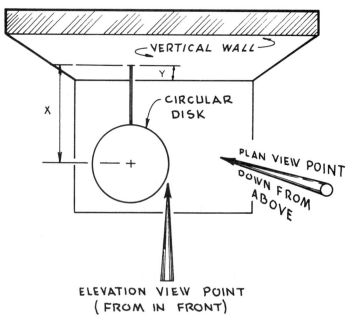

ELEVATION VIEW POINT
(FROM IN FRONT)

Figure 10–41

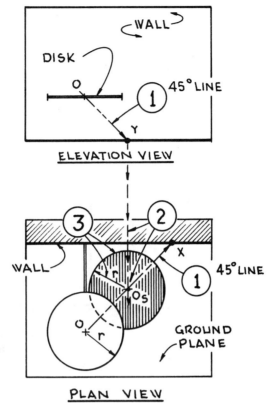

PLAN VIEW

Figure 10-42

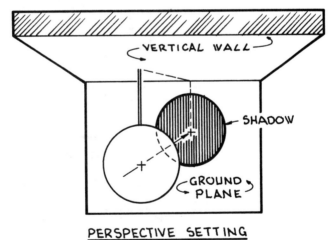

PERSPECTIVE SETTING

Figure 10-43

CASE 3: CIRCULAR DISK CASTING AN ELLIPTICAL SHADOW

Statement 3. *A circular disk will cast an elliptical shadow when the disk is not parallel to the surface receiving the shadow.*

The circular disk shown in Fig. 10–44 is y distance above the ground and x distance from the wall. The disk is closer to the ground plane; therefore, its shadow is likely to fall onto the ground. Since the disk is not parallel with the ground plane, the surface receiving the shadow, the shadow cast will be elliptical. The plan and elevation views of the perspective setting shown in Fig. 10–44 are illustrated in Fig. 10–45. Use the following steps to cast an elliptical shadow.

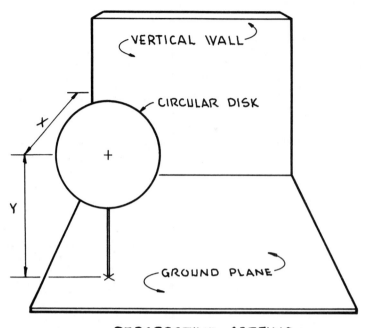

PERSPECTIVE SETTING

Figure 10–44

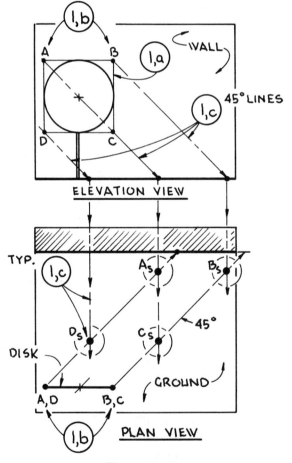

Figure 10–45

Step 1. See Fig. 10–45.

1a. Draw a square around the disk in the view showing the disk as a circle.

1b. Label the four corners of the square in both views.

1c. Using 45° lines, cast the shadows of points A, B, C, and D onto the ground plane.

Step 2. See Fig. 10–46.

2a. Connect these four point shadows with four straight lines. These four lines form a parallelogram that will contain the elliptical shadow.

2b. Draw two diagonals. The intersection of these two diagonals locates the center of the parallelogram (point O).

2c. Through point O draw two quarter lines, locating points 1, 3, 5, and 7 on the parallelogram. These four points are on the elliptical shadow.

Note: With some artistic ability, you could use these four points to sketch the shadow. However, to draw the shadow more accurately, you could find more points on the shadow outline. The following steps will allow you to locate four more points on the elliptical shadow.

Step 3. See Fig. 10–47.

3a. Placing the point of your compass on point O, draw a circle with the same radius as the original circular disk.

3b. This circle intersects the longest quarter line at points E and F.

3c. Project horizontally point E and point F to the two diagonals, locating points 2, 4, 6, and 8. These four points are also on the elliptical shadow.

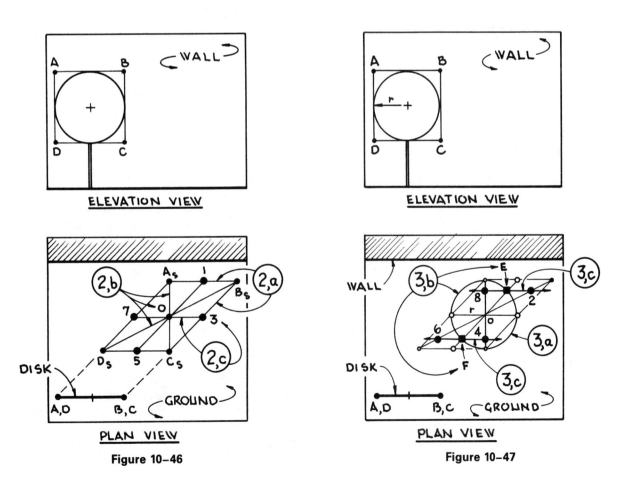

ELEVATION VIEW ELEVATION VIEW

PLAN VIEW PLAN VIEW

Figure 10–46 **Figure 10–47**

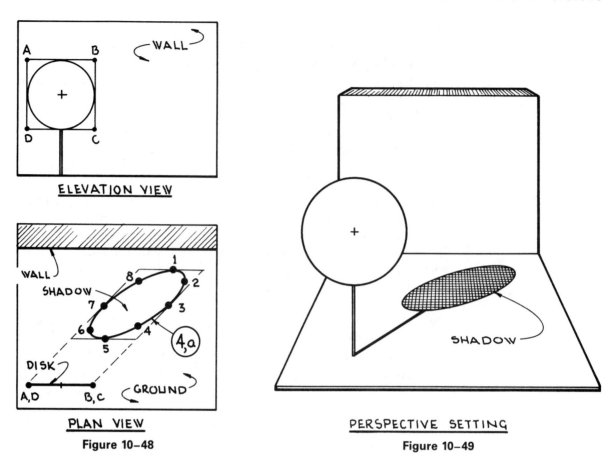

ELEVATION VIEW

PLAN VIEW

Figure 10-48

PERSPECTIVE SETTING

Figure 10-49

Step 4. See Fig. 10–48.

4a. Using points 1–8 as a guide, draw the elliptical shadow on the ground.

Note: The shadow of the circular disk is drawn in perspective in Fig. 10–49.

10.7 SHADOWS OF CYLINDERS

The cylinder is basically a vertical stack of circular disks. Therefore, the process used to cast the shadow of a solid cylinder is quite similar to that used in casting the shadow of a circular disk. The cylinder drawn in Fig. 10–50 will be used in the first example. The plan and the elevation views of the perspective setting shown in Fig. 10–50 are illustrated in Fig. 10–51.

Example 1. Shadow Cast by a Cylinder

Step 1. See Fig. 10–51.

1a. Using 45° lines, cast the shadow of point O.

1b. Using the radius of the cylinder, draw a circle with the shadow of O at its center. This circle represents the shadow cast by the top of the cylinder.

Note: Because this cylinder is a solid object, it will cast a continuous shadow. The sun is coming from behind the observer over his or her left shoulder. This sun location will illuminate the top and the left front part of the cylinder. See Fig. 10–52. The right front and the back of the cylinder will be in shade. Theoretically, there are two vertical lines separating the sunlight and the shade surfaces on the side of the cylinder. You can locate these vertical shade lines by drawing a line through

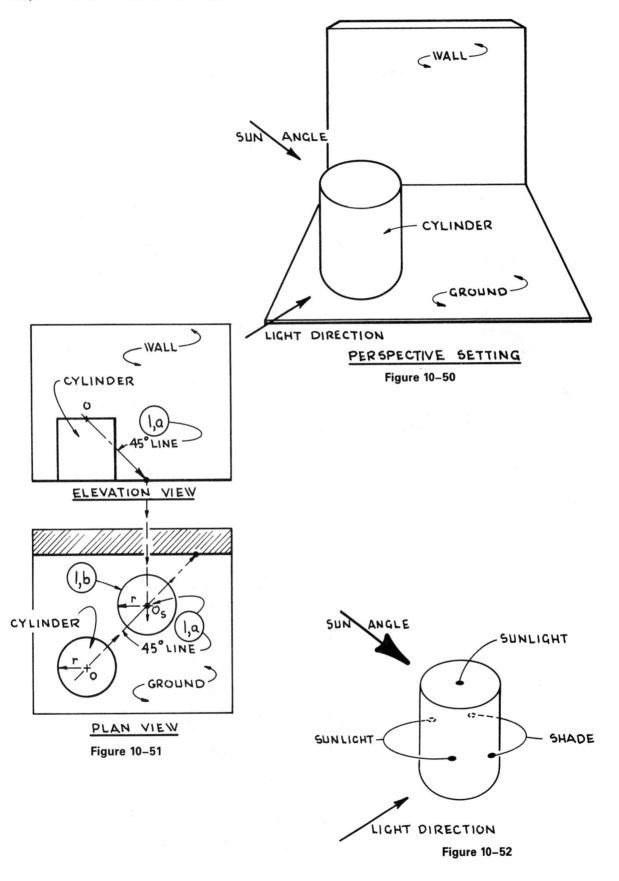

WALL

SUN ANGLE

CYLINDER

GROUND

LIGHT DIRECTION

PERSPECTIVE SETTING

Figure 10–50

WALL

CYLINDER

o

l,a

45° LINE

ELEVATION VIEW

l,b

r O$_s$

CYLINDER

l,a

45° LINE

r
+
o

GROUND

PLAN VIEW

Figure 10–51

SUN ANGLE

SUNLIGHT

SUNLIGHT

SHADE

LIGHT DIRECTION

Figure 10–52

the center of the cylinder perpendicular to the light rays. This is done in the view where you see the cylinder as a circle. See Fig. 10–53. The shade lines, the lines casting the shadows, are drawn darker on the cylinder in Fig. 10–54. Because these vertical shade lines are perpendicular to the ground plane, the surface receiving the shadow, they will cast 45° shadow lines.

Step 2. See Fig. 10–55.

2a. In the plan view, draw a 45° line through the center of the cylinder, perpendicular to the light rays. This line will intersect the vertical wall of the cylinder at points 1 and 2. These points represent the edge views of the two vertical shade lines on the surface of the cylinder.

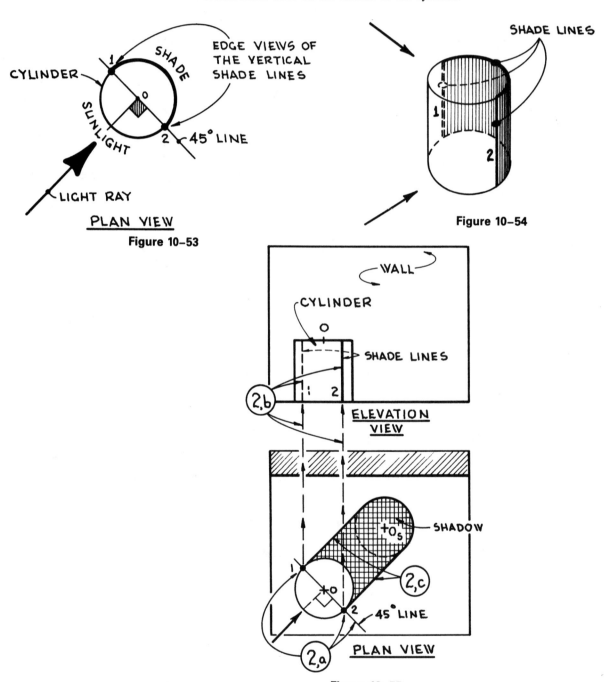

PLAN VIEW

Figure 10–53

Figure 10–54

Figure 10–55

2b. Project points 1 and 2 into the elevation view. Shade line 2 will be visible in the elevation view, while shade line 1 will be hidden.

2c. Vertical shade lines 1 and 2 will cast 45° shadows in the plan view. These two shadow lines plus the shadow of the back half of the cylinder form the entire shadow pattern cast by the cylinder.

Note: The shade and shadow pattern created by the cylinder is shown in Fig. 10–56.

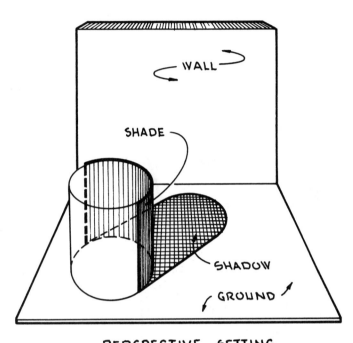

PERSPECTIVE SETTING
Figure 10–56

Example 2. Cylinder With a Rectangular Cap

The object used in this example is shown in Fig. 10–57. The results of the sunlight-shade analysis are shown in Fig. 10–58. The darkened lines are the only lines casting shadows. The plan and elevation views of the perspective setting shown in Fig. 10–57 are drawn in Fig. 10–59.

Step 1. See Fig. 10–59.

1a. To begin to cast the shadow of the rectangular cap onto the base cylinder, draw the vertical center line of the cylinder.

1b. Draw a 45° line through point A in the elevation view. Extend this line until it intersects the vertical center line at point x.

1c. Using point x as the center, scribe an arc having the same radius as the cylinder.

Step 2. See Fig. 10–60.

2a. To locate the vertical shade lines on the cylinder, draw a 45° line through the center of the cylinder perpendicular to the light rays. This will locate points 1 and 2 in the plan view.

2b. Project the vertical shade lines into the elevation view. Shade line 1 is visible, while shade line 2 is hidden.

2c. The shadow cast by the rectangular cap onto the base cylinder is darkened in the elevation view.

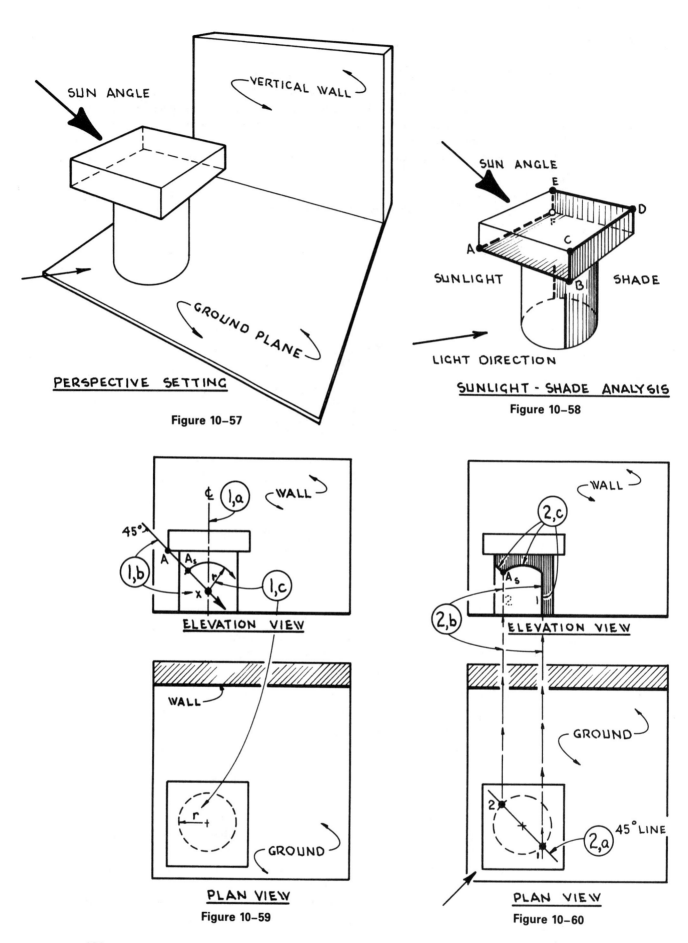

SUN ANGLE

VERTICAL WALL

GROUND PLANE

PERSPECTIVE SETTING

Figure 10-57

SUN ANGLE

E

F

A

C

D

SUNLIGHT

B

SHADE

LIGHT DIRECTION

SUNLIGHT - SHADE ANALYSIS

Figure 10-58

1,a

WALL

45°

1,b

A

A_s

r

1,c

x

ELEVATION VIEW

WALL

r

GROUND

PLAN VIEW

Figure 10-59

2,c

WALL

A_s

2,b

2

1

ELEVATION VIEW

GROUND

2

1

45° LINE

2,a

PLAN VIEW

Figure 10-60

326

Step 3. See Fig. 10–61.

3a. Next, cast the shadow of the rectangular cap onto the ground plane. Refer to the sunlight-shade analysis shown in Fig. 10–58. Points B, C, D, E, and F will cast shadows onto the ground. The shadow of point A is on the cylinder. Proceed to cast the shadow of each one of these points.

Step 4. See Fig. 10–62.

4a. The vertical shade lines on the cylinder will cast 45° shadows onto the ground.

4b. Finalize the shadow outline on the ground by drawing straight lines between the point shadows.

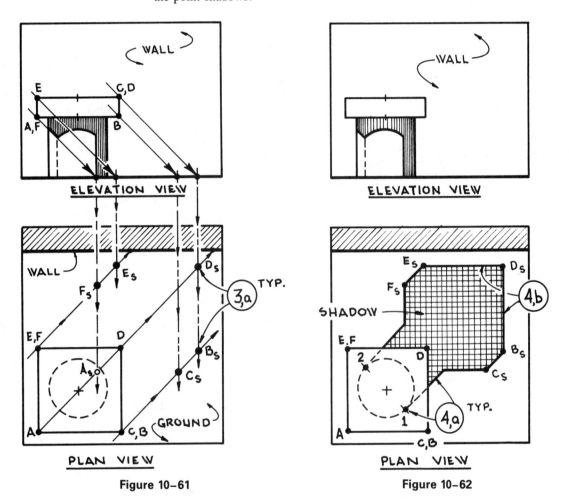

Figure 10–61 **Figure 10–62**

Step 5. See Fig. 10–63.

5a. The shadow pattern developed in the multi-view drawings is transferred to the perspective setting.

Example 3. Cylinder With a Cylindrical Cap

The object used in this example is shown in Fig. 10–64. The results of the sunlight-shade analysis are shown in Fig. 10–65. The darkened lines are casting the shadows. The plan and elevation views of this perspective setting are shown in Fig. 10–66.

Step 1. See Fig. 10–66.

1a. To begin to cast the shadow of the cylindrical cap onto the base cylinder, draw vertical cutting planes through both cylinders parallel with the light rays.

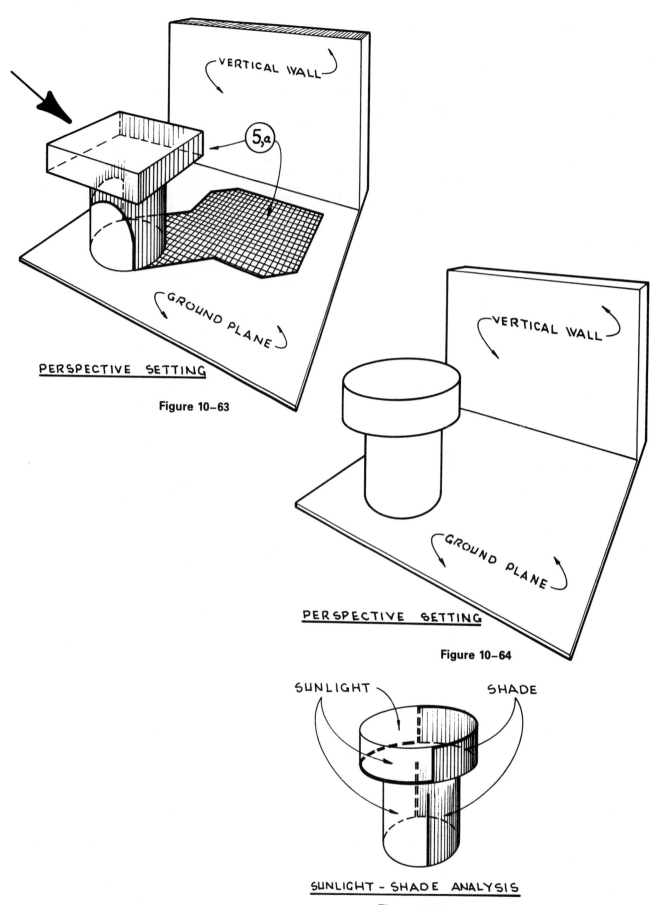

VERTICAL WALL

5,a

GROUND PLANE

PERSPECTIVE SETTING

Figure 10-63

VERTICAL WALL

GROUND PLANE

PERSPECTIVE SETTING

Figure 10-64

SUNLIGHT SHADE

SUNLIGHT-SHADE ANALYSIS

Figure 10-65

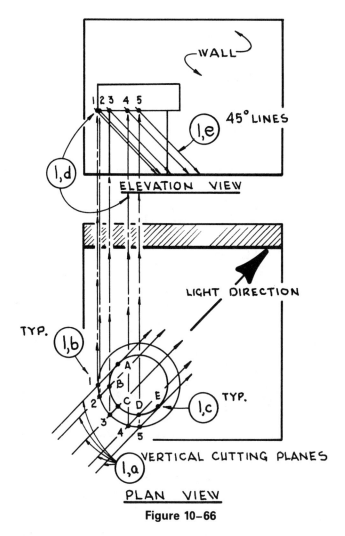

Figure 10–66

1b. The intersection between these vertical cutting planes and the cylindrical cap locate points 1, 2, 3, 4, and 5.

1c. The intersection between the vertical cutting planes and the base cylinder locates points A, B, C, D, and E.

1d. Project points 1, 2, 3, 4, and 5 into the elevation view.

1e. Draw 45° lines through the elevation views of these points.

Step 2. See Fig. 10–67.

2a. To locate points A, B, C, D, and E in the elevation view, you must use vertical lines of projection drawn from the plan view of each point. The elevation view of point A will be located on the 45° line drawn through point 1. Repeat the same procedure to locate the elevation view of points B, C, D, and E.

Note: All these points are on the elliptical shadow cast by the cylindrical cap onto the base cylinder. A portion of this shadow is on the back side of the base cylinder. Therefore, it is hidden from view and would be represented by a dashed line.

Step 3. See Fig. 10–68.

3a. Draw an elliptical curve through points A, B, C, D, and E. The portion of this curve between points A and B is hidden from view. Therefore, that portion of the shadow is represented by a hidden line (dashed).

3b. To locate the vertical shade lines on both cylinders, draw a 45° line perpendicular to the light rays. Draw this line in the plan view, locating points w,

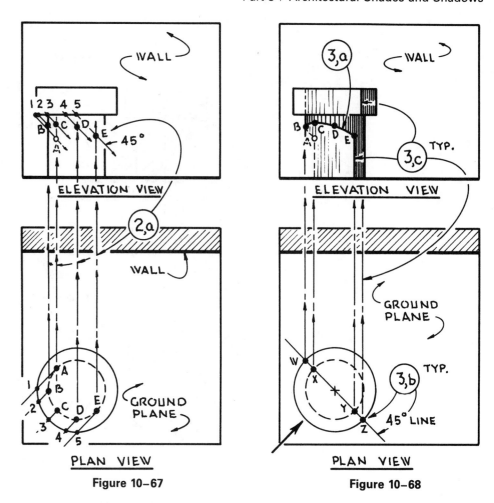

Figure 10–67 **Figure 10–68**

x, y, and z. These points represent the edge views of the vertical shade lines in the plan view. Shade lines w and x will be hidden in the elevation view, while shade lines y and z will be visible.

3c. Draw the vertical shade lines in the elevation view by projecting vertically from the plan view.

Note: This last step completes the shadow and shade process on the two cylinders. Now you must cast the shadow of these cylinders onto the ground plane. The following steps will outline this procedure.

Step 4. See Fig. 10–69.

4a. The vertical center line pierces the top of each cylinder at points O and P. Cast the shadow of each of these points.

4b. Using the point shadows O_s and P_s as the centers, draw two circles, each having the same radius as the cylindrical cap.

4c. Draw two 45° lines tangent to both circles. These two lines represent the shadows cast by the two vertical shade lines on the cylindrical cap.

4d. Two 45° lines drawn tangent to the base cylinder represent the shadows cast by the vertical shade lines on the base cylinder.

Step 5. See Fig. 10–70.

5a. Darken the outline of the shadow cast by both cylinders onto the ground plane. The completed shade and shadow pattern is shown in Fig. 10–71.

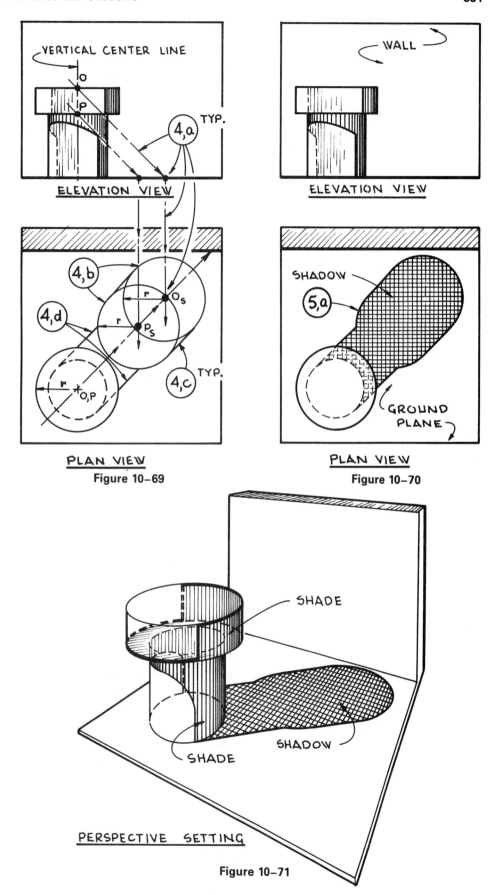

VERTICAL CENTER LINE

O

P

TYP. 4,a

ELEVATION VIEW

WALL

ELEVATION VIEW

4,b

4,d

r

r

O_s

P_s

r

O,P

4,c TYP.

PLAN VIEW
Figure 10-69

SHADOW

5,a

GROUND PLANE

PLAN VIEW
Figure 10-70

SHADE

SHADE

SHADOW

PERSPECTIVE SETTING

Figure 10-71

10.8 SHADOWS OF CONES

Cylinders and cones have at least two basic characteristics in common. Both are geometric solids, and both shapes can be generated by a series of circular disks. These two characteristics and the repetitive nature of casting shadows by the multi-view method make casting shadows of both shapes a similar procedure. The basic difference between these two solids is the cylinder has vertical sides, and the cone's sides are inclined. This basic difference requires a different configuration for the shade lines on the surface of the cone. This variation will be outlined in the following steps. The solid cone illustrated in Fig. 10–72 will be used in this example. The plan and the elevation views of the perspective setting in Fig. 10–72 are shown in Fig. 10–73.

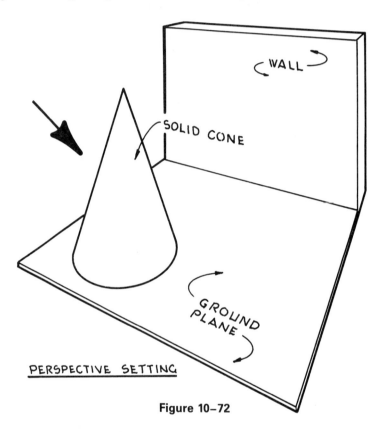

Figure 10–72

Example 1

Step 1. See Fig. 10–73.

1a. Cast the shadow of the apex of the cone (point A).

1b. Starting at the shadow of point A, draw two lines tangent to the base of the cone. These two lines represent the shadows cast by the shade lines on the surface of the cone.

Note: You must first locate these shade lines on the base of the cone. Finding the precise points of tangency between the two shadow lines drawn in step 1b and the base of the cone will enable you to draw the shade lines on the surface of the cone. These shade lines will run from the base of the cone to its apex.

Step 2. See Fig. 10–74.

2a. Use the 90° angle of your 30°-60° triangle. Place one side of the 90° angle along one of the shadow lines drawn in step 1b. The other side of the 90° angle must go through the apex of the cone (point A). The bend of the 90° angle will locate point 1, the precise tangent point.

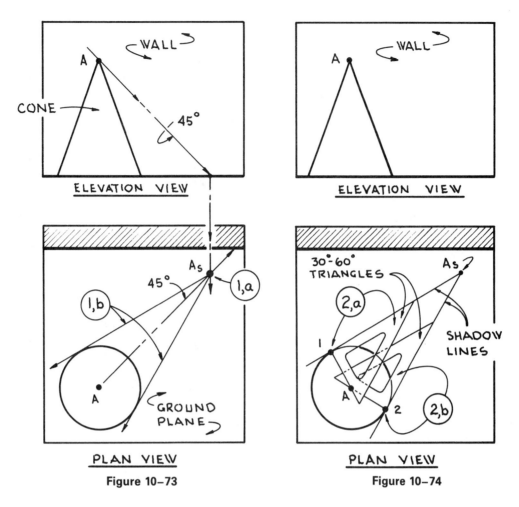

Figure 10–73

Figure 10–74

2b. Repeat this procedure to locate the other tangent point (point 2). See Fig. 10–74.

Step 3. See Fig. 10–75.

3a. In the plan view, draw lines from points 1 and 2 to point A (the apex of the cone). These two lines represent the shade lines on the surface of the cone. Both are visible in the plan view.

3b. Using vertical lines, project points 1 and 2 onto the base of the cone in the elevation view.

Note: Because point 1 is on the back of the cone, the side away from the observer, it is hidden in the elevation view. Therefore, the shade line running from point 1 to the apex of the cone (point A) will also be hidden from sight.

3c. Draw both shade lines in the elevation view of the cone. These lines will run from points 1 and 2 to the apex of the cone. See Fig. 10–75.

Step 4. See Fig. 10–76.

4a. Transfer the shade and shadow patterns developed in the multi-view drawings to the perspective setting.

Example 2

Occasionally, you must locate the shade lines on a cone without the availability of the cone's plan view. This can be done by revolving the elevation view to obtain a superimposed plan view of the cone. The elevation view of a cone drawn in Fig. 10–77 will be used in this example.

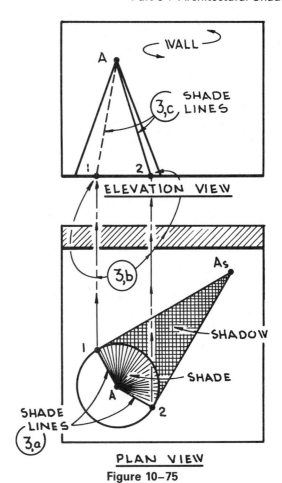

ELEVATION VIEW

PLAN VIEW
Figure 10–75

PERSPECTIVE SETTING
Figure 10–76

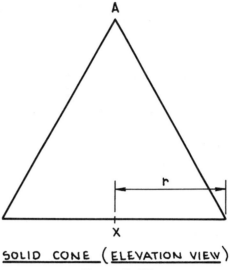

SOLID CONE (ELEVATION VIEW)

Figure 10–77

Step 1. See Fig. 10–78.

1a. Revolve the base of the cone to obtain a plan view. You do this by drawing a circle having the same radius as the base of the cone.

1b. Draw a line through the center of the base of the cone (point x) parallel to the light rays in the revolved plan view.

1c. Draw a horizontal line through the apex of the cone (point A). Extend this line until it intersects with the line drawn in step 1b at point B.

1d. Draw two lines from point B tangent to the revolved base of the cone.

1e. Determine the exact points of tangency between these two lines and the

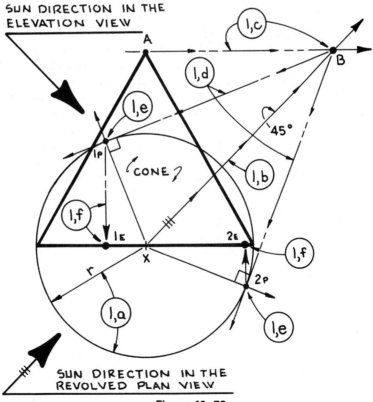

Figure 10–78

base of the cone. Use the triangle method, described in step 2a of the first example, to find these tangent points (points 1_p and 2_p).

1f. Project vertically points 1_p and 2_p from the revolved base of the cone to the elevation view locating points 1_E and 2_E.

Step 2. See Fig. 10–79.

2a. Draw the shade lines in the elevation view of the cone. Shade line 1 is hidden from view; therefore, it is represented by a dashed line.

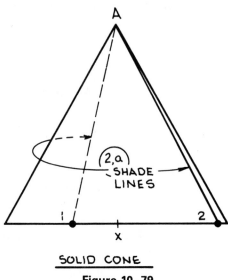

Figure 10–79

Summary Statement

The multi-view method is the most popular way to cast shades and shadows. As stated earlier, there are a number of reasons for this popularity. The most important reason would be the predictability of the shadow patterns. This predictability is a product of the 45° nature of the light ray. You can predict the direction of the cast shadow by determining the relationship between the line casting the shadow and the surface receiving the shadow.

The examples presented in this chapter using the multi-view method range from the simple to the complex. No matter how complex, though, all shade and shadow problems can be solved by casting a series of point shadows. The actual points casting the shadows are determined by a good sunlight-shade analysis. Once the point shadows are located, the complete shadow outline can be drawn by connecting the dots. Accurately drawn shadows can take time and effort to draw. However, most architectural illustrators would agree that the results are worth the effort.

GLOSSARY OF ABBREVIATIONS

AUX. THL: Auxiliary True Height Line
CV: Center of Vision
DIM.: Dimension
D L of S: Direct Line of Sight
DVP: Diagonal Vanishing Point
EV: Edge View
GL: Ground Line
HL: Horizon Line
HML: Horizontal Measuring Line
IHL: Inclined Horizon Line
ILHL: Inclined Light Horizon Line
LBL: Left Base Line
LHL: Light Horizon Line:
LMP: Left Measuring Point
LVHL: Left Vertical Horizon Line
LVP: Left Vanishing Point
MP: Measuring Point

OW: Object Width
PP: Picture Plane
PW: Picture Width
RBL: Right Base Line
RMP: Right Measuring Point
RVHL: Right Vertical Horizon Line
RVP: Right Vanishing Point
SP: Station Point
THL: True Height Line
TYP.: Typical
VH: Vanishing Point for Horizontal
Direction of Light
VHL: Vertical Horizon Line
VL: Vanishing Point for Light Rays
VLHL: Vertical Light Horizon Line
VP: Vanishing Point

Index

PART 4

Lab Exercises

Part Four contains tear-out lab sheets which are designed to give students specific practice with the different techniques discussed in each chapter. These lab sheets are in chronological order and they are number-coded with individual sections in each chapter. In most instances, work will be performed directly on the lab sheets. However, some of the larger perspective problems will require the perspective to be drawn on an 18″ × 24″ sheet of paper. Each lab sheet includes detailed step-by-step instructions. The following detailed instructions are given for sets of similar lab problems.

Lab sheets 3.52, 3.53 and 3.56 illustrate the elevation and plan views of three different architectural structures. These drawings are to be used to draw perspectives of each structure. Lay out the preliminary PP, HL using the given plan views, and then draw the final perspectives on 18″ × 24″ sheets of paper. Use the given guidelines to draw each perspective.

Lab sheets R-4.1 through C-5.31 illustrate the elevation and plan views of 6 different architectural structures. These drawings are to be used to draw perspectives of each structure. Lay out the preliminary PP, HL using the given plan views, and then draw the final perspectives on 18″ × 24″ sheets of paper. Each perspective setup is to be of your own design.*

Lab sheets 6.82 and 6.821 illustrate the floor plans and sectional views of a residential interior. These drawings are to be used to draw the perspective. Lay out the preliminary PP, HL using the given floor plans, and then draw the perspective on a 18″ × 24″ sheet of paper. Each perspective setup is to be of your own design.*

Lab sheets 7.90 through 7.921 illustrate the floor plans and sectional views of two different interiors. These drawings are to be used to draw perspectives of each interior. Lay out the preliminary PP, HL using the given floor plans, and then draw the perspectives on 18″ × 24″ sheets of paper. Each perspective setup is to be of your own design.*

*Your instructor may give some general guidelines.

Lab sheets 10.41 through 10.811 illustrate elevation and plan views and accompanying perspective sketches of different architectural structures. Your assignment on each sheet is to first construct the shadows on the elevation and plan views by the multi-view method. Then by observation, transfer these shadow patterns from the elevations to the perspective sketch. Darken the shade and shadow areas on both the multi-view drawings and the perspective. Shadow areas must be shaded darker than the shade areas.

GIVEN IS A PICTORIAL VIEW OF A TYPICAL PERSPECTIVE SETTING. SEE FIG. 1. ALL THE COMPONENT PARTS OF THE PERSPECTIVE SETUP ARE INCLUDED - THE PICTURE PLANE (PP), THE GROUND PLANE, THE OBJECTS TO BE DRAWN IN PERSPECTIVE, THE OBSERVER (SP), THE HORIZON LINE (HL), THE GROUND LINE (GL), THE HORIZONTAL MEASURING LINE (HML), THE VANISHING POINTS, THE MEASURING POINTS, AND THE CENTER OF VISION. NOTICE THAT THE INVISIBLE PICTURE PLANE CUTS THROUGH THE HOUSE. ALSO, NOTICE POINT "A".

USING THIS PICTORIAL DRAWING AS A REFERENCE AND POINT "A" AS A STARTING POINT, DRAW FREEHAND ON THE SHEET PROVIDED THE PLAN AND ELEVATION VIEWS OF THIS TYPICAL PERSPECTIVE SETTING. SHOW AND LABEL ALL THE COMPONENT PARTS OF THE SETUP IN BOTH MULTI-VIEW DRAWINGS. WATCH YOUR PROPORTIONS, AND REMEMBER THAT THE PLAN AND ELEVATION VIEWS MUST LINE UP VERTICALLY.

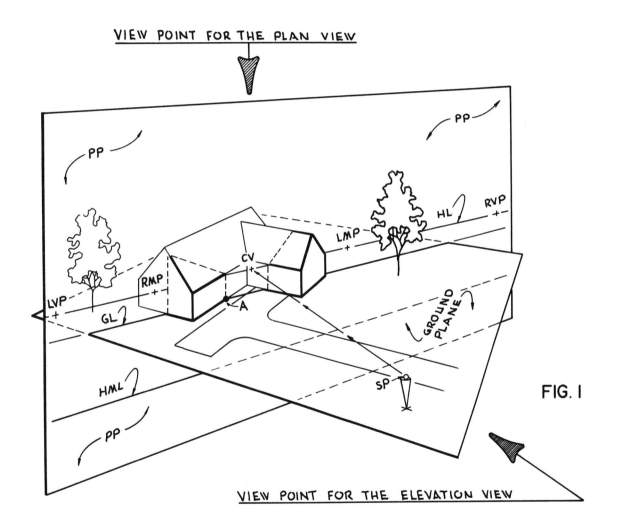

VIEW POINT FOR THE PLAN VIEW

VIEW POINT FOR THE ELEVATION VIEW

FIG. 1

TYPICAL PERSPECTIVE SETTING

SUBJECT	GRADE	NAME	SHEET
PERSPECTIVE SETTING			2.20

PLAN VIEW OF THE PERSPECTIVE SETTING

A

EDGE VIEW OF
THE PP

A

EDGE VIEW OF
THE GROUND
PLANE (GL)

ELEVATION VIEW OF THE PERSPECTIVE SETTING

SUBJECT	GRADE	NAME	SHEET
PERSPECTIVE SETTING			2.201

USING THE PLAN AND ELEVATION VIEWS YOU HAVE JUST DRAWN, DEVELOP THE STANDARD PERSPECTIVE SETUP ON THIS SHEET.

THE STANDARD PERSPECTIVE SETUP IS GENERATED BY MOVING THE TWO MULTI-VIEW DRAWINGS TOGETHER SO THAT THE PICTURE PLANE IN THE PLAN VIEW IS SUPERIMPOSED DIRECTLY OVER THE HORIZON LINE IN THE ELEVATION VIEW. USE YOUR SKETCHES FROM SHEET #2.201 TO DO THIS. FOR THE SAKE OF CLARITY, OMIT FROM THIS SUMPERIMPOSED DRAWING THE PLAN AND ELEVATION VIEWS' OF THE OBJECTS, THE OBSERVER, AND THE CONE OF VISION. NOW YOU HAVE THE SUPERIMPOSED PLAN AND ELEVATION VIEWS OF THE HL (WITH ITS VP's, MP's AND CV), OF THE GL, AND OF THE HML.

LABEL ALL POINTS AND LINES IN THIS DRAWING.

SUBJECT PERSPECTIVE SETUP	GRADE	NAME	SHEET 2.202

THE FOLLOWING FOUR PROBLEMS ARE DESIGNED TO GIVE THE STUDENT PRACTICE PLACING THE PLAN VIEW OF AN OBJECT IN RELATION TO THE PICTURE PLANE (PP) IN ORDER TO FULFILL CERTAIN REQUIREMENTS OF THE PERSPECTIVE.

USE THE FOUR HOUSE PLAN VIEWS ON THIS SHEET TO COMPLETE THE PROBLEMS ON SHEET NUMBER 2.401. HOUSE #1 WILL BE USED IN PROBLEM #1, AND HOUSE #2 WILL BE USED IN PROBLEM #2, ETC. FOR PROBLEM #1, FOR EXAMPLE, SLIP THE PLAN VIEW OF HOUSE #1 UNDERNEATH PROBLEM #1 AND POSITION IT IN SUCH A WAY THAT THE STATED REQUIREMENTS FOR THAT PARTICULAR PROBLEM ARE FULFILLED. ONCE YOU HAVE DONE THIS, TRACE THE PROPERLY ALIGNED IMAGE OF THE HOUSE ONTO THE PROBLEM SHEET. USE A STRAIGHT EDGE.

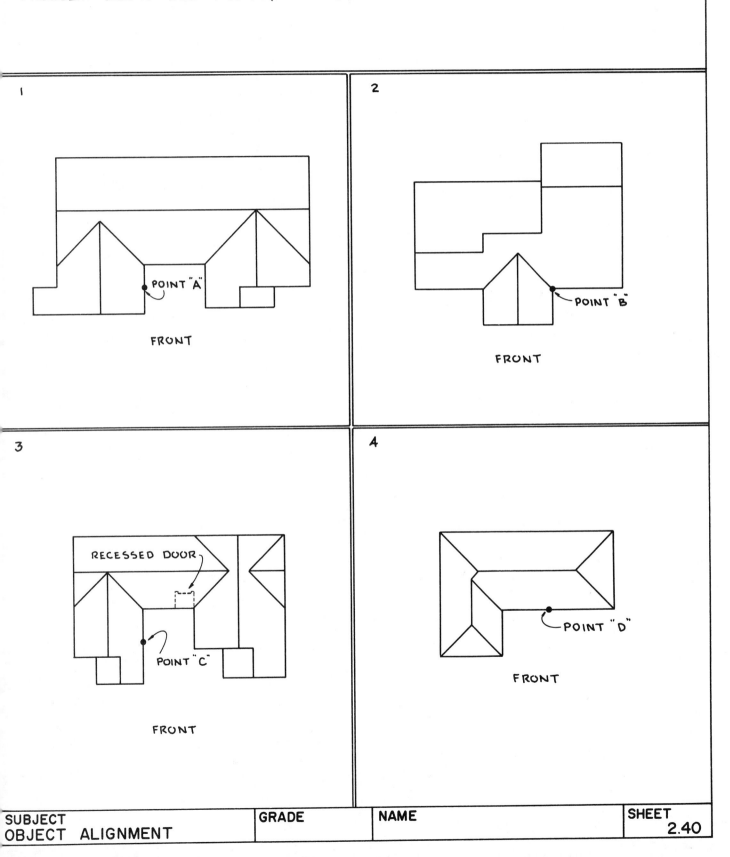

1

POINT "A"

FRONT

2

POINT "B"

FRONT

3

RECESSED DOOR

POINT "C"

FRONT

4

POINT "D"

FRONT

SUBJECT	GRADE	NAME	SHEET
OBJECT ALIGNMENT			2.40

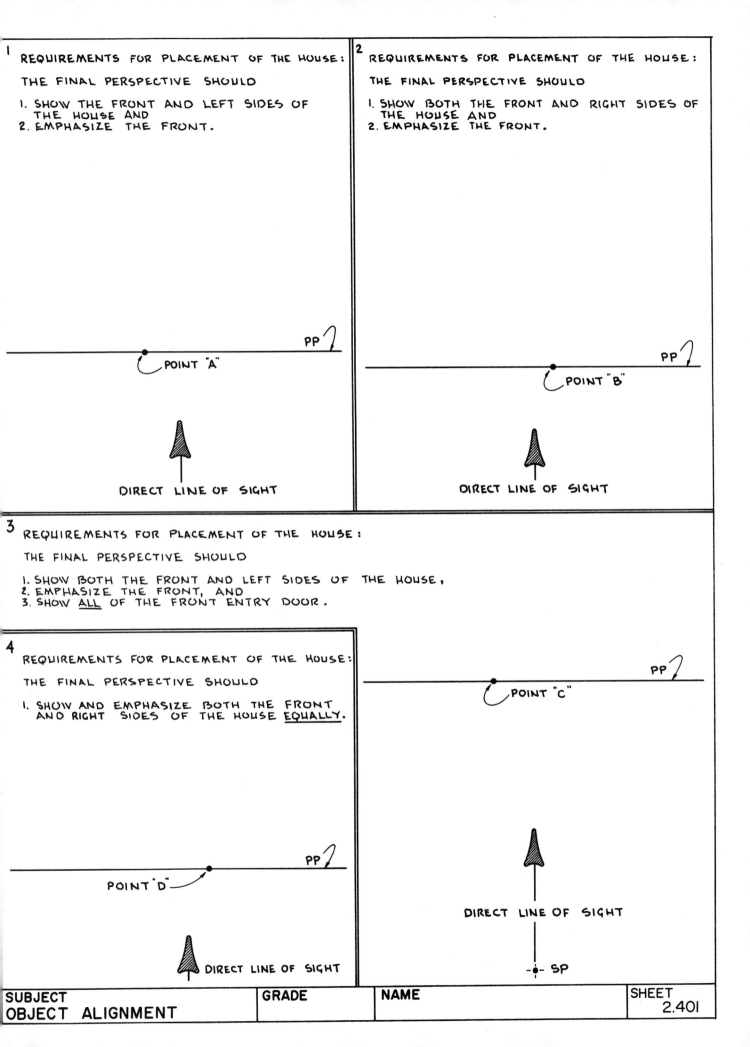

1 REQUIREMENTS FOR PLACEMENT OF THE HOUSE:

THE FINAL PERSPECTIVE SHOULD

1. SHOW THE FRONT AND LEFT SIDES OF THE HOUSE AND
2. EMPHASIZE THE FRONT.

PP

POINT "A"

DIRECT LINE OF SIGHT

2 REQUIREMENTS FOR PLACEMENT OF THE HOUSE:

THE FINAL PERSPECTIVE SHOULD

1. SHOW BOTH THE FRONT AND RIGHT SIDES OF THE HOUSE AND
2. EMPHASIZE THE FRONT.

PP

POINT "B"

DIRECT LINE OF SIGHT

3 REQUIREMENTS FOR PLACEMENT OF THE HOUSE:

THE FINAL PERSPECTIVE SHOULD

1. SHOW BOTH THE FRONT AND LEFT SIDES OF THE HOUSE,
2. EMPHASIZE THE FRONT, AND
3. SHOW ALL OF THE FRONT ENTRY DOOR.

4 REQUIREMENTS FOR PLACEMENT OF THE HOUSE:

THE FINAL PERSPECTIVE SHOULD

1. SHOW AND EMPHASIZE BOTH THE FRONT AND RIGHT SIDES OF THE HOUSE EQUALLY.

PP

POINT "C"

DIRECT LINE OF SIGHT

- SP

PP

POINT "D"

DIRECT LINE OF SIGHT

SUBJECT OBJECT ALIGNMENT	GRADE	NAME	SHEET 2.401

GIVEN ARE FOUR PLAN VIEWS OF A HOUSE IN DIFFERENT ALIGNMENTS WITH THE PICTURE PLANE. SEE FIG. 4. THESE FOUR SETUPS WERE USED TO DRAW THE PERSPECTIVES SHOWN IN FIG. 5. INDICATE WHICH ALIGNMENT WAS USED TO DRAW EACH PERSPECTIVE.

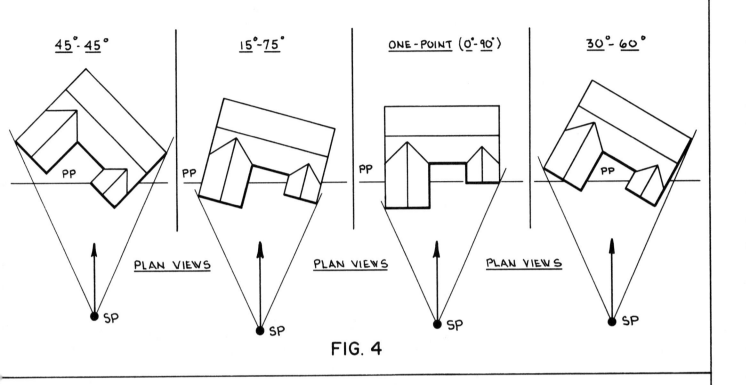

45°-45° 15°-75° ONE-POINT (0°-90°) 30°-60°

PLAN VIEWS PLAN VIEWS PLAN VIEWS

FIG. 4

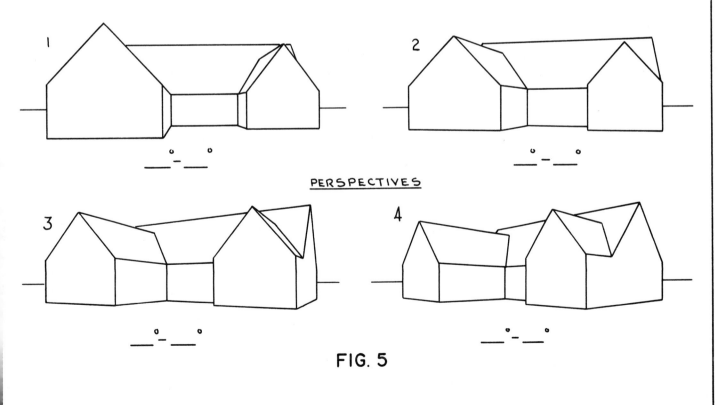

PERSPECTIVES

FIG. 5

SUBJECT	GRADE	NAME	SHEET
OBJECT ALIGNMENT			2.41

LOCATE AND LABEL THE STATION POINTS FOR EACH SETUP USING THE SIZE OF CONES OF VISION INDICATED. SHOW ALL CONSTRUCTION.

1

40° CONE

2 PLAN VIEWS

30° CONE

3

45° CONE

4

38° CONE

5 PLAN VIEWS

FLAG POLE

50° CONE

6

35° CONE

SUBJECT	GRADE	NAME	SHEET
CONE OF VISION			2.50

THE FOUR PERSPECTIVES DRAWN ON THIS SHEET ARE OF THE SAME HOUSE. SEE FIG. 2.
THE HOUSE IS IN A 30°- 60° ALIGNMENT WITH THE PICTURE PLANE. SEE FIG. 3. A
DIFFERENT SIZE OF CONE OF VISION WAS USED TO DRAW EACH PERSPECTIVE. SEE FIG. 3.
USING YOUR KNOWLEDGE OF THE EFFECTS ON THE DRAWN PERSPECTIVE CAUSED
BY USING DIFFERENT SIZES OF CONES OF VISION, IDENTIFY THE SIZE OF CONE
USED TO DRAW EACH PERSPECTIVE.

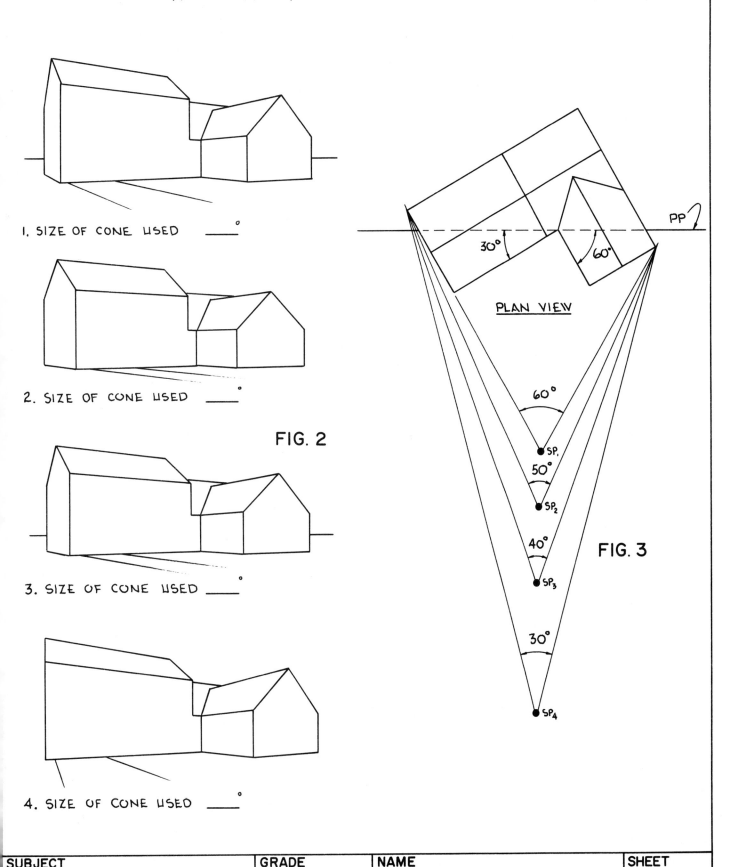

1. SIZE OF CONE USED _____°

2. SIZE OF CONE USED _____°

FIG. 2

3. SIZE OF CONE USED _____°

4. SIZE OF CONE USED _____°

PLAN VIEW

30° 60°

PP

60° SP₁

50° SP₂

40° SP₃

FIG. 3

30° SP₄

SUBJECT	GRADE	NAME	SHEET
CONE OF VISION			2.52

1 USING A 45° CONE OF VISION, DETERMINE THE OBJECT WIDTH FOR THIS PERSPECTIVE SETTING.

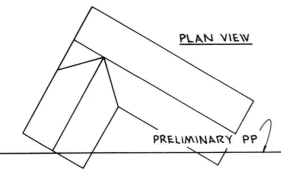

PLAN VIEW

PRELIMINARY PP

3/32" = 1'-0 SCALE

PRELIMINARY OBJECT WIDTH _____

2 USING A 30° CONE OF VISION, DETERMINE THE OBJECT WIDTH FOR THIS PERSPECTIVE SETTING.

PRELIMINARY PP

PLAN VIEW

1/8" = 1'-0 SCALE

PRELIMINARY OBJECT WIDTH _____

3 USING A 50° CONE OF VISION, DETERMINE THE OBJECT WIDTH FOR THIS PERSPECTIVE SETTING.

PRELIMINARY
OBJECT WIDTH _____

PLAN VIEW

PRELIMINARY PP

FLAG POLE

3/32" = 1'-0 SCALE

WHAT WOULD BE THE FINAL OBJECT WIDTH, IN FULL INCHES, IF THE PERSPECTIVE WERE DRAWN AT 1/4" = 1'-0 SCALE?

FINAL OBJECT WIDTH _____"

FULL INCHES

4 USE A 45° CONE OF VISION TO LOCATE THE SP. NOW LOCATE THE PP IN THE PRECISE LOCATION THAT WILL PRODUCE A FINAL OBJECT WIDTH OF 6 FULL INCHES WHEN THE PERSPECTIVE IS DRAWN AT 1/4" = 1'-0 SCALE.

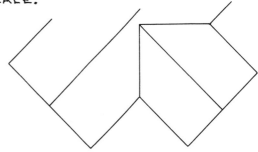

PLAN VIEW

3/32" = 1'-0 SCALE

SUBJECT OBJECT WIDTH	GRADE	NAME	SHEET 2.60

USE A 35° CONE OF VISION TO
LOCATE THE SP. NOW LOCATE THE PP
IN THE PRECISE LOCATION THAT WILL
PRODUCE A FINAL OBJECT WIDTH OF
7 1/2 FULL INCHES WHEN THE PERSPECTIVE
IS DRAWN AT 1/4" = 1-0 SCALE.

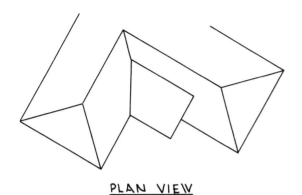

PLAN VIEW

3/32" = 1-0 SCALE

2 USE A 60° CONE OF VISION TO LOCATE
THE SP. WITH THE PP AT ITS PRESENT
LOCATION, HOW LARGE WILL BE THE FINAL
OBJECT WIDTH, IN FULL INCHES, IF THE
PERSPECTIVE IS DRAWN AT 3/8" = 1-0
SCALE?

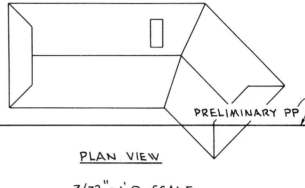

PRELIMINARY PP

PLAN VIEW

3/32" = 1-0 SCALE

FINAL OBJECT WIDTH _____"

FULL INCHES

USE A 48° CONE OF VISION TO LOCATE
THE SP. NOW LOCATE THE PP IN THE
PRECISE LOCATION THAT WILL PRODUCE
A FINAL OBJECT WIDTH OF 15 1/2 FULL
INCHES IF THE PERSPECTIVE IS DRAWN
AT 1/2" = 1-0 SCALE.

PATIO WALLS

PLAN VIEW

3/32" = 1-0 SCALE

4 USING THE WALLS OF THE HOUSE
AND A 53° CONE OF VISION, LOCATE
THE SP. NOW LOCATE THE PP IN
THE PRECISE LOCATION THAT WILL
PRODUCE A FINAL OBJECT WIDTH OF
19 FULL INCHES IF THE PERSPECTIVE
IS DRAWN AT 3/4" = 1-0 SCALE.

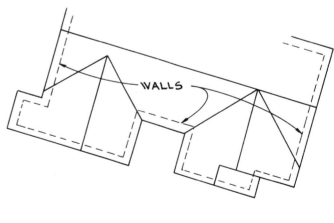

WALLS

PLAN VIEW
3/32" = 1-0 SCALE

SUBJECT	GRADE	NAME	SHEET
FINAL OBJECT WIDTH			2.61

● TWO POSSIBLE OPTIONS WHEN LOCATING THE PICTURE PLANE IN THE PRECISE
LOCATION TO PRODUCE A GIVEN FINAL OBJECT WIDTH :

■ <u>OPTION #1</u> (PERSPECTIVE DRAWN AT AN <u>ARCHITECTURAL SCALE</u>)

 <u>GIVEN:</u>

 a. DESIRED FINAL OBJECT WIDTH IN INCHES (EXAMPLE: <u>15"</u> FINAL OBJECT WIDTH)

 b. SCALE THE PERSPECTIVE IS TO BE DRAWN AT (EXAMPLE: 1/8", 3/16", 1/4", <u>1/2"</u> etc.)

 <u>REQUIRED CALCULATIONS:</u>

 $$\frac{\text{FINAL OBJECT WIDTH} \quad 15"}{\text{PERSPECTIVE SCALE} \quad 1/2 \text{ or } .5} = \begin{array}{l}\text{REQUIRED DISTANCE BETWEEN POINTS 1 AND 2}\\ \text{ON THE PRELIMINARY PP/HL}\end{array}$$

 EXAMPLE: $\dfrac{15}{.5} = \underline{30'\text{-}0}$

 30'-0 PP/HL (PRELIMINARY)

 1 2

 (PLAN VIEW)

 SP

■ <u>OPTION #2</u> (PERSPECTIVE DRAWN AT AN <u>ENGINEERING SCALE</u>)

 <u>GIVEN:</u>

 a. DESIRED FINAL OBJECT WIDTH IN INCHES (EXAMPLE: <u>17"</u> FINAL OBJECT WIDTH)

 b. SCALE THE PERSPECTIVE IS TO BE DRAWN AT (EXAMPLE: 10, <u>20</u>, 30, 40 etc.)

 <u>REQUIRED CALCULATIONS:</u> ↳ 1":20'-0

 (FINAL OBJECT WIDTH) X (PERSPECTIVE SCALE) = REQUIRED DISTANCE BETWEEN POINTS
 1 AND 2 ON THE PRELIMINARY PP/HL

 EXAMPLE: 17 X 20 = <u>340'-0</u> 340'-0 PP/HL (PRELIMINARY)

 1 2

 (PLAN VIEW)

 SP

● TWO POSSIBLE OPTIONS WHEN DETERMINING THE FINAL OBJECT WIDTH WITH THE PICTURE
PLANE IN ITS PRESENT LOCATION :

 <u>GIVEN :</u>

 IN FEET

 PRE. PP/HL

 1 2

 (PLAN VIEW)

 SP

 a. <u>PRELIMINARY OBJECT WIDTH</u> FROM THE PRELIMINARY PP/HL

 b. SCALE THE PERSPECTIVE IS TO BE DRAWN AT

 <u>REQUIRED CALCULATIONS :</u>

■ <u>OPTION #1</u> PERSPECTIVE DRAWN AT AN ║ ■ <u>OPTION #2</u> PERSPECTIVE DRAWN AT AN
 <u>ARCHITECTURAL</u> SCALE ║ <u>ENGINEERING</u> SCALE

$\left(\begin{array}{c}\text{PRELIMINARY}\\ \text{OBJECT WIDTH}\end{array}\right) \times \left(\begin{array}{c}\text{PERSPECTIVE}\\ \text{SCALE}\end{array}\right) =$ ║ $\dfrac{\left(\begin{array}{c}\text{PRELIMINARY}\\ \text{OBJECT WIDTH}\end{array}\right)}{\left(\begin{array}{c}\text{PERSPECTIVE}\\ \text{SCALE}\end{array}\right)} = \begin{array}{l}\text{FINAL OBJECT WIDTH}\\ \text{(IN INCHES)}\end{array}$

 FINAL OBJECT WIDTH
 (IN INCHES)

TYPICAL ARCHITECTURAL SCALES : ║ TYPICAL ENGINEERING SCALES :

<u>1/8"=1'-0</u>, <u>3/16"=1'-0</u>, <u>1/4"=1'-0</u>, <u>3/8"=1'-0</u> ║ <u>1"= 10'-0</u>, <u>1"= 20'-0</u>, <u>1"= 30'-0</u>, <u>1"= 40'-0</u>

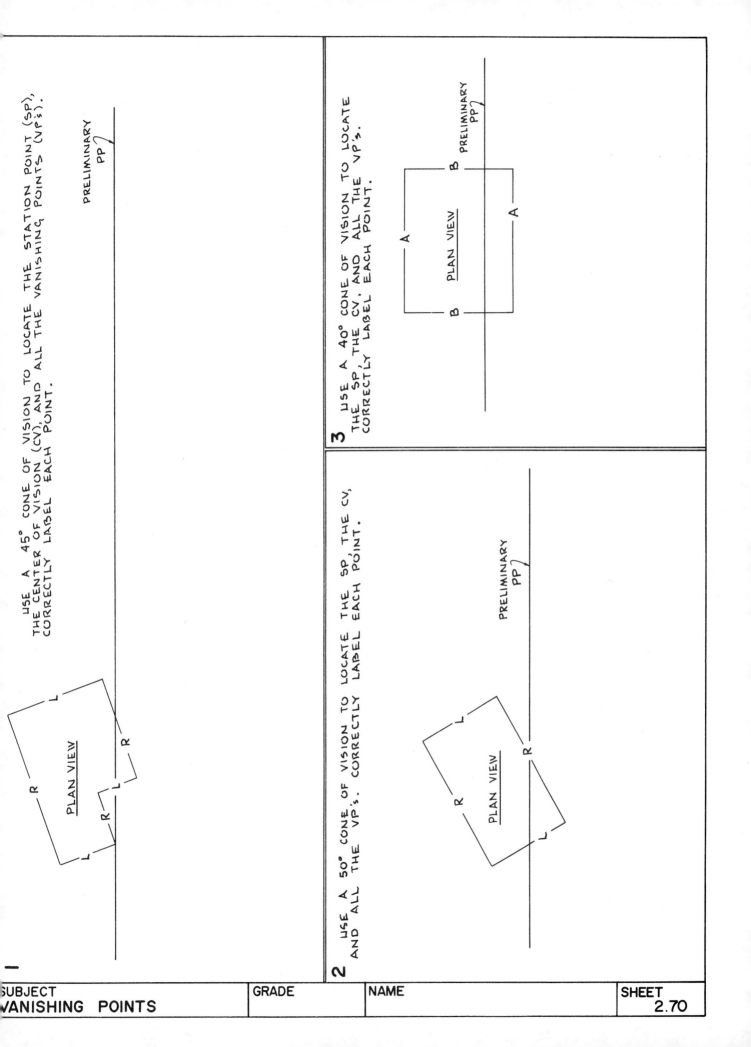

1
USE A 45° CONE OF VISION TO LOCATE THE STATION POINT (SP),
THE CENTER OF VISION (CV), AND ALL THE VANISHING POINTS (VP's).
CORRECTLY LABEL EACH POINT.

PLAN VIEW

PRELIMINARY
PP

2
USE A 50° CONE OF VISION TO LOCATE THE SP, THE CV,
AND ALL THE VP's. CORRECTLY LABEL EACH POINT.

PLAN VIEW

PRELIMINARY
PP

3
USE A 40° CONE OF VISION TO LOCATE
THE SP, THE CV, AND ALL THE VP's.
CORRECTLY LABEL EACH POINT.

PLAN VIEW

PRELIMINARY
PP

SUBJECT	GRADE	NAME	SHEET
VANISHING POINTS			2.70

FIG. 10

1/8" = 1'-0 SCALE

PRELIMINARY PP

PLAN VIEW

YOU ARE GIVEN THE PLAN VIEW OF A MULTI-SIDED OBJECT. SEE FIG. 10. USE A 35° CONE OF VISION TO LOCATE THE STATION POINT (SP), THE CENTER OF VISION (CV), AND THE VANISHING POINTS. CORRECTLY LABEL EACH POINT. DOCUMENT THE DISTANCE BETWEEN THE CV AND EACH VANISHING POINT.

CV TO VPA _____ CV TO VPD _____

CV TO VPB _____ CV TO VPE _____

CV TO VPC _____

FIG. 11

YOU ARE GIVEN THE PLAN VIEW OF THREE OBJECTS. SEE FIG. 11. USE A 30° CONE OF VISION TO LOCATE THE SP, THE CV, AND ALL THE VP's. LABEL EACH POINT CORRECTLY.

PRELIMINARY PP

PLAN VIEW

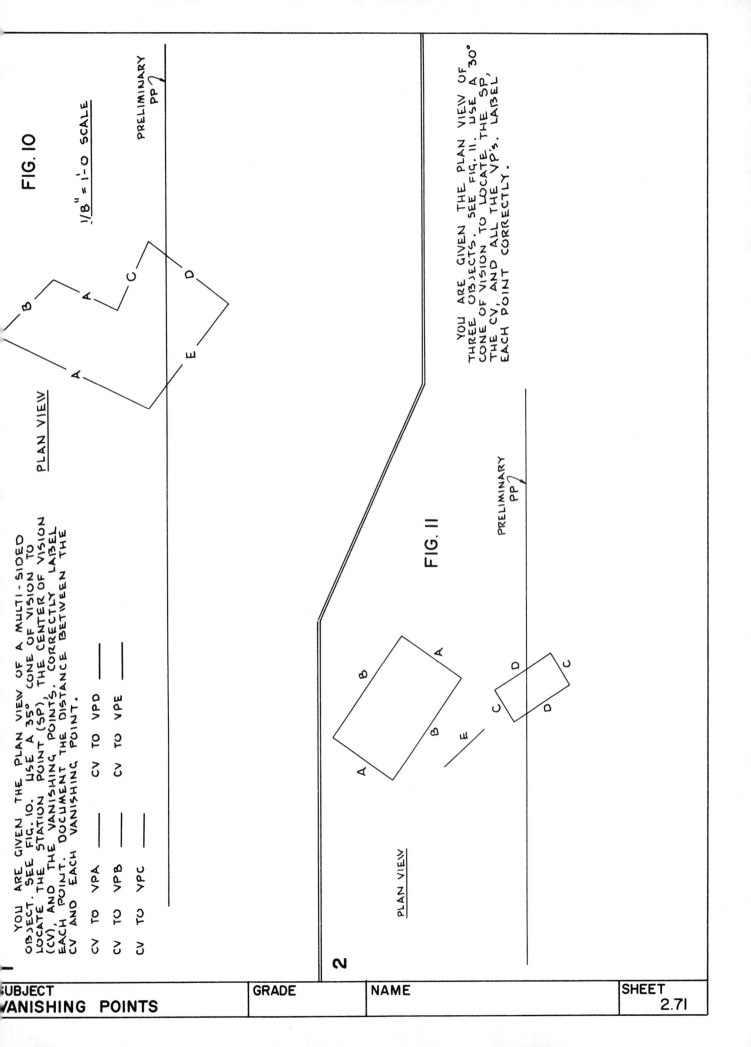

SUBJECT
VANISHING POINTS

GRADE

NAME

SHEET
2.71

GIVEN IS THE PLAN VIEW OF A HOUSE, THE PP AND THE VANISHING POINTS.
DETERMINE THE OBJECT WIDTH FROM THE PRELIMINARY HL.

PRELIMINARY OBJECT WIDTH ——— FEET & INCHES

HOW LARGE WILL BE THE FINAL OBJECT WIDTH, IN FULL INCHES, IF THE
PERSPECTIVE IS DRAWN AT 1/4"=1'-O SCALE?

FINAL OBJECT WIDTH ——— " FULL INCHES

RVP

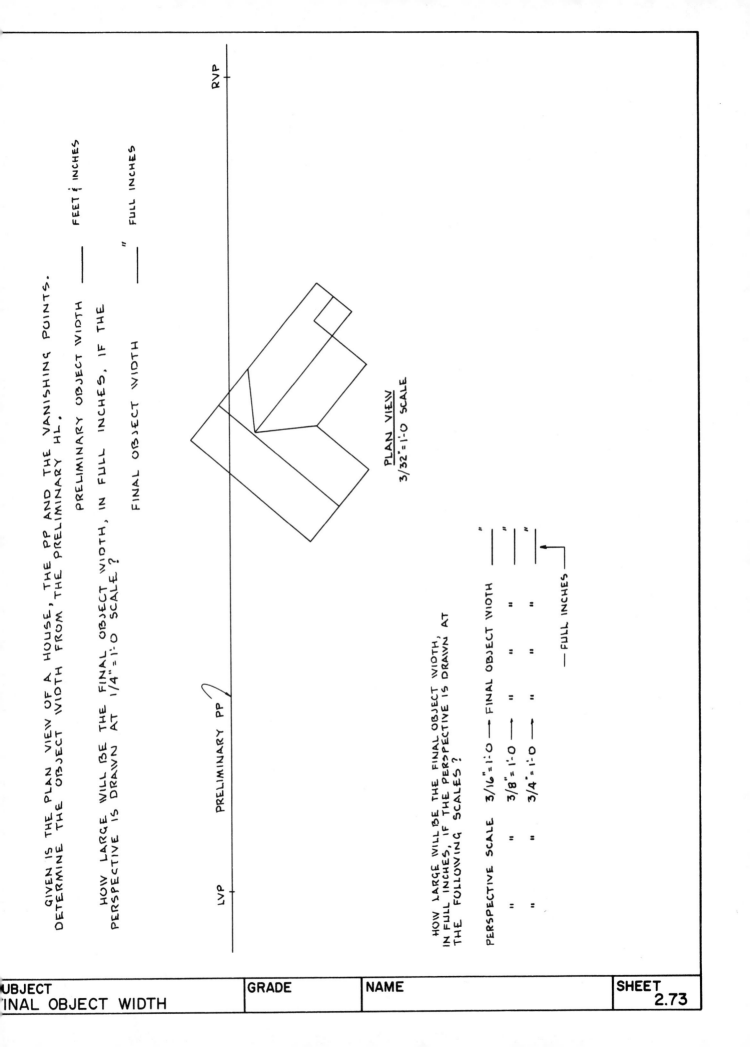

PLAN VIEW
3/32"=1'-O SCALE

PRELIMINARY PP

LVP

HOW LARGE WILL BE THE FINAL OBJECT WIDTH,
IN FULL INCHES, IF THE PERSPECTIVE IS DRAWN AT
THE FOLLOWING SCALES?

PERSPECTIVE SCALE 3/16"=1'-O ——→ FINAL OBJECT WIDTH ——— "

" " 3/8"=1'-O ——→ " " " ——— "

" " 3/4"=1'-O ——→ " " " ——— "

——→ FULL INCHES

SUBJECT
FINAL OBJECT WIDTH

GRADE

NAME

SHEET
2.73

GIVEN IS THE PLAN VIEW OF THE
OBJECT AND THE LOCATION OF THE
PICTURE PLANE (PP). USE A 40° CONE
OF VISION TO LOCATE THE STATION
POINT (SP), THE CENTER OF VISION (CV),
THE VANISHING POINTS (VP's), AND THE
MEASURING POINTS (MP's). CORRECTLY
LABEL EACH POINT AND DOCUMENT THE
DISTANCE FROM THE :

CV TO RVP _____

CV TO RMP _____

CV TO LVP _____

CV TO LMP _____ .

PLAN VIEW

R
L
L
R

1/8" = 1'-0 SCALE

PRELIMINARY
PP

GIVEN IS THE PLAN VIEW OF AN OBJECT
AND THE LOCATION OF THE PP. USE A 30°
CONE OF VISION TO LOCATE THE SP, THE CV,
THE VP's, AND THE MP's.

PRELIMINARY
PP

PLAN VIEW

L
R
L
R

3/32" = 1'-0 SCALE

CORRECTLY LABEL EACH POINT AND
DOCUMENT THE DISTANCE FROM THE :

CV TO LVP _____

CV TO LMP _____

CV TO RVP _____

CV TO RMP _____ .

USE A 45° CONE OF VISION TO
LOCATE THE SP, THE CV, THE VP's,
AND THE MP's. CORRECTLY LABEL
EACH POINT.

PLAN VIEW

A
B
B
A
B
A

PRELIMINARY
PP

SUBJECT
MEASURING POINTS

GRADE

NAME

SHEET
2.74

1 USE A 50° CONE OF VISION TO
LOCATE THE SP AND THE CV. LOCATE
A USABLE STARTING POINT FOR THE
PERSPECTIVE. DIMENSION AND MEASURE
THE DISTANCE FROM THIS STARTING
POINT TO THE CV (DIMENSION "x").

DIMENSION x = _____

PLAN VIEW

PP

3/32"=1'-0 SCALE

2 USING THE BASE LINE DIMENSIONING
TECHNIQUE, IDENTIFY ALL THE
DIMENSION "x" POSSIBILITIES IN THIS
PLAN VIEW.

CV PP

PLAN VIEW

3 USE A 45° CONE OF VISION TO LOCATE THE SP. NOW LOCATE THE PRELIMINARY
PP IN THE PRECISE LOCATION THAT WILL PRODUCE A FINAL OBJECT WIDTH OF
10 1/2 FULL INCHES WHEN THE PERSPECTIVE IS DRAWN AT 1/2"=1'-0 SCALE. NOW
LOCATE AND LABEL THE CV, THE VP'S, AND THE MP'S.

PLAN VIEW
3/32"=1'-0 SCALE

USING THE BASE LINE DIMENSIONING
TECHNIQUE, DIMENSION AND DOCUMENT
THE DISTANCE FROM THE :

CV TO THE LMP _____

CV TO THE RVP _____

CV TO THE RMP _____

CV TO THE LVP _____

ALSO, DIMENSION AND DOCUMENT AN
APPROPRIATE DIMENSION "x".

DIMENSION "x" = _____

SUBJECT	GRADE	NAME	SHEET
STARTING POINT (Dim. x)			2.76

1

GIVEN IS A STANDARD PERSPECTIVE SETUP WITH SIX HORIZONTAL LINES. LABEL EACH LINE AS EITHER A RIGHT OR A LEFT BASE LINE (RBL OR LBL).

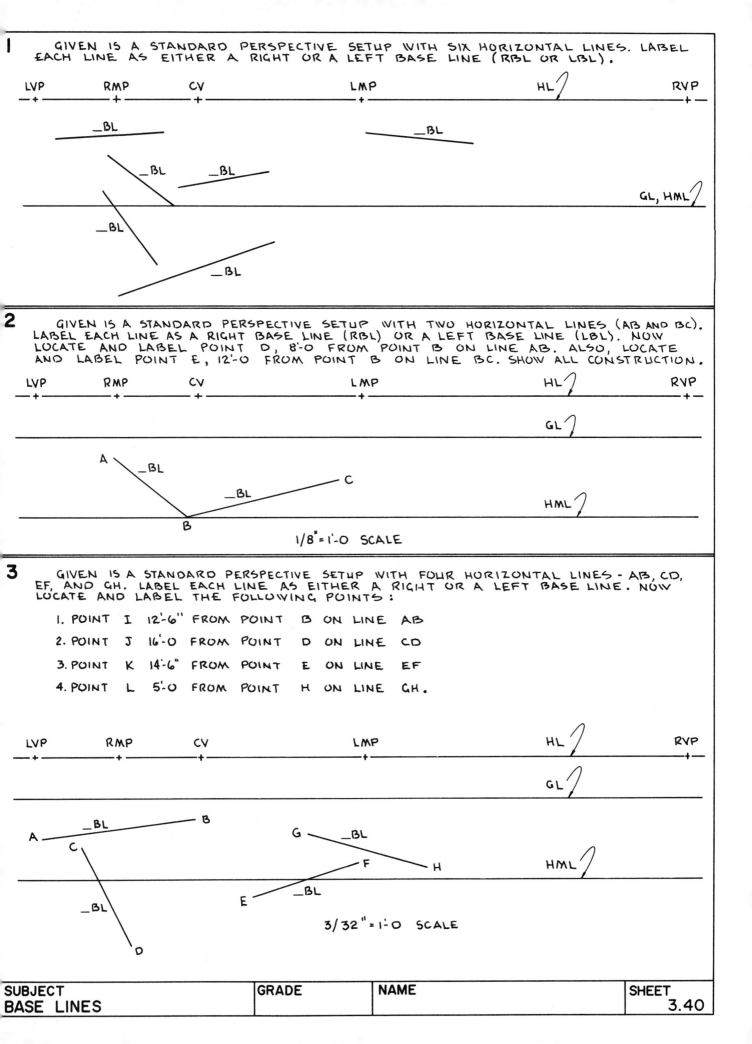

LVP RMP CV LMP HL RVP
—+—————+—————+————————————————+—————————————— —+—

＿BL ＿BL

＿BL ＿BL

GL, HML

＿BL

＿BL

2

GIVEN IS A STANDARD PERSPECTIVE SETUP WITH TWO HORIZONTAL LINES (AB AND BC). LABEL EACH LINE AS A RIGHT BASE LINE (RBL) OR A LEFT BASE LINE (LBL). NOW LOCATE AND LABEL POINT D, 8'-0 FROM POINT B ON LINE AB. ALSO, LOCATE AND LABEL POINT E, 12'-0 FROM POINT B ON LINE BC. SHOW ALL CONSTRUCTION.

LVP RMP CV LMP HL RVP
—+—————+—————+————————————————+—————————————— —+—

GL

A
 ＿BL C
 ＿BL
 HML
 B

1/8" = 1'-0 SCALE

3

GIVEN IS A STANDARD PERSPECTIVE SETUP WITH FOUR HORIZONTAL LINES - AB, CD, EF, AND GH. LABEL EACH LINE AS EITHER A RIGHT OR A LEFT BASE LINE. NOW LOCATE AND LABEL THE FOLLOWING POINTS:

1. POINT I 12'-6" FROM POINT B ON LINE AB

2. POINT J 16'-0 FROM POINT D ON LINE CD

3. POINT K 14'-6" FROM POINT E ON LINE EF

4. POINT L 5'-0 FROM POINT H ON LINE GH.

LVP RMP CV LMP HL RVP
—+—————+—————+————————————————+—————————————— —+—

GL

 ＿BL B
A G ＿BL
 C H
 F HML
 E ＿BL
 ＿BL

D

3/32" = 1'-0 SCALE

SUBJECT	GRADE	NAME	SHEET
BASE LINES			3.40

1

GIVEN IS A STANDARD PERSPECTIVE SETUP WITH FOUR HORIZONTAL LINES - AB, CD, DE, AND FG. LABEL EACH LINE AS EITHER A RIGHT OR A LEFT BASE LINE. NOW LOCATE THE FOLLOWING POINTS:

1. POINT H 2'-0 FROM POINT A ON LINE AB
2. POINT I 4'-0 FROM POINT D ON LINE DC
3. POINT J 2'-6" FROM POINT D ON LINE DE
4. POINT K 3'-9" FROM POINT F ON LINE FG.

ANSWER THE FOLLOWING QUESTION. HOW LONG ARE THESE LINE SEGMENTS?

HB _____ JE _____

CI _____ KG _____

LVP HL RMP CV LMP RVP
—+ ——————————————————————+————————————————+—————————+—————+—

GL

HML

A ———————— _BL ———— B

F ———— _BL

C E G

_BL D _BL

1/4"=1'-0 SCALE PERSPECTIVE PLAN

2

GIVEN IS A STANDARD PERSPECTIVE SETUP WITH THREE HORIZONTAL LINES - AB, CD, AND EF. LABEL EACH LINE AS EITHER A RIGHT OR A LEFT BASE LINE. DETERMINE THE LENGTH OF EACH LINE.

LENGTH OF LINE AB _____

CD _____

EF _____ SHOW ALL CONSTRUCTION.

LVP HL RMP CV LMP RVP
—+ ——————————————————————+————————————————+—————————+—————+—

GL

HML

C ———— _BL ———— D F

A

_BL B _BL

E

3/16"=1'-0 SCALE

PERSPECTIVE PLAN

SUBJECT	GRADE	NAME	SHEET
HORIZONTAL MEASUREMENTS			3.41

1 GIVEN IS A PARTIAL PERSPECTIVE SETUP AND THREE HORIZONTAL LINES - A, B, AND C. LOCATE AND LABEL ALL VANISHING AND MEASURING POINTS. DOCUMENT THE LENGTH OF EACH LINE.

LINE A ____

LINE B ____

LINE C ____ SHOW ALL CONSTRUCTION.

HL CV

GL

 A B C

HML

 B C

 A

1/8"=1'-0 SCALE PERSPECTIVE PLAN

• SP

2 GIVEN IS A STANDARD PERSPECTIVE SETUP AND FOUR HORIZONTAL LINES - A, B, C, AND D. USING THE APPROPRIATE MEASURING POINTS, MAKE LINE "A", 40'-0 LONG; LINE "B", 45'-0 LONG; LINE "C", 35'-0 LONG; AND LINE "D", 22'-0 LONG.

LVP HL RMP CV LMP RVP

 GL
 D
 A B C

 HML

 A B C D

1"=20'-0 SCALE PERSPECTIVE PLAN

SUBJECT	GRADE	NAME	SHEET
HORIZONTAL MEASUREMENTS			3.42

PLAN VIEW 1" = 30'-0 SCALE

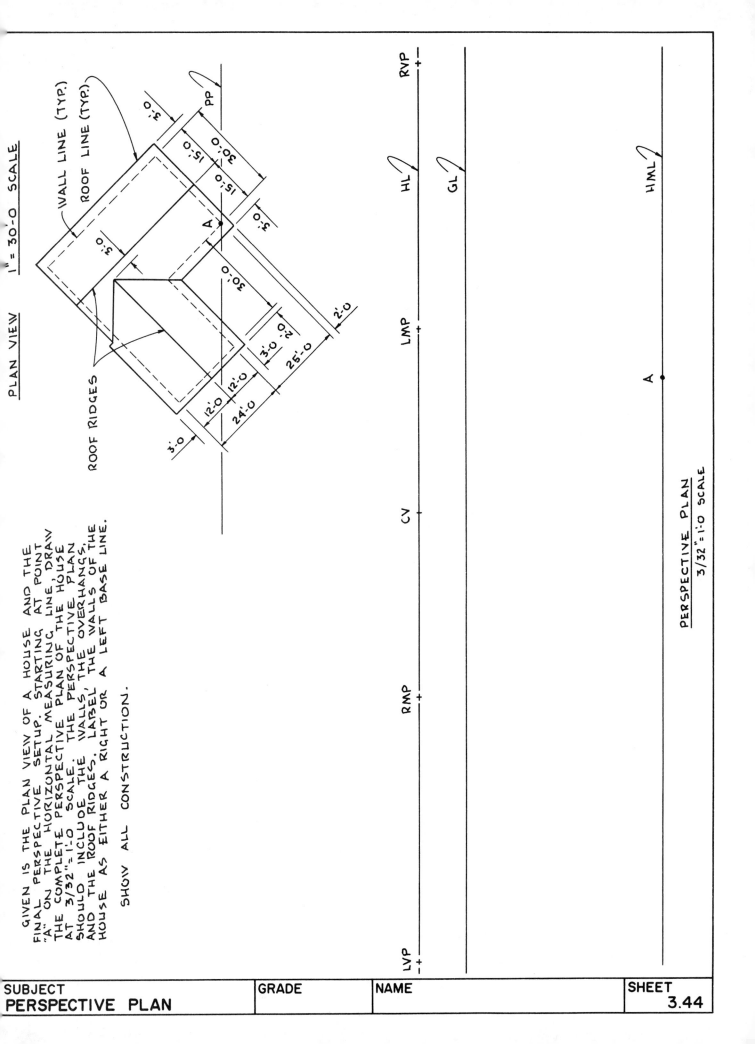

WALL LINE (TYP.)
ROOF LINE (TYP.)
PP
3'-0
30'-0
15'-0
15'-0
3'-0
A
5'-0
30'-0
ROOF RIDGES
3'-0
2'-0
3'-0
25'-0
12'-0
12'-0
24'-0
3'-0

GIVEN IS THE PLAN VIEW OF A HOUSE AND THE
FINAL PERSPECTIVE SETUP. STARTING AT POINT
"A" ON THE HORIZONTAL MEASURING LINE, DRAW
THE COMPLETE PERSPECTIVE PLAN OF THE HOUSE
AT 3/32"=1'-0 SCALE. THE PERSPECTIVE PLAN
SHOULD INCLUDE THE WALLS, THE OVERHANGS,
AND THE ROOF RIDGES. LABEL THE WALLS OF THE
HOUSE AS EITHER A RIGHT OR A LEFT BASE LINE.

SHOW ALL CONSTRUCTION.

RVP
HL
GL
LMP
CV
RMP
LVP
HML
A

PERSPECTIVE PLAN
3/32" = 1'-0 SCALE

SUBJECT
PERSPECTIVE PLAN

GRADE

NAME

SHEET
3.44

1

GIVEN IS A DRAWN PERSPECTIVE PLAN OF A U-SHAPED BUILDING. THE HEIGHT OF EACH SECTION OF THE BUILDING IS INDICATED. DRAW THE PERSPECTIVE AT 1"= 60'-0 SCALE. LABEL ALL THL's AND SHOW ALL CONSTRUCTION.

LVP
+

HL

RVP
+

GL

HML

70'-0

100'-0

30'-0

PERSPECTIVE PLAN
1"= 60'-0 SCALE

2

GIVEN IS A DRAWN PERSPECTIVE PLAN OF A HIGH RISE BUILDING. THE HEIGHT OF EACH SECTION OF THIS BUILDING IS INDICATED. DRAW THE PERSPECTIVE AT 1"= 50'-0 SCALE. LOCATE A NEW THL FOR EACH SECTION OF THE BUILDING. SHOW ALL CONSTRUCTION.

LVP
+

HL

RVP
+

GL

105'-0

350'-0

160'-0

25'-0

63'-0

PERSPECTIVE PLAN

1"= 50'-0 SCALE

HML

SUBJECT	GRADE	NAME	SHEET
TRUE HEIGHT LINES			3.51

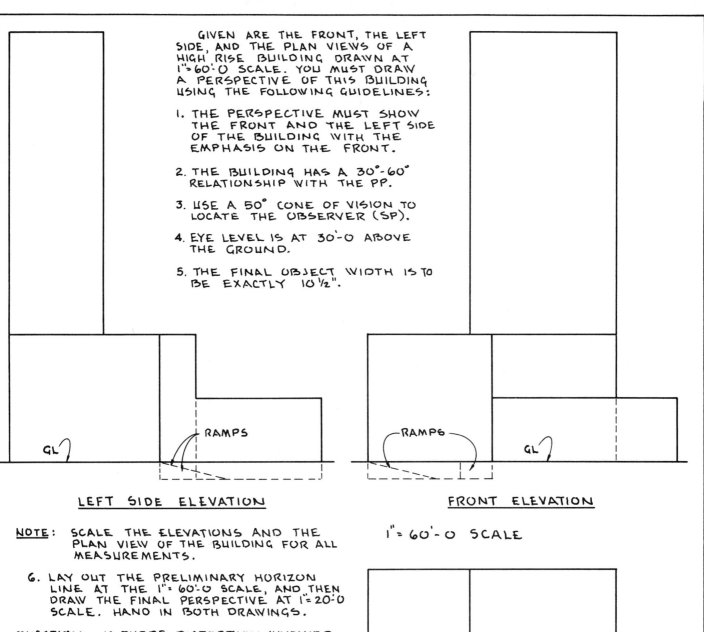

GIVEN ARE THE FRONT, THE LEFT SIDE, AND THE PLAN VIEWS OF A HIGH RISE BUILDING DRAWN AT 1"=60'-0 SCALE. YOU MUST DRAW A PERSPECTIVE OF THIS BUILDING USING THE FOLLOWING GUIDELINES:

1. THE PERSPECTIVE MUST SHOW THE FRONT AND THE LEFT SIDE OF THE BUILDING WITH THE EMPHASIS ON THE FRONT.

2. THE BUILDING HAS A 30°-60° RELATIONSHIP WITH THE PP.

3. USE A 50° CONE OF VISION TO LOCATE THE OBSERVER (SP).

4. EYE LEVEL IS AT 30'-0 ABOVE THE GROUND.

5. THE FINAL OBJECT WIDTH IS TO BE EXACTLY 10½".

RAMPS

GL

LEFT SIDE ELEVATION

NOTE: SCALE THE ELEVATIONS AND THE PLAN VIEW OF THE BUILDING FOR ALL MEASUREMENTS.

6. LAY OUT THE PRELIMINARY HORIZON LINE AT THE 1"=60'-0 SCALE, AND THEN DRAW THE FINAL PERSPECTIVE AT 1"=20'-0 SCALE. HAND IN BOTH DRAWINGS.

QUESTION: IS THERE DISTORTION INVOLVED IN THIS PERSPECTIVE?

YES ___ NO ___

RAMPS

GL

FRONT ELEVATION

1"= 60'-0 SCALE

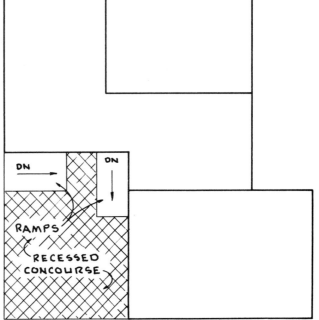

DN

DN

RAMPS

RECESSED CONCOURSE

PLAN VIEW

SUBJECT	GRADE	NAME	SHEET
PERSPECTIVE DRAWING			3.52

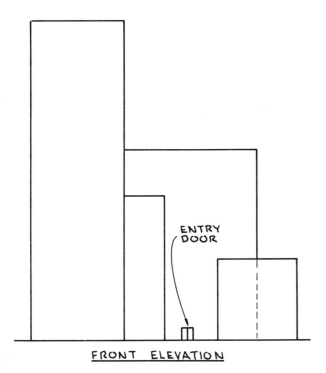

FRONT ELEVATION

1" = 60'-0 SCALE

RIGHT SIDE ELEVATION

ENTRY DOOR

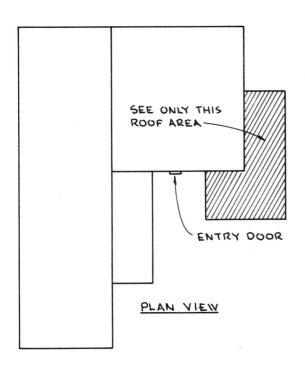

SEE ONLY THIS ROOF AREA

ENTRY DOOR

PLAN VIEW

1" = 60'-0 SCALE

GIVEN ARE THE FRONT, THE RIGHT SIDE, AND THE PLAN VIEWS OF A COMMERCIAL BUILDING DRAWN AT 1"=60'-0 SCALE. YOU MUST DRAW A PERSPECTIVE OF THIS BUILDING USING THE FOLLOWING GUIDELINES:

1. THE PERSPECTIVE MUST SHOW THE FRONT AND THE RIGHT SIDE OF THE BUILDING WITH THE EMPHASIS ON THE FRONT.

2. THE FRONT ENTRY DOORS MUST BE VISIBLE IN THE PERSPECTIVE.

3. CREATE A DRAMATIC PERSPECTIVE. SOME VERTICAL DISTORTION IS PERMITTED.

4. THE EYE LEVEL CHOSEN MUST ALLOW THE OBSERVER TO SEE ONLY THE LOWEST ROOF LEVEL.

5. THE FINAL OBJECT WIDTH IS TO BE EXACTLY 11 FULL INCHES ACROSS.

NOTE: SCALE THE ELEVATIONS AND THE PLAN VIEW TO OBTAIN ALL MEASUREMENTS.

6. LAY OUT THE PRELIMINARY HL AT 1"=60'-0 SCALE, AND THEN DRAW THE FINAL PERSPECTIVE AT 1"=20'-0 SCALE. HAND IN BOTH DRAWINGS.

DOCUMENT THE FOLLOWING INFORMATION:

1. OBJECT ALIGNMENT WITH THE PP - FRONT _____°

_____ SIDE _____°

2. CONE OF VISION SIZE _____°

3. EYE LEVEL _____ FT.

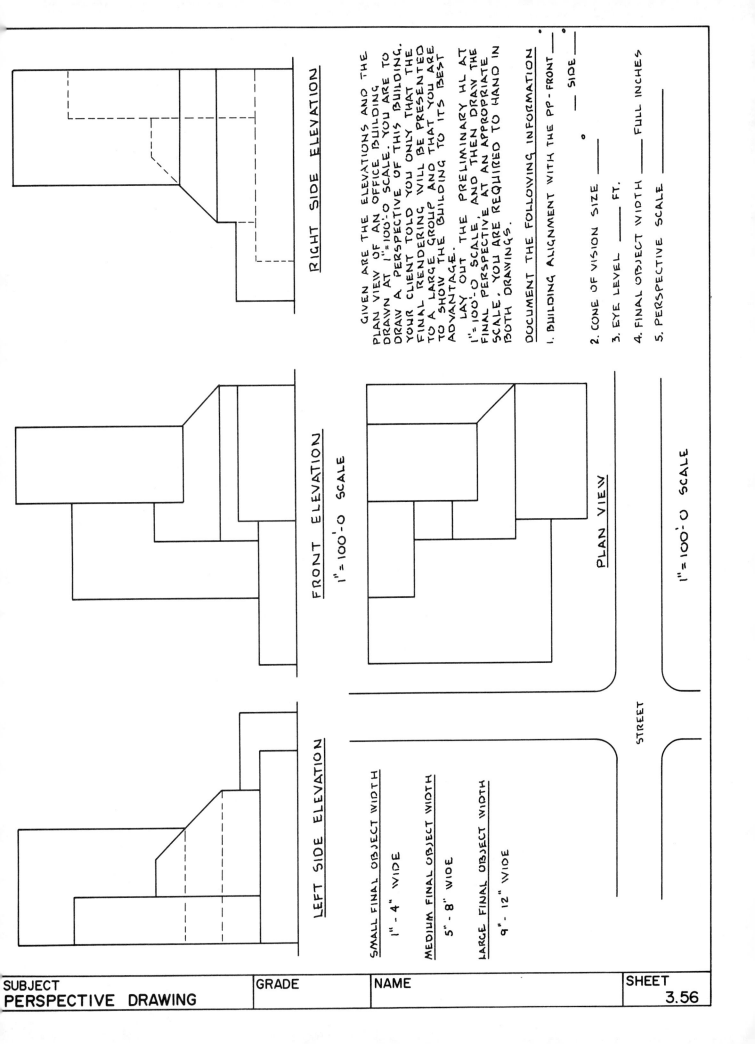

RIGHT SIDE ELEVATION

GIVEN ARE THE ELEVATIONS AND THE PLAN VIEW OF AN OFFICE BUILDING DRAWN AT 1"=100'-0 SCALE. YOU ARE TO DRAW A PERSPECTIVE OF THIS BUILDING. YOUR CLIENT TOLD YOU ONLY THAT THE FINAL RENDERING WILL BE PRESENTED TO A LARGE GROUP AND THAT YOU ARE TO SHOW THE BUILDING TO ITS BEST ADVANTAGE.

LAY OUT THE PRELIMINARY HL AT 1"=100'-0 SCALE, AND THEN DRAW THE FINAL PERSPECTIVE AT AN APPROPRIATE SCALE. YOU ARE REQUIRED TO HAND IN BOTH DRAWINGS.

DOCUMENT THE FOLLOWING INFORMATION

1. BUILDING ALIGNMENT WITH THE PP - FRONT _____
 SIDE _____

2. CONE OF VISION SIZE _____

3. EYE LEVEL _____ FT.

4. FINAL OBJECT WIDTH _____ FULL INCHES

5. PERSPECTIVE SCALE _____

FRONT ELEVATION
1" = 100'-0 SCALE

PLAN VIEW
1" = 100'-0 SCALE

STREET

LEFT SIDE ELEVATION

SMALL FINAL OBJECT WIDTH
1" - 4" WIDE

MEDIUM FINAL OBJECT WIDTH
5" - 8" WIDE

LARGE FINAL OBJECT WIDTH
9" - 12" WIDE

SUBJECT	GRADE	NAME	SHEET
PERSPECTIVE DRAWING			3.56

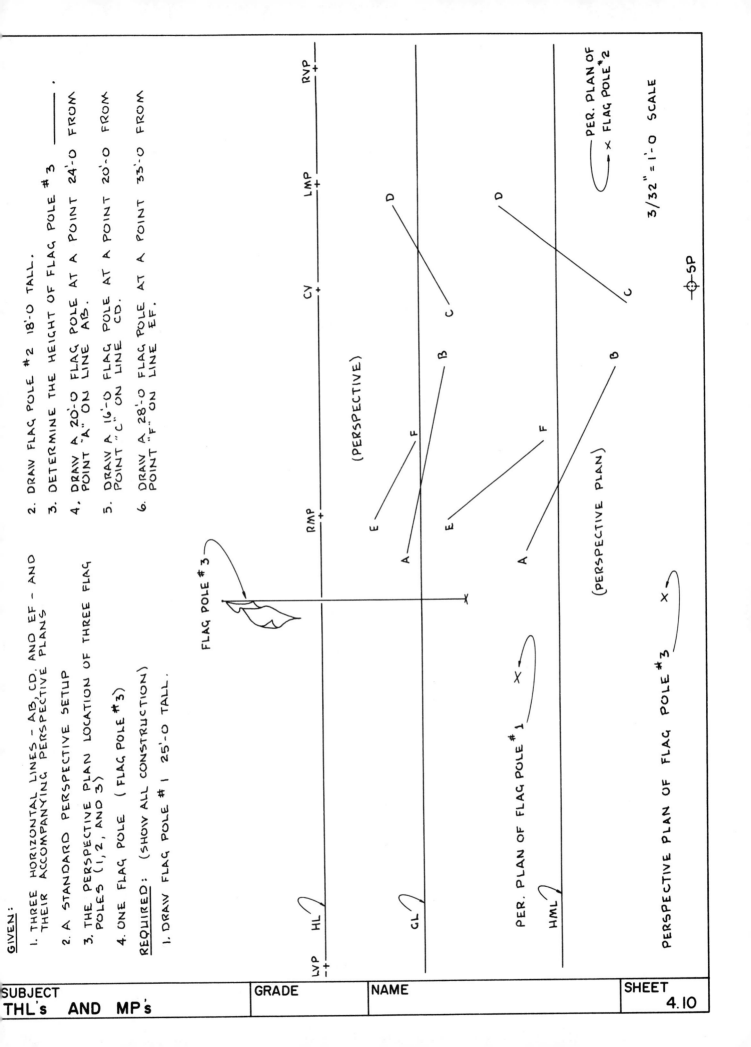

GIVEN:

1. THREE HORIZONTAL LINES – AB, CD, AND EF – AND THEIR ACCOMPANYING PERSPECTIVE PLANS

2. A STANDARD PERSPECTIVE SETUP

3. THE PERSPECTIVE PLAN LOCATION OF THREE FLAG POLES (1, 2, AND 3)

4. ONE FLAG POLE (FLAG POLE #3)

REQUIRED: (SHOW ALL CONSTRUCTION)

1. DRAW FLAG POLE #1 25'-0 TALL.

2. DRAW FLAG POLE #2 18'-0 TALL.

3. DETERMINE THE HEIGHT OF FLAG POLE #3 _____ .

4. DRAW A 20'-0 FLAG POLE AT A POINT 24'-0 FROM POINT "A" ON LINE AB.

5. DRAW A 16'-0 FLAG POLE AT A POINT 20'-0 FROM POINT "C" ON LINE CD.

6. DRAW A 28'-0 FLAG POLE AT A POINT 35'-0 FROM POINT "F" ON LINE EF.

FLAG POLE #3

(PERSPECTIVE)

(PERSPECTIVE PLAN)

PER. PLAN OF FLAG POLE #1

PER. PLAN OF FLAG POLE #2

PERSPECTIVE PLAN OF FLAG POLE #3

3/32" = 1'-0 SCALE

LVP HL RMP CV LMP RVP

GL

HML

| SUBJECT | GRADE | NAME | SHEET |
| THL's AND MP's | | | 4.10 |

GIVEN IS A PERSPECTIVE DRAWING OF A BUILDING. THERE ARE FOUR VERTICAL WALLS OF THE BUILDING VISIBLE IN THIS VIEW. WRITE AN R OR L ON EACH WALL TO INDICATE IF IT IS A RIGHT OR A LEFT VERTICAL PLANE. LOCATE, DRAW AND LABEL THE HORIZON LINE FOR EACH VERTICAL PLANE.

LVP
+-

HL

RVP
+-

2 GIVEN IS A PERSPECTIVE DRAWING OF A HOUSE. THERE ARE FIVE VERTICAL WALLS OF THE HOUSE VISIBLE IN THIS VIEW. WRITE AN R OR L ON EACH WALL TO INDICATE IF IT IS A RIGHT OR A LEFT VERTICAL PLANE. NOW LOCATE, DRAW AND LABEL THE VANISHING POINTS FOR EACH OF THE FOLLOWING INCLINED LINES: AB, CD, EF, AND FG. ALSO, LABEL ALL VERTICAL HORIZON LINES.
 BONUS: LOCATE AND LABEL THE VP FOR
 INCLINED LINE HI.

LVP
+-

HL

RVP
+-

3 GIVEN ARE SIX VERTICAL PLANES, 1 THROUGH 6, STANDING ON A HORIZONTAL SURFACE. LOCATE, DRAW AND LABEL THE VERTICAL HORIZON LINE FOR EACH VERTICAL PLANE (i.e. VERTICAL HORIZON LINE FOR PLANE #1 - VHL 1). NOW LOCATE, DRAW AND LABEL THE VANISHING POINT FOR EACH INCLINED LINE.

HL

HL

SUBJECT	GRADE	NAME	SHEET
VERTICAL PLANES			4.20

1

GIVEN ARE THE FRONT AND LEFT SIDE ELEVATIONS AND A PARTIAL PERSPECTIVE OF A TWO-STORY HOUSE. LABEL THE FOUR VISIBLE VERTICAL WALLS AS RIGHT OR LEFT VERTICAL PLANES. USING THE GIVEN ANGLE DATA, COMPLETE THE PERSPECTIVE DRAWING. LOCATE AND LABEL ALL VERTICAL HORIZON LINES AND ALL VANISHING POINTS. SHOW ALL CONSTRUCTION.

(NOT DRAWN TO SCALE)

30° C 30°
A B
 E
 D,F

LEFT SIDE ELEV.

C
B,A
21° E
D F

FRONT ELEV.

B
A RMP CV
 + +
LVP
+

D
F

LMP HL RVP
-+ +

2

GIVEN ARE THE FRONT AND LEFT SIDE ELEVATIONS AND A PARTIAL PERSPECTIVE OF A TWO-STORY HOUSE. LABEL THE EIGHT VISIBLE VERTICAL WALLS AS EITHER RIGHT OR LEFT VERTICAL PLANES. USING THE GIVEN ANGLE DATA, COMPLETE THE PERSPECTIVE DRAWING. LOCATE AND LABEL ALL VERTICAL HORIZON LINES AND ALL VANISHING POINTS. SHOW ALL CONSTRUCTION.

NOT DRAWN TO SCALE

45° LINES
A C
 B
 F
 E

LEFT SIDE ELEV.

30° LINES
 C D
B
 E F G

FRONT ELEV.

LVP RMP CV LMP HL RVP
-+ + + + +

A C D
 B
 F G
 E

LEFT SIDE VIEW FRONT VIEW

SUBJECT	GRADE	NAME	SHEET
VERTICAL & INCLINED PLANES			4.21

1

GIVEN IS THE COMPLETED PERSPECTIVE OF A BI-LEVEL HOUSE. LABEL THE FIVE VISIBLE VERTICAL WALLS AS EITHER RIGHT OR LEFT VERTICAL PLANES. LOCATE, DRAW, AND LABEL ALL VERTICAL HORIZON LINES.

AFTER LOCATING THE NECESSARY VANISHING POINTS, DRAW AND LABEL THE INCLINED HORIZON LINES FOR PLANES "X" AND "Y". LOCATE THE VANISHING POINT FOR THE LINE OF INTERSECTION BETWEEN THESE TWO INCLINED PLANES (LINE AB). ALSO, DOCUMENT THE ANGLES THAT INCLINED LINES CD AND EF MAKE WITH THE HORIZONTAL GROUND PLANE.

ANGLE OF LINE CD _____°

ANGLE OF LINE EF _____°

BONUS INDICATE THE ANGLE THAT INCLINED LINE AB MAKES WITH THE HORIZONTAL GROUND PLANE.

ANGLE OF LINE AB _____°

SHOW ALL CONSTRUCTION.

INCLINED PLANE "X"
INCLINED PLANE "Y"

LVP HL RVP

* SP

2

GIVEN IS A PARTIALLY DRAWN PERSPECTIVE OF A ONE-STORY HOUSE. LABEL THE FOUR VISIBLE VERTICAL WALLS AS EITHER RIGHT OR LEFT VERTICAL PLANES. COMPLETE THE PERSPECTIVE DRAWING BY LOCATING AND CORRECTLY LABELING THE FOLLOWING ITEMS:

1. THE RIGHT AND LEFT VERTICAL HORIZON LINES
2. THE INCLINED HORIZON LINES FOR INCLINED PLANES X, Y, AND Z
3. THE VANISHING POINTS FOR THE LINES OF INTERSECTION BETWEEN PLANES X AND Z, AND Y AND Z.

ALSO, DOCUMENT THE ANGLES THAT INCLINED LINES A, B, AND C MAKE WITH THE HORIZONTAL GROUND PLANE.

ANGLE OF LINE A _____° ANGLE OF LINE B _____° ANGLE OF LINE C _____°

SHOW ALL CONSTRUCTION.

INCLINED PLANE "X"
INCLINED PLANE "Y" (PORCH ROOF)
INCLINED PLANE "Z"

LVP RMP CV LMP HL RVP

SUBJECT	GRADE	NAME	SHEET
VERTICAL & INCLINED HL's			4.22

GIVEN ARE FIVE VERTICAL PLANES, 1 THROUGH 5, STANDING ON A HORIZONTAL SURFACE.
LOCATE AND LABEL THE VERTICAL HORIZON LINE FOR EACH VERTICAL PLANE. NEXT, LOCATE
AND LABEL THE VANISHING POINT FOR EACH INCLINED LINE "A" THROUGH "G". ALSO,
DOCUMENT THE ANGLE THAT EACH INCLINED LINE MAKES WITH THE HORIZONTAL
GROUND PLANE.

ANGLE OF LINES : A ____° D ____° G ____°

 B ____° E ____°

 C ____° F ____° SHOW ALL CONSTRUCTION.

BONUS: INDICATE THE ANGLE A LINE DRAWN FROM POINT "X" TO POINT "Y" WOULD MAKE
 WITH THE HORIZONTAL GROUND PLANE.

 ANGLE OF LINE XY ____°

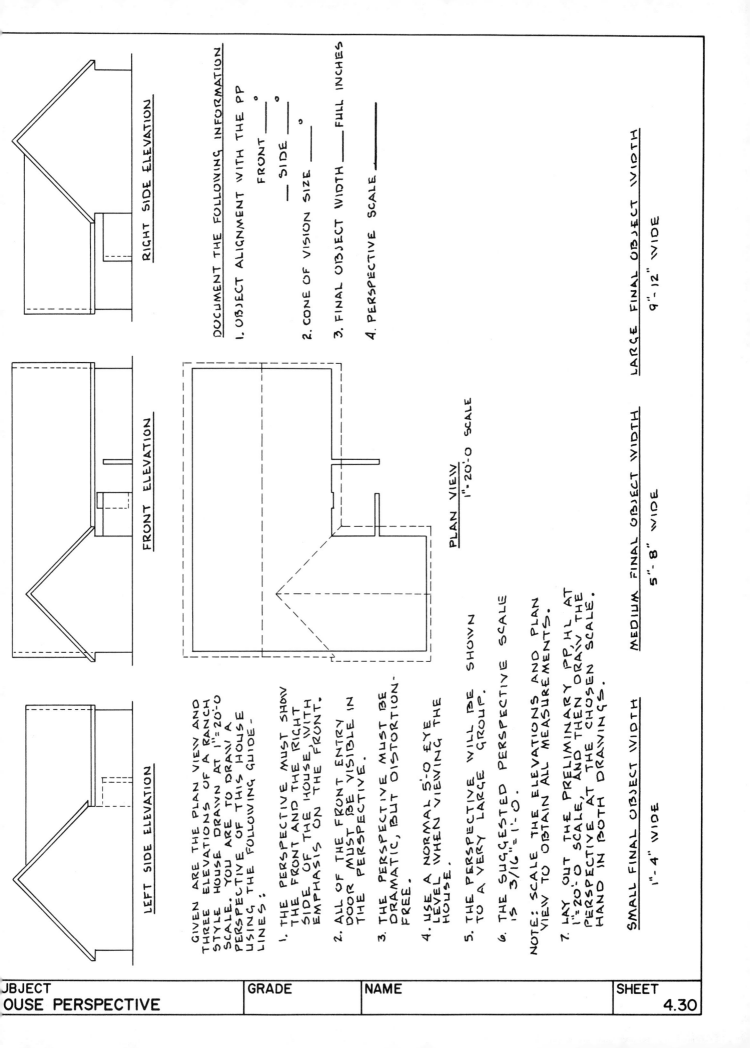

RIGHT SIDE ELEVATION

FRONT ELEVATION

LEFT SIDE ELEVATION

PLAN VIEW
1"=20'-0 SCALE

DOCUMENT THE FOLLOWING INFORMATION

1. OBJECT ALIGNMENT WITH THE PP

 FRONT _____°

 _____ SIDE _____°

2. CONE OF VISION SIZE _____°

3. FINAL OBJECT WIDTH _____ FULL INCHES

4. PERSPECTIVE SCALE _____

GIVEN ARE THE PLAN VIEW AND
THREE ELEVATIONS OF A RANCH
STYLE HOUSE DRAWN AT 1"=20'-0
SCALE. YOU ARE TO DRAW A
PERSPECTIVE OF THIS HOUSE
USING THE FOLLOWING GUIDE-
LINES:

1. THE PERSPECTIVE MUST SHOW
 THE FRONT AND THE RIGHT
 SIDE OF THE HOUSE WITH
 EMPHASIS ON THE FRONT.

2. ALL OF THE FRONT ENTRY
 DOOR MUST BE VISIBLE IN
 THE PERSPECTIVE.

3. THE PERSPECTIVE MUST BE
 DRAMATIC, BUT DISTORTION-
 FREE.

4. USE A NORMAL 5'-0 EYE
 LEVEL WHEN VIEWING THE
 HOUSE.

5. THE PERSPECTIVE WILL BE SHOWN
 TO A VERY LARGE GROUP.

6. THE SUGGESTED PERSPECTIVE SCALE
 IS 3/16"=1'-0.

NOTE: SCALE THE ELEVATIONS AND PLAN
VIEW TO OBTAIN ALL MEASUREMENTS.

7. LAY OUT THE PRELIMINARY PP, HL AT
 1"=20'-0 SCALE, AND THEN DRAW THE
 PERSPECTIVE AT THE CHOSEN SCALE.
 HAND IN BOTH DRAWINGS.

SMALL FINAL OBJECT WIDTH

1"-4" WIDE

MEDIUM FINAL OBJECT WIDTH

5"-8" WIDE

LARGE FINAL OBJECT WIDTH

9"-12" WIDE

SUBJECT	GRADE	NAME	SHEET
HOUSE PERSPECTIVE			4.30

FRONT ELEVATION

LEFT SIDE ELEVATION

PLAN VIEW
1" = 20'-0 SCALE

SMALL FINAL OBJECT WIDTH
1"- 4" WIDE

MEDIUM FINAL OBJECT WIDTH
5"- 8" WIDE

LARGE FINAL OBJECT WIDTH
9"- 12" WIDE

GIVEN ARE THE PLAN VIEW AND TWO ELEVATIONS OF A
TWO-STORY HOUSE DRAWN AT 1"= 20'-0 SCALE. YOU ARE
TO DRAW A PERSPECTIVE OF THIS HOUSE USING THE
FOLLOWING GUIDELINES:

1. THE PERSPECTIVE MUST SHOW BOTH THE FRONT
 AND LEFT SIDE OF THE HOUSE WITH EQUAL EMPHASIS.

2. THE PERSPECTIVE MUST BE DRAMATIC, BUT DISTORTION-
 FREE.

3. USE AN ELEVATED EYE LEVEL, BUT MAKE SURE THE
 SOFFIT AREA ON THE SECOND STORY ROOF IS VISIBLE
 IN THE PERSPECTIVE.

4. THE PERSPECTIVE WILL BE SHOWN TO A LARGE GROUP.

5. SUGGESTED PERSPECTIVE SCALE (3/16" = 1'-0).

NOTE: SCALE THE ELEVATIONS AND PLAN VIEW TO OBTAIN
ALL MEASUREMENTS.

6. LAY OUT THE PRELIMINARY PP HL AT 1"= 20'-0 SCALE,
 AND THEN DRAW THE PERSPECTIVE AT THE CHOSEN
 SCALE. HAND IN BOTH DRAWINGS.

DOCUMENT THE FOLLOWING INFORMATION:

1. OBJECT ALIGNMENT WITH THE PP FRONT ____°
 ____ SIDE °

2. CONE OF VISION SIZE ____°

3. EYE LEVEL ____ FT.

4. FINAL OBJECT WIDTH ____ FULL INCHES

5. PERSPECTIVE SCALE ____

SUBJECT
HOUSE PERSPECTIVE

GRADE

NAME

SHEET
4.31

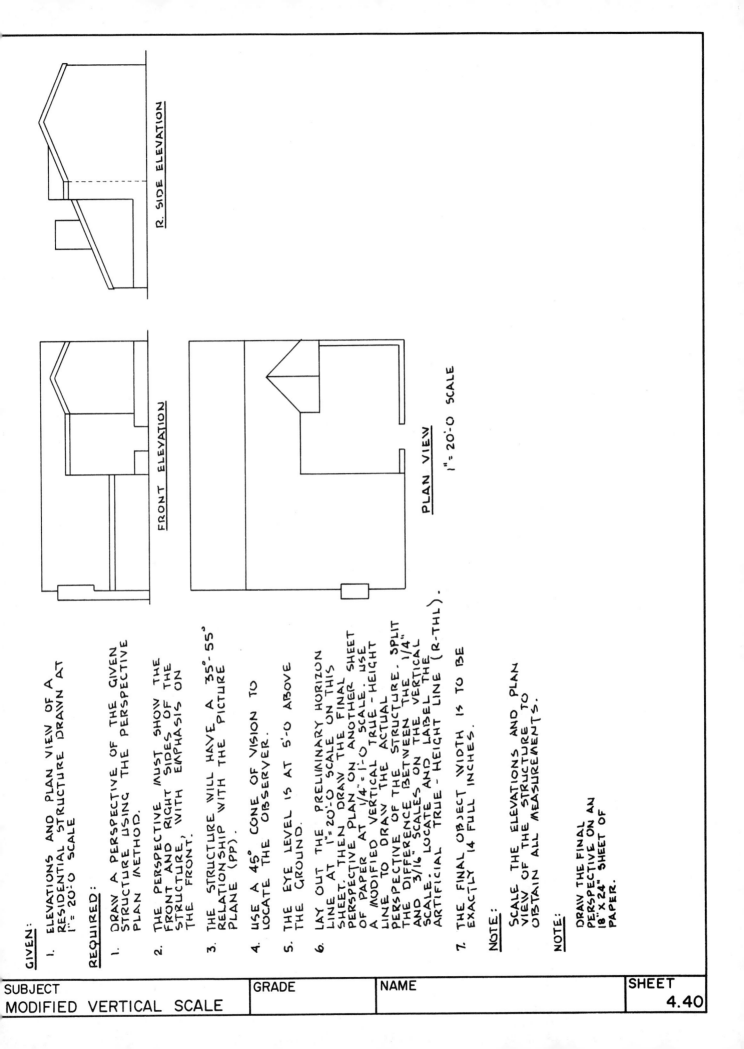

R. SIDE ELEVATION

FRONT ELEVATION

PLAN VIEW
1" = 20'-0 SCALE

GIVEN:

1. ELEVATIONS AND PLAN VIEW OF A RESIDENTIAL STRUCTURE DRAWN AT 1" = 20'-0 SCALE

REQUIRED:

1. DRAW A PERSPECTIVE OF THE GIVEN STRUCTURE USING THE PERSPECTIVE PLAN METHOD.

2. THE PERSPECTIVE MUST SHOW THE FRONT AND RIGHT SIDES OF THE STRUCTURE, WITH EMPHASIS ON THE FRONT.

3. THE STRUCTURE WILL HAVE A 35° - 55° RELATIONSHIP WITH THE PICTURE PLANE (PP).

4. USE A 45° CONE OF VISION TO LOCATE THE OBSERVER.

5. THE EYE LEVEL IS AT 5'-0 ABOVE THE GROUND.

6. LAY OUT THE PRELIMINARY HORIZON LINE AT 1" = 20'-0 SCALE ON THIS SHEET. THEN DRAW THE FINAL PERSPECTIVE PLAN ON ANOTHER SHEET OF PAPER AT 1/4" = 1'-0 SCALE. USE A MODIFIED VERTICAL TRUE - HEIGHT LINE TO DRAW THE ACTUAL PERSPECTIVE OF THE STRUCTURE. SPLIT THE DIFFERENCE BETWEEN THE 1/4" AND 3/16" SCALES ON THE VERTICAL SCALE. LOCATE AND LABEL THE ARTIFICIAL TRUE - HEIGHT LINE (R-THL).

7. THE FINAL OBJECT WIDTH IS TO BE EXACTLY 14 FULL INCHES.

NOTE:

SCALE THE ELEVATIONS AND PLAN VIEW OF THE STRUCTURE TO OBTAIN ALL MEASUREMENTS.

NOTE:

DRAW THE FINAL PERSPECTIVE ON AN 18" x 24" SHEET OF PAPER.

SUBJECT	GRADE	NAME	SHEET
MODIFIED VERTICAL SCALE			4.40

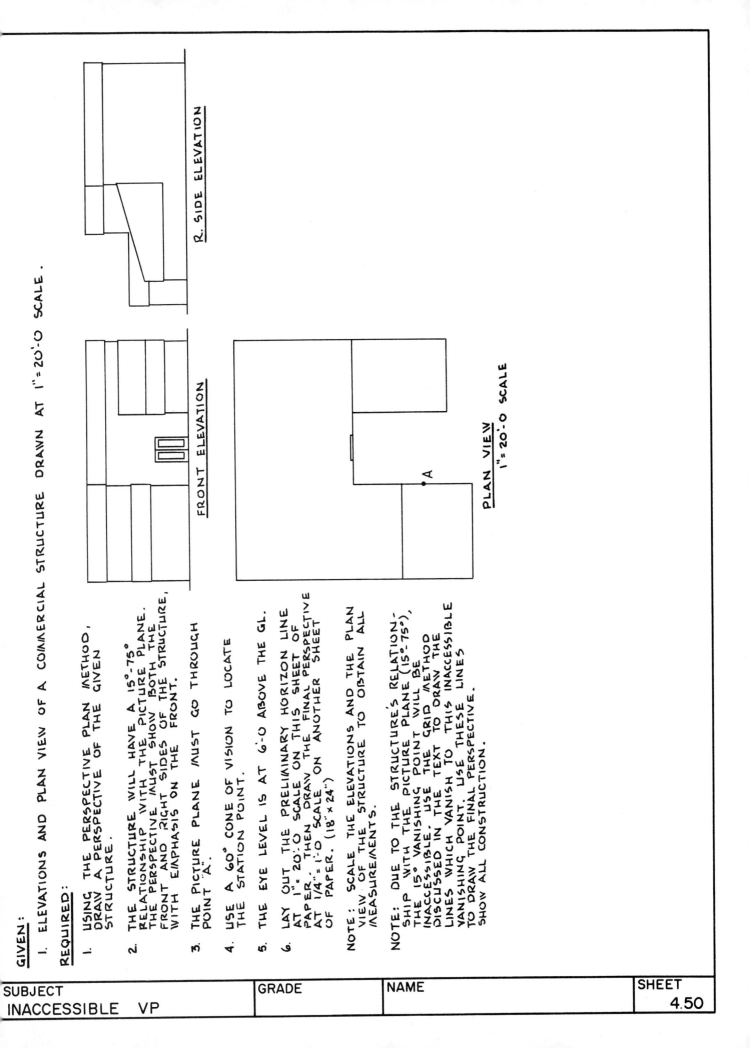

GIVEN:

1. ELEVATIONS AND PLAN VIEW OF A COMMERCIAL STRUCTURE DRAWN AT 1"= 20'-0 SCALE.

REQUIRED:

1. USING THE PERSPECTIVE PLAN METHOD, DRAW A PERSPECTIVE OF THE GIVEN STRUCTURE.

2. THE STRUCTURE WILL HAVE A 15°-75° RELATIONSHIP WITH THE PICTURE PLANE. THE PERSPECTIVE MUST SHOW BOTH THE FRONT AND RIGHT SIDES OF THE STRUCTURE, WITH EMPHASIS ON THE FRONT.

3. THE PICTURE PLANE MUST GO THROUGH POINT "A".

4. USE A 60° CONE OF VISION TO LOCATE THE STATION POINT.

5. THE EYE LEVEL IS AT 6'-0 ABOVE THE GL.

6. LAY OUT THE PRELIMINARY HORIZON LINE AT 1"= 20'-0 SCALE ON THIS SHEET OF PAPER. THEN DRAW THE FINAL PERSPECTIVE AT 1/4"= 1'-0 SCALE ON ANOTHER SHEET OF PAPER. (18" × 24")

NOTE: SCALE THE ELEVATIONS AND THE PLAN VIEW OF THE STRUCTURE TO OBTAIN ALL MEASUREMENTS.

NOTE: DUE TO THE STRUCTURE'S RELATION-SHIP WITH THE PICTURE PLANE (15°-75°), THE 15° VANISHING POINT WILL BE INACCESSIBLE. USE THE GRID METHOD DISCUSSED IN THE TEXT TO DRAW THE LINES WHICH VANISH TO THIS INACCESSIBLE VANISHING POINT. USE THESE LINES TO DRAW THE FINAL PERSPECTIVE. SHOW ALL CONSTRUCTION.

R. SIDE ELEVATION

FRONT ELEVATION

PLAN VIEW
1"= 20'-0 SCALE

A

SUBJECT	GRADE	NAME	SHEET
INACCESSIBLE VP			4.50

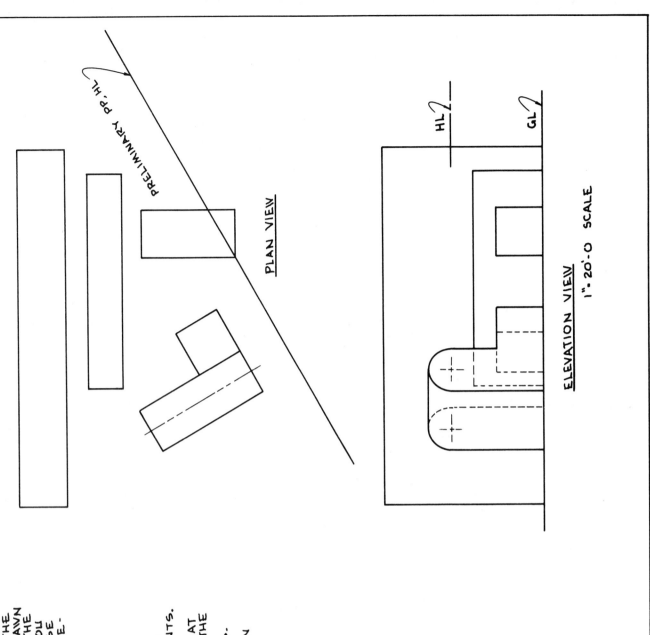

PLAN VIEW

PRELIMINARY PP, HL

HL

GL

ELEVATION VIEW
1"= 20'-0 SCALE

GIVEN ARE THE PLAN VIEWS AND THE
ELEVATION VIEWS OF FOUR OBJECTS DRAWN
AT 1"= 20'-0 SCALE. THE LOCATION OF THE
PRELIMINARY PP, HL IS ALSO GIVEN. YOU
ARE TO DRAW A PERSPECTIVE OF THESE
OBJECTS, USING THE FOLLOWING GUIDE-
LINES:

1. USE A 40° CONE OF VISION TO
 DRAW THE PERSPECTIVE.

2. THE EYE LEVEL IS AT 20'-0 ABOVE
 THE GROUND.

NOTE: SCALE THE PLAN AND ELEVATION
 VIEWS TO OBTAIN ALL MEASUREMENTS.

3. LAY OUT THE PRELIMINARY PP, HL AT
 1"= 20'-0 SCALE, AND THEN DRAW THE
 FINAL PERSPECTIVE AT 3/16"= 1'-0
 SCALE. HAND IN BOTH DRAWINGS.

NOTE: DRAW THE FINAL PERSPECTIVE ON AN
 18"x 24" SHEET OF PAPER.

GIVEN:

1. A PERSPECTIVE DRAWING OF AN OBJECT "X" WIDE, "Z" DEEP, AND "Y" TALL.

2. HORIZON LINE WITH THE TWO VANISHING POINTS.

REQUIRED:

1. USING ONLY DIAGONALS, EXPAND THE GIVEN OBJECT TO THE FOLLOWING DIMENSIONS:

 a. OVERALL HEIGHT 2Y

 b. OVERALL DEPTH 2.5 Z

 c. OVERALL WIDTH 3.25 X. (SHOW ALL CONSTRUCTION.)

2. AFTER EXPANDING THE GIVEN OBJECT, USE AUXILIARY MEASURING POINTS TO DIVIDE THE FRONT AND RIGHT SIDE OF THE OBJECT INTO TEN EQUAL VERTICAL STRIPS.

HL

LVP
+

SUBJECT	GRADE	NAME	SHEET
EXPANDING USING DIAGONALS			4.80

GIVEN:

1. A TWO-STORY HOUSE WITH AN ATTACHED TWO-CAR GARAGE.

REQUIRED:

1. USING THE FOLLOWING GUIDELINES, DRAW IN PERSPECTIVE AN ACCESS DRIVEWAY.

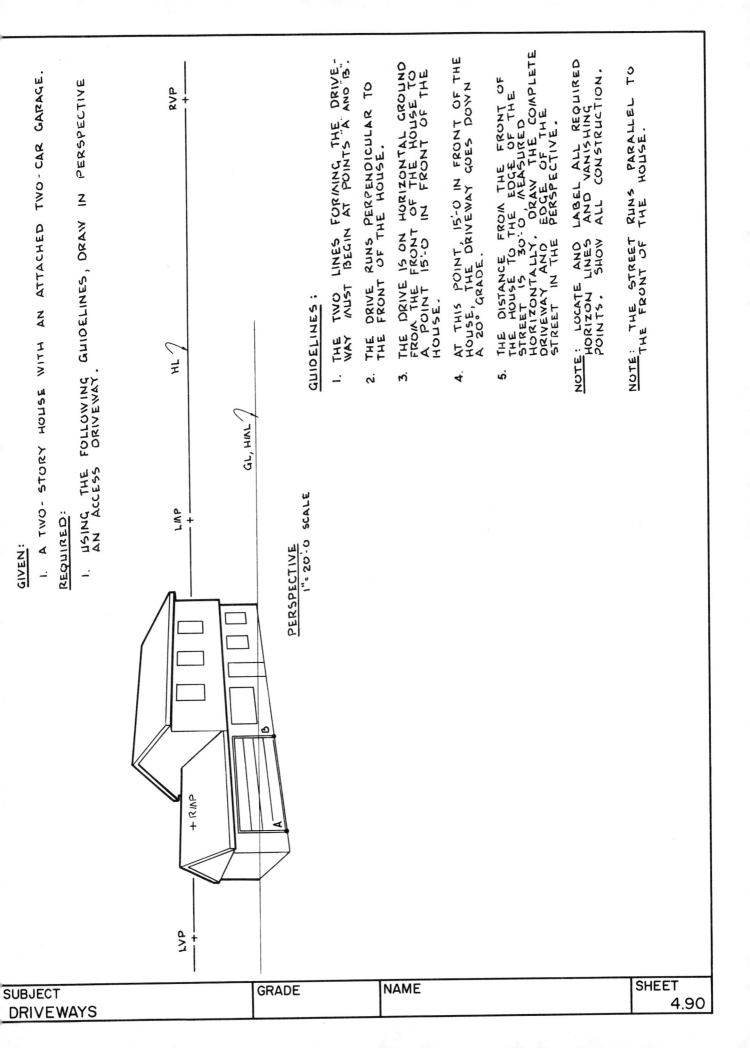

RVP
+

HL

LVP
+

GL, HML

PERSPECTIVE
1" = 20'-0 SCALE

LVP
+

+ RML

B

A

GUIDELINES:

1. THE TWO LINES FORMING THE DRIVE-WAY MUST BEGIN AT POINTS 'A' AND 'B'.

2. THE DRIVE RUNS PERPENDICULAR TO THE FRONT OF THE HOUSE.

3. THE DRIVE IS ON HORIZONTAL GROUND FROM THE FRONT OF THE HOUSE TO A POINT 15'-0 IN FRONT OF THE HOUSE.

4. AT THIS POINT, 15'-0 IN FRONT OF THE HOUSE, THE DRIVEWAY GOES DOWN A 20° GRADE.

5. THE DISTANCE FROM THE FRONT OF THE HOUSE TO THE EDGE OF THE STREET IS 30'-0, MEASURED HORIZONTALLY. DRAW THE COMPLETE DRIVEWAY AND EDGE OF THE STREET IN THE PERSPECTIVE.

NOTE: LOCATE AND LABEL ALL REQUIRED HORIZON LINES AND VANISHING POINTS. SHOW ALL CONSTRUCTION.

NOTE: THE STREET RUNS PARALLEL TO THE FRONT OF THE HOUSE.

SUBJECT	GRADE	NAME	SHEET
DRIVEWAYS			4.90

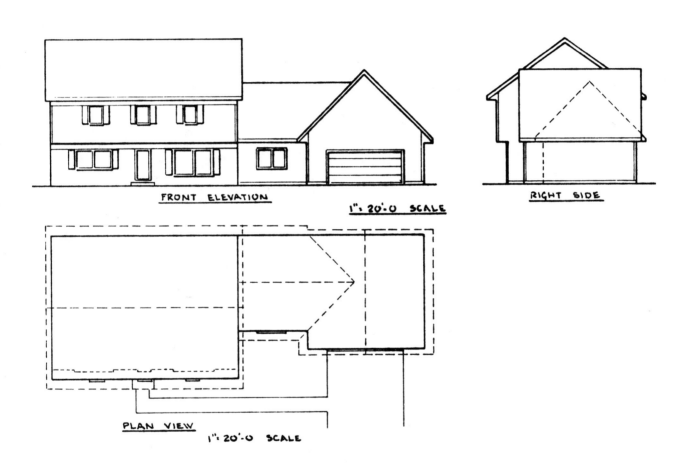

FRONT ELEVATION

1": 20'-0 SCALE

RIGHT SIDE

PLAN VIEW 1": 20'-0 SCALE

SUBJECT	GRADE	NAME	SHEET
RESIDENTIAL PERSPECTIVE			R-4.1

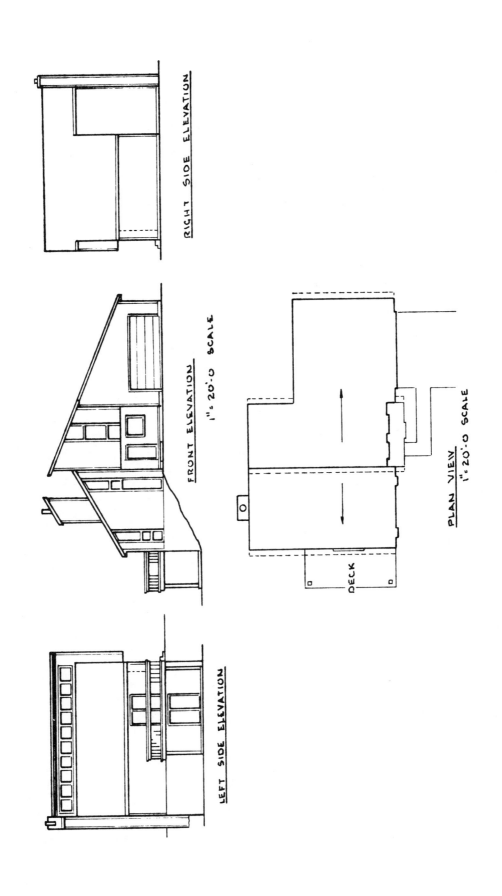

RIGHT SIDE ELEVATION

FRONT ELEVATION
1"= 20'·0 SCALE

PLAN VIEW
1"= 20'·0 SCALE

DECK

LEFT SIDE ELEVATION

SUBJECT	GRADE	NAME	SHEET
RESIDENTIAL PERSPECTIVE			R-4.2

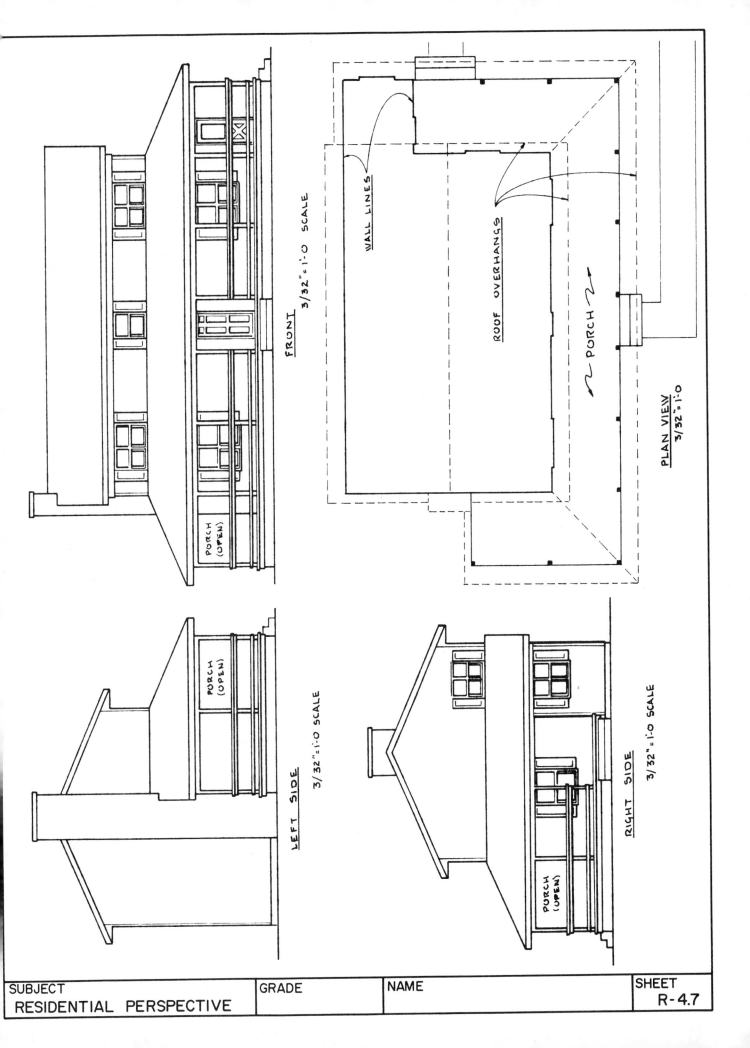

FRONT
3/32"=1'-0 SCALE

WALL LINES

ROOF OVERHANGS

PORCH

PLAN VIEW
3/32"=1'-0

PORCH
(OPEN)

LEFT SIDE
3/32"=1'-0 SCALE

PORCH
(OPEN)

RIGHT SIDE
3/32"=1'-0 SCALE

PORCH
(OPEN)

SUBJECT	GRADE	NAME	SHEET
RESIDENTIAL PERSPECTIVE			R-4.7

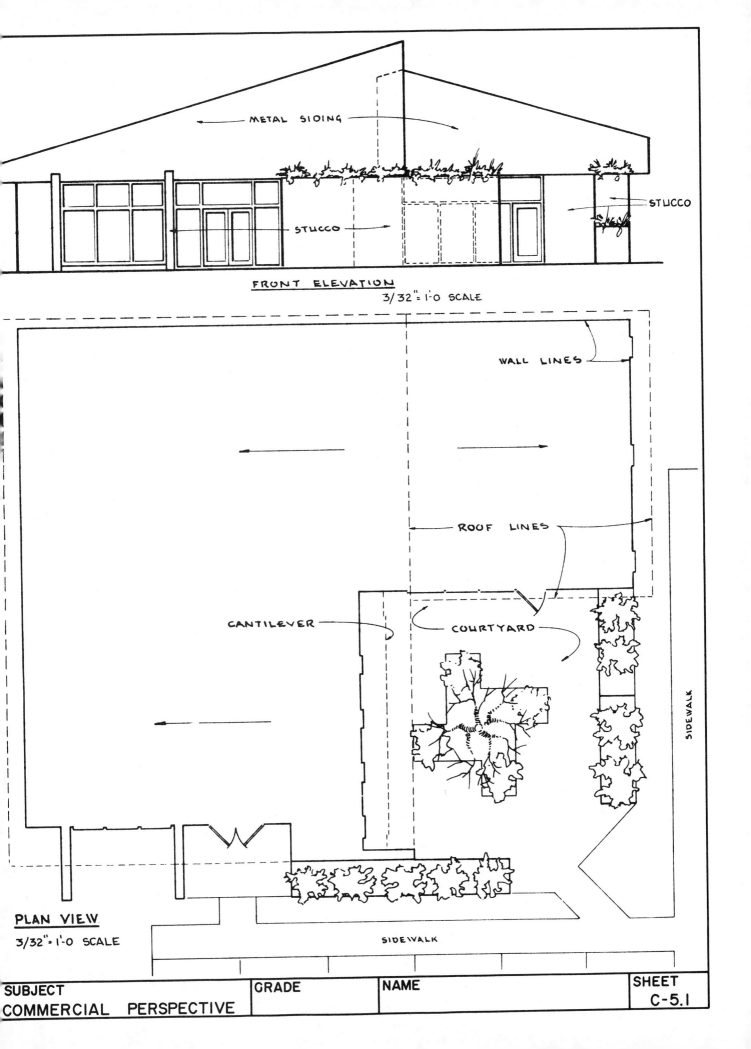

METAL SIDING

STUCCO

STUCCO

FRONT ELEVATION
3/32"=1'-0 SCALE

WALL LINES

ROOF LINES

CANTILEVER

COURTYARD

SIDEWALK

PLAN VIEW
3/32"=1'-0 SCALE

SIDEWALK

SUBJECT	GRADE	NAME	SHEET
COMMERCIAL PERSPECTIVE			C-5.1

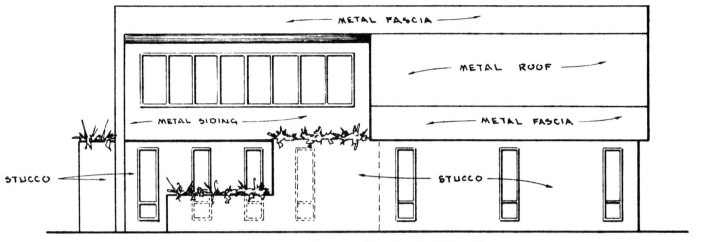

RIGHT SIDE ELEVATION

3/32" = 1'-0 SCALE

Labels in elevation: METAL FASCIA, METAL ROOF, METAL FASCIA, METAL SIDING, STUCCO, STUCCO

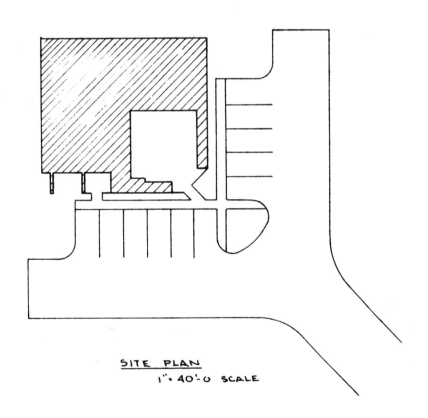

SITE PLAN

1" = 40'-0 SCALE

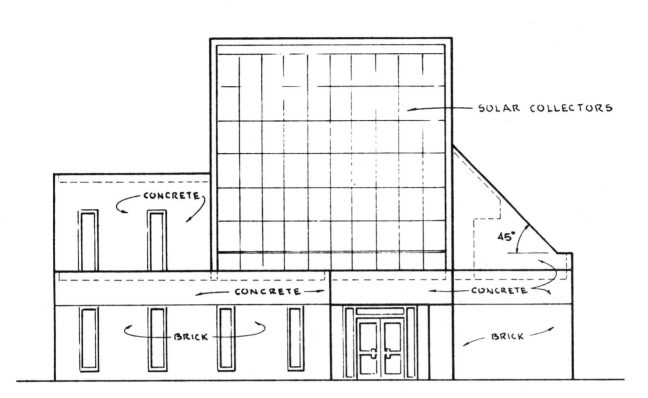

SOLAR COLLECTORS

CONCRETE

45°

CONCRETE CONCRETE

BRICK BRICK

FRONT ELEVATION 3/32"=1'-0 SCALE

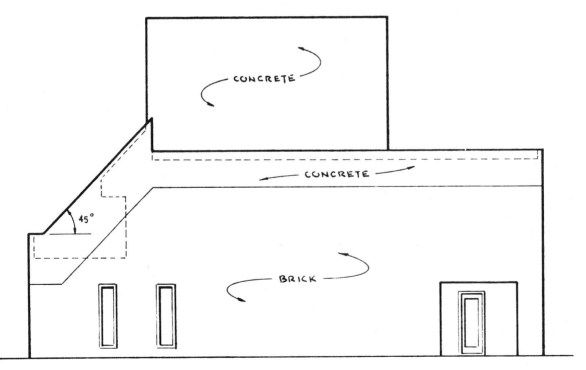

CONCRETE

CONCRETE

45°

BRICK

REAR ELEVATION
3/32"=1'-0 SCALE

| SUBJECT | GRADE | NAME | SHEET |
| COMMERCIAL PERSPECTIVE | | | C-5.2 |

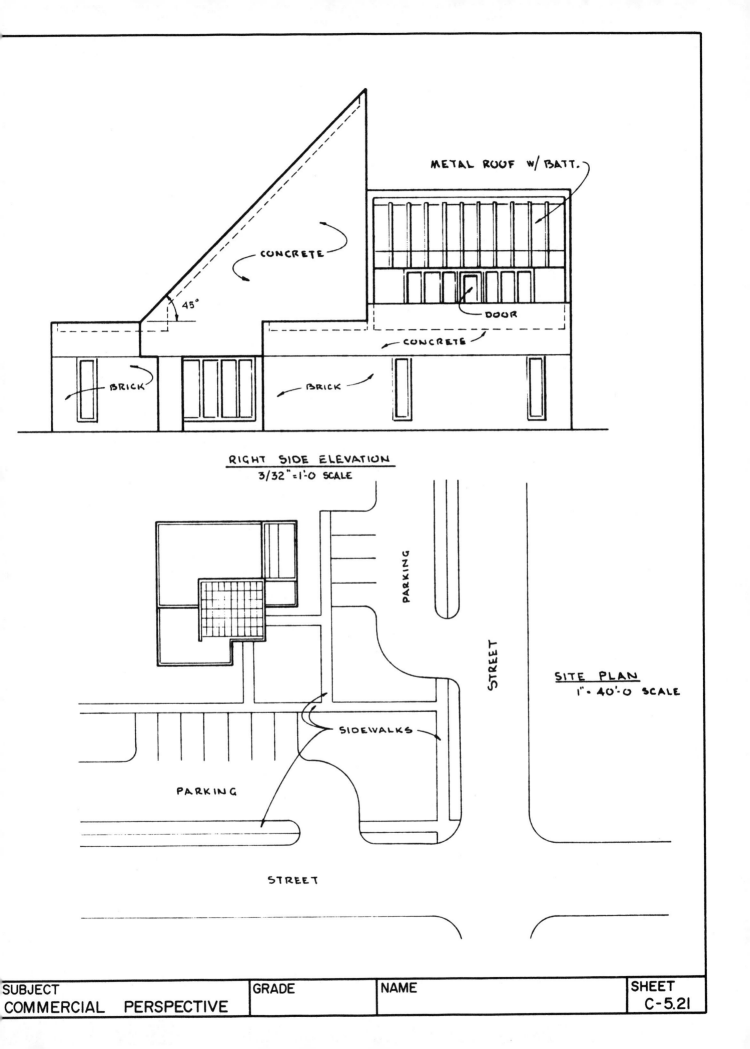

METAL ROOF W/ BATT.

CONCRETE

45°

CONCRETE

DOOR

BRICK

BRICK

RIGHT SIDE ELEVATION
3/32"=1'-0 SCALE

PARKING

STREET

SITE PLAN
1" = 40'-0 SCALE

SIDEWALKS

PARKING

STREET

SUBJECT	GRADE	NAME	SHEET
COMMERCIAL PERSPECTIVE			C-5.21

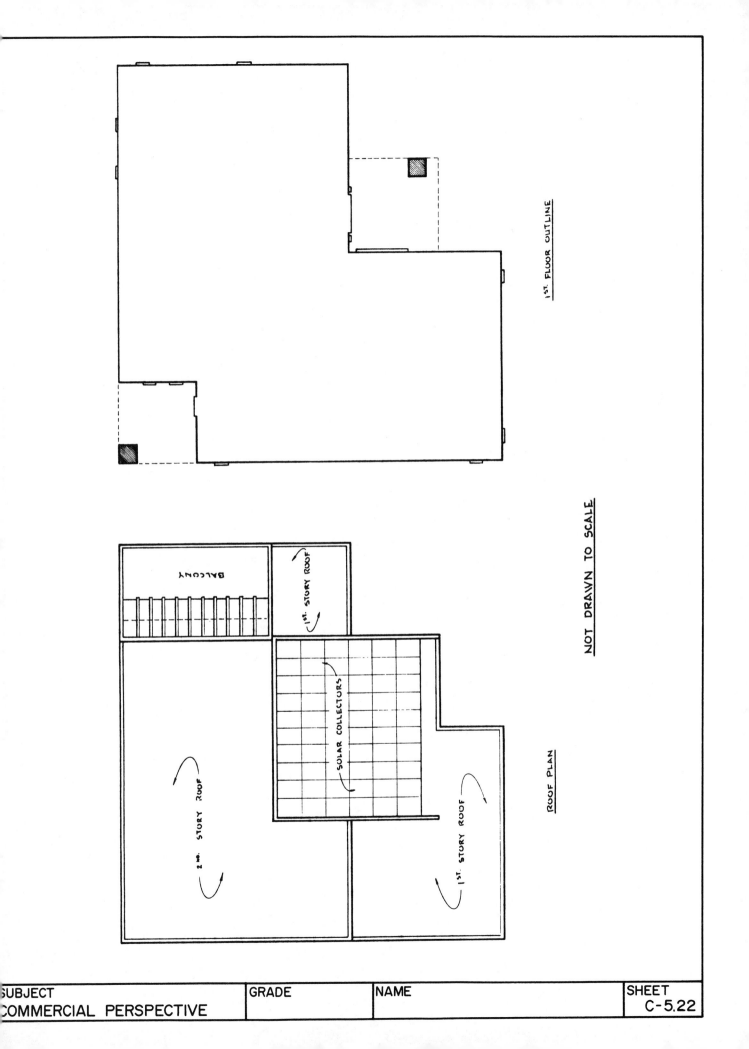

1ST. FLOOR OUTLINE

NOT DRAWN TO SCALE

BALCONY

1ST. STORY ROOF

2ND. STORY ROOF

SOLAR COLLECTORS

1ST. STORY ROOF

ROOF PLAN

| SUBJECT | GRADE | NAME | SHEET |
| COMMERCIAL PERSPECTIVE | | | C-5.22 |

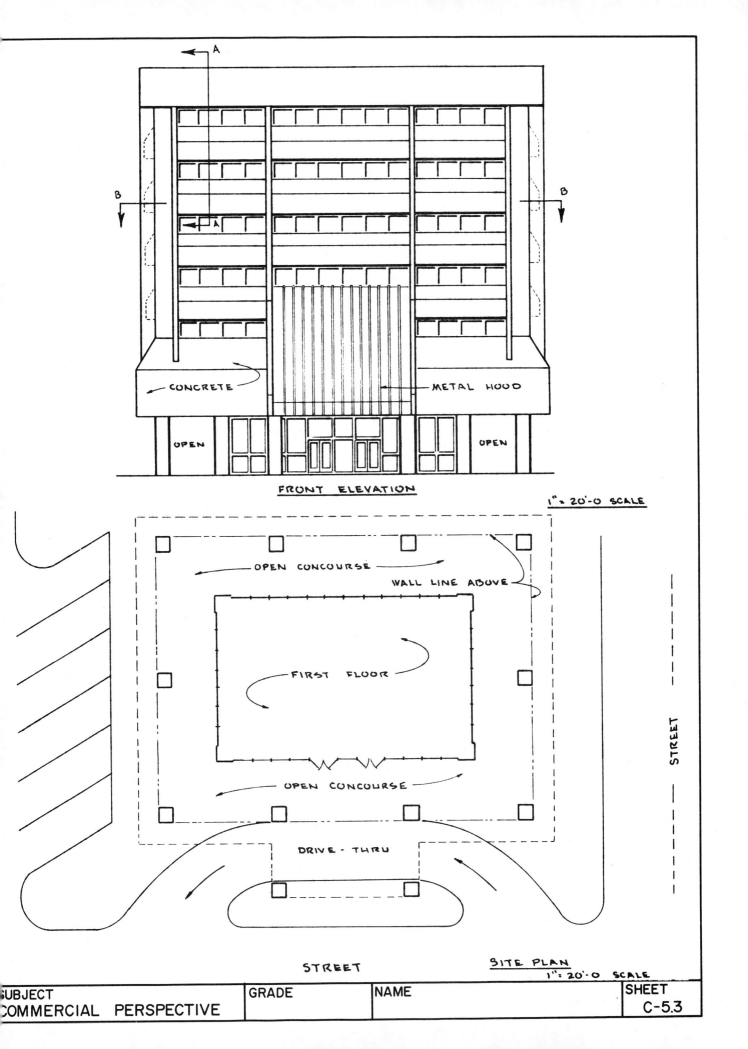

A

B ← → B

CONCRETE ← → METAL HOOD

OPEN OPEN

FRONT ELEVATION

1"= 20'-0 SCALE

OPEN CONCOURSE ←

WALL LINE ABOVE ←

FIRST FLOOR

OPEN CONCOURSE

DRIVE - THRU

STREET

STREET

SITE PLAN
1"= 20'-0 SCALE

SUBJECT	GRADE	NAME	SHEET
COMMERCIAL PERSPECTIVE			C-5.3

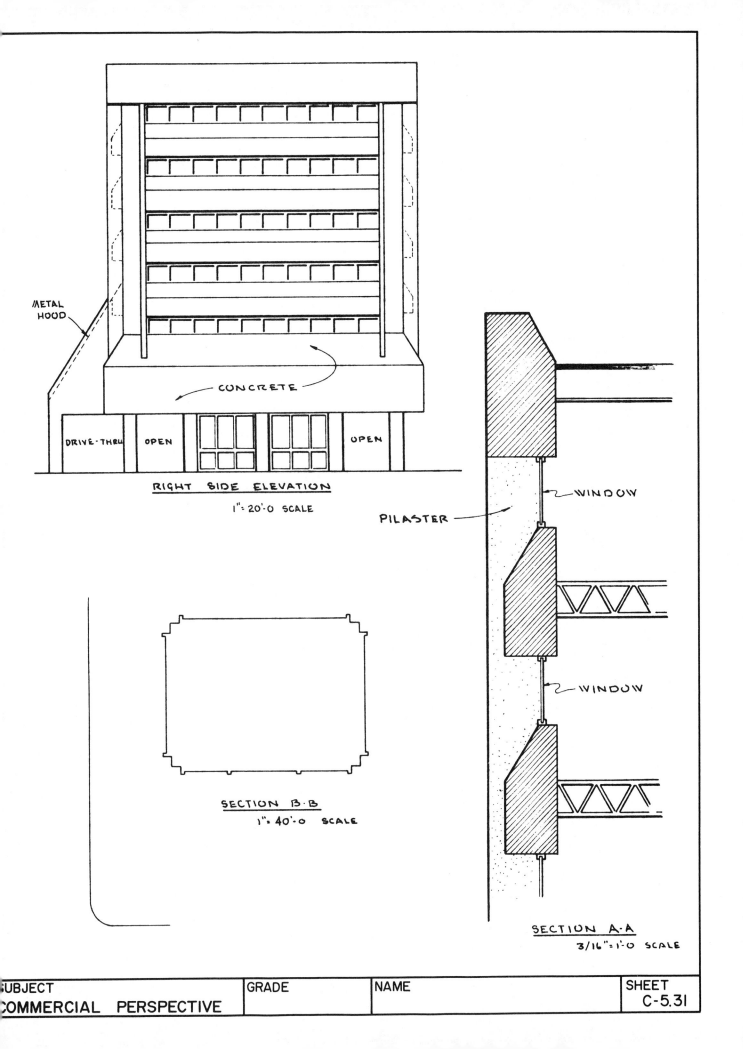

METAL
HOOD

CONCRETE

DRIVE-THRU | OPEN | OPEN

RIGHT SIDE ELEVATION
1":20'-0 SCALE

SECTION B-B
1":40'-0 SCALE

PILASTER

WINDOW

WINDOW

SECTION A-A
3/16"=1'-0 SCALE

SUBJECT	GRADE	NAME	SHEET
COMMERCIAL PERSPECTIVE			C-5.31

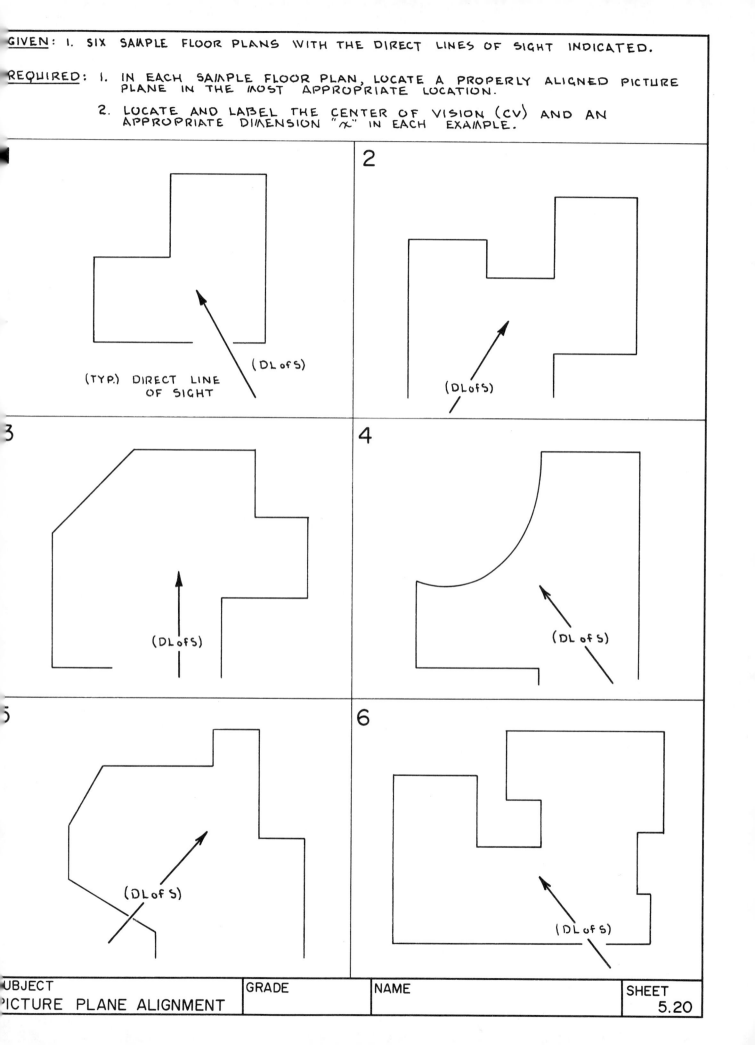

GIVEN: 1. SIX SAMPLE FLOOR PLANS WITH THE DIRECT LINES OF SIGHT INDICATED.

REQUIRED: 1. IN EACH SAMPLE FLOOR PLAN, LOCATE A PROPERLY ALIGNED PICTURE PLANE IN THE MOST APPROPRIATE LOCATION.

2. LOCATE AND LABEL THE CENTER OF VISION (CV) AND AN APPROPRIATE DIMENSION "𝓍" IN EACH EXAMPLE.

(TYP.) DIRECT LINE OF SIGHT

(DL of S)

2

(DL of S)

3

(DL of S)

4

(DL of S)

5

(DL of S)

6

(DL of S)

SUBJECT	GRADE	NAME	SHEET
PICTURE PLANE ALIGNMENT			5.20

GIVEN:

1. THREE SAMPLE FLOOR PLANS WITH THE FOLLOWING INFORMATION:

 a. LOCATION OF THE OBSERVER (SP).

 b. POINTS "A" AND "B" (THE LEGS OF THE 60° CONE OF VISION MUST GO THROUGH THESE POINTS).

 c. POINT "C" (THE PICTURE PLANE MUST GO THROUGH THIS POINT).

REQUIRED IN EACH EXAMPLE:

1. DRAW THE 60° CONE OF VISION.

2. DRAW THE PROPERLY ALIGNED PICTURE PLANE (PP).

3. LOCATE AND LABEL THE FOLLOWING ITEMS:

 a. CENTER OF VISION (CV).

 b. THE RIGHT AND LEFT VANISHING POINTS.

 c. THE RIGHT AND LEFT MEASURING POINTS.

 d. DIMENSION "x".

4. ACCURATELY DOCUMENT THE REQUESTED DATA.

DOCUMENT THE DISTANCE FROM THE:

CV TO THE RVP _____

CV TO THE LMP _____

CV TO THE RMP _____

CV TO THE LVP _____

ALSO, DOCUMENT THE LENGTH OF:

DIMENSION "x" _____

PICTURE WIDTH (PW) _____

FLOOR PLAN
1" = 20'-0 SCALE

2

DOCUMENT THE DISTANCE FROM THE:

CV TO THE MP's _____

CV TO THE VPD _____

CV TO THE VPE _____

ALSO, DOCUMENT THE LENGTH OF:

DIMENSION "x" _____

PICTURE WIDTH (PW) _____

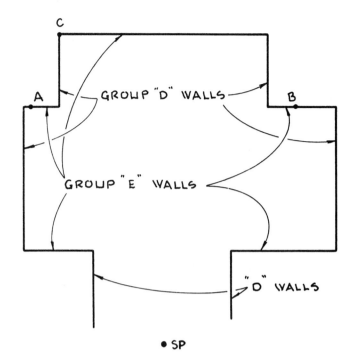

GROUP "D" WALLS

GROUP "E" WALLS

"D" WALLS

• SP

FLOOR PLAN
3/32"=1'-0 SCALE

3

DOCUMENT THE DISTANCE FROM THE:

CV TO THE RVP _____

CV TO THE LMP _____

CV TO THE RMP _____

CV TO THE LVP _____

ALSO, DOCUMENT THE LENGTH OF:

DIMENSION "x" _____

PICTURE WIDTH (PW) _____

• SP

FLOOR PLAN
1" = 30'-0 SCALE

SUBJECT	GRADE	NAME	SHEET
PRELIMINARY HL			5.301

PART #1 PRELIMINARY PP, HL

GIVEN IS A FLOOR PLAN DRAWN AT 3/32"=1'-0 SCALE. YOU ARE TO LAY OUT THE PRELIMINARY PP, HL USING THIS SMALL FLOOR PLAN AND THE FOLLOWING GUIDELINES:

1. USE A STANDARD 60° CONE OF VISION TO LOCATE THE SP. THE SP MUST BE LOCATED INSIDE THE ROOM.

2. THE FINAL PERSPECTIVE MUST EMPHASIZE THE DARKENED WALLS.

3. DRAW THE PP THROUGH THE BACK CORNER OF THE ROOM (POINT "A").

FINISH LAYING OUT THE PRELIMINARY PP, HL BY LOCATING THE CV, THE VP's, AND THE MP's. DOCUMENT THE DISTANCE FROM THE:

CV TO THE LVP _____ FT. & INCHES

CV TO THE RMP _____

CV TO THE RVP _____

CV TO THE LMP _____

CV TO THE BACK CORNER (POINT "A") (DIM. x) _____

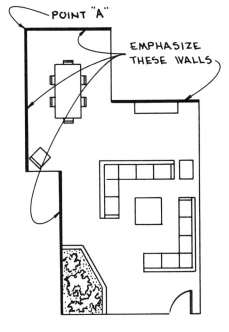

POINT "A"

EMPHASIZE THESE WALLS

FLOOR PLAN
3/32"=1'-0 SCALE

PART #2 FINAL HL

TAKING THE INFORMATION FROM THE PRELIMINARY PP, HL, PROPERLY LAY OUT THE FINAL HL ON A NEW SHEET OF PAPER AT THE CHOSEN PERSPECTIVE SCALE (1"=20'-0).

USING A 10'-0 EYE LEVEL, DRAW THE GL, HML. NOW LOCATE THE STARTING POINT FOR THE PERSPECTIVE ON THIS LINE.

NEW SHEET OF PAPER

FINAL PERSPECTIVE SCALE 1"=20'-0

SUBJECT	GRADE	NAME	SHEET
INTERIOR PERSPECTIVE			5.31

GIVEN:

1. AN INTERIOR SPACE DRAWN AT 1" = 20'-0 SCALE

2. LOCATION OF THE OBSERVER

3. POINTS A AND B ON THE LEGS OF THE 60° CONE
 OF VISION

4. POINT C IN THE PICTURE PLANE

5. TEN - FOOT HIGH WALLS

6. GROUND LINE 6'-0 BELOW THE HORIZON LINE

REQUIRED:

1. LAY OUT THE PRELIMINARY HORIZON LINE ON THE GIVEN
 1" = 20'-0 SCALE FLOOR PLAN. THIS HORIZON LINE SHOULD
 INCLUDE THE VP's, MP's, CV, PW AND DIMENSION x.

2. DOCUMENT THE DISTANCE FROM THE :

 CV TO THE RVP _____

 CV TO THE LMP _____

 CV TO THE RMP _____

 CV TO THE LVP _____

 ALSO, DOCUMENT THE LENGTH OF :

 DIMENSION x _____

 PICTURE WIDTH (PW) _____

3. ON THE SHEET PROVIDED, LAY OUT THE FINAL HORIZON
 LINE AT 3/32" = 1'-0 SCALE - THE SCALE OF THE
 PERSPECTIVE DRAWING. DRAW THE PERSPECTIVE BY THE
 PERSPECTIVE PLAN METHOD.

FLOOR PLAN
1" = 20'-0 SCALE

C

B

A

SP

SUBJECT

PERSPECTIVE - WALLS

GRADE

NAME

SHEET

6.10

NOTE: DRAW THE REQUIRED PERSPECTIVE ON THIS SHEET AT 3/32"=1'-0 SCALE.

HL

VP

CV

VP

SUBJECT	GRADE	NAME	SHEET
PERSPECTIVE - WALLS			6.101

GIVEN:

1. AN INTERIOR SPACE DRAWN AT 1"=20'-0 SCALE

2. LOCATION OF THE OBSERVER

3. POINTS A AND B ON THE LEGS OF THE 60° CONE OF VISION

4. POINT C IN THE PICTURE PLANE

5. TEN-FOOT HIGH WALLS

6. GROUND LINE 6'-0 BELOW THE HORIZON LINE

REQUIRED:

1. LAY OUT THE PRELIMINARY HORIZON LINE ON THE GIVEN 1"=20'-0 SCALE FLOOR PLAN. THIS HORIZON LINE SHOULD INCLUDE THE VP's, MP's, CV, PW AND DIMENSION x.

2. DOCUMENT THE DISTANCE FROM THE:

 CV TO THE RVP _____

 CV TO THE LMP _____

 CV TO THE RMP _____

 CV TO THE LVP _____

 ALSO, DOCUMENT THE LENGTH OF:

 DIMENSION x _____

 PICTURE WIDTH (PW) _____

3. ON THE SHEET PROVIDED, LAY OUT THE FINAL HORIZON LINE AT 3/32"=1'-0 SCALE - THE SCALE OF THE PERSPECTIVE DRAWING. DRAW THE PERSPECTIVE BY THE PERSPECTIVE PLAN METHOD.

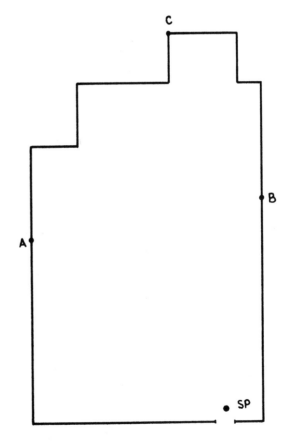

FLOOR PLAN

1"= 20'-0 SCALE

SUBJECT	GRADE	NAME	SHEET
PERSPECTIVE - WALLS			6.11

HL

HML

CV
+

SUBJECT	GRADE	NAME	SHEET
PERSPECTIVE - WALLS			6.III

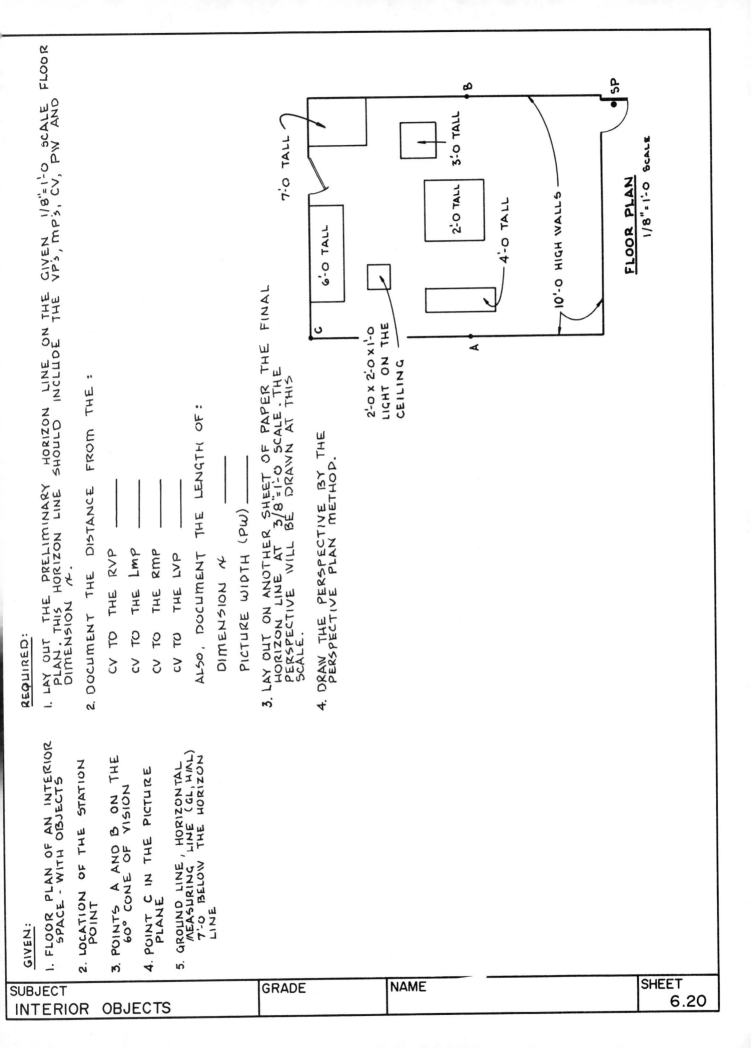

GIVEN:

1. FLOOR PLAN OF AN INTERIOR SPACE - WITH OBJECTS

2. LOCATION OF THE STATION POINT

3. POINTS A AND B ON THE 60° CONE OF VISION

4. POINT C IN THE PICTURE PLANE

5. GROUND LINE, HORIZONTAL MEASURING LINE (GL, HML) 7'-0 BELOW THE HORIZON LINE

REQUIRED:

1. LAY OUT THE PRELIMINARY HORIZON LINE ON THE GIVEN 1/8"=1'-0 SCALE FLOOR PLAN. THIS HORIZON LINE SHOULD INCLUDE THE VP's, MP's, CV, PW AND DIMENSION X.

2. DOCUMENT THE DISTANCE FROM THE:

 CV TO THE RVP _____

 CV TO THE LMP _____

 CV TO THE RMP _____

 CV TO THE LVP _____

 ALSO, DOCUMENT THE LENGTH OF:

 DIMENSION X _____

 PICTURE WIDTH (PW) _____

3. LAY OUT ON ANOTHER SHEET OF PAPER THE FINAL HORIZON LINE AT 3/8"=1'-0 SCALE. THE PERSPECTIVE WILL BE DRAWN AT THIS SCALE.

4. DRAW THE PERSPECTIVE BY THE PERSPECTIVE PLAN METHOD.

FLOOR PLAN
1/8"=1'-0 SCALE

7'-0 TALL

6'-0 TALL

3'-0 TALL

2'-0 TALL

4'-0 TALL

2'-0 x 2'-0 x 1'-0 LIGHT ON THE CEILING

10'-0 HIGH WALLS

C

A

B

SP

SUBJECT	GRADE	NAME	SHEET
INTERIOR OBJECTS			6.20

GIVEN:

1. AN INTERIOR SPACE WHICH REQUIRES MORE THAN
 TWO VANISHING POINTS TO DRAW THE PERSPECTIVE.

2. THE LOCATION OF THE STATION POINT

3. POINTS X AND Y ON THE LEGS OF THE 60° CONE
 OF VISION

4. POINT Z IN THE PP

REQUIRED:

1. LAY OUT THE PRELIMINARY HL ON THE GIVEN
 3/32"=1'-0 SCALE FLOOR PLAN. THIS HL SHOULD
 INCLUDE THE VP's, MP's, CV, PW AND
 DIMENSION X.

2. PLACE THIS COMPLETED PRELIMINARY HL UNDER
 THE FINAL HL ON THE SHEET PROVIDED. ALIGN
 BOTH CV's. TRANSFER ALL MP's AND VP's TO THE
 FINAL HL. LABEL EACH POINT. IN THIS PARTICULAR
 PROBLEM THE PERSPECTIVE WILL BE DRAWN AT
 THE SAME SCALE AS THE PRELIMINARY LAYOUT.

3. DRAW THE PERSPECTIVE BY THE PERSPECTIVE PLAN
 METHOD.

FLOOR PLAN

10'-0 HIGH WALLS

3/32"=1'-0 SCALE

SP •

NOTE: DRAW THE REQUIRED PERSPECTIVE ON THIS SHEET AT THE 3/32"=1'·0 SCALE.

HL

CV

GL, HVL

SUBJECT	GRADE	NAME	SHEET
MULTIPLE VP's			6.601

GIVEN:

1. AN INTERIOR SPACE WITH A CATHEDRAL CEILING DRAWN AT 3/32"=1'-0 SCALE.

2. LOCATION OF THE STATION POINT (SP)

3. POINTS A AND B ON THE LEGS OF THE 60° CONE OF VISION

4. POINT C IN THE PICTURE PLANE (PP)

5. GL, HML 5'-0 BELOW THE HL (EYE LEVEL)

REQUIRED:

1. LAY OUT THE PRELIMINARY HL ON THE GIVEN 3/32"=1'-0 SCALE FLOOR PLAN. THIS HL SHOULD INCLUDE THE VP's, MP's, CV, PV, AND DIMENSION ∡.

2. TRANSFER THESE POINTS FROM THE PRELIMINARY HL TO THE FINAL HL DRAWN ON THE PROVIDED SHEET. THE FINAL HL AND THE PERSPECTIVE WILL BE DRAWN AT 1/4"=1'-0 SCALE.

3. DRAW THE PERSPECTIVE BY THE PERSPECTIVE PLAN METHOD.

C B

10"x10" BEAMS

— 8'-0 HIGH WALLS

— 12'-0 HIGH CEILING LINE

• SP A

FLOOR PLAN
3/32"=1'-0 SCALE

SUBJECT	GRADE	NAME	SHEET
CATHEDRAL CEILING			6.70

CV
+

1/4"=1'-0 HL

SUBJECT	GRADE	NAME	SHEET
CATHEDRAL CEILING			6.701

GIVEN:

1. AN INTERIOR SPACE WITH A CATHEDRAL CEILING DRAWN AT 3/32"=1'-0 SCALE.

2. LOCATION OF THE STATION POINT (SP)

3. POINTS A AND B ON THE LEGS OF THE 60° CONE OF VISION

4. POINT C IN THE PICTURE PLANE (PP)

5. GL, HML 5'-0 BELOW THE HL (EYE LEVEL)

REQUIRED:

1. LAY OUT THE PRELIMINARY HL ON THE GIVEN 3/32" SCALE FLOOR PLAN. THIS HL SHOULD INCLUDE THE VP's, MP's, CV, PW, AND DIMENSION x.

2. TRANSFER THESE POINTS FROM THE PRELIMINARY HL TO THE FINAL HL DRAWN ON THE PROVIDED SHEET. THE FINAL HL AND THE PERSPECTIVE WILL BE DRAWN AT 1/4"=1'-0 SCALE.

3. DRAW THE PERSPECTIVE BY THE PERSPECTIVE PLAN METHOD.

C

B

— 12'-0 HIGH CEILING LINE

— 10"x10" BEAMS

— 8'-0 HIGH WALLS

A

SP

FLOOR PLAN
3/32"=1'-0 SCALE

SUBJECT
CATHEDRAL CEILING

GRADE

NAME

SHEET
6.71

1/4"=1'-0 HL

CV
+

SUBJECT	GRADE	NAME	SHEET
CATHEDRAL CEILING			6.711

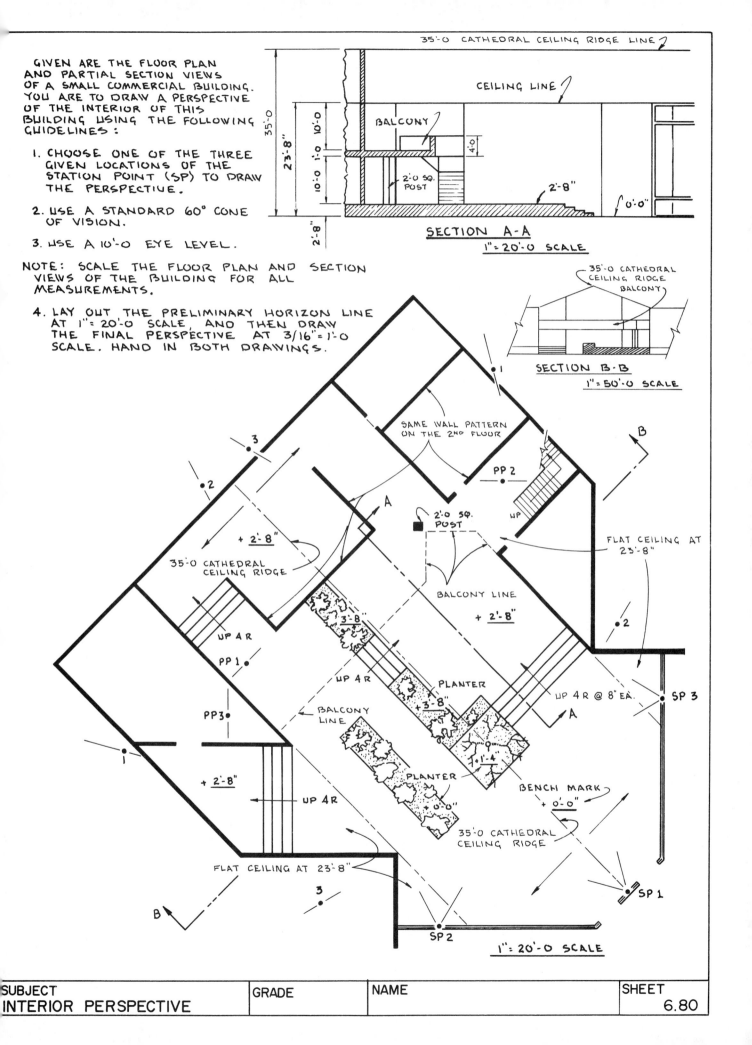

GIVEN ARE THE FLOOR PLAN
AND PARTIAL SECTION VIEWS
OF A SMALL COMMERCIAL BUILDING.
YOU ARE TO DRAW A PERSPECTIVE
OF THE INTERIOR OF THIS
BUILDING USING THE FOLLOWING
GUIDELINES:

1. CHOOSE ONE OF THE THREE
 GIVEN LOCATIONS OF THE
 STATION POINT (SP) TO DRAW
 THE PERSPECTIVE.

2. USE A STANDARD 60° CONE
 OF VISION.

3. USE A 10'-0 EYE LEVEL.

NOTE: SCALE THE FLOOR PLAN AND SECTION
VIEWS OF THE BUILDING FOR ALL
MEASUREMENTS.

4. LAY OUT THE PRELIMINARY HORIZON LINE
 AT 1"= 20'-0 SCALE, AND THEN DRAW
 THE FINAL PERSPECTIVE AT 3/16"= 1'-0
 SCALE. HAND IN BOTH DRAWINGS.

35'-0 CATHEDRAL CEILING RIDGE LINE

CEILING LINE

BALCONY

2'-0 SQ. POST

2'-8"

0'-0"

SECTION A-A
1"= 20'-0 SCALE

35'-0 CATHEDRAL
CEILING RIDGE
BALCONY

SECTION B-B
1"= 50'-0 SCALE

SAME WALL PATTERN
ON THE 2ND FLOOR

PP 2

UP

B

FLAT CEILING AT
23'-8"

+ 2'-8"

35'-0 CATHEDRAL
CEILING RIDGE

A

2'-0 SQ.
POST

BALCONY LINE
+ 2'-8"

• 2

UP 4R

PP 1 •

3'-8"

UP 4R

PLANTER
3'-8"

UP 4R @ 8" EA.

SP 3

PP3 •

BALCONY
LINE

+ 1'-4

+ 2'-8"

UP 4R

PLANTER
+ 0'-0"

BENCH MARK
+ 0'-0"

35'-0 CATHEDRAL
CEILING RIDGE

SP 1

FLAT CEILING AT 23'-8"

3

B

SP 2

1"= 20'-0 SCALE

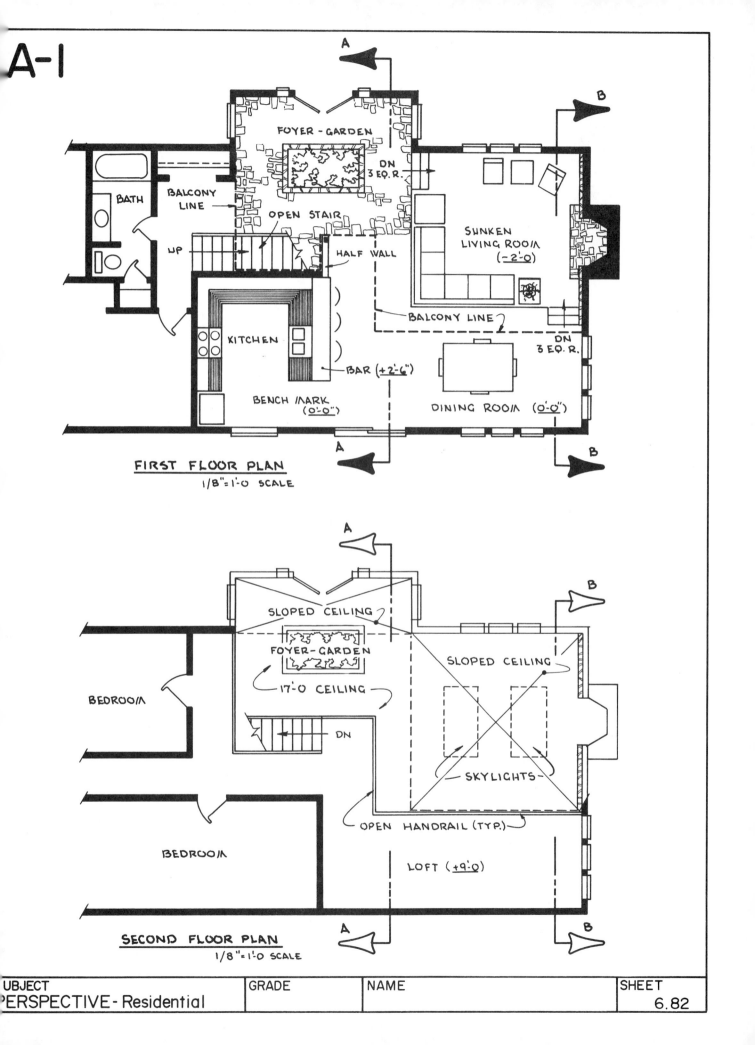

A-1

FOYER - GARDEN

DN
3 EQ. R.

BATH

BALCONY
LINE

OPEN STAIR

UP

HALF WALL

SUNKEN
LIVING ROOM
(-2'-0)

BALCONY LINE

DN
3 EQ. R.

KITCHEN

BAR (+2'-6")

BENCH MARK
(0'-0")

DINING ROOM (0'-0")

FIRST FLOOR PLAN
1/8"=1'-0 SCALE

A

B

SLOPED CEILING

FOYER-GARDEN

17'-0 CEILING

SLOPED CEILING

BEDROOM

DN

SKYLIGHTS

BEDROOM

OPEN HANDRAIL (TYP.)

LOFT (+9'-0)

SECOND FLOOR PLAN
1/8"=1'-0 SCALE

SUBJECT
PERSPECTIVE- Residential

GRADE

NAME

SHEET
6.82

A-2

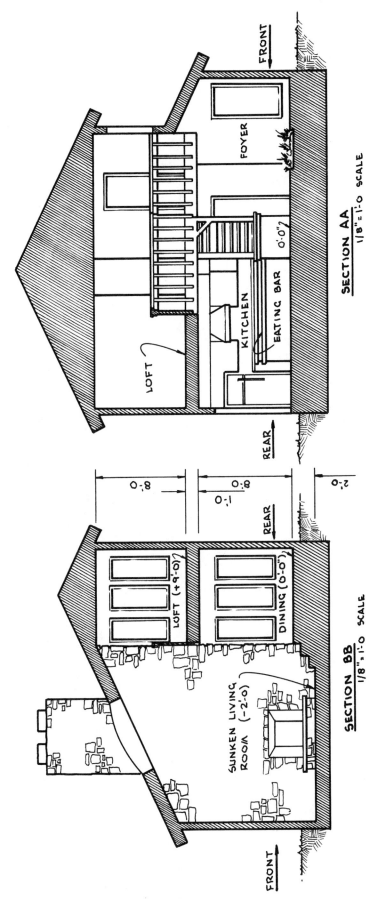

SECTION AA
1/8" = 1'-0 SCALE

FRONT

FOYER

0'-0"

LOFT

KITCHEN

EATING BAR

REAR

8'-0

8'-0

1'-0

2'-0

REAR

LOFT (+9'-0)

DINING (0'-0")

SECTION BB
1/8" = 1'-0 SCALE

SUNKEN LIVING ROOM (-2'-0)

FRONT

SUBJECT	GRADE	NAME	SHEET
PERSPECTIVE - Residential			6.821

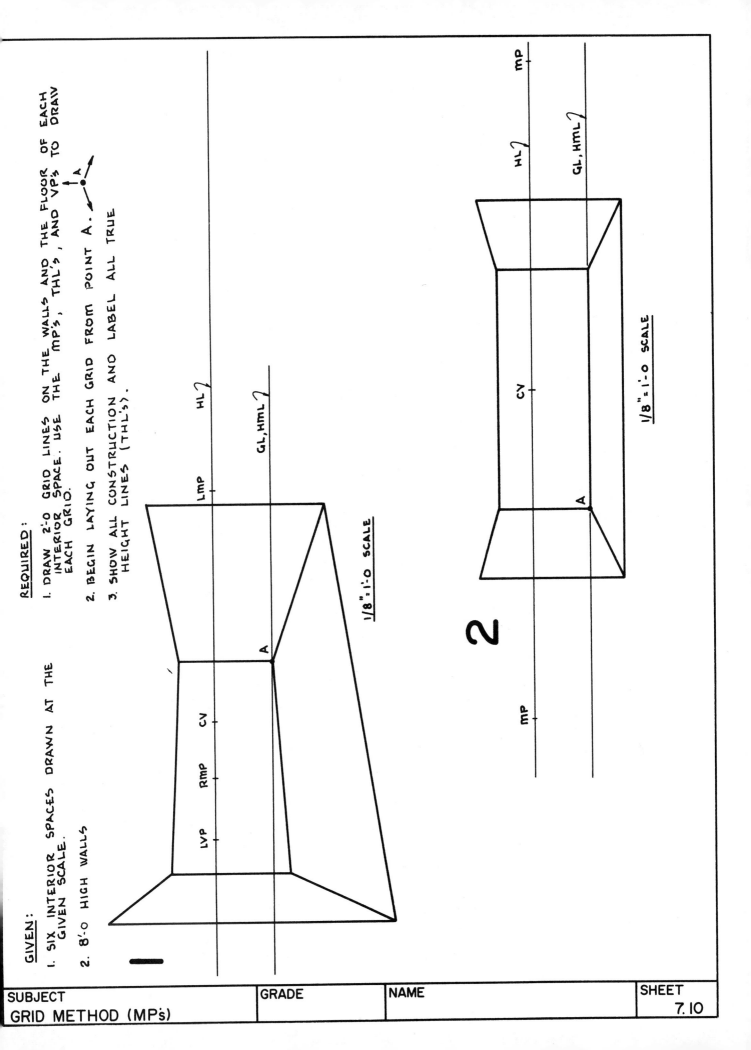

GIVEN:

1. SIX INTERIOR SPACES DRAWN AT THE GIVEN SCALE.

2. 8'-0 HIGH WALLS

REQUIRED:

1. DRAW 2'-0 GRID LINES ON THE WALLS AND THE FLOOR OF EACH INTERIOR SPACE. USE THE MP's, THL's, AND VP's TO DRAW EACH GRID.

2. BEGIN LAYING OUT EACH GRID FROM POINT A.

3. SHOW ALL CONSTRUCTION AND LABEL ALL TRUE HEIGHT LINES (THL's).

LVP RMP CV RMP LMP HL⌐

GL, HML⌐

A

1/8"=1'-0 SCALE

2

MP HL⌐

CV

A

MP GL, HML⌐

1/8"=1'-0 SCALE

SUBJECT	GRADE	NAME	SHEET
GRID METHOD (MP's)			7.10

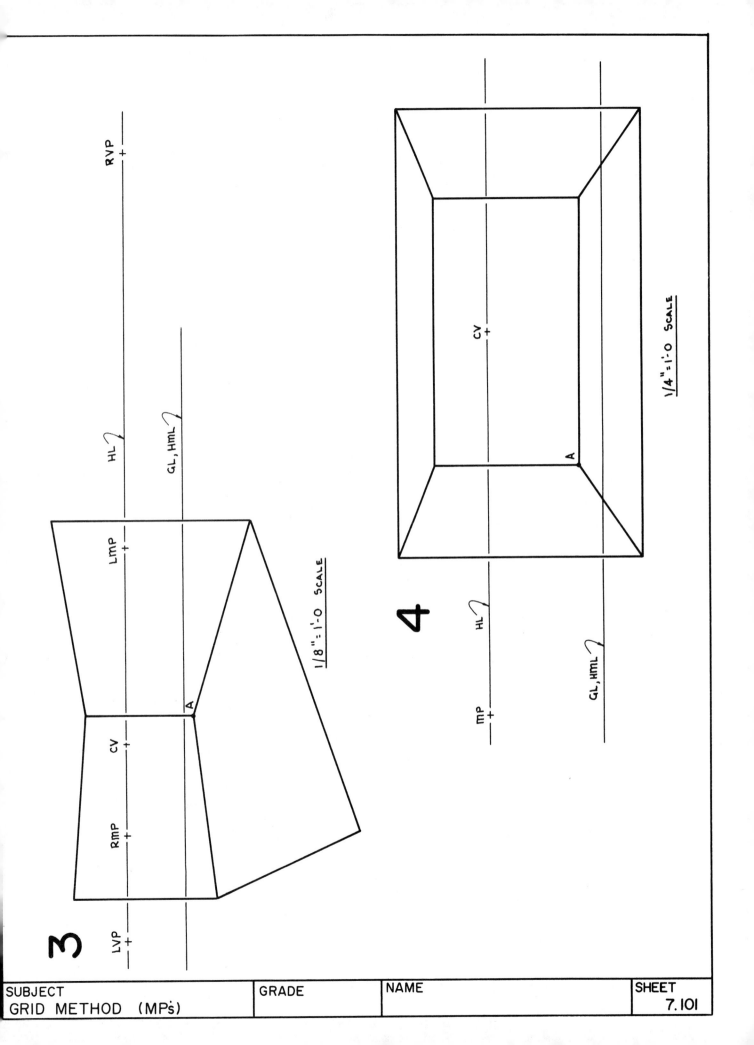

3

RVP +

HL

GL, HmL

LMP +

CV +

A

RMP +

LVP +

1/8" = 1'-0 SCALE

4

CV +

A

HL

MP +

GL, HmL

1/4" = 1'-0 SCALE

SUBJECT
GRID METHOD (MPs)

GRADE

NAME

SHEET
7.101

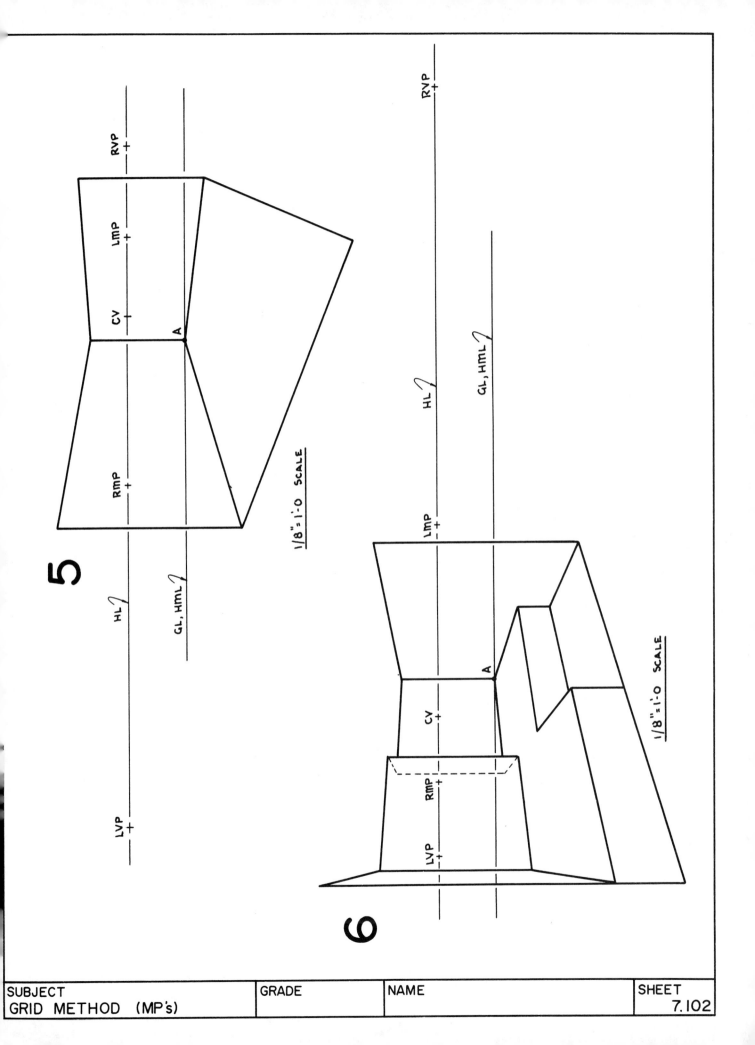

5

RVP +
LMP +
CV +
A
RMP +
HL
GL, HML
1/8"=1'-0 SCALE

6

RVP +
HL
GL, HML
LMP +
CV +
A
RMP +
LVP +
LVP +
1/8"=1'-0 SCALE

| SUBJECT | GRADE | NAME | SHEET |
| GRID METHOD (MP's) | | | 7.102 |

GIVEN:

1. AN INTERIOR GRID SPACE DRAWN AT 3/16" = 1'-0 SCALE.

REQUIRED:

1. DRAW A 4'-0 VERTICAL ABOVE POINT W.

2. DRAW A 6'-0 VERTICAL ABOVE POINT X.

3. DRAW AN 8'-0 VERTICAL ABOVE POINT Y.

4. DRAW A 6'-0 VERTICAL ABOVE POINT Z.

5. DOCUMENT THE HEIGHT OF THE VERTICAL ABOVE POINT O. _____ FEET & INCHES

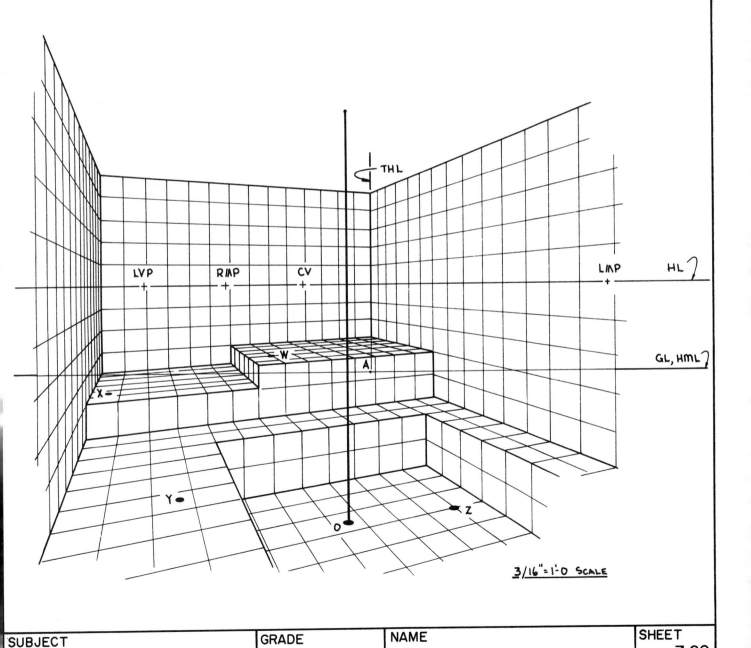

3/16" = 1'-0 SCALE

SUBJECT	GRADE	NAME	SHEET
GRIDS - VERTICAL HEIGHTS			7.20

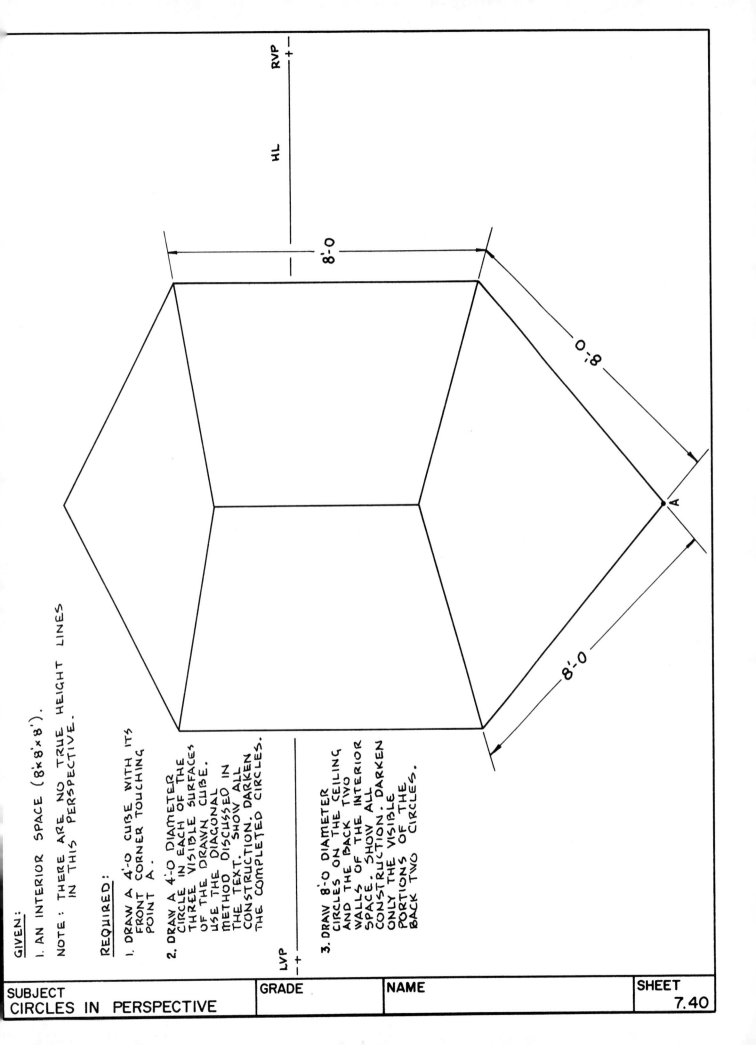

GIVEN:
1. AN INTERIOR SPACE (8'×8'×8').

NOTE: THERE ARE NO TRUE HEIGHT LINES
IN THIS PERSPECTIVE.

REQUIRED:

1. DRAW A 4'-0 CUBE WITH ITS
FRONT CORNER TOUCHING
POINT A.

2. DRAW A 4'-0 DIAMETER
CIRCLE IN EACH OF THE
THREE VISIBLE SURFACES
OF THE DRAWN CUBE.
USE THE DIAGONAL
METHOD DISCUSSED IN
THE TEXT. SHOW ALL
CONSTRUCTION. DARKEN
THE COMPLETED CIRCLES.

3. DRAW 8'-0 DIAMETER
CIRCLES ON THE CEILING
AND THE BACK TWO
WALLS OF THE INTERIOR
SPACE. SHOW ALL
CONSTRUCTION. DARKEN
ONLY THE VISIBLE
PORTIONS OF THE
BACK TWO CIRCLES.

RVP
−
+

HL

8'-0

8'-0

8'-0

8'-0

A

LVP
−
+

SUBJECT	GRADE	NAME	SHEET
CIRCLES IN PERSPECTIVE			7.40

GIVEN:

1. PERSPECTIVE GRID - SCALE 3/16"=1'-0
2. TWO-FOOT GRID SQUARES
3. 10'-0 HIGH WALLS
4. PLAN VIEW OF SPACE
5. CV TO THE LVP = <u>73'-0</u>
6. OMITTED GRID LINES ON THE LEFT WALL
7. PICTURE WIDTH = <u>31'-0</u>

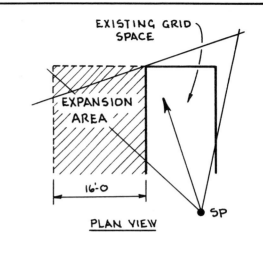

PLAN VIEW

REQUIRED:

1. EXTEND THE HL TO THE LEFT AND LOCATE THE MISSING VANISHING POINT.

2. USING THE VP's AND MP's EXPAND THE EXISTING GRID 16'-0 TO THE LEFT.

3. COMPLETE THE GRID IN THE EXPANSION AREA.

4. DRAW THE 60° CONE OF VISION ON THE PICTURE PLANE.

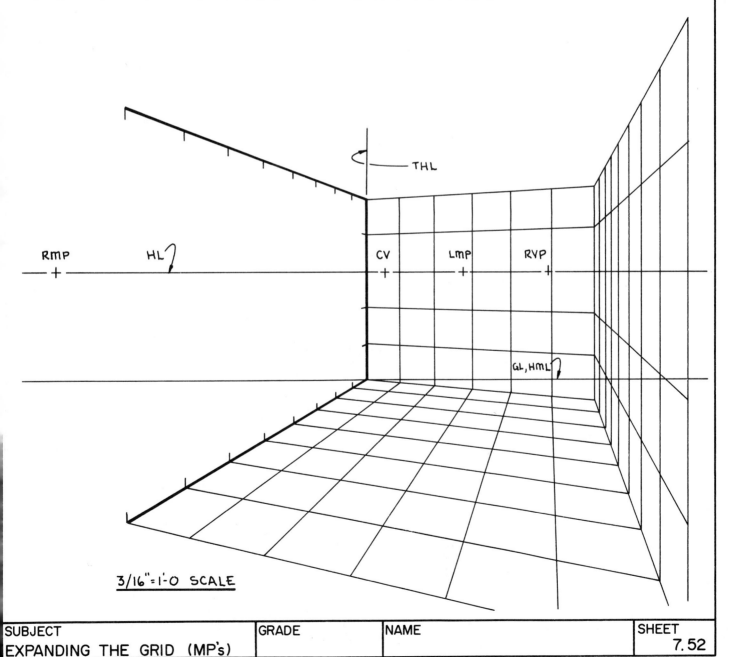

3/16"=1'-0 SCALE

SUBJECT	GRADE	NAME	SHEET
EXPANDING THE GRID (MP's)			7.52

GIVEN:

1. PLAN VIEW OF AN INTERIOR SPACE - 1/8"= 1'-0 SCALE

2. POINTS 3 AND 4 ON THE LEGS OF THE 60° CONE OF VISION

3. POINT A IN THE PICTURE PLANE

4. STATION POINT (SP)

5. 8'-0 HIGH WALLS

6. 1'-0 GRID SQUARES

7. 5'-0 EYE LEVEL

REQUIRED:

1. LAY OUT THE PRELIMINARY HL ON THE GIVEN 1/8"=1'-0 SCALE FLOOR PLAN. THIS HL SHOULD INCLUDE THE CV, THE VP's AND POINTS 1 AND 2.

2. DOCUMENT THE DISTANCE FROM THE:

 * ALL DISTANCES MEASURED AT 1/8"=1'-0 SCALE

CV	TO THE LVP	_____ *	
CV	TO THE RVP	_____	
CV	TO POINT 1	_____	
CV	TO POINT A	_____	(DIM. α)
CV	TO POINT 2	_____	
POINT A TO POINT 3		_____	
POINT A TO POINT 4		_____	

3. TAKING THE DATA FROM THE COMPLETED PRE-LIMINARY HL, LAY OUT THE FINAL HL AT 1/4"=1'-0 SCALE. USE THE SHEET PROVIDED. (7.601)

4. DRAW THE INTERIOR SPACE IN PERSPECTIVE USING THE METHOD DISCUSSED IN SECTION 7.6. DEVELOP 1'-0 GRID SQUARES ON THE WALLS AND FLOOR OF THE SPACE.

5. DRAW THE 60° CONE OF VISION ON THE PICTURE PLANE.

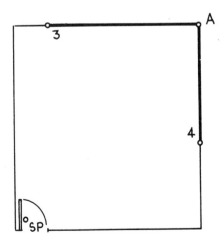

INTERIOR SPACE

1/8"=1'-0 SCALE (PRELIMINARY HL)

SUBJECT	GRADE	NAME	SHEET
ORIGINAL GRID (DIAGONAL)			7.60

DRAW THE PERSPECTIVE GRID ON THIS SHEET AT 1/4"=1'-0 SCALE.

CV

FINAL HL

PERSPECTIVE AT 1/4"=1'-0 SCALE

SUBJECT ORIGINAL GRID (DIAGONAL)	GRADE	NAME	SHEET 7.601

GIVEN:

1. PLAN VIEW OF THE GRID SPACE

2. PERSPECTIVE OF THE ORIGINAL GRID SPACE

3. TWO-FOOT GRID SQUARES

4. PICTURE WIDTH (PW) = <u>32'-0</u> @ 3/16"=1'-0 SCALE

5. CV TO THE LVP - <u>98'-5"</u> @ 3/16"=1'-0 SCALE

REQUIRED:

1. EXTEND THE HL TO THE LEFT AND LOCATE THE MISSING VANISHING POINT.

2. LOCATE AND LABEL THE DIAGONAL VANISHING POINT (DVP).

3. EXPAND THE GRID FORWARD AN ADDITIONAL 6'-0.

4. USING THE VP's COMPLETE THE EXPANDED GRID.

5. DRAW THE 60° CONE OF VISION ON THE PICTURE PLANE.

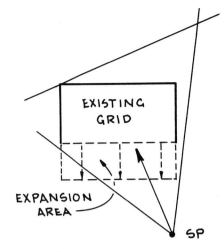

PLAN VIEW

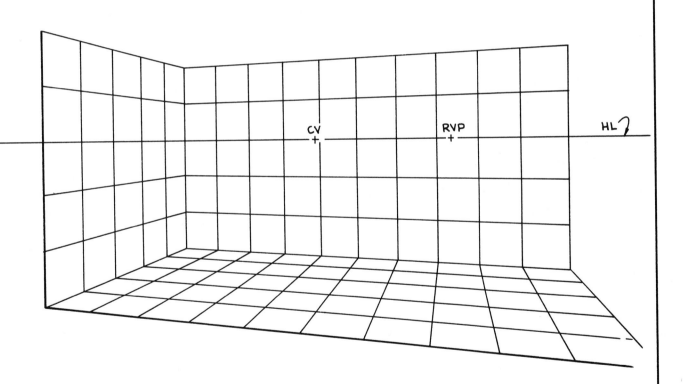

PERSPECTIVE GRID

3/16"=1'-0 SCALE

SUBJECT	GRADE	NAME	SHEET
EXPANDING THE GRID (DIA.)			7.72

1. FOUR PERSPECTIVE DRAWINGS OF:

 a. AN INTERIOR SPACE WITH A <u>5'-0 HL</u> @ 3/16"=1'-0 SCALE

 b. AN INTERIOR SPACE WITH A <u>2'-6" HL</u> @ 3/16"=1'-0 SCALE

 c. A PERSPECTIVE GRID SPACE WITH A <u>3'-6" HL</u> @ 3/16"=1'-0 SCALE

 d. AN INTERIOR SPACE OF <u>UNKNOWN SCALE</u>

2. THE LOCATION AND HEIGHT OF A PERSON OR PERSONS IN EACH SPACE

<u>REQUIRED:</u>

1. USING THE TECHNIQUES DISCUSSED IN SECTION 7.8, DRAW THE REQUIRED FIGURES IN EACH OF THE DESIGNATED LOCATIONS. THESE FIGURES CAN BE DRAWN FREEHAND OR TRACED FROM A DRAWING FILE.

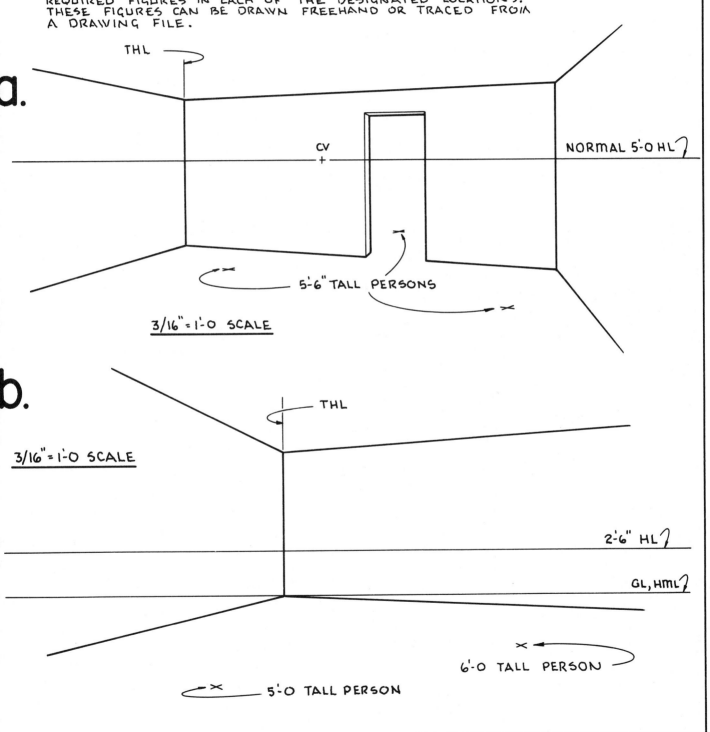

a.

THL

CV

NORMAL 5'-0 HL

5'-6" TALL PERSONS

<u>3/16"=1'-0 SCALE</u>

b.

<u>3/16"=1'-0 SCALE</u>

THL

2'-6" HL

GL, HML

6'-0 TALL PERSON

5'-0 TALL PERSON

SUBJECT	GRADE	NAME	SHEET
PEOPLE IN PERSPECTIVE			7.80

D-1

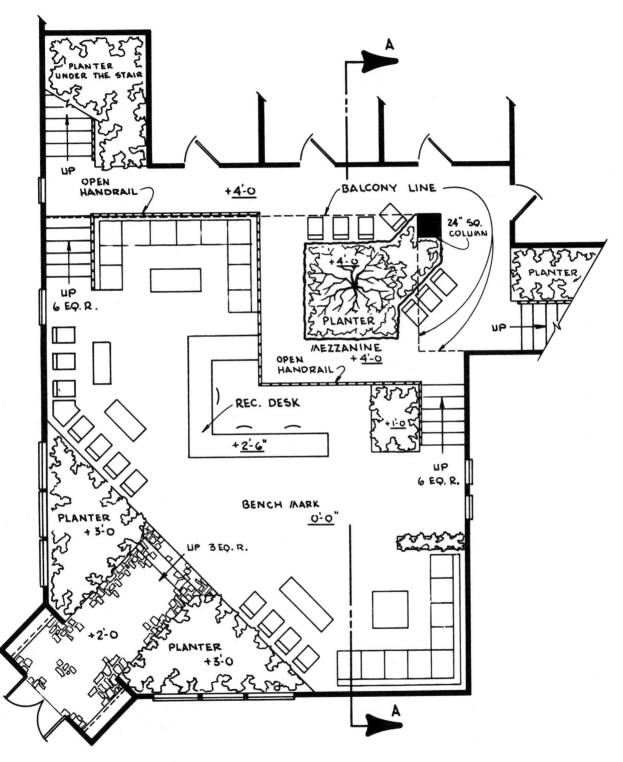

A

PLANTER
UNDER THE STAIR

UP

OPEN
HANDRAIL

+4'-0

BALCONY LINE

A

24" SQ.
COLUMN

PLANTER

UP
6 EQ.R.

+4'-0

PLANTER

UP

MEZZANINE
+4'-0

OPEN
HANDRAIL

REC. DESK

+1'-0

+2'-6"

UP
6 EQ.R.

BENCH MARK
0'-0"

PLANTER
+3'-0

UP 3 EQ.R.

+2'-0

PLANTER
+3'-0

A

FLOOR PLAN
1/8"=1'-0 SCALE

SUBJECT	GRADE	NAME	SHEET
PERSPECTIVE - Commercial			7.90

D-2

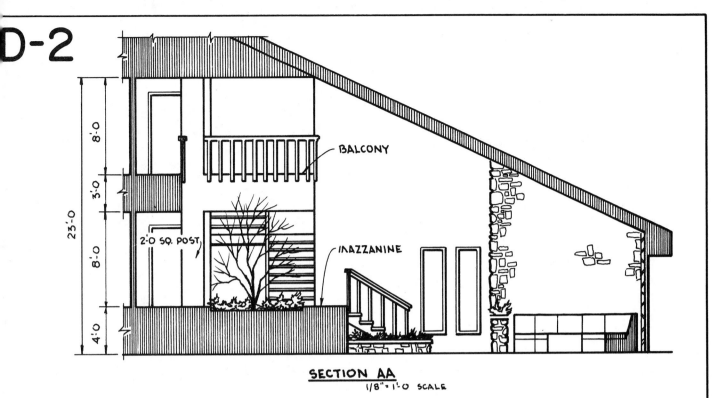

25'-0
8'-0
3'-0
8'-0
4'-0

BALCONY

2'-0 SQ. POST

MAZZANINE

SECTION AA
1/8"=1'-0 SCALE

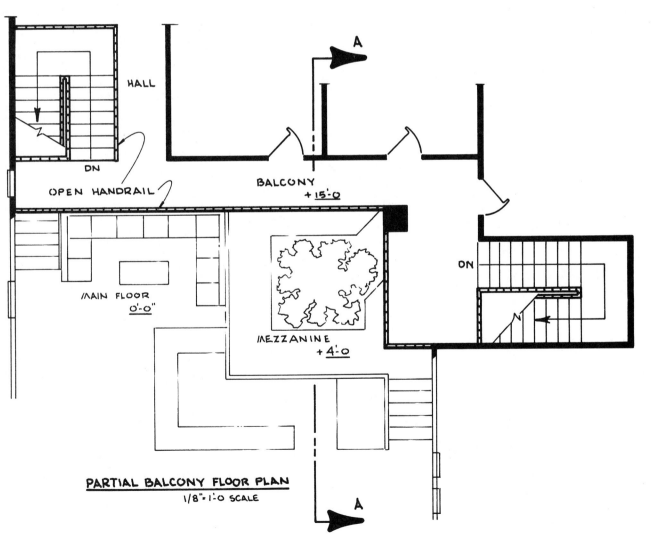

A

HALL

DN

OPEN HANDRAIL

BALCONY
+15'-0

ON

MAIN FLOOR
0'-0"

MEZZANINE
+ 4'-0

PARTIAL BALCONY FLOOR PLAN
1/8"=1'-0 SCALE

A

SUBJECT	GRADE	NAME	SHEET
PERSPECTIVE- Commercial			7.901

F-1

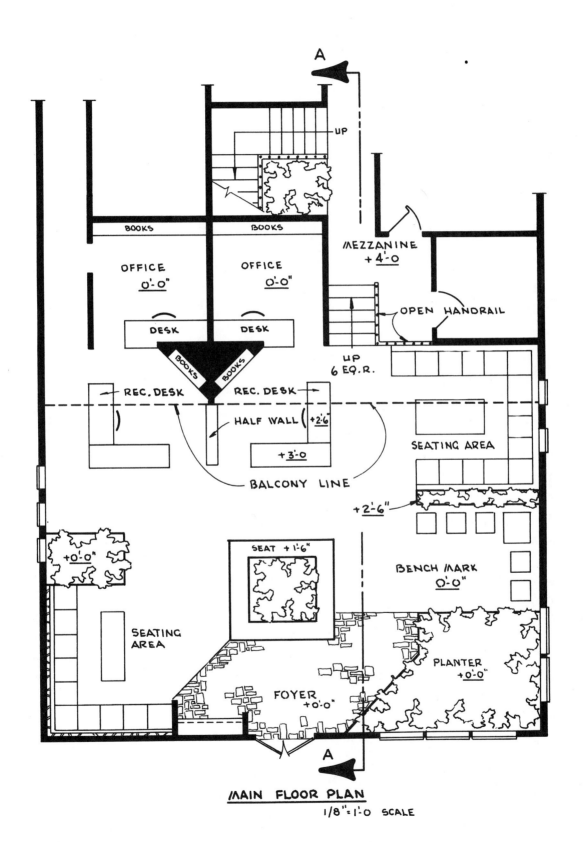

A

UP

BOOKS BOOKS

OFFICE OFFICE
0'-0" 0'-0"

MEZZANINE
+ 4'-0

DESK DESK

OPEN HANDRAIL

BOOKS BOOKS

UP
6 EQ. R.

REC. DESK REC. DESK

HALF WALL (+2'-6"

+ 3'-0

SEATING AREA

BALCONY LINE

+2'-6"

SEAT +1'-6"

BENCH MARK
0'-0"

+0'-0"

SEATING
AREA

PLANTER
+0'-0"

FOYER
+0'-0"

A

MAIN FLOOR PLAN
1/8"=1'-0 SCALE

F-2

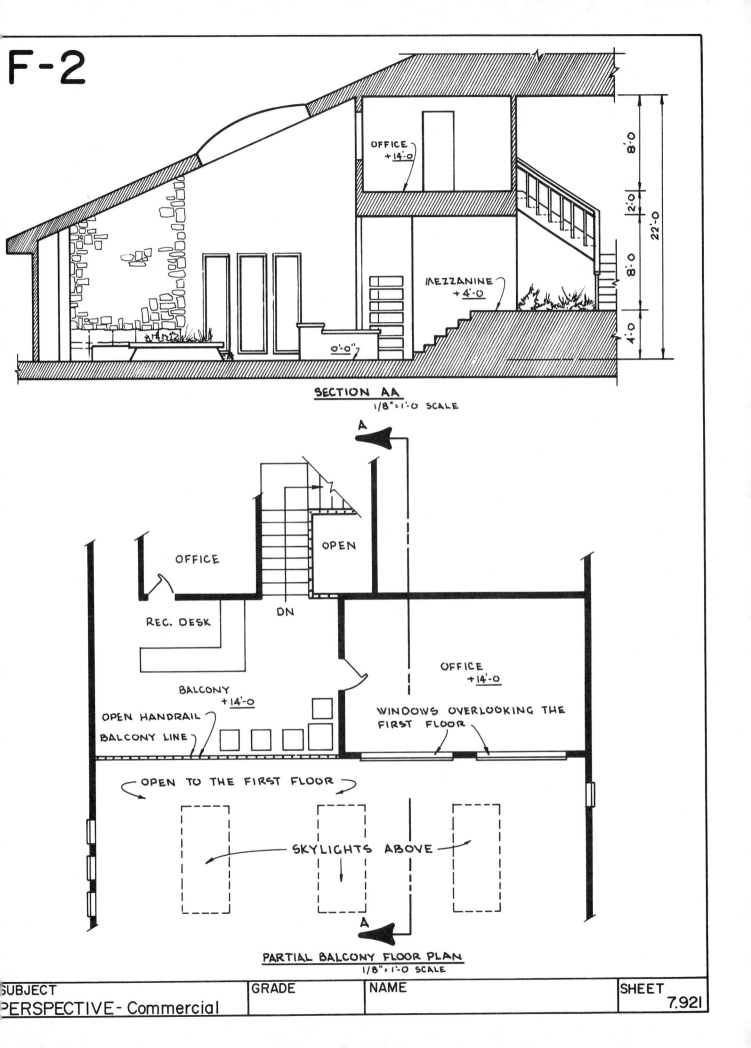

OFFICE
+ 14'-0

8'-0

12'-0

22'-0

MEZZANINE
+ 4'-0

8'-0

4'-0

0'-0"?

SECTION AA
1/8"=1'-0 SCALE

A

OFFICE

OPEN

DN

REC. DESK

BALCONY
+ 14'-0

OFFICE
+ 14'-0

OPEN HANDRAIL
BALCONY LINE

WINDOWS OVERLOOKING THE
FIRST FLOOR

OPEN TO THE FIRST FLOOR

SKYLIGHTS ABOVE

A

PARTIAL BALCONY FLOOR PLAN
1/8"=1'-0 SCALE

SUBJECT	GRADE	NAME	SHEET
PERSPECTIVE- Commercial			7.921

1. FLOOR PLAN - 1/8"=1'-0 SCALE

2. LOCATION OF THE STATION POINT (SP)

3. POINTS A AND B ON THE LEGS OF THE 60° CONE OF VISION

4. POINT C IN THE PICTURE PLANE

5. EYE LEVEL AT 8'-0 ABOVE THE FLOOR

6. 12'-0 HIGH CEILING

REQUIRED:

1. DIRECTLY ON THE GIVEN FLOOR PLAN, DRAW THE 60° CONE OF VISION AND LOCATE AND DRAW THE PROPERLY ALIGNED PICTURE PLANE.

2. ROTATE THE FLOOR PLAN COUNTER-CLOCKWISE UNTIL THE EDGE VIEW OF THE PICTURE PLANE, WHICH WILL ALSO SERVE AS THE HL, IS HORIZONTAL. TAPE THE FLOOR PLAN IN THIS POSITION.

3. LOCATE THE VANISHING POINTS AND CENTER OF VISION ON THIS PICTURE PLANE, HORIZON LINE (PP, HL).

4. CUT AN 8½"x 11" PIECE OF TRANSPARENT TRACING PAPER. SEE FIG. 1 FOR THIS SHEET'S LAYOUT.

FIG. 1

+5'-0 (FILES)

C

COUNTER

+ 3'-0

PLANTER + 3'-0

PLANTER + 3'-0

+2'-8"

A

UP 4R @ 8" EA.

OPEN HANDRAIL

B

+0'-8"

COUNTER

+ 2'-6"

+ 0'-0" BENCH MARK

1/8"=1'-0 SCALE

• SP

5. ALIGNING THE TWO HL's AND THE TWO CV's, TAPE THE TRANSPARENT TRACING PAPER OVER THE GIVEN 1/8" FLOOR PLAN. SEE FIG. 2.

CV HL, PP

FIG. 2

6. USING THE QUICK SKETCH TECHNIQUE DISCUSSED IN CHAPTER 8, DRAW A COMPLETE PERSPECTIVE SKETCH OF THE INTERIOR SPACE.

SUBJECT	GRADE	NAME	SHEET
QUICK SKETCH TECHNIQUE			8.10

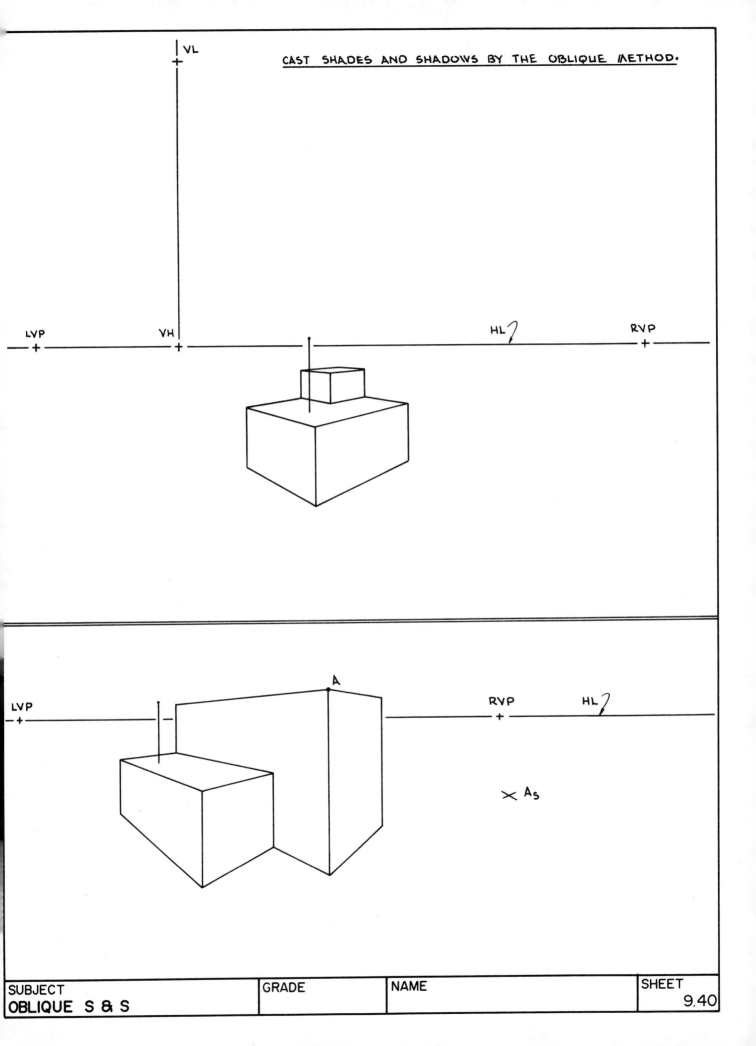

CAST SHADES AND SHADOWS BY THE OBLIQUE METHOD.

VL

LVP VH HL RVP

LVP A RVP HL

× As

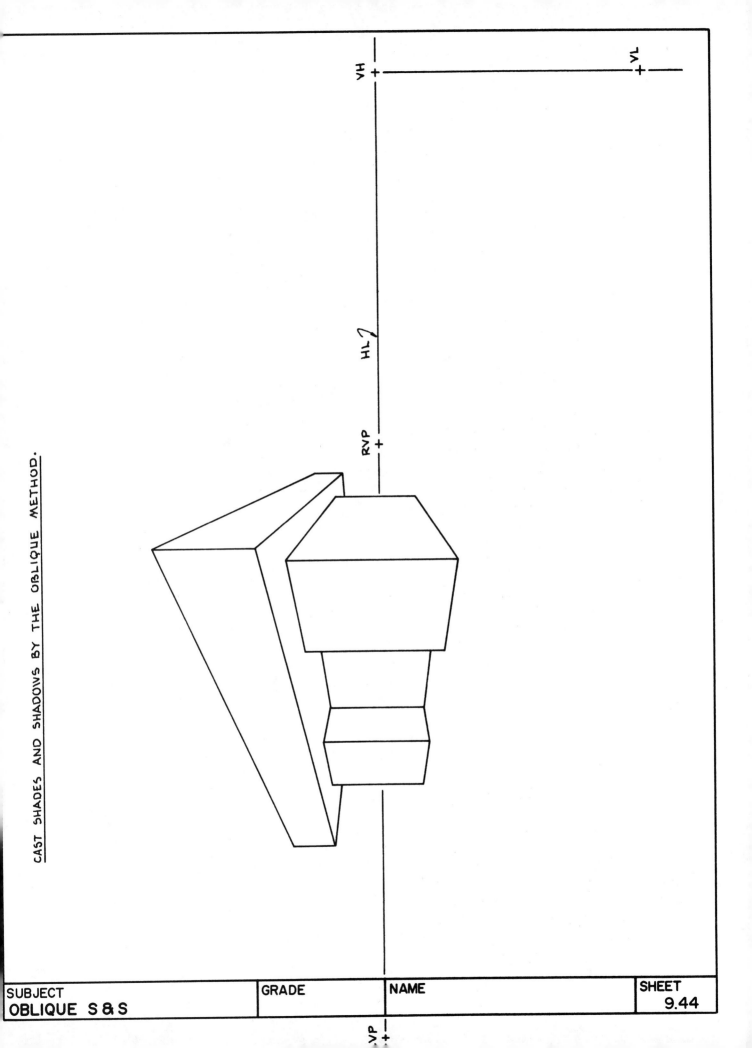

CAST SHADES AND SHADOWS BY THE OBLIQUE METHOD.

VH

VL

HL

RVP

VP

SUBJECT	GRADE	NAME	SHEET
OBLIQUE S & S			9.44

OBLIQUE SHADES AND SHADOWS

POINT As IS THE PERSPECTIVE SHADOW OF POINT A.

LOCATE THE VH AND THE VL AND COMPLETE THE SHADES AND SHADOWS.

RVP

HL

A

LVP

As

SUBJECT
OBLIQUE S & S

GRADE

NAME

SHEET
9.45

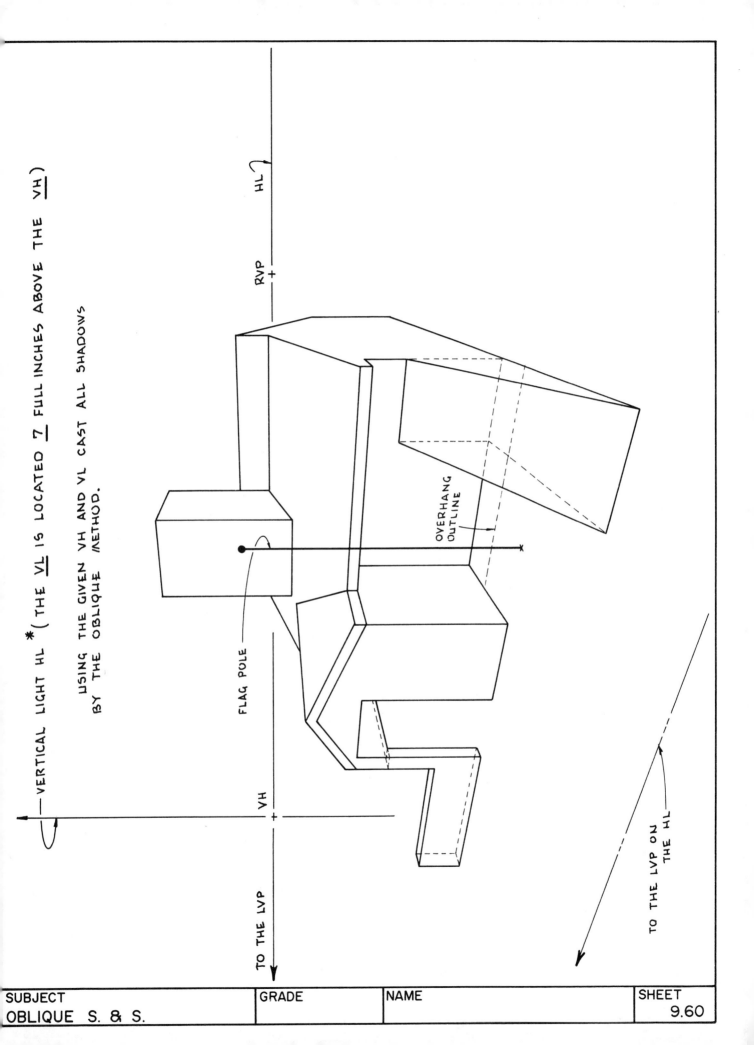

VERTICAL LIGHT HL *(THE VL IS LOCATED 7 FULL INCHES ABOVE THE VH)

USING THE GIVEN VH AND VL CAST ALL SHADOWS
BY THE OBLIQUE METHOD.

HL

RVP
+

OVERHANG
OUTLINE

FLAG POLE

VH
+

TO THE LVP

TO THE LVP ON
THE HL

| SUBJECT | GRADE | NAME | SHEET |
| OBLIQUE S. & S. | | | 9.60 |

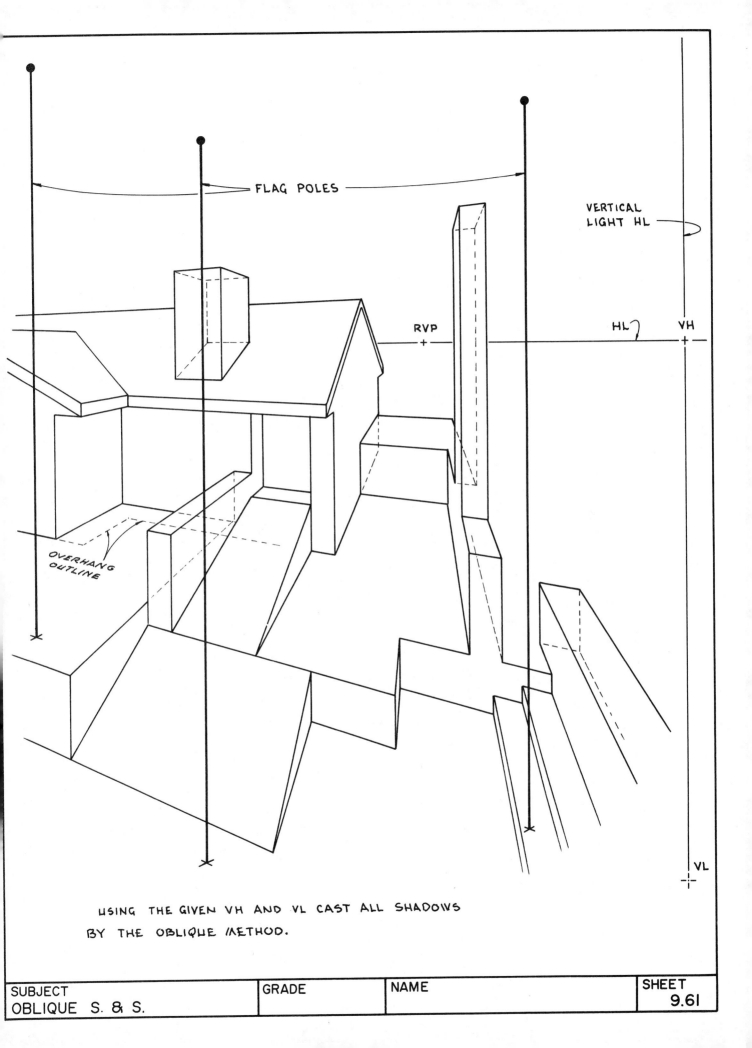

FLAG POLES

VERTICAL
LIGHT HL

RVP

HL

VH

OVERHANG
OUTLINE

VL

USING THE GIVEN VH AND VL CAST ALL SHADOWS
BY THE OBLIQUE METHOD.

SUBJECT	GRADE	NAME	SHEET
OBLIQUE S. & S.			9.61

CAST SHADES AND SHADOWS BY THE OBLIQUE METHOD.

DOCUMENT THE LIGHT
RAY DATA.

PLAN ∠ _____
ELEVATION ∠ _____
TRUE ∠ _____

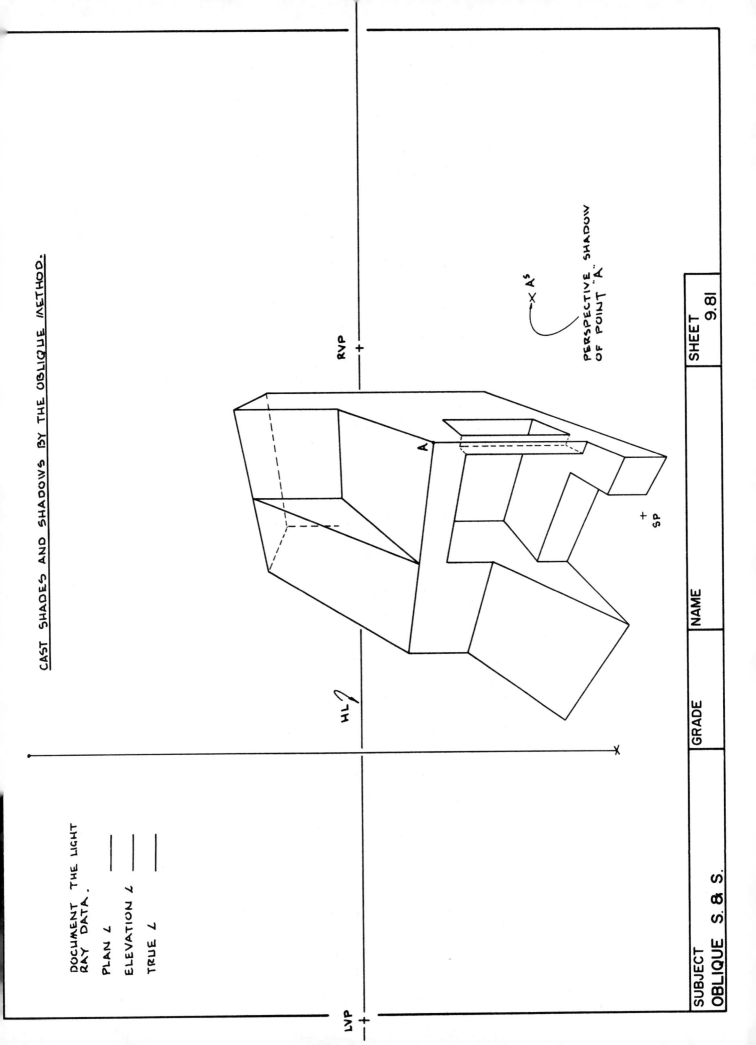

RVP +

A

+ SP

As ×

PERSPECTIVE SHADOW
OF POINT "A"

HL

× X

LVP +

SUBJECT	GRADE	NAME	SHEET
OBLIQUE S. & S.			9.81

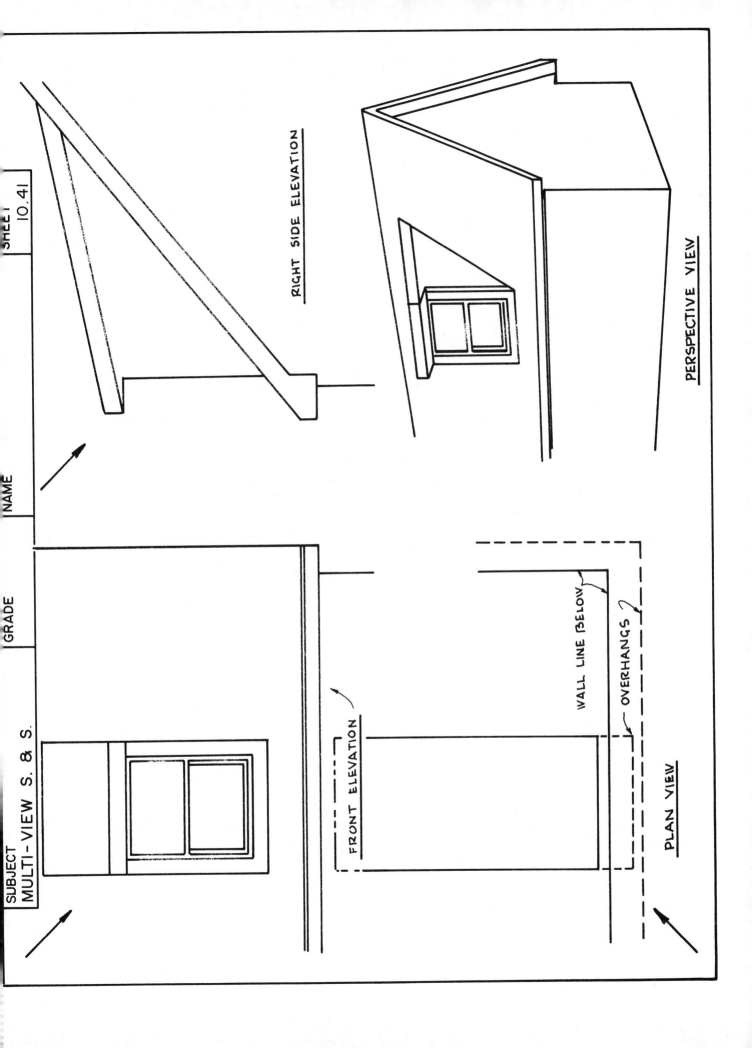

SHEET
10.41

NAME

GRADE

SUBJECT
MULTI-VIEW S. & S.

RIGHT SIDE ELEVATION

PERSPECTIVE VIEW

FRONT ELEVATION

WALL LINE BELOW

OVERHANGS

PLAN VIEW

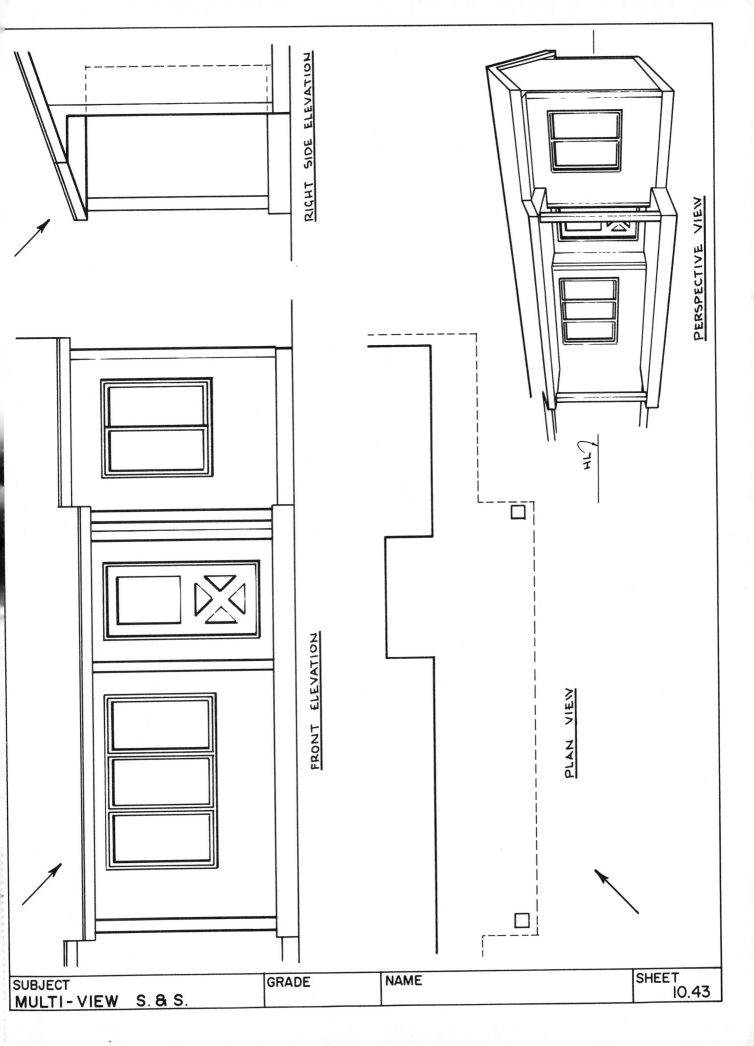

RIGHT SIDE ELEVATION

PERSPECTIVE VIEW

HL

FRONT ELEVATION

PLAN VIEW

SUBJECT	GRADE	NAME	SHEET
MULTI-VIEW S. & S.			10.43

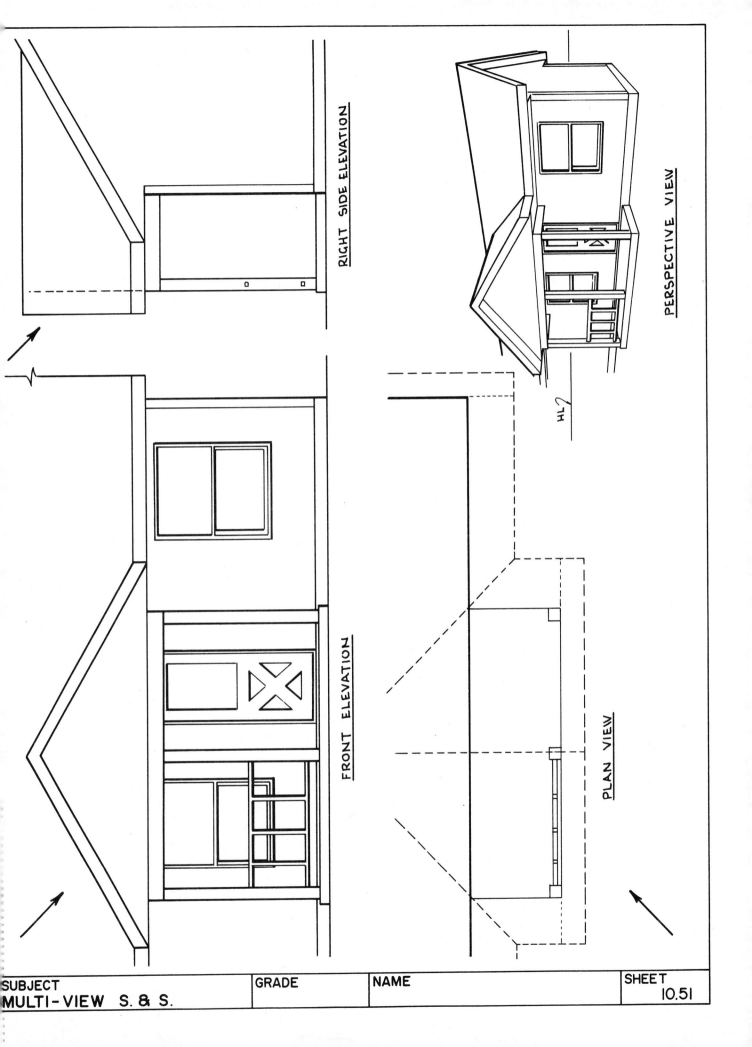

RIGHT SIDE ELEVATION

PERSPECTIVE VIEW

FRONT ELEVATION

PLAN VIEW

SUBJECT	GRADE	NAME	SHEET
MULTI-VIEW S. & S.			10.51

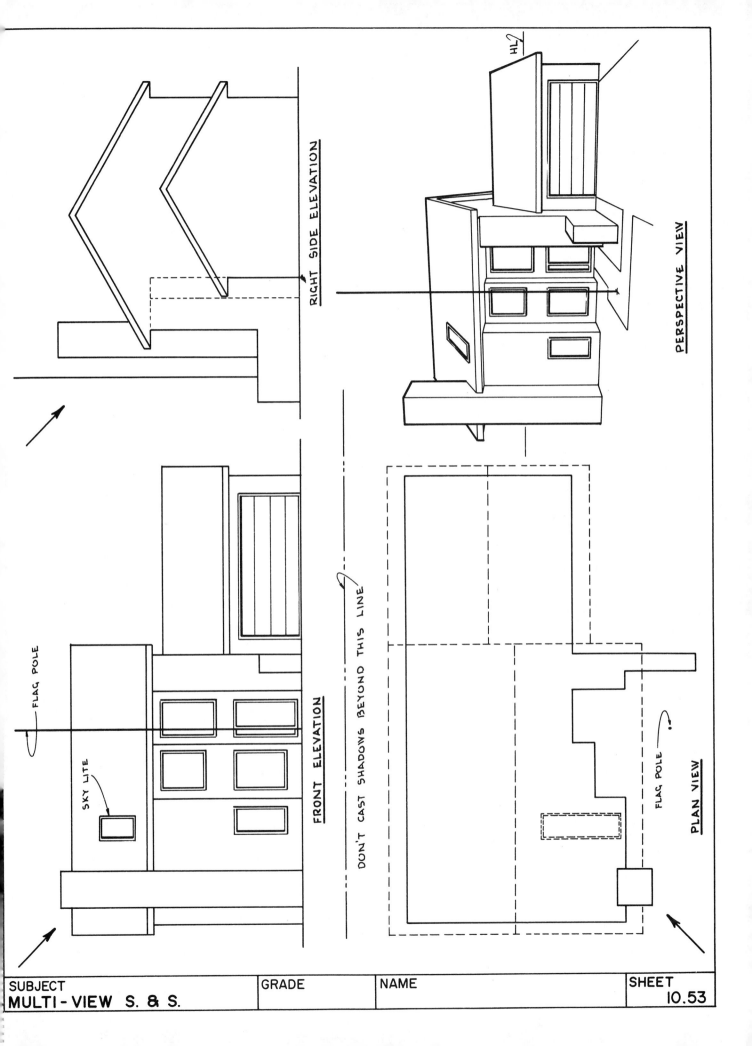

RIGHT SIDE ELEVATION

PERSPECTIVE VIEW

HL

FLAG POLE

SKY LITE

FRONT ELEVATION

DON'T CAST SHADOWS BEYOND THIS LINE

FLAG POLE

FLAG POLE

PLAN VIEW

SUBJECT	GRADE	NAME	SHEET
MULTI - VIEW S. & S.			10.53

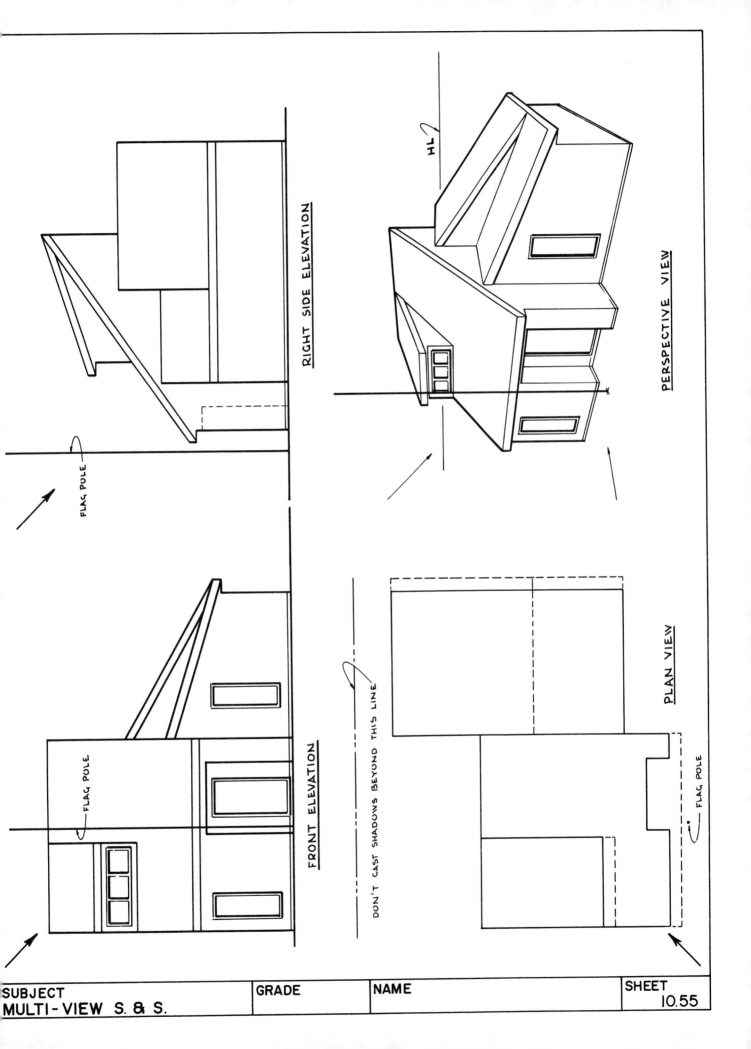

RIGHT SIDE ELEVATION

FLAG POLE

PERSPECTIVE VIEW

HL

FRONT ELEVATION

FLAG POLE

DON'T CAST SHADOWS BEYOND THIS LINE

PLAN VIEW

FLAG POLE

| SUBJECT | GRADE | NAME | SHEET |
| MULTI-VIEW S. & S. | | | 10.55 |

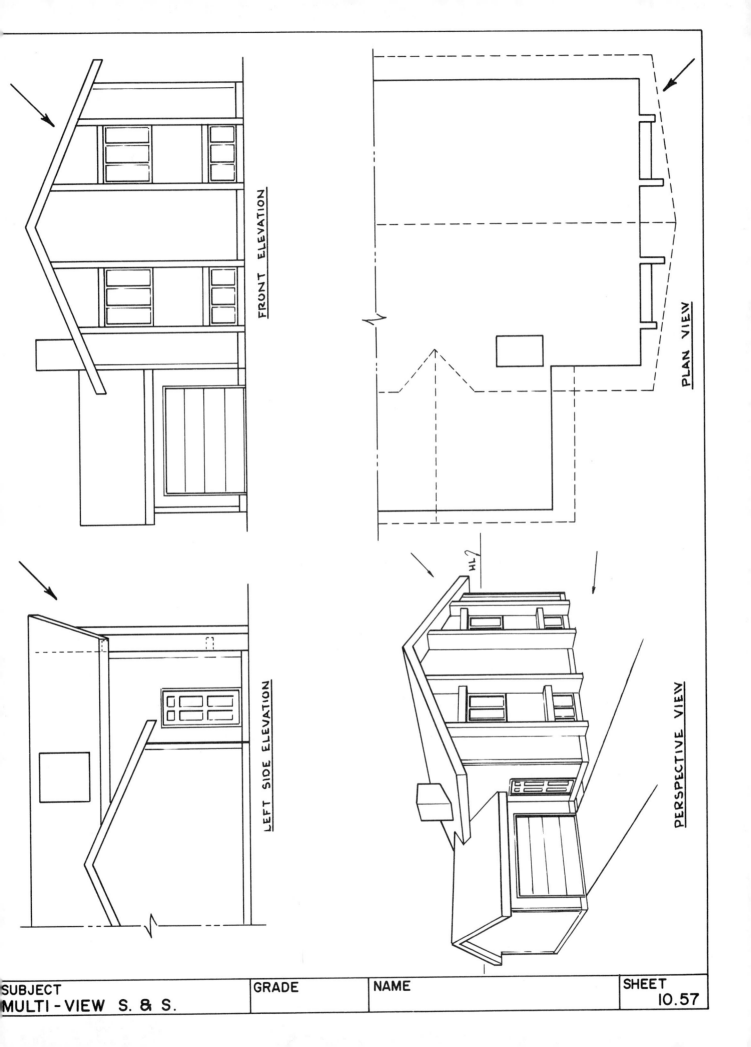

FRONT ELEVATION

PLAN VIEW

LEFT SIDE ELEVATION

PERSPECTIVE VIEW

SUBJECT	GRADE	NAME	SHEET
MULTI - VIEW S. & S.			10.57

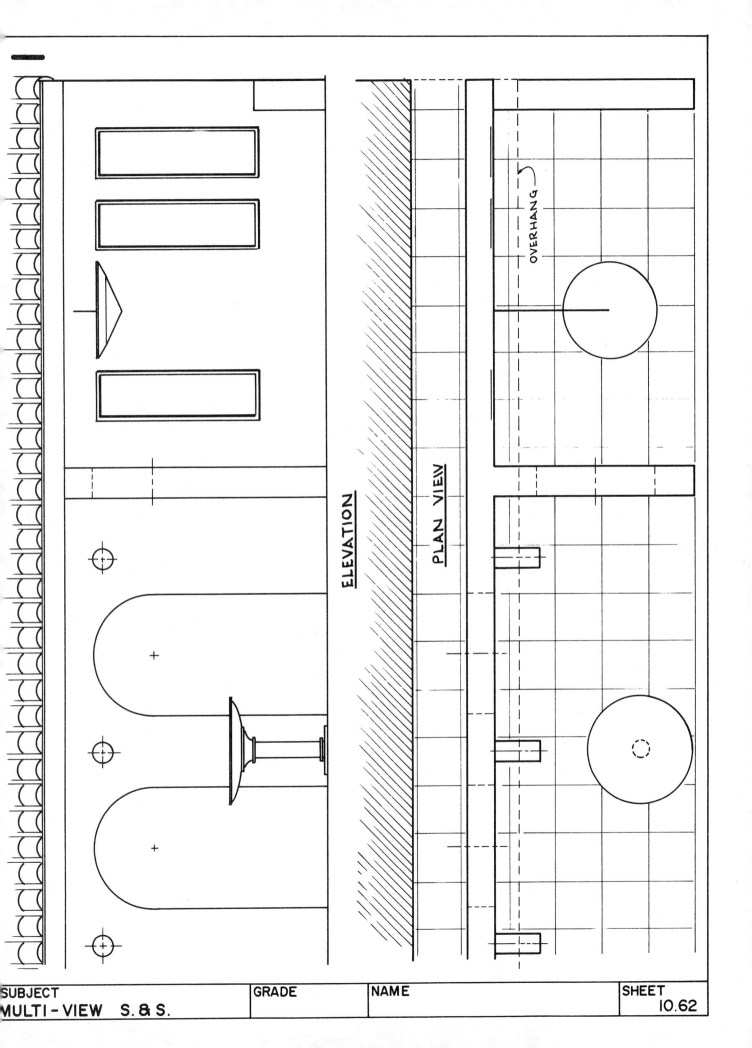

ELEVATION

PLAN VIEW

OVERHANG

SUBJECT
MULTI - VIEW S. & S.

GRADE

NAME

SHEET
10.62

2

31" TO RVP

LVP
+

HL

SUBJECT
MULTI- VIEW S. & S.

GRADE

NAME

SHEET
10.621

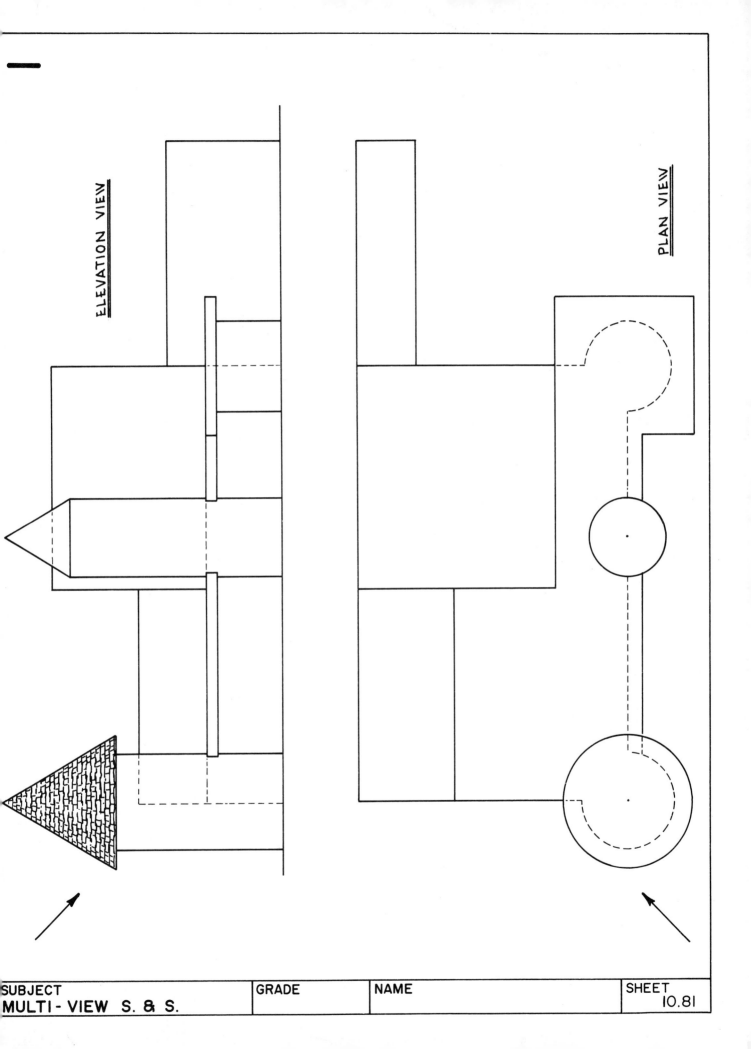

ELEVATION VIEW

PLAN VIEW

SUBJECT
MULTI- VIEW S. & S.

GRADE

NAME

SHEET
10.81

HL

CV